ELECTRONIC
CULTURE

TECHNOLOGY AND VISUAL REPRESENTATION

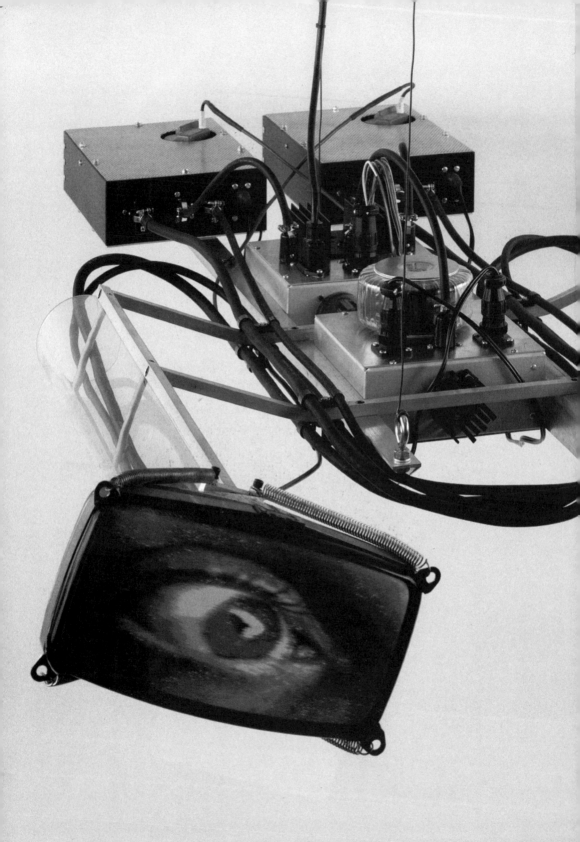

ELECTRONIC CULTURE

TECHNOLOGY AND VISUAL REPRESENTATION

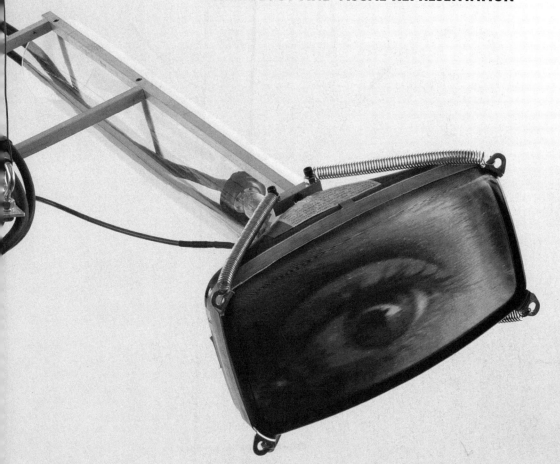

EDITED BY TIMOTHY DRUCKREY

PREFACE BY ALLUCQUÈRE ROSANNE STONE

A P E R T U R E

contents

preface

■ Allucquère Rosanne Stone

WELCOME TO THE PRESENT

Ends of millennia are angst-ridden occasions when reality shifts gears, and it appears that the synchromesh doesn't always work properly. We find ourselves in the paradoxical situation that the more we call "that which becomes known" by the name "reality," the further we distance ourselves from it. Because with time and increasingly sophisticated tools, reality seems more and more intelligible — as images on screens, images of events that we will never ourselves experience, subatomic collisions, the DNA helix, movement of ions within synapses. What's actually happening is that our understanding of the world and of "nature" increasingly becomes secondhand, like a story. Part of the shining thread that runs through the accounts presented in this book is a story of questioning certain deep cultural dreams and growing infatuated with others.

Scientific practice was based on a kind of rugged, hands-on experimentation — students learned to pith and dissect frogs, to roll balls down inclined planes. The outcomes of those experiments are maps too; they also describe phenomena we can't see; the rolling ball demonstrates something about gravity, the frog demonstrates something about life — but we learn to link them tightly with this thing called "the real," to think of them as unbreakable and natural links to an absolute experience of physical phenomena. It is against this background of a hard, obdurate, understandable real world that we fight the wars over who gets to tell the stories about that world. And who gets to tell the stories gets to say what it means to think and to exist as thinking beings.

In his landmark study of scientific discovery, *Laboratory Life*, sociologist Bruno Latour showed that much of producing scientific facts consists of "inscription machines"—little technologies that convert some process of observation into marks on paper. The scientists study the marks, not the objects, and here again is the implied link between the event and the story. Some of this continual process of converting reality into stories is visible to us, but most of it isn't. The

mechanism for carrying out that conversion is a kind of thought-virus, erasing the evidence of its work as soon as it is finished.

We still get our idea of a stable, "real" world muddled up with mechanisms for perceiving that world. Stephen Spielberg's *Jurassic Park* marked another watershed in this process, in which the digital artists at George Lucas's Industrial Light and Magic mingled images of live actors with computer-generated dinosaurs, not models, like King Kong, but completely derealized objects that never existed outside a computer. It's much the same phenomenon Latour saw happening in science work, a loss of boundary distinctions between levels of experience, letting the machine act as an emissary from the invisible. The transition from solid models to digitally generated images has gone to completion in an astonishingly short time: Douglas Trumbull and crew created the visuals for the motion-control ride at Luxor in Las Vegas using laser-carved plastic models photographed by a motion-controlled camera moving on an overhead crane; immediately following that, Trumbull sold off all his photographic equipment and thereafter has designed exclusively in the digital domain. That was in 1993. Makes me feel old, and it certainly makes my 1978 Altair computer feel old.

We, the academic researchers and critics, are as caught up in this as anyone else. Privileging vision has a long history that involves not only photography but text; witness that as a culture we chose to embody our knowledge in the form of books — and until very recently books, too, possessed that ineluctable quality of existing only in discrete locations. With the onset of everything being everyhere, we began to question the authority and mechanism of the specular gaze — i.e., looking at something from a single viewpoint. Specularity, it seems, is tenacious, if not precisely persistent; and in complex ways it's at the heart of debates over how consciousness works. A single visual viewpoint seems to require a single awareness that does the viewing. In the age of Xerox and TV, the presence of an infinity of instantly replicable images hasn't (yet) managed to dislodge our stubborn sense that we exist as individual beings, fixed in space and time. And yet . . . we do change. But it's the other guys who get to take advantage of our senses of singular selfhood, the guys with the credit-checking databanks and consumer profiles. Out of the snail track of our passage through a world of myriad simultaneous opportunities for consumption, they build their own images of who we are, freed from the constraints of linearity or sense. Our database doppelgangers are already free of the tyranny of localized subjectivity; they follow the geodesics of capital and of ideal citizenship. It's ourselves that haven't yet caught up.

In the vast interweaving of stories by means of which we create and maintain our human cultures, the story of progress has been one of the deepest and most powerful. It appears and reappears in an infinite variety of guises. Stripped of any baggage, it is the simple idea that time has an arrow and that one end of the arrow is different from the other. Stories have beginnings and ends, actions have consequences. The entire structure of narrative depends upon this simple relationship.

Implied in this way of thinking about the world is the idea that we are going somewhere, that the end of everything, like the end of a story, is going to be satisfying (otherwise by definition it isn't the end), that it will be in some sense definitive. That's what "end" *means*, with perhaps the sole exception of personal death; and we don't think about that much anyway. The invention of salvation — the idea that we're going *somewhere*, and that that somewhere has *intrinsic value* — must have been a hell of a kick. Among other things, it provided a structure of purpose, intention, reason; it's an immensely powerful idea, so powerful that it's become part of the epistemic wallpaper, still driving things along while being more or less invisible.

SPEAKING OUT OF THE MODERNIST PARADIGM

So, the linearity of narrative and the singularity of consciousness jacks in (or smacks in, as into a food processor) to electronic culture — which, in its current guise, is neither linear nor singular. How to generate a useful critique of this moment? Unfortunately, the easiest error is to examine it from within the modernist paradigm. After all, we're all children of modernism, raised within that mighty architecture and so steeped in it that not only is it invisible but we view with deep suspicion or outright derision ways of circumventing or fracturing its hegemony. This has been the extremely thorny problem for the "post"-foo contingent since its inception. If modernism is the only language you know, how do you make a statement that isn't modernist and still have it understood? Audre Lorde's acerbic comment was that the Master's tools will never dismantle the Master's house — or, I would add, comment on it.

Nevertheless, there has been a considerable body of work in which thoughtful critics have attempted to come to grips with the beast while living inside its belly, and they haven't done too badly. The real action is where it always is and in all probability always will be — not within an existing discipline, which by nature has already achieved a stability from which it will fight any attempt to tinker with its episteme, but out at the margins and in the cracks, the Temporary Autonomous Zones and unlicensed areas that several contributors here have playfully and provocatively suggested. As long as knowledge systems continue to be born and die we will be at war with our own creations — dynamic wars of growth and change in which we will continually battle to surpass ourselves.

CYBERSPACE: RESISTANCE, OR SAME-OLD SAME-OLD?

I'd be remiss if I didn't mention our latest instantiation of the complex idea of electronic culture, because it seems to be implicated in so many of the accounts presented here, and perhaps to point beyond them in complex and sometimes troubling ways.

It's been my pleasure to study cyberspace as an emergent phenomenon in a number of fields, from philosophy to cultural theory to computer science and beyond. In and of itself, the Net, the Infobahn, the whatever-you-callit that's having its moment of deification/demonization, is nothing more than a physical manifestation of pure opportunity, neither liberatory nor restrictive. It's only one aspect of cyberspace, but it's come to stand for the entire epistemic enchilada. However, the global distributed communication system within which the Netfobahn is embedded is an example of the exceedingly rare situation in which designing to military specifications turns out to offer a terrific advantage to everyone else. This is because the very things about the Net that make it nearly indestructible in event of enemy attack also make it nearly uncontrollable by a single, central entity.

However, that situation, while rich with promise, doesn't in any way guarantee that what happens in cyberspace will be liberatory in character or purpose. Our species is endlessly inventive in coming up with new and exciting ways to shoot itself in the foot. On one hand are those, taking after Net architect John Gilmore, who claim that "the Net treats censorship as damage, and routes around it." (It's tempting to add the cognate, "American society treats intelligence as damage, and routes around it.") On the other hand are those who claim that cleverness, religious zeal, fear of the new and strange, and simple downright perversity will be more than sufficient to kill off any transformative potential the Net may possess. It's important, however, to remember that the arrival of cyberspace as a specific concept — oddly in step with the millenium as it may be — neither nullifies any of the philosophical inquiries that preceded it nor valorizes the later work that critiques it; though it certainly provides toothsome opportunities for rethinking some hoary problems of vision and representation.

What I mostly hope is that cyberspace doesn't turn out to be merely a distraction, an energy drain that turns our focus away from deeper changes in the workings of capital, information, and thought — the kinds of issues that various authors in this book address. The most visible debates here in the U.S. are over shallow, hot-button, class issues such as clean versus dirty thinking. Personally, I don't agree with either the cyberutopians or those who believe that freedom of speech must mean unbridled kiddie porn. Value neutrality at the level of the infrastructure has little to do with what happens in the metastructure, which is the level at which we all participate in such electronic culture as it exists. As fledgling social formations struggle to find their identities in the Net, I take heart from CompuServe's early withdrawal from attempts to censor communications between its enclave and the rest of cyberspace, choosing instead to leave issues of appropriate access up to individual subscribers.

At this juncture there is plenty of software available with the ability to limit access to the new electronic communities. In the U.S., our biggest problem in that regard is still the segment of the population, minuscule but powerful in the way

fanaticism can be powerful far beyond its measure, that would rather see abortion providers shot dead than permit individual citizens to make their own decisions about issues perceived as possessing moral scope. So long as the world contains those who would have everyone else step to one tune, the ancient battles over control of both technology and thought will continue to rage as they always have.

The simple point of all this is that it's up to us. We can pay attention or allow ourselves to be distracted. Questions about whether cyberculture will be repressive or liberatory or anything at all ultimately devolve to what each of us, individually, is willing to contribute. It is quite possible that the greatest potential force for change since movable type is at this very moment at our doorstep, or maybe our phone line. In and of itself, that means nothing. What do we bring to the table? Do we understand the stakes? Are we willing to risk? Are we willing to go beyond that which we know, to accept that which is different, or unintelligible, or threatening? Or, should we prove craven as the worst of us would have it, will the train of opportunity stop here again?

AND FINALLY. . .

We're back to the basics. I began by saying that part of the thread that runs through the accounts presented in this book is a story of questioning certain cultural dreams and embracing others. In the narrow view, some folks can't wait to demonize the products of our flirtation with the episteme of pure information and its ecstasies; some find them an unqualified boon. Some say that any way you tell our tribal stories is the right way, but I don't believe all cautionary tales are equal. Does rage against the machine mean rage against antibiotics? Can we just rage against parts of the machine? What, if anything, have we learned from our trip down Ol' Man Timeriver? In the wider view, perhaps Ursula LeGuin had it right once and for all in *Always Coming Home* — if you become ill we can sing you well, but if that doesn't cut it you can always hike up to Wakwaha and check into the hospital. Technology and culture lying down sweetly together in the green fields of High Irony.

Regardless of how we tell those stories, what we seem to learn from observation is that human civilization proceeds not by neat, smooth advances but by a collection of patches and workarounds. Maybe the fact that this is precisely the way the Internet was designed to work tells us something about the blurring of boundaries that herald — some might say "pathognomize"— our moment of time. Could it be that Technology treats Culture as damage, and routes around it? □

introduction

■ Timothy Druckrey

REASONING WITH THE FUTURE

Any articulation of the dynamic relationship between scientific visualization, artistic imagination, social representation, media history, and technical vision ought to be accompanied by a critical archaeology of the very concept of "representation." This entails a critique of the myth of progress, especially in terms of the link between the "triumph" of technical reason and what might be called the anxiety of "telephobic modernity." Also central to this undertaking is a historical examination of the shifting means of reproducibility — particularly the emergence of the screen as the central point of the communicative and aesthetic experience. A crucial goal of *Electronic Culture* is to confront the issues raised by the mapping of technical reality, social reality, and psychological reality onto a historical model of technical rationality, expressed through the transition from television, cinema, and video to hypermedia, virtual reality, and cyberspace.

Tracking the effects of the technologizing of experience demands a cross-disciplinary approach that undermines the utopian premises of progress and reveals reflexive and speculative work done in the fields of art, architecture, literature, photography, cinema, "smart machines," and the culture of everyday life. Much of this work has eluded traditional historical approaches to culture — and to the imagination. Yet cultural life has become the crucial signifier of the bond between representation and technology. Over the past five centuries, a vision of technology has evolved that extends from attempts at mechanically creating life to the ability to decode and map the entire sequence of DNA, from the fantasy of space travel to the colonization of cyberspace, from the transmission of messages to the establishment of global databases — in short, the collapse of the border between the material and the immaterial, the real and the possible.

No longer self-reflexive or analogical, the most cogent expressions of contemporary culture share and extend the language of technology: entertainment, education, labor, economics, architecture, networks, biology, communication, and so on — often glibly incorporating the prefixes "tele," "post," or "cyber." Plainly, the

enormous shift from teleological to telematic notions of human desire and expec-
tation are the subject of intense historical interest, but no less so than the haunting
concepts of posthuman, postbiological, or posthistorical culture, or the "virtualiza-
tion" of matter into the rubric of cyberspace, cybercash, cybercities, and cyborgs.
More pressing, however, is the need to reflect on the very real implications of a not
nearly virtual world. Despite a growing number of recent books assailing technology
for its calamitous disregard for tradition, *Electronic Culture* is neither socially diagnostic
nor historically therapeutic. Instead, this book is an attempt to confront the issues in
terms of their developing meaning across a range of disciplines.

The passage from the machine to the computer is often seen as the logical —
sometimes inevitable — progression of technology. Yet at each point in the history
of the assimilation and miniaturization of the machine, cultural transformations
emerge and broaden in scope, to the extent that technology seems integral to
concepts of the "natural" environment, and suggests that it is no longer possible to
represent or experience the world without the mediation of technology. The
evolution from mechanical to computational culture, however, comprises more
than a series of techniques; it is a fundamental change in the dynamics of culture,
representation, and experience. While the development of machines is often seen
as rooted in industrialization, enlightenment science, and modernity, the
development of computing is linked with technoscience, postindustrialization, and
"postmodernity." And while this kind of periodization may overlook the
transformative impact that technology has had on culture, it nevertheless offers a
vision of cultural interpretation, establishing phases in which social change can be
understood in terms of broad epistemological shifts. It is no exaggeration to suggest
that the cumulative effects of science and technology on twentieth-century culture
have challenged, reoriented, triumphed over, exploded, and infiltrated into notions
of the self, the mechanisms of the biosphere, and the analysis of matter. The entire
concept of communication has likewise been extended into previously unimagined
realms. And, as the century closes, the daunting significance of computation is
extending the material sciences into speculative, genetic, artificial, and rendered
territories, inconceivable just a few decades ago.

A glance at the daily news makes it plain that technology, computing,
telecommunications, free speech and expression, medicine, biology, and politics all
are linked in dynamic ways. The recent attempts to find ways to regulate free
communication over the Internet is only an immediate symptom of a widespread
anxiety about technoculture's effects. The avalanche of new realities — of the
"operating system" of DNA, the "electronic" operation of neurosynapses, visual
models of objects with no physical existence, and so on have their parallels in a
trend of reactionary and pessimistic writing — what might be called the "end of
everything" approach. This alarming trend can only be identified as neo-Luddite,
encompassing a breadth of responses as diverse as the Unabomber's manifesto,
Industrial Society and Its Future, and Kirkpatrick Sale's *Rebels Against the Future.* Not

return to the dial

Julia Scher, *Securityland*, 1995

coincidentally, this trend comes at the same time as the new frenzy to find cultural and historical languages to cope with the sciences and aesthetics of the artificial. Indeed, one might ask if the current metaphor of "connectionism"— explaining everything from cognitive science to the social mechanism of disease, high-level scientific computing to the use of the Internet, the international economy and the appearance of "digicash"— might not serve as the basis for questioning the reinvention of the comforting illusion of social totality.

We would do well to bear in mind that a reading of works by such figures as Lewis Mumford, Siegfried Gidieon, and even Martin Heidegger (for so many reasons) should supercede the hollow thinking of an emerging class of corporate CEOs masquerading as cultural visionaries. And without aestheticizing the digital, we might find a way to think through what Mumford called the "magnificent bribe" of technology and into the epistemologies of teletechnology.

In his essay "Visualization Lost and Regained," Arthur I. Miller writes, "There is a domain of thinking, where the distinctions between conceptions in art and science become meaningless." Increasingly, this concept takes on twin meanings: a realm of creative thinking in which art and science are undifferentiated, and one in which the core significance of each merges in the technological. As much a philosophical issue as an aesthetic one, the shifting boundaries between science, technology, and creativity both echo the Renaissance notion of the artist/scientist, and extend that idea into a time when technoscience has become the signifier of an implosion that collapses the distinctions between disciplines. As Peter Weibel writes: "With machine vision, man has lost another anthropological monopoly."

This kind of decentering is distributed across many domains. Phrases from the essays in this volume reflect concerns, speculations, and assessments whose

intentions differ, but in which the denominator resides in "the entanglement of signal and materiality" (N. Katherine Hayles), in the ability to "use the role to work on the self" (Sherry Turkle), in "the 'true' reality itself posited as a semblance of itself, a pure symbolic construct" (Slavoj Žižek), in "the disappearance of cultural diversity in the network of systems, in the system of networks" (Florian Rötzer), and in "a violent decentering of the place of mastery" (Jean-Louis Comolli).

Positioned critically, the essays here suggest that the issues of technoculture are not confined to the reception of media images, but extend into the very core of our concepts of cognition, identity, and biology. Positioned creatively, the essays are persuasively entangled in reasoning about the future without falling into the traps of either faux totality or cliché utopia. Positioned historically, these essays offer conclusive evidence that considered study of the effects of technology constitutes a coherent and evolving field in which important work has been accomplished.

TELEPHOBIA, TELETOPIA, TELEAESTHETICS

The technologies of rationality have ceaselessly distanced us from what we've taken as the advent of an objective world.

—Paul Virilio

The historical, aesthetic, and moral consequences of information technology did not emerge in the age of computation. The developing history of ties between technology and creativity should realign assumptions about the reciprocity between them, just as that history extends our understanding of the bond that unifies them. Indeed, representation, intelligibility, and the mechanisms of power share histories not bound by any specific technology, although they were formed in technology's midst. These histories, deeply ingrained in the ideologies of modernity, are at the core of both the cultural and the cognitive developments of electronic media. The urgency of the need to confront the effects of an increasingly electronic epistemology becomes conspicuous when one considers the broad implications for representation (linguistic, visual, and computational), the increasingly invisible dispersal of electronic tracking — at almost every imaginable level—and legislative attempts to regulate behavior in the public sphere.

The history of the bond between media (in a broad sense), modernity, technology, identity, representation, and power is finally emerging as a network of affiliations with decisive political and psychological consequences. The collapse of Enlightenment rationality, as a system framed within the development of postindustrial and eventually postmodern theory and the emerging "sciences of the artificial" (after 1945), is a dystopic signifier of catastrophic proportions. This collapse is as much a recognition of culturally destructive illusions as it is a realization of the formative interests of modernity itself. In no way the "end of ideology," the fusion of technology and the far-

reaching agenda of postwar media formulated an "other" ideology, an ideology as Orwellian as it is Kafkaesque. Too complex to explore in detail in this essay, the postwar shift toward systems theory is a pivot on which "post-everything" culture turns.

Norbert Wiener's *Cybernetics*, Claude Shannon and Warren Weaver's *The Mathematical Theory of Communication*, John von Neumann's *The Computer and the Brain*, James Watson and Francis Crick's recognition (grounded in programming) of DNA as a genetic code, Vannevar Bush's texts on hypermedia, and Alan Turing's essay "Computing Machinery and Intelligence," were all part of the ideology on which a transformation of postwar social logic was being constructed. The postwar political environment was resoundingly transfixed by the dual compulsions of deterrence and technological mastery — evidenced in the pathological junction of command, control, and communication technologies teeming in the research-and-development labs of the "military-industrial complex."

Such approaches to information technologies form the foundation for the transformation of the social logic of culture; this shift has been addressed in books such as Siegfried Giedion's *Mechanization Takes Command* (1948), Lewis Mumford's *Art and Technics* (1952), E. J. Dijksterhuis's *The Mechanization of the World Picture* (1959), C. P. Snow's *The Two Cultures* (1959), and other works in which the technical rationale was being questioned as the basis for social order. This transformation of the terms of political and social discourse led inexorably toward a reconceptualization of individual agency, reception, and political action limited by the "exchange" system of broadcast media. Whether broadcast politics, broadcast information, or broadcast entertainment, the bully-pulpit of postwar ideology was dispersed as a kind of cultural fallout, surrounded by hazy metaphors of the global village. Politics, information, entertainment, and technology merged, while a reconfigured subject was being constructed from marketing and statistical analysis produced by data collection, logistical management, and computation. The crisis culture of the ensuing Cold War — saturated by secrecy, systems, and spectacle — found, in cybernetics, the archetype for sustaining power in the midst of metaphors as unwieldy as "the Iron Curtain," "the military-industrial complex," and the "Soviet bloc." Beneath the threat of annihilation, the agenda of postwar technology was clearly toward information. As Friedrich Kittler cogently writes, "Unconditional surrender meant the transfer of technology."[1] And more broadly, "The project of modernity had essentially been one of arms and media technology. . . . All the better that it was shrouded in a petty phraseology of democracy and the communication of consensus."[2] Cold War tactics of command, control, and communication were obviously more than mere metaphors; they stood as stark reminders that technology represented slightly more than the spin-off benefit of the war.

Steven Heims writes: "Although the world of politics seems removed from mathematics, both Wiener and von Neumann based their conceptual frameworks for describing society on some mathematical ideas. For von Neumann, game theory was the cornerstone; for Wiener, it was cybernetics." And indeed, while von Neumann

and Wiener's work diverged greatly, their collaboration (von Neumann in the military boardrooms of Cold War paranoia, and Wiener in the lecture halls of the scientific enlightenment) set the agenda for Cold War brinkmanship. Game theory, as Heims characterizes it, "portrays a world of people relentlessly and ruthlessly but with intelligence and calculation pursuing what each perceives to be his own interest." Cybernetics for Heims, is more deeply inflected by reflexivity and feedback (clear harbingers of interactivity), while it is no less effective as a means for grounding media in control, communication, and computation in its theory of biology and engineering.[3] This bond, only tentatively established at the time, extends into the 1990s in the intricate link between the cybernetic and the biological.

N. Katherine Hayles, referring to Shannon and Weaver's mathematical theory of communication, states that "Information theory as Shannon developed it has only to do with the efficient transmission of messages through communication channels, not with what the messages mean. He especially did not want to get involved in having to consider the receiver's mind-set as part of the communication system." The leap from the "mind-set" to the operating system to the genetic code no longer seems so startling. For Watson and Crick, "genetical information" was a code or an instruction. Game theory, signal-to-noise ratios, feedback, and the genetic code share a relationship with representation in powerful new ways. Join this with computing and the rise of televisual display, and the tidal proportions of postwar systems-thinking becomes as clear as the passage from industrial to electronic culture. Varied in their implementations, affiliations, and implications, these media and their histories form the core of the "artificial sciences." Hayles suggests that in the "third wave" of cybernetics, "the idea of a virtual world of information that coexists with and interpenetrates the material world of objects is no longer an abstraction. It has come home to roost, so to speak, in the human sensorium itself."[4] What seems certain is that the foundations set in the 1950s have converged in the 1990s, and that an entire range of human disciplines is now formed within an algorithmic imperative.

But media theory, with a few notable exceptions, has primarily focused on either the metaphor of the observable or the attempt to resuscitate the culture industries in the telebroadcast era. And, despite the current relevance of Frankfurt School media theory across a broad range of disciplines, the evolving technological and social environment of the postwar period presented a sharp contrast to the propaganda ideology inflecting prewar media. What emerged, bolstered by the American "triumph," was a media theory inebriated with the potential of new technology.

Marshall McLuhan's rationale of imperialism-as-globalization mirrored the multinational development that grounded the merging media of the 1960s. Pithy slogans poised ideas on the tightrope between morality and propaganda — aligned with the advertising logos (that's *logos* in both senses of the term) that fueled the galaxy of fragmentation. New televisual and informational technologies joined at a time of social transformation, when broadcast media seemingly swept across the "global village," and was at the same time providing what Hans Magnus Enzensberger

rightly called a "reactionary doctrine of salvation" rooted in the Goebbels' effort in the 1930s to "retribalize" Germany using the then-new technology of the radio.

But the "McLuhanization" of media did not then (and will not now) salvage the collapse of modernity, so much as it served as a patch joining utopic dispersions of media with the broad corporate and political objectives in which these technologies were developing. And of course Herbert Marcuse's *One-Dimensional Man* (1964) had already unmasked the potential effects of the superficial culture of the medium, and that the tactics of "repressive tolerance" shadowing the counterculture were evolving as elements in the battle for communication and control. It is not surprising that the shift from the "cultural industry" to the "consciousness industry," as Enzensberger articulates it in the essay "Constituents of a Theory of the Media," represents both new technologies and new strategies for their utilization. Against the backdrop of "resignation," an understanding of the reciprocity between production and reception emerges in which technology can be used directly as mobilization — for better or worse.

Add to this the development of the imaging technologies of the postwar period, and the volcanic importance of the visual media intensifies. The strategies of modernity steeped in visualization, "techniques of the observer" (Jonathan Crary's phrase), and "scopic regimes" (as Martin Jay observes)[5] were being slowly transformed by technologies that incorporated the new metaphors of cybernetics and television. The assimilation of vision into technology had begun. In this environment, the reflexive representation systems of modernity were being gradually outdistanced by forms of recording, rendering, and surveillance in which information served as deeply as observation to regulate behavior. Indeed, information and representation were becoming firmly entangled in the discourses of advertising, politics, aesthetics, and cultural history.

In modernity, seeing and being seen empowered the subject, while imaging and being imaged involved control mechanisms. As the self was centralized, it was also configured within a broad panoptic system. A politics of seeing, recording, and accumulation emerged. Experience was circumscribed by a series of stages in which the displacement of vision by representational systems was both scientifically legitimated and culturally necessary. Photography, cinema, and scientific visualization coalesced with systems of illusion, recording, spectacle, information, and the public sphere. In a panoptic culture, the management of visuality identifies consumption as passive and production as empowering — essentials in the system of capital. But if dialectics and domination suggest the Scylla and Charybdis of modernity, it is because representation was always poised between phenomenology and mastery. This power dynamic, institutionalized in the authoritarian presumptions of the Enlightenment, became the constituents of a social ecosystem in which, as Michel Foucault has aptly noted, "the gaze that sees is the gaze that dominates."[6] This gaze was triumphantly technological, whether in the architecture of Jeremy Bentham's Panopticon or in the lens of the camera. This disembodied authority

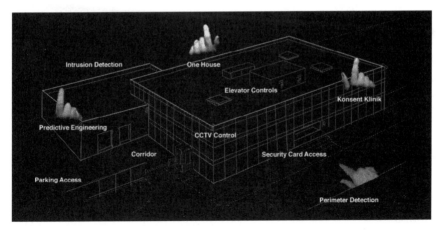

Julia Scher, *Securityland*, 1995

extended power into a sublime invisibility. As Miran Bozovic writes in his intro-
duction to Bentham's *The Panopticon Writings*, "A gaze and a voice that cannot be
pinned down to any particular bearer tend to acquire exceptional powers."[7]

But while some essentials are comparable, the culture of modernity — in which
the universalization, moralization, and mechanization of representation evolved —
has been surpassed. A technological model has been usurped by a cybernetic model.
If there is a common denominator within the divergent discourses of postmodernity,
it is the concept that a system of scientific visualization and any totalizing model of
either the "real" world or its representations cannot be put into place, even while the
stability of representation is alternately established and disestablished by the
continuing social effect of either the image (think of the fate of the Rodney King
video) or information (think of the fate of overwhelming genetic evidence in the
O. J. Simpson trial). The camouflage over the shaky epistemological foundation of
representation has been effaced by the dual effects of psychoanalytic deconstruction
and recombinant technology. The unrepresentable "real" collides with the unreflected
"virtual." And, as Slavoj Žižek remarks, "Virtuality is already at work operating in the
symbolic order . . . to the extent to which virtual phenomena retroactively enable us
to discover to what extent our most elementary self-experience was virtual."[8] The
panoptic metaphors of Bentham and Foucault are reinvented in the technosphere in
the guise of electronic "agents," digital security systems, genetic screening, satellite-
imaging technologies with an imaging capability of under one meter resolution from
35,000 miles in "space," SkyCam news networks with robotic cameras surveying for
crisis . . . in short, more than a panoptic metaphor, a *transoptic* one, in which the
invisible threat of the gaze is welcomed as a symptom of containment and stability.

Indeed, while issues of space dominated discourses of modernity, the related
issues of presence and duration have come to stand within postmodernity as
signifiers of a far more complex situation. Worn traditions of the public sphere, the

sociology of postindustrialization, the discreteness of identity, have been supplanted by a kind of distributed embeddedness — or, better, *immersion* — of the self in the mediascapes of teleculture, which must generate a communicative practice, whose boundaries are mapped in virtual, transitory networks, whose hold on matter is ephemeral, whose position in space is tenuous, and whose agency is measured in acts of implication rather than mere coincidences of location.

Writing about the catastrophic transformation of the *topos*, Paul Virilio remarks, "In spite of all this machinery of transfer, we get no closer to the productive unconscious of sight. . . . Instead, we only get as far as its unconsciousness, an annihilation of place and appearance the future of which it is still hard to imagine."[9] Mediated by the televisual, the issues of memory, consciousness, and perception are disassociated from experience, other than the experience of the perceiving self. Perception becomes scanning, thinking becomes processing, and retention becomes retrieval. And while the model of the mind as a distributed parallel processor might be useful in explaining the ability to store, process, and retrieve vast amounts of memory, the metaphor is only useful as discourse and not as fact. Siegfried Zielinski is right in citing the link between Kant's "subjective" and Wittgenstein's "border." Wittgenstein's proposition, "The subject does not belong to the world, it is a border of the world," is a powerful realization — often left out of the thinking of technology — implying that the subject is more or less a system to be adapted rather than an adaptive system.

Distributed models of cognition have been studied for years, but the studies are as yet inconclusive and not fully convincing as to their efficacy in a scientific or psychological context. Proving the Turing test in no way legitimates the computer as an organism, much less as a consciousness. The effectiveness of destabilizing the human-machine interface by eradicating their difference serves primarily to demonstrate a more or less obvious notion that people are gullible. Yet the merging of the cybernetic and the cognitive is having remarkable effects on human experience and expectation. Norbert Wiener wrote, in *The Human Use of Human Beings*, that "every instrument in the repertory of the scientific-instrument maker is a possible sense organ."[10] But instrumental recording and sensing are not wholly synonymous, even if the extension of the perceptual field is enlarged by technology. The effects of this interfacing with technology have already generated a reconfigured subject whose "border" is porous and whose autonomy is "enframed" not by but *within* technology.

The complication arises when the experiential field that situates cognition is no longer rooted in the affinity between representation and reception, but in a more problematic circumstance in which the act of consciousness itself could be rendered. In this logic, the interface with technology could suggest much more than the navigation through hyper- or virtual environments. It could suggest the programming of the neurological process at the level of the formation of consciousness (or perhaps unconsciousness) itself.

Vilém Flusser writes, "Electronic memories provide us with a critical distance that will permit us, in the long run, to emancipate ourselves from the ideological belief that we are 'spiritual beings,' subjects that face an objective world.... Our brains will thus be freed for other tasks, like processing information." He continues, on the benefits of electronic memory, that "A person will no longer be a worker (*homo faber*) but an information processor, a player with information (*homo ludens*)," and that "we shall enhance our ability to obliterate information ... this will show us that forgetting is just as important a function of memory as remembering."[11] Situational knowledge, contingent expression? Perhaps the aftereffects of the eradication of legitimate canons of artistic, literary, even political narratives have created a circumstance in which the meaning and usefulness of experience are wholly related to its engagement with the present. In this context, electronic media demand a multilevel participation in the flow of information, intention, and technology.

REASONING WITH HISTORY

In the 1930s a critique of the issues of reproducibility hinged on the "revolutionary potential" of technology. Walter Benjamin's essay "The Work of Art in the Age of Mechanical Reproduction," or the later essay (reprinted in this volume) by Martin Heidegger, "The Age of the World Picture" (or, for that matter, Heidegger's "The Question Concerning Technology") focus attention on the political repercussions of representation and technology. Indeed, the reading of these essays in light of current developments in digital media demonstrates the affiliations — and differences — between materialist critiques of technology and media (one might call them "exogenic" theories) and postmaterialist approaches to immersive media (one might call these "endogenic" theories). And while the exigencies surrounding the critical positions of Benjamin and Heidegger reveal that issues of technology played a crucial role in the maturation of fascism and modernism, the essays did not lead to a radicalization of artistic production as much as they stood as assessments of the impact technology was having on the means of communication and expression.

What is crucial is that the demands of distribution and reception were to be reconsidered as fundamental to any further thinking about representation. In the ideas of reproducibility, politics and "enframing" laid the groundwork for a reconfiguration of representation as integral to the cultural concerns of technology. The issues of mass communication through technology were to alter the signification of the means of production irrevocably.

As reproducibility and the issues of mass psychology set the agenda for a critique of culture during the 1930s, the technologies of transmission and consciousness wound themselves into the broadcast era after the 1950s. Joined by the televisual and the cybernetic, the inexorable drift toward an information economy and the emergence of the "consciousness industry" (Enzensberger's phrase) were recognized as

pivots in the discourse of transformed reproducibility. Enzensberger's term departed from what he saw as the affectation of the cultural, and honed in on the dilemma of McLuhan, offering instead a kind of manifesto for the usurpation of the hierarchy of production and consumption. While both Benjamin and Enzensberger were embroiled in a dialectic with the circulatory system of information, the next generation was emerging with a greater interest in neurocognitive issues than in those of perception and ideology. Today, the sphere of immersive and networked media is heading toward a rendezvous with cognition on several planes.

The 1950s also represented a watershed in other ways relevant to representation. The first postwar publications concerned with semiotics emerged, particularly in the work of Roland Barthes. Running on parallel tracks, semiotics, cybernetics, and genetics laid the foundation for a reckoning, perhaps "ciphering," of communication. Régis Debray writes:

> Without passing through linguistics at all, Norbert Wiener (inventor of cybernetics) had already as early as 1948 defined man without reference to interiority as a communication machine, a machine for exchanging information. . . . The idea that all reality must be broken up in the final analysis into a set of relations between elements came together by an entirely different angle with the structural postulate, imputing every effect of meaning to a combination of minimal units or pertinent traits of a determinate code. While resolutely aware of it, French semiology was metaphorizing and 'culturalizing' the American mechanist paradigm. From the domains of metaphor to immediate surroundings, all aspects of social life soon came under the empire of signs. . . . Thus by the fiction of codes conceived as structural models of possible communicative exchange one could deduce here and there what Lacan was calling at the moment "realist imbecility."[12]

REASONING WITH THE PRESENT

Until modern times, when technics itself learned to make use of symbolism of the most refined order, invention was a slow, piecemeal process.

—Lewis Mumford

"Psychology," wrote a well-known virtual-reality researcher, "is the physics of virtual reality." This rather bold pronouncement signifies a shift in the trajectory of thinking about the relationship between consciousness and representation, if not between matter and reception. And yet, by implication, the remark is increasingly sustained in the overlapping terrains of cognitive science, neuro-computing initiatives, the development of genetic programming and imaging, and the linkage between parallel processing and the Internet. Witness this astonishing announcement by the Max Planck Institute, as reported in the *New York Times*: "The

accomplishment announced Monday (August 21, 1995) has thus established a signaling channel between a nerve cell and a silicon chip that works in both directions." [13] Exchangeable messages between carbon and silicon represent a step toward the derealization of the border between human and computer, even toward the cybernetic organism, the initiation of the model of "methodological individualism," as Donna Haraway called it. Indeed, the implications of the evolving and alarming application of computation into the management of the sciences of the artificial (particularly artifical life and artificial intelligence), suggests that the algorithmic assumptions of programming represent a kind of essentialism in which the indistinguishability of the natural, the artificial, and the simulated is outdistanced in the overarching metaphor of information and code.

Digital media presupposes a communicative system that assimilates representation into the technosphere, the neurosphere, and the genosphere. Responses to the stimuli of experiential phenomena are being replaced by study of the neuro-reflexive activities of the brain as an operating system. In this system, cultural representation is less significant than psychological representation. The cognitive system becomes a more pertinent subject than the communication system. Systems supplant cultures. This metaphor goes hand-in-hand with the connectionist models being utilized to link everything from the Internet to the electrical impulses of the neuron. Networked communities, the emergence of biocomputing, and genetic mapping represent fields in which information has become essentialism. Evelyn Fox Keller writes that, "Even while researchers in molecular biology and cyberscience displayed little interest in each other's epistemological program, information, either as metaphor or as material or technological inscription, could not be contained." [14] The collision of these disciplines in the fast-growing fields of networking, DNA-based computer programming and nanotechnology suggests the reconceptualization of the subject of computing. Rather than the human-computer interface, the thrust of research is bio- or neuro-informatics, the constitution of identity not in terms of the relationship between machine and person but within the formation of ideas and meanings.

The emergence of electronic grammar and the increasing grasp of the development of systems theory come nearly at the end of the biosphere as an ecosystem immune from technology. This development also coincides with the completion of the mastery of nature implicit in modernity, whether we want to think about life after modernism or not. Even more so, the movement from ecosystems to info-systems, codes to algorithms, individuals to agents, cognition to neurocognition, recording to rendering, observation to interaction, reflection to behavior, science to technoscience, biology to genetics, genetics to artificial life, demonstrates that the "moralization of objectivity" that came with the Enlightenment is having profound effects on a broad range of human activities, and has, in some ways, exposed the triumph of technology as already assimilated into the worlds of the ecosphere and the infosphere. The conflation of the organism and the code that operates it is rooted in confused assumptions about both open and closed systems. The Global Brain and the network

ecology are metaphors with staggering consequences not rationalized by electronic positivism. These "mechanisms of planetary metabolism" reinforce a kind of determinism that teeters between biology and "back to nature mysticism" (Haraway).

At Ars Electronica's Wired World symposium in 1995, the economic theorist Saskia Sassen gave a talk about the collapse of the Barings Bank in England. She opposed two systems — the system of judgment and the system of computing. The ability of the computer to model vast amounts of information was linked to the ability to mobilize billions of dollars so quickly that human judgment could hardly understand what was happening. Upper management, sustained by well-mannered and, no doubt, well-meaning leadership, had little grasp of the programs that could predict and then be used to transfer the entire resources of the bank at speeds that were unimaginable. On the one hand, she identified this as a crisis of centrality. And on the other hand, in a transterritorial economy, power was dispersed so invisibly that understanding and judgment could not preclude the event before it happened. Perhaps more significantly, Sassen concluded her talk by suggesting that mobilization and collapse represented the triumph of pure reason. Computation destroyed the Barings Bank in an act of programming that is deeply inflected with human greed and simultaneously beyond the scope of judgment. It was not so long ago that so-called programmed trading in the New York Stock Exchange initiated sell algorithms that caused a near collapse of the American economy (well, one has to remember that the American economy is almost virtual anyway). One might think of this as "viral trading."

Couple this with the failed switch in the telephone system on the East Coast a few years ago, the switch that initiated a domino effect that effectively shut down the communication systems of the banks, the air-traffic-control system, police, emergency services . . . and one begins to realize that even the most stable systems are not necessarily redundant enough to sustain themselves against the law of thermodynamics, the one that "synthetic biologist" Tom Ray suggested is inoperative in the digital world! One can only begin to wonder how autonomous agents, DNA computing, and artificial life forms will learn to behave once they are unleashed into the slightly less precise world in which we live.

If there is a shift represented by these transformations in the late twentieth century, it is not one effected by an attempt to resolve notions of closed systems dialectically, but to confront discursively constituted networks: the biology network, the genetic network, the identity network, the culture network, the political network, the economic network, the technology network, the communication network, the image network.

Within this overarching network metaphor, the "availability" of information leads to the presumption of empowerment on the one hand, while on the other, in the words of Žižek, it is "paid for by derealization," in which presence is equivalent to the absence of desire. In this new order of representation, metaphor and performativity are intimately connected. To be within the image is to be in a set of circumstances that are

inexhaustible. Every nuance of the image extends the meaning. Seeing, like gesture, is provoked by desire. "What is the desire," asks Lacan, "which is caught, fixed in the picture, but which also urges the artist to put something into operation? The inversion of the subject implied in the interactive gesture demands new thinking about the position of the subject. For it is a structural fact, if not a structural effect, that when man comes to terms with the symbolic order, his being is, from the very start, entirely absorbed in it, and produced by it, not as man, but as *subject*." [15]

"The fundamental event of the modern age," writes Heidegger, "is the conquest of the world as picture." Enveloped by a concept of the world understood already structured as an image, the dynamic shifts in the making of art in the past decade make more sense. Characterized by deconstruction, encoding, and reconceptualization, the "sphere" of the image has assumed greater and greater effect, despite mounting doubts concerning the stability of the image as information. Add to this the merging of the computer, telecommunication, entertainment, and cultural industries, and the potential dissolution of the image as we understand it seems obvious. In a culture in which the logic of information has shattered any comforting notion of order, emerging nonlinear signifiers become the ideology of an already operating transposition of epistemology. In this environment, information comes as an array rather than as a sequence or narrative. Deciphering the array — or producing the array — is no longer a sign of "schizophrenic" experience or expression, but the rendering of experience within a social logic of contingency. From the point of view of "mediology" (in Debray's sense), the shift from "logosphere," "graphosphere," and "videosphere" has "pathological tendencies" in the shift from the "paranoic," to "obsessive" to "schizophrenic" experience. In philosophic terms, Deleuze and Guattari suggest in *A Thousand Plateaus* that, "The world has lost its pivot; the subject can no longer even dichotomize, but accedes to a higher unity, of ambivalence or over-determination, in an always supplementary dimension to that of its subject. A system of this kind could be called a 'rhizome.' The rhizome is altogether different, a map and not a tracing. Perhaps one of the most important characteristics of the rhizome is that it has multiple entryways." [16]

What seems so important is a rethinking of imaging beyond the limited terms of aesthetics, memory, sentiment, or phenomenology. Instead, a consideration might be made of the image not only as a signifier, but rather as an event. Retaining, for example, photography's crucial link to perception, the idea of the image-as-event extends its legitimacy as mere description by introducing it as experiential. Suddenly one might imagine the navigation of the image as more than the scrutiny of its signifiers, as a dynamic process in which the contingent stability of the moment itself is extended. With all the hoopla around simulation and the artificial, theory has yet to account for the efficacy of the *image-as-experience*. And while the stakes of immersive technologies often seem to leapfrog over this transition, the fact remains that imaging has far from exhausted its potential, even as it is assimilated into the ecosystem of electronic media. □

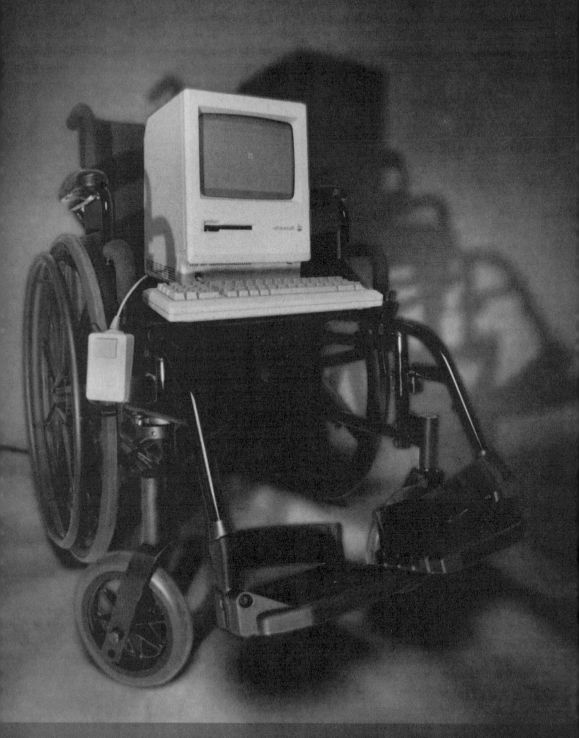

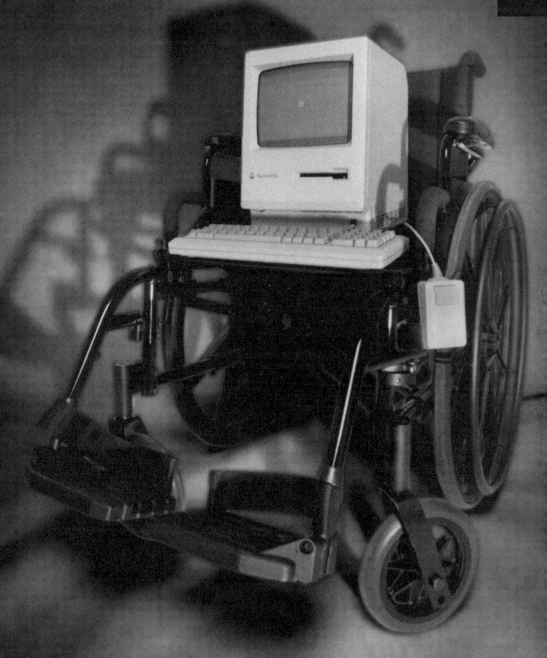

OBSOLESCENCE

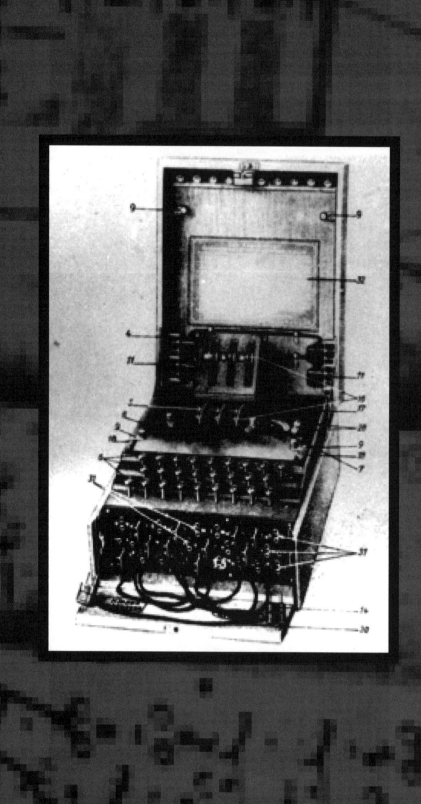

As We May Think

■ *V a n n e v a r B u s h*

This has not been a scientist's war; it has been a war in which all have had a part. The scientists, burying their old professional competition in the demand of a common cause, have shared greatly and learned much. It has been exhilarating to work in effective partnership. Now, for many, this appears to be approaching an end. What are the scientists to do next?

For the biologists, and particularly for the medical scientists, there can be little indecision, for their war work has hardly required them to leave the old paths. Many indeed have been able to carry on their war research in their familiar peacetime laboratories. Their objectives remain much the same.

It is the physicists who have been thrown most violently off stride, who have left academic pursuits for the making of strange destructive gadgets, who have had to devise new methods for their unanticipated assignments. They have done their part on the devices that made it possible to turn back the enemy. They have worked in combined effort with the physicists of our allies. They have felt within themselves the stir of achievement. They have been part of a great team. Now, as peace approaches, one asks where they will find objectives worthy of their best.

I

Of what lasting benefit has been man's use of science and of the new instruments which his research brought into existence? First, they have increased his control of his material environment. They have improved his food, his clothing, his shelter; they have increased his security and released him partly from the bondage of bare existence. They have given him increased knowledge of his own biological processes so that he has had a progressive freedom from disease and an increased span of life. They are illuminating the interactions of his physiological and psychological functions, giving the promise of an improved mental health.

Science has provided the swiftest communication between individuals; it has provided a record of ideas and has enabled man to manipulate and to make extracts from that record so that knowledge evolves and endures throughout the life of a race rather than that of an individual.

There is a growing mountain of research. But there is increased evidence that

we are being bogged down today as specialization extends. The investigator is staggered by the findings and conclusions of thousands of other workers — conclusions which he cannot find time to grasp, much less to remember, as they appear. Yet specialization becomes increasingly necessary for progress, and the effort to bridge between disciplines is correspondingly superficial.

Professionally our methods of transmitting and reviewing the results of research are generations old and by now are totally inadequate for their purpose. If the aggregate time spent in writing scholarly works and in reading them could be evaluated, the ratio between these amounts of time might well be startling. Those who conscientiously attempt to keep abreast of current thought, even in restricted fields, by close and continuous reading might well shy away from an examination calculated to show how much of the previous month's efforts could be produced on call. Mendel's concept of the laws of genetics was lost to the world for a generation because his publication did not reach the few who were capable of grasping and extending it; and this sort of catastrophe is undoubtedly being repeated all about us, as truly significant attainments become lost in the mass of the inconsequential.

The difficulty seems to be, not so much that we publish unduly in view of the extent and variety of present-day interests, but rather that publication has been extended far beyond our present ability to make real use of the record. The summation of human experience is being expanded at a prodigious rate, and the means we use for threading through the consequent maze to the momentarily important item is the same as was used in the days of square-rigged ships.

But there are signs of a change as new and powerful instrumentalities come into use. Photocells capable of seeing things in a physical sense, advanced photography which can record what is seen or even what is not, thermionic tubes capable of controlling potent forces under the guidance of less power than a mosquito uses to vibrate his wings, cathode ray tubes rendering visible an occurrence so brief that by comparison a microsecond is a long time, relay combinations which will carry out involved sequences of movements more reliably than any human operator and thousands of times as fast — there are plenty of mechanical aids with which to effect a transformation in scientific records.

Two centuries ago Leibnitz invented a calculating machine which embodied most of the essential features of recent keyboard devices, but it could not then come into use. The economics of the situation were against it: the labor involved in constructing it, before the days of mass production, exceeded the labor to be saved by its use, since all it could accomplish could be duplicated by sufficient use of pencil and paper. Moreover, it would have been subject to frequent breakdown, so that it could not have been depended upon; for at that time and long after, complexity and unreliability were synonymous.

Babbage, even with remarkably generous support for his time, could not produce his great arithmetical machine. His idea was sound enough, but con-

struction and maintenance costs were then too heavy. Had a pharaoh been given detailed and explicit designs of an automobile, and had he understood them completely, it would have taxed the resources of his kingdom to have fashioned the thousands of parts for a single car, and that car would have broken down on the first trip to Giza.

Machines with interchangeable parts can now be constructed with great economy of effort. In spite of much complexity, they perform reliably. Witness the humble typewriter, or the movie camera, or the automobile. Electrical contacts have ceased to stick when thoroughly understood. Note the automatic telephone exchange, which has hundreds of thousands of such contacts, and yet is reliable. A spider web of metal, sealed in a thin glass container, a wire heated to brilliant glow, in short, the thermionic tube of radio sets, is made by the hundred million, tossed about in packages, plugged into sockets — and it works! Its gossamer parts, the precise location and alignment involved in its construction, would have occupied a master craftsman of the guild for months; now it is built for thirty cents. The world has arrived at an age of cheap complex devices of great reliability; and something is bound to come of it.

2

A record, if it is to be useful to science, must be continuously extended, it must be stored, and above all it must be consulted. Today we make the record conventionally by writing and photography, followed by printing; but we also record on film, on wax disks, and on magnetic wires. Even if utterly new recording procedures do not appear, these present ones are certainly in the process of modification and extension.

Certainly progress in photography is not going to stop. Faster material and lenses, more automatic cameras, finer-grained sensitive compounds to allow an extension of the minicamera idea, are all imminent. Let us project this trend ahead to a logical, if not inevitable, outcome. The camera hound of the future wears on his forehead a lump a little larger than a walnut. It takes pictures 3 millimeters square, later to be projected or enlarged, which after all involves only a factor of 10 beyond present practice. The lens is of universal focus, down to any distance accommodated by the unaided eye, simply because it is of short focal length. There is a built-in photocell on the walnut such as we now have on at least one camera, which automatically adjusts exposure for a wide range of illumination. There is film in the walnut for a hundred exposures, and the spring for operating its shutter and shifting its film is wound once for all when the film clip is inserted. It produces its result in full color. It may well be stereoscopic, and record with spaced glass eyes, for striking improvements in stereoscopic technique are just around the corner.

The cord which trips its shutter may reach down a man's sleeve within easy reach of his fingers. A quick squeeze, and the picture is taken. On a pair of ordinary glasses is a square of fine lines near the top of one lens, where it is out of

the way of ordinary vision. When an object appears in that square, it is lined up for its picture. As the scientist of the future moves about the laboratory or the field, every time he looks at something worthy of the record, he trips the shutter and in it goes, without even an audible click. Is this all fantastic? The only fantastic thing about it is the idea of making as many pictures as would result from its use.

Will there be dry photography? It is already here in two forms. When Brady made his Civil War pictures, the plate had to be wet at the time of exposure. Now it has to be wet during development instead. In the future perhaps it need not be wetted at all. There have long been films impregnated with diazo dyes which form a picture without development, so that it is already there as soon as the camera has been operated. An exposure to ammonia gas destroys the unexposed dye, and the picture can then be taken out into the light and examined. The process is now slow, but someone may speed it up, and it has no grain difficulties such as now keep photographic researchers busy. Often it would be advantageous to be able to snap the camera and to look at the picture immediately.

Another process now in use is also slow, and more or less clumsy. For fifty years impregnated papers have been used which turn dark at every point where an electrical contact touches them, by reason of the chemical change thus produced in an iodine compound included in the paper. They have been used to make records, for a pointer moving across them can leave a trail behind. If the electrical potential on the pointer is varied as it moves, the line becomes light or dark in accordance with the potential.

This scheme is now used in facsimile transmission. The pointer draws a set of closely spaced lines across the paper one after another. As it moves, its potential is varied in accordance with a varying current received over wires from a distant station, where these variations are produced by a photocell which is similarly scanning a picture. At every instant the darkness of the line being drawn is made equal to the darkness of the point on the picture being observed by the photocell. Thus, when the whole picture has been covered, a replica appears at the receiving end.

A scene itself can be just as well looked over line by line by the photocell in this way as can a photograph of the scene. This whole apparatus constitutes a camera, with the added feature, which can be dispensed with if desired, of making its picture at a distance. It is slow, and the picture is poor in detail. Still, it does give another process of dry photography, in which the picture is finished as soon as it is taken.

It would be a brave man who could predict that such a process will always remain clumsy, slow, and faulty in detail. Television equipment today transmits sixteen reasonably good images a second, and it involves only two essential differences from the process described above. For one, the record is made by a moving beam of electrons rather than a moving pointer, for the reason that an electron beam can sweep across the picture very rapidly indeed. The other difference involves merely the use of a screen which glows momentarily when the electrons hit, rather than a chemically treated paper or film which is permanently altered. This

speed is necessary in television, for motion pictures rather than stills are the object.

Use chemically treated film in place of the glowing screen, allow the apparatus to transmit one picture rather than a succession, and a rapid camera for dry photography results. The treated film needs to be far faster in action than present examples, but it probably could be. More serious is the objection that this scheme would involve putting the film inside a vacuum chamber, for electron beams behave normally only in such a rarefied environment. This difficulty could be avoided by allowing the electron beam to play on one side of a partition, and by pressing the film against the other side, if this partition were such as to allow the electrons to go through perpendicular to its surface, and to prevent them from spreading out sideways. Such partitions, in crude form, could certainly be constructed, and they will hardly hold up the general development.

Like dry photography, microphotography still has a long way to go. The basic scheme of reducing the size of the record, and examining it by projection rather than directly, has possibilities too great to be ignored. The combination of optical projection and photographic reduction is already producing some results in microfilm for scholarly purposes, and the potentialities are highly suggestive. Today, with microfilm, reductions by a linear factor of 20 can be employed and still produce full clarity when the material is re-enlarged for examination. The limits are set by the graininess of the film, the excellence of the optical system, and the efficiency of the light sources employed. All of these are rapidly improving.

Assume a linear ratio of 100 for future use. Consider film of the same thickness as paper, although thinner film will certainly be usable. Even under these conditions there would be a total factor of 10,000 between the bulk of the ordinary record on books, and its microfilm replica. The *Encyclopaedia Britannica* could be reduced to the volume of a matchbox. A library of a million volumes could be compressed into one end of a desk. If the human race has produced since the invention of movable type a total record, in the form of magazines, newspapers, books, tracts, advertising blurbs, correspondence, having a volume corresponding to a billion books, the whole affair, assembled and compressed, could be lugged off in a moving van. Mere compression, of course, is not enough; one needs not only to make and store a record but also to be able to consult it, and this aspect of the matter comes later. Even the modern great library is not generally consulted; it is nibbled by a few.

Compression is important, however, when it comes to costs. The material for the microfilm Britannica would cost a nickel, and it could be mailed anywhere for a cent. What would it cost to print a million copies? To print a sheet of newspaper, in a large edition, costs a small fraction of a cent. The entire material of the Britannica in reduced microfilm form would go on a sheet 8½ by 11 inches. Once it is available, with the photographic reproduction methods of the future, duplicates in large quantities could probably be turned out for a cent apiece beyond the cost of materials. The preparation of the original copy? That introduces the next aspect of the subject.

To make the record, we now push a pencil or tap a typewriter. Then comes the process of digestion and correction, followed by an intricate process of type-setting, printing, and distribution. To consider the first stage of the procedure, will the author of the future cease writing by hand or typewriter and talk directly to the record? He does so indirectly, by talking to a stenographer or a wax cylinder; but the elements are all present if he wishes to have his talk directly produce a typed record. All he needs to do is to take advantage of existing mechanisms and to alter his language.

At a recent World Fair a machine called a Voder was shown. A girl stroked its keys and it emitted recognizable speech. No human vocal cords entered in the procedure at any point; the keys simply combined some electrically produced vibrations and passed these on to a loudspeaker. In the Bell Laboratories there is the converse of this machine, called a Vocoder. The loudspeaker is replaced by a microphone, which picks up sound. Speak to it, and the corresponding keys move. This may be one element of the postulated system.

The other element is found in the stenotype, that somewhat disconcerting device encountered usually at public meetings. A girl strokes its keys languidly and looks about the room and sometimes at the speaker with a disquieting gaze. From it emerges a typed strip which records in a phonetically simplified language a record of what the speaker is supposed to have said. Later this strip is retyped into ordinary language, for in its nascent form it is intelligible only to the initiated. Combine these two elements, let the Vocoder run the stenotype, and the result is a machine which types when talked to.

Our present languages are not especially adapted to this sort of mechaniza-tion, it is true. It is strange that the inventors of universal languages have not seized upon the idea of producing one which better fitted the technique for transmitting and recording speech. Mechanization may yet force the issue, especially in the scientific field; whereupon scientific jargon would become still less intelligible to the layman.

One can now picture a future investigator in his laboratory. His hands are free, and he is not anchored. As he moves about and observes, he photographs and comments. Time is automatically recorded to tie the two records together. If he goes into the field, he may be connected by radio to his recorder. As he ponders over his notes in the evening, he again talks his comments into the record. His typed record, as well as his photographs, may both be in miniature, so that he projects them for examination.

Much needs to occur, however, between the collection of data and observa-tions, the extraction of parallel material from the existing record, and the final insertion of new material into the general body of the common record. For mature thought there is no mechanical substitute. But creative thought and essentially repetitive thought are very different things. For the latter there are, and may be, powerful mechanical aids.

Adding a column of figures is a repetitive thought process, and it was long ago properly relegated to the machine. True, the machine is sometimes controlled by the keyboard, and thought of a sort enters in reading the figures and poking the corresponding keys, but even this is avoidable. Machines have been made which will read typed figures by photocells and then depress the corresponding keys; these are combinations of photocells for scanning the type, electric circuits for sorting the consequent variations, and relay circuits for interpreting the result into the action of solenoids to pull the keys down.

All this complication is needed because of the clumsy way in which we have learned to write figures. If we recorded them positionally, simply by the configuration of a set of dots on a card, the automatic reading mechanism would become comparatively simple. In fact, if the dots are holes, we have the punched-card machine long ago produced by Hollorith for the purposes of the census, and now used throughout business. Some types of complex businesses could hardly operate without these machines.

Adding is only one operation. To perform arithmetical computation involves also subtraction, multiplication, and division, and in addition some method for temporary storage of results, removal from storage for further manipulation, and

recording of final results by printing. Machines for these purposes are now of two types: keyboard machines for accounting and the like, manually controlled for the insertion of data, and usually automatically controlled as far as the sequence of operations is concerned; and punched-card machines in which separate operations are usually delegated to a series of machines, and the cards then transferred bodily from one to another. Both forms are very useful; but as far as complex computations are concerned, both are still embryo.

Rapid electrical counting appeared soon after the physicists found it desirable to count cosmic rays. For their own purposes the physicists promptly constructed thermionic-tube equipment capable of counting electrical impulses at the rate of 100,000 a second. The advanced arithmetical machines of the future will be electrical in nature, and they will perform at 100 times present speeds, or more.

Moreover, they will be far more versatile than present commercial machines, so that they may readily be adapted for a wide variety of operations. They will be controlled by a control card or film, they will select their own data and manipulate it in accordance with the instructions thus inserted, they will perform complex arithmetical computations at exceedingly high speeds, and they will record results in such form as to be readily available for distribution or for later further manipulation. Such machines will have enormous appetites. One of them will take instructions and data from a roomful of girls armed with simple keyboard punches, and will deliver sheets of computed results every few minutes. There will always be plenty of things to compute in the detailed affairs of millions of people doing complicated things.

4

The repetitive processes of thought are not confined, however, to matters of arithmetic and statistics. In fact, every time one combines and records facts in accordance with established logical processes, the creative aspect of thinking is concerned only with the selection of the data and the process to be employed, and the manipulation thereafter is repetitive in nature and hence a fit matter to be relegated to the machines. Not so much has been done along these lines, beyond the bounds of arithmetic, as might be done, primarily because of the economics of the situation. The needs of business, and the extensive market obviously waiting, assured the advent of mass-produced arithmetical machines just as soon as production methods were sufficiently advanced.

With machines for advanced analysis no such situation existed; for there was and is no extensive market; the users of advanced methods of manipulating data are a very small part of the population. There are, however, machines for solving differential equations — and functional and integral equations, for that matter. There are many special machines, such as the harmonic synthesizer which predicts the tides. There will be many more, appearing certainly first in the hands of the scientist and in small numbers.

If scientific reasoning were limited to the logical processes of arithmetic, we should not get far in our understanding of the physical world. One might as well attempt to grasp the game of poker entirely by the use of the mathematics of probability. The abacus, with its beads strung on parallel wires, led the Arabs to positional numeration and the concept of zero many centuries before the rest of the world; and it was a useful tool — so useful that it still exists.

It is a far cry from the abacus to the modern keyboard accounting machine. It will be an equal step to the arithmetical machine of the future. But even this new machine will not take the scientist where he needs to go. Relief must be secured from laboriously detailed manipulation of higher mathematics as well, if the users of it are to free their brains for something more than repetitive detailed transformations in accordance with established rules. A mathematician is not a man who can readily manipulate figures; often he cannot. He is not even a man who can readily perform the transformation of equations by the use of calculus. He is primarily an individual who is skilled in the use of symbolic logic on a high plane, and especially he is a man of intuitive judgment in the choice of the manipulative processes he employs.

All else he should be able to turn over to his mechanism, just as confidently as he turns over the propelling of his car to the intricate mechanism under the hood. Only then will mathematics be practically effective in bringing the growing knowledge of atomistics to the useful solution of the advanced problems of chemistry, metallurgy, and biology. For this reason there will come more machines to handle advanced mathematics for the scientist. Some of them will be sufficiently bizarre to suit the most fastidious connoisseur of the present artifacts of civilization.

5

The scientist, however, is not the only person who manipulates data and examines the world about him by the use of logical processes, although he sometimes preserves this appearance by adopting into the fold anyone who becomes logical, much in the manner in which a British labor leader is elevated to knighthood. Whenever logical processes of thought are employed — that is, whenever thought for a time runs along an accepted groove — there is an opportunity for the machine. Formal logic used to be a keen instrument in the hands of the teacher in his trying of students' souls. It is readily possible to construct a machine which will manipulate premises in accordance with formal logic, simply by the clever use of relay circuits. Put a set of premises into such a device and turn the crank, and it will readily pass out conclusion after conclusion, all in accordance with logical law, and with no more slips than would be expected of a keyboard adding machine.

Logic can become enormously difficult, and it would undoubtedly be well to produce more assurance in its use. The machines for higher analysis have usually been equation solvers. Ideas are beginning to appear for equation transformers, which will rearrange the relationship expressed by an equation in accordance with strict and

rather advanced logic. Progress is inhibited by the exceedingly crude way in which mathematicians express their relationships. They employ a symbolism which grew like Topsy and has little consistency; a strange fact in that most logical field.

A new symbolism, probably positional, must apparently precede the reduction of mathematical transformations to machine processes. Then, on beyond the strict logic of the mathematician, lies the application of logic in everyday affairs. We may someday click off arguments on a machine with the same assurance that we now enter sales on a cash register. But the machine of logic will not look like a cash register, even a streamlined model.

So much for the manipulation of ideas and their insertion into the record. Thus far we seem to be worse off than before — for we can enormously extend the record; yet even in its present bulk we can hardly consult it. This is a much larger matter than merely the extraction of data for the purposes of scientific research; it involves the entire process by which man profits by his inheritance of acquired knowledge. The prime action of use is selection, and here we are halting indeed. There may be millions of fine thoughts, and the account of the experience on which they are based, all encased within stone walls of acceptable architectural form; but if the scholar can get at only one a week by diligent search, his syntheses are not likely to keep up with the current scene.

Selection, in this broad sense, is a stone adze in the hands of a cabinetmaker. Yet, in a narrow sense and in other areas, something has already been done mechanically on selection. The personnel officer of a factory drops a stack of a few thousand employee cards into a selecting machine, sets a code in accordance with an established convention, and produces in a short time a list of all employees who live in Trenton and know Spanish. Even such devices are much too slow when it comes, for example, to matching a set of fingerprints with one of five millions on file. Selection devices of this sort will soon be speeded up from their present rate of reviewing data at a few hundred a minute. By the use of photocells and microfilm they will survey items at the rate of thousands a second, and will print out duplicates of those selected.

This process, however, is simple selection: it proceeds by examining in turn every one of a large set of items, and by picking out those which have certain specified characteristics. There is another form of selection best illustrated by the automatic telephone exchange. You dial a number and the machine selects and connects just one of a million possible stations. It does not run over them all. It pays attention only to a class given by a first digit, and so on; and thus proceeds rapidly and almost unerringly to the selected station. It requires a few seconds to make the selection, although the process could be speeded up if increased speed were economically warranted. If necessary, it could be made extremely fast by substituting thermionic-tube switching for mechanical switching, so that the full selection could be made in one-hundredth of a second. No one would wish to spend the money necessary to make this change in the telephone system, but the general idea is applicable elsewhere.

Take the prosaic problem of the great department store. Every time a charge sale is made, there are a number of things to be done. The inventory needs to be revised, the salesman needs to be given credit for the sale, the general accounts need an entry, and, most important, the customer needs to be charged. A central records device has been developed in which much of this work is done conveniently. The salesman places on a stand the customer's identification card, his own card, and the card taken from the article sold — all punched cards. When he pulls a lever, contacts are made through the holes, machinery at a central point makes the necessary computations and entries, and the proper receipt is printed for the salesman to pass to the customer.

But there may be ten thousand charge customers doing business with the store, and before the full operation can be completed someone has to select the right card and insert it at the central office. Now rapid selection can slide just the proper card into position in an instant or two, and return it afterward. Another difficulty occurs, however. Someone must read a total on the card, so that the machine can add its computed item to it. Conceivably the cards might be of the dry photography type I have described. Existing totals could then be read by photocell, and the new total entered by an electron beam.

The cards may be in miniature, so that they occupy little space. They must move quickly. They need not be transferred far, but merely into position so that the photocell and recorder can operate on them. Positional dots can enter the data. At the end of the month a machine can readily be made to read these and to print an ordinary bill. With tube selection, in which no mechanical parts are involved in the switches, little time need be occupied in bringing the correct card into use — a second should suffice for the entire operation. The whole record on the card may be made by magnetic dots on a steel sheet if desired, instead of dots to be observed optically, following the scheme by which Poulsen long ago put speech on a magnetic wire. This method has the advantage of simplicity and ease of erasure. By using photography, however, one can arrange to project the record in enlarged form, and at a distance by using the process common in television equipment.

One can consider rapid selection of this form, and distant projection for other purposes. To be able to key one sheet of a million before an operator in a second or two, with the possibility of then adding notes thereto, is suggestive in many ways. It might even be of use in libraries, but that is another story. At any rate, there are now some interesting combinations possible. One might, for example, speak to a microphone, in the manner described in connection with the speech-controlled typewriter, and thus make his selections. It would certainly beat the usual file clerk.

<div align="center">6</div>

The real heart of the matter of selection, however, goes deeper than a lag in the adoption of mechanisms by libraries, or a lack of development of devices for their use. Our ineptitude in getting at the record is largely caused by the artificiality of

systems of indexing. When data of any sort are placed in storage, they are filed alphabetically or numerically, and information is found (when it is) by tracing it down from subclass to subclass. It can be in only one place, unless duplicates are used; one has to have rules as to which path will locate it, and the rules are cumbersome. Having found one item, moreover, one has to emerge from the system and re-enter on a new path.

The human mind does not work that way. It operates by association. With one item in its grasp, it snaps instantly to the next that is suggested by the association of thoughts, in accordance with some intricate web of trails carried by the cells of the brain. It has other characteristics, of course: trails that are not frequently followed are prone to fade, items are not fully permanent, memory is transitory. Yet the speed of action, the intricacy of trails, the detail of mental pictures, is awe-inspiring beyond all else in nature.

Man cannot hope fully to duplicate this mental process artificially, but he certainly ought to be able to learn from it. In minor ways he may even improve,

for his records have relative permanency. The first idea, however, to be drawn from the analogy concerns selection. Selection by association, rather than by indexing, may yet be mechanized. One cannot hope thus to equal the speed and flexibility with which the mind follows an associative trail, but it should be possible to beat the mind decisively in regard to the permanence and clarity of the items resurrected from storage.

Consider a future device for individual use, which is a sort of mechanized private file and library. It needs a name, and to coin one at random, "memex" will do. A memex is a device in which an individual stores all his books, records, and communications, and which is mechanized so that it may be consulted with exceeding speed and flexibility. It is an enlarged intimate supplement to his memory.

It consists of a desk, and while it can presumably be operated from a distance, it is primarily the piece of furniture at which he works. On the top are slanting translucent screens, on which material can be projected for convenient reading. There is a keyboard, and sets of buttons and levers. Otherwise it looks like an ordinary desk.

In one end is the stored material. The matter of bulk is well taken care of by improved microfilm. Only a small part of the interior of the memex is devoted to storage, the rest to mechanism. Yet if the user inserted 5,000 pages of material a day it would take him hundreds of years to fill the repository, so he can be profligate and enter material freely.

Most of the memex contents are purchased on microfilm ready for insertion. Books of all sorts, pictures, current periodicals, newspapers, are thus obtained and dropped into place. Business correspondence takes the same path. And there is provision for direct entry. On the top of the memex is a transparent platen. On this are placed longhand notes, photographs, memoranda, all sort of things. When one is in place, the depression of a lever causes it to be photographed onto the next blank space in a section of the memex film, dry photography being employed.

There is, of course, provision for consultation of the record by the usual scheme of indexing. If the user wishes to consult a certain book, he taps its code on the keyboard, and the title page of the book promptly appears before him, projected onto one of his viewing positions. Frequently-used codes are mnemonic, so that he seldom consults his code book; but when he does, a single tap of a key projects it for his use. Moreover, he has supplemental levers. On deflecting one of these levers to the right he runs through the book before him, each page in turn being projected at a speed which just allows a recognizing glance at each. If he deflects it further to the right, he steps through the book 10 pages at a time; still further at 100 pages at a time. Deflection to the left gives him the same control backwards.

A special button transfers him immediately to the first page of the index. Any given book of his library can thus be called up and consulted with far greater facility than if it were taken from a shelf. As he has several projection positions, he can leave one item in position while he calls up another. He can add marginal

notes and comments, taking advantage of one possible type of dry photography, and it could even be arranged so that he can do this by a stylus scheme, such as is now employed in the telautograph seen in railroad waiting rooms, just as though he had the physical page before him.

<div align="center">7</div>

All this is conventional, except for the projection forward of present-day mechanisms and gadgetry. It affords an immediate step, however, to associative indexing, the basic idea of which is a provision whereby any item may be caused at will to select immediately and automatically another. This is the essential feature of the memex. The process of tying two items together is the important thing.

When the user is building a trail, he names it, inserts the name in his code book, and taps it out on his keyboard. Before him are the two items to be joined, projected onto adjacent viewing positions. At the bottom of each there are a number of blank code spaces, and a pointer is set to indicate one of these on each item. The user taps a single key, and the items are permanently joined. In each code space appears the code word. Out of view, but also in the code space, is inserted a set of dots for photocell viewing; and on each item these dots by their positions designate the index number of the other item.

Thereafter, at any time, when one of these items is in view, the other can be instantly recalled merely by tapping a button below the corresponding code space. Moreover, when numerous items have been thus joined together to form a trail, they can be reviewed in turn, rapidly or slowly, by deflecting a lever like that used for turning the pages of a book. It is exactly as though the physical items had been gathered together to form a new book. It is more than this, for any item can be joined into numerous trails.

The owner of the memex, let us say, is interested in the origin and properties of the bow and arrow. Specifically he is studying why the short Turkish bow was apparently superior to the English long bow in the skirmishes of the Crusades. He has dozens of possibly pertinent books and articles in his memex. First he runs through an encyclopedia, finds an interesting but sketchy article, leaves it projected. Next, in a history, he finds another pertinent item, and ties the two together. Thus he goes, building a trail of many items. Occasionally he inserts a comment of his own, either linking it into the main trail or joining it by a side trail to a particular item. When it becomes evident that the elastic properties of available materials had a great deal to do with the bow, he branches off on a side trail which takes him through textbooks on elasticity and tables of physical constants. He inserts a page of longhand analysis of his own. Thus he builds a trail of his interest through the maze of materials available to him.

And his trails do not fade. Several years later, his talk with a friend turns to the queer ways in which a people resist innovations, even of vital interest. He has an example, in the fact that the outranged Europeans still failed to adopt the

Turkish bow. In fact he has a trail on it. A touch brings up the code book. Tapping a few keys projects the head of the trail. A lever runs through it at will, stopping at interesting items, going off on side excursions. It is an interesting trail, pertinent to the discussion. So he sets a reproducer in action, photographs the whole trail out, and passes it to his friend for insertion in his own memex, there to be linked into the more general trail.

<div align="center">8</div>

Wholly new forms of encyclopedias will appear, ready-made with a mesh of associative trails running through them, ready to be dropped into the memex and there amplified. The lawyer has at his touch the associated opinions and decisions of his whole experience, and of the experience of friends and authorities. The patent attorney has on call the millions of issued patents, with familiar trails to every point of his client's interest. The physician, puzzled by its patient's reactions, strikes the trail established in studying an earlier similar case, and runs rapidly through analogous case histories, with side references to the classics for the pertinent anatomy and histology. The chemist, struggling with the synthesis of an organic compound, has all the chemical literature before him in his laboratory, with trails following the analogies of compounds, and side trails to their physical and chemical behavior.

Memex in the form of a desk would instantly bring files and send material on any subject to the operator's fingertips. Slanting translucent viewing screens magnify supermicrofilm filed by code numbers. At left is a mechanism which automatically photographs longhand notes, pictures and letters, then files them in the desk for future reference.

The historian, with a vast chronological account of a people, parallels it with a skip trail which stops only at the salient items, and can follow at any time contemporary trails which lead him all over civilization at a particular epoch. There is a new profession of trailblazers, those who find delight in the task of establishing useful trails through the enormous mass of the common record. The inheritance from the master becomes, not only his additions to the world's record, but for his disciples the entire scaffolding by which they were erected.

Thus science may implement the ways in which man produces, stores, and consults the record of the race. It might be striking to outline the instrumentalities of the future more spectacularly, rather than to stick closely to the methods and elements now known and undergoing rapid development, as has been done here. Technical difficulties of all sorts have been ignored, certainly, but also ignored are means as yet unknown which may come any day to accelerate technical progress as violently as did the advent of the thermionic tube. In order that the picture may not be too commonplace, by reason of sticking to present-day patterns, it may be well to mention one such possibility, not to prophesy but merely to suggest, for prophecy based on extension of the known has substance, while prophecy founded on the unknown is only a doubly involved guess.

All our steps in creating or absorbing material of the record proceed through one of the senses — the tactile when we touch keys, the oral when we speak or listen, the visual when we read. Is it not possible that someday the path may be established more directly?

We know that when the eye sees, all the consequent information is transmitted to the brain by means of electrical vibrations in the channel of the optic nerve. This is an exact analogy with the electrical vibrations which occur in the cable of a television set: they convey the picture from the photocells which see it to the radio transmitter from which it is broadcast. We know further that if we can approach that cable with the proper instruments, we do not need to touch it; we can pick up those vibrations by electrical induction and thus discover and reproduce the scene which is being transmitted, just as a telephone wire may be tapped for its message.

The impulses which flow in the arm nerves of a typist convey to her fingers the translated information which reaches her eye or ear, in order that the fingers may be caused to strike the proper keys. Might not these currents be intercepted, either in the original form in which information is conveyed to the brain, or in the marvelously metamorphosed form in which they then proceed to the hand?

By bone conduction we already introduce sounds into the nerve channels of the deaf in order that they may hear. Is it not possible that we may learn to introduce them without the present cumbersomeness of first transforming electrical vibrations to mechanical ones, which the human mechanism promptly transforms back to the electrical form? With a couple of electrodes on the skull, the encephalograph now produces pen-and-ink traces which bear some relation

to the electrical phenomena going on in the brain itself. True, the record is unintelligible, except as it points out certain gross misfunctioning of the cerebral mechanism; but who would now place bounds on where such a thing may lead?

In the outside world, all forms of intelligence, whether of sound or sight, have been reduced to the form of varying currents in an electric circuit in order that they may be transmitted. Inside the human frame exactly the same sort of process occurs. Must we always transform to mechanical movements in order to proceed from one electrical phenomenon to another? It is a suggestive thought, but it hardly warrants prediction without losing touch with reality and immediateness.

Presumably man's spirit should be elevated if he can better review his shady past and analyze more completely and objectively his present problems. He has built a civilization so complex that he needs to mechanize his record more fully if he is to push his experiment to its logical conclusion and not merely become bogged down part way there by overtaxing his limited memory. His excursion may be more enjoyable if he can reacquire the privilege of forgetting the manifold things he does not need to have immediately at hand, with some assurance that he can find them again if they prove important.

The applications of science have built man a well-supplied house, and are teaching him to live healthily therein. They have enabled him to throw masses of people against another with cruel weapons. They may yet allow him truly to encompass the great record and to grow in the wisdom of race experience. He may perish in conflict before he learns to wield that record for his true good. Yet, in the application of science to the needs and desires of man, it would seem to be a singularly unfortunate stage at which to terminate the process, or to lose hope as to the outcome. □

This article was originally published in the July 1945 issue of the *Atlantic Monthly*.

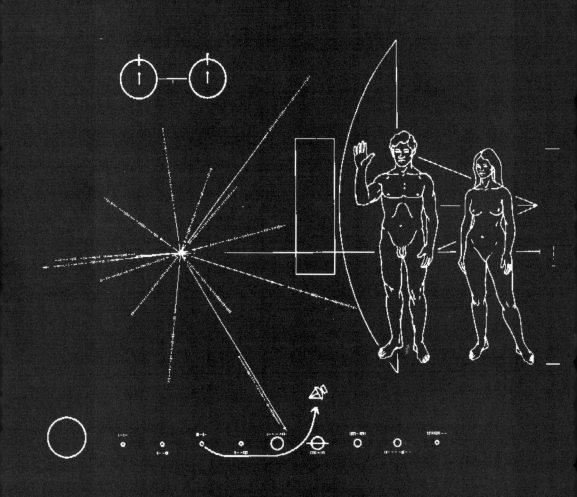

THE AGE OF THE WORLD PICTURE

■ *M a r t i n H e i d e g g e r*

In metaphysics reflection is accomplished concerning the essence of what is and a decision takes place regarding the essence of truth.[1] Metaphysics grounds an age, in that through a specific interpretation of what is and through a specific comprehension of truth it gives to that age the basis upon which it is essentially formed.[2] This basis holds complete dominion over all the phenomena that distinguish the age. Conversely, in order that there may be an adequate reflection upon these phenomena themselves, the metaphysical basis for them must let itself be apprehended in them. Reflection is the courage to make the truth of our own presuppositions and the realm of our own goals into the things that most deserve to be called in question (see Appendix 1).[3]

One of the essential phenomena of the modern age is its science. A phenomenon of no less importance is machine technology. We must not, however, misinterpret that technology as the mere application of modern mathematical physical science to praxis. Machine technology is itself an autonomous transformation of praxis, a type of transformation wherein praxis first demands the employment of mathematical physical science. Machine technology remains up to now the most visible outgrowth of the essence of modern technology, which is identical with the essence of modern metaphysics.

A third equally essential phenomenon of the modern period lies in the event of art's moving into the purview of aesthetics. That means that the art work becomes the object of mere subjective experience, and that consequently art is considered to be an expression of human life.[4]

A fourth modern phenomenon manifests itself in the fact that human activity is conceived and consummated as culture. Thus culture is the realization of highest values, through the nurture and cultivation of the highest goods of man. It lies in the essence of culture, as such nurturing, to nurture itself in its turn and thus to become the politics of culture.

A fifth phenomenon of the modern age is the loss of the gods.[5] This expression does not mean the mere doing away with the gods, gross atheism. The loss of the gods is a twofold process. On the one hand, the world picture is

Christianized inasmuch as the cause of the world is posited as infinite, unconditional, absolute. On the other hand, Christendom transforms Christian doctrine into a world view (the Christian world view), and in that way makes itself modern and up to date. The loss of the gods is the situation of indecision regarding God and the gods. Christendom has the greatest share in bringing it about. But the loss of the gods is so far from excluding religiosity that rather only through that loss is the relation to the gods changed into mere "religious experience." When this occurs, then the gods have fled. The resultant void is compensated for by means of historiographical and psychological investigation of myth.

What understanding of what is, what interpretation of truth, lies at the foundation of these phenomena?

We shall limit the question to the phenomenon mentioned first, to science [*Wissenschaft*].

In what does the essence of modern science lie?

What understanding of what is and of truth provides the basis for that essence? If we succeed in reaching the metaphysical ground that provides the foundation for science as a modern phenomenon, then the entire essence of the modern age will have to let itself be apprehended from out of that ground.

When we use the word "science" today, it means something essentially different from the *doctrina* and *scientia* of the Middle Ages, and also from the Greek *epistēmē*. Greek science was never exact, precisely because, in keeping with its essence, it could not be exact and did not need to be exact. Hence, it makes no sense whatever to suppose that modern science is more exact than that of antiquity. Neither can we say that the Galilean doctrine of freely falling bodies is true and that Aristotle's teaching, that light bodies strive upward, is false; for the Greek understanding of the essence of body and place and of the relationship between the two rests upon a different interpretation of beings and hence conditions a correspondingly different kind of seeing and questioning of natural events. No one would presume to maintain that Shakespeare's poetry is more advanced than that of Aeschylus. It is still more impossible to say that the modern understanding of whatever is, is more correct than that of the Greeks. Therefore, if we want to grasp the essence of modern science, we must first free ourselves from the habit of comparing the new science with the old solely in terms of degree, from the point of view of progress.

The essence of what we today call science is research. In what does the essence of research consist?

In the fact that knowing [*das Erkennen*] establishes itself as a procedure within some realm of what is, in nature or in history, procedure does not mean here merely method or methodology. For every procedure already requires an open sphere in which it moves. And it is precisely in opening up such a sphere that is the fundamental event in research. This is accomplished through the projection within some realm of what is — in nature, for example — of a fixed ground plan[6] of natural events. The projection sketches out in advance the manner in which the knowing

procedure must bind itself and adhere to the sphere opened up. This binding adherence is the rigor of research.[7] Through the projecting of the ground plan and the prescribing of rigor, procedure makes secure for itself its sphere of objects within the realm of Being. A look at that earliest science, which is at the same time the normative one in the modern age, namely, mathematical physics, will make clear what we mean. Inasmuch as modern atomic physics still remains physics, what is essential — and only the essential is aimed at here — will hold for it also.

Modern physics is called mathematical because, in a remarkable way, it makes use of a quite specific mathematics. But it can proceed mathematically in this way only because, in a deeper sense, it is already itself mathematical. *Ta mathemata* means for the Greeks that which man knows in advance in his observation of whatever is and in his intercourse with things: the corporeality of bodies, the vegetable character of plants, the animality of animals, the humanness of man. Alongside these, belonging also to that which is already-known, i.e., to the mathematical, are numbers. If we come upon three apples on the table, we recognize that there are three of them. But the number three, threeness, we already know. This means that number is something mathematical. Only because numbers represent, as it were, the most striking of always-already-knowns, and thus offer the most familiar instance of the mathematical, is "mathematical" promptly reserved as a name for the numerical. In no way, however, is the essence of the mathematical defined by numberness. Physics is, in general, the knowledge of nature, and, in particular, the knowledge of material corporeality in its motion; for the corporeality manifests itself immediately and universally in everything natural, even if in a variety of ways. If physics takes shape explicitly, then, as something mathematical, this means that, in an especially pronounced way, through it and for it something is stipulated in advance as what is already-known. That stipulating has to do with nothing less than the plan or projection of that which must henceforth, for the knowing of nature that is sought after, *be* nature: the self-contained system of motion of units of mass related spatiotemporally. Into this ground plan of nature, as supplied in keeping with its prior stipulation, the following definitions among others have been incorporated: motion means change of place. No motion or direction of motion is superior to any other. Every place is equal to every other. No point in time has preference over any other. Every force is defined according to — i.e., *is* only — its consequences in motion, and that means in magnitude of change of place in the unity of time. Every event must be seen so as to be fitted into this ground plan of nature. Only within the perspective of this ground plan does an event in nature become visible as such an event. This projected plan of nature finds its guarantee in the fact that physical research, in every one of its questioning steps, is bound in advance to adhere to it. This binding adherence, the rigor of research, has its own character at any given time in keeping with the projected plan. The rigor of mathematical physical science is exactitude. Here all events, if they are to enter at all into representation

as events of nature, must be defined beforehand as spatiotemporal magnitudes of motion. Such defining is accomplished through measuring, with the help of number and calculation. But mathematical research into nature is not exact because it calculates with precision; rather it must calculate in this way because its adherence to its object-sphere has the character of exactitude. The humanistic sciences, in contrast, indeed all the sciences concerned with life, must necessarily be inexact just in order to remain rigorous. A living thing can indeed also be grasped as a spatiotemporal magnitude of motion, but then it is no longer apprehended as living. The inexactitude of the historical humanistic sciences is not a deficiency, but is only the fulfillment of a demand essential to this type of research. It is true, also, that the projecting and securing of the object-sphere of the historical sciences is not only of another kind, but is much more difficult of execution than is the achieving of rigor in the exact sciences.

Science becomes research through the projected plan and through the securing of that plan in the rigor of procedure. Projection and rigor, however, first develop into what they are in methodology. The latter constitutes the second essential characteristic of research. If the sphere that is projected is to become objective, then it is a matter of bringing it to encounter us in the complete diversity of its levels and interweavings. Therefore, procedure must be free to view the changeableness in whatever encounters it. Only within the horizon of the incessant-otherness of change does the plenitude of particularity — of facts — show itself. But the facts must become objective [*gegenständlich*]. Hence procedure must represent [*vorstellen*] the changeable in its changing,[8] must bring it to a stand and let the motion be a motion nevertheless. The fixedness of facts and the constantness of their change as such is "rule." The constancy of change in the necessity of its course is "law." It is only within the purview of rule and law that facts become clear as the facts that they are. Research into facts in the realm of nature is intrinsically the establishing and verifying of rule and law. Methodology, through which a sphere of objects comes into representation, has the character of clarifying on the basis of what is clear — of explanation. Explanation is always twofold. It accounts for an unknown by means of a known, and at the same time it verifies that known by means of the unknown. Explanation takes place in investigation. In the physical sciences investigation takes place by means of experiment, always according to the kind of field of investigation and according to the type of explanation aimed at. But physical science does not first become research through experiment; rather, on the contrary, experiment first becomes possible where and only where the knowledge of nature has been transformed into research. Only because modern physics is a physics that is essentially mathematical can it be experimental. Because neither medieval *doctrina* nor Greek *epistēmē* is science in the sense of research, for these it is never a question of experiment. To be sure, it was Aristotle who first understood what *empeiria* (*experientia*) means: the observation of things themselves, their qualities and modifications under changing

conditions, and consequently the knowledge of the way in which things as a rule behave. But an observation that aims at such knowledge, the *experimentum*, remains essentially different from the observation that belongs to science as research, from the research experiment; it remains essentially different even when ancient and medieval observation also works with number and measure, and even when that observation makes use of specific apparatus and instruments. For in all this, that which is decisive about the experiment is completely missing. Experiment begins with the laying down of a law as a basis. To set up an experiment means to represent or conceive [*vorstellen*] the conditions under which a specific series of motions can be made susceptible of being followed in its necessary progression, i.e., of being controlled in advance by calculation. But the establishing of a law is accomplished with reference to the ground plan of the object-sphere. That ground plan furnishes a criterion and constrains the anticipatory representing of the conditions. Such representing in and through which the experiment begins is no random imagining. That is why Newton said, *hypothesis non fingo*, "the bases that are laid down are not arbitrarily invented." They are developed out of the ground plan of nature and are sketched into it. Experiment is that methodology which, in its planning and execution, is supported and guided on the basis of the fundamental law laid down, in order to adduce the facts that either verify and confirm the law or deny it confirmation. The more exactly the ground plan of nature is projected, the more exact becomes the possibility of experiment. Hence the much-cited medieval schoolman Roger Bacon can never be the forerunner of the modern experimental research scientist; rather he remains merely a successor of Aristotle. For in the meantime, the real locus of truth has been transferred by Christendom to faith — to the infallibility of the written word and to the doctrine of the Church. The highest knowledge and teaching is theology as the interpretation of the divine word of revelation, which is set down in Scripture and proclaimed by the Church. Here, to know is not to search out; rather it is to understand rightly the authoritative Word and the authorities proclaiming it. Therefore, the discussion of the words and doctrinal opinions of the various authorities takes precedence in the acquiring of knowledge in the Middle Ages. The *componere scripta et sermones*, the *argumentum ex verbo*,[9] is decisive and at the same time is the reason why the accepted Platonic and Aristotelian philosophy that had been taken over had to be transformed into scholastic dialectic. If, now, Roger Bacon demands the *experimentum* — and he does demand it — he does not mean the experiment of science as research; rather he wants the *argumentum ex re* instead of the *argumentum ex verbo*, the careful observing of things themselves, i.e., Aristotelian *empeiria*, instead of the discussion of doctrines.

The modern research experiment, however, is not only an observation more precise in degree and scope, but is a methodology essentially different in kind, related to the verification of law in the framework, and at the service of an exact plan of nature. Source criticism in the historical humanistic sciences

corresponds to experiment in physical research. Here the name "source criticism" designates the whole gamut of the discovery, examination, verification, evaluation, preservation, and interpretation of sources. Historiographical explanation, which is based on source criticism, does not, it is true, trace facts back to laws and rules. But neither does it confine itself to the mere reporting of facts. In the historical sciences, just as in the natural sciences, the methodology aims at representing what is fixed and stable and at making history an object. History can become objective only when it is past. What is stable in what is past, that on the basis of which historiographcial explanation reckons up the solitary and the diverse in history, is the always-has-been-once-already, the comparable. Through the constant comparing of everything with everything, what is intelligible is found by calculation and is certified and established as the ground plan of history. The sphere of historiographical research extends only so far as historiographical explanation reaches. The unique, the rare, the simple — in short, the great — in history is never self-evident and hence remains inexplicable. It is not that historical research denies what is great in history; rather it explains it as the exception. In this explaining, the great is measured against the ordinary and the average. And there is no other historiographical explanation so long as explaining means reduction to what is intelligible and so long as historiography remains research, i.e., an explaining. Because historiography as research projects and objectifies the past in the sense of an explicable and surveyable nexus of actions and consequences, it requires source criticism as its instrument of objectification. The standards of this criticism alter to the degree that historiography approaches journalism.

Every science is, as research, grounded upon the projection of a circumscribed object-sphere and is therefore necessarily a science of individualized character. Every individualized science must, moreover, in the development of its projected plan by means of its methodology, particularize itself into specific fields of investigation. This particularizing (specialization) is, however, by no means simply an irksome concomitant of the increasing unsurveyability of the results of the research. It is not a necessary evil, but is rather an essential necessity of science as research. Specialization is not the consequence but the foundation of the progress of all research. Research does not, through its methodology, become dispersed into random investigations, so as to lose itself in them; for modern science is determined by a third fundamental event: ongoing activity (Appendix 2).[10]

By this is to be understood first of all the phenomenon that a science today, whether physical or humanistic, attains to the respect due a science only when it has become capable of being institutionalized. However, research is not ongoing activity because its work is accomplished in institutions, but rather institutions are necessary because science, intrinsically as research, has the character of ongoing activity. The methodology through which individual object-spheres are conquered does not simply amass results. Rather, with the help of its results it adapts [*richtet*

sich . . . ein] itself for a new procedure. Within the complex of machinery that is necessary to physics in order to carry out the smashing of the atom lies hidden the whole of physics up to now. Correspondingly, in historiographcal research, funds of source materials become usable for explanation only if those sources are themselves guaranteed on the basis of historiographical explanation. In the course of these processes, the methodology of the science becomes circumscribed by means of its results. More and more the methodology adapts itself to the possibilities of procedure opened up through itself. This having-to-adapt-itself to its own results as the ways and means of an advancing methodology is the essence of research's character as ongoing activity. And it is that character that is the intrinsic basis for the necessity of the institutional nature of research.

In ongoing activity the plan of an object-sphere is, for the first time, built into whatever it is. All adjustments that facilitate a plannable conjoining of types of methodology, that further the reciprocal checking and communication of results, and that regulate the exchange of talents are measures that are by no means only the external consequences of the fact that research work is expanding and proliferating. Rather, research work becomes the distant sign, still far from being understood, that modern science is beginning to enter upon the decisive phase of its history. Only now is it beginning to take possession of its own complete essence.

What is taking place in this extending and consolidation of the institutional character of the sciences? Nothing less than the making secure of the precedence of methodology over whatever is (nature and history), which at any given time becomes objective in research. On the foundation of their character as ongoing activity, the sciences are creating for themselves the solidarity and unity appropriate to them. Therefore historiographical or archeological research that is carried forward in an institutionalized way is essentially closer to research in physics that is similarly organized than it is to a discipline belonging to its own faculty in the humanistic sciences that still remains mired in mere erudition. Hence the decisive development of the modern character of science as ongoing activity also forms men of a different stamp. The scholar disappears. He is succeeded by the research man who is engaged in research projects. These, rather than the cultivating of erudition, lend to his work its atmosphere of incisiveness. The research man no longer needs a library at home. Moreover, he is constantly on the move. He negotiates at meetings and collects information at congresses. He contracts for commissions with publishers. The latter now determine along with him which books must be written (Appendix 3).

The research worker necessarily presses forward of himself into the sphere characteristic of the technologist in the essential sense. Only in this way is he capable of acting effectively, and only thus, after the manner of his age, is he real. Alongside him, the increasingly thin and empty Romanticism of scholarship and the university will still be able to persist for some time in a few places. However, the effective unity characteristic of the university, and hence the latter's reality, does not lie in some

intellectual power belonging to an original unification of the sciences and emanating from the university because nourished by it and preserved in it. The university is real as an orderly establishment that, in a form still unique because it is administratively self-contained, makes possible and visible the striving apart of the sciences into the particularization and peculiar unity that belong to ongoing activity. Because the forces intrinsic to the essence of modern science come immediately and unequivocally to effective working in ongoing activity, therefore, also, it is only the spontaneous ongoing activities of research that can sketch out and establish the internal unity with other like activities that is commensurate with themselves.

The real system of science consists in a solidarity of procedure and attitude with respect to the objectification of whatever is — a solidarity that is brought about appropriately at any given time on the basis of planning. The excellence demanded of the system is not some contrived and rigid unity of the relationships among object-spheres, having to do with content, but is rather the greatest possible free, though regulated, flexibility in the shifting about and introducing of research apropos of the leading tasks at any given time. The more exclusively science individualizes itself with a view to the total carrying on and mastering of its work process, and the more realistically these ongoing activities are shifted into separate research institutes and professional schools, the more irresistibly do the sciences achieve the consummation of their modern essence. But the more unconditionally science and the man of research take seriously the modern form of their essence, the more unequivocally and the more immediately will they be able to offer themselves for the common good, and the more unreservedly too will they have to return to the public anonymity of all work useful to society.

Modern science simultaneously establishes itself and differentiates itself in its projections of specific object-spheres. These projection-plans are developed by means of a corresponding methodology, which is made secure through rigor. Methodology adapts and establishes itself at any given time in ongoing activity. Projection and rigor, methodology and ongoing activity, mutually requiring one another, constitute the essence of modern science, transform science into research.

We are reflecting on the essence of modern science in order that we may apprehend in it its metaphysical ground. What understanding of what is and what concept of truth provide the basis for the fact that science is being transformed into research?

Knowing, as research, calls whatever is to account with regard to the way in which and the extent to which it lets itself be put at the disposal of representation. Research has disposal over anything that is when it can either calculate it in its future course in advance or verify a calculation about it as past. Nature, in being calculated in advance, and history, in being historiographically verified as past, become, as it were, "set in place" [gestellt].[11] Nature and history become the objects of a representing that explains. Such representing counts on nature and takes account of history. Only that which becomes object in this way is — is

considered to be in being. We first arrive at science as research when the Being of whatever it is, is sought in such objectiveness.

This objectifying of whatever is, is accomplished in a setting-before, a representing, that aims at bringing each particular being before it in such a way that man who calculates can be sure, and that means be certain, of that being. We first arrive at science as research when and only when truth has been transformed into the certainty of representation. What it is to be is for the first time defined as the objectiveness of representing, and truth is first defined as the certainty of representing, the metaphysics of Descartes. The title of Descartes's principal work reads: *Meditationes de prima philosophia* [*Meditations on First Philosophy*]. *Prōtē philosophia* is the designation coined by Aristotle for what is later called metaphysics. The whole of modern metaphysics taken together, Nietzsche included, maintains itself within the interpretation of what it is to be and of truth that was prepared by Descartes (Appendix 4).

Now if science as research is an essential phenomenon of the modern age, it must be that that which constitutes the metaphysical ground of research determines first and long beforehand the essence of that age generally. The essence of the modern age can be seen in the fact that man frees himself from the bonds of the Middle Ages in freeing himself to himself. But this correct characterization remains, nevertheless, superficial. It leads to those errors that prevent us from comprehending the essential foundation of the modern age and, from there, judging the scope of the age's essence. Certainly the modern age has, as a consequence of the liberation of man, introduced subjectivism and individualism. But it remains just as certain that no age before this one has produced a comparable objectivism and that in no age before this has the non–individual, in the form of the collective, come to acceptance as having worth. Essential here is the necessary interplay between subjectivism and objectivism. It is precisely this reciprocal conditioning of one by the other that points back to events more profound.

What is decisive is not that man frees himself to himself from previous obligations, but that the very essence of man itself changes, in that man becomes subject. We must understand this word *subiectum*, however, as the translation of the Greek *hypokeimenon*. The word names that-which-lies-before, which, as ground, gathers everything onto itself. This metaphysical meaning of the concept of subject has first of all no special relationship to man and none at all to the I.

However, when man becomes the primary and only real *subiectum*, that means: man becomes that being upon which all that is, is grounded as regards the manner of its Being and its truth. Man becomes the rela-tional center of that which is as such. But this is possible only when the comprehension of what is as a whole changes. In what does this change manifest itself? What, in keeping with it, is the essence of the modern age?

When we reflect on the modern age, we are questioning concerning the modern world picture [*Weltbild*].[12] We characterize the latter by throwing it into

relief over against the medieval and the ancient world pictures. But why do we ask concerning a world picture in our interpreting of a historical age? Does every period of history have its world picture, and indeed in such a way as to concern itself from time to time about that world picture? Or is this, after all, only a modern kind of representing, this asking concerning a world picture?

What is a world picture? Obviously a picture of the world. But what does "world" mean here? What does "picture" mean? "World" serves here as a name for what is, in its entirety. The name is not limited to the cosmos, to nature. History also belongs to the world. Yet even nature and history, and both interpenetrating in their underlying and transcending of one another, do not exhaust the world. In this designation the ground of the world is meant also, no matter how its relation to the world is thought (Appendix 5).

With the word "picture" we think first of all of a copy of something. Accordingly, the world picture would be a painting, so to speak, of what is as a whole. But "world picture" means more than this. We mean by it the world itself, the world as such, what is, in its entirety, just as it is normative and binding for us. "Picture" here does not mean some imitation, but rather what sounds forth in the colloquial expression, "We get the picture" [literally, we are in the picture] concerning something. This means the matter stands before us exactly as it stands with it for us. "To get into the picture" [literally, to put oneself into the picture] with respect to something means to set whatever it is, itself, in place before oneself just in the way that it stands with it, and to have it fixedly before oneself as set up in this way. But a decisive determinant in the essence of the picture is still missing. "We get the picture" concerning something does not mean only that what is, is set before us, is represented to us, in general, but that what is stands before us — in all that belongs to it and all that stands together in it — as a system. "To get the picture" throbs with being acquainted with something, with being equipped and prepared for it. Where the world becomes picture, what is, in its entirety, is juxtaposed as that for which man is prepared and which, correspondingly, he therefore intends to bring before himself and have before himself, and consequently intends in a decisive sense to set in place before himself (Appendix 6). Hence world picture, when understood essentially, does not mean a picture of the world but the world conceived and grasped as picture. What is, in its entirety, is now taken in such a way that it first is in being and only is in being to the extent that it is set up by man, who represents and sets forth.[13] Wherever we have the world picture, an essential decision takes place regarding what is, in its entirety. The Being of whatever is, is sought and found in the representedness of the latter.

However, everywhere that whatever is, is *not* interpreted in this way, the world also cannot enter into a picture; there can be no world picture. The fact that whatever is comes into being in and through representedness transforms the age in which this occurs into a new age in contrast with the preceding one. The expressions "world picture of the modern age" and "modern world picture" both

mean the same thing and both assume something that never could have been before, namely, a medieval and an ancient world picture. The world picture does not change from an earlier medieval one into a modern one, but rather the fact that the world becomes picture at all is what distinguishes the essence of the modern age [der Neuzeit].[14] For the Middle Ages, in contrast, that which is, is the *ens creatum*, that which is created by the personal Creator-God as the highest cause. Here, to be in being means to belong within a specific rank of the order of what has been created — a rank appointed from the beginning — and as thus caused, to correspond to the cause of creation (*analogia entis*) (Appendix 7). But never does the Being of that which is consist here in the fact that it is brought before man as the objective, in the fact that it is placed in the realm of man's knowing and of his having disposal, and that it is in being only in this way.

The modern interpretation of that which is, is even further from the interpretation characteristic of the Greeks. One of the oldest pronouncements of Greek thinking regarding the Being of that which is runs: *To gar auto noein estin te kai einai*.[15] This sentence of Parmenides means: The apprehending of whatever is belongs to Being because it is demanded and determined by Being. That which is, is that which arises and opens itself, which, as what presences, comes upon man as the one who presences, i.e., comes upon the one who himself opens himself to what presences in that he apprehends it. That which is does not come into being at all through the fact that man first looks upon it, in the sense of a representing that has the character of subjective perception. Rather, man is the one who is looked upon by that which is; he is the one who is — in company with itself — gathered toward presencing, by that which opens itself. To be beheld by what is, to be included and maintained within its openness and in that way to be borne along by it, to be driven about by its oppositions and marked by its discord — that is the essence of man in the great age of the Greeks. Therefore, in order to fulfill his essence, Greek man must gather (*legein*) and save (*sozein*), catch up and preserve,[16] what opens itself in its openness, and he must remain exposed (*aletheuein*) to all its sundering confusions. Greek man *is* as the one who apprehends [der Vernehmer] that which is,[17] and this is why in the age of the Greeks the world cannot become picture. Yet, on the other hand, that the beingness of whatever is, is defined for Plato as *eidos* [aspect, view] is the presupposition, destined far in advance and long ruling indirectly in concealment, for the world's having to become picture (Appendix 8).

In distinction from Greek apprehending, modern representing, whose meaning the word *repraesentatio* first brings to its earliest expression, intends something quite different. Here to represent [vor-stellen] means to bring what is present at hand [das Vorhandene] before oneself as something standing over against, to relate it to oneself, to the one representing it, and to force it back into this relationship to oneself as the normative realm. Wherever this happens, man "gets into the picture" in precedence over whatever is. But in that man puts himself into the picture in this way, he

puts himself into the scene, i.e., into the open sphere of that which is generally and publicly represented. Therewith man sets himself up as the setting in which whatever is must henceforth set itself forth, must present itself [*sich...präsentieren*], i.e., be picture. Man becomes the representative [*der Repräsentant*] of that which is, in the sense of that which has the character of object.

But the newness in this event by no means consists in the fact that now the position of man in the midst of what is, is an entirely different one in contrast to that of medieval and ancient man. What is decisive is that man himself expressly takes up this position as one constituted by himself, that he intentionally maintains it as that taken up by himself, and that he makes it secure as the solid footing for a possible development of humanity. Now for the first time is there any such thing as a "position" of man. Man makes depend upon himself the way in which he must take his stand in relation to whatever is as the objective. There begins that way of being human which mans the realm of human capability as a domain given over to measuring and executing, for the purpose of gaining mastery over that which is as a whole. The age that is determined from out of this event is, when viewed in retrospect, not only a new one in contrast with the one that is past, but it settles itself firmly in place expressly as the new. To be new is peculiar to the world that has become picture.

When, accordingly, the picture character of the world is made clear as the representedness of that which is, then in order fully to grasp the modern essence of representedness we must track out and expose the original naming power of the worn-out word and concept "to represent" [*vorstellen*]: to set out before oneself and to set forth in relation to oneself. Through this, whatever is comes to a stand as object and in that way alone receives the seal of Being. That the world becomes picture is one and the same event with the event of man's becoming *subiectum* in the midst of that which is (Appendix 9).

Only because and insofar as man actually and essentially has become subject is it necessary for him, as a consequence, to confront the explicit question: is it as an "I" confined to its own preferences and freed into its own arbitrary choosing or as the "we" of society; is it as an individual or as a community; is it as a personality within the community or as a mere group member in the corporate body; is it as a state and nation and as a people or as the common humanity of modern man, that man will and ought to be the subject that in his modern essence he already is? Only where man is essentially already subject does there exist the possibility of his slipping into the aberration of subjectivism in the sense of individualism. But also, only where man remains subject does the positive struggle against individualism and for the community as the sphere of those goals that govern all achievement and usefulness have any meaning.

The interweaving of these two events, which for the modern age is decisive — that the world is transformed into picture and man into *subiectum* — throws light at the same time on the grounding event of modern history, an event

that at first glance seems almost absurd. Namely, the more extensively and the more effectually the world stands at man's disposal as conquered, and the more objectively the object appears, all the more subjectively, i.e., the more importunately, does the *subiectum* rise up, and all the more impetuously, too, do observation of and teaching about the world change into a doctrine of man, into anthropology. It is no wonder that humanism first arises where the world becomes picture. It would have been just as impossible for a humanism to have gained currency in the great age of the Greeks as it would have been impossible to have had anything like a world picture in that age. Humanism, therefore, in the more strict historiographical sense, is nothing but a moral-aesthetic anthropology. The name "anthropology" as used here does not mean just some investigation of man by a natural science. Nor does it mean the doctrine established within Christian theology of man created, fallen, and redeemed. It designates that philosophical interpretation of man which explains and evaluates whatever is, in its entirety, from the standpoint of man and in relation to man (Appendix 10).

The increasingly exclusive rooting of the interpretation of the world in anthropology, which has set in since the end of the eighteenth century, finds its expression in the fact that the fundamental stance of man in relation to what is, in its entirety, is defined as a world view (*Weltanschauung*). Since that time this word has been admitted into common usage. As soon as the world becomes picture, the position of man is conceived as a world view. To be sure, the phrase "world view" is open to misunderstanding, as though it were merely a matter here of a passive contemplation of the world. For this reason, already in the nineteenth century it was emphasized with justification that "world view" also meant and even meant primarily "view of life." The fact that, despite this, the phrase "world view" asserts itself as the name for the position of man in the midst of all that is, is proof of how decisively the world became picture as soon as man brought his life as *subiectum* into precedence over other centers of relationship. This means: whatever is, is considered to be in being only to the degree and to the extent that it is taken into and referred back to this life, i.e., is lived out, and becomes life-experience. Just as unsuited to the Greek spirit as every humanism had to be, just so impossible was a medieval world view, and just as absurd is a Catholic world view. Just as necessarily and legitimately as everything must change into life-experience for modern man the more unlimitedly he takes charge of the shaping of his essence, just so certainly could the Greeks at the Olympian festivals never have had life-experiences.

The fundamental event of the modern age is the conquest of the world as picture. The word "picture" [*Bild*] now means the structured image [*Gebild*] that is the creature of man's producing which represents and sets before.[18] In such producing, man contends for the position in which he can be that particular being who gives the measure and draws up the guidelines for everything that is. Because this position secures, organizes, and articulates itself as a world view, the modern relationship to that which is, is one that becomes, in its decisive unfolding, a

confrontation of world views; and indeed not of random world views, but only of those that have already taken up the fundamental position of man that is most extreme, and have done so with the utmost resoluteness. For the sake of this struggle of world views and in keeping with its meaning, man brings into play his unlimited power for the calculating, planning, and molding of all things. Science as research is an absolutely necessary form of this establishing of self in the world; it is one of the pathways upon which the modern age rages toward fulfillment of its essence, with a velocity unknown to the participants. With this struggle of world view the modern age first enters into the part of its history that is the most decisive and probably the most capable of enduring (Appendix 11).

A sign of this event is that everywhere and in the most varied forms and disguises the gigantic is making its appearance. In so doing, it evidences itself simultaneously in the tendency toward the increasingly small. We have only to think of numbers in atomic physics. The gigantic presses forward in the form that actually seems to make it disappear — in the annihilation of great distances by the airplane, in the setting before us of foreign and remote worlds in their everydayness, which is produced at random through radio by a flick of the hand. Yet we think too superficially if we suppose that the gigantic is only the endlessly extended emptiness of the purely quantitative. We think too little if we find that the gigantic, in the form of continual not-ever-having-been-here-yet, originates only in a blind mania for exaggerating and excelling. We do not think at all if we believe we have explained this phenomenon of the gigantic with the catchword "Americanism" (Appendix 12).

The gigantic is rather that through which the quantitative becomes a special quality and thus a remarkable kind of greatness. Each historical age is not only great in a distinctive way in contrast to others; it also has, in each instance, its own concept of greatness. But as soon as the gigantic in planning and calculating and adjusting and making secure shifts over out of the quantitative and becomes a special quality, then what is gigantic, and what can seemingly always be calculated completely, becomes, precisely through this, incalculable. This becoming incalculable remains the invisible shadow that is cast around all things everywhere when man has been transformed into *subiectum* and the world into picture (Appendix 13).

By means of this shadow the modern world extends itself out into a space withdrawn from representation and so lends to the incalculable the determinateness peculiar to it, as well as a historical uniqueness. This shadow, however, points to something else, which is denied to us of today to know (Appendix 14). But man will never be able to experience and ponder this that is denied so long as he dawdles about in the mere negating of the age. The flight into tradition, out of a combination of humility and presumption, can bring about nothing in itself other than self-deception and blindness in relation to the historical moment.

Man will know, i.e., carefully safeguard into its truth,[19] that which is incalculable, only in creative questioning and shaping out of the power of genuine

reflection. Reflection transports the man of the future into that "between" in which he belongs to Being and yet remains a stranger amid that which is (Appendix 15). Holderlin knew of this. His poem, which bears the superscrition "To the Germans," closes:

> *How narrowly bounded is our lifetime,*
> *We see and count the number of our years.*
> *But have the years of nations*
> *Been seen by mortal eye?*
>
> *If your soul throbs in longing*
> *Over its own time, mourning, then*
> *You linger on the cold shore*
> *Among your own and never know them.*[20] □

References to Appendixes and additional sources within the Notes are to be found in Martin Heidegger, The Question Concerning Technology and Other Essays *(Harper & Row, 1977).*

Constituents of a
Theory of the Media

■ *H a n s M a g n u s E n z e n s b e r g e r*

If you should think this is Utopian, then I
would ask you to consider why it is Utopian.

—Berthold Brecht, *Theory of Radio*

With the development of the electronic media, the industry that shapes consciousness has become the pace–setter for the social and economic development of societies in the late industrial age. It infiltrates all other sectors of production, takes over more and more directional and control functions, and determines the standard of the prevailing technology.

> In lieu of normative definitions, here is an incomplete list of new developments that have emerged in the last twenty years: news satellites, color television, cable-relay television, cassettes, videotape, videotape recorders, videophones, stereophony, laser techniques, electrostatic reproduction processes, electronic high-speed printing, composing and learning machines, microfiches with electronic access, printing by radio, time-sharing computers, data banks. All these new forms of media are constantly forming new connections both with each other and with older media such as printing, radio, film, television, telephone, teletype, radar, and so on. They are clearly coming together to form a universal system.

1. The general contradiction between productive forces and productive relationships emerges most sharply, however, when they are most advanced. By contrast, protracted structural crises, as in coal mining, can be solved merely by updating and modernizing, that is to say, essentially they can be solved within the terms of their own system, and a revolutionary strategy that relied on them would be shortsighted.

Monopoly capitalism develops the consciousness-shaping industry more quickly and more extensively than other sectors of production; it must at the same

time fetter it. A socialist media theory has to work at this contradiction, demonstrate that it cannot be solved within the given productive relationships — rapidly increasing discrepancies, potential explosive forces. "Certain demands of a prognostic nature must be made" of any such theory (Walter Benjamin).

> A "critical" inventory of the status quo is not enough. There is danger of underestimating the growing conflicts in the media field, of neutralizing them, of interpreting them merely in terms of trade unionism or liberalism, on the lines of traditional labor struggles or as the clash of special interests (program heads/executive producers, publishers/authors, monopolies/medium-sized businesses, public corporations/private companies, etc.). An appreciation of this kind does not go far enough and remains bogged down in tactical arguments.

So far there is no Marxist theory of the media. There is therefore no strategy one can apply in this area. Uncertainty, alternations between fear and surrender, marks the attitude of the socialist left to the new productive forces of the media industry. The ambivalence of this attitude merely mirrors the ambivalence of the media themselves without mastering it. It could only be overcome by releasing the emancipatory potential that is inherent in the new productive forces — a potential that capitalism must sabotage just as surely as Soviet revisionism, because it would endanger the rule of both systems.

2. The open secret of the electronic media, the decisive political factor, which has been waiting, suppressed or crippled, for its moment to come, is their mobilizing power.

When I say *mobilize* I mean *mobilize*. In a country that has had direct experience of fascism (and Stalinism) it is perhaps still necessary to explain, or to explain again, what that means — namely, to make men more mobile than they are. As free as dancers, as aware as football players, as surprising as guerrillas. Anyone who thinks of the masses only as the object of politics cannot mobilize them. He wants to push them around. A parcel is not mobile; it can only be pushed to and fro. Marches, columns parades, immobilize people. Propaganda, which does not release self-reliance but limits it, fits into the same pattern. It leads to depoliticization.

For the first time in history, the media are making possible mass participation in a social and socialized productive process, the practical means of which are in the hands of the masses themselves. Such a use of them would bring the communications media, which up to now have not deserved the name, into their own. In its present form, equipment like television or film does not serve communication but prevents it. It allows no reciprocal action between transmitter and receiver; technically speaking, it reduces feedback to the lowest point compatible with the system.

This state of affairs, however, cannot be justified technically. On the contrary. Electronic techniques recognize no contradiction in principle between transmitter and receiver. Every transistor radio is, by the nature of its construction, at the same time a potential transmitter; it can interact with other receivers by circuit reversal. The development from a mere distribution medium to a communications medium is technically not a problem. It is consciously prevented for understandable political reasons. The technical distinction between receivers and transmitters reflects the social division of labor into producers and consumers, which in the consciousness industry becomes of particular political importance. It is based, in the last analysis, on the basic contradiction between the ruling class and the ruled class — that is to say, between monopoly capital or monopolistic bureaucracy on the one hand and the dependent masses on the other.

> This structural analogy can be worked out in detail. To the programs offered by the broadcasting cartels there correspond the politics offered by a power cartel consisting of parties constituted along authoritarian lines. In both cases marginal differences in their platforms reflect a competitive relationship that, on essential questions, is nonexistent. Minimal independent activity on the part of the voter/viewer is desired. As is the case with parliamentary elections under the two-party system, the feedback is reduced to indices. "Training in decision-making" is reduced to the response to a single, three-point switching process: Program 1; Program 2; Switch off (abstention).

"Radio must be changed from a means of distribution to a means of communication. Radio would be the most wonderful means of communication imaginable in public life, a huge linked system — that is to say, it would be such if it were capable not only of transmitting but of receiving, of allowing the listener not only to hear but to speak, and did not isolate him but brought him into contact. Unrealizable in this social system, realizable in another, these proposals, which are, after all, only the natural consequences of technical development, help towards the propagation and shaping of that other system." [1]

3. George Orwell's bogey of a monolithic consciousness industry derives from a view of the media that is undialectical and obsolete. The possibility of total control of such a system at a central point belongs not to the future but to the past. With the aid of systems theory, a discipline that is part of bourgeois science — using, that is to say, categories that are immanent in the system — it can be demonstrated that a linked series of communications or, to use the technical term, a switchable network, to the degree that it exceeds a certain critical size, can no longer be centrally controlled but only dealt with statistically. This basic "leakiness" of stochastic systems admittedly allows the calculation of probabilities based on sampling and extrapolations; but blanket supervision would demand a monitor bigger than the system itself. The monitoring of all telephone conver-

sations, for instance, postulates an apparatus that would need to be *n* times more extensive and more complicated than that of the present telephone system. A censor's office, which carried out its work extensively, would of necessity become the largest branch of industry in its society.

But supervision on the basis of approximation can only offer inadequate instruments for the self-regulation of the whole system in accordance with the concepts of those who govern it. It postulates a high degree of internal stability. If this precarious balance is upset, then crisis measures based on statistical methods of control are useless. Interference can penetrate the leaky nexus of media, spreading and multiplying there with the utmost speed resonance. The regime so threatened will in such cases, insofar as it is still capable of action, use force and adopt police or military methods.

A state of emergency is therefore the only alternative to leakage in the consciousness industry; but it cannot be maintained in the long run. Societies in the late industrial age rely on the free exchange of information; the "objective pressures" to which their controllers constantly appeal are thus turned against them. Every attempt to suppress the random factors, each diminution of the average flow and each distortion of the information structure must, in the long run, lead to an embolism.

The electronic media have not only built up the information network intensively, they have also spread it extensively. The radio wars of the fifties demonstrated that, in the realm of communications, national sovereignty is condemned to wither away. The further development of satellites will deal it the coup de grace. Quarantine regulations for information, such as were promulgated by fascism and Stalinism, are only possible today at the cost of deliberate industrial regression.

EXAMPLE. The Soviet bureaucracy, that is to say the most widespread and complicated bureaucracy in the world, must almost entirely deny itself an elementary piece of organizational equipment, the duplicating machine, because this instrument potentially makes everyone a printer. The political risk involved, the possibility of a leakage in the information network, is accepted only at the highest levels, at exposed switchpoints in political, military, and scientific areas. It is clear that Soviet society has to pay an immense price for the suppression of its own productive resources — clumsy procedures, misinformation, *faux frais*. The phenomenon incidentally has its analogue in the capitalist West, if in a diluted form. The technically most-advanced electrostatic copying machine, which operates with ordinary paper — which cannot, that is to say, be supervised and is independent of suppliers — is the property of a monopoly (Xerox), on principle it is not sold but rented. The rates themselves ensure that it does not get into the wrong hands. The equipment crops up as if by magic where economic and political power are concentrated. Political control of the equipment goes hand in hand with maximization of profits for the manufacturer. Admittedly, this control, unlike Soviet methods, is by no means "watertight" for the reasons indicated.

The problem of censorship thus enters a new historical stage. The struggle for the freedom of the press and freedom of ideas has, up till now, been mainly an argument within the bourgeoisie itself; for the masses, freedom to express opinions was a fiction since they were, from the beginning, barred from the means of production — above all from the press — and thus were unable to join in freedom of expression from the start. Today censorship is threatened by the productive forces of the consciousness industry which are already, to some extent, gaining the upper hand over the prevailing relations of production. Long before the latter are overthrown, the contradiction between what is possible and what actually exists will become acute.

4. The New Left of the sixties has reduced the development of the media to a single concept — that of manipulation. This concept was originally extremely useful for heuristic purposes and has made possible a great many individual analytical investigations; but now it threatens to degenerate into a mere slogan that conceals more than it is able to illuminate, and therefore itself requires analysis.

The current theory of manipulation on the left is essentially defensive; its effects can lead the movement into defeatism. Subjectively speaking, behind the tendency to go on the defensive lies a sense of impotence. Objectively, it corresponds to the absolutely correct view that the decisive means of production are in enemy hands. But to react to this state of affairs with moral indignation is naive. There is in general an undertone of lamentation when people speak of manipulation that points to idealistic expectations — as if the class enemy had ever stuck to the promises of fair play it occasionally utters. The liberal superstition that in political and social questions there is such a thing as pure, unmanipulated truth seems to enjoy remarkable currency within the socialist left. It is the unspoken basic premise of the manipulation thesis.

This thesis provides no incentive to push ahead. A socialist perspective that does not go beyond attacking existing property relationships is limited. The expropriation of Springer is a desirable goal, but it would be good to know to whom the media should be handed over. The party? To judge by all experience of that solution, it is not a possible alternative. It is perhaps no accident that the left has not yet produced an analysis of the pattern of manipulation in countries with socialist regimes.

The manipulation thesis also serves to exculpate oneself. To cast the enemy in the role of the devil is to conceal the weakness and lack of perspective in one's own agitation. If the latter leads to self-isolation instead of a mobilization of the masses, then it's attributed holus-bolus to the overwhelming power of the media.

The theory of repressive tolerance has also permeated discussion of the media by the left. This concept, which was formulated by its author with the utmost care, has also, when whittled away in an undialectical manner, become a vehicle for resignation. Admittedly, when an office-equipment firm can attempt

to recruit sales staff with the picture of Che Guevara and the slogan, "We would have hired him," the temptation to withdraw is great. But fear of handling shit is a luxury a sewerman cannot necessarily afford.

The electronic media do away with cleanliness; they are by their nature "dirty." That is part of their productive power. In terms of structure, they are antisectarian — a further reason why the left, insofar as it is not prepared to reexamine its traditions, has little idea what to do with them. The desire for a cleanly defined "line" and for the suppression of "deviations" is anachronistic and now serves only one's own need for security. It weakens one's own position by irrational purges, exclusions, and fragmentation, instead of strengthening it by rational discussion.

These resistances and fears are strengthened by a series of cultural factors that, for the most part, operate unconsciously, and that are to be explained by the social history of the participants in today's leftist movement — namely their bourgeois class background. It often seems as if it were precisely because of their progressive potential that the media are felt to be an immense threatening power; because for the first time they present a basic challenge to bourgeois culture and thereby to the privileges of the bourgeois intelligentsia — a challenge far more radical than any self-doubt this social group can display. In the New Left's opposition to the media, old bourgeois fears, such as the fear of "the masses," seem to be reappearing along with equally old bourgeois longings for preindustrial times dressed up in progressive clothing.

> At the very beginning of the student revolt, during the Free Speech Movement at Berkeley, the computer was a favorite target for aggression. Interest in the Third World is not always free from motives based on antagonism toward civilization which has its source in conservative culture critique. During the May events in Paris the reversion to archaic forms of production was particularly characteristic. Instead of carrying out agitation among the workers with a modern offset press, the students printed their posters on the hand presses of the École des Beaux Arts. The political slogans were handpainted; stencils would certainly have made it possible to produce them *en masse*, but it would have offended the creative imagination of the authors. The ability to make proper strategic use of the most advanced media was lacking. It was not the radio headquarters that were seized by the rebels, but the Odéon Theatre, steeped in tradition.

The obverse of this fear of contact with the media is the fascination they exert on left-wing movements in the great cities. On the one hand, the comrades take refuge in outdated forms of communication and esoteric arts and crafts instead of occupying themselves with the contradiction between the present constitution of the media and their revolutionary potential; on the other hand, they cannot escape from the consciousness industry's program or from its esthetic.

This leads, subjectively, to a split between a puritanical view of political action and the area of private "leisure"; objectively, it leads to a split between politically active groups and subcultural groups.

In Western Europe the socialist movement mainly addresses itself to a public of converts through newspapers and journals that are exclusive in terms of language, content, and form. These news sheets presuppose a structure of party members and sympathizers and a situation, where the media are concerned, that roughly corresponds to the historical situation in 1900; they are obviously fixated on the *Iskra* model. Presumably, the people who produce them listen to the Rolling Stones, watch occupations and strikes on television, and go to the cinema to see a Western or a Godard movie; only in their capacity as producers do they make an exception, and, in their analyses, the whole media sector is reduced to the slogan of "manipulation." Every foray into this territory is regarded from the start with suspicion as a step toward integration. This suspicion is not unjustified; it can, however, also mark one's own ambivalence and insecurity. Fear of being swallowed up by the system is a sign of weakness; it presupposes that capitalism could overcome any contradiction — a conviction that can easily be refuted historically and is theoretically untenable.

If the socialist movement writes off the new productive forces of the consciousness industry and relegates work on the media to a subculture, then we have a vicious circle. For the underground may be increasingly aware of the technical and esthetic possibilities of the disk, of videotape, of the electronic camera, and so on, and systematically exploring the terrain; but it has no political viewpoint of its own and therefore mostly falls a helpless victim to commercialism. The politically active groups then point to such cases with smug maliciousness. A process of unlearning is the result and both sides are the losers. Capitalism alone benefits from the left's antagonism to the media, as it does from the depoliticization of the counterculture.

5. Manipulation — literally, "handling"— means technical treatment of a given material with a particular goal in mind. When the technical intervention is of immediate social relevance, then manipulation is a political act. In the case of the media industry, that is by definition the case.

Thus, every use of the media presupposes manipulation. The most elementary processes in media production, from the choice of the medium itself to shooting, cutting, synchronization, dubbing, right up to distribution, are all operations carried out on the raw material. There is no such thing as unmanipulated writing, filming, or broadcasting. The question is there-fore not whether the media are manipulated, but who manipulates them. A revolutionary plan should not require the manipulators to disappear; on the contrary, it must make everyone a manipulator.

All technical manipulations are potentially dangerous; the manipulation of the media cannot be countered, however, by old or new forms of censorship, but only

by direct social control, that is to say, by the mass of the people, who will have become productive. To this end, the elimination of capitalistic property relationships is a necessary but by no means sufficient condition. There have been no historical examples up until now of the mass, self-regulating learning process that is made possible by the electronic media. The Communists' fear of releasing this potential, of the mobilizing capabilities of the media, of the interaction of free producers, is one of the main reasons why even in the socialist countries the old bourgeois culture, greatly disguised and distorted but structurally intact, continues to hold sway.

> As an historical explanation, it may be pointed out that the consciousness industry in Russia at the time of the October Revolution was extraordinarily backward; their productive capacity has grown enormously since then, but the productive relationships have been artificially preserved, often by force. Then, as now, a primitively edited press, books, and theater were the key media in the Soviet Union. The development of radio, film, and television has been politically arrested. Foreign stations like the BBC, the Voice of America, and the Deutsche Welle, therefore, not only find listeners, but are received with almost boundless faith. Archaic media like the handwritten pamphlet and poems orally transmitted play an important role.

6. The new media are egalitarian in structure. Anyone can take part in them by a simple switching process. The programs themselves are not material things and can be reproduced at will. In this sense the electronic media are entirely differ-ent from the older media like the book or easel painting, the exclusive class character of which is obvious. Television programs for privileged groups are certainly technically conceivable — closed-circuit television — but run counter to the structure. Potentially, the new media do away with all educational privileges and thereby with the cultural monopoly of the bourgeois intelligentsia. This is one of the reasons for the intelligentsia's resentment against the new industry. As for the "spirit" that they are endeavoring to defend against "depersonalization" and "mass culture," the sooner they abandon it the better.

7. The new media are oriented toward action, not contemplation; toward the present, not tradition. Their attitude toward time is completely opposed to that of bourgeois culture, which aspires to possession, that is to extension in time, best of all, to eternity. The media produce no objects that can be hoarded and auctioned. They do away completely with "intellectual property" and liquidate the "heritage," that is to say, the class-specific passing-on of nonmaterial capital.

That does not mean to say that they have no history or that they contribute to the loss of historical consciousness. On the contrary, they make it possible for the first time to record historical material so that it can be reproduced at will. By making this material available for present-day purposes, they make it obvious to anyone using it that the writing of history is always manipulation. But the memory

they hold in readiness is not the preserve of a scholarly caste. It is social. The banked information is accessible to anyone, and this accessibility is as instantaneous as its recording. It suffices to compare the model of a private library with that of a socialized data bank to recognize the structural difference between the two systems.

8. It is wrong to regard media equipment as mere means of consumption. It is always, in principle, also means of production and, indeed, since it is in the hands of the masses, socialized means of production. The contradiction between producers and consumers is not inherent in the electronic media; on the contrary, it has to be artificially reinforced by economic and administrative measures.

> An early example of this is provided by the difference between telegraph and telephone. Whereas the former, to this day, has remained in the hands of a bureaucratic institution that can scan and file every text transmitted, the telephone is directly accessible to all users. With the aid of conference circuits, it can even make possible collective intervention in a discussion by physically remote groups. On the other hand, those auditory and visual means of communication that rely on "wireless" are still subject to state control (legislation on wireless installations). In the face of technical developments, which long ago made local and international radio-telephony, possible, and which constantly opened up new wave bands for television — in the UHF band alone, the dissemination of numerous programs in one locality is possible without interference, not to mention the possibilities offered by wired and satellite television — the prevailing laws for control of the air are anachronistic. They recall the time when the operation of a printing press was dependent on an imperial license. The socialist movements take up the struggle for their own wavelengths and must, within the foreseeable future, build their own transmitters and relay stations.

9. One immediate consequence of the structural nature of the new media is that none of the regimes at present in power can release their potential. Only a free socialist society will be able to make them fully productive. A further characteristic of the most advanced media — probably the decisive one — confirms this thesis: their collective structure.

For the prospect that in the future, with the aid of the media, anyone can become a producer, would remain apolitical and limited were this productive effort to find an outlet in individual tinkering. Work on the media is possible for an individual only insofar as it remains socially and therefore esthetically irrelevant. The collection of transparencies from the last holiday trip provides a model of this.

That is naturally what the prevailing market mechanisms have aimed at. It has long been clear from apparatus like miniature and 8-mm movie cameras, as well as the tape recorder, which are in actual fact already in the hands of the masses, that the individual, so long as he remains isolated, can become with their help at best an amateur but not a producer. Even so potent a means of production as the

short-wave transmitter has been tamed in this way and reduced to a harmless and inconsequential hobby in the hands of scattered radio hams. The programs that the isolated amateur mounts are always only bad, outdated copies of what he in any case receives.

Private production for the media is no more than licensed cottage industry. Even when it is made public it remains pure compromise. To this end, the men who own the media have developed special programs that are usually called "Democratic Forum" or something of the kind. There, tucked away in the corner, "the reader (listener, viewer) has his say," which can naturally be cut short at any time. As in the case of public-opinion polling, he is only asked questions so that he may have a chance to confirm his own dependence. It's a control circuit where what is fed in has already made complete allowance for the feedback.

The concept of a license can also be used in another sense — in an economic one: the system attempts to make each participant into a concessionaire of the monopoly that develops his films or plays back his cassettes. The aim is to nip in the bud in this way that independence that video equipment, for instance, makes possible. Naturally, such tendencies go against the grain of the structure, and the new productive forces not only permit but indeed demand their reversal.

The poor, feeble, and frequently humiliating results of this licensed activity are often referred to with contempt by the professional media producers. On top of the damage suffered by the masses comes triumphant mockery because they clearly do not know how to use the media properly. The sort of thing that goes on in certain popular television shows is taken as proof that they are completely incapable of articulating on their own.

Not only does this run counter to the results of the latest psychological and pedagogical research, but it can easily be seen to be a reactionary protective formulation; the "gifted" people are quite simply defending their territories. Here we have a cultural analogue to the familiar political judgments concerning a working class that is presumed to be "stultified" and incapable of any kind of self-determination. Curiously, one may hear the view that the masses could never govern themselves out of the mouths of people who consider themselves socialists. In the best of cases, these are economists who cannot conceive of socialism as anything other than nationalization.

10. Any socialist strategy for the media must, on the contrary, strive to end the isolation of the individual participants from the social learning and production process. This is impossible unless those concerned organize themselves. This is the political core of the question of the media. It is over this point that socialist concepts part company with the neoliberal and technocratic ones. Anyone who expects to be emancipated by technological hardware, or by a system of hardware however structured, is the victim of an obscure belief in progress. Anyone who imagines that freedom for the media will be established if only everyone is busy, transmitting and

receiving, is the dupe of a liberalism that, decked out in contemporary colors, merely peddles the faded concepts of a preordained harmony of social interests.

In the face of such illusions, what must be firmly held onto is that the proper use of the media demands organization and makes it possible. Every production that deals with the interests of the producers postulates a collective method of production. It is itself already a form of self-organization of social needs. Tape recorders, ordinary cameras, and movie cameras are already extensively owned by wage earners. The question is why these means of production do not turn up at factories, in schools, in the offices of the bureaucracy, in short, everywhere where there is social conflict. By producing aggressive forms of publicity that were their own, the masses could secure evidence of their daily experiences and draw effective lessons from them.

Naturally, bourgeois society defends itself against such prospects with a battery of legal measures. It bases itself on the law of trespass, on commercial and official secrecy. While its secret services penetrate everywhere and plug into the most intimate conversations, it pleads a touching concern for confidentiality and makes a sensitive display of worrying about the question of privacy when all that is private is the interest of the exploiters. Only a collective, organized effort can tear down these paper walls.

Communication networks that are constructed for such purposes can, over and above their primary function, provide politically interesting organizational models. In the socialist movements the dialectic of discipline and spontaneity, centralism and decentralization, authoritarian leadership and antiauthoritarian disintegration has long ago reached deadlock. Network-like communications models built on the principle of reversibility of circuits might give indications of how to overcome this situation: a mass newspaper, written and distributed by its readers, a video network of politically active groups.

More radically than any good intention, more lastingly than existential flight from one's own class, the media, once they have come into their own, destroy the private production methods of bourgeois intellectuals. Only in productive work and learning processes can their individualism be broken down in such a way that it is transformed from morally based (that is to say, as individual as ever) self-sacrifice to a new kind of political self-understanding and behavior.

11. An all-too-widely disseminated thesis maintains that present-day capitalism lives by the exploitation of unreal needs. That is at best a half-truth. The results obtained by popular American sociologists such as Vance Packard are not unuseful but limited. What they have to say about the stimulation of needs through advertising and artificial obsolescence can in any case not be adequately explained by the hypnotic pull exerted on the wage earners by mass consumption. The hypothesis of "consumer terror" corresponds to the prejudices of a middle class, which considers itself politically enlightened, against the allegedly integrated proletariat, which has become petty bourgeois and corrupt. The attractive power

of mass consumption is based not on the dictates of false needs, but on the falsification and exploitation of quite real and legitimate ones without which the parasitic process of advertising would be ineffective. A socialist movement ought not to denounce these needs, but take them seriously, investigate them, and make them politically productive.

That is also valid for the consciousness industry. The electronic media do not owe their irresistible power to any sleight-of-hand but to the elemental power of deep social needs that come through even in the present depraved form of these media.

Precisely because no one bothers about them, the interests of the masses have remained a relatively unknown field, at least insofar as they are historically new. They certainly extend far beyond those goals that the traditional working-class movement represented. Just as in the field of production, the industry that produces goods and the consciousness industry merge more and more, so too, subjectively, where needs are concerned, material and nonmaterial factors are closely interwoven. In the process, old psychosocial themes are firmly embedded — social prestige, identification patterns — but powerful new themes emerge that are utopian in nature. From a materialistic point of view, neither the one nor the other must be suppressed.

Henri Lefebvre has proposed the concept of the "spectacle"— the exhibition, the show — to fit the present form of mass consumption. Goods and shop windows, traffic and advertisements, stores and the world of communications, news and packaging, architecture and media production come together to form a totality, a permanent theater, which dominates not only the public city centers but also private interiors. The expression "beautiful living" makes the most commonplace objects of general use into props for this universal festival, in which the fetishistic nature of the commodities triumphs completely over their use value. The swindle these festivals perpetrate is, and remains, a swindle within the present social structure. But it is the harbinger of something else. Consumption as spectacle contains the promise that want will disappear. The deceptive, brutal, and obscene features of this festival derive from the fact that there can be no question of a real fulfillment of its promise. But so long as scarcity holds sway, use value remains a decisive category that can only be abolished by trickery. Yet trickery on such a scale is only conceivable if it is based on mass need. This need — it is a utopian one — is there. It is the desire for a new ecology, for a breaking down of environmental barriers, for an esthetic not limited to the sphere of "the artistic." These desires are not — or are not primarily — internalized rules of the game as played by the capitalist system. They have physiological roots and can no longer be suppressed. Consumption as spectacle is — in parody form — the anticipation of a utopian situation.

The promises of the media demonstrate the same ambivalence. They are an answer to the mass need for nonmaterial variety and mobility — which at present

finds its material realization in private-car ownership and tourism — and they exploit it. Other collective wishes, which capitalism often recognizes more quickly and evaluates more correctly than its opponents, but naturally only so as to trap them and rob them of their explosive force, are just as powerful, just as unequivocally emancipatory: the need to take part in the social process on a local, national, and international scale; the need for new forms of interaction, for release from ignorance and tutelage; the need for self-determination. "Be everywhere!" is one of the most successful slogans of the media industry. The readers' parliament of *Bild-Zeitung* was direct democracy used against the interests of the *demos*. "Open spaces" and "free time" are concepts that corral and neutralize the urgent wishes of the masses.

There is corresponding acceptance by the media of utopian stories: e.g., the story of the young Italian-American who hijacked a passenger plane from California to get home to Rome was taken up without protest even by the reactionary mass press and undoubtedly correctly understood by its readers. The identification is based on what has become a general need. Nobody can understand why such journeys should be reserved for politicians, functionaries, and businessmen. The role of the pop star could be analyzed from a similar angle; in it the authoritarian and emancipatory factors are mingled in an extraordinary way. It is perhaps not unimportant that beat music offers groups, not individuals, as identification models. In the productions of the Rolling Stones (and in the manner of their production) the utopian content is apparent. Events like the Woodstock Festival, the concerts in Hyde Park, on the Isle of Wight, and at Altamont, California, develop a mobilizing power that the political left can only envy.

It is absolutely clear that, within the present social forms, the consciousness industry can satisfy none of the needs on which it lives and which it must fan, except in the illusory form of games. The point, however, is not to demolish its promises but to take them literally and to show that they can be met only through a cultural revolution. Socialists and socialist regimes which multiply the frustration of the masses by declaring their needs to be false, become the accomplices of the system they have undertaken to fight.

12. Summary.

REPRESSIVE USE OF MEDIA	EMANCIPATORY USE OF MEDIA
Centrally controlled program	Decentralized program
One transmitter, many receivers	Each receiver a potential transmitter
Immobilization of isolated individuals	Mobilization of the masses
Passive consumer behavior	Interaction of those involved, feedback
Depoliticization	A political learning process
Production by specialists	Collective production
Control by property owners or bureaucracy	Social control by self-organization

13. As far as the objectively subversive potentialities of the electronic media are concerned, both sides in the international class struggle — except for the fatalistic adherents of the thesis of manipulation in the metropoles — are of one mind. Frantz Fanon was the first to draw attention to the fact that the transistor receiver was one of the most important weapons in the Third World's fight for freedom. Albert Hertzog, ex-Minister of the South African Republic and the mouthpiece of the right wing of the ruling party, is of the opinion that "television will lead to the ruin of the white man in South Africa."[2] American imperialism has recognized the situation. It attempts to meet the "revolution of rising expectations" in Latin America — that is what its ideologues call it — by scattering its own transmitters all over the continent and into the remotest regions of the Amazon basin, and by distributing single-frequency transistors to the native population. The attacks of the Nixon administration on the capitalist media in the United States reveal its understanding that their reporting, however one-sided and distorted, had become a decisive factor in mobilizing people against the war in Vietnam. Whereas only twenty-five years ago the French massacres in Madagascar, with almost one hundred thousand dead, became known only to the readers of *Le Monde* under the heading of "Other News" and therefore remained unnoticed and without follow-up in the capital city, today the media drag colonial wars into the centers of imperialism.

The direct mobilizing potentialities of the media become still clearer when they are consciously used for subversive ends. Their presence is a factor that immensely increases the demonstrative nature of any political act. The student movements in the United States, in Japan, and in Western Europe soon recognized this and, to begin with, achieved considerable momentary success with the aid of the media. These effects have worn off. Naive trust in the magical power of reproduction cannot replace organizational work; only active and coherent groups can force the media to comply with the logic of their actions. That can be demonstrated from the example of the Tupamaros in Uruguay, whose revolutionary practice has implicit in it publicity for their actions. Thus the actors become authors. The abduction of the American ambassador in Rio de Janeiro was planned with a view to its impact on the media. It was a television production. The Arab guerrillas proceed in the same way. The first to experiment with these techniques internationally were the Cubans. Fidel appreciated the revolutionary potential of the media correctly from the first (Moncada, 1953). Today, illegal political action demands at one and the same time maximum secrecy and maximum publicity.

14. Revolutionary situations always bring with them discontinuous, spontaneous changes brought about by the masses in the existing aggregate of the media. How far the changes thus brought about take root and how permanent they are demonstrates the extent to which a cultural revolution is successful. The situation in the media is the most accurate and sensitive barometer for the rise of bureaucratic or

Bonapartist anticyclones. So long as the cultural revolution has the initiative, the social imagination of the masses overcomes even technical backwardness and transforms the function of the old media so that their structures are exploded.

> With our work the Revolution has achieved a colossal labor of propaganda and enlightenment. We ripped up the traditional book into single pages, magnified these a hundred times, printed them in color and stuck them up as posters in the streets. Our lack of printing equipment and the necessity for speed meant that, though the best work was hand-printed, the most rewarding was standardized, lapidary and adapted to the simplest mechanical form of reproduction. Thus State Decrees were printed as rolled-up illustrated leaflets, and Army Orders as illustrated pamphlets.[3]

In the twenties, the Russian film reached a standard that was far in advance of the available productive forces. Pudovkin's *Kinoglas* and Dziga Vertov's *Kinopravda* were no "newsreels" but political television-magazine programs *avant l'écran*. The campaign against illiteracy in Cuba broke through the linear, exclusive, and isolating structure of the medium of the book. In the China of the cultural revolution, wall newspapers functioned like an electronic mass medium — at least in the big towns. The resistance of the Czechoslovak population to the Soviet invasion gave rise to spontaneous productivity on the part of the masses, who ignored the institutional barriers of the media. (To be developed in detail.) Such situations are exceptional. It is precisely their utopian nature, which reaches out beyond the existing productive forces (it follows that the productive relationships are not to be permanently overthrown), that makes them precarious, leads to reversals and defeats. They demonstrate all the more clearly what enormous political and cultural energies are hidden in the enchained masses and with what imagination they are able, at the moment of liberation, to realize all the opportunities offered by the new media.

15. That the Marxist left should argue theoretically and act practically from the standpoint of the most advanced productive forces in their society, that they should develop in depth all the liberating factors immanent in these forces and use them strategically, is no academic expectation but a political necessity. However, with a single great exception, that of Walter Benjamin (and in his footsteps, Berthold Brecht), Marxists have not understood the consciousness industry and have been aware only of its bourgeois-capitalist dark side and not of its socialist possibilities. Georg Lukács is a perfect example of this theoretical and practical backwardness. Nor are the works of Horkheimer and Adorno free of a nostalgia that clings to early bourgeois media.

> Their view of the cultural industry cannot be discussed here. Much more typical of Marxism between the two wars is the position of Lukács, which can be seen very clearly from an early essay on "Old Culture and New Culture."[4] "Anything that culture

produces" can, according to Lukács, "have real cultural value only *if it is in itself* valuable, if the creation of each individual product is from the standpoint of its maker a single, finite process. It must, moreover, be a process conditioned by the *human* potentialities and capabilities of the creator. The most typical example of such a process is the work of art, where the entire genesis of the work is exclusively the result of the artist's labor and each detail of the work that emerges is determined by the individual qualities of the artist. In highly developed mechanical industry, on the other hand, any connection between the product and the creator is abolished. *The human being serves the machine, he adapts to it.* Production becomes completely independent of the human poten- tialities and capabilities of the worker." These "forces which destroy culture" impair the work's "truth to the material," its "level," and deal the final blow to the "work as an end in itself." There is no more question of "the organic unity of the products of culture, its harmonious, joy-giving being." Capitalist culture must lack "the simple and natural harmony and beauty of the old culture — culture in the true, literal sense of the word." Fortunately things need not remain so. The "culture of proletarian society," although "in the context of such scientific research as is possible at this time" nothing more can be said about it, will certainly remedy these ills. Lukács asks himself "which are the cultural values which, in accordance with the nature of this context, *can be taken over from the old society by the new and further developed.*" Answer: not the inhuman machines but "the idea of mankind as an end in itself, the basic idea of the new culture," for it is "the inheritance of the classical idealism of the nineteenth century." Quite right. "This is where the philistine concept of art turns up with all its deadly obtuseness — an idea to which all technical considerations are foreign and which feels that with the provocative appearance of the new technology its end has come." [5]

These nostalgic backward glances at the landscape of the last century, these reactionary ideals, are already the forerunners of socialist realism, which mercilessly galvanized and then buried those very "cultural values" that Lukács rode out to rescue. Unfortunately, in the process, the Soviet cultural revolution was thrown to the wolves; but this esthete can in any case hardly have thought any more highly of it than did J. V. Stalin.

The inadequate understanding Marxists have shown of the media and the questionable use they have made of them has produced a vacuum in Western industrialized countries into which a stream of non-Marxist hypotheses and practices has consequently flowed. From the Cabaret Voltaire of the Dadaists to Andy Warhol's Factory, from the silent film comedians to the Beatles, from the first comic-strip artists to the present managers of the underground, the apolitical have made much more radical progress in dealing with the media than any grouping of the left (exception: Münzenberg). Innocents have put themselves in the forefront of the new productive forces on the basis of mere intuitions with which communism — to its detriment — has not wished to concern itself. Today this apolitical avant-garde has found its ventriloquist and prophet in Marshall

McLuhan, an author who admittedly lacks any analytical categories for the understanding of social processes, but whose confused books serve as a quarry of undigested observations for the media industry. Certainly, his little finger has experienced more of the productive power of the new media than all ideological commissions of the CPSU and their endless resolutions and directives put together.

Incapable of any theoretical construction, McLuhan does not present his material as a concept but as the common denominator of a reactionary doctrine of salvation. He admittedly did not invent but was the first to formulate explicitly a mystique of the media that dissolves all political problems in smoke — the same smoke that gets in the eyes of his followers. It promises the salvation of man through the technology of television and indeed of television as it is practiced today. Now McLuhan's attempt to stand Marx on his head is not exactly new. He shares with his numerous predecessors the determination to suppress all problems of the economic base, their idealistic tendencies, and their belittling of the class struggle in the naive terms of a vague humanism. A new Rousseau — like all copies, only a pale version of the old — he preaches the gospel of the new primitive man who, naturally on a higher level, must return to prehistoric tribal existence in the "global village."

It is scarcely worthwhile to deal with such concepts. This charlatan's most famous saying — "the medium is the message"— perhaps deserves more attention. In spite of its provocative idiocy, it betrays more than its author knows. It reveals in the most accurate way the tautological nature of the mystique of the media. The one remarkable thing about the television set, according to him, is that it moves — a thesis that in view of the nature of American programs has, admittedly, something attractive about it.

> The complementary mistake consists in the widespread illusion that media are neutral instruments by which any "messages" one pleases can be transmitted without regard for their structure or for the structure of the medium. In the Eastern European countries, the television newsreaders read fifteen-minute-long conference communiqués and Central Committee resolutions that are not even suitable for printing in a newspaper, clearly under the delusion that they might fascinate a public of millions.

"The medium is the message" transmits yet another message, however, and a much more important one. It tells us that the bourgeoisie does indeed have all possible means at its disposal to communicate something to us, but that it has nothing more to say. It is ideologically sterile. Its intention to hold onto the control of the means of production at any price, while being incapable of making the socially necessary use of them, is here expressed with complete frankness in the superstructure. It wants the media *as such* and *to no purpose*.

This wish has been shared for decades and given symbolic expression by an artistic avant-garde whose program logically admits only the alternative of

negative signals and amorphous noise. Example: the already outdated "literature of silence," Warhol's films in which everything can happen at once or nothing at all, and John Cage's forty-five-minute-long "Lecture on Nothing" (1959).

16. The revolution in the conditions of production in the superstructure has made the traditional esthetic theory unusable, completely unhinging its fundamental categories and destroying its "standards." The theory of knowledge on which it was based is outmoded. In the electronic media, a radically altered relationship between subject and object emerges with which the old critical concepts cannot deal. The idea of the self-sufficient work of art collapsed long ago. The long drawn-out discussion over the death of art proceeds in a circle so long as it does not examine critically the esthetic concept on which it is based, so long as it employs criteria that no longer correspond to the state of the productive forces. When constructing an esthetic adapted to the changed situation, one must take as a starting point the work of the only Marxist theoretician who recognized the liberating potential of the new media. Thirty-five years ago, that is to say, at a time when the consciousness industry was relatively undeveloped, Benjamin subjected this phenomenon to a penetrating dialectical-materialist analysis. His approach has not been matched by any theory since then, much less further developed.

> One might generalize by saying: the technique of reproduction detaches the reproduced object from the domain of tradition. By making many reproductions, it substitutes a plurality of copies for a unique existence and in permitting the reproduction to meet the beholder or listener in his own particular situation, it reactivates the object reproduced. These two processes lead to a tremendous shattering of tradition which is the obverse of the contemporary crisis and renewal of mankind. Both processes are intimately connected with the contemporary mass movements. Their most powerful agent is the film. Its social significance, particularly in its most positive form, is inconceivable without its destructive, cathartic aspect, that is, the liquidation of the traditional value of the cultural heritage.
>
> For the first time in world history, mechanical reproduction emancipates the work of art from its parasitic dependence on ritual. To an ever greater degree the work of art reproduced becomes the work of art designed for reproducibility. . . . But the instant the criterion of authenticity ceases to be applicable to artistic production, the total function of art is reversed. Instead of being based on ritual, it begins to be based on another practice — politics. . . . Today, by the absolute emphasis on its exhibition value, the work of art becomes a creation with entirely new functions, among which the one we are conscious of, the artistic function, later may be recognized as incidental.[6]

The trends that Benjamin recognized in his day in the film, and the true import of which he grasped theoretically, have become patent today with the rapid

development of the consciousness industry. What used to be called art has now, in the strict Hegelian sense, been dialectically surpassed by and in the media. The quarrel about the end of art is otiose so long as this end is not understood dialectically. Artistic productivity reveals itself to be the extreme marginal case of a much more widespread productivity, and it is socially important only insofar as it surrenders all pretensions to autonomy and recognizes itself to be a marginal case. Wherever the professional producers make a virtue out of the necessity of their specialist skills and even derive a privileged status from them, their experience and knowledge have become useless. This means that as far as an esthetic theory is concerned, a radical change in perspectives is needed. Instead of looking at the productions of the new media from the point of view of the older modes of production we must, on the contrary, analyze the products of the traditional "artistic" media from the standpoint of modern conditions of production.

> Earlier much futile thought had been devoted to the question of whether photography is an art. The primary question—whether the very invention of photography had not transformed the entire nature of art—was not raised. Soon the film theoreticians asked the same ill-considered question with regard to the film. But the difficulties which photography caused traditional esthetics were mere child's play as compared to those raised by the film.[7]

The panic aroused by such a shift in perspectives is understandable. The process not only changes the old, carefully guarded craft secrets in the superstructure into white elephants, it also conceals a genuinely destructive element. It is, in a word, risky. But the only chance for the esthetic tradition lies in its dialectical supersession. In the same way, classical physics has survived as a marginal special case within the framework of a much more comprehensive theory.

This state of affairs can be identified in individual cases in all the traditional artistic disciplines. Their present-day developments remain incomprehensible so long as one attempts to deduce them from their own prehistory. On the other hand, their usefulness or uselessness can be judged as soon as one regards them as special cases in a general esthetic of the media. Some indications of the possible critical approaches that stem from this will be made below, taking literature as an example.

17. Written literature has, historically speaking, played a dominant role for only a few centuries. Even today, the predominance of the book has an episodic air. An incomparably longer time preceded it in which literature was oral. Now it is being succeeded by the age of the electronic media, which tend once more to make people speak. At its period of fullest development, the book to some extent usurped the place of the more primitive but generally more accessible methods of production of the past; on the other hand, it was a stand-in for future methods that make it possible for everyone to become a producer.

The revolutionary role of the printed book has been described often enough and it would be absurd to deny it. From the point of view of its structure as a medium, written literature, like the bourgeoisie who produced it and whom it served, was progressive (see the *Communist Manifesto*). On the analogy of the economic development of capitalism, which was indispensable for the development of the industrial revolution, the nonmaterial productive forces could not have developed without their own capital accumulation. (We also owe the accumulation of *Das Kapital* and its teachings to the medium of the book.)

Nevertheless, almost everybody speaks better than he writes. (This also applies to authors.) Writing is a highly formalized technique that, in purely physiological terms, demands a peculiarly rigid bodily posture. To this there corresponds the high degree of social specialization that it demands. Professional writers have always tended to think in caste terms. The class character of their work is unquestionable, even in the age of universal compulsory education. The whole process is extraordinarily beset with taboos. Spelling mistakes, which are completely immaterial in terms of communication, are punished by the social disqualification of the writer. The rules that govern this technique have a normative power attributed to them for which there is no rational basis. Intimidation through the written word has remained a widespread and class-specific phenomenon even in advanced industrial societies.

These alienating factors cannot be eradicated from written literature. They are reinforced by the methods by which society transmits its writing techniques. While people learn to speak very early, and mostly in psychologically favorable conditions, learning to write forms an important part of authoritarian social-ization by the school ("good writing" as a kind of breaking-in). This sets its stamp forever on written communication — on its tone, its syntax, and its whole style. (This also applies to the text on this page.)

The formalization of written language permits and encourages the repression of opposition. In speech, unresolved contradictions betray themselves by pauses, hesitations, slips of the tongue, repetitions, anacoluthons, quite apart from phrasing, mimicry, gesticulation, pace, and volume. The esthetic of written literature scorns such involuntary factors as "mistakes." It demands, explicitly or implicitly, the smoothing out of contradictions, rationalization, regularization of the spoken form irrespective of content. Even as a child, the writer is urged to hide his unsolved problems behind a protective screen of correctness.

Structurally, the printed book is a medium that operates as a monologue, isolating producer and reader. Feedback and interaction are extremely limited, demand elaborate procedures, and only in the rarest cases lead to corrections. Once an edition has been printed it cannot be corrected; at best it can be pulped. The control circuit in the case of literary criticism is extremely cumbersome and elitist. It excludes the public on principle.

None of the characteristics that distinguish written and printed literature

apply to the electronic media. Microphone and camera abolish the class character of the mode of production (not of the production itself). The normative rules become unimportant. Oral interviews, arguments, demonstrations, neither demand nor allow orthography or "good writing." The television screen exposes the esthetic smoothing out of contradictions as camouflage. Admittedly, swarms of liars appear on it; but anyone can see from a long way off that they are peddling something. As presently constituted, radio, film, and television are burdened to excess with authoritarian characteristics, the characteristics of the monologue, which they have inherited from older methods of production — and that is no accident. These outworn elements in today's media esthetics are demanded by the social relations. They do not follow from the structure of the media. On the contrary, they go against it, for the structure demands interaction.

It is extremely improbable, however, that writing as a special technique will disappear in the foreseeable future. That goes for the book as well, the practical advantages of which for many purposes remain obvious. It is admittedly less handy and takes up more room than other storage systems, but up to now it offers simpler methods of access than, for example, the microfilm or the tape bank. It ought to be integrated into the system as a marginal case and thereby forfeit its aura of cult and ritual.

This can be deduced from technological developments. Electronics are noticeably taking over writing: teleprinters, reading machines, high-speed transmissions, automatic photographic and electronic composition, automatic writing devices, typesetters, electrostatic processes, ampex libraries, cassette encyclopedias, photocopiers and magnetic copiers, speedprinters.

The outstanding Russian media expert El Lissitsky incidentally, demanded an "electro-library" as far back as 1923 — a request that, given the technical conditions of the time, must have seemed ridiculous or at least incomprehensible. This is how far this man's imagination reached into the future.

I draw the following analogy:

INVENTIONS IN THE FIELD OF VERBAL TRAFFIC	INVENTIONS IN THE FIELD OF GENERAL TRAFFIC
Articulated language	Upright gait
Writing	The wheel
Gutenberg's printing press	Carts drawn by animal power
?	The automobile
?	The airplane

"I have produced this analogy to prove that so long as the book remains a palpable object; i.e., so long as it is not replaced by auto-vocalizing and kino-vocalizing

representations, we must look to the field of the manufacture of books for basic innovations in the near future.

"There are signs at hand suggesting that this basic innovation is likely to come from the neighborhood of the collotype."[8]

Today, writing has in many cases already become a secondary technique, a means of transcribing orally recorded speech: tape-recorded proceed-ings, attempts at speech-pattern recognition, and the conversion of speech into writing.

18. The ineffectiveness of literary criticism when faced with so-called documentary literature is an indication of how far the critics' thinking has lagged behind the stage of the productive forces. It stems from the fact that the media have eliminated one of the most fundamental categories of esthetics up to now — fiction. The fiction/nonfiction argument has been laid to rest just as was the nineteenth century's favorite dialectic of "art" and "life." In his day, Benjamin demonstrated that the "apparatus" (the concept of the medium was not yet available to him) abolishes authenticity. In the productions of the consciousness industry, the difference between the "genuine" original and the reproduction disappears—"that aspect of reality which is not dependent on the apparatus has now become its most artificial aspect." The process of reproduction reacts on the object reproduced and alters it fundamentally. The effects of this have not yet been adequately explained epistemologically. The categorical uncertainties to which it gives rise also affect the concept of the documentary. Strictly speaking, it has shrunk to its legal dimensions. A document is something the "forging"— i.e., the reproduction — of which is punishable by imprisonment. This definition naturally has no theoretical meaning. The reason is that a reproduction, to the extent that its technical quality is good enough, cannot be distinguished any way from the original, irrespective of whether it is a painting, a passport, or a bank note. The legal concept of the documentary record is only pragmatically useful; it serves only to protect economic interests.

The productions of the electronic media, by their nature, evade such distinctions as those between documentary and feature films. They are in every case explicitly determined by the given situation. The producer can never pretend, like the traditional novelist, "to stand above things." He is therefore partisan from the start. This fact finds formal expression in his techniques. Cutting, dubbing — these are techniques for conscious manipulation without which the use of the new media is inconceivable. It is precisely in these work processes that their productive power reveals itself — and here it is completely immaterial whether one is dealing with the production of a reportage or a play. The material, whether "documentary" or "fiction," is in each case only a prototype, a half-finished article, and the more closely one examines its origins, the more blurred the difference becomes. (Develop more precisely. The reality in which a camera turns up is always "posed," e.g., the moon landing.)

19. The media also do away with the old category of works, of art that can only be considered as a separate object, not as independent of material infrastructure. The media do not produce such objects. They create programs. Their production is in the nature of a process. That does not mean only (or not primarily) that there is no foreseeable end to the program — a fact that, in view of what we are now presented with, admittedly makes a certain hostility to the media understandable. It means, above all, that the media program is open to its own consequences without structural limitations. (This is not an empirical description but a demand, a demand that admittedly is not made of the medium from without; it is a consequence of its nature, from which the much-vaunted open form can be derived — and not as a modification of it — from an old esthetic.) The programs of the consciousness industry must subsume their own results, the reactions, and the corrections that they call forth, otherwise they are already out-of-date. They are therefore to be thought of not as means of consumption but as means of their own production.

20. It is characteristic of artistic avant-gardes that they have, so to speak, a presentiment of the potentiality of media that still lie in the future.

> It has always been one of the most important tasks of art to give rise to a demand, the time for the complete satisfaction of which has not yet come. The history of every art form has critical periods when that form strives towards effects which can only be easily achieved if the technical norm is changed, that is to say, in a new art form. The artistic extravagances and crudities which arise in this way, for instance in the so-called decadent period, really stem from art's richest historical source of power. Dadaism in the end teemed with such barbarisms. We can only now recognize the nature of its striving. Dadaism was attempting to achieve those effects which the public today seeks in film with the means of painting (or of literature).[9]

This is where the prognostic value of otherwise inessential productions, such as happenings, flux, and mixed-media shows, is to be found. There are writers who in their work show an awareness of the fact that media with the characteristics of the monologue today have only a residual use value. Many of them admittedly draw fairly shortsighted conclusions from this glimpse of the truth. For example, they offer the user the opportunity to arrange the material provided by arbitrary permutations. Every reader, as it were, should write his own book. When carried to extremes, such attempts to produce interaction even when it goes against the structure of the medium employed, are nothing more than invitations to freewheel. Mere noise permits no articulated interactions. Short cuts, of the kind that Concept Art peddles, are based on the banal and false conclusion that the development of the productive forces renders all work superfluous. With the same justification, one could leave a computer to its own devices on the assumption that

a random generator will organize material production by itself. Fortunately, cybernetics experts are not given to such childish games.

21. For the old-fashioned "artist"—let us call him the author—it follows from these reflections that he must see it as his goal to make himself redundant as a specialist in much the same way as a teacher of literacy only fulfills his task when he is no longer necessary. Like every learning process, this process, too, is reciprocal. The specialist will learn as much or more nonspecialists as the other way round. Only then can he contrive to make himself dispensable.

Meanwhile, his social usefulness can best be measured by the degree to which he is capable of using the liberating factors in the media and bringing them to fruition. The tactical contradictions in which he must become involved in the process can neither be denied nor covered up in any way. But strategically his role is clear. The author has to work as the agent of the masses. He can lose himself in them only when they themselves become authors, the authors of history.

22. "Pessimism of the intelligence, optimism of the will" (Antonio Gramsci). □

TRANSLATED FROM GERMAN BY STUART HOOD.

VISUALIZATION LOST AND REGAINED:

The Genesis of the Quantum Theory in the Period 1913–1927

■ *Arthur I. Miller*

INTRODUCTION

There is a domain of thinking where distinctions between conceptions in art and science become meaningless. For here is manifest the efficacy of visual thinking, and a criterion for selection between alternatives that resists reduction to logic and is best referred to as aesthetics. To demonstrate this domain we can examine a case study in the history of science — the genesis of quantum theory in the years 1913–1927. The notions of aesthetics held by the dramatis personae of this period will not always be associated with the choice of a pleasing visualization, but sometimes with a choice of representation, such as continuity or discontinuity, with combinations of these criteria. And sometimes their aesthetic will change.

In 1929, Niels Bohr could write that the orderly progress of research culminating in a consistent theory of atomic phenomena was made possible because of the "conscious resignation of our usual demands for visualization."[1] Wolfgang Pauli, another pioneer of the quantum theory, hinted in 1955 at "a brief period of spiritual and human confusion caused by a provisional restriction to *Anschaulichkeit*"[2] which ended about 1929. The German *Anschaulichkeit* means visualization through pictures or mechanical models. It was used much less frequently in the German scientific literature of the 1920s than *Anschauung* for which there is no equivalent term in the English language. Unless specified otherwise, *Anschauung* will refer to the intuition through the pictures constructed from previous visualizations of physical processes in the world of perceptions; this best fits its intended meaning in the period 1925–1927 by Bohr and Pauli, among others. For convenience I shall sometimes designate this kind of intuition with the term "ordinary intuition."[3]

A measure of how dramatic was the search for a consistent atomic theory, and of the ambiguities lurking at every turn, is the disagreement between the accounts of Bohr and Pauli. The path to the quantum theory of 1927 was not an orderly progression from visualizable models to a mathematical formalism whose description of matter and phenomena in the atomic domain defied visualization in the ordinary

sense of this word. Rather, the situation was closer to the one recalled by Werner Heisenberg where the physicists experienced despair and helplessness because of their loss of visualization and their distrust in ordinary intuition. It was a period when such time-honored concepts as space, time, causality, substance, and the continuity of motion were separated painfully from their classical basis. The rejection, one by one, of the tenets of classical physics was distressing because classical physics had become so commonsensical, so reflective of the world in which we live. Since it was a causal theory, a particle's motion was continuous and its position could be predicted with, in principle, perfect accuracy. There was no reason to doubt that our intuition could also be extended to phenomena involving the microscopic electron. So it was hoped with confidence that the discontinuities which *emerged* from Max Planck's theory of 1900 for the continuous spectrum of the radiation emitted from a hot substance could be removed somehow in a more fine-grained theory. But in 1913, the twenty-eight-year-old Niels Bohr proposed a new kind of theory for the free atom. It was *predicated* openly upon discontinuities and gross violations of classical physics. Yet despite its transgressions, Bohr's theory retained the pleasing picture of Rutherford's atom as a miniature Copernican system. But Bohr did not consider the theory complete because it conflicted with classical physics. However, by 1918, the break between Bohr's theory and the classical physics became more striking when Bohr folded into his theory a kind of mathematical description for the unvisualizable quantum jump that was forbidden by the accepted view of the classical physics of particles; namely, a priori probabilities which renounce from the start any knowledge of the cause for phenomena. By 1923, the limitations of the picture of the atom as a miniature solar system had become forcefully apparent. The basic problem was that it could not treat quantitatively atoms more complex than the miniature solar system with one planet — the hydrogen atom.

So atomic physics began to slip into an abyss where the planetary electron went from a tiny sphere to an unvisualizable entity. What is so remarkable is that this surrender of visualization was precipitated only in part by empirical data, that is, problems with complex atoms, but more as a result of Bohr's aesthetic choice between the opposing notions of continuity versus discontinuity. Bohr's decision was to reject the light quantum in order to retain the traditional dichotomy between the continuous radiation field and discrete matter. This limited duality was his aesthetic in 1923–1925 and it was not linked to visualization. Heisenberg, at age twenty-three a contemporary of Pauli, spent late 1924 to early 1925 at Bohr's institute for Theoretical Physics at Copenhagen; he was already making his mark in physics. Whereas for Bohr the loss of visualization was painful, Heisenberg found it to be congenial to his nonvisual mode of thinking. In late 1924, Heisenberg's analysis of the data of Wood and Ellett for the scattering of polarized light from mercury and sodium vapors convinced him and Bohr that the loss of visualization might very well be permanent and that since mechanical models had failed, the existing mathematical formalism of quantum theory must be the guide. In mid-

1925, Heisenberg formulated the new quantum mechanics based upon an unvisualizable particle and essential discontinuities and expressed in a mathematical formalism unfamiliar to most physicists. But the desire for visual thinking and for the intuition associated with the world of perceptions, or with classical geometrical concepts, manifested itself repeatedly in the papers of those most closely associated with the new quantum mechanics — Bohr, Heisenberg, and Max Born who, at age forty-three, was Bohr's counterpart at Göttingen. Of great concern to Heisenberg was that due to the loss of visualization and ordinary intuition the new theory was risking internal contradictions.

Even more remarkable than the loss of visualization was how it was regained in the period 1926–1927, when empirical data played almost no role. Rather, the path to regaining visualization is characterized by the high drama of the intense personal struggles among the dramatis personae over their choices of how to represent nature — continually versus discontinuity, the usefulness of mathematical models versus mechanistic-materialistic models, and whether to maintain causality.[4] A scientist's criteria for choice between representations cannot be reduced either to logic or to a suggestion from experimental data. Rather it is based upon the individual scientist's aesthetic. What is so fascinating about the genesis of quantum theory is that not only does the personal nature of the struggle between representations or aesthetic choices emerge from the scientific papers of the period, but the clash is sharper than ever before in the history of scientific thought. The stakes were high in 1926–1927 because the outcome could determine the course of physical theory.

A new figure enters in 1926. Erwin Schrödinger at forty-three was a professor in Zurich and an outsider both geographically in thinking from the small band of physicists concentrated mainly in Copenhagen and Göttingen who were almost entirely responsible for the development of the quantum mechanics. Schrödinger's sentiments were closer to those of the continuum-oriented physicists at Berlin, in particular Einstein and Planck. Schrödinger felt so "repelled" both by the lack of visualization and the mathematics used in the quantum mechanics that he formulated the wave mechanics. His aesthetic was linked to a continuum-based physics which visualized that atomic entities were composed of packets of waves. Nevertheless, he claimed that this was better than no picture at all.

Although Born had been godfather to the quantum mechanics, his desire for visualization led him to enlarge his aesthetic from the one held currently by Bohr and Heisenberg to a viewpoint in 1926 in which particles are guided by waves from Schrödinger's theory. Born considered these waves as transporting only probability. His theory permitted the use of pictures for scattering processes but distinguished between the notion of causality as it referred to scattering processes and to phenomena within the atom, for example, transitions.

Heisenberg, from the beginning, had found the wave mechanics "disgusting" and was further enraged at Born's desertion of the cause of quantum mechanics.

This situation and conversations with Bohr in late 1926 reinforced both Heisenberg's aesthetic and his nonvisual modes of thinking, leading him to boldly *demarcate between* intuition and visualization. The results in early 1927 were the uncertainty relations and the rejection of the only causal law that this viewpoint could consider — classical causality.

To Heisenberg's consternation and eventual distress, Bohr pressed him relentlessly not to publish his results. For Bohr had realized that only the complete wave-particle duality for matter and light could lead to a consistent interpretation of the quantum mechanics containing visualization. However, the causal laws could no longer be associated with space-time pictures but with the conservation laws of energy and momentum. This viewpoint is embodied in Bohr's complementarity principle of 1927. The analysis leading to the complementarity principle plumbed the very depths of knowledge down to the formation of ideas themselves. Bohr emphasized that the necessary prerequisite to this analysis was the discovery that visual thinking preceded verbal thinking, and linked to visual thinking could only be the aesthetic of the symmetry offered by the complete wave-particle duality.

The roots of complementarity are as varied and deep as its ramifications into other disciplines and so I believe it is apropos here to mention Bohr's lifelong interest in art, especially in cubism. The Danish artist Mogens Anderson, a friend of Bohr, recollected what most impressed Bohr in cubism: "face and limbs depicted simultaneously from several angles. . . . That an object could be several things, could change, could be seen as a face, a limb and a fruitbowl."[5] We shall see that this motif has striking parallels to that offered by complementarity where the atomic entity has two sides — wave and particle — and depending on how you look at it (that is, what experimental arrangement is used), that is what it is.

So in late 1927, Bohr raised physics from the darkness of the abyss and the drama was completed. We are reminded here of one of Bohr's favorite sayings from Schiller:

> Only fullness leads to clarity
> And truth lies in the abyss.

VISUALIZATION LOST (1923–1925)

By the first decade of the twentieth century, it was taken for granted that physical theory should be a reflection of the continuity that we observe in the world of our perceptions. Lack of continuity would mean breaking the connection between cause and effect, that is, violating the law of causality. The law of causality in classical physics states that given a particle's initial position and momentum, its continuous path can be predicted with absolute accuracy, at least in principle. The classical physics is also deterministic because there is no reason for a particle to be unable to occupy any point on the path deduced from the equations of motion;

equivalently, since the continuity of the equations of motion ensures determinism, there is no difference in classical physics between causality and determinism. Given the particle's initial momentum and energy, the values of these quantities can be determined for any point on the particle's path from the conservation laws for momentum and energy; in classical physics these laws are linked to the picture of a particle moving through space.

The newly discovered electron was visualized as having a definite shape, and when accelerated it becomes the source of electromagnetic waves (light) spreading out like the circular ripples caused by a stone thrown into water. This dichotomy between discrete matter and the continuous or wave picture of light was acceptable in classical physics. Even though the electron introduced a discontinuity into the substratum of nature, the laws governing physical theory were required to be continuous.

But in 1900, Max Planck discovered, to his horror, that he might have opened a Pandora's box.[6] The issue concerned his radiation law describing the continuous spectrum of the light emitted from a cavity within a hot substance. This is a most interesting spectrum because it is independent of the substance's constitution; such phenomena fascinate physicists and until 1900 a formula describing this spectrum had eluded them, despite intense efforts. Since the spectrum is independent of the constitution of the cavity walls, it matters not at all what model is used for the source of radiation. Planck decided to use a currently accepted model that is both easily visualizable and whose equations of motion are easily soluble; namely, the electrons comprising the cavity walls are charged spheres on springs or charged oscillators. According to Planck's theory of 1900, the continuous spectrum of radiation from the cavity results from the charged oscillators emitting and absorbing light energy discontinuously in bursts or energy quanta. This gross violation of continuity caused Planck to devote many years of his life seeking other theories for the radiation law consistent with classical physics.

Planck's reputation notwithstanding, his theory of 1900 was politely ignored until it was resurrected twice over by an unknown patent clerk third class in Bern. Albert Einstein proposed in 1905 that certain phenomena could be described easily if light were considered as having a granular structure, thereby flying through space like a hail of shot or light quanta.[7] Sensitive to the mood of the times, Einstein in 1905 did not use Planck's radiation law in calculations supporting this viewpoint. Nevertheless, it is clear from the light quantum paper of 1905 and his later writings that he knew of it and that he was boldly extending its consequences beyond the quantization of energy. Among the critics of the hypothesis of light quanta was Planck who could not construct a visualizable model in which light quanta produced interference,[8] whereas almost three hundred years previously Christian Huygens had proposed a visualizable construction for light waves interfering. Einstein in 1907 used Planck's law of radiation (without light quanta) toward a quantum theory of solids.[9] This research

was discussed at the first summit meeting of physics — the Solvay Congress of 1911. The theme was the theory of radiation and Planck's energy quanta; for by this time the special relativity theory, another product of Einstein's *annus mirabilis* of 1905, was considered well understood. This congress provides us with a glimpse into the accepted view of what a physical theory should be.

Perhaps the best survey of the Solvay Congress was written by Henri Poincaré,[10] who placed a high premium upon visual thinking and those physical theories whose mathematical framework exhibited the highest degree of symmetry.[11] Poincaré focused upon his recent proof that a physically meaningful description of cavity radiation can be obtained only if the energies of the charged oscillators were restricted. This result deeply disturbed Poincaré because it meant that any law for cavity radiation, for example, Planck's, must possess discontinuities. But, Poincaré lamented, should "discontinuity reign over the physical universe,"[12] then determinism would be invalid since all positions of the charged oscillators would not be permitted (the charged oscillator's energy is dependent upon how much the spring is extended from its equilibrium position). Fundamental changes in the laws of mechanics would be necessary because they could no longer be considered as describing continuous motion. Poincaré, as did most others including Planck, preferred a wait-and-see attitude. With confidence they believed in the possibility of extending our customary intuition into the domain of the atom, and of finding there the mechanism or cause for the emission of radiation by the atoms lining the cavity wall; as expected, there would be a continuous causal chain. The search for causes, with the optimism that they would be found, was a hallmark of classical physics; for this was necessary in order to maintain both causality and visualization of physical process.

Should this search fail, a dramatic change in world view would be necessary because it could very well signal the need for statistical laws denying knowledge of the cause for phenomena — a priori probabilities. For example, Ernest Rutherford's law for how many of a large number of atoms will undergo radioactive decay in a certain time period is a statistical law, but not a priori probabilistic. Poincaré emphasized that the laws governing the behavior in *individual* atoms would turn out to be causal laws, and this faith would be realized by future analyses of Rutherford's recently proposed model of the atom as a miniature Copernican system.[13]

In contrast to the continuous spectrum of cavity radiation stood the discrete spectrum of free atoms. For if a gas of, for example, hydrogen is heated, it emits light whose spectrum is a series of unequally spaced lines differing in brightness and frequency. The spectral lines of hydrogen were especially well known, and by the end of the first decade of the twentieth century there were formulae without theoretical foundation that served to classify them. In 1913, Bohr offered a theory from which these series could be deduced.[14]

Bohr's theory was predicted explicitly upon discontinuities in nature and in its laws, as well as violating both classical mechanics and electrodynamics. The theory is

based upon two postulates: first, in order to account for the stability of matter and to set a scale for the size of the atom, Bohr asserts that contrary to classical mechanics not every orbit is permissible for the planetary electron. Bohr refers to the permitted orbits as "stationary states"[15] which can be calculated from classical mechanics suitably altered to include Planck's constant h from his theory of the continuous spectrum of cavity radiation. In particular, there is a ground state below which the electron cannot descend. While in a stationary state an electron does not radiate as it should according to classical electrodynamics. Metaphorically, Bohr describes the stationary states as "waiting places"[16] where the electron resides before making a transition to another stationary state. Neither classical mechanics nor electrodynamics can discuss the transition process. So Bohr proposed a second postulate: the transition downward of the electron is accompanied by the emission of radiation of energy hv, where v is the frequency of the emitted radiation. For Bohr the quantum jump is an "essential discontinuity"[17] because it is demanded by the two postulates of the theory. Moreover, the quantum jump is unvisualizable. Consider, for example, the simplest element hydrogen, which the Bohr theory regards as a solar system with one planet — the electron. The electron makes a quantum jump by disappearing from one stationary state and reappearing in another one, somewhat like the Cheshire cat.

Despite Bohr's bold departures from classical physics, a picture survived of the atom as a miniature Copernican system, so familiar and so easy to visualize because, as Rudolf Arnheim observed of corpuscular models, there is a sharp difference between "figure" and "ground."[18] Bohr's theory achieved astonishing successes. For example, it could discuss quantitatively many of the chemical and physical characteristics of hydrogen as well as offer a means to relate the atomic structure and chemical properties of the more complex elements. By 1920, it had also disposed of the classical theory of the scattering of light by atoms, that is, dispersion. The classical theory of dispersion uses a model of the atom analogous to that of Planck: an atom reacting to light is represented by the easily visualizable model of charged oscillators. The charged oscillators are set into motion by the incident radiation thereby becoming sources of coherent secondary waves; and the frequencies of the spectral lines are closely approximated by the frequencies of the oscillators. On the other hand, according to Bohr's atomic theory, atoms are not charged oscillators but miniature planetary systems, and the frequency of a spectral line is not the frequency of an electron in a stationary state. By 1920, the matter had gone beyond the competition between two theoretical viewpoints because certain patterns of spectral lines from dispersion experiments could be accounted for only by the quantum theory (as Bohr's theory of the atom was referred to by then).[19] However, in 1920 the quantum theory could offer no detailed description of dispersion; this would have to await further development of an idea proposed in detail by Bohr two years earlier.

In 1918, Bohr extended the quantum theory by proposing a method to discuss the brightness, that is, intensity, of spectral lines.[20] It is based upon a

limiting process which would be a guiding theme in the years ahead, and which in 1920 he named the "correspondence principle.[21] The correspondence principle is based upon the following observation. The spectral limes of hydrogen are unequally spaced, becoming ever closer with the lines' decreasing frequencies, until, to the naked eye, the spectrum becomes a blur of white. The white blur is the case expected from the viewpoint of classical electrodynamics according to which the planetary electron radiates continually and eventually spirals into the nucleus, but matter is stable and hence Bohr's first postulate. The low-frequency spectral lines are the result of transitions downward between stationary states far from the nucleus. The correspondence principle asserts that in this region the classical and quantum predictions for the characteristics of the emitted radiation approach each other asymptotically. Thus, in this region, to a high degree of accuracy, the well-known results of classical electrodynamics, suitably altered to contain quantum instead of classical frequencies, could be equated to the expressions offered by the quantum theory. Then, these equalities are assumed to hold reasonably well in the regions close to the nucleus. Bohr's problem was to find a quantum-theoretical description of the unvisualizable quantum jump. He found it in the A and B coefficients of Einstein's quantum theory of 1916–1917 for the case of atoms in equilibrium with cavity radiation.[22] The A and B coefficients are the probabilities for an atom to make transitions that are spontaneous or induced by external radiation, respectively. Although Einstein's researches in the years 1905–1916 is too often looked upon as revolutionary, he viewed it as extending classical physics. So it is not surprising that like Poincaré, Einstein considered the appearance of probabilities to be a "weakness"[23] of his quantum theory of radiation. Bohr, on the other hand, took them over into his quantum theory of the atom as a priori probabilities in order to provide a mathematical description for the unvisualizable quantum jump. This was a courageous step for it widened the gap between the quantum theory and classical physics where there is no room for a priori probabilities.

In a major monograph of 1923, Bohr presented a scientific and epistemological analysis of the problems confronting the "possibility of forming a consistent picture [*Bild*] of phenomena" with which the principles of the quantum theory "can be brought into conformity."[24] Although Bohr's reason for writing it almost certainly concerned the withering away in 1921–1923 of the picture of the atom as a miniature Copernican system, he does not consider of fundamental importance problems concerning the constitution of complex atoms. He emphasizes that despite the "good service" offered by the classical theory of radiation through the correspondence principle, "we must always keep clearly before us the far-reaching character of the departure from our customary ideas [*Vorstellungen vor Augen*] which is effected by the introduction of discontinuities." Among the immediate departures were the two postulates of Bohr's theory of 1913 and introduction of a priori probability to discuss the unvisualizable quantum jump in 1918; in 1923,

others would follow. In facing these problems, Bohr warns the reader of the difficulties of extending our ordinary intuition into the microscopic domain: "we have in mind the fundamental difficulties which stand in the way of the effort to reconcile the appearance of discontinuities in atomic processes with conceptions of classical electrodynamics."

A method Bohr proposes for removing the "fundamental difficulties" concerns strictly maintaining the conservation laws of energy and momentum in "individual processes" using light quanta, that is, in the scattering of light by individual atoms. However, Bohr continues, this method cannot be "considered as a satisfactory solution" because the "picture [*Bild*]" of light quanta excludes the possibility of discussing interference. The success of the hypothesis of light quanta in accounting for certain experimental results led him to conclude that no matter which hypothesis on the nature of light would prove ultimately to be satisfactory, a space and time description of atomic processes could not "be carried through in a manner free from contradiction by the use of conceptions borrowed from classical electrodynamics." Since classical physics links the conservation laws of energy and momentum with the picture of particles moving continuously in space and time, then "we must be prepared for the fact that deduction from these laws will not possess unlimited validity." The correspondence principle rather than the conservation laws would be a guide to a consistent quantum theory.

Bohr's other method for removing fundamental difficulties concerns a new approach to the problem of dispersion that will dramatically alter the course of quantum theory. Toward using the correspondence principle to extend the classical theory of dispersion into the quantum theory, Bohr writes that the atom responds to external radiation like a "number of classical oscillators" whose frequencies are those of the observed spectral lines. He refers to this response as the "coupling mechanism," and cites recent work by Rudolf Ladenburg who independently had a similar "train of thought" in 1921.[25] Then, in 1923, Ladenburg applied the correspondence principle to the classical theory of dispersion in order to formulate a mathematical version of the coupling mechanism.[26] In summary, the new theory of dispersion was not based upon the picture of the atom as a miniature Copernican system.

By 1924, Arthur Compton's interpretation for the change of wavelength of very high-frequency radiation (X rays) scattered from metal foils furnished further evidence for the reality of the light quantum.[27] Among the physicists who disagreed with Compton was Bohr, for whom the tension between the two conceptions of light would have to be resolved on the basis of a wave theory. For although there may be essential discontinuities in individual processes, our ordinary intuition demands that light be a continuous phenomenon.

Bohr's viewpoint appeared in a paper of 1924 co-authored with H. A. Kramers and John C. Slater, but almost certainly written entirely by Bohr.[28] They consider this paper to be a "supplement" to Bohr's monograph of 1923, and the

solution to the "fundamental difficulties" which stand in the way of reconciling classical electrodynamics with the essential discontinuities of atomic physics. Their solution is based upon Bohr's coupling mechanism which asserts that the atom reacts to incident radiation like a "set of 'virtual oscillators' " with the proper quantum frequencies, and "such a Picture [*Bild*] was used by Ladenburg." Bohr's use here of the notion of a "picture" is in the sense of the interpretation offered by Ladenburg's mathematical framework, and this differs from the notion of "picture" in the essay of 1923 where it was meant as visualization. Indeed, one cannot visualize the planetary electron in a stationary state in the hydrogen atom represented by as many oscillators as there are transitions from this state. The set of virtual oscillators replacing the image of the planetary electron in a stationary state continually emits a virtual radiation field transporting only the probability for an electron to make a transition; a priori probability is introduced into the theory through the correspondence principle which contains the *A* and *B* coefficients. Thus, for example, since the virtual radiation field of one atom can induce a transition upward in another atom without undergoing the corresponding downward transition, Bohr, Kramers, and Slater abandon "any attempt at a causal connexion between transitions in distant atoms," as well as energy and momentum conservation in the individual interactions "so characteristic of the classical theories." Nevertheless, they continue, energy and momentum are conserved statistically—that is, for many scattering processes (this contrasts with Poincaré's assessment of laws like that of radioactive decay).

In contrast to Compton's "formal interpretation" using light quanta, and hence energy and momentum conservation, Bohr, Kramers, and Slater consider the Compton effect as a continuous process. Each illuminated electron in the target emits coherent secondary wavelets which can be understood as light scattered from a virtual oscillator. This description displaced physical reality further from the "classical conceptions" because the scattered electron and virtual oscillator need not have the same velocity or position. Additionally, since the virtual radiation field transports probability, they predicted that the scattered electron possesses the probability of having momenta in any direction.

Thus, in order to maintain the wave concept of radiation, Bohr was willing to pay a high price — namely, relinquishing the picture of an electron as a localized quantity, the laws of energy and momentum conservation and causality. This was a desperate time for Bohr because he could very well have believed that the hypothesis of the virtual oscillators was the last gasp of his program for a description of the interpretation of light with matter that was macroscopically continuous. He as much as admits that this is a physics of desperation in the Bohr, Kramers, and Slater paper of 1924, where he writes that "it seems at the present state of science hardly justifiable to reject a formal interpretation as that under consideration as inadequate." The violation of energy and momentum conservation was treated with caution by most physicists; Born, Heisenberg, and Kramers omitted it from their

subsequent research based upon the virtual oscillators.[29] The experimentalist E. N. da C. Andrade caught the mood of the times in the third edition of his book *The Structure of the Atom* which appeared in late 1926. There he considered the suggestion of nonconservation of energy as "repugnant."[30]

Although it is not my goal here to discuss the nature of Heisenberg's discovery of the new quantum mechanics in mid-1925, a few words are necessary nevertheless on the thinking that led him to it. The reason is that to Heisenberg during period from mid-1924 to mid-1925 the virtual oscillators went from being merely appealing to becoming a guiding theme.[31] But we must keep in mind that the hypothesis of virtual oscillators was treated purely formally in the paper of Bohr, Kramers, and Slater, and then in subsequent elaborations using the Bohr, Kramers, and Slater theory of Ladenburg's preliminary theory of dispersion by Bohr and Kramers. Furthermore, Born and Kramers had been unable to extract from their formalisms assertions concerning empirical data.

My research has led me to a missing piece in the jigsaw of Heisenberg's discovery — his paper of 1925, "On an Application of the Correspondence Principle to Problems Concerning the Polarization of Fluorescent Light"[32] and its analysis of the dispersion experiment of the eminent American physicist R. W. Wood with A. Ellett, [33] which in retrospect must be considered as a turning point in the genesis of the quantum theory. In the paper of 1925, Heisenberg used the virtual oscillators to free himself from the notion of electrons in stationary states that are planetary orbits, for the "virtual oscillators are connected only in a very symbolic manner" with electrons in such states. Of great importance to Heisenberg was that he could use the virtual oscillators to make certain predictions that agreed adequately with the data of Wood and Ellett. He recollected that this paper showed the "necessity for detachment from intuitive models."[34] It was clear that the set of virtual oscillators were "more real than the orbit";[35] indeed, although particle tracks had been observed in cloud chambers, an electron in a planetary orbit had never been observed. The virtual oscillator representation would be Heisenberg's starting point in the seminal paper on the new quantum mechanics.[36] There the unvisualizable electron is characterized by relations among observable quantities, for example, the frequency of the atom's spectral lines. When Pauli, early in 1926, deduced the Balmer formula from Heisenberg's theory (that is, one of the spectral line series for the hydrogen atom), he emphasized at the outset in words conflicting with his reminiscence of 1955 (see introduction) that "Heisenberg's form of the quantum theory completely avoids a mechanical-kinematical demonstration [*Veranschaulichung*] of the notion of electrons in the stationary states of the atom."[37] Although the renunciation of a picture of the bound electron was a necessary prerequisite to the discovery of the new quantum mechanics, nevertheless, the lack of *Veranschaulichung* or *Anschaulichkeit* or an intuitive [*anschauliche*] interpretation was of great concern to Bohr, Born, and Heisenberg, and this concern emerges from their scientific papers of the period 1925–1927. For example, in the important

paper of Born, Jordan and Heisenberg of late 1925, Heisenberg writes in the introduction that the present theory labors "under the disadvantage of not being directly amenable to a geometrically intuitive interpretation [*anschauliche interpretiert*] since the motion of electrons cannot be described in terms of the familiar concepts of space and time."[38] Heisenberg continues, "In the further development of the theory, an important task will lie in the closer investigation of the nature of this correspondence between classical and quantum mechanics and in the manner in which symbolic geometry goes over into intuitive classical geometry [*anschaulich klassische Geometrie*]."[39] In the section on the Zeeman effect, probably also written by Heisenberg, the notion of planetary stationary states arises when he writes of the inability of the new quantum mechanics to resolve the problem of the anomalous Zeeman effect as perhaps due to the result of an "intimate connection between the innermost and outermost orbits. . . ." However, Heisenberg hoped that the recent hypothesis of an electron spin by Uhlenbeck and Goudsmit might provide an alternate route.[40] Yet this fourth degree of freedom for the electron could not be visualized because a point on a spinning electron of finite extent could move faster than light.

Born also felt uncomfortable without a means to visualize the concepts in the mathematical formalism of the new quantum mechanics. In late 1925, Born writes that "we have the right to use the terms 'orbit' or 'ellipse,' hyberbola,' etc. in the new theory. . . . Our new imagination is restricted to a limiting case of possible physical processes."[41]

Andrade, in his book published in late 1926, tempered his praise of the new quantum mechanics by pointing out that "its weakness is that we have no geometrical or mechanical picture" of the physical processes to which it is applied of the type to which we are accustomed."[42]

In the latter part of 1925, Bohr acknowledged the empirical disproof of the prediction of Bohr, Kramers, and Slater for the nonconservation of energy and momentum in the Compton effect.[43] The experimental data[44] showed that if the initial energy and momentum of the light quantum is known, then the final values of these quantities for the scattered light quantum and electron could be predicted (initially the target electron is at rest). Nevertheless, Bohr steadfastly maintained his traditionally dualistic viewpoint by asserting that the data did not decide definitely between "two well-defined conceptions of light propagation in empty space." Rather the identification of a "coupling of individual processes. . . forced upon the picture a corpuscular transmission of light." In Bohr's view, accompanying the inclusion of light quanta are "unavoidable fluctuations in time" for systems in small volumes, making it even more difficult to use" intuitive pictures [*anschaulicher Bilder*]"[45] to discuss collision process and the structure of the atoms. Of importance to Bohr was recent theoretical work offering further evidence for the renunciation of pictures in space and time — the research of L. de Broglie of 1924 and of Einstein in 1924–1925.[46] De Broglie proposed a wave-particle duality for matter. A

result of Einstein's theory of the ideal quantum gas was the indistinguishability of its particles. This was a dramatic event for, in addition to the bound electron being unvisualizable, free particles have now lost their individuality.

Acknowledging Heisenberg's new quantum mechanics, Bohr writes that it may at first "seem, deplorable" that in atomic physics "we have apparently met with such a limitation in our usual means of visualization"; nevertheless, "mathematics in this field too, presents us with tools to prepare the way for further progress."[47] Thus, where visualization has been lost, mathematics must be the guide toward "further progress." In summary, by the latter part of 1925, empirical data and theoretical results caused Bohr to demarcate between the conservation laws and pictures in space and time.

VISUALIZATION REGAINED (1926–1927)

Erwin Schrödinger, in the third of the four "communications" of 1926, left no room for doubt that a sense of aesthetics inspired him to formulate the wave mechanics.[48]

> My theory was inspired by L. de Broglie, *Ann. de Physique* (10) 3, p. 22, 1925 (Thèses, Paris, 1924) and by short but incomplete remarks by A. Einstein, *Berl. Ber.* (1925) pp. 9 ff. No genetic relationship whatever with Heisenberg is known to me. I knew of his theory, of course, but felt discouraged, not to say repelled, by the methods of transcendental algebra, which appeared very difficult to me and by the lack of visualizability [*Anschaulichkeit*].

In a more objective tone, one of his principal criticisms against the quantum mechanics is that it appeared to him "extraordinarily difficult" to approach such processes as collision phenomena from the viewpoint of a "theory of knowledge" in which we "suppress intuition [*Anschauung*] and operate only with abstract concepts such as transition probabilities, energy levels, and the like." For although, he continues, there may exist "things" which cannot be comprehended by our "forms of thought," and hence do not have a space and time description, "from the philosophic point of view" Schrödinger was sure that "the structure of the atom" does not belong to this set of things.

Another of Schrödinger's reasons for preferring a wave-theoretical approach is his preference for a continuum-based theory in which he claimed there are no quantum jumps, over the "true discontinuum theory" of Heisenberg. In addition, Schrödinger pushed his proof of the mathematical equivalence of the wave and quantum mechanics to the conclusion natural to his viewpoint — when discussing atomic theories he "could properly also use the singular."

But what sort of picture did Schrödinger offer? He maintains that no picture at all is preferable to the miniature Copernican atom, and in this sense the purely

positivistic standpoint of the quantum mechanics is preferable because of "its complete lack of visualization"; however, this conflicts with Schrödinger's philosophic viewpoint. Schrödinger bases his visual representation of bound and free electrons on the comparison with classical electrodynamics of the solution to the fundamental wave equation of the wave mechanics—that is, the wave function. The electron in a hydrogen atom is represented as a distribution of electricity around the nucleus. However, Schrödinger's proof of the localization of a free electron represented as a packet of waves[49] was shown by Heisenberg to be invalid;[50] rather, the packet of waves does not remain localized. In addition, Schrödinger does emphasize that his visual representation is unsuitable for systems containing two or more electrons because the wave function must be represented in a space of 3N-dimensions, where N is the number of particles.

To summarize the state of quantum physics in the first half of 1925: while no adequate atomic theory existed as of July 1925, by mid-1926 there were two seemingly dissimilar theories. Quantum mechanics was purported to be a "true discontinuum theory."[51] Although a corpuscular-based theory, it renounced any visualization of the bound corpuscle itself (at this time quantum mechanics could discuss only bound state problems). However, its mathematical apparatus was unfamiliar to physicists and also difficult to apply. On the other hand, there was Schrödinger's wave mechanics which was a continuum theory focusing entirely upon matter as waves, offering a visual representation of atomic phenomena and accounting for discrete spectral lines. Its more familiar mathematical apparatus set the stage for a calculational breakthrough. The wave mechanics delighted the more continuum-based portion of the physics community, particularly Einstein and Planck.[52] Although the final experimental verification of the complete wave-particle duality of matter would not appear until 1927, many already subscribed to it.

To the best of my knowledge Heisenberg's first published response to Schrödinger's wave mechanics is the paper of 1926, "Many-Body Problem and Resonance in Quantum Mechanics."[53] There Heisenberg explains that although the physical interpretation of the two theories differ, their mathematical equivalence allows this difference to be put aside; for "expediency" in calculations he will utilize the Schrödinger wave functions, with the caveat that one must not impose upon the quantum theory Schrödinger's "intuitive pictures [*anschaulichen Bilder*]." In fact, Heisenberg points out that such an attitude would prevent treating the many-body problem. To make this clear, he refers to Schrödinger's viewpoint concerning the principal difficulty confronting either the quantum or wave mechanics in treating many-body systems; namely both theories use formulae from classical mechanics which discuss these interactions as if the atomic objects were point particles, but this "is no longer permissible" because point charges are "actually extended states of vibration which penetrate into one another."[54] Heisenberg's rebuttal in his paper treating the many-body problem is that we must set limitations "upon the discussion of the intuition-problem [*Anschauungsfrage*],"

for there are cases in which the "wave representation is more constrained"—for example, "the notion of the spinning electron"[55] which resists perception or intuition through pictures. Heisenberg also objects that Schrödinger's method is not a consistent wave theory of matter in the sense of de Broglie whose waves are in a visualizable space of three dimensions.

The tension between the quantum and wave mechanics increased with the appearance of Born's quantum theory of scattering in the latter part of 1926.[56] Born's analysis of data from the scattering of electrons from hydrogen atoms convinced him of the need for a quantum-theoretical description of scattering consistent with the conservation of energy and momentum; yet, Born writes, neither scattering problems nor transitions in atoms can be "understood by the quantum mechanics in its present form"[57]—here, under quantum mechanics, Born includes both Heisenberg's and Schrödinger's mechanics. His reasons are: Heisenberg's quantum mechanics denies an "exact representation of the processes in space and time"[58]; Schrödinger's wave mechanics denies visualization of phenomena with more than one particle. In Born's view, treating problems concerning scattering and transitions requires the "construction of new concepts," and his vehicle would be Schrödinger's version because it allows the use of the "conventional ideas of space and time in which events take place in a completely normal manner"—that is, the possibility of visualization.

One new concept that Born proposes is rooted in some unpublished speculations of Einstein; namely, that light quanta are guided by a wave field that carries only probability, providing a means to discuss interference and diffraction using light quanta. Born boldly assumes the "complete analogy" between a light quantum and an electron in order to postulate the interpretation that the "de Broglie-Schrödinger waves," that is, the wave function in a three-dimensional space, is the "guiding field" for the electron. From this wave function can be found the probability for the electron to be in a certain region of space. Thus, Born's quantum theory of scattering combines the de Broglie-Schrödinger waves with corpuscles. This view led Born "to be prepared to give up determinism in the world of atoms."[59] For although the carrier of probability develops causally; that is, according to Schrödinger's equation, all final states are probable (although in general not equally probable) that are consistent with the conservation laws of energy and momentum. So, in Born's view, quantum mechanics distinguishes between causality and determinism (compare this with Poincaré's statement of indeterminism in the previous section).

But Born had to go even further, for since the quantum "jump itself" in an atom "def[ies] all attempts to visualize it," then for transition processes, as they occur in atoms, the notion of causality is meaningless, and one is left only with the "quantum mechanically determinate."[60]

Heisenberg was enraged over Born's use of the Schrödinger theory and his assessment of the quantum mechanics. In fact, from the beginning Heisenberg

had been no less outspoken than Schrödinger, for soon after the appearance of wave mechanics he referred to it as "disgusting" in a letter to Pauli.[61] Heisenberg remarked that "Schrödinger tried to push us back into a language in which we had to describe nature by '*anschauliche Methoden*'. . . . Therefore I was so upset about the Schrödinger development in spite of its enormous successes."[62] Then came Born's paper in which "he went over to the Schrödinger theory."

Heisenberg described these developments as very disturbing to his "actual psychological situation at that time"; namely, that quantum mechanics was a complete and thus closed system. Born, on the other hand, had assessed it as incomplete and introduced a new hypothesis using Schrödinger's wave mechanics. It was in response to this highly charged emotional atmosphere that Heisenberg wrote his 1926 paper "Fluctuation Phenomena and Quantum Mechanics."[63] He remembered that although this paper received very little attention, "For myself it was a very important paper."[64] Indeed, it is a paper written by an angry man in which Born's theory of scattering is not cited and Schrödinger is sharply criticized. There Heisenberg demonstrated that a probability interpretation emerges naturally from the quantum mechanics and can be understood only if there are quantum jumps. At the conclusion he comes down firmly in favor only of a corpuscular viewpoint. This becomes crystal clear in Heisenberg's important review paper of 1926 "Quantum Mechanics"[65] where once again Born is not mentioned and Schrödinger is soundly criticized.

"Our ordinary intuition [*Anschauung*]," Heisenberg begins, is contradicted by the phenomena occurring in small volumes where there is the "typically discontinuous element," and where a concept such as that of the light quantum has proven fertile. He continues with a statement carrying an implicit rebuke of Born's theory of scattering: "Nevertheless, in contrast to material particles, we have never before attributed the kind of reality to light quanta which befits objects of the everyday world." His reason is that the light quantum contradicts the "known laws of optics," for example, interference phenomena. On the other hand, Heisenberg continues, perhaps it is as Einstein has emphasized that "conversely the *electron* is due a similar degree of reality as the light quantum." Heisenberg considers this point as symptomatic of the fundamental problem of atomic physics — namely, "the investigation of that typically discontinuous element and of that 'kind of reality.' "

Heisenberg's "*first decisive restriction* in the discussion of the reality of particles" is the renunciation of the notion of the electron's position in an atom because this was necessary in order to formulate the quantum mechanics in terms of relationships among observable quantities. Heisenberg cites as a "further restriction" on the reality of the corpuscle a result from Einstein's theory of the ideal quantum gas —"the individuality of a corpuscle is lost."

Whereas Heisenberg began this essay by demonstrating how nature in the small contradicts our customary intuition, he concludes with emphasis upon the fact that the existing scheme of quantum mechanics contains contradictions of the

"intuitive interpretations [*anschaulichen Deutungen*]" of different phenomena, and this is not satisfactory. For the quantum theory places restrictions on the reality of the corpuscle and there lurks the notion of the light corpuscle. Heisenberg's essay ends with a most interesting and curious passage. Despite repeated warnings throughout this paper and in the many-body paper against intuitive interpretations of the quantum mechanics, Heisenberg reports from Copenhagen where he and Bohr are in the midst of their intense struggle toward a physical interpretation of the quantum mechanics (late fall 1926-spring 1927): "Hitherto there is missing in our picture [*Bild*] of the structure of matter any substantial progress toward a contradiction-free intuitive [*anschaulichen*] interpretation of experiments which in themselves are contradiction-free."

It was on this note that Heisenberg began his publication of 1927 on the fundamental problems of the quantum mechanics, "On the Intuitive [*anschaulichen*] Content of the Quantum-Theoretical Kinematics and Mechanics,"[66] where he brings to a conclusion the analysis begun in "Quantum Mechanics." But what kind of "intuitive content" can a physicist offer who denies visualization of physical processes? In the very first sentence Heisenberg begins his bold reply to this question by stating two criteria for a theory "to be understood intuitively": in all simple cases, the theory's experimental consequences can be thought of in a qualitative manner; and its application should lead to no internal contradictions. Although the mathematical scheme of quantum mechanics requires no revisions, Heisenberg continues, "Heretofore, the intuitive [*anschauliche*] interpretation of the quantum mechanics is full of internal contradictions which become apparent in the struggle of the opinions concerning discontinuum — and continuum — theory, waves and corpuscles." Thus, the quantum mechanics satisfies only one of Heisenberg's criteria "to be understood intuitively." Heisenberg writes that just as in the general relativity theory, where the extension of our usual conceptions of space and time to very large volumes follows from the mathematics of the theory, a revision of our usual kinematical and mechanical concepts "appears to follow directly from the fundamental equations of the quantum mechanics." Heisenberg deduced from these equations the result that, unlike in classical physics, in the atomic domain the uncertainties in measuring the position and momentum of an atomic particle cannot be simultaneously reduced (even in principle) to zero. Rather, the product of the uncertainties is a small but nonzero number — Planck's constant. For example, the more precisely the particle's position is measured, the less precisely can its momentum be ascertained. Heisenberg attributed the cause of this uncertainty relation to be the "typical discontinuities" which contradict our customary intuition. He concludes that the mathematical formalism of quantum mechanics determines the restriction in the atomic domain of such classical concepts as position and momentum. Clearly, in order to maintain his aesthetic of a limited wave-particle duality which is not linked to visualization, Heisenberg has boldly demarcated the notion of "to be understood intuitively" from the

visualization of atomic processes. He has chosen to resolve the "struggle of the opinions" with a corpuscular-based theory that lacks visualization of the corpuscle and severely restricts visualization of physical processes.

This viewpoint led him to assert that in the case of "the strong formulation of the causal law:'if we know the present exactly, then we can calculate the future,' it is not the consequent that is false but the presupposition." The "strong formulation of the causal law" is the one from classical physics, and it is dependent upon visualization and the absence of discontinuities. However, the uncertainty relation between position and momentum places limits upon the precision with which the initial conditions of an atomic particle can be specified; its path cannot be traced to any arbitrary degree of accuracy as in classical physics. Heisenberg's rejection of the causal law from classical physics is therefore not unexpected.

With these results, Heisenberg concludes with a remarkable passage, "one will not have to any longer regard the quantum mechanics as unintuitive [unanschaulich] and abstract."

Heisenberg's strong predisposition to his successful quantum mechanics predicated upon a lack of visualizability is a reflection of his preference at this time for nonvisual thinking, and is undoubtedly the root of his redefinition of intuition. His lack of trust in visual thinking to understand quantum mechanics could very well have been further reinforced by discussions with Bohr during the period of their intense struggle to understand the riddles of the quantum theory. For imagine using visual representations, as Heisenberg writes in the uncertainty principle paper, to think qualitatively of the experimental results in all simple cases—for example, the determination of the slit through which an electron passes in the diffraction of a low-intensity beam of electrons by a double slit grating, or what it means for a light quantum to be polarized.[67] Heisenberg recalled that "we couldn't doubt that this [i.e., quantum mechanics] was the correct scheme but even then we didn't know how to talk about it"; these discussions left them in "a state of almost complete despair."[68] The loss of visualization must have been especially difficult for Bohr whose essays are filled with visual words—for example, picture [Bild], visual ideas [Vorstellungen vor Augen], mechanical models. Arnheim, in an essay on the psychology of art, writes of the "apprehension" that develops in a scientist during a transition from a corpuscular theory with "determined contour line" to more complex models.[69] The states of mind of both Bohr and Heisenberg fit this description, for they were set adrift, Bohr lacking visualization and both Bohr and Heisenberg distrusting their intuitions.

Heisenberg recalled that their approaches to gedanken experiments differed. Bohr, by late 1926, had accepted the duality in the quantum theory and its reflection in nature as the complete wave-particle duality, even though the wave aspect of matter had not yet been definitively established experimentally. For Bohr the wave particle duality was the "central point in the whole story,"[70] because it permitted him to use visual thinking once again; that is, to play with pictures of waves and particles.

Heisenberg relied solely upon the mathematical scheme of quantum mechanics until December of 1926 when he became aware of the Dirac and Jordan transformation theories, proving to his satisfaction the equivalence between the wave and quantum mechanics.[71] Then Heisenberg could understand Bohr's interchangeable use of wave and quantum mechanics because he could mathematize Bohr's visual arguments. Nevertheless, Heisenberg steadfastly refused to believe that there was a complete dualism in quantum theory, rather the transformation theory showed how "very flexible"[72] was the quantum mechanics.

In the light of their different viewpoints, Bohr's dissatisfaction with Heisenberg's uncertainty principle paper should come as no surprise. Bohr insisted that one cannot allow the mathematical formalism to restrict words like position and momentum because, despite the uncertainty relation, you have to use them "just because you haven't got anything else."[73] An unpleasant atmosphere developed in which Heisenberg refused to change the content of the paper but did acquiesce to add a "*Nachtrag bei Korrectur*" (Postscript with Corrections).[74] There Heisenberg writes that Bohr's recent investigations led him to conclude that uncertainty in observation is not rooted "exclusively upon the presence of discontinuities," but in the wave-particle duality of matter.

On 16 September 1927 at the International Congress of Physics at Como, Italy, Bohr presented a viewpoint which he hoped would "be helpful" to "harmonize the apparently conflicting views taken by different scientists."[75] He realized that the "classical mode of description must be generalized" because our customary intuition cannot be extended into the atomic domain. There Planck's constant links the measuring apparatus to the physical system under investigation in a way that is "completely foreign to the classical theories," and this is the root of the unavoidable statistics of the quantum theory. While in the classical theories this interaction can be neglected, in the atomic domain it cannot. Then, in the atomic domain, the notion of an undisturbed system developing in space and time is an abstraction and "there can be no question of causality in the ordinary sense of the word"; that is, strong causality. Bohr's viewpoint on this situation is the complementarity principle:

> The very nature of the quantum theory thus forces us to regard the space-time coordination and the claim of causality, the union of which characterizes the classical physical theories, as complementary but exclusive features of the description, symbolizing the idealization of observation and definition respectively.

Bohr's response is to separate the causal law from a space-time description; the union of the two was the classical or strong causality. The causal law and space-time pictures are complementary because they are both necessary for a complete description of phenomena.

Bohr next emphasizes that his deliberations upon the relationship between visual thinking and the wave-particle duality of light were central to the genesis

of the complementarity viewpoint. Light as a wave is useful for describing interference phenomena. But the conservation of energy and momentum in the individual interactions of light with atoms, for example, the Compton effect, "finds its adequate expression" in the light quantum (recall that in classical physics also these conservation laws were linked to particles). Since a description of the characteristics of a light quantum involves Planck's constant, tracing its path means an interaction with a measuring apparatus and so we are "confined to statistical considerations." Bohr continues: "This situation would seem clearly to indicate the impossibility of a space-time description of light phenomena." This was Bohr's view of light quanta in 1923 and in the face of experimental data in 1925 as well. Here, however, Bohr associates causality with the predictive powers of the conservation laws of energy and momentum, rather than with space-time pictures that illustrate predictions for the position of the light quantum. Since the wave-particle duality holds also for atomic entities, for example, the electron, then space-time pictures cannot be associated with a causal description of the interactions among these particles. In the atomic domain the quantities that characterize a particle (energy and momentum) are connected through Planck's constant with the quantities that characterize a wave (frequency and wavelength). However, in the physics of macroscopic bodies this connection has been neglected because of the insensitivity of our perceptions to the effects of a physical constant as small as Planck's constant; for this reason the wave and particle pictures seem contradictory. According to the viewpoint of complementarity, the pictures of light and matter as waves and particles are not contradictory, as had been thought previously, but are "complementary pictures" because they are both necessary for a complete description of atomic phenomena; they are mutually exclusive because in a given experimental arrangement atomic entities can exhibit only one of their two sides. The scheme of complementarity permits a self-consistent description of how the quantum theory relates to the simple experiments that had driven Bohr and Heisenberg to despair. For in the complementarity paper Bohr emphasizes that "every word in the language refers to our ordinary perception," and according to our ordinary perception there are only two kinds of phenomena — corpuscular and undulatory — just as our intuition tells us that "things" are either discontinuous or continuous. The failure of our ordinary intuition in the atomic domain, Bohr writes, is rooted in the "general difficulty in the formation of human ideas, inherent in the distinction between subject and object."

This completes Bohr's analysis of 1927, which contains the viewpoint soon to be referred to as the *Kopenhagener Geist der Quantentheorie*.[76] It is an extraordinary analysis because Bohr's method to arrive at a contradiction-free interpretation of the quantum theory led him to ever-deeper levels of analysis: from a purely scientific analysis, to an epistemological analysis, to an analysis of perceptions, and then to the origins of scientific concepts. A necessary prerequisite to this analysis

was the acceptance of the complete wave-particle duality in nature. This permitted Bohr to use the symmetry of the pictures of waves and particles which are familiar from our customary intuition. He could then discuss all simple experiments. Visual thinking preceded verbal thinking, and linked with visual thinking was Bohr's new aesthetic of the symmetry of pictures afforded by accepting the complete wave-particle duality. Bohr's viewpoint stands in contrast to the views of Heisenberg and Born. Although Heisenberg's viewpoint maintained the validity of the conservation of energy and momentum, it was corpuscular-based and severely restricted visualization as well as the use of words such as position and momentum. Heisenberg considered the classical law of causality which is linked to pictures to be invalid in the atomic domain. Born's viewpoint of 1926 contained energy and momentum conservation, visualization, waves and particles, but the waves were not observable quantities. Furthermore, defining causality according to Schrödinger's equation as the development in space and time of the probability waves led Born to accept the validity of causality in scattering processes and its lack of meaning in atomic transition processes. However, Bohr realized that only the choice of a complete dualism, vis-à-vis the holistic view of Heisenberg and the incomplete dualism of Born could offer the visualization associated with the ordinary intuition rejected by Heisenberg's holistic view. In addition, this choice led Bohr to a new causal law that is separated from visualization: Space-time pictures of atomic processes can be constructed using concepts from our customary intuition, but one must understand that they are not causal descriptions. There is one point, however, shared by the views of Born and Bohr; namely, that contrary to the classical physics, the quantum theory is causal but not deterministic.

A study of Heisenberg's writings in the period 1928–1929 in conjunction with his reminiscences reveals, not unexpectedly, that he understood the symmetry of the "complementary picture" from the mathematical statements of the complementarity principle—the methods of the quantization of wave fields formulated for the electromagnetic field by Dirac in 1927 and then extended to particles with mass by Jordan, Klein, and Wigner in 1927–1928.[77] This is a form of the quantum theory in which the wave and particle aspects of matter can be transformed mathematically into one another and yet remain mutually exclusive. A fine illustration of the different modes of thinking of Heisenberg and Bohr is in Heisenberg's recollection of a conversation they had in the period just after the appearance of the papers of Jordan, Klein, and Wigner.[78]

So the symmetry was complete only after these papers. Well Bohr perhaps in the first moment did not feel exactly that way, but I think later on he saw quite well that this was an illustration that he wanted.

In conclusion, the importance for creative thinking of the domain where art and science merge has been emphasized by great philosopher-scientists of the twentieth century—Bohr, Einstein, Heisenberg, and Poincaré. For in their research the boundaries between disciplines are often dissolved and they proceed neither deductively through logic nor inductively through the exclusive use of empirical data, but by visual thinking and aesthetics.[79] □

MACHINES OF THE VISIBLE

■ *J e a n - L o u i s C o m o l l i*

INTRODUCTION

One of the hypotheses tried out in some of the fragments gathered together here would be on the one hand that the cinema — the historically constitutable cinematic statements — functions with and in the set of apparatuses of representation at work in a society. There are not only the representations produced by the representative apparatuses as such (painting, theater, cinema, etc.); there are also, participating in the movement of the whole, the systems of the delegation of power (political representation), the ceaseless working-up of social imaginaries (historical, ideological representations) and a large part, even, of the modes of relational behavior (balances of power, confrontations, maneuvers of seduction, strategies of defense, marking of differences or affiliations). On the other hand, but at the same time, the hypothesis would be that a society is only such in that it is *driven by representation*. If the social machine manufactures representations, it also manufactures *itself* from representations — the latter operative at once as means, matter, and condition of sociality.

Thus the historical variation of cinematic techniques, their appearance-disappearance, their phases of convergence, their periods of dominance and decline seem to me to depend not on a rational-linear order of technological perfectibility nor an autonomous instance of scientific "progress," but much rather on the offsettings, adjustments, arrangements carried out by a social configuration in order to represent itself, that is, at once to grasp itself, identify itself, and itself produce itself in its representation.

What happened with the invention of cinema? It was not sufficient that it be technically feasible, it was not sufficient that a camera, a projector, a strip of images be technically ready.[1] Moreover, they were already there, more or less ready, more or less invented, a long time already before the formal invention of cinema, 50 years before Edison and the Lumière brothers. It was necessary that something else be constituted, that something else be formed: the *cinema machine*, which is not essentially the camera, the film, the projector, which is not merely a combination of instruments, apparatuses, techniques. Which is a machine: a *dispositif* articulating between different sets — technological certainly, but also economic and ideological. A *dispostif* was required which implicates its motivations, which is the

arrangement of demands, desires, fantasies, speculations (in the two senses of commerce and the imaginary): an arrangement which gives apparatus and techniques a social status and function.

The cinema is born immediately as a social machine, and thus not from the sole invention of its equipment but rather from the experimental supposition and verification, from the anticipation and confirmation of its *social profitability*: economic, ideological, and symbolic. One could just as well propose that it is the spectators who invent cinema: the chain that knots together the waiting queues, the money paid, and the spectators' looks filled with admiration. "Never," say Gilles Deleuze and Claire Parnet, "is an arrangement combination technological, indeed it is always the contrary. The tools always presuppose a machine, and the machine is always social before it is technical. There is always a social machine which selects or assigns the technical elements used. A tool, an instrument, remains marginal or little used for as long as the social machine or the collective arrangement-combination capable of taking it in its *phylum* does not exist."[2] The hundreds of little machines in the nineteenth century destined for a more or less clumsy reproduction of the image and the movement of life are picked up in this "phylum" of the great representative machine, in that zone of attraction, lineage, influences that is created by the displacement of the social coordinates of analogical representation.

The second half of the nineteenth century lives in a sort of frenzy of the visible. It is, of course, the effect of the social multiplication of images: ever wider distribution of illustrated papers, waves of prints, caricatures, etc. The effect also, however, of something of a geographical extension of the field of the visible and the representable: by journeys, explorations, colonizations, the whole world becomes visible at the same time that it becomes appropriable. Similarly, there is a visibility of the expansion of industrialism, of the transformations of the landscape, of the production of towns and metropolises. There is, again, the development of the mechanical manufacture of objects which determines by a faultless force of repetition their ever identical reproduction, thus standardizing the idea of the (artisanal) copy into that of the (industrial) series. Thanks to the same principles of mechanical repetition, the movements of men and animals become in some sort more visible than they had been: movement becomes a visible mechanics. The mechanical opens out and multiplies the visible, and between them is established a *complicity* all the stronger in that the codes of analogical figuration slip irresistibly from painting to photography and then from the latter to cinematography.

At the very same time that it is thus fascinated and gratified by the multiplicity of scopic instruments which lay a thousand views beneath its gaze, the human eye loses its immemorial privilege; the mechanical eye of the photographic machine now sees *in its place*, and in certain aspects with more sureness. The photograph stands as at once the triumph and the grave of the eye. There is a violent decentering of the place of mastery in which since the Renaissance the look had come to reign; to which testifies, in my opinion, the return, synchronous with the

rise of photography, of everything that the legislation of the classic optics — that geometrical *ratio* which made of the eye the point of convergence and centering of the perspective rays of the visible — had long repressed and which hardly remained other than in the controlled form of anamorphoses: the massive return to the front of the stage of the optical aberrations, allusions, dissolutions. Light becomes less obvious, sets itself as problem and challenge to sight. A whole host of inventors, lecturers, and image showmen experiment and exploit in every way the optical phenomena which appear irrational from the standpoint of the established science (refraction, mirages, spectrum, diffraction, interferences, retinal persistence, etc.). Precisely, a new conception of light is put together, in which the notion of wave replaces that of ray and puts an end to the schema of rectilinear propagation, in which optics thus overturned is now coupled with a chemistry of light.

Decentered, in panic, thrown into confusion by all this new magic of the visible, the human eye finds itself affected with a series of limits and doubts. The mechanical eye, the photographic lens, while it intrigues and fascinates, functions also as a *guarantor* of the identity of the visible with the normality of vision. If the photographic illusion, as later the cinematographic illusion, fully gratifies the spectator's taste for delusion, it also reassures him or her in that the delusion is in conformity with the norm of visual perception. The mechanical magic of the analogical representation of the visible is accomplished and articulated from a doubt as to the fidelity of human vision, and more widely as to the truth of sensory impressions.

I wonder if it is not from this, from this lack to be filled, that could have come the extreme eagerness of the first spectators to *recognize* in the images of the first films — devoid of color, nuance, fluidity — the identical image, the double of life itself. If there is not, in the very principle of representation, a force of disavowal which gives free rein to an analogical illusion that is yet only weakly manifested by the iconic signifiers themselves? If it was not necessary at these first shows to forcefully deny the manifest difference between the filmic image and the retinal image in order to be assured of a new hold on the visible, subject in turn to the law of mechanical reproduction.

THE CAMERA SEEN

The camera, then.

For it is here indeed, on this *camera-site,* that a confrontation occurs between two discourses: one which locates cinematic technology in ideology, the other which locates it in science. Note that whether we are told that what is essential in the technical equipment which serves to produce a film has its founding origin in a network of scientific knowledge or whether we are told that that equipment is governed by the ideological representations and demands dominant at the time it was perfected, in both cases — discourse of technicians on the one hand, attempts to elaborate a materialist theory of the cinema on the other — the example given is *always* that which produces

the cinematic *image*, and it *alone*, considered from the sole point of view of optics.[3]

Thus what is in question is a certain *image* of the camera: metonymically, it represents the whole of cinema technology, it is the part for the whole. It is brought forward as the *visible part* for the *whole of the technics*. This symptomatic displacement must be examined in the very manner of posing the articulation of the couple Technology/Ideology.

To elect the camera as "delegated" representative of the whole of cinematic equipment is not merely synecdochical (the part for the whole). It is above all an operation of reduction (of the whole to the part), to be questioned in that, *theoretically,* it reproduces and confirms the split which is ceaselessly marked in the technical practice of cinema (not only in the practice of film-makers and technicians and in the spontaneous ideology of that practice; but also in the "idea," the ideological representation that spectators have of work in cinema: concentration on shooting and studio, occultation of laboratory and editing) between the *visible* part of the technology of cinema (camera, shooting, crew, lighting, screen) and its *"invisible"* part (black between frames, chemical processing, baths and laboratory work, negative film, cuts and joins of editing, sound track, projector, etc.), the latter repressed by the former, generally relegated to the realm of the unthought, the "unconscious" of cinema. It is symptomatic, for example, that Lebel, so concerned to assert the scientific regulation of cinema, thinks to deduce it only from geometrical optics, mentioning only once retinal persistence which nevertheless is what brings into play the specific difference between cinema and photography, the synthesis of movement (and the scientific work which made it possible); at the same time that he quite simply forgets the other patron science of cinema and photography, photochemistry, without which the camera would be no more precisely than a *camera obscura*. As for Pleynet's remarks, they apply indiscriminately to the quattrocento *camera obscura,* the seventeenth-century magic lantern, the various projection apparatus ancestors of the *cinématographe* and the photographic apparatus. Their interest is evidently to indicate the links that relate these diverse perspective mechanisms and the camera, but in so doing they risk not seeing exactly what the camera hides (it does not hide its lens): the film and its feed systems, the emulsion, the frame lines, things which are essential (not just the lens) to cinema, without which there would be no cinema.

Hence it is not certain that what is habitually the case in practice should be reproduced in theory: the reduction of the hidden part of technics to its visible part brings with it the risk renewing the domination of the visible, that *ideology of the visible* (and what it implies: masking, effacement of work) defined by Serge Daney:

Cinema postulated that from the 'real' to the visual and from the visual to its filmed reproduction a same truth was infinitely reflected, without distortion or loss. In a world where 'I see' is readily used for 'I understand,' one conceives that such a dream had nothing fortuitous about it, the dominant ideology — that which equates the real with the visible — having every interest in encouraging it. . . . But why not, going further

back still, call into question what both serves and precedes the camera: a truly blind confidence in the visible, the hegemony, gradually acquired, of the eye over the other senses, the taste and need a society has to put itself in spectacle, etc. . . . The cinema is thus bound up with the Western metaphysical tradition of seeing and vision whose photological vocation it realizes. What is photology, what could be the discourse of light? Assuredly a teleological discourse if it is true, as Derrida says, that teleology 'consists in neutralizing duration and force in favor of the illusion of simultaneity and form.'[4]

Undeniably, it was this "hegemony of the eye," this secularization, this ideology of the visible linked to Western logocentrism that Pleynet was aiming at when stressing the pregnancy of the quattrocento perspective code in the basic apparatus: the image produced by the camera cannot do otherwise than confirm and reduplicate "the code of specular vision such as it is defined by the renaissant humanism," such that the human eye is at the center of the system of representation, with that centrality at once excluding any other representative system, assuring the eye's domination over any other organ of the senses and putting the eye in a strictly divine place (Humanism's critique of Christianity).

Thus is constituted this situation of *theoretical paradox*: that it is by identifying the domination of the camera (of the visible) over the whole of the technology of cinema which it is supposed to represent, inform, and program (its function as *model*) that the attempt is made to denounce the submission of that camera, in its conception and its construction, to the dominant ideology of the visible.

If the gesture privileging the camera in order to set out from it the ideological chain in which cinema is inscribed is theoretically grounded by everything that is implied in that apparatus, as in any, case by the determining and principal role of the camera in the production of the film, it too will nevertheless remain caught in the same chain unless taken further. It is therefore necessary to change perspective, that is, to take into account what the gesture picking out the camera sets aside in its movement, in order to avoid that the stress on the camera — necessary and productive — is not reinscribed in the very ideology to which it points.

It seems to me that a materialist theory of the cinema must at once disengage the ideological "heritage" of the camera (just as much as its "scientific heritage," for the two, contrary to what seems to be stated by Lebel, are in no way exclusive of one another) and the ideological investments in that camera, since neither in the production of films nor in the history of the invention of cinema is the camera alone at issue; if it is the fact that what the camera brings into play of technology, of science and/or ideology is determining, this is so only in relation to other determining elements which may certainly be secondary relative to the camera but the *secondariness* of which must then be questioned: the status and the function of what is covered over by the camera.

To underline again the risk entailed in making cinema function theoretically entirely on the *reduced model* of the camera, it is enough to note the almost total lack of theoretical work on the sound track or on laboratory techniques (as if the

sight of light — geometrical optics — had blocked its work: the chemistry of light), a lack which can only be explained by the dominance of the visible at the heart of both cinematic practice and reflection. Is it not time, for example, to bring out the ideological function of two techniques (instruments + processes + knowledges + practice - interdependent)? Together to realize an aim, an objective which henceforth constitutes that technique, founds, and authorizes it both of which are on the side of the hidden, the cinematic unthought (except by very few filmmakers: Godard, Rivette, Straub): *grading* and *mixing?*

COVERING OVER AND LOSS OF DEPTH OF FIELD

No more than in the case of the "close-up" is it possible to postulate a continuous chain (a filiation) of "depth-of-field shots" running through the "history of cinema." No more than in the case of the "close-up" (or of any other term of cinematic practice and technical metalanguage) is the history of this technical disposition possible without considering determinations that are *not exactly technical* but economic and ideological: determinations which thus go beyond the simple realm of the cinematic, working it over with series of supplements, grasping it on other scenes, having other scenes inscribe themselves on that of cinema. Which shatter the fiction of an autonomous history of cinema (of its "styles and techniques"). Which affect the complex articulation of this field and this history with other fields, other histories. Which thus allow the taking into account, here for the particular technical procedure of depth of field, of the regulation of the functions it assumes — that is to say, of the *meanings* it assumes — in filmic signifying production through codes that are not necessarily cinematic (in this instance: pictorial, theatrical, photographic), and allow the taking into account of the (economic/ideological) forces which put pressure for or against the inscription of this regulation and these codes.

For historian-aestheticians like Mitry and theoreticians like Bazin to have let themselves fall for a determination of filmic writing and of the evolution of cinematic language by the advances of technology (development and improvement of means), to fall, that is, for the idea of a "treasure house" of techniques into which filmmakers could "freely" dip according to the effects of writing sought, or, again, for an "availability" of technical processes which located them in some region outside of systems of meaning (histories, codes, ideologies) and "ready" to enter into the signifying production, it was necessary that the whole technical apparatus of cinema seem so "natural" to them, so "self-evident," that the question of its utility and its purpose (what it is used for) be totally obscured by that of its utilization (how to use it).

It is indeed of "strength of conviction," "naturalness" — and, as a corollary, of the blindness on the part of the theoreticians — that we must talk. Mitry, for example, who notes the fact that deep focus, almost constantly used in the early years of cinema, disappears from the scene of filmic signifiers for some 20 years (with a few

odd exceptions: certain films by Renoir), offers strictly technical reasons as sole explanation for this abandonment, hence establishing technology as the last instance, constituting a closed and autonomous circuit within which technical fluctuations are taken as determined only by other technical fluctuations.

From the very first films, the cinematic image was "naturally" an image in deep focus; the majority of the films of Lumière and his cameramen bear witness to that depth which appears as constituent of these images. It is in fact most often in out-of-doors shooting that depth in the period finds its field. The reason is indisputably of a technical nature: the lenses used before 1915 were, Mitry stresses, "solely f35 and f50," "medium" focal lengths which had to be stopped down in order to produce an image in depth, thus necessitating a great deal of light, something to be found more easily and cheaply outside than in the studio.

One must then ask why, precisely, these "medium" focal lengths were only in use during the first 20 years of cinema. I can see no more pertinent reason than the fact that they restore the spatial proportions corresponding to "normal vision" and that they thereby play their role in the production of the impression of reality to which the *cinématographe* owed its success. These lenses themselves are thus dictated by the codes of analogy and realism (other codes corresponding to other social demands would have produced other types of lenses). The depth of field that they permit is thus also that which permits them, that which lays the ground for their utilization and their existence. The deep focus in question is not a supplementary "effect" which might just as well have been done without; on the contrary, it is what *had* to be obtained and what it was necessary to strive to produce. Set up to put its money on, and putting its money wholeheartedly on, the identification — the desire to identify, to duplicate, to recognize specularly — of the cinematic image with "life itself" (consider the fantastic efforts expended over decades by hundreds of inventors in search of "total cinema," of complete illusion, the reproduction of life with sound and color and relief included), the ideological apparatus cinema could not, in default of realizing in practice the technical patent for relief, neglect the production of effects of relief, of effects of depth. Effects which are due on the one hand to the inscription within the image of a vanishing perspective and on the other to the movements of people or other mobile elements (the La Ciotat train) along vanishing lines (something which a photograph cannot provide, nor *a fortiori* a painting; which is why the most perfect *trompe l'oeil* minutely constructed in conformity with the laws of perspective is powerless to trick the eye). The two are linked: in order that people can move about "perpendicularly" on the screen, the light must be able to go and take them there, it requires a depth, planes spaced out, in short, the code of artificial perspective. Moreover in studio filming, where space was relatively tight and lighting not always adequate, tile backgrounds were often precisely painted *trompe l'oeil* canvases which, while unable to inscribe the movement in depth of the characters, at least inscribed its perspective.

We know what perspective brings with it and thus what deep focus brings into the cinematic image as its *constitutive codes*: the codes of classic Western representation,

pictorial and theatrical. Méliès, specialist in "illusion" and interior shooting, said as early as 1897 of his Montreuil "studio": "In brief, it is the coming together of a gigantic photographic workshop and a theatrical stage." No more exact indication could be given of the double background on which the cinematic image is raised, and not fortuitously but explicitly, deliberately. Not only is deep focus in the early cinematic image the mark of its submission to these codes of representation and to the histories and ideologies which necessarily determine and operate them, but more generally it signals that the ideological apparatus cinema is itself produced by these codes and by these systems of representation, as at once their complement, their perfectionment, and the surpassing of them. There is nothing accidental, therefore, or specifically technical in the cinematic image immediately claiming depth, since it is just this depth which governs and informs it; the various optical instruments are regulated according to the possibility of restoring depth. Contrary to what the technicians seem to believe, the restoration of movement and depth are not effects of the camera; it is the camera which is the effect, the solution to the problem of that restoration.

Deep focus was not "in fashion" in 1986, it was one of the factors of credibility in the cinematic image (like, even if not quite with the same grounds, the faithful reproduction of movement and figurative analogy). And it is by the transformation of the conditions of this credibility, by the displacement of the codes of cinematic verisimilitude from the plane of the impression of reality alone to the more complex planes of fictional logic (narrative codes), of psychological verisimilitude, of the impression of homogeneity and continuity (the coherent space-time classical drama) that one can account for the effacement of depth. It will not then be a question merely of technical "delays": such "delays" are themselves caught up in and effects of the displacement, of this replacement of codes.

It seems surprising indeed (at least if one remains at the level of "technical causes") that a process which "naturally" dominated a large proportion of the films made between 1895 and 1925 could disappear or drop into oblivion for so long without — leaving aside a few exceptions, Renoir being one — filmmakers showing the slightest concern (so it seems).

Everything, Mitry assures us, stems from "the generalization of panchromatic stock round about 1925." Agreed. But to say that — offered with the weight of the obvious — and to pass on quickly to the unsuitability of the lighting systems to the spectrum of this emulsion is exactly *not to say* what necessity attaches to this "generalization," what (new) function the new film comes to fulfill that the old was unable to serve. It is to avoid the question as to what demands the replacement of an emulsion in universal use and which (if we follow Mitry) did not seem so mediocre by another which (still according to Mitry) was far from its immediate equal. As far as we know, it is not exactly within the logic of technology, nor within that of the economics of the film industry (in the mid-twenties already highly structured and well equipped) to adopt (or impose) a new product which in an initial moment poses more problems than the old and hence incurs the expense of adaptation (modification of lighting

systems, lenses, etc.) *without somewhere finding something to its advantage and profit.*

In fact, it is a matter not simply of a gain in the sensitivity of the film but also of a gain in *faithfulness* "to natural colors," a *gain in realism.* The cinematic image becomes more refined, perfects its "rendering," competes once again with the quality of the photographic image which had long been using the panchromatic emulsion. The reason for this "technical progress" is not merely technical, it is ideological: it is not so much greater sensitivity to light which counts as "being more true." The hard, contrasty image of the early cinema no longer satisfied the codes of photographic realism developed and sharpened by the spread of photography. In my view, depth (perspective) loses its importance in the production of "reality effects" in favor of shade, range, color. But this is not all.

A further advantage, that is, that the film industry could find "round about 1925" in imposing on itself—despite the practical difficulties and the cost of the operation—the replacement of orthochromatic by panchromatic stock depends again on the greater sensitivity of the latter. Not only did the gain in sensitivity permit the realignment of the "realism" of the cinematic image with that of the photographic image,[5] it also compensated for the loss of light due to the change from a shutter speed of 16 or 18 frames per second to the speed of 24 frames per second necessitated by sound. This "better" technical explanation, however, can only serve here to re-mark the coincidence of the coming of the talkie and the setting aside of depth, not to provide the reason for it. Although certain of its effects are, that reason is not technical. More than one sound film before *Citizen Kane* works with depth; the generalization of large aperture lenses even does not exclude its possibility: with the sensitivity of emulsions increasing and the quantity of light affordable, there was nothing to prevent—technically—the stopping down of these lenses (if indeed, as Renoir did, one could not find any others). So it is not as final "technical cause" that the talking picture must be brought into the argument; it is in that in a precise location of production—distribution (Hollywood)—it re-models not just the systems of filmic writing but, also the ideological function of the cinema and the economic facts of its functioning.

It is not unimportant that it be—in Hollywood—at the moment when the rendering of the cinematic image becomes subtle, opens up to the shades of grays (monochrome translation of the range of colors), thus drawing nearer to a more faithful imitation of photographic images promoted (fetished) as the very norms of realism, that Speech and the speaking Subject come onto the scene. As soon as they are produced, sound and speech are plebiscited as *the 'truth' which was lacking* in the silent film—the truth which is all of a sudden noticed, not without alarm and resistance, as having been lacking in the silent film. And at once this truth renders no longer valid all films which do not possess it, which do not produce it. The decisive supplement, the "ballast of reality" (Bazin) constituted by sound and speech intervenes straightaway, therefore, as *perfectionment and redefinition of the impression of reality.*

It is at the cost of a series of blindnesses (of disavowals) that the silent image

was able to be taken for the reflection, the objective double of "life itself": disavowal of color, relief, sound. Founded on these lacks (as any representation is founded on a lack which governs it, a lack which is the very principle of any simulacrum: the spectator is anyhow well aware of the artifice but he/she prefers all the same to believe in it), filmic representation could find its production only by working to diminish its effects, to mask its very reality. Otherwise it would have been rejected as too visibly factitious: it was absolutely necessary that it facilitate the disavowal of the veritable sensory castrations which founded its specificity and that it not, by remarking them, prevent such disavowal. *Compromises* were necessary in order that the cinema could function as ideological apparatus, in order that its delusion could take place.

The work of suffering, of filling in, of patching up the lacks which ceaselessly recalled the radical difference of the cinematic image was not done all at one go but piece by piece, by the *patient accumulation of technical processes*. Directly and totally programmed by the ideology of resemblance, of the "objective" duplication of a "real" itself conceived as specular reflection, cinema technology occupied itself in improving and refining the initial imperfect *dispotif, always* imperfect by virtue of the ideological delusion produced by the film as "impression of reality." The lack of relief had been immediately compensated for (this is the original impression of reality) by movement and the depth of the image, inscribing the perspective code which in Western cultures stands as principal emblem of spatial relief. The lack of color had to make do with panchromatic stock, pending the commercialization of three-color processes (1935-1940). Neither the pianos nor the orchestras of the silent film could really substitute for "realistic sound": synchronized speech and sound — in spite of their imperfections, in truth of little weight at a time when it is the whole of sound reproduction, records, radios, which is affected by background noise and interference — thus considerably *displace the site and the means (until then strictly iconic)* of the production of the impression of reality.

Because the *ideological* conditions of production-consumption of the initial impression of reality (figurative analogy + movement + perspective) were changing (if only in function of the very dissemination of photo and film), it was necessary to tinker with its technical modalities in order that the act of disavowal renewing the deception could continue to be accomplished "automatically," in a reflex manner, without any disturbance of the spectacle, above all without any work or effort on the part of the spectator. The succession of technical advances cannot be read, in the manner of Bazin, as the progress towards a "realism plus" other than in that they accumulate realistic supplements which all aim at reproducing — in strengthening, diversifying, rendering more subtle — the impression of reality; which aim, that is, to reduce as much as possible, to minimize the gap which the "yes-I-know/but-all-the-same" has to fill.

What is at stake in deep focus, what is at stake in the historicity of the technique, are the codes and the modes of production of "realism," the transmission, renewal, or transformation of the ideological systems of recognition, specularity, and truth-to-lifeness. □

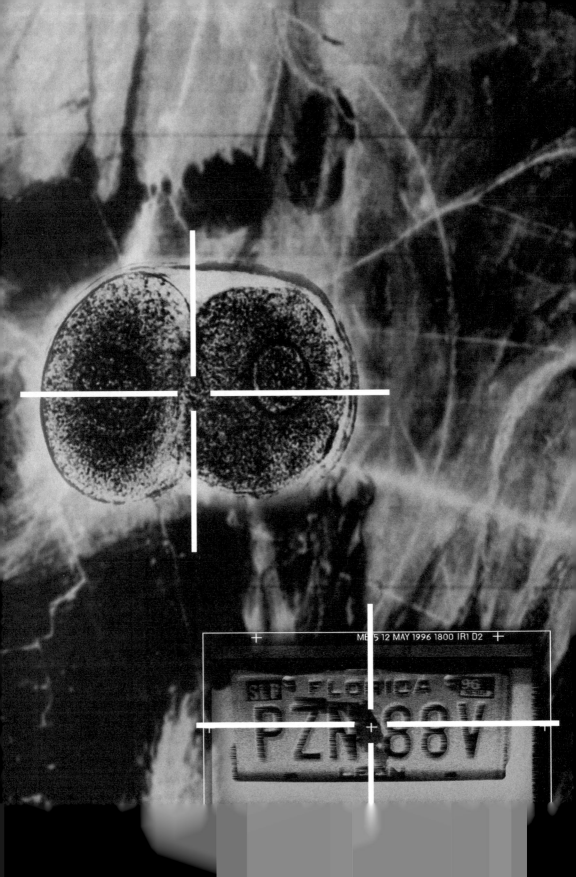

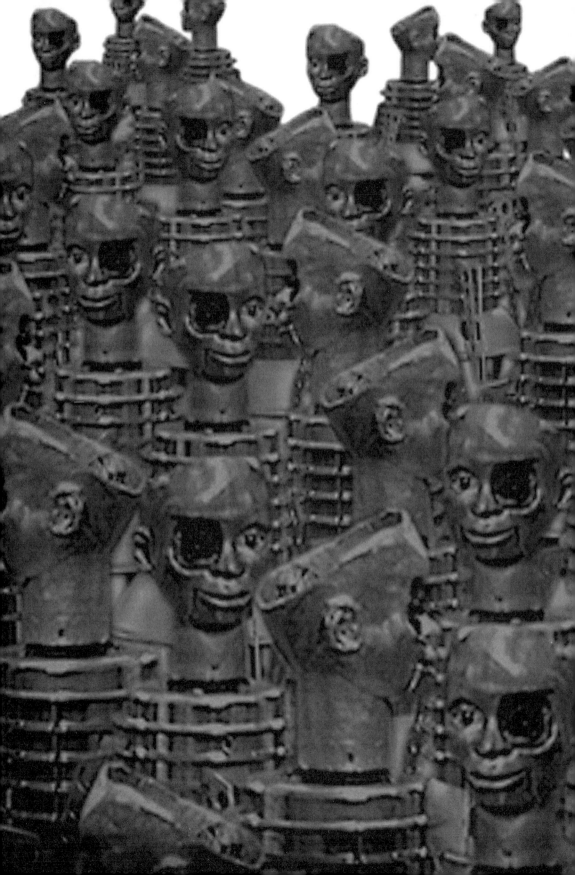

The Work of Culture in the Age of Cybernetic Systems

■ *Bill Nichols*

The computer is more than an object: it is also an icon and a metaphor that suggests new ways of thinking about ourselves and our environment, new ways of constructing images of what it means to be human and to live in a humanoid world. Cybernetic systems include an entire array of machines and apparatuses that exhibit computational power. Such systems contain a dynamic, even if limited, quotient of intelligence. Telephone networks, communication satellites, radar systems, programmable laser video disks, robots, biogenetically engineered cells, rocket guidance systems, videotex networks—all exhibit a capacity to process information and execute actions. They are all "cybernetic" in that they are self-regulating mechanisms or systems within predefined limits and in relation to predefined tasks. Just as the camera has come to symbolize the entirety of the photographic and cinematic processes, the computer has come to symbolize the entire spectrum of networks, systems, and devices that exemplify cybernetic or "automated but intelligent" behavior.

This article traverses a field of inquiry that Walter Benjamin has crossed before, most notably in his 1936 essay, "The Work of Art in the Age of Mechanical Reproduction." My intention, in fact, is to carry Benjamin's inquiry forward and to ask how cybernetic systems, symbolized by the computer, represent a set of transformations in our conception of and relation to self and reality of a magnitude commensurate with the transformations in the conception of and relation to self and reality wrought by mechanical reproduction and symbolized by the camera. This intention necessarily encounters the dilemma of a profound ambivalence directed toward that which constitutes our imaginary Other, in this case not a mothering parent but those systems of artificial intelligence I have set out to examine here. Such ambivalence certainly permeates Benjamin's essay and is at best dialectical, and at worst, simply contradictory. Put more positively, those systems against which we test and measure the boundaries of our own identity require subjection to a double hermeneutic of suspicion and revelation in which we must

acknowledge the negative, currently dominant, tendency toward control, and the positive, more latent potential toward collectivity.[1] It will be in terms of law that the dominance of control over collectivity can be most vividly analyzed.

In summary, what I want to do is recall a few of the salient points in Benjamin's original essay, contrast characteristics of cybernetic systems with those of mechanical reproduction, establish a central metaphor with which to understand these cybernetic systems, and then ask how this metaphor acquires the force of the real—how different institutions legitimate their practices, recalibrate their rationale, and modulate their image in light of this metaphor. In particular, I want to ask how the preoccupations of a cybernetic imagination have gained institutional legitimacy in areas such as the law. In this case, like others, a tension can be seen to exist between the liberating potential of the cybernetic imagination and the ideological tendency to preserve the existing form of social relations. I will focus on the *work* of culture — its processes, operations, and procedures — and I will assume that culture is of the essence: I include within it text and practices, art and actions that give concrete embodiment to the relation we have to existing conditions to a dominant mode of production, and the various relations of production it sustains. Language, discourse, and messages are central. Their style and rhetoric are basic. Around each "fact" and every "datum," all realities and evidence, everything "out there," a persuasive, affective tissue of discourse accrues. It is in and through this signifying tissue, arranged in discursive formations and institutional arenas, that struggle takes place and semiosis occurs.

MECHANICAL REPRODUCTION AND FILM CULTURE

Benjamin argues for correspondences among three types of changes: in the economic mode of production, in the nature of art, and in categories of perception. At the base of industrial society lies the assembly line and mass production. Technological innovation allows these processes to extend into the domain of art, separating off from its traditional ritual (or "cult") value a new and distinct market (or "exhibition") value. The transformation also strips art of its 'aura' by which Benjamin means its authenticity, its attachment to the domain of tradition:

> The authenticity of a thing is the essence of all that is transmissible from its beginning, ranging from its substantive duration to its testimony to the history which it has experienced.[2]

The aura of an object compels attention. Whether a work of art or natural landscape, we confront it in one place and only one place. We discover its use value in the exercise of ritual, in that place, with that object, or in the contemplation of the object for its uniqueness. The object in possession of aura, natural or historical,

inanimate or human, engages us as if it had "the power to look back in return."[3]

One thing mechanical reproduction cannot, by definition, reproduce is authenticity. This is at the heart of the change it effects in the work of art. "Mechanical reproduction emancipates the work of art from its parasitical dependence on ritual" (p. 224). The former basis in ritual yields to a new basis for art in politics, particularly, for Benjamin, the politics of the masses and mass movements, where fascism represents an ever-present danger. The possibilities for thoroughgoing emancipation are held in check by the economic system surrounding the means of mechanical reproduction, especially in film where "illusion-promoting spectacles and dubious speculations" (p. 232) deflect us from the camera's ability to introduce us to "unconscious optics" that reveal those forms of interaction our eyes neglect:

> The act of reaching for a lighter or a spoon is familiar routine, yet we hardly know what goes on between hand and metal, not to mention how this fluctuates with our moods. Here the camera intervenes with the resources of its lowerings and liftings, its interpretations and isolations, its extensions and accelerations, its enlargements and reductions. (p. 237)

Objects without aura substitute mystique. In a remarkable, prescient passage, relegated to a footnote, Benjamin elaborates how political practice opens the way for a strange transformation of the actor when democracies encounter the crisis of fascism. Mechanical reproduction allows the actor an unlimited public rather than the delimited one of the stage or, for the politician, parliament. "Though their tasks may be different, the change affects equally the actor and the ruler. . . . This results in a new selection, a selection before the equipment (of mechanical reproduction) from which the star and the dictator emerge victoriously" (p. 247).

Alterations like the replacement of aura with mystique coincide with the third major change posited by Benjamin, change in categories of perception. The question of whether film or photography is an art is here secondary to the question of whether art itself has not been radically transformed in form and function. A radical change in the nature of art implies that our very ways of seeing the world have also changed: "During long periods of history, the mode of human sense perception changes with humanity's entire mode of existence" (p. 222).

Mechanical reproduction makes *copies* of visible objects, like paintings, mountain ranges, even human beings, which until then had been thought of as unique and irreplaceable. It brings the upheavals of the industrial revolution to a culmination. The ubiquitous copy also serves as an externalized manifestation of the work of industrial capitalism itself. It paves the way for seeing, and recognizing, the nature and extent of the very changes mechanical reproduction itself produces.

What element of film most strongly testifies to this new form of machine-age perception? For Benjamin it is that element which best achieves what Dadaism has aspired to: "changes of place and focus which periodically assail the spectator." Film

achieves these changes through montage, or editing. Montage rips things from their original place in an assigned sequence and reassembles them in everchanging combinations that make the contemplation invited by a painting impossible. Montage multiplies the potential of collage to couple two realities on a single plane that apparently does not suit them into the juxtaposition of an infinite series of realities. As George Bataille proclaimed, "Transgression does not negate an interdiction, it transcends and completes it." In this spirit, montage transcends and completes the project of the Dadaists in their conscious determination to strip aura from the work of art and of the early French ethnographers who delighted in the strange juxtapositions of artifacts from different cultures.

Montage has a liberating potential, prying art away from ritual and toward the arena of political engagement. Montage gives back to the worker a view of the world as malleable. Benjamin writes:

> Man's need to expose himself to shock effects is his adjustment to the changes threatening him. The film corresponds to profound changes in the apperceptive apparatus — changes that are experienced on an individual scale by the man in the street in big-city traffic, on a historical scale by every present-day citizen. (p. 250)
>
> By close-ups of the things around us, by focusing on hidden details of familiar objects, by exploring commonplace milieus under the ingenious guidance of the camera, the film, on the one hand, extends our comprehension of the necessities which rule our lives; on the other hand, it manages to assure us of an immense and unexpected field of action. Our taverns and our metropolitan streets, our offices and furnished rooms, our railroad stations and our factories appeared to have us locked up hopelessly. Then came the film and burst this prison-world asunder by the dynamite of the tenth of a second, so that now, in the midst of its far-flung ruins and debris, we calmly and adventurously go traveling (p. 236).

Mechanical reproduction involves the appropriation of an original, although with film even the notion of an original fades: that which is filmed has been organized in order to be filmed. This process of appropriation engenders a vocabulary: the "take" or "camera shot" used to "shoot" a scene where both stopping a take and editing are called a "cut." The violent reordering of the physical world and its meanings provides the shock effects Benjamin finds necessary if we are to come to terms with the age of mechanical reproduction. The explosive, violent potential described by Benjamin and celebrated by Brecht is what the dominant cinema must muffle, defuse, and contain. And what explosive potential can be located in the computer and its cybernetic systems for the elimination of drudgery and toil, for the promotion of collectivity and affinity, for interconnectedness, systemic networking and shared decision-making, this, too, must be defused and contained by the industries of information which localize, condense, and consolidate this potential democratization of power into hierarchies of control.

"Montage—the connecting of dissimilars to shock an audience into insight—becomes for Benjamin a major principle to artistic production in a technological age."[4]

Developing new ways of seeing to the point where they become habitual is not ideological for Benjamin but transformative. They are not the habits of old ways but new; they are skills which are difficult to acquire precisely because they are in opposition to ideology. The tasks before us "at the turning points of history" cannot be met by contemplation. "They are mastered gradually by habit, under the guidance of tactile appropriation" (p. 240). The shocks needed in order to adjust to threatening changes may be coopted by the spectacles a culture industry provides. For Benjamin the only recourse is to use those skills he himself adopted: the new habits of a sensibility trained to disassemble and reconstruct reality, of a writing style intended to relieve idlers of their convictions, of a working class trained not only to produce and reproduce the existing relations of production but to reproduce those very relations in a new, liberating form. "To see culture and its norms—beauty, truth, reality—as artificial arrangements, susceptible to detached analysis and comparison with other possible dispositions" becomes the vantage point not only of the surrealist but the revolutionary. [5]

The process of adopting new ways of seeing that consequently propose new forms of social organization becomes a paradoxical, or dialectical, process when the transformations that spawn new habits, new vision, are themselves endangered and substantially recuperated by the existing form of social organization which they contain the potential to overcome. But the process goes forward all the same. It does so less in terms of a culture of mechanical reproduction, which has reached a point similar to that of a tradition rooted in Benjamin's time, than in terms of a culture of electronic dissemination and computation.

We might then ask in what ways is our "sense of reality" being adjusted by new means of electronic computation and digital communication? Do these technological changes introduce new forms of culture into the relations of production at the same time as the "shock of the new" helps emancipate us from the acceptance of social relations and cultural forms as natural, obvious, or timeless? The distinction between an industrial capitalism, even in its "late" phase of monopoly concentration, and an information society that does not "produce" so much as "process" its basic forms of economic resource has become an increasingly familiar distinction for us. Have cybernetic systems brought about changes in our perception of the world that hold liberating potential? Is it conceivable, for example, that contemporary transformations in the economic structure of capitalism, attended by technological change, institute a less individuated, more communal form of perception similar to that which was attendant upon face-to-face ritual and aura but which is now mediated by anonymous circuitry and the simulation of direct encounter? Does montage now have its equivalent in interactive simulations and simulated interactions experienced according to predefined constraints? Does the work of art in the age of

postmodernism lead, at least potentially, to apperceptions of the 'deep structure' of postindustrial society comparable to the apperceptive discoveries occasioned by mechanical reproduction in the age of industrial capitalism?

CYBERNETIC SYSTEMS AND ELECTRONIC CULTURE

We can put Benjamin's arguments, summarized cursorily here, in another perspective by highlighting some of the characteristics associated with early, entrepreneurial capitalism, monopoly capitalism, and multinational or postindustrial capitalism:

ENTREPRENEURIAL capitalism	MONOPOLY capitalism	MULTINATIONAL capitalism
steam and locomotive power	electricity and petro-chemical power	microelectronics and nuclear energy
property rights	corporate rights	copyright and patents
nature as Other/conquest of nature	aliens as Other/conquest of Third World	knowledge as Other/conquest of intelligence
nationalism	imperialism	multinationalism
working-class vanguard	consumer-group vanguard	affinity-group vanguard
Tuberculosis contamination by nature	Cancer contamination by an aberrant self	AIDS deficiency of self (collapse of system that distinguishes self from environment)
isolation of self from threatening environment	isolation of aberrant tissue from self	isolation of self by artificial life support
vulnerability to invasive agents	vulnerability to self-consumption	vulnerability to systemic collapse
heightened individuation	heightened schizophrenia	heightened sense of paranoia
realism	modernism	postmodernism
film	television	computer
mechanical reproduction	instantaneous broadcast	logico-iconic simulations
reproducible instances	ubiquitous occurrences	processes of absorption and feedback
the copy	the event	the chip (and VDT display)
subtext of possession	subtext of mediation	subtext of control
image and representation	collage and juxtaposition	simulacra

Simulacra introduce the key question of how the control of information moves towards control of sensory experience, interpretation, intelligence, and knowledge. The power of the simulation moves to the heart of the cybernetic matter. It posits

the simulation as an imaginary Other which serves as the measure of our own identity and, in doing so, prompts the same form of intense ambivalence that the mothering parent once did: a guarantee of identity based on what can never be made part of oneself. In early capitalism, the human was defined in relation to an animal world that evoked fascination and attraction, repulsion and resentment. The human animal was similar to but different from all other animals. In monopoly capitalism, the human was defined in relation to a machine world that evoked its own distinctive blend of ambivalence. The human machine was similar to but different from all other machines. In postindustrial capitalism, the human is defined in relation to cybernetic systems — computers, biogenetically engineered organisms, ecosystems, expert systems, robots, androids, and cyborgs — all of which evoke those forms of ambivalence reserved for the Other that is the measure of ourselves. The human cyborg is similar but different from all other cyborgs. Through these transformations questions of difference persist. Human identity remains at stake, subject to change, vulnerable to challenge and modification as the very metaphors prompted by the imaginary Others that give it form themselves change. The metaphor that's meant (that's taken as real) becomes the simulation. The simulation displaces any antecedent reality, any aura, any referent to history. Frames collapse. What had been fixed comes unhinged. New identities, ambivalently adopted, prevail.

The very concept of a text, whether unique or one of myriad copies, for example, underpins almost all discussion of cultural forms including film, photography, and their analogue in an age of electronic communication, television (where the idea of "flow" becomes an important amendment). But in cybernetic systems, the concept of "text" itself undergoes substantial slippage. Although a textual element can still be isolated, computer-based systems are primarily interactive rather than one-way, open-ended rather than fixed. Dialogue, regulated and disseminated by digital computation, de-emphasizes authorship in favor of "messages-in-circuit"[6] that take fixed but effervescent, continually variable form. The link between message and substrate is loosened: words on a printed page are irradicable; text on a video display terminal (VDT) is readily altered. The text conveys the sense of being addressed to us. The message-in-circuit is both addressed to and addressable by us; the mode is fundamentally interactive, or dialogic. That which is most textual in nature — the fixed, read-only-memory (ROM), and software programs — no longer addresses us. Such texts are machine addressable. They direct those operational procedures that ultimately give the impression that the computer responds personally to us, simulating the processes of conversation or of interaction with another intelligence to effect a desired outcome. Like face-to-face encounter, cybernetic systems offer (and demand) almost immediate response. This is a major part of their hazard in the workplace and their fascination outside it. The temporal flow and once-only quality of face-to-face encounter becomes embedded within a system ready to restore, alter, modify or transform any given moment to us at any time. Cybernetic interactions can become intensely demand-

ing, more so than we might imagine from our experience with texts, even powerfully engaging ones. Reactions must be almost instantaneous, grooved into eye and finger reflexes until they are automatic. This is the bane of the "automated workplace" and the joy of the video game. Experienced video-game players describe their play as an interactive ritual that becomes totally self-absorbing. As David, a lawyer in his mid thirties interviewed by Sherry Turkle, puts it,

> At the risk of sounding, uh, ridiculous, if you will, it's almost a Zen type of thing. . . .
> When I can direct myself totally but not feel directed at all. You're totally absorbed and
> it's all happening there. . . . You either get through this little maze so that the creature
> doesn't swallow you up or you don't. And if you can focus your attention on that, and
> if you can really learn what you're supposed to do, then you really are in relationship
> with the game.[7]

The enhanced ability to test the environment, which Benjamin celebrated in film ("The camera director in the studio occupies a place identical with that of the examiner during aptitude tests," p. 246) certainly continues with cybernetic communication.[8] The computer's dialogic mode carries the art of the "what if" even further than the camera eye has done, extending beyond the "what if I could see more than the human eye can see" to "what if I can render palpable those possible transformations of existing states that the individual mind can scarcely contemplate?"

If mechanical reproduction centers on the question of reproducibility and renders authenticity and the original problematic, cybernetic simulation renders experience, and the real itself, problematic. Instead of reproducing, and altering, our relation to an original work, cybernetic communication simulates, and alters, our relation to our environment and mind. As Jean Baudrillard argues, "Instead of facilitating communication, it (information, the message-in-circuit) exhausts itself in the *staging* of communication . . . this is the gigantic simulation process with which we are familiar."[9]

Instead of a representation of social practices recoded into the conventions and signs of another language or sign-system, like the cinema, we encounter simulacra that represent a new form of social practice in their own right and represent nothing. The photographic image, as Roland Barthes proposed, suggests "having been there" of what it represents, of what is present-in-absentia. The computer simulation suggests only a "being here" and "having come from nowhere" of what it presents, drawing on those genetic-like algorithms that allow it to bring its simulation into existence, *sui generis*. Among other things, computer systems simulate the dialogical and other qualities of life itself. The individual becomes nothing but an ahistorical position within a chain of discourse marked exhaustively by those shifters that place him or her within speech acts ("I," "here," "now," "you," "there," "then"). In face-to-face encounter this "I" all speakers share can be inflected to represent some part of the self not caught by words. To respond to the query,

"How are you?" by saying "Not *too* bad," rather than "Fine," suggests something about a particular state of mind or style of expression and opens onto the domains of feeling and empathy. What cannot be represented in language directly (the bodily, living "me" that writes or utters words) can significantly inflect speech, and dialogue, despite its enforced exclusion from any literal representation.

In cybernetic systems, though, "I" and "you" are strictly relational propositions attached to no substantive body, no living individuality. In place of human inter-subjectivity we discover a systems interface, a boundary between cyborgs that selectively passes information but without introducing questions of consciousness or the unconscious, desire or will, empathy or conscience, saved in simulated forms.

Even exceptions like ELIZA, a program designed to simulate a therapeutic encounter, prove the rule. "I" and "you" function as partners in therapy only as long as the predefined boundaries are observed. As Sherry Turkle notes, if you introduce the word "mother" into your exchange, and then say, "Let's discuss paths toward nuclear disarmament," ELIZA might well offer the nonsense reply, "Why are you telling me that your mother makes paths toward nuclear disarmament?"[10] Simulations like these may bring with them the shock of recognizing the reification of a fundamental social process, but they also position us squarely within the realm of communication and exchange cleanly evacuated of the intersubjective complexities of direct encounter. Cybernetic systems give form, external expression, to processes of the mind (through messages-in-circuit) such that the very ground of social cohesion and consciousness becomes mediated through a computational apparatus. Cybernetic interaction achieves with an other (an intelligent apparatus) the simulation of social process itself.

Cybernetic dialogue may offer freedom from many of the apparent risks inherent in direct encounter; it offers the illusion of control. This use of intelligence provides a lure that seems to be much more attractive to men than women. At first there may seem to be a gain, particularly regarding the question of the look or gaze. Looking is an intensely charged act, one significantly neglected by Benjamin, but stressed in recent feminist critiques of dominant Hollywood cinema. There looking is posed as a primarily masculine act and "to-be-looked-at-ness" a feminine state, reinforced, in the cinema, by the camera's own voyeuristic gaze, editing patterns that prompt identification with masculine activism and feminine passivity, and a star system that institutionalizes these uses of the look through an iconography of the physical body. [11] This entire issue becomes circumvented in cybernetic systems that simulate dialogic interaction, or face-to-face encounter, but exclude not only the physical self or its visual representation but also the cinematic apparatus that may place the representation of sexual difference within a male-dominant hierarchy.

Correct in so far as it goes, the case for the circumvention of the sexist coding of the gaze overlooks another form of hierarchical sexual coding that revolves around the question of whether a fascination with cybernetic systems is not itself a gender-

related (i.e., a primarily masculine) phenomenon (excluding from consideration an even more obvious gender coding that gives almost all video games, for example a strong aura of aggressive militaristic activity). The questions that we pose about the sexist nature of the gaze within the cinematic text and the implications this has for the position we occupy in relation to such texts, may not be wholly excluded so much as displaced. A (predominantly masculine) fascination with the *control* of simulated interactions replaces a (predominantly masculine) fascination with the to-be-looked-at-ness of a projected image. Simulated intersubjectivity as a product of automated but intelligent systems invokes its own peculiar psycho-dynamic. Mechanical reproduction issues an invitation to the fetishist—a special relationship to the images of actors or politicians in place of any more direct association. The fetish *object* — the image of the other that takes the place of the other — becomes the center of attention while fetishistic viewers look on from their anonymous and voyeuristic, seeing-but-unseen sanctuary in the audience. But the output of computational systems stresses simulation, interaction, and process itself. Engagement with this *process* becomes the object of fetishization rather than representations whose own status as produced objects has been masked. Cybernetic interaction emphasizes the fetishist rather than the fetish object: instead of a taxonomy of stars we find a galaxy of computer freaks. The consequence of systems without aura, systems that replace direct encounter and realize otherwise inconceivable projections and possibilities, is a fetishism of such systems and processes of control themselves. Fascination resides in the subordination of human volition to the operating constraints of the larger system. We can talk to a system whose responsiveness grants us an awesome feeling of power. But as Paul Edwards observes, "Though individuals . . . certainly make decisions and set goals, as links in the chain of command they are allowed no choices regarding the ultimate purposes and values of the system. Their 'choices' are . . . always the permutations and combinations of a predefined set."[12]

The desire to exercise a sense of control over a complex but predefined logical universe replaces the desire to view the image of another over which the viewer can imagine himself to have a measure of control. The explosive power of the dynamite of the tenth of a second extolled by Benjamin is contained within the channels of a psychopathology that leaves exempt from apperception, or control, the mechanisms that place ultimate control on the side of the cinematic apparatus or cybernetic system. These mechanisms — the relay of gazes between the camera, characters and viewer, the absorption into a simulacrum with complex problems and eloquent solutions — are the ground upon which engagement occurs and are not addressable within the constraints of the system itself. It is here, at this point, that dynamite must be applied.

This is even more difficult with computers and cybernetics than with cameras and the cinema. Benjamin himself noted how strenuous a task it is in film to mask the means of production, to keep the camera and its supporting paraphernalia and crew from intruding upon the fiction. Exposure of this other scene, the one behind

the camera, is a constant hazard and carries the risk of shattering the suspension of disbelief. Only those alignments between camera and spectator that preserve the illusion of a fictional world without camera, lights, directors, studio sets, and so on are acceptable. Benjamin comments, perhaps with more of a surrealist's delight in strange juxtapositions than a Marxist's, "The equipment-free aspect of reality here (in films) has become the height of artifice; the sight of immediate reality has become an orchid in the land of technology" (p. 233).

With the contemporary prison-house of language, in Frederic Jameson's apt phrase, the orchid of immediate reality, like the mechanical bird seen at the end of *Blue Velvet*, appears to have been placed permanently under glass; but for Benjamin, neither the process by which an illusionistic world is produced nor the narrative strategies associated with it receive extended consideration. For him, the reminders of the productive process were readily apparent, not least through the strenuous efforts needed to mask them. The "other scene" where fantasies and fictions actually become conceptually and mechanically produced may be repressed but is not obliterated. If not immediately visible, it lurks just out of sight in the offscreen space where the extension of a fictional world somewhere collides with the world of the camera apparatus in one dimension and the world of the viewer in another. It retains the potential to intrude at every cut or edit; it threatens to reveal itself in every lurch of implausibility or sleight of hand with which a narrative attempts to achieve the sense of an ending.

With cybernetic systems, this other scene from which complex rule-governed universes actually get produced recedes further from sight. The governing procedures no longer address us in order to elicit a suspension of belief; they address the cybernetic system, the microprocessor of the computer, in order to absorb us into their operation. The other scene has vanished into logic circuits and memory chips, into "machine language" and interface cards. The chip replaces the copy. Just as the mechanical reproduction of copies revealed the power of industrial capitalism to reorganize and reassemble the world around us, rendering it as commodity art, the automated intelligence of chips reveals the power of postindustrial capitalism to simulate and replace the world around us, rendering not only its exterior realm but also its interior ones of consciousness, intelligence, thought and intersubjectivity as commodity experience.

The chip is pure surface, pure simulation of thought. Its material surface is its meaning without history, without depth, without aura, affect, or feeling. The copy reproduces the world, the chip simulates it. It is the difference between being able to remake the world and being able to efface it. The micro-electronic chip draws us into a realm, a design for living, that fosters a fetishized relationship with the simulation as a new reality all its own based on the capacity to control, within the domain of the simulation, what had once eluded control beyond it. The orchids of immediate reality that Benjamin was wont to admire have become the paper flowers of the cybernetic simulation.

Electronic simulation instead of mechanical reproduction. Fetishistic addiction to a process of logical simulation rather than a fascination with a fetishized object of desire. Desire for the dialogic or interactive and the illusion of control versus desire for the fixed but unattainable and the illusion of possession. Narrative and realism draw us into relations of identification with the actions and qualities of characters. Emulation is possible, as well as self-enhancement. Aesthetic pleasure allows for a revision of the world from which a work of art arises. Reinforcing what is or proposing what might be, the work of art remains susceptible to a double hermeneutic of suspicion and revelation. Mechanical reproduction changes the terms decidedly, but the metonymic or indexical relationship between representational art and the social world to which it refers remains a fundamental consideration.

By contrast, cybernetic simulations offer the possibility of completely replacing any direct connection with the experiential realm beyond their bounds. Like the cinema, this project, too, has its origins in the expansion of nineteenth-century industrialism. The emblematic precursors of the cyborg — the machine as self-regulating system — were those animate, self-regulating systems that offered a source of enchantment even museums could not equal: the zoo and the botanical garden.

At the opening of the first large-scale fair or exhibition, the Great Exhibition of 1851, Queen Victoria spoke of "the greatest day in our history [when] the whole world of nature and art was collected at the call of the queen of cities." Those permanent exhibitions — the zoo and botanical garden — introduced a new form of vicarious experience quite distinct from the aesthetic experience of original art or mechanically reproduced copies. The zoo brings back alive evidence of a world we could not otherwise know, now under apparent control. It offers experience at a remove that is fundamentally different as a result of having been uprooted from its original context. The indifferent, unthreatened, and unthreatening gaze of captive animals provides eloquent testimony to the difference between the zoo and the natural habitat to which it refers. The difference in the significance of what appears to be the same thing, the gaze, indicates that the change in context has introduced a new system of meanings, a new discourse or language.

Instead of the shocks of montage that offer a "true means of exercise" appropriate to the "profound changes in the apperceptive apparatus" under industrial capitalism, the zoo and botanical garden exhibit a predefined, self-regulating world with no reality outside of its own boundaries. These worlds may then become the limit of our understanding of those worlds to which they refer but of which we seldom have direct knowledge. "Wildlife" or "the African savannah" is its simulation inside the zoo or garden or diorama. Absorption with these simulacra and the sense of control they afford may be an alternative means of exercise appropriate to the apperceptive changes required by a service and information economy.

Computer-based systems extend the possibilities inherent in the zoo and garden much further. The ideal simulation would be a perfect replica, now

controlled by whomever controls the algorithms of simulation — a state imagina-
tively rendered in films like *The Stepford Wives* or *Blade Runner* and apparently
already achieved in relation to certain biogenetically engineered micro-organisms.
Who designs and controls these greater systems and for what purpose becomes a
question of central importance.

THE CYBERNETIC METAPHOR: TRANSFORMATIONS OF SELF AND REALITY

The problems of tracking antiaircraft weapons against extremely fast targets
prompted the research and development of intelligent mechanisms capable of
predicting future states or positions far faster than the human brain could do. The
main priorities were speed, efficiency and reliability; i.e., fast-acting, error-free
systems. ENIAC (Electronic Numerical Integrator and Computer), the first high-
powered digital computer, was designed to address precisely this problem by
performing ballistic computations at enormous speed and allowing the outcome
to be translated into adjustments in the firing trajectory of antiaircraft guns.

"The men [*sic*] who assembled to solve problems of this order and who
formalized their approach into the research paradigms of information theory and
cognitive psychology through the Macy Foundation Conferences, represent a
who's who of cybernetics: John von Neuman, Oswald Weblen, Vannevar Bush,
Norbert Wiener, Warren McCulloch, Gregory Bateson and Claude Shannon,
among others." Such research ushers in the central metaphors of the cybernetic
imagination: not only the human as an automated but intelligent system, but also
automated, intelligent systems as human, not only the simulation of reality but the
reality of the simulation. These metaphors take form around the question, the still
unanswered question, put by John Stroud at the Sixth Macy Conference:

> We know as much as possible about how the associated gear bringing the information
> to the tracker [of an anti-aircraft gun] operates and how all the gear from the tracker
> to the gun operates. So we have the human operator surrounded on both sides by
> very precisely known mechanisms and the question comes up, "What kind of machine
> have we placed in the middle?"[14]

This question of "the machine in the middle" and the simulation as reality
dovetails with Jean Baudrillard's recent suggestion that the staging powers of
simulation establish a hyperreality we only half accept but seldom refute:
"Hyperreality of communication of meaning: by dint of being more real than the
real itself, reality is destroyed."[15]

Such metaphors, then, become more than a discovery of similarity, they
ultimately propose an identity. Norbert Wiener's term "cyborg" (cybernetic

organism) encapsulates the new identity which, instead of seeing humans reduced to automata, sees simulacra which encompass the human elevated to the organic. Consequently, the human cognitive apparatus (itself a hypothetical construct patterned after the cybernetic model of automated intelligence) is expected to negotiate the world by means of simulation.

Our cognitive apparatus treats the real as though it consisted of those properties exhibited by simulacra. The real becomes simulation. Simulacra, in turn, serve as the mythopoeic impetus for that sense of the real we posit beyond the simulation. A sobering example of what is at stake follows from the Reagonomic conceptualization of war. The Strategic Defense Initiative (SDI) represents a vast Battle of the Cyborgs video game where players compete to save the world from nuclear holocaust. Reagan's simulated warfare would turn the electromagnetic force fields of fifties science-fiction films that shielded monsters and creatures from the arsenal of human destructive power into ploughshares beyond the ozone. Star Wars would be the safe-sex version of international conflict: not one drop of our enemy's perilous bodily fluids, none of their nuclear ejaculations, will come into contact with the free world.

Reagan's simulation of war as a replacement for the reality of war does not depend entirely on SDI. We have already seen it at work in the invasion of Grenada and the raid on Libya. Each time, we have had the evocation of the reality of war: the iconography of heroic fighters, embattled leaders, brave decisions, powerful technology, and concerted effort rolled into the image of military victory, an image of quick, decisive action that defines the "American will."

These simulacra of war, though, are fought with an imaginary enemy, in the Lacanian sense, and in the commonsense meaning of an enemy posited within those permutations allowed by a predefined set of assumptions and foreign-policy options: a Grenadian or Libyan "threat" appears on the video screens of America's political leadership. Long experience with the Communist menace leads to prompt and sure recognition. Ronny pulls the trigger. These simulations lack the full-blown, catastrophic consequences of real war, but this does not diminish the reality of this particular simulation nor the force with which it is mapped onto a historical "reality" it simultaneously effaces. Individuals find their lives irreversibly altered, people are wounded, many die. These indelible punctuation marks across the face of the real, however, fall into place according to a discourse empowered to make the metaphoric reality of the simulation a basic fact of existence.

A more complex example of what it means to live not only in the society of the spectacle but also in the society of the simulacrum involves the preservation/simulation of life via artificial life-support systems. In such an environment, the presence of life hinges on the presence of "vital signs." Their manifestation serves as testimony to the otherwise inaccessible presence of life itself, even though life in this state stands in relation to the "immediate reality" of life as the zoo stands in relation to nature. The important issue here is that the

power of cybernetic simulations prompts a redefinition of such fundamental terms as life and reality, just as, for Benjamin, mechanical reproduction alters the very conception of art and the standards by which we know it. Casting the issue in terms of whether existence within the limits of an artificial life-support system should be considered "life" obscures the issue in the same way that asking whether film and photography are "art" does. In each case a presumption is made about a fixed, or ontologically given, nature of life or art, rather than recognizing how that very presumption has been radically overturned.

And from preserving life artificially, it is a small step to creating life by the same means. There is, for example, the case of Baby M. Surrogate mothering, as a term, already demonstrates the reality of the simulation: the actual mothering agent — the woman who bears the child — becomes a *surrogate,* thought of, not as a mother, but as an incubator or "rented uterus," as one of the trial's medical "experts" called Mary Beth Whitehead. The *real* surrogate mother, the woman who will assume the role of mother for a child not borne of her own flesh, becomes the real mother, legally and familiarly. The law upholds the priority of the simulation and the power of those who can control this system of surrogacy — measured by class and gender, for it is clearly upper-class males (Judge Harvey Sorkow and the father, William Stem) who mobilized and sanctioned this particular piece of simulation, largely, it would seem, given the alternative of adoption, to preserve a very real, albeit fantastic preoccupation with a patriarchal blood line.

Here we have the simulation of a nuclear family — a denucleated, artificial simulation made and sanctioned as real, *bona fide.* The trial evoked the reality of the prototypical bourgeois family: well-educated, socially responsible, emotionally stable, and economically solvent, in contrast to the lower middle-class Whitehead household. The trial judgment renders as legal verdict the same moral lesson that Cecil Hepworth's 1905 film, *Rescued by Rover,* presents as artistic theme: the propriety of the dominant class, the menace of an unprincipled, jealous and possessive lower class, the crucial importance of narrative donors like the faithful Rover and of social agents like the patronizing Sorkow, and the central role of the husband as the patriarch able to preside over the constitution and re-constitution of his family. Now replayed as simulation, the morality play takes on a reality of its own. People suffer, wounds are inflicted. Lives are irreversibly altered, or even created. Baby M is a child conceived as a product to be sold to fill a position within the signifying discourse of patriarchy.

The role of the judge in this case was, of course, crucial to its outcome. His centrality signals the importance of the material, discursive struggles being waged within the realm of the law. Nicos Poulantzas argues that the juridical-political is the dominant or articulating region in ideological struggle today. Law establishes and upholds the conceptual frame in which subjects, "free and equal" with "rights" and "duties," engage on a playing field made level by legal recourse and due process. These fundamental concepts of *individuals* with the right to enter into

and withdraw from relations and obligations to others underpin, he argues, the work of other ideologically important regions in civil society.[16]

Whether the juridical-political is truly the fulcrum of ideological contestation or not, it is clearly a central area of conflict and one in which some of the basic changes in our conception of the human/computer, reality/simulation metaphors get fought out. Reconceptualizations of copyright and patent law, brought on by computer chip design, computer software, and biogenetic engineering, give evidence of the process by which a dominant ideology seeks to preserve itself in the face of historical change.

Conceptual metaphors take on tangible embodiment through discursive practices and institutional apparatuses. Such practices give a metaphor historical weight and ideological power. Tangible embodiment has always been a conscious goal of the cybernetic imagination where abstract concepts become embedded in the logic and circuitry of a material substrate deployed to achieve specific forms of result such as a computer, an antiaircraft tracking system or an assembly-line robot. These material objects, endowed with automated but intelligent capacities, enter our culture as, among other things, commodities. As a peculiar category of object these cyborgs require clarification of their legal status. What proprietary rights pertain to them? Can they be copyrighted, patented, protected by trade secrets acts; can they themselves as automated but intelligent entities, claim legal rights that had previously been reserved for humans or other living things on a model akin to that which has been applied to animal research?

The answers to such questions do not fall from the sky. They are the result of struggle, of a clash of forces, and of the efforts, faltering or eloquent, of those whose task it is to make and adjudicate the law. New categories of objects do not necessarily gain the protection of patent or copyright law. One reason for this is that federal law in the United States (where most of my research on this question took place) and the Constitution both enshrine the right of individuals to private ownership of the means of production while also enjoining against undue forms of monopoly control. The Constitution states, "The Congress shall have power. . . to promote the progress of science and useful arts, by securing for limited times to authors and inventors the exclusive right to their respective writings and discoveries." Hence the protection of intellectual property (copyright and trademark registration) or industrial and technological property (patents) carves out a proprietary niche within the broader principle of a "free flow" of ideas and open access to "natural" sources of wealth.

The cybernetic organism, of course, confounds the distinction between intellectual and technological property. Both a computer and a biogenetically designed cell "may be temporarily or permanently programmed to perform many different unrelated tasks."[17] The cybernetic metaphor, of course, allows us to treat the cell and the computer as sources of the same problem. As the author of one legal article observed, "A ribosome, like a computer, can carry out any sequence of

assembly instructions and can assemble virtually unlimited numbers of different organic compounds, including those essential to life, as well as materials that have not yet been invented."[18] What legal debates have characterized the struggle for proprietary control of these cyborgs?

Regarding patents, only clearly original, unobvious, practical applications of the "laws of nature" are eligible for protection, a principle firmly established in the Telephone Cases of 1888 where the Supreme Court drew a sharp distinction between electricity itself as nonpatentable since it was a "force of nature" and the telephone where electricity was found, "A new, specific condition not found in nature and suited to the transmission of vocal or other sounds."

Recent cases have carried the issue further, asking whether "intelligent systems" can be protected by patent and, if so, what specific elements of such a system are eligible for protection. Generally, and perhaps ironically, the United States Supreme Court has been more prone to grant protection for the fabrication of new life forms, via recombinant DNA experiments, than for the development of computer software. In *Diamond v. Chakrabatry* (1980), the Supreme Court ruled in favor of patent protection for Chakrabatry who had developed a new bacterial form capable of degrading petroleum compounds for projected use in oil-spill clean-ups. In other, earlier cases, the Supreme Court withheld patent protection for computer software. In *Gottschalk v. Benson* (1972) and in *Parker v. Flook* (1979), the Court held that computer programs were merely algorithms, i.e., simple, step-by-step mathematical procedures, and as such were closer to basic principles or concepts than to original and unobvious applications. These decisions helped prompt recourse to a legislative remedy for an untenable situation (for those with a vested interest in the marketability of computer programs); in 1980 Congress passed the Software Act, granting some of the protection the judicial branch had been reluctant to offer but still leaving many issues unsettled. A Semiconductor Chip Protection Act followed in 1984 with a new *sui generis* form of protection for chip masks (the templates from which chips are made). Neither copyright nor patent, this protection applies for ten years (less than copyright) and demands less originality of design than does patent law. In this case, the law itself replicates the "having come from nowhere" quality of the simulation. The *Minnesota Law Review* 70 (December 1985) is devoted to a symposium on this new form of legal protection for intellectual but also industrial property.

The Software Act began the erosion of a basic distinction between copyright and patent by suggesting that useful objects were eligible for copyright. In judicial cases such as *Diamond v. Diehr* (1981), the court held that "when a claim containing a mathematical formula implements or applies that formula in a structure or process which, when considered as a whole, is performing a function which the patent laws were designed to protect (for example, transforming or reducing an article to a different state of things), then the claim satisfies the requirements of [the copyright law]."

This finding ran against the grain of the long-standing *White-Smith Music Publishing Co v. Apollo Co* decision of 1908 where the Supreme Court ruled that a player-piano roll was ineligible for the copyright protection accorded to the sheet music it duplicated. The roll was considered part of a machine rather than the expression of an idea. The distinction was formulated according to the code of the visible: a copyrightable text must be visually perceptible to the human eye and must "give to every person *seeing* it the idea created by the original."[19]

Copyright had the purpose of providing economic incentive to bring new ideas to the marketplace. Copyright does not protect ideas, processes, procedures, systems or methods, only a specific embodiment of such things. (A book on embroidery could receive copyright but the process of embroidery itself could not.) Similarly, copyright cannot protect useful objects or inventions. If an object has an intrinsically utilitarian function, it cannot receive copyright. Useful objects can be patented, if they are original enough, or protected by trade secrets acts. For example, a fabric design could receive copyright as a specific, concrete rendition of form. It would be an "original work of authorship" fixed in the tangible medium of cloth and the "author" would have the right to display it as an ornamental or artistic object without fear of imitation. But the same fabric design, once embodied in a dress, can no longer be copyrighted since it is now primarily a utilitarian object. Neither the dress, nor any part of it, can receive copyright. Others would be free to imitate its appearance since the basic goal (according to a somewhat non-fashion-conscious law) is to produce a utilitarian object meant to provide protection from the elements and a degree of privacy for the body inside it.

What then of a video game? Is this an original work of authorship? Is it utilitarian in essence? And if it is eligible for copyright, what element or aspect of it, exactly, shall receive this copyright? The process of mechanical reproduction had assured that the copyright registration of one particular copy of a work would automatically insure protection for all its duplicates. Even traditional games like *Monopoly,* which might produce different outcomes at each playing, were identical to one another in their physical and visible parts. But the only visible part of a video game is its video display. The display is highly ephemeral and varies in detail with each play of the game. For a game like Pac-Man, the notion of pursuit or pursuit through a maze would be too general. Like the notion of the western or the soap opera, it is too broad for copyright eligibility. Instead the key question is whether a general idea, like pursuit, is given concrete, distinctive, *expression.* The working out of this distinction, though, lends insight into the degree of difference between mechanical reproduction and cybernetic systems perceived by the United States judicial system.

For video games like Pac-Man, a copyright procedure has developed that gives protection to the outward manifestation of the underlying software programs. Registration of a copyright does not involve depositing the algorithms structuring the software of the ROM (read-only memory) chip in which it is stored. Instead,

registration requires the deposit of a videotape of the game in the play mode.[20]

Referring to requirements that copyright is for "original works of authorship fixed in any tangible medium," Federal District Courts have found that creativity directed to the end of presenting a video display constitutes recognizable authorship and "fixation" occurs in the *repetition* of specific aspects of the visual scenes from one playing of a game to the next. But fixing precisely what constitutes repetition when subtle variations are also in play is not a simple matter. For example, in *Atari v. North American Phillips Consumer Electronics Corp* (1981), one District Court denied infringement of Atari's Pac-Man by the defendant's K.C Munchkin. The decision rested on a series of particular differences between the games despite overall similarities. In elaboration, the court noted that the Munchkin character, unlike Pac-Man, "initially faces the viewer rather than showing a profile." K.C. Munchkin moves in profile but when he stops, "he turns around to face the viewer with another smile." Thus the central character is made to have a personality which the central character in Pac-Man does not have. K.C. Munchkin has munchers which are "spookier" than the goblins in Pac-Man. Their legs are longer and move more dramatically, their eyes are vacant — all features absent from Pac-Man.

This opinion, however, was overturned in *Atari vs North American Phillips* (1982). The Seventh Circuit Court found Pac-Man's expressive distinctiveness to lie in the articulation of a particular kind of pursuit by means of "gobbler" and "ghost-figures," thereby granting broad protection to the game by likening it to a film genre or subgenre. The Circuit Court found the Munchkin's actions of gobbling and disappearing to be "blatantly similar," and went on to cut through to the basic source of the game's appeal and marketability:

> Video-games, unlike an artist's painting or even other audio visual works, appeal to an audience that is fairly undiscriminating insofar as their concern about more subtle differences in artistic expression. The main attraction of a game such as Pac-Man lies in the stimulation provided by the intensity of the competition. A person who is entranced by the play of the game, "would be disposed to overlook" many of the minor differences in detail and "regard their aesthetic appeal as the same."[21]

In this decision, the Court stresses the process of absorption and feedback sustained by an automated but intelligent system that can simulate the reality of pursuit. The decision represents quite a remarkable set of observations. The fetishization of the image as object of desire transforms into a fetishization of a process as object of desire. This throws as much emphasis on the mental state of the participant as on the exact visual qualities of the representation ("A person who is entranced by the play of the game").

In these cases the courts have clearly recognized the need to guarantee the exclusive rights of authors and inventors (and of the corporations that employ

them) to the fruits of their discoveries. Simultaneously, this recognition has served to legitimate the cybernetic metaphor and to renormalize the political-legal apparatus in relation to the question: who shall have the right to control the cybernetic system of which we are a part? On the whole, the decisions have funneled that control back to a discrete proprietor, making what is potentially disruptive once again consonant with the social formation it threatens to disrupt.

Such decisions may require recasting the legal framework itself and its legitimizing discourse. Paula Samuelson identifies the magnitude of the transformation at work quite tellingly: "It [is] necessary to reconceptualize copyright and patent in ways that would free the systems from the historical subjects to which they have been applied. It [is] necessary to rethink the legal. forms, pare them down to a more essential base, and adjust their rules accordingly. It [is] necessary to reconceive the social bargain they now reflect."22

If efforts to gain proprietary control of computer chip masks, soft-ware and video games have prompted little radical challenge from the left, the same cannot be said for bacteria and babies, for, that is, the issues of proprietorship that are raised by new forms of artificial life and artificial procreation where the "social bargain" woven into our discursive formations undergoes massive transformation.

The hidden agenda of mastery and control, the masculinist bias at work in video games, in Star Wars, in the reality of the simulation (of invasions, raids and wars), in the masculine need for autonomy and control as it corresponds to the logic of a capitalist marketplace becomes dramatically obvious when we look at the artificial reproduction of human life. The human as a metaphorical, automated, but intelligent system becomes quite literal when the human organism is itself a product of planned engineering.

Gametes, embryos, and fetuses become, like other forms of engineered intelligence that have gained legal status, babies-to-be, subject now to the rules and procedures of commodity exchange. Human life, like Baby M herself, becomes in every sense a commodity to be contracted for, subject to the proprietary control of those who rent the uterus, or the test tube, where such entities undergo gestation.

As one expert in the engineering of human prototypes put it, reproduction in the laboratory is willed, chosen, purposed, and controlled, and is, therefore, more human than coitus with all its vagaries and elements of chance.23 Such engineering affirms the "contractor's" rights to "take positive steps to enhance the possibility that offspring will have desired characteristics, as well as the converse right to abort or terminate offspring with undesired or undesirable characteristics."24 But what is most fundamentally at stake does not seem to be personal choice, but power and economics. These opportunities shift reproduction from family life, private space, and, domestic relations to the realm of production itself by means of the medical expert, clinical space, and commodity relations. The shift allows men who previously enjoyed the privilege of paying for their sexual

pleasure without the fear of consequence the added opportunity of paying for their hereditary preferences without the fear of sexual pleasure.

Such "engineered fetuses" and babies become so much like real human beings that their origin as commodities, bought and sold, may be readily obscured. They become the perfect cyborg. As with other instances in which a metaphor becomes operative and extends across the face of a culture, we have to ask who benefits and who suffers? We have to ask what is at stake and how might struggle and contestation occur? What tools are at our disposal and to what conception of the human do we adhere that can call into question the reification, the commodification, the patterns of mastery, and control that the human as cyborg, the cyborg as human, the simulation of reality, and the reality of the simulation make evident?

Like the normalization of the cybernetic metaphor as scientific paradigm or the judicial legitimization of the private ownership of cybernetic systems (even when their substrate happens to be a living organism), the justification for hierarchical control of the cybernetic apparatus takes a rhetorical form because it is, in essence, an ideological argument. Dissent arises largely from those who appear destined to be controlled by the "liberating force" of new cybernetic technologies. But in no arena will the technologies themselves be determining. In each instance of ideological contestation, what we discover is that the ambivalences regarding cybernetic technology require resolution on more fundamental ground: that domain devoted to a social theory of power.

PURPOSE, SYSTEM, POWER: TRANSFORMATIVE POTENTIAL VERSUS CONSERVATIVE PRACTICE

Liberation from any literal referent beyond the simulation, like liberation from a cultural tradition bound to aura and ritual, brings the actual process of constructing meaning, and social reality, into sharper focus. This liberation also undercuts the Renaissance concept of the individual. "Clear and distinct" people may be a prerequisite for an industrial economy based on the sale of labor power, but mutually dependent cyborgs may be a higher priority for a postindustrial postmodern economy. In an age of cybernetic systems, the very foundation of western culture and the very heart of its metaphysical tradition, the individual, with his or her inherent dilemmas of free will versus determinism, autonomy versus dependence, and so on, may very well be destined to stand as a vestigial trace of concepts and traditions which are no longer pertinent

The testing Benjamin found possible with mechanical reproduction — the ability to take things apart and reassemble them, using, in film, montage, the "dynamite of the tenth of a second"— extends yet further with cybernetic systems: what had been mere possibilities or probabilities manifest themselves in the

simulation. The dynamite of nanoseconds explodes the limits of our own mental landscape. What falls open to apperception is not just the relativism of social order and how, through recombination, liberation from imposed order is possible, but also the set of systemic principles governing order itself, its dependence on messages-in-circuit, regulated at higher levels to conform to predefined constraints. We discover how, by redefining those constraints, liberation from them is possible. Cybernetic systems and the cyborg as human metaphor refute a heritage that celebrates individual free will and subjectivity.

If there is liberating potential in this, it clearly is not in seeing ourselves as cogs in a machine or elements of a vast simulation, but rather in seeing ourselves as part of a larger whole that is self-regulating and capable of long-term survival. At present this larger whole remains dominated by parts that achieve hegemony. But the very apperception of the cybernetic connection, where system governs parts, where the social collectivity of mind governs the autonomous ego of individualism, may also provide the adaptive concepts needed to decenter control and overturn hierarchy.

Conscious purpose guides the invention and legitimization of cybernetic systems. For the most part, this purpose has served the logic of capitalism, commodity exchange, control and hierarchy. Desire for short-term gain or immediate results gives priority to the criteria of predictability, reliability, and quantifiability. Ironically, the survival of the system as a whole (the sum total of system plus environment on a global scale) takes a subordinate position to more immediate concerns. We remain largely unconscious of that total system that conscious purpose obscures. Our consciousness of something indicates the presence of a problem in need of solution, and cybernetic systems theory has mainly solved the problem of capitalist systems that exploit and deplete their human and natural environment, rather than conserving both themselves and their environment.

Anthony Wilden makes a highly germane observation about the zero-sum game, Monopoly. The goal of the game is to win by controlling the relevant environment, the properties, and the capital they generate. But Monopoly and its intensification of rational, conscious purpose masks a logic in the form of being "merely a game" that is deadly when applied to the open ecosystem. Wilden writes, "We usually fail to see that Monopoly supports the ideology of competition by basing itself on a logical and ecological absurdity. It is assumed that the winning player, having consumed all the resources of all the opponents, can actually survive the end of the game. In fact this is impossible. . . . The Monopoly winner [must] die because in the context of the resources provided by the game, the winner has consumed them all, leaving no environment (no other players) to feed on."[25]

"There is the discovery," Gregory Bateson writes in one of his more apocalyptic essays, "that man is only a part of larger systems and that the part can never control the whole."[26] The cybernetic metaphor invites the testing of the purpose and logic of any given system against the goals of the larger ecosystem

where the unit of survival is the adaptive organism-in-relation-to-its-environment, not the monadic individual or any other part construing itself as autonomous or "whole."[27] "Transgression does not negate an interdiction; it transcends and completes it." The transgressive and liberating potential which Bataille found in the violation of taboos and prohibitions, and which Benjamin found in the potential of mechanically reproduced works of art, persists in yet another form. The cybernetic metaphor contains the germ of an enhanced future inside a prevailing model that substitutes part for whole, simulation for real, cyborg for human, conscious purpose for the decentered goal-seeking of the totality — system plus environment. The task is not to overthrow the prevailing cybernetic model but to transgress its predefined interdictions and limits, using the dynamite of the apperceptive powers it has itself brought into being. □

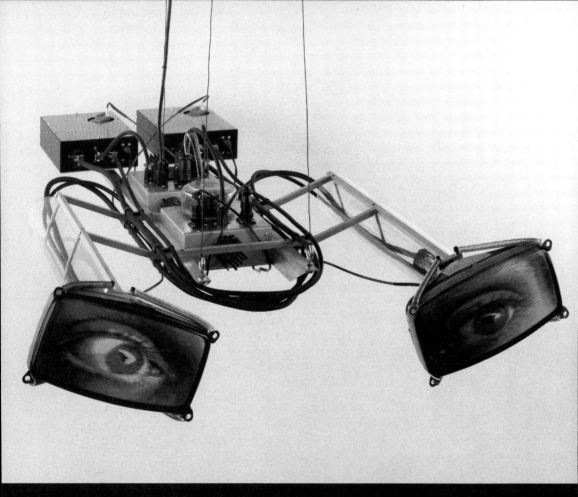

Alan Rath, *Soar Eyes*, 1994

FROM THE PHOTOGRAPH TO POSTPHOTOGRAPHIC PRACTICE:
Toward a Postoptical Ecology of the Eye

■ *David Tomas*

Since 1839, the constituents of Western cultures and, to an increasing degree, those of other cultures, have been conditioned to see their world and the worlds of other peoples through the medium of photographic images. That conditioning, however, has not been homogeneous. One has only to examine the discourses informing photographic activity to become aware of the tensions that govern photography's various practices. Perhaps one of the most persistent and influential of these tensions concerns photography's "objective" versus its "subjective" foundations. Are photographs fundamentally factual? — are they the sites of privileged truths? — or are they in essence particularly complex fictions? As the history of debates on photography's exact cultural status reveals, the most interesting answers to such questions tend to be localized and coupled with the practical uses and the discursive formations that define particular zones of photographic activity. There is, however, another position that can be explored in relation to photography's historical-epistemological identity that has not yet been surveyed. This position is connected to an alternative culture that can be discovered to exist in relation to photography's modes of production. A culture of photography does not necessarily have to be defined in terms of the images that have come to embody much of its current historical and social value. Photography's historical-epistemological identity can also be defined in terms of the cultural dimensions of its processes of production — after all, photographs do not simply appear; they are *produced* by a complex transformational process that might also be impregnated with a range of symbolic values.

In the following pages, an alternative *postphotographic practice* will be described, and its strategic and practical consequences will be presented. This photographic "counter-practice" is an illegitimate offspring of a correspondence established between the visual classification system governing image formation in photographs and the cultural priorities and authorial logic embodied in the Judeo-Christian myth of origins as presented in the first ten verses of Genesis. This correspondence will provide a point of departure for exposing the authorial and deterministic foundations of all photographic images. Of particular interest in this light is the relationship

between the photograph's authorial and deterministic foundations and the principal historical priority sustaining a *culture of photographic images* — namely, a historical-epistemological *fixation* on the photograph as the most valued product of photographic activity. It is on the basis of a critical re-evaluation of this relationship that a counter practice will be proposed. This counter practice is based on a critique of the cultural priorities that operate in the case of all photographic activity whose objective is the production of photographs. I will suggest that such a counter practice can only be the product of a strategic inversion in the hierarchic binary classification system product/process. In contrast to a haunting cultural fixation on images and the transcendental determinism of current photographic practices, I will argue that there exists another set of possibilities connected to an ecologically based postphotographic culture whose distinguishing characteristics are located in a continuum of processes of production. In this alternative culture's terms, a postphotographic practice can be proposed in the context of an immanent postoptical and plural ecology of the eye. The two key references in the development of this alternative to current photographic activity are Friedrich Nietzsche's theory of the use value of history and Gregory Bateson's critique of a transcendent nonecological epistemology of Mind.

GOD, PHOTOGRAPHY, AND HISTORICAL DETERMINISM

Photographic subject/images are fixed in terms of tonal gradations that range between white and black, light and dark, or over- and underexposure.[1] Such subject/images are therefore governed by a binary classification system composed of the elements light (white) and darkness (black) — with their inferential correlates of presence and absence. As in the case of the Judeo-Christian myth of creation, photography's progenitive logic is governed by a fundamental opposition between darkness and light — absence and presence, the two other terms, only becoming marked in disjunctive association with their contrary terms (light in the case of absence, and darkness in the case of presence). However, the correspondences between the two processes of creation — the one optical, mechanical, and photochemical, the other mythic — go beyond an initial cognitive dualism. For example, both the photographic and the creation processes emphasize the primacy of ocular perception at the expense of the other four senses; both are mediated by a perceiving entity, man in the former and God in the latter instance; in each case, a process of naming is of particular importance; and finally, both eschew the question of the origin or nature of matter.[2]

Since the second quarter of the nineteenth century, photographic media have used this dualistic principle of ordering and have been the primary cultural techniques for celebrating an ocular process of cognitive differentiation. Furthermore, the progressive social and cultural diffusion of these media, since their initial public unveiling in August 1839 and their current omnipresence and the omniscience of their products, has been achieved under the governing authority

of a mobile and ultimately transcendent representation of an "eye" whose various shapes have been cast under the supervision of "rational" or "scientific" man.

Photographic technology is used to separate appearances optically from substantive contexts and permanently stabilize the resulting "subject/images" by mechanical and chemical operations. The photographs which emerge from this process were mediated by a perceiving entity — "the photographer" — and embody another fundamental cultural distinction. They replicate the dichotomy between the word and its "referent" in their differentiation between the subject/image and the subject photographed.

The similarities that can be traced between photography and the Judeo-Christian myth of creation suggest common symbolic contents and cultural functions. Although there is no direct historical connection to be drawn between the two processes of creation, the similarities that do exist point to a common cultural theme pertaining to the existence and normative functions of a perpetual "trans-historical" collective mythic social presence — at the very least, a mediative authorial slot sustaining an optical apparatus—an eye.

The basic physiological structure of the biological eye, a photosensitive surface encased by a darkened chamber with an opening formed of a lens, is replicated by the camera. Both systems are able to detect and translate a similar range of electromagnetic material. In each case, the construction of synthetic vision involves an extremely complicated process — from a physiological and a cultural point of view — and this complexity is compounded by the common cultural relations that have been forged between these two types of optical instruments.[3] These systems are not only sophisticated photochemical receptors for selected electromagnetic waves; the light they respond to is also suffused with cultural value and is intimately intertwined in their material/symbolic fabric.

The information contained in a photograph is defined by optical and perceptual hierarchies of difference. Photographs are produced by the action of light on darkness: information emerges by way of luminiferous actions the effects of which have been mediated by photographic lenses that are designed to control light rather than its absence (darkness). Light is also the precondition of vision and as a consequence it is culturally valorized over darkness. Light thus becomes the unmarked (contextual) cultural field in which darkness becomes marked.[4]

Light is accorded an unmarked value because it is a constructive agent, as well as the common substantive medium that unites the biological eye of the particular psychohistorical individual and the mechanical eye — a collective cultural artifact. Light is also the active and unmarked element in the hierarchic binary system delimiting the possibilities of visual representation. Insofar as cultural forms emerge from a light-sensitive material to be continuously and differentially fixed in the form of photographs, light is the medium of action in terms of which the history of photography was and continues to be "created." Given the intimate role of light in the process of biological vision and the cultural production of

photographs, it is not surprising to discover that the dominant history of photography is the one defined in terms of *photographs* and their *authors*, since both are contiguous mediums of cultural enlightenment.

PHOTOGRAPHY: AT THE SERVICE OF HISTORY

The special position of photography in our culture is predicated on a unique form of contiguous, causal link that unites the photograph with its referent. That link is formed of light. It is worth recalling the words of Joseph Nicéphore Niépce, in this connection: "The discovery I have made and which I call *Heliography*, consists in reproducing *spontaneously*, by the action of light, with gradations of tints from black to white, the images received in the camera obscura."[5] The phrase "*spontaneously*, by the action of light" stands as a worthy antecedent to a widespread belief in the unmediated nature of a subject/image's photographic process of optical and chemical inscription.[6] Light—both natural and artificial—can thus be perceived as a custodian of truth. As the medium for the transmission as well as the inscription of "fact" in the guise of an enlightened presence, light seems to act as its own guarantor—seeing has become a cultural form of believing. Light also provides the connection that allows for the cultural ascription of an iconic correspondence between the photograph and its referent, and as this luminous mediation precipitates the cultural bias of a photograph's factually real nature, the history of photography emerges as the product of the chemical fixing of light images. In contrast to mirror images, photographs are also historical because they are fixed slices out of time. Such images can therefore escape the chaos of an undifferentiated temporal reality and enter the differentiated (chronological) realm of historical time.[7] This explains one facet of the widespread cultural value that photographs have acquired in time: the displacement of an appearance from a substantive context and its permanent fixation on a two-dimensional surface severs it from its ecosystem, which, if it were a mirror image, would define its spatial and temporal qualities. Photographs therefore have the capacity to enter the service of history at the expense of the prephotographic substantive context which initially served to coordinate the social and cultural conditions of their production. But the cultural connotations of light also resurrect the spectral presence of a mythic author. In fact, photography is mediated by a double authorial presence: a collective mythic figure and the individual photographer.

Photography represents a secularization and democratization of the creation myth—what Lady Elizabeth Eastlake referred to as "the craving, or rather necessity, for cheap, prompt, and correct facts" was satisfied by photographic processes that valorized product over mode of production—as the 1888 Eastman Kodak slogan unequivocally stated: "You press the button and we do the rest."[8] Divine inspiration and its handmaiden, divine labor, became antiquated after the rise of mechanical reproduction and artistic labor was relegated to a choice of subject (a question of

framing) in a technological and industrial narrative that connects Eastman's Kodak to the Polaroid process (and beyond to instant digital-imaging systems). But this narrative has preserved the signs (photographic images) of a transcendent creative act (the differentiation between darkness and light) and thus continues to authorize the mythic act of differentiation that inaugurated the privileging of light over darkness.

The culturally sanctioned, photographically fixed relationship between light and dark provides an authoritative site for the condensation of an originative mythic presence and mythic value. With the development of each photograph, the symbolic position and authority of a transcendent Mind is resurrected: clothed in difference, each individual photograph is an authorial function with a particular iconic inflection. Poised between darkness and light, myth and science, the figure of the "author" takes the form of a transcendent being, and the product of "his" photographic activity fixes a mythic creation process —"And God *said*. . . , and God *saw*. . . , and God *called* . . ." (my emphases) — in terms of a fundamental classification system. Given this mythic phantom presence, all the historical uses of photography are excessively antiquarian in Nietzsche's sense of a celebration of preservation (stasis) as opposed to creativity (change) because subject/images are defined (fixed) in terms of a fundamental perceptual/mythic opposition dominated by light and the hand of a distant father figure.

The photographic process therefore represents a rational, technologically oriented model for a mythic creation process — its hegemonic role in the symbolic and material consciousness of the Occident is the result of the articulation of a classification system that mediates such fundamental questions as the transcendent origins of light and darkness, day and night, and the presence and absence of earthly things. Given these connections, photography represents the astonishing triumph of an industrial culture precisely because it presents in each of its products a singular instance of the mechanization and hence the recreation of creation, and it does so on the basis of an extraordinary technological feat: the operational transmutation of a mythic figure into a material/symbolic production process.

Any attempt to subvert the remarkable cultural authority of photography's mythic power and produce another practice dislodged and rerouted from this origin will be reflexively confronted by a grammar of seeing governed by principles echoing a transcendent authorial presence. If we now function under the historical illusion that we have replaced this mythic presence, we must not forget that we collectively take, make and read photographs, and therefore, in the words of Nietzsche, "We are not getting rid of God because we still believe in [his/our] grammar. . . ."[9]

TOWARD A POSTPHOTOGRAPHIC PRACTICE

At the root of the cultural epistemology governing our relationship to the natural environment are the fundamental hierarchic binary oppositions of Mind/Body and

Culture/Nature. Gregory Bateson has pointed out that the espousal of a subject/object dichotomy through which we can adopt a transcendent position with regard to the natural world and which also is enshrined in the Cartesian separation of Mind and Body has resulted in an understanding of Mind as being synonymous with an individual consciousness. This cultural dichotomy, which incidentally also echoes the distinction God/Man, is projected into space and is then formalized in Man/Nature and Culture/Nature.[10] Technology can then be used to control an independently conceived and often hostilely perceived ecosystem (Nature) and, in this role, technology inevitably becomes the representation of a historical, progressive, and competitive spirit that reproduces the alienation and potentially fatal consequences of the original subject/object, Mind/Body dichotomies. This pathological condition can only be neutralized by redefining the boundaries of Mind in order that it corresponds to the movement and circulation of information or ideas across the classical boundaries of a biological body (a perceiving consciousness) and throughout a social and environmental context. The concept of Mind that emerges as a result of this redefinition is ecologically immanent rather than transcendent, and the Cartesian opposition between Mind and Body evaporates as traditional material and cultural boundaries are dissolved into a broad ecological network of "pathways of information."[11]

Photography, as previously noted, is also governed by a number of binary oppositions such as photograph/subject photographed, light/dark, product/process which tend to (re)produce the dichotomy between Mind (a mythic authorial position signified by the photograph) and Body (a substantive prephotographic context — the context of photographic production). But the hierarchic nature of these oppositions suggests a possibility of change should one choose to subvert an existing hierarchy by inverting the relationship between its elements. In fact, radical change can be inaugurated through an inversion in one of the principal binary oppositions governing a photographic culture: the fundamental, traditional, hierarchic opposition between the product of photographic activity and the process of its production. A different field of possibilities appears as a consequence of this inversion, a new context for a radically differing post-photographic practice that is predicated upon an ecological approach to the production of images in a culture.

POSTPHOTOGRAPHIC PRACTICE AND A POSTOPTICAL ECOLOGY OF THE EYE

Postphotography is based on the premise that critical and strategic transformations in the cultural dimensions of photographic modes of production lead to the development of alternative representational practices. Unlike a practice that valorizes a culture of images, postphotography critically explores and transforms the historical

and contemporary contexts that define current modes of image production in a culture. But the practical application of this premise presupposes a type of gestalt shift in the traditional figure/ground relationship of process/product in the history of photography. The operational logic that conveys this shift is based on a Nietzschean strategy of historical and cultural amnesia, inasmuch as this strategy can be used to subvert the traditional values that are associated with the products of conventional photographic activity. The possibility of a postphotographic practice is therefore predicated on the strategic denial of the subject/image's conventional cultural value.

Nietzsche argued that any attempt to effect change had to be linked to "the power of forgetting" or "the capacity of feeling *unhistorically*" (my emphasis). This "unhistorical preconscious" was a condition without conscience and knowledge precipitated by the ability to forget. It lay at the roots of a happiness that Nietzsche identified with "the will to live," and, hence, it functioned in the service of life.[12] In that the unhistorical was a pretext for change, Nietzsche maintained that "we must know the right time to forget as well as the right time to remember, and instinctively see when it is necessary to feel historically and when unhistorically." Thus, he suggested, the historical and the unhistorical were "equally necessary to the health of an individual, a community, and a system of culture."[13] As a product of this Nietzschean strategy, postphotography operates under the guidance of an art of forgetfulness, and initially and continuously oscillates between the historical (post*photography*) and the unhistorical (*post*photography).

A strategic inversion in the process/product hierarchy that governs current photographic practices clears the way for the development of an ecological approach to the "production of images in a culture." This approach results in a considerable broadening of the boundaries that have traditionally served to define photography. Instead of seeking legitimization in terms of a narrow, institutionally sanctioned history of photography — a history of subject/images, chemical processes, lens designs, or camera forms — postphotographic practice seeks to trace the networks of its cultures and operational logics throughout broadly conceived spatial, temporal, social, and environmental contexts. Thus through the photographic process, one can now enter the various worlds of its contexts of production. The result of this strategic inversion is the emergence of different and plural cultures of representation, where images are considered in terms of ecological systems and extended patterns of information.

The cultural ecology of postphotographic practice is composed of three formerly distinct cultural contexts — an environmental context (Nature), a social context (Culture), and an individual biological context (an individual psycho-historical biological entity). The ecosystem governing these previously distinct contexts defines the metacontextual characteristics of a postphotographic practice — the cultures of its technology — conceived beyond the limitations of its particular material forms. These metacontextual characteristics are not only ecological from the viewpoints of the plurality of contexts that simultaneously

define them (an intersystem of spatial axes), but they are ecological along an inter-systemic network of temporal axes (a plurality of spatial contexts across time).

As previously noted, this ecosystemic approach to photography emerges as a consequence of a choice: a denial (the forgetting) of the grand narrative of a given subject/image culture (a culture of images). This denial creates the possibility of engaging a neglected zone of contextual and metacontextual image production. Access to this zone is based on a strategy of denial that is coupled with an inversion in the traditional oppositional hierarchy of product over process through which a photographic culture of images has achieved sovereignty in the Occident. In Nietzschean terms, postphotographic practice is simultaneously historical and unhistorical inasmuch as the cultural context of photographs (the narrative history of subject/images) is absorbed by the ecosystem of contextually current processes of production. Postphotographic practice operates through strategic oscillations of ever-present contexts of production. This perpetual *recontextualization* of its productive processes ensures that postphotography continuously reproduces and redefines its culture(s) — hence, the dissimilitude in its cultural practice.

This counter practice produces a number of important changes in the relative values that have been granted to the traditional constituents of photography. For example, conventional photographs can have no hegemonic role or position in a postphotographic culture because they no longer serve any of their traditional functions. In a recontextualized ecosystemic postphotographic practice, there is no need to escape a present so as to engage a future in order to serve a past. Pho-tographs are no longer the necessary decontextualized and transcendent signifiers of photography. An eclipse of the transcendent functions of conventional photographs also precipitates the collapse of their authors' sovereign power. In this ecosystemic context, with its shattering of point of view by ever present oscillations between the historical and the unhistorical, the traditional photographic author and eye are reduced to epiphenomenal effects — continuously differing, contextually defined iconic inflections that reverberate like distant echoes throughout the networks and intersystems of postphotographic cultures.

The primary sense organ of photography is a mobile camera/eye which mimics the structure and instrumental functions of the human biological eye. Its lens, however, is made of glass, its retina is a photosensitive surface and its optic nerve is a perceiving authorial consciousness. In contrast to this all-seeing cultural artifact, the postphotographic eye has no need of a lens and its darkened chamber, the mediums for the differentiation, focusing, and fixation of point of view. Postphotog-raphy is no longer modeled on an optical consciousness operating independently of its material and symbolic contexts. Its mirror-like surfaces, which correspond to raw retinas, provide pretexts to continuously contextualize and metacontextualize systemic visual processes of production.

CONCLUSION: POSTPHOTOGRAPHIC PRACTICE AND THE END OF HISTORY

The ecological absorption of the photograph and the obsolescence of the photographer precipitate the cultural dissolution of the photographic eye. A postphotographic culture has no need for a witness, a transcendent and discriminating eye, to testify to the significance of events by organizing and fixing them according to a chronological code of before and after. With postphotography there is no longer a point of view, but visual contexts; no longer an eye, but a continuous contextually interactive, visually educative process in which biological eyes reflexively commune with the fragments and possibilities of their cultures. With this negation of perspective and chronological codification, postphotographic practice calls into question the sovereignty of history. The inauguration of this postoptical practice will signal the beginning of the end of history as postphotography liberates the fixed "superhistorical" aspects of a culture of images and communicates the eternal as the continuing.[14] Images will now take the form of ecologically immanent processes that unfold in a perceptual present, the continuous product of contextual oscillations between the unhistorical and the historical.

If photographic history was the product of a sovereign teleological perspective in which a visual event or an aggregate of events were optically and chemically fixed from a chronological point of view, postphotography is that illusory and postocular nowhere where everything is becoming and already is. It is the eternal (superhistorical) present of Nietzsche's "life and action": the pulse of the unhistorical in the context of the use value of the historical. Postphotographic practice thus precipitates the dusk inaugurating the posthistorical — an era that has no need of a point of view and its optical products, visual facts or witnesses, and thus no need of light. □

THE VIRTUAL UNCONSCIOUS
IN POSTPHOTOGRAPHY

▧ *K e v i n R o b i n s*

In our world we sleep and eat the image
and pray to it and wear it too.

—Don DeLillo, *Mao II*

I want to raise some preliminary questions about images, and, particularly I have some questions about the ways in which new image technologies are inserting themselves into our culture. Not to consider these technologies in technological terms, but rather to explore what might be described as their unconscious motivations. In "A Small History of Photography," Walter Benjamin describes the "magical value" of new photography in the 1840s: "For it is another nature that speaks to the camera than to the eye: other in the sense that a space informed by human consciousness gives way to a space informed by the unconscious." "It is," he continues, "through photography that we first discover the existence of this optical unconscious, just as we discover the instinctual unconscious through psychoanalysis."[1] Now, 150 years later, what speaks to the camera? What has happened to this unconscious of the image?

CHEMICAL PHOTOGRAPHY TO ELECTRONIC IMAGE

"I can see it's the end of chemical photography," says David Hockney:

> We had this belief in photography, but that is about to disappear because of the computer. It can re-create something that looks like the photographs we've known. But it's unreal. What's that going to do to all photographs? Eh? It's going to make people say: that's not real—that's just another invention. And I can see there's a side of it that's disturbing for us all. It's like the ground being pulled from underneath us.[2]

For a century and a half, chemical photography held a special position as a representation of reality, and now, it would seem, that standing is being called into question.

With the explosion of new image and information technologies, a whole new cultural, political, and philosophical agenda is opening up around postphotography.

What is this disturbing new "unreality"? In its simplest form it does not seem too problematical. At the cheaper, consumer, end of the range we can see the shape of things to come in the new Photo CD system codeveloped by Kodak and Philips, or the new DAT image recorders proposed by Aiwa and Casio, heralding the convergence of still and moving image technologies and the emergence of a generalized image product and market. In more sophisticated forms, however, these new electronic image technologies are becoming subsumed within computer systems and networks, constituting part of an embracing information industry and market. The image-information product, in the new form of digital electronic signals, is then opened up to whole new possibilities of processing, manipulation, storage, and transmission. The photographic image becomes increasingly malleable:

> It is possible to change any element in a photograph no matter how small or large, undetectably using digital manipulation techniques. One simply scans in a photograph or negative so that it appears on a computer screen, and employs one of a large variety of tools to add or subtract elements, or change color or focus. One can change one's filter or f-stop after the fact, as well as making more major modifications such as the adding or subtracting of people or things. [3]

At the same time, it has also become increasingly possible to expand the range of "photographic vision" through the remote sensing and processing of microwave, infrared, ultraviolet, and even short-wave radar imagery. These vision technologies make it possible to open up new — and once "secret"— dimensions of reality to electronic scrutiny, analysis, and manipulation.

But postphotography is more than this. For, once it becomes possible to capture photographs or other visual images in the form of digital information, then it also becomes feasible to reverse this process and to generate information that will produce or simulate an image *ex nihilo*, as it were. Timothy Binkley describes a new "meta-visual world" accessible only to the computer, "The computer not only proffers us an imaginary piece of film (the image memory)," he says, "but also an imaginary camera — and a rich phantasmagoria of computed chimera just waiting to be photographed." "A new technology has been born," Binkley argues, "which disinherits photography from its legacy of truth and severs its umbilical cord to the body of past reality."[4]

This capacity to generate a "realistic" image on the basis of mathematical applications that model reality is the most dramatic and significant development of postphotography. At research centers like MIT's Media Lab and NASA's Ames Research Center in Mountain View, California, more sophisticated and futuristic developments of these technological principles are centered around creating the virtual reality of an artificial computer universe. In 1995, the world's first virtual

reality theme park opened in the Japanese city of Osaka. This postphotography promises a new image world where the real and unreal intermingle.

Photography has now become something we can call image-information: it can be deconstructed into its component bits in order to reveal more information, and it can be reconstructed and recomposed to generate new meanings. Think of the scene in *Blade Runner* where Deckard digitally scans and enhances, and almost enters, a photographic information space to capture the image of a fugitive replicant. Contrast this instrumental approach with the forlorn and anachronistic attempt by the replicant, Rachael, to hang on to the idea of a (fake) photograph as the thread of memory and identity. The complex new mechanisms through which visual data can be captured, processed, and manipulated clearly have profound implications for the ways in which we know and apprehend — and thereby control — the world. The most thoughtful critics have endeavored to explore the philosophical consequences and ramifications of these developments, the epistemological and ontological questions thrown up by this new postphotography.

Digital technologies put into doubt the nature and function of the photograph/image as representation. The essence of digital information is that it is inherently malleable: "The unique computer tools available to the artist, such as those of image processing, visualization, simulation, and network communication are tools for *changing, moving,* and *transforming,* not for *fixing,* digital information."[5] Through techniques of electronic montage and manipulation, what we once trusted as pictures of reality can now be edited and altered seamlessly and undetectably. The February 1982 issue of *National Geographic* has become the classic example: in a photograph of the pyramids at Giza, the pyramids were digitally moved closer to each other in order to fit the layout of the front cover. The status of the photographic document as evidence is thus called into doubt. Whole new vistas are opened up for the manufacture of fakes, fabrications and misinformation. The relationship between the photographic image and the "real world" is subverted, "leaving the entire problematic concept of representation pulverized . . . and destabilizing the bond the image has with time, memory or history." What it represents is "a fundamental transformation in the epistemological structure of our visual culture."[6]

The crisis of the relation between photograph and "reality" not only raises questions about representation, knowledge, and the truth of the image, but also profound ontological questions concerning the status, the alter-reality, of the image realm. By superseding any indexical or referential relation to reality, the new image space assumes increasing autonomy. What is the nature of this space? How and where does it exist? While computer images "exist informally in an intuitive space with other visual objects, they derive from a formal space in the computer's memory." What we perceive as a photographic duplication exists in fact as a mathematical algorithm simulating or modeling the geometrical form of the image it generates. This dislocation of image and referent "reinforces its perception as an object in its own right. . . . It presents itself as a new source of knowledge."[7]

In the factitious space of the computer memory it becomes possible to simulate a surrogate reality, a synthetic hyperreality that is difficult to differentiate from our conventional reality, and that, indeed, now threatens to eclipse it.

These philosophical perspectives raise critical issues about our uncomfortable relationship to this new world of images. Of course, photography has always had a disturbing relationship with what we have understood to be the real world: it has exposed us to the unreal and uncanny dimensions of that reality, and it has encouraged us to see the captured image as somehow more real. The photograph has also always promised to take us beyond vision, as with Victorian spirit photography, for example, which aspired to reveal secret realities, to afford us access to "the Invisible, the Unseen and the Unknown."[8]

Now, however, the image seems to have assumed a new and boundless authority. The transformation of photography opens onto a bigger agenda about the cultural significance of image, information, and technology in contemporary society. What seems significant about our time is the growing power of the image, and the idea that new technologies may actually have inverted the primacy of reality over the image. We seem to live in a world where images proliferate independently from meaning and from referents in the real world. Modern life appears to be increasingly a matter of interaction and negotiation with images and simulations which no longer serve to mediate reality. This simulation culture promises to open up whole new dimensions of existence and experience.

FROM TELE-PRESENCE . . .

As Susan Sontag argues in her seminal book *On Photography,* the photographic image has been mobilized to achieve symbolic or imaginary possession over reality: it has been at once a "tool of power" and a "defense against anxiety."[9] Simulation technologies have also been driven by this same desire or need for containment and control. In one sense, they can actually turn symbolic control into literal control.

A fundamental application of simulation technologies has involved the development of what has been called *tele-presence* or *tele-robotics,* developed with the objective of controlling, or potentially controlling, operations over distance or at hazardous sites (space and deep-sea exploration; battlefield situations; nuclear and toxic environments). Through the use of a range of input devices (a helmet-mounted display panel, data-gloves, data-suit), it becomes possible to simulate a three-dimensional world in which the operator is an active and involved participant. It is as if he or she were inside the image, immersed in the new symbolic environment, with the "means of interacting with that virtual world — of literally reaching in and touching the virtual objects, picking them up, interacting with virtual control panels, etc."[10] The virtual environment is one in which cybernetic feedback and control systems mimic the interaction with real objects,

such that the environment appears to be real and can be used as if it were real. In the projected United States space station, for example, it is envisaged that the astronaut will be able to control a robot outside the station with "the robot's camera system providing stereo images to the operator's head-mounted display while precisely miming his head movements, and the robot's dexterous end-effectors would be controlled by data-glove gestures."[11] If the means is to create the illusion of presence at such a site, the clear objective is to manage or transform real situations and events.

The most developed example of this logic of simulation and control is in military applications, and it is here that we can most clearly see the disturbing consequences. As we saw in the Gulf War, combat is increasingly mediated and simulated through the screen.[12] This creates a *derealization* effect, which makes it *seem* as if the war is being conducted in some imaginary space. Thus, the scale and speed of contemporary war become associated with an intensification of what Paul Virilio calls the "logistics of perception." "The bunkered commander of total war suffers," he argues, "a loss of real time, a sudden cutting-off of any involvement in the ordinary world."[13] Simulation is the form in which military activities are represented, and, for the commander, involvement in those activities is a question of interaction with the simulated image. For the unbunkered fighter, too, the experience of combat becomes similarly derealized: the United States Air Force is reported to be currently developing a virtual reality helmet "that projects a cartoonlike image of the battlefield for the pilot, with flashing symbols for enemy planes, and a yellow-brick road leading right to the target."[14] It is as if the simulation has effaced the reality it modeled—as if commander and fighter were engaged in mastering a game logic, a computer game, rather than being involved in a bloody, destructive combat.

The power of the simulation should not be allowed to seduce us into believing that war is now only a "virtual" occurrence, however. If military simulation reminds us of a video game, we should recognize that its objectives go far beyond symbolic mastery of the screen. We should remember that the simulation is a model of the real world, and that the ultimate objective is to use the model to intervene in that world. It is precisely the functions of tele-presence and tele-operation that are crucial in this context. The computer simulation technology is part of a cybernetic system, which includes sensors and weapon systems, to monitor remotely, and then to control remotely (that is, "strike") real-world situations and events. The new systems of surveillance, simulation, and strike technologies operate across, and through, two different levels of reality, the virtual and the material. It is right to observe that there has been a kind of derealization of military engagement: postmodern warfare is, indeed, increasingly a mediated affair, characterized by simulation, tele-presence and remote control. But this insubstantial and synthetic reality has an interface with another reality that we are still right to call our *real* world: the world of real targets.

If the aim has been to control reality through the instrument of illusion, it has also become apparent that it is possible to use illusion in its own right. It is the exploitation of "pure" simulation that characterizes virtual reality systems proper. The system of images, self-contained and auto-referential, comes to assume its own autonomy and authority. The spectacular culmination of this tendency to replace the world around us with an alternative space of simulation is now coming with the "virtual reality environments" development of virtual reality fantasy games and theme parks. In these virtual reality systems a multisensory and interactive display environment simulates the experience of "being there": "We can have a completely synthesized image [and] we can become part of it."[15] These heroic endeavors are inspired by the desire or compulsion to create a new and better reality: a simulated reality more real than the reality of which it is a simulation. This is to be a higher order of reality: a world that knows no limits and that can be shaped by human creativity and imagination.

To understand this great dream about virtual reality technologies, we need to understand how they implicate their dreamer-users. What of themselves are these users investing in the virtual reality? What is that particular combination of rational and pre-rational pleasures that the technologies speak to? Discussions of these technologies have tended to place greatest emphasis on the seductive realism of the virtual reality image. So realistic is it that it seems to be an alternative, and better, world of its own. But, if the fascination of the reality effect is important, perhaps more so is the question of *interactivity*, and it is through this dimension, I think, that we can gain a better insight into conscious and unconscious investments in the new technologies. Virtual reality environments, we are told, depend on the "ability to interact with an alter ego":

> Interfaces form bridges between the real and the virtual and back again. We cross them to inhabit a strange place that is both concrete and abstract. A human hand grasping a real sensor holds, at the same time, a virtual paint brush or the controls of a virtual space vehicle.[16]

Interactivity is fundamental to simulation. What is exciting about the virtual reality experience, says Gene Youngblood, is that it involves "interaction not with machines but with people mediated through machines: it's interaction with intelligence, with mind." With this high level of interactivity, "the environment changes as a result of the user's interaction with it, so that possibilities are generated that the author didn't think of."[17]

The objective (still a long way from being realized) is to make the interface as direct and immediate as possible: "With a little imagination, one can envision human-machine interaction beyond a keyboard and mouse to the natural and

kinesthetic way we encounter the real world. Input devices for our hands, arms, heads, eyes, body, and feet can sense positions, gesture, touch, movement, and balance."[18] The challenge is to create a direct connection between the technology and the human nervous system. The dream of eliminating the interface —"the mind-machine information barrier"— reflects the desire to create a perfect symbiosis between the technology and its user.

What it will afford are new possibilities of control, the capacity to control, within the domain of the simulation, what had once eluded control beyond it. It is a fantasy powerful because it is both rational and irrational — that entails the redefinition of self and identity in terms of the virtual microworld. But it is a regressive fantasy. The virtual world is a container in which "reality" is made tractable and composable. The real world that was once beyond is now effaced: there is no longer any need to negotiate that messy and intractable reality. The (disembodied) user of virtual reality is reconceived as an aspect of, and operates entirely in terms of, the logical universe of the simulation.

This idea of entering a new reality appears to have enormous imaginative resonance (reflected in a stream of newspaper articles and television programs). The ideologues of virtual reality are already creating the myths, pontificating on the enormous "philosophical" implications of this "technological revolution." There is the expectant sense that this new image technology is changing the nature of reality or identity, or humanity, or existence or something. In this domain, says Youngblood, the mundane laws of reality are suspended and transcended and all phenomena exist virtually. The techno-philosopher can only feel exhilaration and intoxication:

> Only a tradition bound to the precious object as commodity would find problematic the replacement of "reality" by "simulacrum of simulations." For those who conspire in electronic visualization the issue is not a return to some "authentic" reality but the power to control the context of simulation. The fear of "losing touch with reality," of living in an artificial domain that is somehow "unnatural," is for us simply not an issue, and we have long since elected to live accordingly. What matters is the technical ability to generate simulations and the political power to control the context of their presentation. Moralistic critics of the simulacrum accuse us of living in a dream world. We respond with Montaigne that to abandon life for a dream is to price it exactly at its worth. And anyway, when life is a dream there's no need for sleeping.[19]

There is excitement about the possibility of immersing one's disembodied self in artificially constructed symbolic, visual, sonorous, and tactile spaces.

This hype is epic. John Perry Barlow plays the visionary: "There seems to be a flavor of longing here which I associate with the desire to converse with aliens or dolphins or the discarnate. . . . Or maybe this is just another expression of what may be the third oldest human urge, the desire to have visions."[20] Howard Rheingold

is the philosopher. Speculating on the possibilities of "tele-dildonics" and virtual sex, he contemplates what this might entail for the meaning of life: "Where does identity lie? What new meanings will 'intimacy' and 'morality' accrete? Will our [tele-dildonic] communications devices be regarded as 'its' or will they be part of us?"[21] And techno-guru Jaron Lanier plays the sensitive mystic: "What I'm hoping the virtual reality will do is sensitize people to the subjective or experiential aspects of life and help them notice what a marvelous, mystical thing it is to communicate with another person."[22]

THE VIRTUAL UNCONSCIOUS

The Western political project, as Anne-Marie Willis argues, implies that the more clearly we can see, the more we will know:

> The means to grasp, categorize, store and access the world of appearance has been relentlessly pursued. This desire to grasp the physical "real," to duplicate it in order to know and control it, has been the impetus behind the move towards greater naturalism, speed and ease of production of the visual image. From still to moving, silent to talking, black and white to color, there has been a double movement — on the one hand to be subservient to a truth assumed to be pre-existent in the visible world and on the other to create a duplicate reality that will be more intensely compelling than "the real world."[23]

Tele-presence now is about knowing and controlling the physical "real"; and virtual reality is the duplicate reality that is more compelling than "the real world." Through the new image and vision technologies our powers of seeing have been dramatically expanded, and so it seems that rational knowledge and control have made a great leap forward in their inevitable progress. The new image world is a "mind-space," and in it "minds of tomorrow will mirror themselves, meet each other, enter the universe of information and knowledge."[24] Closer to the rational utopia?

Well, maybe. But rational utopias have always been marred by a fear of the technological power that makes them possible, by a profound anxiety about what that power can create and at what cost. Walter Benjamin believed that another nature spoke to the camera than to the eye: other in the sense that a space informed by human consciousness gave way to a space informed by the unconscious. He described it as the optical unconscious. We can, perhaps, develop this metaphor. We can consider what has happened to this unconscious now that optics has given way to virtual seeing. And we can also suggest how this virtual unconscious relates to the instinctual unconscious. In our culture, it has seemed that vision is associated with the project of reason and the logic of knowledge and control. But vision also mobilizes unconscious forces, primitive and prerational desires, anxieties and fantasies.

In the space of simulation and virtual reality, the "user" is immersed in a dematerialized and surrogate reality that has no apparent relation to the "real world." He functions as a component of a microworld, operating at a purely cognitive level within a closed world of reason and logic (although it seems to him that it is more than this). His existence in this alternative space is disembodied, and any engagement with the real world (that is, tele-operation) is indirect, mediated through a screen or some other imaging technology. It is as if there is a "desire to escape both the human body and the human world," as if the obsolete human body no longer has any place in the new "datascape."[25] In this derealized state of being, anything and everything becomes possible, whether it is fantasy adventure in a virtual environment or pushing buttons and watching screened simulations of slaughter in real, so-called Nintendo wars.

The real world is screened out. The possibilities of the image space overpower the principles of reality. As Jean Baudrillard suggests, "Simulation pushes us close to the sphere of psychosis."[26] Within this space, the disembodied user assumes what Gerard Raulet calls the "floating identity" of a kind of schizophrenia or neonarcissism. It is, he says, a kind of "autism," which involves the drawing in of object-cathexes and the dissociation of social bonds.[27] But, of course, this disembodied user is always also another person. The user of virtual reality is like the video-game player: "Apparently a double or a split subject since the game is simultaneously in the first person (you in the real world pressing keys) and the third person (a character on the screen, such as a knight, who represents you in the world of fiction)."[28] The military game player is, similarly, a double or a split subject, a first person pushing buttons and a third person involved in the combat on the screen.

Thus the user is a split person. James Grotstein describes a kind of psychotic behavior, in which the psychotic "may protectively identify a split-off, disembodied twin self who is free to move about at will, leaving the body self abandoned." This, he argues, is a defense mechanism which, at its most benign, postpones confrontation with some experience that cannot be tolerated, but which, at its worst, can negate, destroy, and literally obliterate the sense of reality.[29] This is highly suggestive. The psychoanalyst, Hanna Segal, also observes this psychotic tendency. In contemporary military activity, she comments, "There is a kind of prevailing depersonalization and de-realization. Pushing a button to annihilate parts of the world we have never seen is a mechanized split-off activity." "This obliteration of boundaries between reality and fantasy," she says, "characterizes psychosis."[30]

There has always been a monster to haunt the dream of technological power and technological order. The Enlightenment project has sought to make the human world into a closed space. Within the ontological closure of this rational universe, the human world has become increasingly transparent to conscious knowledge and control. But this closed space, as Manuel Aguirre (1990) stresses, has always also been the scene of horror fantasies, of dramas of the unconscious processes. The closed space of simulation can quickly turn into a frightening

space. What might happen to us "inside" the fantasy space of virtual adventure? Virtual reality could be used as a "terrifying instrument of torture"; according to the representative of one virtual reality company, W Industries, "People are already talking about virtual rape and murder."[31]

And what happens to us if the "outside" world, the "real world," loses its reality? Now, after the "Nintendo war" in the Gulf, we are beginning to see the consequences of screen and simulation killing for the killers. Psychologists are saying that high-tech killing is creating more mental disorders than the more direct and bloody slaughter of earlier warfare. After the Gulf War, we are seeing the casualties of simulation, soldiers who are suffering from "zombie-like" withdrawal or from "Rambo-like paranoia," soldiers who can no longer relate to real life.[32]

That distancing from reality, encouraged by the Gulf War, characterizes virtual reality in general, which likewise cannot escape disturbing consequences for the human psyche. In the name of enhancing sensuous experience, virtual reality promotes unconscious processes which treat that experience as reified things, disembodied from social relations. Although Youngblood presents virtual reality as liberating us from the tradition of "the precious object as commodity,"[33] this technical advance in fact serves to extend a commodity-like reification to the unconscious: "When life is a dream, there's no need for sleeping," he says. As I have argued, this cynical substitution of simulation for reality can only superficially overcome the alienation of our social existence; our pain will return to haunt us as nightmares the more we seek refuge in the "dream" of virtual reality. □

Manual, details from *The Constructed Forest* ('This is the End — Let's Go On' — El Lissitzky), 1993

PHOTOGRAPHY
AT THE INTERFACE

■ *Roy Ascott*

There has been a long-running debate about the relationship between photography and the real, which for many has meant faking faith in its power to represent adequately, or even at all, the true nature of things seen, or the reality of surfaces encountered, while for others it has meant a faith in fakes — photographic deception in the service of power. Some have argued that photography has used the alias of truth to impose its fictions. It is now more than ten years since Stewart Brand saw the Giza pyramid move.[1] To that generation of photographers, contemplating the sins of digital retouching, it meant endless (and for some, wearisome) self-questioning, moralizing, and fretting about truth to appearance, and confusion about truth and reality. But now, who cares? Did the pyramids move for you, darling? We don't care because our virtual worlds allow us to construct pyramids in all kinds of dataspace, because we have no trust whatsoever in either journalism or art as purveyors of reality, because we've had, like Blonsky, close encounters with semiotics of the third kind, "not the representation, or meaning, but the way the meaning is announced."[2]

Now this disbelief, directed toward the media whenever corruption and dissimulation are its editorial intent, is not a reproach to art. It is rather a recognition that art has grown to embrace, in addition to its continuing critical concern with representation and on-again, off-again flirtations with simulation, a computer-mediated virtualization. (From the light and shade of the mimetic, through the trough of deconstruction, toward the radiance of a radical constructivism,[3] might be one way to put it.) Undeveloped as this view may be, we are sufficiently self-aware to know that reality is built by us, to fit our psychic and sensory specifications and to satisfy our conceptual longings. It's all tied up with the role of the viewing subject (in the world, in the laboratory, in art) on the one hand, and with the technology of cognition on the other. The field of digital photography plays its part in this prospectus, and the artists here play a leading role within this field.

The golden age of the electronic, post-biological culture may be far ahead, but the world of digital photography is opening up, just as the world of analog photography as it has been practiced is, if not closing down, then being absorbed within the digital discourse. This is not a debate about the relative merits of gold

Esther Parada, *Native Fruits*, 1992

and silver. It's a matter of attitude, both of the artist and of the viewer. We are at the beginning of the era of postphotographic practice. The work presented here by Paul Berger, Carol Flax, Manual, and Esther Parada testifies vigorously to this overture. It's not that these artists are no longer focused on things seen, or that they no longer want to make images which fix our attention into a composite moment. Although it is true that their various interests are evidently and potently invested more in what cannot be seen at the surface level of reality, in what is invisible, fluid, and transient: human relationships, systems, forces and fields as they are at work in nature, politics, and culture. It's that photography as a stable medium is giving way to a practice which celebrates instability, uncertainty, incompleteness, and transformation. And I don't just mean semantically. What these artists have taken on board is the radical change in the technology of image-emergence, not only how the meaning is announced but how it comes on stage; not only how the world is pictured, or how it is framed, but how frameworks are constructed from which image-worlds can emerge, in open-ended process.

This postphotographic technology captures images ("seen" images from still video and other cameras), constructs images ("unseen" data from remote sensors and databanks), and generates images (from raw numbers); it treats them, stores them, associates them, disburses them, transmits them, into a media-flow which is, in every serious sense, unending and ubiquitous. Or, to put it more comfortably for those still chemically connected to image production, and for the present anyway, it is a technology which allows us to do so, if we wish. What has changed, though, from the old economy of the image, is that the processes of transformation I have described are now in the hands of the viewer as much as

the artist. Or are implicitly so. And, just around the corner, not yet playing peek-a-boo but close to doing so, is the artificial observer, the eye of the neural net, that artificial intelligence which will surely become a part of the observing system. But that's for the future.

Here and now, in the popular culture (of 1992), the world takes its photographic negatives to the neighborhood photo shop, slips them the 35mm roll, and later collects a compact disc ready to view . . . on the TV screen. "CD killed the video star" is likely to be the refrain for this decade. And the CD ROM, compact discs with read-only memory, will, of course, eventually give way in the mass market to interactive discs, CD-I, allowing the public not only to interact with the (photo) data at their disposal, to travel through it with their own connective patterns of viewing, but to interfere with the images themselves, to distort, collage, dismember, fractionalize, and in every way transform the image at will. Coupled with the easier availability of scanners, no photographic images — from Walker Evans to *Playboy* centerfold — will be immune to violation or domestication. This "opening" of the image and the distribution, across time, of authorship, at the public level, will doubtless have unprecedented effects both on the perceived legitimacy of the photograph and on the perceived authenticity and cultural status of the photographic artist.

The combination of complexity in capturing, constructing, storing and accessing data, combining that data at various levels of resolution, in a variety of sensory and semantic modes — image, text, sound — places digital photography in a kind of virtual space, on the road to hypermedia.[4] It is an important component of the complex ensembles that these new media sustain. This route, actually consisting of many personal pathways, is being opened up by artists to whom silver is no longer precious, significant among them the artists presented in this exhibition. For them, dataspace is infinitely layered, and data images exist always and at all times in a sea of interdata, just as the hypertext exists within the boundless domain of the intertext, where Ted Nelson[5] meets Roland Barthes, or where Apple[6] makes a nonintuitive, natural bid to be regrafted onto the tree of knowledge.

"The computer has provided the technology to facilitate the representation of the multi-dimensional and layered aspects of my ideas," writes Carol Flax. It is this need, to model, reflect, contain, and distribute complexity (in life, in personal experience, in politics) that leads her, as with the other artists here, to employ the complex systems of new technology "never thinking of them," as she says, "simply as painting tools, but always as communications devices." Similarly, as Esther Parada shows, these mixtures of text and image, layering and montage, can serve distinctly critical ends, allowing for the revisioning, reworking, and reconstructing of racial, political, and cultural myths and mendacity found in earlier photographic practices.

For the viewer it's the difference between absorption and immersion. In classical photography, we wanted to absorb as much as we could of the beauty of the image, of its content, its politics, its culture. The photograph always lingered

between "documentum" and "monumentum," between the official piece of evidence and the legitimized record; between sighting and reminding, between collecting and storing. That is, between process and substance, activity and object. It is salutary to remind ourselves that the provenance of documentum lies in *docere*, "to teach," "to give proof," but also touches on *decere*, "to be fitting and decent," and, if *docere* is "to work," "docile." There is a sense that much photography has underwritten, if not official reality, then an ideologically coherent one, set very much, as if, in the here and now .

There has always been a pull in photography toward "normal" viewing, the "real" language of seeing: photographic reality is after all the synonym for ordinary reality, couched in ordinary language.

"This pull toward ordinary language was often, is often, a pull toward current consciousness: a framing of ideas within certain polite but definite limits."[7] Neil Postman has pointed out that "by itself photography cannot deal with the unseen, the remote, the internal, the abstract, it does not speak of "Man," only of "a man"; not of "Tree," only of "a tree." You can only photograph a fragment of here and now. The photograph presents the world as object; language, the world as idea. There is no such thing in nature as "Man" or "Tree." The universe offers no such categories or simplifications; only flux and infinite variety."[8]

Absorption in the here and now is re-enacted in a more focused, compact, bounded, and therefore more intense way by means of the photograph. The context is one of empathy. The transfer of feeling. But photography easily lulls us into a false sense of reality, a reality reaffirmed by its familiarity. The routines of seeing.

"Life seems clear enough as long as it is routine; i.e., as long as people remain docile, read texts in a standard manner, and are not challenged in a fundamental way. The clarity dissolves, strange ideas, perceptions, feelings raise their head when routine breaks down."[9]

Just as our interest nowadays is less in what photographs mean, as in "how" they mean, so empathy with an artwork's evocation of a given state, or a given fragment of the here and now, is of less importance to us than a vivid involvement, through our interaction with the photodata image, in the construction of a reality, of multiple realities. In postphotographic practice, the lust for verisimilitude gives way to the love of construction.

In postphotographic practice, the routine to which Feyerabend refers breaks down. The metaphor for this practice is emphatically aquatic, notwithstanding its necessary arrays of computers, imaging peripherals, and optical and magnetic storage devices. The hypermedia systems in which photodata float call for sensory immersion and conceptual navigation on the part of the viewing subject. Immersion in the images which are brought up from the database into our realm of seeing, and navigation through the layers of data, the multiplicity of routes and passages, within which the images are enfolded.

Thus the new photographic discourse, both within its stereographic virtuality

and its hypermedia potentiality, must put as much emphasis on the behavior of the viewing subject, her interaction with the apparatus and the image, as on her introspective re-action. The window onto a world of analog actualities gives way to the doorway into a world of digital potentialities. It is a process of creation that invites collaboration and cooperation both by those who, as artists, instigate the process and those who, as viewers, respond to the process in the public arena. In the practice of Manual, collaboration and participation in the construction of the digital photograph is initiated at the very point of conception. Their work is insistently and paradigmatically collaborative, but whereas this partnership is seamless in its process of production, it is concerned with revealing the divisions of digital and analog media employed, and to make transparent their composite structures, as a strategy in presenting the overall problems which the work poses. Paul Berger, similarly, seeks to visualize something of the conflict that exists between the competing information vehicles of computer interface, mechanical hand-drawing, and camera-based imaging systems.

But it would be false to set up the different aspects of photography, digital or analog, in complete and total opposition. And these artists are certainly not doing that. It's a case of both/and *and* either/or. All strategies are open to deployment. Photography both affirms gravity and gravitates around immateriality. As for its relationship to the real, and to truth, it is as relativistic, and can be as pragmatic, as those current discourses which have replaced philosophy as the guide to artistic practice. "Contingency, irony, and solidarity"[10] play their part in its formation, despite Manual's witty allusion to Americans being "irony bored." Just as, in his

Carol Flax, *Casey*, 1991

Paul Berger, detail of *Face-03*, 1993

contributions to Radical Constructivism, Paul Watzlawick asks how we know what we believe we know, so photography has the potential to ask how realities are constructed, and with digital photography, to admit us, as participating viewers, into the process of construction.

Hypermedia, which provides the layered space for digital photography, is a site of interactivity and connectivity, in which the viewer can play an active part in the transformation or affirmation of the images the photographer provides. But once flowing in dataspace, stand-alone meanings and conceptual linearities disappear. A world of fuzzy ambiguities, darting associations, shifting contexts, and semantic leaps opens up. This is the second order of Reproduction, a stage beyond Benjamin's "work of art in the age of mechanical reproduction." This is the stage of co-production. First, we understood a co-production between the photographer and the viewer in the creation of meaning, now we see a technology of co-production extending to transformation of the image itself.

Where there was once a photography which always ended up with its back to the wall, or pressed between the covers of a book, impenetrable by other media, now we are seeing the emergence in digital photography of a permeable datafield, whose sources may well be photographic, focused on a photonic given, but whose image is a lightly woven structure, open to other image sources, other insertions into the purity of the photographic field. Esther Parada sees it as "an electronic loom . . . into which I can weave other material . . . an equivalent to Guatemalan textiles, in which elaborate embroidery plays against the woven pattern of the cloth."

As photography moves along the path to hypermedia, to a place on the CD-Interactive disc, so to speak, it can be seen that the permeability of the photographic

image is not due solely to the obliterating of silver grains by digital pixels, and not just to the expansion from the single frame to a multiplicity of layers, nor from image frozen in time to image flowing in time, but also to the repositioning of the viewer, to her empowerment as a manipulator of that image, as the one in whose hands the destiny of the image may lie. "Once digitized," writes Paul Berger, "the image, which on the screen resembles a very clean video freeze-frame, can be endlessly manipulated, recombined with other elements, and transformed."

So to the question, naively but frequently asked: "What is the difference between digital photography and regular photography other than the fact that lies and dissimulations may be inserted more seamlessly into the veridical space of its image?" we can answer: "Its object lies in a virtual space, and in an implicit world which evolves within the flow of hypermedia — layered, relational, and constantly shifting in content and context, depending on the behavior and consciousness of the viewer." The answer cannot be simply that it lies in the difference between the material image on paper and the immaterial apparition at the computer interface, nor that the one depends upon perception by the physical and organic machine, and the other on perception by the technological machine. It lies finally in the opportunity for its further transformation by the viewing subject.

As digital photography moves toward the scene of hypermediated transactions, the ink-jet printer is as much a metaphor as an instrument. All contradictions, it is the very precision of the printing process that allows the artist to postulate a semantic uncertainty, and it is the crisp certainty of its defined images that allow the photo image to reveal its fuzzy shifts in meaning. Visions, dreams, and illusions, however tenuous and imprecise, are given a clarity of form and a critical density of image. Due to their digital provenance, the destiny of these images, apparently anchored on a surface in real space, is as likely to be realized in the evanescence of a television screen, the embrace of a stereographic display, embedded in an LCD screen, projected, holographed, or illuminated, as on a wall or in a book.

These artists have opened the door into dataspace, and stepped into the future. Although they have closed the shutters on the picture-window view of reality, they are very grounded in the present. Their themes of family ecology, political oppression, and cultural discontinuity are made more vivid rather than diminished by the high technology they have employed. They confound those critics of the electronic age who see only a technoculture of progressive dehumanization. Photography is now at the interface, and these artists have taken up the challenge which the new complexity of technological systems and diversity of media present. They bring us images and issues of a subtle sensibility, and the assurance that the computerization of photographic practice is profoundly human at base. □

Jeff Wall, *Eviction Struggle*, 1988

THE DOUBLE HELIX

■ *R a y m o n d B e l l o u r*

> *"I still smile it's not worth the trouble any more*
> *for a long time now it's not been worth the trouble*
> *the tongue spring goes into the mud I stay like*
> *this not thirsty any more the tongue goes back into*
> *the mouth it closes it has to make a straight line*
> *now it's done I've made the image."*

—Beckett, *The Image*

> *"From one mist to one flesh, passages are infinite*
> *in the land meidosem..."*

—Michaux, *La Vie dans les plis*

No doubt we know less and less about the nature of *the* image, *an* image, or *the* images. Not that it is easy, today, to say what they meant in other times, for other people. The investigations that have (more or less recently) been appearing in ever greater numbers on one turning point or another in the history and consciousness of images (the inexhaustible Renaissance, the iconoclastic crisis, the inventions of photography, cinema in its early stages, etc.) show very clearly that, by borrowing from others, we are trying to mitigate the panic that has gathered in our expression. The striking thing about such works is not so much the individual viewpoints that emerge, each corresponding to its respective phase, as the accumulation of those viewpoints, like so many conceivable potentialities of an impracticable history of images — made up of firm links and hesitant waverings — that has become an indication of our own history, a sign of the impressive accumulation of images. So, strictly speaking, it is not saturation that we are concerned with here. "Whether we are flooded with pictures or not, we don't know anything about them and we never will. We weren't back in the caves, where blokes were probably flooded with pictures because they had their faces glued on their scribblings and it was a lot worse than T.V."[1] Our problem is really the variety of different kinds of image. And it also lies in the fact that there are fewer Image(s), as a result of the virtually infinite

proliferation of images, which are characterized by the fissures and combinations (the vagueness) between their different forms rather than by their intrinsic fecundity — which must always be inferred.

This is what, in their way, the words *passages of the image* refer to. First of all, the ambiguous word *of* includes the sense of *between*. It is between images that passages and contaminations of beings and systems occur more and more often, and such passages are sometimes clear but sometimes hard to define and, above all, to give a name to. But the reason why so many new things are happening among images is that we also pass *in front of* images more and more and they pass just as often in front of us, according to a movement with certain effects that we might try to define. Finally, the word "of" can imply what is missing in the image, in the sense that it would steadily become more inappropriate to turn the image into something that is really appropriate, a truly namable entity. So there are passages from the image to what contains it without being reduced to it, from it to what it is made from—it is not surprising that this is the obscure, indeterminable spot which is suggested rather than stated by the words.

ANALOGY, ONCE MORE

1. We could almost start again from anywhere. From the "tavoletta" of Brunelleschi or the computer image: the latter could be given as a program to calculate the former; and the purpose of the Italian master's construction could have been to open painting up to the fiction of a first (pre-computer) synthesis capable of ensuring that the subject of the view would have a balanced mastery of reality.

But why put the computer image on one side and the "tavoletta" on the other in order to define the "passages of the image" that we are trying to come to grips with? Because the computer image not only requires us to question what it produces or could produce as art, but, above all, to evaluate — as Benjamin did for photography — what becomes of art when it is confronted with what it embodies (or disembodies), represents (or de-represents) and constructs (or destroys). What the present state of the computer image has to show is nothing compared with the potentialities it displays. In particular, both in principle and in depth, it affects two of the most important forms of passage that have long presided over the fate of images, and that today form a part of a crisis and junction where they have together acquired new strength, the kind of force that has to do with the relationship between mobility and immobility, and the sort that depends on the (above all, variable) amount of analogy that the image can sustain—its power to resemble and to represent.

As for the tavoletta, there are three reasons to include it in an evaluation. First, as Hubert Damisch has shown quite clearly, it is the "prototype" through which the modern space of visibility was instituted, both historically and

legendarily, at the confluence of art and science, of psychology and scenography: at the "origin of perspective."[2] This "installation" also had the merit of foreshadowing the procedure of mixing images. We know that two heterogeneous levels are combined in the mirror that the subject held in Brunelleschi's experiment: a painting of a monument conceived according to the forms of perspective that is invented; and a polished silver surface, "so that the air and natural sky are reflected in it, as well as the clouds that can be seen, driven by the wind when it is blowing." What Damisch retains, first in *Théorie du nuage* and then in his book on perspective, is the index value of the clouds, which are "shown" rather than "demonstrated," and elude perspectivist rationality thanks to their natural fluidity (so the theory is built on an exclusion that the prototype — and, through it, the painting — recognizes but moderates by bringing together the two levels so that it can be valid for all nature).[3] What I find particularly attractive is the conception of a picture making allowances for movement, or for its potentiality, and thus for a very modern midpoint: if the sky remains stationary, the situation recalls painting or photography; if clouds pass by, it would be the cinema or video. Manetti's account puts special emphasis on the fact that, in this arrangement "what people saw seemed to be reality itself."[4] Without going into the details of what Damisch sees in this conclusion, we can reduce it to two objectives that have paralleled the long adventure that has reached a point of reversal today: a demand for science and truth, the history of which is aided by painting as a form of construction; and the recognition of an analogy between the results of this construction and the real world whose image it holds up.

This impression of analogy will, of course, only seem natural because it is constructed, even though it may be based on the physiology of vision. But it is precisely because — no doubt, for the first time in history — the impression of analogy has been the object of such a deliberate construction (at the level of the perspective itself as well as of the subject who perceives it) that it has been able to stand out as such and to put an emphasis, in the perception of art, on the question of an identity (which, though partial and relative, is constitutive and constituent) between the work and the natural world. To be more precise, perception itself, as the source of art, comes to the fore, either through the assertion of a common viewpoint shared by art and science or in the resulting demand that art should have a certain amount of autonomy (from the first to the second phase of the Renaissance). But the main point here (at least in my opinion) is that the rise of visuality is more fundamentally conceived according to a thought and certain techniques to the extent that such techniques become the guarantee of a capacity for analogies, the problems of which are posed by the techniques themselves.

As an example, we can take the subject, which is well-known among historians but nevertheless crucial, of the comparison between the arts, the *paragone*. If we take a look at da Vinci's notebooks (section XXVIII), we'll see that the first thing to be done is to raise painting to the level of poetry or even higher, thus turning this

"mechanical" art into one of the liberal arts *par excellence*: "granddaughter of nature and relative of God himself."[5] While poetry "describes the actions of the spirit," painting "considers the spirit through the movements of the body"; and this is how, in the name of both pleasure and truth, it acquires a privilege the core of which is resemblance ("Haven't we seen pictures that offer a striking resemblance with the real object, to the point that men and beasts have been deceived?"). The privilege granted to the image over the word leads to a second debate, within the realm of visuality, on the comparative merits of sculpture and painting, where da Vinci concludes with great forcefulness in favor of the latter. The famous survey by Benedetto Varchi (1547–1549), inquiring into the matter a half a century after da Vinci wrote his notes, leaves no doubt that, as far as painters are concerned, painting is superior. Like da Vinci, they maintain that, in view of the relationships it shares with nature, painting brings many more qualities into play than sculpture (ten instead of five, according to da Vinci's calculation). If, in one sense, it is less directly connected with nature, because of the material and relief, in another, it has all it needs to become its equivalent at a higher level. "Painting demands greater speculative and more speculative capacities than sculpture, and it is more amazing in that the painter's spirit has to change according to the spirit of nature itself in order to become an interpreter between nature and art. By referring itself to nature, painting justifies the reasons for the picture that agrees with its laws (those of vision and perspective).[6] The collection by Robert Klein and Henri Zerner, from which I have borrowed these references, mentions a perverse example (referred to by the painter Paolo Pino, in his *Dialogo di pittura,* 1548): a lost picture by Giorgione in which an armed Saint George could be seen at a single glance from every side, "to the everlasting shame of sculptors" (thanks to a spring and two cleverly placed mirrors).

The question, of course, is not simply to know whether da Vinci was right when he asserted the sensual, abstract triumph of painting as an image, or Michelangelo, when he dismissed him to his daydreams and praised sculpture. But such debates have highlighted the idea of a *variable quantity of the impression of analogy*, in connection with the different means capable of forming such an impression and thus, singly and together, making a synthesis of the world. In the visual arts, besides painting and sculpture (and the bas-relief halfway between the one and the other), this especially involves drawing, and the abundance of prints that have appeared along with the development of book publishing. Here, too, what we call the "reality" of the world has to do with the proliferation of pictures. They seem to emanate from it, since the reference point then is a natural and divine world that we think we see directly. But the eye ensures the connection between the world and its images, since it perceives them. In this way, it confirms their distinction as soon as they become sufficiently detached from it and show that they are attractive enough for the question of their nature to be raised (or raised again in new terms). Perceptive action focuses all the more clearly on *the impression of analogy* from the moment (both real and symbolic, though magnified

by Damisch) a visual machine becomes a visual reference. So the quality of the different ways of focusing what is visible is in direct proportion to the *amount of analogy* they are capable of producing.[7]

This is what I would like to go over quickly, but thoroughly, from the invention of mechanical forms of reproduction — photography, cinema, video — to the computer image, which goes on its own path but maintains an ambiguous relationship with their representational aspect. This would not account for everything that has nourished and modified the impression of analogy from the birth of perspective to the invention of photography. But, on the other hand, it must be noted that, since then, it has been caught up in a spiral movement that we can make an attempt to pin down, up to the extreme limits that give it such strong quality of vertigo: on the one hand, more and more differentiations, and, on the other, a virtual indifferentiation.

Taking the analogy as a guide does not amount to displaying blind faith in the powers of what it designates. The analogue is not the real thing, even if, once was or thought it was. But, as part of a history — broadly speaking, the history of resemblance — idea or impression of analogy contributes, first of all, to situate the periods and forms of an evolution. Furthermore, if we use the concept of nature, in keeping with its religious origin, to designate the relationship of dependence between two terms, the world and the image, the "analogy" also leads us to presuppose such a relationship between the images themselves, in other words, between forms of image as well as between forms and world(s). But, in spite of this, when the relationships of interdependence split and crumble, the images will have supplanted the world and will create worlds themselves ad infinitum. In a few words, by resorting to analogy we can continue evaluating according to a divergence, despite the alterations of the standard, and even almost up its disappearance — which we are often too ready fear or to rejoice at. A reality in art, or at least the idea of the reality — if we believe it will, and, above all, if we want it to go on being useful in some way — still depends on such a divergence, no matter how hard it may seem to define sometimes. If the reality or its idea is no longer of any use, we can throw a vague, cumbersome notion overboard, especially since it is so transferable. That's why it's so interesting.

11. There is something spiritually satisfying about Peter Galassi's hypothesis on the origins of photography. It emerges naturally from the transformations of painting, especially from the new speed with which, at the turn of the century, the eye started studying nature. The eye, which was central and perspective in classical perspective, has become mobile in front of a nature that is now fragmentary and contingent, concerning which photography seems to have been called to perform a justifiable task.[8] Thus photography, removed from the history of techniques, returns to the history of art, and it becomes much easier to deny that, coming from the outside, it could have usurped the functions of painting and hurled it down

into the adventures of abstraction. Well and good. But this way of looking at things has the inconvenience of immediately relativizing the fantastic supplement that was and would be inherent in photography: its *supplementary analogy*. As has been said over and over, this has to do, first of all, with the act itself, its index value, the "that has been" of the instant and the shot. The degree of reality that the lens, which is very aptly called the "objective" as well, gives to the picture is, moreover, apparent in the picture itself. There will be no need to come back to this degree of reality, no matter what divergences (precise, and at the same time wavering) there are between optics (the different optics), natural vision (natural visions) and the signs of de-reality (or of less reality) that photography has never stopped producing, at random or with an ulterior motive, as an art does. A careful look at the rubrics in the catalog of the recent exhibition titled "l'invention d'un regard" at Orsay would be enough to make it clear that the impression of analogy involves not only degrees but also levels, styles and elements (they can be evaluated, if necessary, more or less precisely, as could already be done — though without the complexity and confusion introduced by photography — with painting, drawing, engraving . . .).[9]

It is also clear that the supplementary analogy inherent in photography has enabled it alone to respond, throughout the age, to the extraordinary extension of nature, of the world which has become at the same time always more visible and invisible. Nature is extended through the analogies and is also (re)defined according to whatever can become analogical. The example of the scientific photograph shows how perception, thanks to the optical prostheses that are given to natural vision (microscope, telescope, etc.), acquires an endless number of new images, including even representations that could be described as abstract or fictitious if they didn't belong to the depths of a nature that had never been seen before. It is in relation to its boundaries (concrete realism, abstract realism), which mark the amount of analogy that photography gives to a new spectrum, that a liberation of painting by photography begins, which the latter, in turn, is influenced by (pictorialism, art photography).[10] So, in this way, painting opens the field of vision up to a level of experience that photography is less capable of grasping (and a "model" of which is also offered to painting by science, through its theories of light and color). Thus painting will make an *analogy of impression,* which, at one and the same time, expands, concentrates, unfocuses, and abstracts the vision reduced to a canvas, culminating in the analogy of perception. The remarkable thing here is that impressionism tended (among other things) to immobilize what, in the tavoletta, had been mobile and evanescent — clouds and, in broader terms, the atmosphere — at the very moment when the cinema was turning such volatile material into the rather guileless supplement of an invention which gave it access, both at the end of a long evolution and after a sudden turning point, to the analogy of movement (the famous leaves shaking in the views by the Lumière brothers, which no painter ever would have dreamt of). But the most amazing thing of all is that, precisely while this cinematographic movement was developing (through

the division of space and the first experiences with film editing), painting was moving, with Cézanne, towards the *analogy of feeling* and was on its way, as we know, towards cubism and the various abstractions that enhanced it or continued on from it (all the movements which photography, in its turn, was to embrace on the fringes of its activity).[11] It was as if perceptive analogy, which had first been pushed to the fore by photography, could not burrow into itself and hollow itself out to the point of eliminating itself in favor of a sort of *mental analogy*, until it had, on the contrary, expanded spectacularly by winning the analogy of movement over to its side. Thus the ontological analogy underlying the perceptive analogy became divided in a way that had never occurred before.

Starting from here, we can briefly make four comments.

1. It is by joining ranks as a single mass that the various arts of the image expand and transform the reality of the world (nature) they form part of, while maintaining a divergence in that world between its seizure as such and its seizure as an image (through the common test of "natural" vision). Art, in particular, exemplifies and gives form and voice to divergence by opening itself up to the seizure. The extension of the amount and capacity of the analogy first threatens art in so much as it constantly seems to reduce the divergence in which art recognizes itself. But it seizes it again and incorporates it into its principle, while, at the same time diversifying the analogical qualities (styles, movements, works, etc., which prove to be so many particular treatments of the new quantity), thus more clearly raising the question of the variable quantity of analogy peculiar to each art as that of a concomitant variation between arts.

2. Each art in itself, within its material limits, though it also exerts a pressure on them, is tempted to cover the entire spectrum of the community it forms with other arts, of the amount of analogy that they can assume and ruin severally and jointly. Thus the cinema, at first in a straightforward, bluntly analogical way, extended this quantity, made of corresponding qualities, to the maximum, when it discovered itself as an art (a little like the way painting, a mental thing, extended its possibilities on the basis of perspective). But this quantity was very soon divided and, precisely because of that, it was heightened and relativized. On the one hand, there was the invention (in the second decade of this century) of cartoon films, which shifted the analogy of movement by recomposing it according to a representational vision that replaced the photographic analogy with the old forms of drawing and caricature, in other words, with an idea of vision centering around schematism rather than tangible presence. On the other, ten or fifteen years later came the birth of a movement which was partial but essential, and has never stopped haunting the great representational cinema as the reverse side of itself: abstract cinema, or more or less abstract (it has also been called concrete, "integral," conceptual, structural), which, in its many forms, constantly turned to the preoccupations of painting (of what has become, to some extent — but, in a way, permanently — of painting).

3. Thus, in the gradation that goes from one to two arts founded on mechanical reproduction and set beside the visual arts that preceded them, a pattern of possibilities is established, formed by the overlappings and passages that are capable of operating (technically, logically, and historically) between the different arts. If the twenties still exert great pressure today, it is because that was when the accomplishments that performed the levels of indeterminacy that have become essential for us first crystallized. For instance: Malevich challenging Eisenstein with the need for a higher analogy that goes beyond any visible recognition; the photodynamism of the Bragaglia brothers as they try to extract movement from the cinema and incorporate it into the denseness of photographic material; the cinema, starting, with Vertov and a few others, to wonder about the naturalness and validity of the movement it has just achieved.[12]

4. This is how what we could metaphorically call the *double helix* is set in place. It does homage to the extension of nature foreseen by science (which always exerts a certain amount of pressure). Above all, it underscores the extent of the connection between the two important forms according to which the analogy is constantly threatened and refashioned. The first form has to do with photographic analogy, the way in which the world, objects, and bodies seem to be defined (always partially, and just roughly) in reference to natural vision, a certain fixed state of natural vision, which implies resemblance and recognition. The second form concerns the analogy peculiar to the reproduction of movement. Those are the two forces which, separately and together, are at stake and are misused in a film whenever the image has a tendency towards distortion and the loss of recognition, or its movement is diverted, congealed, interrupted, or paralyzed by the brutal intrusion of photography (the photo-effect: this goes from the snapshot to the freeze frame, and includes the fictions of fixedness and the still shot).

This requires reference to two more points.

— A similar question is posed regarding photography, in many very subtle forms (which I will not dwell upon): either in a very obvious way, through series, montages, collages, etc., as if by means of the *flou, bougé, filé*, etc.; or, more profoundly and, above all, more enigmatically, through the condensation of movement which, strictly speaking, consists of the photographic descent of reality in large images. Each time, in fact, it is time itself, the presence or lack of time, that is aimed at (beyond or through the historical and anthropological time of the "that has been").

— If the cinema is more involved than photography in the functioning of the "double helix," it's simply because it's more vast and its access to movement and time is more general, direct, and complex. And, the more the analogy spreads and goes towards its limits, the more clearly its forms appear in all their variety and force. It's because it alone — the seventh art — has emerged with the capacity to take the place of the previous great arts, if not also, as has been thought, to permit their synthesis.[13] Of course there are other forms, often more refined, than the photographic one, by means of which movement is taken beyond itself in the

cinema. The only real privilege of the photographic mode is that it constitutes a material intrusion of time, which marks and condenses many others, thus attesting the passages between two dimensions and two arts of the image, like those that operate between two forms of image in a single art. Also, in cinema there are many imperceptible spaces on the vague scale of degrees of representation and distortion. But if there is a particular power in the moments and forms that visibly ensure the passage between those degrees, it is because they attest to the peculiar tension that links the cinema with several intermixed ages of painting and the arts of the figure whose fields it has partly taken over.

In short, the two forms of passage combined here in the double-helix image are the edges, or the present virtual anchorage points through which we can imagine what is happening today among images. They have been closely connected since the cinema of the twenties, which brought them closer together and altered their course with the invention of unheard of configurations of images. But it is in modern cinema and the video age that the link has tightened, exploded, and accelerated with extremely violent intersections — video has expanded cinema even to the point of dissolving it in a generality with neither name nor number among the arts.

In a fine article on *L'avventura*, Pascal Bonitzer pointed out the specific instant when the hero, with a sort of deliberate torpor, knocks over an inkpot on a fine architectural drawing, one of those perspectives whose perfection is a secret of Italian art, making another design both over it and beyond it, "a singular figure, though shapeless and nameless." "Aesthetic vertigo," "stain vertigo": an example of photographic analogy drawn, in this case by very simple, natural means, towards something that corrupts it.[14] In the same way the freeze frame, like any too sudden intrusion of photography or photographic elements into the movement of the film, introduces a comparable vertigo and makes a stain.

Video is such a stain. And it is certainly often too glaring. But it is indelible, and already rich in a range of capacities thanks to which a technique has very quickly turned into an art. Its paradox would be that it has gripped analogy in a pair of pincers: on the one hand, it increases its power tenfold, and on the other, it ruins it. In effect, video extends the analogy directly from movement to time: instantaneous, real time, which redoubles and goes farther than the prerecorded time of films, and shows its purest and most atrocious face in video surveillance. Invisible because it is everywhere; blind by dint of seeing everything, it crosses the ages to represent the neutral and negative version of Christ Pantocrator, visible and all-seeing. Thus the capacity of analogy that has been extended to a universal range is led to its destruction by video: for the first time, the bodies and objects in the world become virtually disfigurable (and hence refigurable) according to a power which, in real time or barely prerecorded time (and not only, as in the cinema, by means of a slow elaboration based on special effects), transforms the representations that the mechanical eye captures. This explains why the video image, which was the last reproduction picture to be created, can appear born as

a new image that cannot be reduced to the one that preceded it, and also as an image that is capable of attracting, absorbing, and blending all the previous images of painting, photography, and the cinema. Thus it reduces all the passages that had functioned until then among arts and turns the passage capacity both into what characterizes it in relation with each one of them and what defines it (positively and negatively) with respect to the concept of art. And this is done starting from its double position. On the one hand, it is by nature related to television, in other words, to the case of broadcasting all images; on the other, it is related with video art as a new form of utopia or, at least, of the difference of art. But the video image is still connected, even in its digital transformations, with the analogy of the world that it drives "out of its mind with rage."

This is the "last analog" that Jean-Paul Fargier wanted to exorcise by playing on the two senses of the word *analogical*: its technical sense (we speak in video of "analogical signals" or "analog data"), in which it is opposed to digital or numerical (in computer technology), and its common sense, which implies representation and resemblance.)[15] To the "demon of analogy" that obsessed Mallarmé, as Fargier reminds us, he opposes the "digital angel," which he sees descending today from the intelligible sky of images. This implies that, when it was written, *Un coup de dés* would have enabled Mallarmé to transmute the demon into an angel; and, from there, it can be deduced that video does the same when it goes from analogical to digital. Fargier clearly states: "You don't digitize what you have already analogized. But here's the hitch: while you digitize you are de-analogizing." And he mentions the process through which every image, since then, has tended to be treated as an object and, through self-implication, to become its own sole referent. So the direct effect "in the new space of numerical television" operates among images rather than with the world; and in many of the most powerful works in video art one can no longer distinguish between shot and shots, image and images, to the point that any reference seems to have dissolved to the advantage of a generalized relativity. Even so, the demon of analogy is not definitively exorcised any more than it was for Mallarmé. It is referred to, with the gesture itself, in the first words in the poem *Un coup de dés (A Toss of the Dice)*, throughout which fiction, though it is scattered "in the prismatic divisions of the idea," comes to the surface, as Mallarmé says, and becomes an image. In the same sense, the voice that announces (in *Le Démon de l'anologie*) that "The Penultimate is dead" cannot free itself from the association that it implied at that time for Mallarmé (scraping a palm leaf on a violin) or, even worse, from the sight of the very object which bad "luck" set in front of his eyes in a shop window. The same can be said of the digital image, and all the more so because it is an image. It is not because, in his *Mount Fuji* (in three versions, in order to emphasize the value of the act), Ko Nakajima subjected the image of the famous mountain to every conceivable perceptive-perspective fluctuation, that its referential value is really obliterated. The image floats, is destroyed, becomes objectivized, and reproduces

itself, like the world where it has been produced; and this is not unimportant. But in each image or fragment of an image there is a mount Fuji that is eternized, an image of the real mount Fuji that you can see in Japan, even if it is veiled in a plethora of images of all sorts that are prolonged on Nakajima's tape. Likewise, there is a Sainte-Victoire that can still be filmed (Straub-Huillet have just done so in their superb *Cézanne*, even if the trees were burnt), whose image has been both reduced to triteness and elevated to sublimity by the numerous reproductions that have made Cézanne's views of it known all over the world. Its very clear: either the image is transported and immediately reaches the level of a mental analogy, in the shape that it finally took in Kandinsky and Malevich, or of a sensual abstraction, as in other painters; or the digital carries the analogical inside itself, even if it is as the divergence between what the image designates and what it becomes, in front of the fiction that it establishes in this way, and cannot avoid establishing. Can the same be said of the computer image? Everyone who describes it stresses its insurmountable difference: strictly speaking, the rigorously numerical, calculated computer image would not really be an image, but an object that eludes the predominance of representation and opens up towards what breaks off from it: a simulation.[16] The first thing we notice is that the difficulties involved in defining it have to do with the waverings between two distinctions on the one hand, between the nature of the image and its use; on the other, between its reality (what it is today) and its potentiality (what it may be tomorrow or the next day).

As we can see, the very idea of a calculated image obtained not through recording but through models, according to a form of expression which, over and above language, has dispelled the doubts about meaning and resemblance, does away with the questions of analogy. If the only analogy of the language machine is the human brain, the bounds stretch far beyond what it can handle. But, on the other hand, there is still the eye: there are images, quasi images, what ones sees, and what one foresees. The computer image is always connected with what it represents, no matter what the conditions for the formation and appearance of the representation are (in the form of interactivity or of sight, since it is connected with both, and with all the oscillations that may take place between them). If we take things up where we left them off, we will see that the computer image reduces the power of analogy out of all proportion, while absorbing it and making it disappear by removing the image from recording and time. It is all the more "represented" in that it reduces all representation to zero and, for both the eye and the spirit, can claim of everything it calculates and represents that such things are and are not representations. The computer image is the final, paradoxical expression of the double helix: by itself, without resorting to any precondition, it can virtually modulate the four sides that make it up, and, above all, vary their tensions at will, ad infinitum. In a sense, the pixel is (or will be or would like to be) capable of doing *everything*. But the extent of this everything suffocates it, and leaves the computer image with doubts about itself, in the grips of its own myth, so to speak, and of what it gives to us.

The computer image wants the whole of an overreal reality: the replica of life as it can be imagined from the confusion of the cinema and hologram, but through the vastly magnified power of a program. Thus it becomes the Analog in person, and its tricky reverse side. It is not an image that follows the long-neglected paths that lead from the natural to the supernatural, from the visible to the invisible, from the empirical to the ontological, in an attempt to bear witness, through signs taken from nature, to the Creator whose existence it takes for granted or to the Creation as a living frame and an enigma. The computer image, in aiming at a reality beyond life, involves both an imitated creation and a creation that has begun anew. Total Analogy and the absolute non-Analog. Since we are well aware that we are not imitating God, much less pretending to be God, this would explain why the computer image is suddenly at such a loss when confronted with what it could produce as an art.

It is amazing that, after a fair number of years in existence, it has not yet produced anything resembling a work, or even a real act, of art, despite the fantastic visions it has conferred on our comprehension of images (unlike video art, which soon found appropriate lines of work to situate itself in relation with television and then acquire increasing autonomy; or the cinema, which transformed "an invention with no future" by limiting it to its basic acquisitions, then redeployed most of the previous arts in an unsuspected range of uses). It seems that, as soon as it tended to go beyond the stage of a purely local process or the attainment of an isolated technological feature and to become engaged in a committed production and sketch the outlines of a world or the draft for a work of fiction, the computer image has basically accomplished four things (if we stick to what we have seen). The alteration and recycling of earlier images (the cinema and, above all, painting, with a significant emphasis on key periods, styles, and works — Renaissance, trompe-l'oeil, Picasso, Magritte, etc.). A dubious coexistence with cartoon films, between two extremes: pure mimicry, which only goes to show — but this is quite a lot — that synthesis can catch up with drawing and the eye may not be able to tell them apart in the future (the astonishing cartoon by John Lasseter, *Luxo Junior*); the creation of new components, halfway between cinema and painting, which leads to new possibilities in the fictional treatment of bodies (as in the exquisite *Particle Dreams*, by Karl Sims, in which a swarm of wandering atoms comes together, forming a solid but threatened head that empties itself by breathing in and out). More direct, "realistic" attempts — though they are naively held up on the threshold of fiction — to model nature, the body, and the face. Finally, we have seen a number of compositions that are hard to define: forms, textures, materials, wavering between representation and abstraction, vague, random images. It is in minor ventures, on the fringes, that we find rare attempts that reveal a world and give evidence of a vision of their own, thus proving to be works in their own right — like *Pictures* or *Is There Any Room for Me Here?* by Tamas Waliczky.

This is all, no doubt, influenced by the difficulties inherent in computer

images: costs, computing time, training, etc. And every day new solutions for old and new problems appear. But the computer image is nevertheless held up on the boundary of an everything-analog whose limits are obviously the creative (or should I say reproductive?) capacity of human movement and the interest that inspires it, with an outcome that is uncertain and stakes that are problematic. This is the situation that the scientific images we have seen here and there, which are often so admirable, have to show us (in particular, the simulations of plant growth). In their exemplary purity, on the crossroads between the schematism of drawing and the achievements of photography, they are comparable to the Lumière "views" of an art that does not yet know if it has a future, and if it does, which one — a future of its own, or merely in proportion to its as yet unsuspected combinations with the techniques and arts that preceded it. By programming limited segments of nature, thus opening an access to the invisible, and by recording this invisibility in the collected time of natural vision, such images show that the computer image proposes the following paradox: *a virtual analogy*. In other words, an image that becomes actual and therefore real for eyesight to the extent that it is, above all, real for the spirit, in an optics which, in the long run, is fairly close to what happened when perspective was invented, unless it is precisely the optics that is relativized. The eye becomes secondary with respect to the spirit that contemplates it and asks the eye to believe it. But it is also because, in order for the image to be simulated, as well as to be seen (that is its function as a spectacle, which remains), it has to be touched and handled (that is its properly interactive feature).

If Bill Viola, a superb video artist who is more open than anybody else to violences of the body and the tangible world, was so filled with wonder, a few years ago, at the idea of an "end of the camera,"[17] it is because he saw the mutation as the end of a privilege that had centered (since the camera obscura) around light as the precondition for the formation of images and was destined to evolve in two complementary dimensions: a conceptual space and a tactile space. The former goes beyond the overly pure visual impression to permit an approach to a more complete relationship with space, insofar as it makes it possible to recover the relationship between sensations and cerebral simulations "according to a process that goes from the inside to the outside, rather than the other way round"[18] (in Freud, this is the situation of the dream image). Here the image is conceived as a diagram, a mental projection, rather than a seizure of light-time. The second space is that of manipulating the computer that creates the images; such manipulation is, of course, skillful, but, above all, instrumental, corporeal and gestural. These are the two conditions to "go forward towards the past,"[19] to buckle the buckle which, from Brunelleschi to video, as the last panoptic eye, has concentrated the power to make images around a god who has become more and more absent but always has remained invisibly fruitful. This also implies throwing the spectator out of his allotted seat and bringing him in as an actor, producer, and coproducer of a potentiality. This is the objective that continual references to interactivity in so

Chris Marker, *Sans Soleil*, 1982

many writings on the computer, image aim at — and, along with it, a supplement that is strong and vague at the same time.

There is clearly great power in interactivity (beyond the computer image but also through it). Having played Pac-Man would be enough to convince one of this — or having manipulated a videodisk, (*The Erl King,* by Roberto Friedman and Grahame Weinbren, for instance, which is the most accomplished one I know of to date). As the traveler in *Sans Soleil,* by Chris Marker, says, this power partakes of the "machine aid plan to help mankind, the only plan that has a future in it for intelligence." If it takes the place of the "unsurpassable philosophy of our times," then it is the only social and political utopia we have left. But, as the traveler also says, spinning out the Pac-Man metaphor, "if there is any honor in launching the greatest number of attacks, in the long run, they will always end in disaster." So the question could be formulated as follows: is interactivity, as a necessary, inevitable function with the future in its hands, to be added to the credit of a new utopia, one that is more sensible than McLuhan's "Global Village"? On the one hand, television has changed society neither for the better nor for the worse; on the other, with the symbolic reply of Paik and his *Global Groove* — an implicit manifesto of video art — it has opened new grounds in the difference of art. This suggests that interactivity could be much more profound. On the orbit of a circle that is just as fertile as it is vicious, which we have gone over but may have to look at again, interactivity would be the new dimension of experience which is capable, this time thanks to science combined with technique, of reconciling art with society and life — while reducing their difference — by means of a larger access adjusted for everybody to new standards. The dream of a new "language" approaching a mediate space, between the transparency "of speech relationships" and "those of social relationships."[20] We might also expect, rather more sadly, that, behind what it

betokens of "conversation" and access to new forms of subjective do-it-yourself operation, interactivity, as myth and reality, may finally work in favor of an even greater dispersion of the social community, and also of art, which, once again, will only be able to survive by endowing itself with new instruments.

This tension could be expressed through three images. The first is the "quick dip" that all images would finish in. If *Who Framed Roger Rabbit?* is a solid film, it is not because, like others before it, it combined cartoons (schematism) with traditional shots (the photographic analog); it is because it did so with such quickness and confidence in the procedure.[21] Thanks to the rapidity that prevails in mixing the figures (the computer's contribution), the image reaches a level of blending that had been unimaginable before, with a "naturalness" that is immediately accepted and establishes a new wavering between levels of representation. But, above all, as in typical great Hollywood films, the power of the entangled screenplay lies in its having turned the wavering into its subject: can we distinguish between one image and another? Toontown and Hollywood? A toon and a man? Can we still conceive the function of a show that serves as a catharsis for the community? Or does it run the risk of dissolving, along with the images, in the "quick dip," the acid in which the true-false judge, a symbol of disorderly law, wants to plunge all the cartoon creatures that have been conceived in the history of (American) cinema?

The second image emerges from the teletransport machine in *The Fly* or the television in *Videodrome*. If David Cronenberg is an important director, it is because he was the first to show so clearly and overwhelmingly that the transformation of bodies through pharmacology, genetics, and surgery is contemporary and comparable to the fashioning and broadcasting of images and, in broader terms, to the data of television, video, telephone, and computer communication. Against an obsessively genealogical, sexual background, a mortal duel begins around the image and reality of bodies, between man and machine, between imaginary components that have become hyperreal and a subject that has been left to the pangs of its own psychic and physiological mutation.

The last image is that of *L'Eve future*. A century ago, barely ten years after the invention of cinema, Villiers de l'Isle Adam imagined having the inventor of the gramophone and electric light bulb be the creator of a sublime creation: Hadaly (the Ideal), a robot, the first computer-woman, programmed as a woman-version work of the utopia of the Book, a writing machine as well as the "supreme vision machine." In short, interactivity itself, since Edison has promised it to only one person, the lover thirsting for an ideal, who is destined, in solitude, to go to the very end of his desire. The story has a sad ending, like romantic love affairs and exaggerated utopias. But not before Villiers has made his point through the substance that is necessary to the conception of his machine as well as to the art that starts taking shape in connection with it. The writer took care to have the scientist enhance the beauty of the model that allows Hadaly to be endowed with an appearance and the genius of the inventor who turns his fabulous Andréide

into a crossroads of sciences and techniques with the element without which there would be neither woman, machine, nor work. The substance that he borrows from one woman to give to another: a soul.

FRAGMENTS OF AN ARCHIPELAGO

"Between"

There is a famous sequence in *Blade Runner* (Ridley Scott, 1983) where the hero analyzes a photograph with the help of an "electronic magnifier." This is the moment that reveals the core of a film based on the idea of the double and the transition between the mechanical and the living, in which sweet automatons add something more to the opposition between superior androids — the "replicants"— and human beings. The heroine is one of the five creatures whom Deckard, the "blade runner," has been ordered to exterminate after their intrusion on Earth, in Los Angeles, 2019. Rachel has a unique status that enables her to survive and justifies the fact that the hero finally falls in love with her once his mission has been accomplished. She has memories, but they are false and, based on photographs, they belong to someone else's past. ("She clung to a snapshot of a mother she had never had, of a little girl she had never been.") The film is full of these static pictures, the erroneous tokens of an identity, the obligatory passage-ways through which the replicants, who have been programmed to "imitate human beings in every aspect except their emotions," nevertheless become too human and fall into the grips of emotions in their search for a genealogy and in their tormented fear of death.

The sequence where Deckard looks about in a snapshot (a snapshot that he has put on his piano among his family photographs) in search of a tiny clue is paradoxical in that it treats the still picture as a space that has two or three dimensions (unlike the sequence with a similar theme in *Blow Up,* by Antonioni (1966), where a "stain," lost in the frame, finally became the clue to a crime). Here the machine obeys Deckard's voice and enters the picture, which reduces itself from the whole piece to its details. But the series of forward-backward and lateral movements that the "camera" performs presupposes an improbable space where it would have turned inside the picture or crossed it upon discovering its depth (even, symbolically, crossed a mirror, to find the concealed body of a woman stretched out on a bed, with the scale he had been looking for on her ear). Thus the fiction of a space that has been prephotographed from different angles is constructed, a sort of synthetic space with data that have all been programmed and a finite number of frames that will be brought into sight as the investigation unfolds. This is a way of combining the analogical and the digital, of going from one into the other. Two things must be added to this. Movement inside the photograph takes place through a series of decompositions, of focusing on static

details belonging to motionless material (they are predrawn electronically by a series of as yet virtual frames fitted into one another and encircled by a blue line); so we jump, together with the machine, from one still shot to another and, hence, from one level of representation and recognition to another (one imagines a single photo from *La Jetée* worked upon as the space in *Sauve qui peut la vie)*. But the phases of movement, of false-movement, of passage from one frame to the next, which are very sudden and punctuated with a blue flash, amount to so many outbursts of distortion whose effect spreads beyond their own duration; they damage the image we discover, the resemblance that is being created to the point that we are hardly surprised at what is most surprising, and look at it twice before we watch out: the Polaroid Deckard asks the machine for when the operation is over shows an image that is a little different from the simple close-up of a face that we had just come to. Thanks to the angle Deckard's hand gives to the photo, the variation of light in a more condensed frame lets us catch a glimpse, on the left, of a fleeting reflection of the inclined face; as though the mirror we had just crossed were invisibly represented. These are phantom effects of photography, which are sometimes close to painting or the way video is used. This is how the midpoints between mobility and immobility, between the identity of representation and its loss, on the borderline between life and death, subject and simulacrum, are very closely adjusted to the image of the whole film.

In *Granny's Is,* by David Larches (1989, 50mn)*,* there is a moment that condenses the disturbing effects of a radical work, the title of which clearly announces a unique capacity to interweave and overlap its elements. In it, the author recalls the figure of his grandmother (he spent ten years filming it up until her death), sometimes falling back (in a voice off) on what Proust wrote about the death of his own grandmother — the deceptive image he gets from the photograph and the one he has as he remembers her. In a very unstable material, built on a vibrant fusion of painting (representational and "abstract"), photography, cinema, and video (Larcher was mainly a director of experimental films and had just recently started working with video), the moment I mentioned is of interest because, in a well-nigh theoretical way, it fixes the intensity of passages that sometimes function on the limits of what is recognizable.

In a room where he is both actor and director, in a real house, Larcher goes about his business, leads his life, shoots the film and talks (off) with his grandmother. When he gets up and the camera goes back, the picture goes along with him into the picture box (a photographic chamber inlaid so as to make a monitor), which is now situated in the room itself, and an innerscreen appears in relation to which and in which the scene takes place. Larcher, who is now outside this picture, adjusts the lights and modulates rich, arbitrary color effects. Then he goes in front of the screen (from right to left), and his body blots out the picture, thus giving rise to another picture: a boat tilted among waves and thick clouds, reminiscent of an improbably blue Turner. And at that very moment (likewise the moment when a distant bass voice starts reading

the text by Proust) a formless form, green and yellow trimmed with black, a sort of streamer, enters on the upper right-hand side, as though following the course of the body, comes forward in the frame and, slowly unfolding, covers the screen: it is a very large close-up of the face of his grandmother, lying down, entirely motionless, one eye closed, the other invisible. Then an identical image, this time coming from the lower left-hand corner, rises, and presses, in its turn, against the first one, causing a movement at the point where the two images come together: his grandmother turns her head and speaks (we never see her mouth, so it is never clear whether the voice is off or not), her eyes alight with a very delicate pulsation. Then her head falls back in exactly the same position as the first image, and a slight tremor runs over it.

What can we infer from this moment that goes on under the increasingly precise pressure of the text by Proust, of the representation of the boat (it returns three times), of the images of the grandmother, amounting to so many variations on the same theme (until her image, overflowing the borders of the inner screen, occupies the entire frame, and disperses in a number of still shots that slide under one another)? First we notice that the painting, photograph, still shot, and videogram form part of a single chain (they are distinct and, at the same time, indiscernible: we can't tell whether the boat belongs to the painting or the photograph; and the entire work wavers between two supports, film and video). Next, our attention is caught by the fact that the passage from the unrepresented to the representation (and the potential reverse movement) is a dimension peculiar to this chain, its condition as well as its effect. Finally, all this is in accordance with the need to maintain a tenuous vacillation, which has rarely been mastered so perfectly, between the mobile and the immobile image: an intermediate element made up of what, in each one, tends towards and returns to the other. The theme, of course, is conducive to this. But it is never more than the representation *par excellence* of everything that incessantly hesitates and moves from death to life.

Sans Soleil, by Chris Marker (1982, 100 mn), is inspired by a similar desire of intellection, between a vision of a future society and the relentless search for personal existence. How can we speak of what we love, say what moves us, what inspires us, the pregnant instant experienced as a succession of threatened, but nevertheless intangible, images?

In Marker's film there are three characters, three forms of image, and three urgent questions. The first character is Sandor Krasna, the "cameraman," who gathers documentary pictures and draws up a state of the world (this is Cape Verde, Guinea-Bissou, Iceland, France and, above all, Japan). The second is Hayao Yamoneko, the "video artist": he handles some of his own images and other pictures by introducing them into a synthesizer. The third is the "film director" and master of heteronyms; we have to live in all the images and others as well in a film that is a block of space-time worth all space and all time. The first type of image is the cinema-picture, which is shown in the rough in the documentary, flashing by with nothing to alter its analogical value (even if, depending on its

motifs — everything that tends towards still life, for example — it fosters confusion with photography). The second kind influences the movement in several ways, marked by three fairly sudden freeze frames: three sharp images, sustained by the key terms in a commentary-narrative which, in a woman's voice, relates long bits of letters that Sandor Krasna sent to her during his travels (thus he questions, through these three shots the possibility of remembering, the democracy of sight, and the prohibition that has been affixed to sight in the camera for so long). But the suspension of movement spreads much farther, as though contagious: the multiple, suddenly frozen shots of Japanese television (some of which, swept away by the motion of succession, throw the effect of immobilization into relief all the more clearly; others are tracked down by a camera that scans them as though they belonged to supplementary titles); numerous photographs, strip cartoons, the proliferation of tableaux vivants, stuffed animals, paintings, and sculptures — in short, everything in past and present culture that bears the stamp of the frozen instant. There is also something to be said of the more or less constant immobility of sleepers, dreamers, and the dead. The third sort of image has to do with distortion. It varies from the mere supplement (inflation of color, as in old tinted films) to persistent transformation and nearly to unrecognizability. All this is handled by Hayao Yamaneko, in his retreat in Tokyo, on his synthesizer, as well as virtually all the images. Thus the three questions that haunt *Sans Soleil* take shape. First, the power of the instant: how can one keep the instant; in other words, how can one have access to it? How can one remember at the very moment when the instant occurs, at one and the same time ideal, decisive, and fruitful? Second question: how can one exist in time and in space? In other words, how can the simultaneity of points in space (that of the subject who travels, records and witnesses, but also, beyond that, the space of the occurrence that takes place everywhere) be turned into an experience with memory and time? Third question: how can the two questions be turned into a single question?

In a sense, the whole film, caught up in the tension between impatience and indolence that modulates its circular composition, never stops giving the answer, according to a text that keeps coming back to the question. But the answer emerges more precisely from the conflict, from the passage between three forms of image. The moment of the freeze, for example, is the instant that makes it possible to fix "the real sight, looking straight forward, which lasted one twenty-fifth of a second; the time of an image." That's the photo time, the duration of the still. But, at the other extreme, the only time capable of dilating the instant and working on it by incorporating it into all the others in order to make it enter real time is the one that comes out of Hayao's machine: a machine to go back in time, in which he transforms the images of the past in order to give them over to their contemporary present, to their destiny as new images. "Hayao calls the world of his machine the Zone — in homage to Tarkovsky. . . . He asserts that electronic material is the only kind that can deal with sentiment, memory, and imagination." Through "non-images"— images that are

dealt with thanks to the forgetfulness of which this new memory is still capable ("while awaiting the year 4001 and its total memory") — the image-instant retains its vividness among the surrounding images and, all together, they form a time block — this film— thus affecting the three sorts of time in all the images.

This is apparent in a symbolic way twice. First, in the long sequence devoted to *Vertigo*, the only film that has been capable of saying "impossible memory, mad memory." With the necessary tact, Marker immobilizes the instants in *Vertigo* that grip him, among scenes chosen in the film, and makes them enter into the sphere of his forms of image. Furthermore, he isolates the famous spiral of the credit titles and uses it as the emblem of the new time by treating it as it is, as though in anticipation: the very image of the Zone, almost a computer image already, bearing the "time figure" inside it. Then there is the next-to-last shot of *Sans Soleil*: "the real sight, looking straight forward, which lasted one twenty-fifth of a second," the time of an idea, decisive, fruitful instant, had at first (in the first third of the film) been on enchanting glimpse of a woman; there had been no reason to freeze it then, as there had been with the three preceding images, since the text fulfilled the function of the image, while reserving its mystery. But at the end of the film we find this shot, this photo, this still, both immobilized and, at the same time, fallen into the Zone. Perceptible and, at the same time, remote. Thus it has become a sort of weft that condenses, in itself, the passage that continually operates between the three questions, the three forms of image and the three characters.

"In front of"

The most important difference between the cinema and television is, no doubt, that we keep passing in front of our set, even when we choose to stare at it as though we were in a seat in a movie theater. And this goes hand in hand with the fact that everything, absolutely everything, happens on television (indiscriminately and simultaneously). This is the situation that the video installation in the ambiguous gallery and museum spaces invites us to conceive anew, condensing certain gestures, postures, and moments in a story that cannot be controlled: the spectator's own story.[22] Here he is, a viewer-visitor, who does not know if his vision is a look at sculpture, if he is discovering part of a church (the strange effect, in a chapel in Cologne, of the Christ with five monitors — *Crux,* by Gary Hill, or of *St. John of the Cross,* by Bill Viola — beneath a subterranean vault in the Charterhouse in Avignon), or if he is a stroller domesticating the stained glass windows nearly of the twenty-first century in new "passages," a composite being trying to bring the fixed vision peculiar to the cinema and the multiple visions that have taken their place in front of canvases in the history of painting together in a single view. So the installation is a place where there are passages. But it is also a place of worship. Restricted by its own space, it is paradoxically not very suited to reproduction (it is often fragile, costly, and hard to photograph), while it has recourse to the most sophisticated

elements of reproduction techniques. For these reasons as well as by choice, the installation, in the best of cases, provides a supplement, which is very clear though difficult to name, for the double helix of the image.

Let's take *Eté - Double Vue*, by Thierry Kuntzel. The contrast between fixedness and movement is immediately taken to the extreme. And it is intensified by the contrast between the screens and what they represent. On the one hand, there is a tiny picture, where a scene takes place, as in very early films, in a single shot-*tableau* where the smallest actions are arrayed. On the other, there is a gigantic picture, hypothetically taken from a detail of the first one, made of a single, large close-up, and animated by a movement on a body. The cruel, programmed hypercontinuity of the movement is heightened by the somber clearness of an image that may seem less candid than that of the little image facing it, with its hyperreality, merely because of the enlargement due to the projection. But what interests me here, without stressing the fact that painting is brought into play again as an important part of the operation (*Eté*, the picture by Poussin, the art book in which the spectator looks at it, the perspective discovery in the small picture, its implication in the large one), is the effect that comes from the spectator's view. He cannot, of course, see both pictures at the same time. So he can only remember one while he's looking at the other, since the time of passage from one to the other is so brief. But what happens in that instant? Simply a jamming effect, a blot. A dimming. A fixedness that checks movement. A sliding that disturbs the static shot. In the instant of transition when the two images are combined, as in the contemplation of each one of the two images invaded by the other, blending perception and recollection, the mental operation introduces a distortion that is characteristic of the mental image itself as soon as it enters into a perception, and thus makes it take part in a hallucination. And it is all the more apparent because the vision of the thing that it perceived displays a total clarity. It quivers with clarity, like a mirage in summer sunlight. A double view: the supplement of vision disturbs it and produces a fragile anamorphosis or the dividing line between mobility and immobility.

A similar effect is produced by *Eviction Struggle*, by Jeff Wall, though with a greater gap between the materials and mechanisms. This time, a course is followed on both sides of a single enormous rectangle that has to do with more than a simple reversion in a mirror. The contrast between the materials is radical. On one side, the sublunar brilliance of the cibachrome illuminates a huge photograph of a cityscape. On the other, nine video-film images extract nine actions in motion from the static action of the large image. They become more and more complicated while alternately showing the shot and reverse shot of each action, repeated and varied ten times over, linked in a chain for an indefinite length of time, and more or less slowed down and chained to themselves in a sort of locked progression. As a result, we have a very strange feeling when we go from one side of the block to another and receive the global effect in front of each one of its sides. The overly static image seems animated by all the milling about that takes place in its depths and spreads virtually

to its slightest motifs. Meanwhile, we try in vain to recapture a complete scene which has been destroyed by the black holes between the monitors and punctured, like a canvas, or shattered, like a mirror, by the outburst of actions that seem to acquire a real death, a density that has entered the third dimension. All this also takes place in the box, in the dark, which becomes an image of the brain crushed by its own visions. And, once more, one can imagine to what extent the confused-impressions combine two levels of analogy that grip the image — the images — in a vice.

The passage leading to the image is long and narrow. But when you reach the image, it's too large, too high, and too close. We can only remain standing or sit down on the floor, overwhelmed, also having to face the idea that, this time, the show lasts six and a half hours, since the original twenty-six minute film has been slowed down sixteen times by Bill Viola in order to obtain such an extraordinary result. *Passage* aims, in a more direct way than most installations, at playing with the situation of the typical cinema spectator stockstill in front of the film. Kuntzel had tried to do this in another way in *Nostos II*, by bringing the divergence to bear on a tumultuous perception of space, through twenty minutes of images scattered at random over a screen reconstructed with nine monitors (in other words, eighty condensed minutes) — whereas Viola bases his disjunction of space on an excessive expansion of time. This means that the spectator is invited simply to pass by, unrestrained by time, but that he is, nevertheless, constrained to take position in a procession, in conditions that confront him with a screen as though with a place that is so disturbingly close that he can fondle the illusion of touching, piercing, intruding. What happens in it could have been trite — a child's birthday, the American rite *par excellence* — if the image were not located very precisely at a midpoint, habitually surrounded by a combination of more acute differences heightened by a multitude of' postures. What we see is no longer mobile or motionless, representational or abstract. It never stops flowing like an organic matter that rocks you because it is swinging along with the slightest possible gaps between the four extreme sides that form it. With nothing more than a red, yellow, purple ball, a blinding light bulb, a blue window, the four candles on the birthday cake in the dark, a quick zoom, a close-up of a child illuminated by a flash of light or suddenly plunged in shadows, we go from one side to the other; but so imperceptibly that we think we're touching a mental form, while the screen is very close, very material. And the sound, treated in a similar way, makes our speculative activity, like an enveloping wave from the depths, surge up in the two installations by Wall and Kuntzel and reverberate in the purest silence.

"A"

Writing about *Lettre de Sibérie* (1958), André Bazin pointed out that Chris Marker had invented an entirely new form of montage: "Here, instead of sending you back to what preceded it or forward to what follows it, the image goes sideways, so to

speak, to what is said about it."[23] With his habitual lucidity, Bazin anticipated an entire aspect of modern cinema that he could not have known, a cinema that was to become more and more spoken, or vocal, fashioned with complements and disassociations stemming from voices, texts, and speech. The cinema of Resnais, Duras, Straub, Syberberg, and Godard. This is the cinema that video and all new forms of pictures are endowing with a supplement, which Marker uses and interprets in *Sans Soleil*, leaving us with a premonition that there is more in what he says than meets the eye by putting the stamp of what he says on what he shows.

Here we come to a critical point. The question is no longer merely to speak of the image, or of the implication between the soundtrack and filmstrip, between the text-language and the picture, but rather to speak of alterations that affect both image and language, directly conceived in relation to each other as materials. As I said, this implies taking the *of* in "Passages of the Image" to mean not only the recently discussed *between* and *in front of*, but also, with and through them, it involves going from the image *to* what, having been formed along with it, goes beyond it, or at least shifts the idea we have acquired of it enough so that it becomes hard to define: beyond the image, an analogy that surpasses it, since language also has a role to play — led by its demon (which, like the image's, will never turn into a pure digital angel). This rounds out the diagram of the double helix. As we see in science books, it is dominated by two "risings" that intertwine and spiral upwards. Here the two risings have been used as metaphorical prefigurations of the two fundamental forms of the image. But between the risings, in and adjoined to them, are the "rungs" that contain a genetic code.

Such as the language which, for us, is lodged in the image. It should be understood that the point here is only to bring the matter up as an object of perspective. Its materialization basically involves two names, with Chris Marker as a mediator: Gary Hill and Jean-Luc Godard.

For a long time now Hill has been looking for a way to see language in images, to pour both of them into the depths of a single material. He has tried to extract it from sound, the first experimental terrain related with the image, and has gone deeper and deeper into the enigma of sound that makes sense and, as it makes an image, is capable of making images and embedding itself as something utterable in a that it partakes of. Hill has also frequently made use of the power of the voice, of the text, of the pressure that is thus exerted on an image that would be inconceivable if it weren't saturated by the flood of words. But he has to find the voice he needs to make it resound through its visibility, with words that become the warp and woof of an image that they contribute to and in which they tend to live the life of an image. Bear in mind the extent to which they are caught up in the sense that existed before, just as the image is taken from the preexisting body of the world (no matter how disembodied this world may become). A single example: the end of *Happenstance*. A tree conceived as a phantasmal tree-pattern, halfway between diagram, painting, and photograph (were not trees predestined

for such a midpoint, since they have been used as models for machines and speech?) sheds thin white layers of film; we naturally associate them with leaves or birds, but when they fall on the ground they turn into letters and words. Words that undulate and shimmer like substantial things, and give us their message "NOTHING TALKING, SILENCE THERE." Meanwhile, the voice, as in the utterance in *Un Coup de dés*, restates what the words do in order to confirm what they become: "The words are arriving listen to them. They are speaking of nothing — nothing but themselves with a self-confident logicality. I speak — I speak to them. . . ." They speak as images.

If *Disturbance* (after the installation, *In Situ*, and the tape, *Incidence of Catastrophe*) opens such broad horizons, it is not only because this installation, with its seven monitors, has developed all the effects of the double helix, with its dual language: speech and images. The theme and the range of views it involves reach to the foundations of our culture by entering the image through the book, by reexamining it on the basis of the book. Kuntzel had already touched upon this, from *Nostos I* (tape) to *Nostos II* (installation), pouring a book that had been skimmed through in the form of images, multiplying it with a screen made of nine screens and then taking the cinema-mechanism that had been conceived anew by means of video back to its psychic-poetic (Freud, Mallarmé) origins. Gary Hill adds nature — rocks, water, fruit, animals — and the words to express it, for which he finds a sort of substance in the *Acts of Thomas* (apocryphal Gnostic Gospel). He has to be able to establish himself fully in the world all over again, amid the shock and *disturbance* that are involved in the search for a new contract between words and images.

This is the same question that Godard has brought out with renewed precision in a marginal film, which is his most important work in recent years and the one that comes closest to the venture he achieved with *Histoire(s) du cinema: Puissance de la parole*. From the very first words — the only ones that Godard himself wrote in this case — the purpose is to go from cinema to video: "Within the entrails of the dead planet, a tired old mechanism quivers" (film comes and goes in the reel containers on the editing table). "Tubes radiating a pale, vibrant glow awoke" (this refers to video). "Slowly, as though reluctantly, a switch, in neutral, changed position" (this difficult passage from cinema to video enables the image-sound to gain new positions). From there the intrigue unfolds, with two actions alternating: a broken, resumed, halting telephone conversation between two lovers (this hypostasis of Godard's domestic scene is taken word for word from *The Postman Always Rings Twice* by James M. Cain); a metaphysical dialogue between a man and a young woman, two angels (it is taken from the tale by Poe to which the film owes its title). Everything has to do with the relationship that is established, in images and words, between the two actions and inside each of them. During the exchange between the two lovers, their bodies melt into the landscapes that the voices evoke and cross, to the rhythm of an acceleration-superimposition of images harmonized by the numerical montage. Thus there is a representation (in a realistic-poetic style, with cables and satellites) of the voice's trip

through space, sometimes modulated with echoes (Frank's first "hello!" is repeated eight times). The first utterance that goes, solemnly and splendidly, from the man to the woman, with the tree-bird, at the end of the route, alternated-superimposed on the heroine's body, seems like an Annunciation. In this way, the mimetic swiftness of the images sustains a metamorphosis: words turn into images, which become the embodiment, vibration, and echo of the words that presuppose them.

All the work prepared since *Ici et ailleurs* and *Numéro Deux* to put words on the screen, to make them work in images, culminates in this magnificent mutation effect: words identified with the material spaces they cross, thought forming one body with the earth, everything in the universe opening double and single fires of emotion. Amorous transports — passion — become transport for word-images between united and separated bodies in a sort of essence of (impossible) Communication — "above and below communication," in search of a new form of expression. The power of the following dialogue, forming part of the first one, lies in its intensification, in the words themselves, of the sensitive division in the conversation between the lovers. "Did there not (says Mr. Agathos to Miss Oinos) cross your mind some thought of the *physical power of words*? Is not every word an impulse on the air?" In other words, an image doubled: the sound image of the vibration of the word as well as the visual image of the fragments of landscape and matter mixed together, in the conversation between the lovers and the dialog of the angels. Images of nature, elementary and cosmic. Images of painting (Bacon, Ernst, Picasso, etc.) involve the passions of bodies and the earth again through the question of their representation. Pictures in slow motion, frozen, shattered; or reconstructed, transformed, represented anew thanks to the swiftness of the montage and the potency of the special effects. In short, images in search of a new speed, which Godard has been looking for since *France Tour Détour Deux Enfants,* but this time really capable of changing speed, for instance, of going from a "photographic" representation to (more or less emphatic) sketches of distortion. So here all the elements speak among one another and represent one another as, I think, had never before been seen or heard in a fiction film. So what is the achievement shared by *Puissance de la parole* and *Disturbance*? For each author, it must be situated according to what completes it and adds something to its sense: for Hill, the force that has been compelling him for several years now to explore Blanchot's *Thomas l'obscur* (*In Situ, Incidence of Catastrophe,* and recently the installation *And Sat Down Beside Her*); for Godard, the evangelical screenplay of *Je vous salue Marie.* The idea is to return to the origins of the world, of our world, the world of the law the book, in order to understand how it turned into a book of images, and what the consequences are.

When St. Augustine stated his famous proposition "Though man worries in vain, he walks in the image,"[24] and when the iconodule Nicéphorus based his defense of images on this extraordinary assertion, "Not only Christ, but the entire universe will disappear if there is no more circumscription or icon,"[25] it was only possible to place such trust in the image and the incarnation it implies insofar as the image was

dependent on a Word on which its visibility depended. This dependence imperceptibly crumbled, starting with the "crisis" of the Renaissance, and gradually, over the centuries, led to the autonomization of the visual image. This, in connection, as we know, with the autonomization and diffusion of the book, endowed the image with a power of its own, regardless of the discourses around it or the verbal background from which it emerged. While the prototype of Brunelleschi was the symbolic starting point for such an autonomy, the invention of the cinema was certainly its culmination and turning point. It is not irrelevant that, at the very moment when cinema appeared, a theory of the unconscious was being elaborated in which a division was formulated: in Freud's thought it opposes the representation of things with that of words, conferring on the former, the additional attributes of an image and originality, of being irreducible and having body, which one must break away from in order to have access to the latter, and from there to the language that will be able to utter them. All French reflection for half a century has thus been drawn between the pincers of the word and the image (of the figure and the discourse): from Lacan restoring a privilege to the Word, reversing Freud, to Lyotard trying to switch the deal around and reshuffle the cards; from Barthes, short of words, concentrating on the ineffability of the image, to Foucault and Deleuze, refining new strategies (in Foucault the "visible" and "utterable," which have been given such prominence by Deleuze) in an attempt to go further than the antinomies, autonomies, and dependencies of a long history. This, I think, is what Hill and Godard accomplish, in turn, by giving the question a special turn of the screw, perhaps an additional aspect, when they try, not to rediscover God, but to envisage a new foundation of the word in the image (or through the image). A word that is both consistent and dissolved, with no more privileges than the image to which it gives itself and which it thus tears away all the more clearly from the sphere of a groundless divinity that has no grounds for existing.

This is not, to be sure, an appeal to a decline or even to a substitution of the visual image (though it is clear, as history and ideals show, that there has been a tendency — in Benjamin, for example — as there still too often is, to identify it with "art"). In a certain sense, nothing is more important than the silence of great images. The kind that remains attached to real photographs. Or the less common kind that emerges, for instance, from the works of Kuntzel and Wall, which is so different from that of silent films (which had not been sought and, above all, was less thorough than has been thought), and, on the contrary, so close to the silence that has been diffused through experimental films up to the time of video art. So the point would rather be (and the entire *Image Passages* exhibition, on the whole, bears witness to this) to make this commonplace but necessary observation: there is no visual image that is not more and more tightly gripped, even in its essential, radical withdrawal, inside an audiovisual or scriptovisual (what horrid words) image that envelops it, and it is in this context that the existence of something that still resembles art is at stake today. We are well aware, as Barthes and then Eco have

been pointing out for some time now, and as was so admirably reformulated by Deleuze with an extraordinary emphasis on the image,[26] that we are not really living in "a civilization of the image"—even though pessimistic prophets have tried to make us believe that it has become our evil spirit *par excellence*, no doubt because it had been mistaken for an angel for such a long time.[27] We have gone beyond the image, to a nameless mixture, a discourse-image, if you like, or a sound-image ("Son-Image," Godard calls it), whose first side is occupied by television and second side by the computer, in our all-purpose machine society. This is clearly where we can observe all the potentialities anticipated by the computer image, over and above the image itself, since it is produced by the same machine which, better than any other, can combine and relate interplays with images and with language to any conceivable extent. But this discourse-image is also a murmur that reverberates like a larger and larger voice that becomes more and more alien (the alien voice that was evoked so splendidly by Blanchot in its always potentially close relationship with *dictare*, dictatorship).[28] And, as he says, it is in front of this murmur, but as close to it as possible, that art ("art or nearly art," as Mallarmé said of *Un Coup de dés*) finds its duty and its chance. "Harmony parallel to nature," as Straub-Huillet have Cézanne say, so aptly, in a film that was made, precisely, in our time. No matter what the new nature is, or what remains of the old. In the long run, we'll have to invent a name for this new art, or — why not? — simply go on calling it "cinematography." On condition that *graphein* embraces the power of the voice as well as the physical quality of words, and that *kinema* includes the touch of the hand and all kinds of time. □

TRANSLATED FROM FRENCH BY JAMES EDDY.

Video, Networks, and Architecture

Some Physical Realities of Electronic Space

■ Kathy Rae Huffman

A form of architecture can now be located within video and computer technology. It is electronic volume, a phenomenon that also provides cohesion for radical artistic communication practices. This is intelligent space! It defines information as site, especially as it informs the influence of experimental art and the fundamental discourse relevant to the *reality* of data space. The expanded redefinition of the virtual as real has been reconstructed by traditional communication practices such as radio, telephone, and television, and their manifest contemporary forms in electronic network environments and their evolving multimedia network applications. These spatial expressions employ electronics not only to decode the transparencies inherent in the video and computer images we normally observe, but in this case they are also used to define the physical, navigable properties of electronic data space itself. In an obvious contradiction, these *spaces* are conceptually embedded in the intelligent mechanisms that exist independently of what is visible on the surface of an electronic screen. This spatial transparency, which as Virilio notes has long supplanted appearances,[1] takes on physical dimensions of a new order at this point because the representation of overlapping physical and electronic realities can now be readily constructed, observed, and experienced in convenient formats.

Equally important in a discussion of an electronically created terrain and virtual architecture is the consideration of the critical and theoretical discourse that connects video, informatics, and the geography of space.[2] These concerns, which have evolved during the past three decades of practical experience, research, and observation by artists using the new media of their era, are the direct consequence of the exploration of the media's potential, including the investigation of the altered and elaborated electronic image. Likewise, the rapid advancement of the understanding of information networks underscores a completely new phenomena: the traceable grid that exists in electronic space. A revolutionary new understanding of this volume is a result of what once seemed to be an impossibility: the representation of depth in the electronic frame. But, according to Deleuze, impossible ideas from one medium often translate to another, because a creator who is not seized at the throat by a set of

impossibilities is no creator. A creator is someone who creates his own impossibilities, and thereby creates possibilities.[3] Network communication and navigation now transcend the political understanding of boundaries, and a travel route can also be understood as the trajectory of movement into experiential trails of electronic memory. The radical shift of understanding towards the idea of media volume is a revised understanding of space.

The experiences of artists and technicians, throughout the history of video and multimedia technology, has advanced the understanding of how the viewing of something progresses from the metaphysical, or psychological act, toward a perceptual understanding complete with physical experience and comprehension. This experiential phenomena translates into an awareness of how images function on various levels of the communication scale. The online real-time exercise in the simultaneous transmission of ideas functions as an example of the numerous communication energies and impulses crowding earth's airwaves, outerspace, and the universe. In our real-world environment, we participate in the network of intense frequencies that intrude into — and upon — the rhythm of the human body. Both tangible and intangible effects of this information bombardment are physically evidenced. As invisible phenomena, this is media information portrayed by way of digital decoding, and analogue visualization processes. In a selection of video for the exhibition "Intelligente Ambiente/Intelligent Environments,"[4] an attempt is made to create a new awareness of these mysterious communication media as a new epistemological space: a real space that combines video and computer technology with theoretical and practical issues of architecture and appearances.[5]

ARCHITECTURE AND COMMUNICATION

The intrusion of media in today's urban environment is overwhelmingly apparent as a system of electronic space mapping. These abstract functions range from real surveillance mechanisms, to the analysis of how traffic moves, or how design

Left: Merce Cunningham in Nam June Paik's "Good Morning Mr. Orwell," 1984. Center: Ponton European Media Art Lab — Arts Project. Piazza Virtuale: a. i. Right: LIVE AID — from TV.

functions in physical space. We have grown accustomed to these systems, which are ongoing, and are always quietly at work. The next generation of communication technologies will require more advanced, conceptual ability to receive and perceive abbreviated language, as bits of images from commercial and authoritative sources. This information will involve the physical and psychological immersion into electronic advertising, official regulations, and state propaganda. Therefore, the necessity to expand the creative expressions of environmental electronic architecture is a developing concern of designers. The alternative, unrestricted exploration of multimedia artists is of real value to urban planners, architects who are socially concerned with the numerous electronic augmentations and configurations of natural space.

This cinematic phenomena, previously known and visually translated as the genre of architecture on film dates back to the beginning of experimental filmmaking at the turn of the century. By tradition, this activity was primarily an interpretive look into spaces and structures, and the early films made by architects, sometimes in collaboration with filmmakers, primarily analyzed architectural forms. As a genre of documents, these films preserve valuable images of structures threatened or lost through time, war, or renovation. As conceptual statements and observational practices, the favorite filmed subjects included cities, housing projects, highway systems, landscapes, and workplaces. The effect of these film studies on contemporary architecture has been strong, and the relationship between the two is a powerful precedent for today's new media concerns. In fact, in an interaction between film and architecture, it has been noted that architecture does not merely put forward prospects for viewing. Rather it creates energy spaces with which the cinematic interfere, so as to gain its own topology in loco. The cinema will grow so enormously that the architectural itself will begin to charge itself with cinematic forces. . . .[6]

ELECTRONIC MEMORIES

The consumer video boom of the 1980s propelled ordinary folks to purchase Super 8 home movie cameras or, a little later, VHS video recorders. These home recorders made it possible to discover how to see and experience space differently, and began the accumulation of an entirely distinct set of memories that were experienced differently from the preceding generations' memories — in large part because of the ability to replay recordings of personal events instantaneously. With the endless opportunities to document life around them during the past decade, individuals have become so familiar with the act of observing space and time — in electronic form — that the medium has become infused with new meanings and opportunities to understand the self and others. Video, which portrays these moments without judgment, or the filter of emotion, reflects them as ordinary memories in a continuously moving, and thoroughly integrated, picture of reality. Created from an

electronic light source that overlaps and juxtaposes the now-familiar memory-images in new combinations — unnatural in physical life but familiar in the state of video — the encountering of the electronic memory as reality has become commonplace. The resulting commercial mass consumption of mega-information, which is supposed to be by everyone and for everyone is, in reality, the art of being everywhere while really being nowhere. A question is the degree to which individuals will continue to affect and establish the real space of network environments, neighborhoods, and communities. A witness and transmutation of representation, the emergence of forms as volumes destined to persist as long as their materials would allow has given way to images whose duration is purely retinal.[7]

VIDEO, INSTALLATION, AND PSYCHOLOGICAL SPACE

Videotape provided a breakthrough in the understanding of the relationship between artistic image making, space, and perception of oneself. In the mid-1970s, when video first began to be used widely by the first generation of video pioneers, these artists, coming from various creative fields, explored new ways to examine the technology and to observe themselves simultaneously in personal and public space.[8] Video was a rejection of the frozen moments in time most familiar to artists, in which temporal space was painted atmosphere or a mood captured in a photograph. The video medium was a statement against consumerism, against the art market, and toward a communication practice that involved community and consciousness. In the earliest actual practice, video was used in the same way as surveillance devices are today, it was employed to keep watch over and to observe reality. Much of this video research material remains unedited — and unwatched. It was, however, a valuable experience that facilitated artists' understanding of electronic space, memory, and video's ability to document experience in real time. Towards these goals, many artists created sophisticated settings in which a prepared physical environment was integral to the

Left: Russel Connor interviewing Rainbow Video at WGBH-TV's first-ever live, on-the-air, half-inch video festival, 1972. Center: Douglas Davis, Documenta 6 Satellite Telecast, 1977. Right: Kit Galloway and Sherrie Rabinowitz, documentation of Hole in Space communications sculpture, 1980.

Left: WGBH-TV: Lulu, or the chicken who ate Columbus. Interactive TV à la 1980. Center: Michael Smith and Mike Kelley in *The Arts for Television*, 1982. Right: First moon landing, 1969.

understanding of the electronic space being created with video technology. This act — creating electronic territory and involving the viewer in it as a physical entity — is a direct predecessor to contemporary, interactive multimedia art, and immersive technology. Installation artists introduced strong concepts of both psychological and physiological territory, and advanced an awareness of extended boundaries, and an electronic ability to define space, time, and energy.

LIVE TELEVISION EXPERIMENTS—
BEING TOGETHER IN ELECTRONIC SPACE

Television experience has extended the territory of the home and the sensibilities of its inhabitants. Like radio and the telephone, its direct-indirect capabilities were, on the one hand, all-pervasive yet for the most part uncontrollable. As a private/public space, television was often referred to as a window on the world — a phrase now understood more clearly for its political-commercial context and as a control mechanism for the public than as a method to gain cultural information. In television terms, information, cultural standards, and trend setting is big business, and the subject of culture is generally connected with research into its effective control. The explorations of television space by artists from the 1960s include live and interactive experimental events that allude to a real space, but were actually created as an alternative television space that connected, or allowed communication, between sites. Live television and satellite performances were designed to combine two or more places. Spaces were first attempted by artists under the concept of event and spectacle. Interactive and live broadcasts were, however, usually closed circuit, or broadcast to a limited number of homes or limited market, as broadcasters normally refer to the viewers. The earliest television experiments were possible only because they were not considered to be important, because broadcasters considered art to be a neutral subject, and for public and cable television, the artist held a special position, much like that of a researcher.[9]

For telecommunications, coming together in time means, inversely, distancing oneself in space.[10]

Many of the early television projects were at the time called interactive but were actually performances held in more than one location to attempt mutuality of time and space from different locations. These connections between spaces were often accompanied by theoretical subtexts on mass communication, and the political issue surrounding the control of information by broadcasters. Even now, in the context of advanced computer technology, some of the early live historic television transmissions stand up as seminal works, integral to the communication industry's acceptance of art and technology. Douglas Davis, Allen Kaprow, and Nam June Paik were three primary artists who experimented by creating the first live and interactive television events, first dating from 1968, and continuing into the early 1970s, on WGBH television, Boston's public television station and on PBS WNET 13, in New York City. Other experiments were conducted on the West Coast at KQED, the San Francisco public television station. The archeology of artist's broadcast work, including radio, television, telephone, and various communication networks, continues to be compiled and examined. Important keys to an interrelated history of the cultural and individual vitality of seeing electronic images and spaces will be revealed in the analysis of this history.

The 1990s introduced a relatively new concept of the interactive/digital-television environment. The first of the artistic experimental electronic networks featured direct access to the communication system from home by way of the common communication interface: the telephone. The capabilities exist for multimedia exploration of the television and information networks, the specific architectural forms and realities created by electronics. As physical places, three contemporary references include: Piazza Virtuale the Ponton European Media Art Labs interactive computer environment for live television (broadcast for 100 continuous days from the Documenta IX), which featured Picturephone ISDN connections, telephone keypad-controlled games and activities, and chat programs using modems, FAX, telephone and live entry-points; the interactive television space Yorb World, an interactive community cable television program developed at New York University, in which a little world can be explored by viewers using the telephone keypad; and the Electronic Cafe, a real site that connects participants in point-to-point communication from various sites around the world in conversations, poetry, and communication art. In these examples it is important to recognize that place is still a necessary space, but architecture can no longer be bound by the static conditions of locally defined place, here or there, but as architecture in data space.[11]

In the mediated virtual world, there are no longer fixed places in the sense that we once knew them. Architecture must now address the problem of the event, and even rock concerts may be considered the archetypal form for an architectural event.[12] If, as Peter Eisenman states, the new architecture is a rock concert, then the ultimate skyscraper of the recent past is the example by U2, with their concert

Left: Nam June Paik, Picturephone performance between Los Angeles and New York, 1979. Center: Pier Marton meditates on the world situation in *The Arts for Television*, 1982. Right: Bill Viola, a lot of young people at WGBH-TV's first-ever live, on-the-air, half-inch video festival, 1972.

tour of ZOO TV, a mobile live satellite spectacle connecting their concert with the broadcast of regular television programs, and the viewers to the concert, by satellite dish and by telephone. And, as a finale and sign-off at the end of each concert, a call is placed to the White House, asking the president for peace, with the background roar of applause and agreement from the thousands of spectators in the live audience. Another example is of course the m-Bone transmission of the Rolling Stones concert, as a full Internet experience over broad-band systems.

CHECKING OUT DATA SPACE FOR PHYSICAL REALITIES AND SOCIAL PRACTICES

The new electronic territory is media information. This is an invisible architecture without the interface of technology, and it faces new challenges in the public domain. But, it is not a fictional nor simply a virtual environment. Artists, for expressive and theoretical intent, have discovered important lessons about the image and its relationship to this created space, especially as it relates to the vast worldwide Internet territory of seemingly unlimited and compounding information. This space, a potential new shared platform for collaborative artmaking and communication, demands an entirely new use of language, space, and time. And, if we believe Wittgenstein — that language is also a fundamental technology, and not merely a vehicle for expressing thought but the driver of thought — then the new information technologies are doubly important for our future understanding of space and information. Very seriously we must judge how they affect our culture, our lives, our living. As a working space, electronic architecture impacts our creative practices and physical reality — which certainly will bring about new social practices and observed realities.

There are collapsing boundaries and new case histories for representation: "boundary," or "limiting surface" has turned into an osmotic membrane, like a

blotting pad. Even this definition is more rigorous than earlier ones, and yet it still signals a change in the notion of limitation.[13] These ideas are urgent challenges for architects and communications experts, who — together with the designers of new formats for information systems — should be collectively recognized as the influential media artists of the late 1990s. The growing public interest in electronic data space, interactive television, and the virtual experience has been compounded by the news media, by its excitement and enthusiastic journalism regarding the large financial investments being made by computer companies, entertainment, television, and public utility systems. It is a crisis of physical dimensions in the mediated world that the practical and theoretical interests, and the information technology itself, have shifted toward multimedia, virtual reality, and cyber-connected networks: all new territories created to explore and to understand spatial realms. □

A semi-regular solid in a treatise on perspective by Nielsen (1812).
Similar forms appeared in manuscripts as early as 1570.

ELECTRONIC MEDIA:

The Rebirth of Perspective and the Fragmentation of Illusion

■ *K i m H . V e l t m a n*

In the first decades of the twentieth century a number of famous artists abandoned traditional spatial techniques and experimented with new forms of art: cubism, expressionism, abstract expressionism. Some critics believed that these experiments heralded a new period of nonfigurative art. For instance, Novotny claimed that scientific perspective had ended with Cezanne[1]. Arnason, in his standard history of modern art[2], spread this view that perspective had died in the early twentieth century.[3]

In retrospect it is clear that nonfigurative art has become a new alternative rather than a replacement for all the earlier goals of art. Realism has not died: it has taken on new forms, including surrealism, hyperrealism, and superrealism. As a result, a significant drop in the publications on perspective from 1914 to 1945 (during and between the two great wars), the number of books on perspective has risen steadily ever since. Indeed more books have been published on the subject in this century than during the fifteenth, sixteenth, and seventeenth centuries combined (Fig. 1).

There are a number of reasons for this rebirth of perspective particularly in the second half of the twentieth century. The enormous rise in world population has brought a hitherto unprecedented emphasis on the built environment, with a corresponding rise in publications on architectural perspective and technical drawing.[4] Related to this has been a dramatic rise in the fields of surveying and mapping, culminating in the emergence of Geographical Information Systems (GIS) and Area/Facilities Management (AM/FM) in the context of public administration at the town, municipal, and provincial levels, concerns with law and order (police departments), and security (insurance companies).

New technologies have played an integral role in these developments. In the course of World War I, the introduction of aerial photography brought new challenges of relating terrestrial maps with aerial photographs often taken at an angle, and led to the new field of photogrammetry. The rise of satellite photography added an unprecedented quantity of raster images such that even today only an estimated 10 percent of all satellite images are ever examined.

Integrally connected with this quest for recording the world has been a quest for reconstructing it electronically in terms of vector images. The discovery of basic

algorithms for perspective in electronic form led to computer graphics and the emergence of the so-called four C's, namely, Computer Aided Design (CAD), Computer Aided Engineering (CAE), Computer Aided Manufacturing (CAM), and Computer Integrated Manufacturing (CIM), each of which assumes the use of systematic spatial coordinates in the rendering of objects and contexts.[5] This has expanded greatly the use of linear and other forms of perspective because once an image has been rendered in vector form it can be rotated, tilted, and viewed from any direction either in its true dimensions (e.g., ground plan, elevation) or perspectivally.

Analog cameras are increasingly being replaced by both digital cameras and by virtual cameras; i.e., where computers reproduce the effects of a photographic image through graphics software.[6] This is leading to ever greater links between analog and digital methods in terms of vector and raster images.

Cinema, as an application of photography, has also implicitly broadened the scope of perspective. New explicit uses for perspective have been introduced by movie set designers who replace actual cityscapes with illusionistic painted facades in order to save money, adapting accelerated perspective used in stage scenery in the theater. Some of these dramatic effects have become permanent fixtures in theme parks such as Disneyworld and Universal Studios (Orlando).

The emergence of virtual reality is a further stimulus for this resurgence of perspective, because it entails a combination of different viewpoints (see Inside-Outside below). For the purposes of this essay, developments since 1950 will be referred to as modern perspective and will be compared and contrasted to Renaissance perspective where appropriate.

RENAISSANCE THEMES

It is well known that Renaissance artists made copies of paintings. They also copied individual elements of paintings such that a hand from Leonardo's *Last Supper* was used in a painting of a *Virgin and Child*. In modern terms, they introduced the equivalent of clip art long before the notion was formally introduced.

One aspect of the rebirth of interest in Renaissance perspective in the twentieth century has been the adaptation of particular objects and motifs in new contexts. For instance, fifteenth-century artists such as Piero della Francesca and Leonardo da Vinci revived an interest in regular and semiregular solids. Modern artists use these shapes in holographic art. Euclid, in his *Elements*, described the construction of a seventy-two–sided figure. Leonardo da Vinci, included this figure in his illustrations for Pacioli's *Divine Proportion* (1496–1499, printed 1509). It was taken up by Fra Giovanni da Verona in his inlaid wood panels (intarsia) in Santa Maria in Organo. It was a symbol for perfection in the Renaissance and became a recurrent theme in perspective treatises by Jamnitzer, Sirigatti, Dubreuil, and others. In modern perspective, Salvador Dali adapts a variant of this seventy-two–sided

figure in a painting of a woman's head. Other semi-regular solids found in Jamnitzer recur as garden ornaments in a book by Nielsen (1812) and in variant form in *Waterfall,* Escher's famous engraving. Similarly, a cylindrical shape or toroid, known in the Renaissance as a *mazzocchio,* and a leit motif in Barbaro's *Practice of Perspective* (1568), recurs in variant form in a woodcut by Escher. While the shapes are similar, their function changes. During the Renaissance, color and shading were used to distinguish clearly between different sides and layers of a solid or series of nested solids. In modern perspective, artists such as Escher deliberately use color and shading to introduce ambiguities in our reading of such shapes.

This continuity of images extends to other objects such as stairs, which are an important theme in the treatises of Jan Vredeman De Vries, and are said to have inspired at least one of the staircases in a painting by Rembrandt. In the twentieth century, this theme of stairs continues in the famous staircases of Escher. Individual elements also recur in new contexts, as with the perspectival dragon in Uccello's *Saint George and the Dragon* (London, National Gallery) that also appears in one of David Hockney's stage sets. Or individual elements are substituted, as with the protagonist in Botticelli's *Birth of Venus* (Florence, Uffizi), who is replaced by Elvis Presley in Richard W. Maile's adaptation (SIGGRAPH, 1990). Sometimes the adaptation is merely a small part of the original as with the hands in Michelangelo's *Creation of Man* (Vatican, Sistine Chapel), which recur in variant form in *E. T.* Hence, while there is a continuity of objects and motifs, a two-way process transforms the Renaissance examples into modern ones. Objects which were originally isolated figures during the Renaissance become integrated into complex scenes in modern perspective. Alternatively, objects originally integrated in a scene during the Renaissance recur either as isolated objects or in new contexts in the twentieth century. This is one of the sources of the fragmentation of illusion considered below and is important because it means that the problems associated with electronic image-editing packages were prefigured by Renaissance artists.

TRANSFORMATIONS

During the Renaissance, artists devised a number of means of recording perspectival views. The two chief means were instruments and constructions. Instruments included the perspectival window, *camera obscura,* and various surveying instruments such as Jacob's staff, the astrolabe, the pantograph, and the proportional compass. By the nineteenth century there were other instruments such as the *camera lucida* (or Claude glass). Constructions included the legitimate construction (*costruzione legittima*) and distance-point construction, although there is evidence that a great number of other makeshift constructions were in use. The twentieth century has seen many developments in both physical instruments, such as pantographs, and electronic equivalents through CAD programs (from high-

end packages, such as Softimage and Alias, to Autodesk products and lower-level products, such as TurboCAD, and illustration programs such as Corel Draw).

In terms of perspective, the rise of photogrammetry focused attention on problems of translating anamorphic images into regular linear perspective and conversely. With the advent of high-altitude photography, and subsequently satellite photography, there were new problems of translating spherical perspective to linear perspective. This greatly increased experience in both alternative projection methods and translation from these alternative methods to linear perspective.

The quest to record and reproduce systematically the physical and the built environment led to algorithms for the construction of linear perspectival space, its translation into alternative forms, and vice versa. These algorithms are gradually being incorporated into software programs. For instance, Aldus Photo Styler includes a function for changing a regular perspectival scene to a fish-eye view, spherical perspective or cylindrical perspective. Image Ware includes a whole range of painterly effects including a volume devoted to brushstroke techniques and another to motion and time sequences. More recently, such algorithms are being incorporated directly into hardware chips. For instance, the Genesis Acuity gm833x2 chip permits one to take a regular video image and transform it into its anamorphic equivalents (through translation), spherical perspective, and other transformations. A construction that would have taken days to do manually is now performed almost instantaneously with software and hardware: a globe is

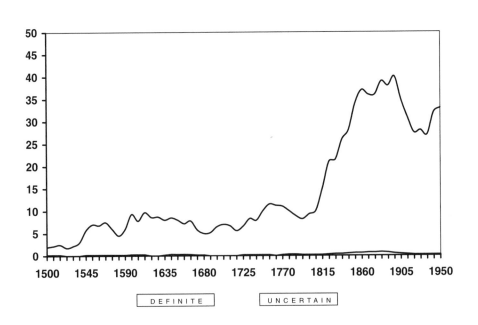

Fig. 1. Graph of publications on perspective in the twentieth century.

transformed to a flat map of the earth which, in turn, becomes a three-dimensional landscape. As a result operations that would once have required the hand of a master artist can now be executed in a few simple steps by anyone in a matter of minutes.

While there is no doubt that the rise of new technologies such as satellites and new software packages has played an enormous role in this new emphasis on transformational geometries, it is important to note that this process was initiated in large part by twentieth-century artists. While some aspects of their contribution have been examined elsewhere, a comprehensive history thereof has yet to be written.[7] Such a history would need to begin with the transformations in the function of the window. One might, for instance, begin with cubist paintings such as Juan Gris's *Still Life with a Landscape* (Philadelphia, 1915) showing the Place Ravignan in Paris. In Renaissance perspective, there was a fundamental assumption that windows were transparent and that walls occluded. In cubist perspective this assumption is challenged. Hence we find ourselves looking through walls. Artists such as Magritte and Dali take these experiments much further and make them the basis of a new movement in art: surrealism. For instance, Magritte, in his *Promenades of Euclid* (New York, Iolas Gallery, 1955), creates deliberate ambiguities between a window that reveals a scene beyond it and an easel painting based thereon which occludes the scene beyond it. In the same painting he also creates deliberate ambiguities between a pyramidal tower and the pyramidal diminution of a street. Dali takes these ideas even further in a painting that shows the posterior view of a nude woman framed by a cross-shaped transparent window in one focus, which is reduced to the occluding portrait of Abraham Lincoln when viewed in another focus. More complex transformations of the window principle are found in the context of holography.

Another of the underlying assumptions of Renaissance linear perspective was that the window would be plane or flat. Some artists experimented with alternatives: Jan van Eyck in his *Arnolfini Wedding* (London, National Gallery) or Parmigianino in his *Self-Portrait* (Vienna, Kunsthistorisches Museum), which are famous precisely because they were exceptions to the rule. Modern perspective, by contrast, makes much greater use of spherical and other alternative methods of perspective. It also combines these methods to create new hybrids. For instance, Escher depicts spaces which begin as spherical perspective and recede into linear perspective. Dick Termes (Spearfish, North Dakota) adapts this theme and renders it more complex by depicting on a spherical surface which can then be viewed from all points of the compass. In *Pieces of the Whole*, one of his most intriguing paintings, Termes paints on a large sphere, this time depicting several individual boys in the act of painting their own canvases, some of which use linear perspective while others use curvilinear perspective. Termes also experiments with a number of other variations by combining two or more spheres as the surface of his painting or using regular solids as his projection planes.

In addition to experimenting with alternative picture planes, modern

perspective also explores alternative directions in the projection process. For instance, in the Renaissance, anamorphosis entailed taking a regular object which was projected onto a picture plane in an elongated or distorted form which, when viewed from a proper angle, appeared in its original shape. The skull in Holbein's *Ambassadors* is a classic case in point. As Baltrusaitis has shown these themes continue in the twentieth century.[8] But there has also been a trend to reverse the process. Hence a contemporary Swiss artist, Bourset, builds anamorphic chairs, the projections of which are regular shapes.[9] This approach also has unexpected applications in the realm of stage design. The walls of stages in theaters are often curved or irregular in shape. As a result, when a regular image was projected onto such a wall, it appeared in distorted form (keystoning). To resolve this problem, Julie O'B. Dorsey (of Cornell University), came up with an ingenious solution. She studied the irregular shape of the wall, then predistorted the original image in such a way that, when it was projected onto the curved wall, the image appeared in undistorted form. In other words, whereas Renaissance perspective used anamorphosis to create deliberate distortions in images, modern perspective uses anamorphosis deliberately to hide the distortions of images. Similar techniques are being adopted in the case of virtual-reality glasses.

INSIDE-OUTSIDE

The early practitioners of protoperspective and linear perspective explored the uses of these new techniques in the context of both exteriors and interiors. The development of these new genres typically went hand in hand, such that perspectival views of rooms contained windows which revealed exterior views. Only gradually did these new genres emerge as independent forms of expression such that landscapes and interiors were treated separately. Hence the window became a window in a room and then a window in an interior which gave a view of an exterior in the form of a landscape.

Modern perspective continues these themes but is also transforming the nature of inside-outside, inner and outer. Video shows interiors and exteriors in ways that remove the distinctions between them. Two-dimensional virtual reality as developed by Myron Krueger increases this ambiguity. Some modern paintings based on photography continue distinctions between the inner and outer. Others blur these distinctions, as in the case of a painting by Robert Gonsalves (Toronto) showing bookshelves as seen from the inside looking outside onto a lawn. A young American student has painted a puzzle showing the man depicted in the puzzle also constructing the puzzle. A young English artist, photographed a house, which was then cut up in puzzle form and re-photographed such that what was inside and outside was difficult to discern. A painting by Gonsalves pursues these themes. We are shown a painting of a puzzle

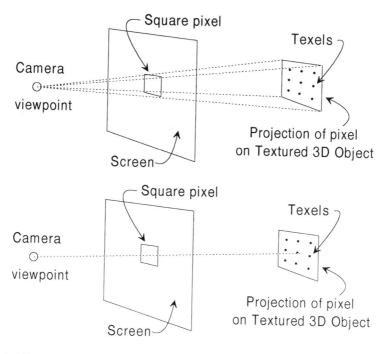

Figs. 2–3. Two examples of perspectival principles being applied to contemporary ray tracing. From Robert Lansdale, *Texture Mapping and Resampling for Computer Graphics* (1991, p. 14).

in which a boy is inside a house making a puzzle showing a boy outside a house.

Some examples of spherical perspective take these ambiguities of inner and outer even further. For instance, Dick Termes's painting entitled *God's Eye View* shows Brunelleschi's interior of San Spirito in Florence, which is said to have been the first church constructed with a view coordinating perspectival effects into architecture. Termes depicts this interior on the exterior of a sphere. In the case of his *Order in Disorder*, this interplay of interior and exterior is rendered the more extreme when we recognize that the artist painted these exteriors from inside the sphere. In Termes's *Pieces of the Whole*, we have a viewpoint from the outside showing boys painting the scenes in which they are painting.

The introduction of various alternative mapping techniques has increased these paradoxical treatments of inner and outer. Cartographers have explored new ways of morphing planes such that satellite images can be "draped" over contour maps to transform two-dimensional photographs into three-dimensional spatial images. For instance, Brandenberger shows how a map of the University of Zurich can be warped to fit different curved planes.[10] It is intriguing to note that artists such as Escher have been pursuing analogous experiments in spatial transformation.[11] One of his early woodcuts, *Senglea*, shows a ship outside this Maltese island (1935). Some ten

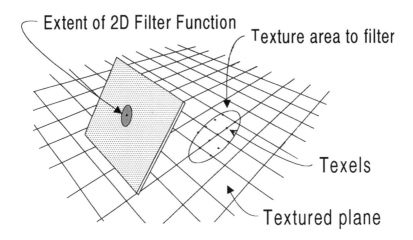

Extent of 2D Filter Function

Texture area to filter

Texels

Textured plane

Fig. 4. An example of anamorphic principles of perspective being used in contemporary ray tracing. From Robert Lansdale (1991, p. 33).

years later, in the lithograph *The Balcony* (1945), he introduces the equivalent of spherical perspective into the central portion of this view. A later lithograph, *Picture Gallery* (1956), further transforms the same scene. The view of Senglea is now a picture in the inside of a gallery in the upper left of the lithograph and spills out to the right in such a way that the awning of one of the houses becomes the roof of the gallery, and we find ourselves simultaneously outside the gallery looking in at the viewer looking at the picture which also functions as if it were a window. In short, inner and outer are fully ambiguous. More importantly for our theme, the transformations and alterations of images which we now associate with electronic tools were introduced by artists. The difference, of course, is that artists' transformations required a great deal of effort and had built into them a personal signature, whereas their electronic equivalents require hardly any effort and lack a personal signature. For this reason, it makes sense to distinguish a spectrum of possibilities ranging from direct correspondence to non-correspondence.

CORRESPONDENCE AND NONCORRESPONDENCE

Renaissance perspective assumed a one-to-one correspondence between each point on an original object and an image. Modern perspective sometimes entails a one-to-one correspondence, but the nature thereof varies greatly: sometimes it is theoretical, assumed, possible, transposed, or deliberately not a direct correspondence. These new kinds of correspondence have greatly expanded the scope of perspective.

Technically speaking, a one-to-one correspondence is only possible in the case of vector graphics, where entire lines are copied. In the case of raster graphics the copying of points presents problems of aliasing especially in the case of distant objects.[12] Even so it is noteworthy that the underlying assumptions governing perspective apply equally to pixel projection used in ray tracing. As Mitchell noted in *The Reconfigured Eye*: "The basic strategy implemented by ray-tracing algorithms is to consider the picture plane as a fine grid of pixels placed between the viewer's eye and the screen and to send a ray from the eye through each pixel to the scene."[13] Scholars such as Mitchell have also emphasized differences between the continuous lines of analogue methods and the discrete pixels of digital methods, suggesting that perspective applies only to the former.[14]

By contrast, Lansdale, in a fundamental dissertation on the subject, has demonstrated lucidly how the principles of linear perspective can be extended to discrete pixels in ray tracing and radiosity programs.[15] In traditional Renaissance perspective, one often begins with a square tile parallel or at right angles to the picture plane and records its projected size. In Lansdale's approach this procedure is reversed; i.e., a square pixel is treated in the manner of a projected square tile on the picture plane or screen and is then projected back onto the textured three-dimensional object. In this way, the specific texels (unprojected pixels of the textured three-dimensional object) occluded by the projected pixel can be calculated. Although the direction is reversed, the projection of this pixel from a screen onto a textured object in modern perspective corresponds precisely to the projection of a square from a wall or pavement onto a perspectival window in Renaissance perspective. Seen in this way the recording of electronic pixels is analogous to a microscopic approach in recording tiles of a wall or pavement perspectivally (Figs. 2–3). In other examples, a spherical shape on the picture plane or screen is projected as an oval shape onto the pavement positioned at an angle relative to the plane (Fig. 4). This is precisely the reverse of an anamorphic form which is projected as a regular sphere on a tilted projection plane (Fig. 4). Hence, perspective remains a valuable tool in understanding the frontiers of aliasing problems in image processing.[16]

Until recently these operations were difficult and often not feasible from a sheer computational point of view. For example, a screen of 1000 x 1000 pixels requires one million rays which means that even a single object required hours and sometimes days to render. As computing power becomes ever more efficient and affordable, more complex perspectival effects involving light and shade, color, and even aerial perspective are becoming increasingly popular.

Fractals pose one of the most complex examples with respect to theoretical correspondence between original and image. According to Benoit Mandelbrot, the rectilinear properties of Euclidean geometry imposed serious restrictions on attempts to analyze the curvilinear complexities of (organic and inorganic) nature.[17]

As an example he gave the coast of England, pointing out that if one chose smaller measuring sticks, the number of sides and length of the coastline would increase greatly. Perspective had assumed that only size changed with distance or scale. In Mandelbrot's example, shape was also a function of scale or distance. He proposed that fractals offered a way of getting beyond these restrictions. Unfortunately because fractals involve iterations, changes in scale affect only their size but not their shape. Hence, strictly speaking, discussions concerning fractals have brought into focus an important problem which fractals are not able to solve.

Needed is a new approach to perspective which defines the scales within which the traditional laws of size as a function of distance are maintained, and identifies those changes of scale where both shape and size become a function of distance. Interestingly enough, this is a case where we have been familiar with the underlying problem for centuries in a quite different context. Anyone who has used a microscope knows perfectly well that increasing the scale changes the shape as well as the size of the insect or specimen which we are examining and yet within a certain range of scales shape remains effectively constant while size changes. It is this phenomenon to which fractals have drawn attention and which a future scaled approach to perspective will need to solve.

The limitations of present-day fractals have not prevented enthusiasts such as Barnsley from claiming that fractals can in fact reproduce nature efficiently.[18] Paradoxically, as compression ratios increase, fractal landscapes look increasingly plausible as illustrated by software programs such as VistaPro. When combined with ancillary programs one can create impressive perspectival fly-bys. As a result, fractals, which seem to contradict the principles of perspective, have become a new source of perspectival experiences.

ASSUMED CORRESPONDENCE

In Europe there has been tendency to use experience of present objects to visualize past objects. Among the most striking examples to date are IBM's elaborate reconstruction of the former Abbey at Cluny and of the Frauenkirche in Dresden which was bombed in World War II.[19] Also impressive is the reconstruction to scale by Chimenti and Menci (Arezzo) of 11,000 houses and buildings in Florence at the time of Lorenzo the Magnificent.

In these cases, there is an assumed correspondence between image and the original object which is sometimes no longer extant. This applies equally to persons and animals. For example, in the case of *Terminator II* (1991), the animated robot is so impressive largely because it is a perfect clone of a real figure. Similarly, the animated dinosaurs in *Jurassic Park* (1993) are assumed to correspond to how they actually looked in real life according to the latest theories.

POSSIBLE CORRESPONDENCE

In the United States, the exploration of possible correspondence is much more marked than elsewhere. Indeed it has been the subject of a new field called scientific visualization, championed by centers such as the National Center for Supercomputing Applications (NCSA) at Urbana-Champaign, Illinois. This entails a whole range of applications including dynamic simulations of chemical bonding, visualizations of shock patterns, and models of complex weather phenomena such as smog and violent storms. Much of this visualization is concerned with the frontiers of quantitative science and frequently requires the use of Cray computers. At the same time there are other contexts whereby such possible correspondence serves as a starting point in very different directions as in the following quote:

> Image Capture is where the image actually begins its trip into reality. If you can call it reality. Often our ideas are conceived with reality as the basis, but they depend on our audience's ability to suspend disbelief and play along with you as you toy with their perception of what is real and what is fantastic. The fun comes when we can make a seamless transition into a world we know is not real but into which we gladly enter.[20]

What makes this striking is not so much the statement itself as its context, namely, the introduction to a recent booklet by Kodak. There is of course considerable interest in realism in the United States: witness the amount of attention paid to news. Yet, increasingly the approach to news as a documentary of what actually happened is being undermined by a notion of news as a combination of real and imaginary. Information is combined with entertainment to pose as info-tainment; education is combined with entertainment to pose as edu-tainment such that the event in itself is considered somehow to be suspect because it lacks the (enter-) tainment side of things. Individuals watch the CNN version of the Iraq war, conscious that they are witnessing a staged event reported from one side, and yet there is no framework for making visible other versions of the reality.

In the United States there has also been a deliberate strategy of using experience of real places and things to visualize unexperienced ones. For instance, members of NASA study rocky places in Nevada and California deserts in preparing for explorations on the moon, Mars and other planets.[21] While this has obvious pragmatic advantages, it introduces a danger philosophically that persons lose their sense of difference and the other. Is the American tourist abroad who is continually saying that there is something bigger, better or very similar back home in the United States merely a stereotype or actually a direct consequence of this mentality?[22] Klotz has recently suggested that this marks a rejection of Renaissance perspective, which deserves further analysis:

> Simulation is a further step away from the vanishing point of Renaissance perspective towards a world of appearances which is virtually real for the subject. A person can get so wrapped up in this apparent world, as if they could live in it, as if they themselves as a three-dimensional being existed in an artistically produced three-dimensional space. This is a new theme that one should study.[23]

On the positive side, there have been a number of famous applications of this principle in the case of the cinema. For instance, Steven Spielberg has explored this in films such as *E.T.* (1982) and *Gremlins* (1984, 1990). Equally, if not more famous, is George Lucas, whose special effects facility, Industrial Light and Magic (ILM), has produced movies such as *Star Wars* (1977), *Raiders of the Lost Ark* (1981), *Willow* (1988), and worked with the great Japanese filmmaker Kurosawa in producing *Dreams* (1990).[24]

TRANSPOSED CORRESPONDENCE

Sometimes one may deliberately choose to have no direct correspondence between original and image and yet use an external visible experience as a metaphor for some otherwise invisible experience. For example, some investment firms have begun using images of grain fields as a metaphor for fluctuations in the stock market.[25] Is this insistence on visualizing situations of transposed correspondence (where no direct correspondence is possible) one of the reasons why metaphors have become so common in the United States and why they are treated with such unexpected seriousness? To a European, *Metaphors We Live By* could readily sound more like a parody than the title of a scholarly tome.

It should be noted that some individuals take this metaphorical treatment seriously. A Toronto-based firm, Visible Decisions, has copyrighted the term "information animation" and sees in these new techniques a new methodology for understanding statistics in a space-time continuum. Interestingly enough a Singapore scholar working in the realm of knowledge navigation has reached similar conclusions independently.[26]

NO DIRECT CORRESPONDENCE

Sometimes there is no direct correspondence at all as in cases when the external world is used as a point of departure for images of the internal world. In the case of films such as *Fantastic Voyage* (1966), this reconstruction can be remarkably realistic. In others such as *Tron* (1982), the spaces are much more idealized.

Renaissance perspective assumed a strict one-to-one correspondence and led to a limited number of perspective applications. By contrast, twentieth-century per-

spective entails a whole spectrum in kinds of correspondence, ranging from direct and theoretical, to assumed, possible, transposed and deliberately no direct correspondence, and has contributed to the enormous increase in perspective applications.

VIRTUAL REALITY IN EXTERNAL AND INTERNAL WORLDS

During the Renaissance, artists used linear perspective to represent a static space in a picture as determined by the position of a viewer looking at the scene from a given viewpoint. In virtual reality much more is involved. First, artists use perspective dynamically to create different spaces of the picture such that one can see how the relative sizes and positions of objects change as one travels through this space. Second, as one's viewpoint in this space changes, one can move different persons and/or objects at will. Third, one can move through the space from the viewpoint of a person or an object such as an automobile moving through this space. Fourth, one can move through this space at a set distance from such a moving person or object. For instance, the World Editor in Dimension International's software includes a plan view, perspective view, and a North, South, East, and West view.[27] Hence, whereas Renaissance perspective was concerned mainly with the static space of the picture, recent developments in virtual reality integrate dynamic views of observers in their picture space, which is one of the reasons why virtual reality has also played a major role in expanding the scope of perspective.

Europe	Integration of historical and projected objects with real landscapes
Japan	Development of futuristic scenarios independent of present
Canada	Development of future scenarios building on the present
United States	Development of fictive scenarios blurring present and future

Fig. 5.

CULTURAL DIFFERENCES IN APPROACHES TO VIRTUAL REALITY

The possible uses of virtual reality vary with different cultures (cf. Fig. 5). In Japan, the trend of cartoon films such as *Akira* (1987) and Sega games involve highly imaginative futuristic cityscapes with little reference to actual buildings in everyday experience. In Europe there has been a trend to use virtual reality as a

means of linking imaginary images with physical reality. A project by Renault superimposes a computer image of a prototype car, the Racoon, onto a real landscape.[28] A project at the ETH in Zurich uses virtual reality to visualize real Roman ruins such as Aventicum, or the underlying structures of medieval monasteries.[29] An Italian project called the *City of Giotto* uses virtual reality to reconstruct the Upper Church of Saint Francis at Assisi such that one can go down (or up) its aisles, enter the space of any of the frescoes on the walls and explore their features.[30] A virtual reality project of the Gesellschaft für Matehematik und Datenverarbeitung (GMD) at Schloss Birlinghoven reconstructs the interior of the castle, but warns: "What you see is never what you get."[31] Another project of the GMD reconstructs a pulsating human heart and allows one to change one's views of sections in real time.

This European concern with visualizing hidden elements of existing physical structures is paralleled in Canada by a concern with visualizing potentially physical structures: hence, more concern with design of future buildings than with the study of past buildings (often for purposes of conservation). In this respect Canada is closer to traditions of Europe than to those of the United States. The software of companies such as Alias and SoftImage typically serves as a tool for heightening our understanding of planned, existing, and possible objects rather than in creating visions with no (possible) basis in physical reality.[32]

Whereas Europeans and Canadians often focus on visualizing external objects, there is a trend in the United States towards visualizing processes that would otherwise be invisible.[33] Some, such as Robinett,[34] see virtual reality as an electronic expansion of human perception. More often, virtual reality is treated as an environment in which one can be immersed such that it can be seen as a direct extension of illusionistic worlds such as *Back to the Future* at the Universal Studios theme park and more generally of the celluloid recreations of Hollywood. Opinions differ concerning the extent to which this can imitate physical reality. For instance, Aukstakalnis and Blatner are convinced that it will not:

> be possible to create realities so clear and complex that we won't be able to perceive the difference between our everyday reality and a computer-generated one. . . . But the worlds that we use computers to create may eventually be so realistic, so enticing, and so interesting that we may intensely want to believe in them and they will become like mirages in the desert.[35]

Others, such as Pimentel and Teixeira, are more optimistic concerning the power of computers to simulate realistic effects:

> Virtual reality is all about illusion. It's about computer graphics in the theater of the mind. It's about the use of high technology to convince yourself that you're in another reality, experiencing some event that doesn't physically exist in the world in front of

you. . . . Simply, virtual reality, like writing and mathematics is a way to represent and communicate what you can imagine with your mind . . . and it can be shared with other people.[36]

In this view, virtual reality is the best means of externalizing the contents of the mind, an ultimate tool for exteriorization, for perfecting the extrovert. Ironically in a culture where the passive tendencies of television are a dominant mode, there is a danger that this tool for externalizing the interior becomes a weapon for imposing onto the internal minds of most the carefully crafted external views of some few. This is a major problem. Of interest for the purposes of this paper is that the European, Canadian, Japanese, and American interpretations of virtual reality all entail extensions of perspective. Hence virtual reality is yet another reason for the rebirth of perspective in the later twentieth century.

FRAGMENTATION OF ILLUSION

During the Renaissance, perspective aimed at a representation that potentially copied an image of the physical world such that it created a coherent illusion of that physical world. Initially this quest involved mainly the medium of paint. By the Baroque period sculpture and architecture had been integrated within this framework, and one could argue that the next centuries saw an extension of these principles culminating in *Gesamtkunstwerk,* the Viennese concept of the comprehensive work of art.

Not all art followed this ideal. Already in the sixteenth century there was a practice of combining elements of a series of ruins in a single composite picture. By the seventeenth century this had become the fashion in the art form known as the capriccio. Even so, these fanciful combinations remained within carefully defined limits. For instance, Pannini combined a series of Roman ruins in one painting and a series of modern Roman buildings in another.[37] Capriccios shifted the physical locations of buildings. They questioned neither the principles of creating coherent illusionistic views of buildings nor of revealing the source of the original image. Even when it was hidden, the visual equivalent of a footnote or reference was always in place.

The electronic versions of perspectival space have brought fundamental changes to this process. They entail a fragmentation in the process of creating illusion and amount to removing this implicit footnote to the original object in the physical world. In its simplest version, an image of a location in the physical world may have superimposed on it an image from the world of animation as in *Who Framed Roger Rabbit?* or *Terminator 2.* Conversely, a computer-animated space may have superimposed upon it the figure of a live person from the physical world as also happens in *Roger Rabbit* and more dramatically in Kurosawa's *Dreams,* where a modern spectator

in a museum walks into two paintings of van Gogh. In both of these cases the illusion of the context is quite separate from and provides no hint concerning the source of the isolated figures within them. Traditionally there was a challenge of making classical quotations which could and would be recognized. Notwithstanding, isolated demonstrations in the Hitchcock pavilion at Universal Studios, and occasional studies on the subject, the modern art appears to be in hiding the source (*ars est celare artis*, in a new sense). Indeed, special effects have become the main theme of movie series such as *FX* (1986, 1991) and play a serious role in other movies such as *Darkman* (1991), *Lawnmower Man* (1992), and *Ghost in the Machine* (1994).

In the case of multimedia contexts, this process of fragmentation becomes more marked. For instance, in the preparation of the first full-length feature computer-animated film, an adaptation of Jules Verne's *Twenty Thousand Leagues Under the Sea* (1995), Channels software of SoftImage is used to copy information from sensors attached to the face of a live actor onto the face of a computer-generated figure. As a result, the facial expressions of this computer-animated version of Captain Nemo are perfectly "realistic" but there is no way of knowing the source of this realism, namely the facial expressions of a given live actor.

In the case of virtual reality, this fragmentation process is even more complex. Hence turning the head in the physical world leads to a corresponding turning of the head in the virtual world. Turning the hand within a data-glove leads to a corresponding movement of the virtual body. Other systems use a hand-controlled space-ball to introduce six degrees of freedom with respect to movement. In the case of other parts of the body there is no correspondence between motions in the physical and virtual worlds. As a result, a beginner experiences considerable confusion because correlations are neither intuitive nor systematic.

PROCESS	PHYSICAL WORLD	VIRTUAL WORLD
Channels Software	Sensors on Face	Movements on Face of Model Figure
Virtual Reality	Turning Head	Turning Head
"	"	Moving Glove Moving Body
"	"	Moving Other Parts No Effect

Fig. 6. Some examples of correspondences and noncorrespondences between actions in the physical and the virtual world.

NEW VERACITY TESTS AND SOURCE CRITERIA

In the case of books and articles, scholars have developed the use of footnotes and references to document these sources and as a means of checking the reliability of

any claims made. In the case of images, captions served an equivalent function. Because the medium of print brought to words and images a stability with respect to content, any changes that were made were documented clearly as a revised or new edition. Hence, footnotes, references, and captions sufficed as tools for establishing the authenticity of claims.

Electronic media are transforming our abilities to edit collections of words and images. An article or book written in a word processing package such as Microsoft Word or WordPerfect can all too easily be amended. If such texts are online how are we to know which version is being cited? At present, backups are dated but this information does not usually appear in printouts. We need new techniques that document the time of changes and new ways of archiving earlier versions of texts. We need electronic equivalents for revised versions and new editions. Work-flow software such as Digital's Linkworks version manager allows one to see who modified which details when. Thus, software also provides a series of seven different levels of access to materials. These standards being introduced to the corporate world need to be adapted by the scholarly world.

1. Standard
2. Personal
3. Internal Use
4. For Information
5. Internal Use Info
6. For Notification
7. For Feedback

Fig. 7. Seven different levels of access used in Digital's Linkworks software.

Similar problems obtain in the case of Computer Aided Design packages which presently enable users to edit and transform images. Parts of a scene can readily be taken and integrated elsewhere to form new composite pictures and hence these new tools have contributed considerably to the fragmentation of illusion noted above. At present, image-editing software such as PhotoShop, PhotoStyler or TBase offer choices in terms of image resolution (e.g., 1024 x 768 or 640 x 480), dithering, filtering, resampling, and scaling. However, once an image has gone through these transformations, the changes are not recorded on the image. Needed is a set of captions, which might usually be invisible, that documents technical characteristics of the original image and changes that it has undergone.

Some of the attendant difficulties these image editing programs introduce with respect to certifying the veracity of images have been the subject of an important recent study by Mitchell[38] and are currently a subject of discussion on the Internet.[39] Meanwhile, firms such as Kodak[40] have been investing considerable energies to introduce hidden methods for determining whether or not an image

that began as a photograph has been altered. Without such precautions the uses of photography in legal evidence would soon disappear.

If images are to retain their scholarly as well as their legal respectability, it will prove useful to adapt other techniques that have been developed in the case of textual studies. For instance, scholars of manuscripts (codicologists and paleographers) have devised subtle tools for determining which manuscript was copied from another manuscript in order to arrive at the equivalent of family trees (*stemma*) of tradition. Corresponding pedigrees of images are needed such that one can determine, where possible, the number of generations they are removed from the original, analogous to the way that one distinguishes among different states of engravings (Fig. 8). In addition to this we need to know who owns (or owned) the copyright to each of these generations. Only then will we be able to write captions that serve as equivalents to footnotes in the realm of images.

1. Original	1. Original	1. Original	1. Original
2. Digital Image	2. Photograph	2. Photograph	2. Photograph
3. Digital Image	3. Slide	3. Photograph in Book	
4. Digital Image	4. Slide		
5. Digital Image			

Fig. 8. Pedigree of an image defined in terms of numbers of generations between the original and its digital version.

Using such a system for determining the pedigree of an image, museums and galleries might decide that only second-and third-generation images fall within their purview and are subject to copyright controls with respect to reproduction. Hence images beyond three generations would not be acceptable as "official" images. In the future, it might be decided that new scholarly claims should only be made on the basis of such official images.

In a penetrating study on Renaissance wall paintings, Sandström distinguished between different levels of unreality.[41] An electronic equivalent is needed such that a user can see how many levels an image on the screen is removed from the physical world (Fig. 9).

Some of these levels, geometrical figures, for instance, would be further divided into different modes, such that one could distinguish between those which were drawn by hand, by instrument, and electronically. The introduction of such levels would have a further advantage of providing a new sense of context for various images and versions of objects.

In the case of image manipulation, we probably need to make a number of further distinctions, namely whether reality was subtracted or added. Professional photographers are all too familiar with photographs of Mr. or Mrs. X in which the light on a pimple or blemish was unflattering. With the aid of finishing tech-

niques, this was quietly removed. Such covering up of unwanted reality is rather different from cases where a figure has been added to a scene in order to put someone in a compromising context. Experts are aware that each medium and each technology leaves its own traces and produces its own particular artifacts (or "artifacting" as they say). This evidence should be documented and placed in a header file such that it remains hidden under normal situations but still accessible if needed, much in the way that one can turn to endnotes when one is concerned with checking an author's sources.

1. Original	Physical Object	
2. Model of	"	"
3. Photograph of	"	"
4. Drawing of	"	"
5. Geometrical Figure of	"	"
6. Algebraic Formula of	"	"

Fig. 9. Levels of abstraction seen in relation to the media used to record knowledge of the physical world.

CONCLUSIONS

Following a temporary decline during the period 1914–1945, the second half of the twentieth century has witnessed a dramatic rebirth in the uses of perspective. A number of reasons for this rebirth are: a radical increase in population which has led to new concern with recording and reconstructing the built environment in particular and the physical world generally; and new developments in aerial photography, cinema, computer graphics, and virtual reality.

The second part of the paper compares and contrasts Renaissance and modern perspective. Whereas Renaissance artists favored static, one-point, linear perspective, modern perspective has focused ever more attention to dynamic transformations. Whereas Renaissance perspective assumed a strict one-to-one correspondence between original object and image, modern perspective entails a whole range of alternatives including theoretical, assumed, possible, transposed, and deliberate noncorrespondence. These new kinds of correspondence have greatly expanded the scope of perspective, as have recent developments in virtual reality. Among the more complex ancillary effects of modern perspective has been a new fragmentation of illusion. To counter these developments new veracity tests are proposed. □

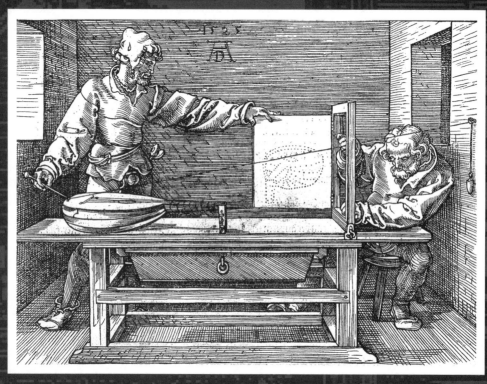

Two draftsmen plotting points for the drawing of a luite in foreshortening,
from Dürer's *Underweysung der Messung*, Nurnberg, 1525.

THE AUTOMATION OF SIGHT:

From Photography to Computer Vision

■ *L e v M a n o v i c h*

PROLOGUE

Nothing perhaps symbolizes mechanization as dramatically as the first assembly lines installed by Henry Ford in United States factories in 1913. It seemed that mechanical modernity was at its peak. Yet, in the same year the Spanish inventor Leonardo Torres y Quevedo had already advocated the industrial use of programmed machines.[1] He pointed out that although automatons had previously existed, they had never before been used to perform useful work:

> The ancient automatons … imitate the appearance and movement of living beings, but this has not much practical interest, and what is wanted is a class of apparatus which leaves out the mere visible gestures of man and attempts to accomplish the results which a living person obtains, thus replacing a man by a machine.[2]

With mechanization, work is performed by a human but his or her physical labor is augmented by a machine. Automation takes mechanization one step further: the machine is programmed to replace the functions of human organs of observation, effort, and decision.

Mass automation was made possible by the development of digital computers during World War II and thus became synonymous with computerization. The term "automation" was coined in 1947; and in 1949 Ford began the construction of the first automated factories.

Barely a decade later, automation of imaging and of vision were well under way. By the early 1960s, construction of static and moving two-dimensional and perspectival images, correction of artifacts in photographs, the identification of objects from their images, and many other visual tasks were already handled by computers. A number of new disciplines were emerging as well—computer image processing, computer vision, computer graphics, computer-aided design.

What these new disciplines all had in common is that they employed perspectival images. In other words, automation of imaging and vision was first of all directed at perspectival sight.

The reasons for this are twofold. On the one hand, by the time digital computers became available, modern society was already heavily invested in lens-based methods of image gathering (photography, film, television) which all produced perspectival images. Therefore, it is not surprising that modern society would want first of all to automate various uses of such images in order to obtain a new return from its investment. On the other hand, the automation of perspectival sight has already begun well before this century with the development of perspective machines, descriptive and perspective geometry, and, of course, photography. Computers certainly proved to be very fast perspectival machines, but they were hardly the first.

PERSPECTIVE, PERSPECTIVAL MACHINES, PHOTOGRAPHY

From the moment of adaptation of perspective, artists and draftsmen have attempted to aid the laborious manual process of creating perspectival images.[3] Between the sixteenth and the nineteenth centuries various "perspectival machines" were constructed. They were used to construct particularly challenging perspectival images, to illustrate the principles of perspective, to help students learn how to draw in perspective, to impress artists' clients, or to serve as intellectual toys. Already in the first decades of the sixteenth century, Dürer described a number of such machines.[4] One device is a net in the form of a rectangular grid, stretched between the artist and the subject. Another uses a string representing a line of sight. The string is fixed on one end, while the other end is moved successively to key points on the subject. The point where the string crosses the projection plane, defined by a wooden frame, is recorded by two crossed strings. For each position, a hinged board attached to the frame is moved and the point of intersection is marked on its surface. It is hard to claim that such a device, which gave rise to many variations, made the creation of perspectival images more efficient; however, the images it helped to produce had reassuring mechanical precision. Other major types of perspectival machines that appeared subsequently included the perspectograph, pantograph, physionotrace, and optigraph.

Why manually move the string imitating the ray of light from point to point? Along with perspectival machines, a whole range of optical apparatuses was in use, particularly for depicting landscapes and in conducting topographic surveys. They included versions of camera obscura from large tents to smaller, easily transportable boxes. After 1800, the artist's ammunition was strengthened by camera lucida, patented in 1806.[5] Camera lucida utilized a prism with two reflecting surfaces at 135°. The draftsman carefully positioned his eye to see both the image and the drawing surface below and traced the outline of the image with a pencil.

Optical apparatuses came closer than previous perspectival devices to the automation of perspectival imaging. However, the images produced by camera

obscura or camera lucida were only ephemeral and considerable effort was still required to fix these images. A draftsman had to trace the image meticulously to transform it into the permanent form of a drawing.

With photography, this time-consuming process was finally eliminated. The process of *imaging physical reality*, the creation of perspectival representations of real objects, was now automated. Not surprisingly, photography was immediately employed in a variety of fields, from aerial photographic surveillance to criminal detection. Whenever the real had to be captured, identified, classified, and stored, photography was put to work.

Photography automated one use of perspectival representation — but not others. According to Bruno Latour, the greatest advantage of perspective over other kinds of representations is that it establishes a "four-lane freeway" between physical reality and its representation.[6] We can combine real and imagined objects in a single geometric model and go back and forth between reality and the model. By the twentieth century, the creation of a geometric model of both existing and imagined reality still remained a time-consuming manual process, requiring the techniques of perspectival and analytical geometry, pencil, ruler, and eraser. Similarly, if one wanted to visualize the model in perspective, hours of drafting were required. And to view the model from another angle, one had to start all over again. The automation of geometrical modeling and display had to wait the arrival of digital computers.

3-D COMPUTER GRAPHICS: AUTOMATION OF PERSPECTIVAL IMAGING

Digital computers were developed toward the end of World War II. The automation of the process of constructing perspectival images of both existent and nonexistent objects and scenes followed quite soon.[7] By the early 1960s Boeing designers already relied on 3-D computer graphics for the simulation of landings on the runway and of pilot movement in the cockpit.[8]

By automating perspectival imaging, digital computers completed the process which began in the Renaissance. This automation became possible because perspectival drawing has always been a step-by-step procedure, an algorithm involving a series of steps required to project coordinates of points in 3-D space onto a plane. Before computers, the steps of the algorithm were executed by human draftsmen and artists. With a computer, these steps can be executed automatically and, therefore, much more efficiently.

The details of the actual perspective-generating algorithm which could be executed by a computer were published in 1963 by Lawrence G. Roberts, then a graduate student at MIT.[9] The perspective-generating algorithm constructs perspectival images in a manner quite similar to traditional perspectival techniques. In fact, Roberts had to refer to German textbooks on perspectival geometry from

the early 1800s to get the mathematics of perspective.[10] The algorithm reduces reality to solid objects, and the objects are further reduced to planes defined by straight lines. The coordinates of the endpoint of each line are stored in a computer. Also stored are the parameters of a virtual camera — the coordinates of a point of view, the direction of sight, and the position of a projection plane. Given this information, the algorithm generates a perspectival image of an object, point by point.

The subsequent development of computer graphics can be seen as the struggle to automate other operations involved in producing perspectival stills and moving images. The computerization of perspectival construction made possible the automatic generation of a perspectival image of a geometric model as seen from an arbitrary point of view — a picture of a virtual world recorded by a virtual camera. But, just like with the early perspectival machines described by Dürer, early computer graphics systems did not really save much time over traditional methods. To produce a film of a simulated landing, Boeing had to supplement computer technology with manual labor. As in traditional animation, twenty-four plots were required for each second of film. These plots were computer-generated and consisted of simple lines. Each plot was then hand-colored by an artist. Finished plots were filmed, again manually, on an animation stand.[11] Gradually, throughout the 1970s and the 1980s, the coloring stage was automated as well. Many algorithms were developed to add the full set of depth cues to a synthetic image — hidden line and hidden surface removal, shading, texture, atmospheric perspective, shadows, reflections, and so on.[12]

At the same time, to achieve interactive perspectival display, special hardware was built. Each step in the process of 3-D image synthesis was delegated to a special electronic circuit: a clipping divider, a matrix multiplier, a vector generator. Later on, such circuits became specialized computer chips, connected together to achieve real-time, high resolution, photorealistic 3-D graphics. Silicon Graphics Inc., one of the major manufacturers of computer graphics hardware, labeled such a system "geometry engine."

The term appropriately symbolizes the second stage of the automation of perspectival imaging. At the first stage, the photographic camera, with perspective physically built into its lens, automated the process of creating perspectival images of existing objects. Now, with the perspectival algorithm and other necessary geometric operations embedded in silicon, it becomes possible to display and interactively manipulate models of nonexistent objects as well.

COMPUTER VISION: AUTOMATION OF SIGHT

In his papers, published between 1963 and 1965, Roberts formalized the mathematics necessary for generating and modifying perspective views of geometric models on the computer. This, writes William J. Mitchell, was "an event as

momentous, in its way, as Brunelleschi's perspective demonstration."[13] However, Roberts developed techniques of 3-D computer graphics having in mind not the automation of perspectival imaging but another, much more daring goal — "to have the machine recognize and understand photographs of three dimensional objects."[14] Thus, the two fields were born simultaneously: 3-D computer graphics and computer vision, *automation of imaging and of sight*.

The field of computer vision can be seen as the culmination of at least two histories, each a century long. The first is the history of mechanical devices designed to aid human perception, such as Renaissance perspectival machines. This history reaches its final stage with computer vision, which aims to replace human sight altogether. The second is the history of automata, whose construction was especially popular in the seventeenth and eighteenth centuries. Yet, despite similarity in appearance, there is a fundamental difference between Enlightenment automata, which imitated humans, or animals, bodily functions, and the modern-day robots equipped with computer vision systems, artificial legs, and arms. As noted by Leonardo Torres, old automata, while successfully copying the appearance and movement of living beings, had no economic value. Indeed, such voice-synthesis machines as Wolgang von Kempelen's 1778 device, which directly imitated the functioning of the oral cavity, or Abbé Mical's *Têtes parlantes* (1783), operated by a technician hiding offstage and pressing a key on a keyboard, were used only for entertainment.[15] When in 1913 Torres called for automata that would "accomplish the results which a living person obtains, thus replacing a man by a machine," he was expressing a fundamentally new idea of using automata for productive labor. A few years later, the brother of the Czech writer Karel Capek coined the word robot from the Czech word *robota*, which means "forced labor."[16] Capek's play *R.U.R.* (1921) and Fritz Lang's *Metropolis* (1927) clearly demonstrate this new association of automata with physical industrial labor.

Therefore, it would be erroneous to conclude that, with computer vision, twentieth-century technology simply added the sense of sight to eighteenth-century mechanical statues. But even to see computer vision as the continuation of Torres's, Capek's, or Lang's ideas about industrial automation as the replacement for manual labor would not be fully accurate. The idea of computer vision became possible and the economic means to realize this idea became available only with the shift from industrial to postindustrial society after World War II. The attention turned from the automation of the body to the automation of the mind, from physical to mental labor. This new concern with the automation of mental functions such as vision, hearing, reasoning, and problem solving is exemplified by the very names of the two new fields that emerged during the 1950s and 1960s — artificial intelligence and cognitive psychology. The latter gradually replacing behaviorism, the dominant psychology of the "Fordism" era. The emergence of the field of computer vision is a part of this cognitive revolution, a revolution which was financed by the military escalation of the Cold War.[17] This connection is solidified in the very term "artificial

intelligence," which may refer simultaneously to two meanings of "intelligence": (1) reason, the ability to learn or understand; and (2) information concerning an enemy or a possible enemy or an area. Artificial intelligence—artificial reason to analyze collected information, collected intelligence.

In the 1950s, faced with the enormous task of gathering and analyzing written, photographic, and radar information about the enemy, the CIA and the NSA (National Security Agency) began to fund the first artificial intelligence projects. One of the earliest projects was a Program for Mechanical Translation, initiated in the early 1950s in the attempt to automate the monitoring of Soviet communications and media.[18] The work on mechanical translation was probably the major cause of many subsequent developments in modern linguistics, especially its move towards formalization; it can be discerned in Noam Chomsky's early theory which, by postulating the existence of language universals in the domain of grammar, implied that translation between arbitrary human languages could be automated. The same work on mechanical translation was also one of the catalysts in the development of the field of pattern recognition, the precursor to computer vision. Pattern recognition is concerned with automatically detecting and identifying pre-determined patterns in the flow of information. A typical example is character recognition, the first stage in the process of automating translation. Pattern recognition was also used in the United States for the monitoring of Soviet radio and telephone communication. Instead of listening to every transmission, an operator would be alerted if the computer picked up certain words in the conversation.

As a "logistics of perception" came to dominate modern warfare and surveil-lance and as the space race began, image processing became another major new field of research.[19] Image processing comprises techniques to improve images for human or computer interpretation. In 1964, the space program for the first time used image processing to correct distortions in the pictures of the moon introduced by an on-

board television camera of Ranger 7.[20] In 1961, the National Photographic Interpretation Center (NPIC) was created to produce photoanalysis for the rest of the United States intelligence community and, as Manual De Landa points out, by the end of the next decade computers "were routinely used to correct for distortions made by satellite's imaging sensors and by atmospheric effects, sharpen out-of-focus images, bring multicolored single images out of several pictures taken in different spectral bands, extract particular features while diminishing or eliminating their backgrounds altogether. . . ." De Landa also notes that computer analysis of photographic imagery became the only way to deal with the pure volume of intelligence being gathered: "It became apparent during the 1970s that there is no hope of keeping up with the millions of images that poured into NPIC . . . by simply looking at them the way they had been looked at in World War II. The computers therefore also had to be taught to compare new imagery of a given scene with old imagery, ignoring what had not changed and calling the interpreter's attention to what had."[21]

The techniques of image processing, which can automatically increase an image's contrast, remove the effects of blur, extract edges, record differences between two images, and so on, greatly eased the job of human photoanalysts. And the combining of image processing with pattern recognition made it possible in some cases to delegate the analysis of photographs to a computer. For instance, the technique of pattern matching used to recognize printed characters can also be used to recognize objects in a satellite photograph. In both cases, the image is treated as consisting of two-dimensional forms. The contours of the forms are extracted from the image and are then compared to templates stored in computer memory. If a contour found in the image matches a particular template, the computer signals that a corresponding object is present in a photograph.

A general-purpose computer vision program has to be able to recognize not just two-dimensional but three-dimensional objects in a scene taken from an

ACRONYM computer vision system processes an aerial photograph, identifying its various elements.

arbitrary angle.[22] Only then it can be used to recognize an enemy's tank, to guide an automatic missile toward its target or to control a robotic arm on the factory floor. The problem with using simple template matching is that "a two-dimensional representation of a two-dimensional object is substantially like the object, but a two-dimensional representation of a three-dimensional object introduces a perspective projection that makes the representation ambiguous with respect to the object."[23] While pattern recognition was working for images of two-dimensional objects, such as letters or chromosomes, a different approach was required to "see" in 3-D.

Roberts's 1965 paper, "Machine Recognition of Three-dimensional Solids," is considered to be the first attempt at solving the general task of automatically recognizing three-dimensional objects.[24] His program was designed to understand the artificial world composed solely of polyhedral blocks — a reduction of reality to geometry that would have pleased Cézanne. Using image-processing techniques, a photograph of a scene was first converted into a line drawing. Next, the techniques of 3-D computer graphics were used:

> Roberts's program had access to three-dimensional models of objects: a cube, a rectangular solid, a wedge, and a hexagonal prism. They were represented by coordinates (x, y, z) of their vertices. A program recognized these objects in a line drawing of the scene. A candidate model was selected on the basis of simple features such as a number of vertices. Then the selected model was rotated, scaled, projected, and matched with the input line drawing. If the match was good, the object was recognized, as were its position and size. Roberts's program could handle even a composite object made of multiple primitive shapes; it subtracted parts of a line drawing from the drawing as they were recognized, and the remaining portions were analyzed further.[25]

Was this enough to automate human vision completely? This depends upon how we define vision. The chapter on computer vision in *The Handbook of Artificial Intelligence* (1982) opens with the following definition: "Vision is the information-processing task of understanding a scene from its projected images."[26] But what does "understanding a scene" mean? With computer vision research financed by the military-industrial complex, the definition of understanding becomes highly pragmatic. In the best tradition of the pragmatism of James and Pierce, cognition is equated with action. The computer can be said to "understand" a scene if it can act on it — move objects, assemble details, destroy targets. Thus, in the field of computer vision "understanding a scene" implies two goals. First, it means the identification of various objects represented in an image. Second, it means reconstruction of three-dimensional space from the image. A robot, for instance, need not only recognize particular objects, but it has to construct a representation of the surrounding environment to plan its movements. Similarly, a missile not only has to identify a target but also to determine the position of this target in three-dimensional space.

LEV MANOVICH

It can be seen that Roberts's program simultaneously fulfilled both goals. His program exemplified the approach taken by most computer vision researchers in the following two decades. A typical program first reconstructs the three-dimensional scene from the input image and then matches the reconstructed objects to the models stored in memory. If the match is good, the program can be said to recognize the object, while simultaneously recording its position.

A computer vision program thus acts like a blind person who "sees" objects (i.e., identifies them) by reading their shapes through touch. As for a blind person, understanding the world and the recognition of shapes are locked together; they cannot be accomplished independently of one another.

In summary, early computer vision was limited to recognition of two-dimensional forms. Later, researchers began to tackle the task of recognizing 3-D objects, which involves reconstruction of shapes from their perspectival representations (a photograph or a video image). From this point on, the subsequent history of computer vision research can be seen as a struggle against perspective inherent to the photographic optics.

THE RETREAT OF PERSPECTIVE

With the emergence of the field of computer vision, perspectival sight reaches its apotheosis and at the same time begins its retreat. At first computer vision researchers believed that they could invert the perspective and reconstruct the represented scene from a single perspectival image. Eventually, they realized that it is often easier to bypass perspectival images altogether and use other means as a source of three-dimensional information.

Latour points out that with the invention of perspective it became possible to represent absent things and plan our movement through space by working on representations. To quote him again, "one cannot smell or hear or touch Sakhalin island, but you can look at the map and determine at which bearing you will see the land when you send the next fleet."[27] Roberts's program extended these abilities even further. Now the computer could acquire full knowledge of the three-dimensional world from a single perspectival image! And because the program determined the exact position and orientation of objects in a scene, it became possible to see the reconstructed scene from another viewpoint. It also became possible to predict how the scene would look from an arbitrary viewpoint.[28] Finally, it also became possible to guide the movement of a robot automatically through the scene.

Roberts's program worked using only a single photograph — but only because it was presented with a highly artificial scene and because it "knew" what it could expect to see. Roberts limited the world which his program could recognize to simple polyhedral blocks. The shapes of possible blocks were stored in a computer. Others simplified the task even further by painting all objects in a scene the same color.

However, given an arbitrary scene, composed from arbitrary surfaces of arbitrary color and lighted in an arbitrary way, it is very difficult to reconstruct the scene correctly form a single perspectival image. The image is "underdetermined." First, numerous spatial layouts can give rise to the same two-dimensional image. Second, "the appearance of an object is influenced by its surface material, the atmospheric conditions, the angle of the light source, the ambient light, the camera angle and characteristics, and so on," and all of these different factors are collapsed together in the image.[29] Third, perspective, as any other type of projection, does not preserve many geometric properties of a scene. Parallel lines turn into convergent lines; all angles change; equal lines appear unequal. All this makes it very difficult for a computer to determine which lines belong to a single object.

Thus, perspective, which until now served as a model of visual automation, becomes the drawback which needs to be overcome. Perspective, this first step towards the rationalization of sight (Ivins), has eventually become a limit to its total rationalization — the development of computer vision.

The realization of the ambiguities inherent in a perspectival image itself came after years of vision research. In trying to compensate for these ambiguities, laboratories began to scrutinize the formal structure of a perspectival image with a degree of attention unprecedented in the history of perspective. For instance, in 1968 Adolpho Guzman classified the types of junctions that appear in line representations after he realized that a junction type can be used to deduce whether regions of either side of a junction line were part of the same object.[30] In 1986 David Lowe presented a method to calculate the probability that a particular regularity in an image (for instance, parallel lines) reflects the physical layout of the scene rather than being an accident due to a particular viewpoint.[31] All other sources of depth information such as shading, shadows, or texture gradients were also systematically studied and described mathematically.

Despite these advances, a single perspectival image remained too ambiguous a source of information for practical computer vision systems. An alternative has been to use more than one image at a time. Computer stereo systems employ two cameras which, like human eyes, are positioned a distance apart. If the common feature can be identified in both images, then the position of an object can be determined simply through geometric calculations. Other systems use a series of continuous images recorded by a video camera.

But why struggle with the ambiguity of perspectival images at all? Instead of inferring three-dimensional structure from a two-dimensional representation, it is possible to measure depth directly by employing various remote sensing technologies. In addition to video cameras, modern vision systems also utilize a whole range of different *range finders* such as lasers or ultrasound.[32] Range finders are devices which can directly produce a three-dimensional map of an object. The same basic principle employed in radar is used: the time required for an electromagnetic wave to reach an object and reflect back is proportional to the distance to the object. But

while radar reduces an object to a single point and in fact is blind to close-by objects, a range finder operates at small distances. By systematically scanning the surface of an object, it directly produces a "depth map," a record of an object's shape which can be then matched to geometric models stored in computer memory, thus bypassing the perspectival image altogether.

EPILOGUE

The Renaissance adaptation of perspective represented the first step in the automation of sight. While other cultures used sophisticated methods of space mapping, the importance of perspective lies not in its representational superiority but in its algorithmic character. This algorithmic character enabled the gradual development of visual languages of perspective and descriptive geometry and, in parallel, of perspectival machines and technologies, from a simple net described by Dürer to photography and radar. And when digital computers made possible mass automation in general, automation of perspectival vision and imaging followed soon.

The use of computers allowed to extend perspective, utilizing to the extreme its inherent qualities such as the algorithmic character and the reciprocal relationship it establishes between reality and representation. The perspective algorithm, a foundation of both computer graphics and computer vision, is used to generate perspectival views given a geometric model and to deduce the model given a perspectival view. Yet, while giving rise to new technologies of "geometric vision," perspective also becomes a limit to the final automation of sight — recognition of objects by a computer. Finally, it is displaced from its privileged role, becoming just one among other techniques of space mapping and visualization. □

Seattle-Tacoma airport by Boeing — one of the earliest 3-D computer-graphic images.

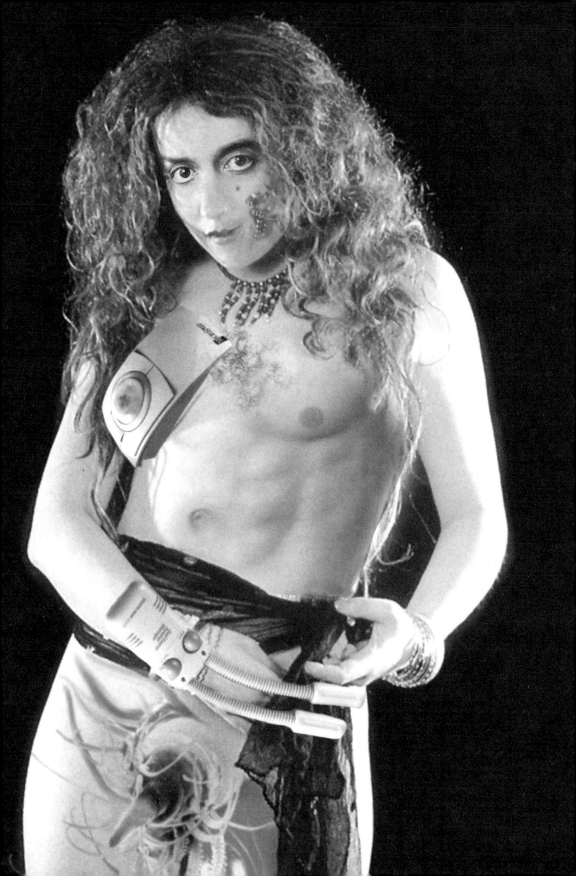

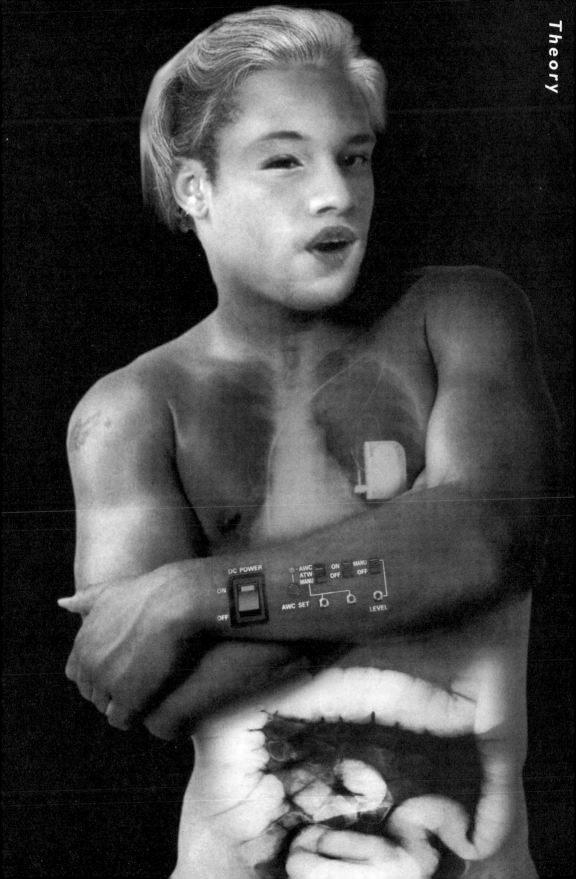

Digital Apparition

■ *V i l é m F l u s s e r*

Before our doubting eyes, alternative worlds begin to emerge from the computers: lines, surfaces, and soon also bodies and moving bodies, made up of point elements. These worlds are colorful and emit sounds, and in the near future they will probably also be touched, smelled, and tasted. But that isn't all, because the moving bodies that will soon be realized through calculation and which are beginning to emerge from computation, will be equipped with the artificial intelligence of Turing's man, so that we will be able to enter into dialogical relationships with them. Why is it that we distrust these synthetic images, sounds, and holograms? Why do we disparage them as "apparitions"? Why are they not real for us? The precipitous answer is: because these alternative worlds are nothing but computed point elements, because they are hazy figments hovering in nothingness.

This answer is precipitous because it measures reality by the density of distribution, and because we can rely on the fact that, in the future, technology will be able to distribute the point elements as densely as is the case with objects in the given world. The table on which I am writing this is nothing but swarm of points. When the elements can be distributed as densely in the hologram of the table, our senses will no longer be able to distinguish between the two. The problem therefore can be posed as follows: either the alternative worlds are as real as the given one, or the given reality is as ghostly as the alternative ones.

There is, however, also a completely different answer to the question about our distrust regarding alternative worlds. It is based on the fact that they are worlds that we ourselves have designed, rather than something that has been given to us, like the surrounding world. The alternative worlds are not givens (data), but artificially produced (facts). We distrust these worlds because we distrust all things artificial, all art. "Art" is beautiful, but a lie, something that is implied in the term "apparition." However this answer also leads to a further question: why does the apparition deceive? Is there anything that does not deceive? This is the decisive question, the epistemological question, which the alternative worlds pose for us. If we talk about the "digital apparition," this and no other question has to be addressed.

Obviously it is not a new question, because it has been worrying us ever since our eyes became doubting, i.e., at least since the pre-Socratic philosophers, even if it achieved its full radicality only at the beginning of the modern period. The alternative worlds with

their digital apparitions propel these irritations toward culmination. Therefore it is apt to begin a consideration of digitization with the beginning of the modern period.

What happened at the time? Briefly speaking, people discovered that although the world may be unimaginable and indescribable, it is calculable. The result of this discovery becomes apparent only now, with respect to the alternative worlds.

In the following section of his essay, Flusser describes how, at the beginning of the modern period, artisans and theorists developed a linear, processual, logical, and historical mode of thought that was opposed to the assumption of fixed, ideal entities and values. He talks about modern, formal, theoretical thought, which, at least since Nicolas Cusanus, Galileo, and Descartes, has been recoded from being letter-based to being figure-based, and how this has created the problem of "filling the gaps" of the intervals. This way of thinking has also afforded the increasing projection of the calculatory model onto notions of reality, which has caused continuous frustration with the elite of scientists and thinkers who, in trying to get control over the world, have consistently been let down by the impossibility of shaping it according to their mathematical projections. According to Flusser, the computer might change this because it is not merely a machine that can calculate at an extremely high speed. It can not only analyze, but also synthesize, and thus actually create artificial spaces and beings.

At this point in the dizzying considerations of "digital apparitions," it is apt to pause in order to review the path we have taken. The view can be described as follows: people have thought in a formal manner at least since the Bronze Age, e.g., by designing sewage systems on clay tablets. In the course of history, formal thought has been subjected to developing processual thought and only returned to the foreground at the beginning of the modern period in the form of "analytical geometry," i.e., as geometrical forms that are recoded into figures. Having been disciplined in such a way, formal thought affected the emergence of modern science and technology. Eventually, it ended in a blind alley. In order to alleviate the practical obstacles, the computer was invented, which in turn radicalized the theoretical problems. At the beginning of the modern period, people were searching for something that would not deceive, and they were certain to have found this in the clear, precise, and disciplined thinking in figures. Then they began to suspect that science was only projecting the figure-code outwards, so that for instance natural laws were equations that had been imposed on nature. Even later, the far-reaching suspicion emerged that perhaps the entire universe, with all its fields and relations, from Big Bang to heat death, might be a projection which calculatory thought attempts to retrieve "experimentally." Ultimately, computers demonstrate that we can not only project and win back this one universe, but that we can do the same with as many as we want. In short: our epistemological problem, and therefore also our existential problem, is whether everything, including ourselves, may have to be understood as a digital apparition.

Here the bull of the alternative worlds can be grabbed by its horns. If everything is delusive, if everything is a digital apparition — not only the synthetic image on the computer screen, but also this typewriter, these typing fingers and these thoughts being expressed by the typing fingers — then the word "apparition" itself has become

meaningless. What remains is that everything is digital, i.e., that everything has to be looked at as a more or less dense distribution of point elements, of bits. Hence, it becomes possible to relativize the term "real" in the sense that something is more real the denser the distribution is, and more potential the more scattered it is. What we call "real," and also perceive and experience as such, are those areas, those curvatures and convexities, in which the particles are distributed more densely and in which potentialities realize themselves. This is the digital world picture as it is being suggested to us by the sciences and presented to our eyes by computers. We will have to live with this from now on, whether we like it or not.

This imposes on us not only a new ontology, but also a new anthropology. We have to understand ourselves — our "self" — as such a "digital distribution," as a realization of possibilities thanks to dense distribution. We have to understand ourselves as curvatures and convexities in the field of criss-crossing, especially human, relations. We are "digital computations" of swirling point-potentialities. This new anthropology, going back to Judeo-Christianity, where humans were conceived of as mere dust, not only has to be worked through epistemologically, e.g., psycho-analytically or neuro-physiologically, but also put into practice. It is not enough to acknowledge that the "self" is a node of criss-crossing virtualities, an iceberg swimming in the sea of the unconscious, or a computation that leaps across neuro-synapses: we also have to act accordingly. The alternative worlds emerging from the computers are a transformation of this understanding into agency.

What do those do who sit in front of the computers, who are pressing keys and who produce lines, surfaces, and bodies? What do they really do? They realize possibilities. They gather points according to precisely formulated programs. What they thus realize is an outside as well as an inside: they realize alternative worlds and thereby themselves. From possibilities they "design" realities which are more effective the more densely they are structured. Thus, the new anthropology is put into practice: "we" is a node of possibilities that increasingly realizes itself — as it gathers more and more densely the possibilities swirling in itself and around itself, i.e., as it creatively shapes them. Computers are apparatuses for the realization of inner-human, inter-human, and trans-human possibilities, thanks to exact calculatory thought. This formulation can be understood as a possible definition of "computer."

We are no longer the objects of a given objective world, but projects of alternative worlds. From the submissive position of subjection we have arisen into projection. We grow up. We know that we dream.

The existential transformation from subject into project is clearly not the result of a "free decision." We are forced into it, just as our distant ancestors found themselves forced to stand up on two legs because the ecological catastrophe of the period compelled them somehow to cross the spaces between the more widely scattered trees. We, on the other hand, have to learn to perceive the objects around us, as well as our own "self," which was formerly called "mind," "soul," or simply "identity," as computations of points. We can no longer be subjects, because there are no more objects

whose subjects we might be, and no hard kernel which might be the subject of some object. The subjective attitude and therefore also any subjective insight have become untenable. We have to leave all that behind as a childish illusion and dare to step into the wide-open field of possibilities. With us, the adventure of becoming human has entered a new phase. This becomes most apparent in the indistinguishability between truth and apparition, or between science and art. We are "given" nothing but realizable possibilities, which are "nothing yet." What we call "the world," what our senses, by not entirely clear methods, have computed into perceptions, into emotions, desires, insights, even the senses themselves, are reified processes of computation. Science calculates the world as it has already been conceived. It deals with facts, with things made, not with data. The scientists are computer artists *avant la lettre*, and the results of science are not some "objective insights," but models for handling the computed. Understanding that science is a form of art does not debase it.

Quite the contrary: science has become a paradigm for all other arts. Indeed, all forms of art only become truly real, i.e., they only construct realities, when they strip themselves of their empiricism and reach the theoretical precision of science. This is the "digital apparition" that we talk about here: through digitization all art forms become exact scientific disciplines and can no longer be distinguished from science.

The German word *Schein* (apparition) has the same root as the word *schön* (beautiful), and will become of prime importance in the future. When the childish desire for "objective insight" is abandoned, then insights will be judged according to aesthetical criteria. This is also nothing new: Copernicus is better than Ptolemy, and Einstein is better than Newton, because they offer more elegant models. What is really new, however, is that from now on we will have to embrace beauty as the only acceptable criterion of truth: "art is better than truth." This is already observable in relation to computer art: the more beautiful the digital apparition, the more real and truthful the projected alternative worlds. Man, as a project, this formally thinking systems analyst and synthesist, is an artist.

This insight returns us to the starting point of the train of thought developed here. We began with the notion that we are distrustful of the emerging alternative worlds because they are artificial and because we have designed them ourselves. This distrust can now be placed in context: it is our old, subjective, linear-thinking, and historically conscious distrust of the new that expresses itself in the alternative worlds, and that cannot be grasped by the received categories like "objectively real" or "simulation." This distrust is based on a formal, calculatory, structural consciousness for which "real" is everything that is experienced concretely (*aisthestai* = experience). Insofar as the alternative worlds are felt to be beautiful, they are realities inside which we live. The "digital apparition" is the light that illuminates for us the night of the yawning emptiness around and in us. We ourselves, then, are the spotlights that project the alternative worlds against the nothingness and into the nothingness. □

TRANSLATED FROM GERMAN BY ANDREAS BROECKMANN.

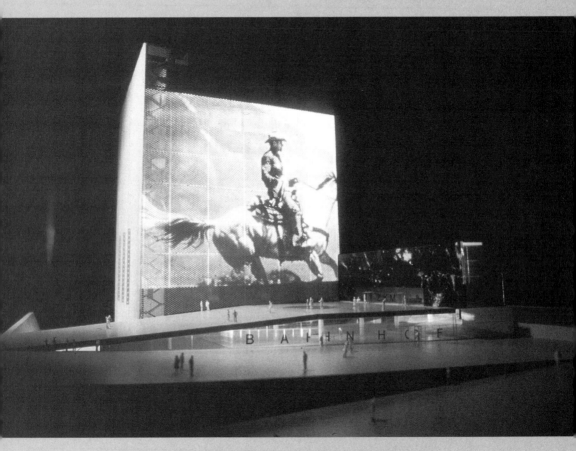

Rem Koolhaas, detail from *Zentum fur Kunst und Medientechnologie,*
competition design development, 1989-1992

Karlsruhe is a city in denial. While, with the imminence of a united Europe, each city positions itself
by claiming maximum centrality, Karlsruhe is Europe's geographical middle, a condition it can
therefore afford to ignore. It prefers the oblivious pose of "typical West German city at the end of
the century." Its citizens serenely inhabit the baroque idyll of their reconstructed townscape, united
in their determination to resist unpleasantness from wherever it may come....

BETWEEN NODES AND
DATA PACKETS

■ *F l o r i a n R ö t z e r*

1. What will the intelligent houses and cities of the digital age be like? How will the life within them be organized? How will McLuhan's global electronic village integrate itself in the cities and villages?

There are the known horror scenarios of the electronic globetrotter, otaku, or the data dandy who holes up, lonely but in a teleorgiastic mood, in his media center, which is connected to the rest of the world via networks. At the same time, the environment does not interest him at all, and his home has become a mere housing, the interior walls and facades of which are decorated with images and symbols. Life between the intelligent housings in which artificial nature settles dies out for the most part, reduced to specific areas for transportation of goods and physical sports, social encounters, staged events, or the aesthetic perception of nature. Even the shrinking of the body, which has been prophesied by some technophiles who are not afraid of this eventuality.

With the help of the media of immersion, journeys, adventures, and encounters with other people are possible without having to leave the house. We could also move robots outside of the space built around us, which contains our bodies by means of telepresence and telemechanics, should our virtual face appearing on some type of surface not suffice. An American company is planning to send a remote-controlled vehicle to the moon which can be piloted by anyone who is willing to pay, either from an amusement park or his or her private home. Furthermore, remote-controlled robots can be sent into wars and violent uprisings, contaminated areas, distant workplaces, or just to the store, and one will be able to listen, speak, move, touch, and feel at long-distance. Although one's presence in this world was formerly dependent on the body's location, teletechnology splits the experience of presence: one can be two places at the same time.

Body developments are progressing rapidly. Assuming that commercial interests are presently concentrated on making it possible for people to be connected to the networks at all times and by means of even smaller battery-operated devices, wherever they might be, thereby filling in the gaps in virtual space, then the first steps are being made to replace the body in its function as an

instrument of control. Cybersex with data suits and all the equipment for simulating and stimulating the body's surfaces seems even now to be the nostalgic mechanics of teleintimacy, comparable to a novel of chivalrous romance. The next step is directed toward the most important part of the body, the brain, and is intended to stimulate it directly, thereby dispensing with cumbersome apparatuses, and possibly even to enable its replacement.

Up until now, neural prostheses, the coupling of natural and artificial data-processing systems, have been designed solely to replace damaged brain functions. However, they simultaneously increase the knowledge of how to influence and change the brain in other ways, thereby clearing the path for neurohacking. Screens will no longer be needed. A laser will draw the images into the retina. Headphones will no longer be needed. A cochlea implant will stimulate our auditory center. Hands and body movements are no longer needed to control computer programs: eye movements, speaking — EEG signals from brain waves will perform the same function. At present, direct stimulation of the visual center by means of signals from video cameras is being made possible. The direct coupling of neural tissue to computer systems and the implantation of chips in the brain is now the hot, new subject of research projects. Finally, we will no longer need our bodies for telemechanics; picking up the signals to the motor systems and directing them to machines will be sufficient.

At the same time, we are trying to lock biological life into easily grasped and controllable cells which are independent of their environment. Biosphere II has failed, but the project points the way from the ruined earth to the future of self-sufficient systems, of "singles" that have freed themselves from local conditions, from the intelligent houses to an intelligent biotope. What is left of nature, permanently monitored by sensors, retreats to the innermost part of the space constructed around us, which is connected to other spaces solely by means of tele-communications. The organization of the static space around us, between the cells of which the data packets circulate, will always be necessary. The important thing at present is not favoring an existence in the networks over the body's existence in "real" space, to say nothing of praising the former as being essentially superior, but designing the body's housing and its conditions for self-preservation. At present, of course, coupling the brain to computer systems directly and enabling the remote control of robots by means of telepresence and telemechanics is being worked on. Ambivalence concerning whether computer systems are being coupled to the brain or vice versa characterizes this project, which could lead in the long term to the detachment of cognition from the body and the implied here-and-now restrictions in a postbiological age. The near future, however, will bring different problems, the core of which will be the coordination of the various areas of tele-existence in the global network architectures, which are slowly drifting apart, and life at fixed locations. The important issues are therefore how cyberspace will be embedded in the real world and the retroactive effects it will have on the world.

11. We do not even know how the conventional mass media — books and news-papers, but above all telephone, radio and television — have intervened in the structure of our cities, in their architecture and especially in the details of the urban forms of life. Therefore, one can only speculate on the changes which will result from the broadband cable networks just now being installed. The telegraph and telephone have already extensively transformed the city into an instrument of spatial condensa-tion, and therefore of acceleration, intensification, and the coupling of communications and decision-making processes. When the difference between local and long-distance communication has been reduced, spatial condensation, which characterizes the cities, will become dispensable. In addition to the expansion of the global media, this process is, of course, driven by the acceleration of transportation and traffic.

Cities have always fulfilled the function of networking through condensation for the areas surrounding them; they are the focus of power, capital, the movement of goods, labor, knowledge and culture. Since the birth of the first cities, they have dominated history. Cities have not only been characterized by the fact that they are centers or main allures in their regions; they have also connected the various regions and, with their traffic routes, have represented a material network. Internally, the short distances have made it possible for all the different areas to interact quickly with one another and with the areas surrounding other centers; coordination and escalating competition have been made possible; their dynamism has led them to use their elbows against one another. The collision of heterogeneous cultures and sharp social contrasts has contributed to the cities' dynamism, just as with the urban lifestyle, in the anonymity of which subcultures can develop. These subcultures have torn down the reigning social convention and enabled new ways of dealing with foreignness.

The public sphere determined by the spatial nearness is migrating more and more to the realm of the media and networks. Still, as was already the case when telephone lines were laid, large conglomerations are the first to be connected to the information highways, which means that the cities are again more privileged than the countryside at first glance. However, this is a temporary process which aids the urban periphery in its growth and, as a whole, further undermines the importance of location. Information which travels through the networks replaces the paths along which objects, people, and information pass from one place to another, and uses a new kind of simultaneity to connect locations far removed from one another in a virtual space which can no longer be localized. The telephone gave birth to the dimension of tele-existence in cyberspace, which is beyond real space and changes its coupling function. The telephone, the prototype for the networked media, made spatial distortion and coordination of actions and decisions possible. This has affected not only commerce, politics, and administration, but also private life. Meetings can be arranged quickly; close relationships develop at long distance. The private sphere and its opportunity for chance encounter loses importance.

In the past few decades in Europe, the trend of turning the old urban centers into open-air museums has begun. They are to be protected as monuments and

exhibits, while everything behind the facades is changed. On the other hand, the Komission Zukunft Stadt 2000 (Urban Future Commission 2000) called into being by the German federal government determined the following: "City planning on the periphery is no longer characterized by a consensus, or by a code of regulations and rules of behavior. In the past 15 to 20 years, city planning on the periphery has pursued ad hoc solutions leading to arbitrary results for the structural shapes and designs of the investors." In spite of the regionalistic attitude, which emerged in the postmodern period, this caprice is not very widespread in the rest of the world: more than ever, construction makes use of an international style, which brings peripheries into conformity with one another just as the rest of the culture has conformed with popular culture. Multinational companies and the increasing concentration of capital permeate regional centers with their branch offices, which are identical wherever they are found. If the public sphere is in any case too dangerous or too barren and therefore to be avoided as much as possible or only transversed quickly, the old city centers are transformed into urban museums and shopping zones; these areas are pervaded with the cathedrals of international concerns while the networks permit the commercialization of every step taken in their "public" spaces: the pedestrian pays for everything that he or she sees or is bombarded with advertising to which he or she must submit when merely passing from one place to the next. Advertising, however, is no longer diffusely directed at everyone and is therefore directed at no one; now, every step taken is tracked and the offerings are tailored to the individual pedestrian.

The influence of the mass media and the opportunity to come into contact with others at any time is possibly an important reason why many people live in the suburbs, holed up in their private spheres, and why traditional familial structures are disintegrating. Spatial closeness develops into mere coexistence, and interaction from within the private caves takes place only with distant partners. At present, urban space is occupied by the media. In contrast to streets, paths, doors and windows, information highways and networks, the doors to cyberspace are not immediate elements of architectural design, even if they must lead into and out of its structures.

We probably still underestimate the meaning of cities because they exist at present as relics. In the last decades, the most important changes have taken place behind the distracting theatrical architecture in the urban periphery and in rural areas — and always outside of the "great" architecture and urban planning. After networks with broadband cable and satellites have made many of those functions of the cities which are based on the concentration of heterogeneous institutions and superfluous cultures, a ruralization of the information society might begin.

Concentration through condensation would no longer be important; dispersion and networking over great distances would set the standards for the sizes of orientation. That would correspond to the transition from the serial processing, centralized von Neumann computer to decentralized computer architectures

which function parallel on a massive scale. Rural or digital urbanism (Martin Pawley) and its lack of densely settled areas and a universalistic face extends along the traffic networks, mixing residential areas in the countryside with settlements in industrial regions, warehouses, administration buildings, agriculture, and biotopes, leaving the city centers empty of social life. Because of the greater quality of life offered and thanks to the spatial independence enabled by telecommunications, the middle class is withdrawing from the city centers, and this trend is especially obvious in the United States. The new cities leave the differentiation between center, periphery and countryside behind and destroy the traditional hierarchy through which regions are organized, controlled, and represented by a center, or a central accounting unit, so to speak. Even now, the contours of the new European metropolises can be seen; they begin in Milan, run through Switzerland and along the Rhine into the Benelux countries and end in London.

III. The body's material environment, as shown by the value now placed on the body and nature, will not become unimportant in the society of digital networks, though it will be organized and directed strictly according to functional criteria, and at the same time, more and more of the external world's functions will be assumed by the constructed spaces of the internal world. The informatization of ecological systems, the permanent monitoring by means of all kinds of sensors, serves the primary purpose of providing warning and security systems designed to enable the protection of the foundations of human life; the resulting knowledge, however, is directed toward the ability to control the complex ecological machine and, should this be impossible, to construct autonomous microcosms which are isolated from the environment, which are completely monitored, and which can be run in the same way as other extensive technical systems. The external world is used for the transportation of goods and people; nature serves as the place of food production and that of certain recreational needs, to which the aesthetic perception of "staged" nature in parks, nature preserves, and biotopes belongs. The environment continues to be a resource one must protect in order to maintain life in the constructed areas, which, however, tend to become more independent and autonomous because of their "intelligence." The homebodies in their bunkers will replace spatial closeness with an intimate telepresence; the encounters in cyberspace will supersede those in the public space, which will become more and more inhospitable.

If Biosphere II is the ultimate model for digital urbanism, then the intelligent box is its predecessor. One of the first steps in this direction, less important but still spectacular, was the creation of "media facades," which will cover the walls of certain buildings of the future. Architecture, which stands immobile, is dynamized not only in its form; its interior and exterior will be transformed to make it a vehicle which navigates through the virtual spaces.

When the Center for Art and Media Technology in Karlsruhe, Germany,

invited architects to make entries in a contest for a new building (which was never constructed due to a lack of funds), Rem Koolhaas's design won the first prize. The main body, a symbol of the media culture which would exist within it, was to be simple and monumental. A "media facade" was planned, and the visual spectacle would have delighted those persons arriving on the highway rather than the passersby on the street. Surely, the mythos of functionalism has been shattered just as that of being able to read a book by its cover. Media facades are only sequels to the decorated boxes of which Venturi had spoken — the vehicles of advertising messages, residue from the public sphere which lives within its housing. Toyo Ito's "Tower of the Winds," on the other hand, controls the facade according to ecological data. A computer program translates the random audio-visual impulses into a constantly changing light installation. Here, too, however, facts are only transformed into a monumental aesthetic event in that the intelligent facades of the future will use sensors to scan the events taking place in the environment in order to maintain the stability of the interior climate. The box planned by Koolhaas not only shows that the architecture of the digital age will reduce buildings to mere housings, he also expresses the form in which the digital technology is embedded. It is the form which continues to serve a function solely for the multifunctional and mutable internal spaces, specifically those functions of providing protection with the necessary interface ports.

IV. Sweeping promises accompany the future network of the so-called information superhighways through which it will be possible to send data packets around the world. Many things are supposed to change, and these changes will exercise considerable influence on the nature of urban life and its architecture, assuming that it will be possible for everyone to afford (or that everyone will be forced to acquire for reasons of survival) access to the networks everywhere and all the time, and therefore be able to communicate with everyone in the world, who are all connected to the network as well. The pillars of this change would be tele-homework, teleshopping, tele-education, etc., and the resulting decentralization of organizations, the slimming down of companies and administrations to the point of their becoming virtual enterprises, and the increase in freelance labor without any job security. The latter is a factor which makes the necessity of spatial condensation largely superfluous and could reduce the volume of traffic while the transport of goods will certainly continue to increase as a result of the growing dislocation and decentralization. The media stations in private apartments and houses will be in the center of the upheaval. One will no longer travel to work by car or public transportation, but by modem. Telecommuting will sustain a new form of labor. At least, this is the goal of telecommunication enthusiasts: "The standard apartment or house will not only have a living room, bedroom, kitchen and bathroom — a new room which we could call the 'communications room,' will become the focus. The

media station, or the monitor, will be located at the center. All information will arrive or depart from this room. This media station, or the monitor will be connected to an 'in-house network' which links all the rooms in the house or apartment. One will then be able to activate the station from the yard, via cellular devices, meaning that the physical presence in the communications room is unnecessary. This creates the possibility of relaxing outside and still being on standby. By relocating the workplace to the area which was formerly exclusively private, the apartment will become a living space to a considerably larger degree. A consequence of this development: the amount of office space will decrease, and the size of apartments and residential houses will grow. The remaining 'industrial administration space' will also have a different appearance. The archi-tecture will be forced to adapt to the status of a 'meeting-place.' This means the issue of living and working space must be redefined and discussed anew."[1]

That which sounds so inviting (and which will probably be reality only for a certain class) will not really be, in the final analysis, so very attractive, especially as everything depends on whether the utilization of information superhighways makes economic sense in the first place. IBM Deutschland has apparently already halted the further increase in the number of tele-workstations in the face of the immense costs involved. On the other hand, residents of the Third World are already being hired to perform simple telework tasks, of course without any job security and at extremely low wages, because the location of the workplace is no longer important and the multinational companies can easily divert operations to other locations which promise to provide higher profits.

At present, the decentralization of production, made possible by telecom-munications and the opportunity for swift transportation, is leading to an increase in inexpensive labor in the service sectors of wealthy countries, in other words, in that sector which fills the gaps created by automation and telecommunications. In spite of the renewed upswing of and increase in these low-paid jobs, the process of pauperization has increased by leaps and bounds in the United States in recent years and can also be observed in Europe. As long as the world is organized into nation-states, the various countries and communities *will* be hostages of the multinational companies, and wherever the population density and concentration of problems are greatest, dreams of the reawakening of cities will also founder on the money that these cities no longer have.

V. If this diagnosis is correct, further erosion in the border between city and country will be the result for urban areas. As the need for living space rises, complete utilization will increase, as will the ecological problems of uncontrolled development, even if there are no considerable changes in the areas with intensive agricultural industries or artificial ecotopes are created to replace the landscape which has disappeared. With the exception of a few global cities, which

will continue to exist (as Saskia Sassen has argued) and which will be the places where management and certain special services provided by the multinational companies are concentrated, the urban areas will decline in importance, as can be seen in the downfall of the once great and powerful industrial bases.

Of course, the pathways to work and those to meetings will be shortened, but passenger-car traffic will not decrease considerably because the construction of public transportation networks which service large areas of the periphery and the countryside is impossible. Public-transport networks are usually star-shaped in alignment with the urban center and adapted to the currents of conventional cities from the exterior to the interior and vice versa. As more and more working and living spaces are moved out of the center, traffic between it and the periphery or the country will increase, and the trips which have been saved by teleshopping will be made up for through delivery.

The new world of telework is intended to turn the private domicile into a workplace. With the exception of a few jobs in production, distribution, and customer service, many processes could be controlled by remote control via the networks and with the aid of the technologies of telepresence and telemechanics. This would include custom mass production of consumer goods within certain standards by means of Computer-Integrated Manufacturing (CIM), combined with just-in-time production. The customer, in addition to choosing and ordering prefabricated goods at a distance, would be able to determine and control the design of the desired product. Life in the electronic cave, which increasingly combines work and leisure time, will also promote isolation, at least in that one will no longer be forced to leave the private sphere every working day and spend a relatively large amount of time with strangers in the same room. This might not be a problem only for singles but also for small families, which presumably are able to keep functioning more or less because they are not forced to be together constantly and because fixed working hours provide them with time apart. Telework, on the other hand, could lead to personal conflicts in the process of balancing interests which, in turn, may cause psychological stress, thereby possibly making relationships with a quantum of distance, telesocial relationships, more attractive. In any case, the consequences of a society networking via telecommunications will extend into the private sphere and require a change in the organization of the private life which will, in turn, be reflected in architecture and urban spatial structure.

VI. The brave new world of the networks and the life forms developing in them contain huge areas which remain unexplored and lag behind. These areas can be found not in rural areas but in the cities. After it seemed for a time that the attraction of the cities in Europe had disappeared, as if their death, proclaimed by many, had finally taken place, they have begun to grow in the recent past, above all because of the immigration and influx of foreigners. At same time, the cities of

the Third World continue to explode, and the rural population figures sink steadily. At present, between 45 percent and 60 percent of the world's population live in cities, and this figure was only 10 percent thirty years ago. Slums and ghettos are replacing the villages, and their growth is exponential. In many metropolises in developing countries, almost half of the residents will soon live in slums or on the streets — in the city, or at least in an area connected to the city, but strictly separated form urban life, caught in the trap of new social structures with their own rules, and almost always living with the fact that they will have to resign themselves to remaining outsiders.

Territorial closeness in this case does not only provide the chance to integrate oneself into the established urban life at some point. Suburbs, ghettos, and slums are characterized by poverty and unemployment, by ethnic minorities, refugees and immigrants, by crime, drugs and alcohol, by warring youth gangs and an underground economy, by a more or less lawless area which evades the political authorities and urban administration. Many other characteristics of urban life are also missing in the European suburbs; only boredom is in abundance. There are few businesses and fewer jobs. Leisure-time facilities are just as rare as those of the public transportation system. Instead, radio and television form a link between the people and urban life, which is often further removed from the suburbs and slums in a social sense than from the villages and small towns, although the standards of the popular culture, which in principle promise participation, are omnipresent thanks to telecommunications technology. To a great extent, they have drowned out and destroyed the social culture and neighborhood control of even the earlier worker settlements. One constantly sees that which one can neither be nor have. Interactive media such as computer games reinforce this trend of promising participation, though even television has, of course, already undermined social ties, which are, of course, always constraints. Media do not always force themselves onto their consumers; they do not always attempt to draw them in by constantly showing the crossing of borders and making the intimate public. They also have a tendency to invade every niche of everyday life, thereby blurring the conventional borders between the private and public spheres.

This process of "mediatization" began after the end of the World War II. The cumbersome tabletop radios were replaced by portable and ever cheaper transistor models. Television established itself as an instrument of mass media in the sixties. Since then, we have approached a situation in which everyone has his or her own set and several hours or more of leisure time are spent connected to the electronic world. This process is accompanied by the decay of broadcasting in programs which cater to ever smaller social groups with ever more specialized programs. The withdrawal from the streets and the squares, the urban public media, is accompanied by a withdrawal from social ties. Coupling to the media, which is especially evident in the case of Walkman headsets and interactive media, leads to an uncoupling from the immediate surroundings. This last uncoupling involves considerable conse-

quences in the urban areas characterized by unemployment, although it may be possible that this will occur only in a time of transition from industrial to information society. Because the street, the public space, is becoming more and more dangerous: one no longer knows one's neighbors; fluctuation is great and unemployment hinders the formation of a common social identity; the apartment becomes a place of retreat; a person's close, personal sphere is being replaced by the media's public sphere, which is becoming more and more fragmented. The windows no longer open to the outside; the screen brings the distant reality into the room: an immediate spatial coupling at long distance and herald of a telexistence, which is being ushered in by the expansion of the networks.

The real contact with the "other" world which takes place in the impoverished suburbs is often maintained only by the school, social workers, and police officers. Some people hardly ever leave their neighborhoods, while the residents of the rest of the city avoid those areas and close themselves off more and more from public life in social niches and barricaded homes, workplaces and shopping centers rolled into one. In a social regard, these enclaves give birth to the autonomous systems of which Biosphere II is the forerunner in an ecological sense. "Security is one of the most important features of an apartment or an office, and furnishing it with the appropriate technology has already become a status symbol: armed response. The formerly open city is being equipped with doors, gratings, and observation cameras." Increasingly, public places are being monitored, if not transformed, into fortresses: "The new architecture is oriented entirely toward creating bunkers, towards strict separation of the public and private. . . . More and more activities — traveling, theater-going, dining, shopping — must take place indoors; mingling with unmonitored groups is to be avoided."[2]

The division of the cities and their gentrification make networks seem to be bridges which span the growing urban black holes and, in so doing, they intensify the exclusion. In their report on the black holes of the French suburbs, Dubet and Lapeyronnie present an exemplary characterization of the dire situation of young people brought about by the lack of an organic everyday culture and the failure of social integration: "The *galore* [French slang for suburbs] is borne of the destruction of a certain way of life. It consists of the ruins of the old world, and its pieced-together nature prohibits understanding it as a subculture. . . . Youths who grow up in the *galore* are uprooted. Whether their parents are native French or immigrants has no bearing; there are no cultural contrasts between these two groups. The experiences of both are based in an unstable world of assorted props in which local ties are more vital than national or ethnic roots. In the world of the *galore*, interpersonal relationships are burdened by distrust, hostility, and fear. Racial conflict expresses itself there in social and economic competition and not in irreconcilable cultural differences. The result is not confrontation between various cultures and communities, but a war free-for-all."[3]

Although when examined from a superficial perspective, racism and ethnicity

seem to characterize these new ways of life, the disintegration of cultural identity as a result of a leveled global culture is revealed in the book *Aus der Vorstadte*. Ethnic props, ethnic discrimination and ethnic alliances play a certain role in this culture, but only as an erstaz for the expected participation in the global culture visible everywhere in the media images. As an example, a type of transitional culture develops in the urban suburbs, which could, of course, also be located in the center. This transitional culture, showing here its desperate and brutal side, participates in those processes which serve a standard for the networked global culture and all its racist rejections: dissolutions of traditions and the bonds to localities and regions through increasing mobility and global telecommunications leading to the creation of new ways of life and a future telexistence which uses and radicalizes the free areas established in conventional urban life. Regional bonds and identities are preventing the transition to the age of the networks. The present flare-up of national and ethnic ambitions is only one last desperate struggle before the disappearance of cultural diversity in the network of systems, in the system of the networks. ☐

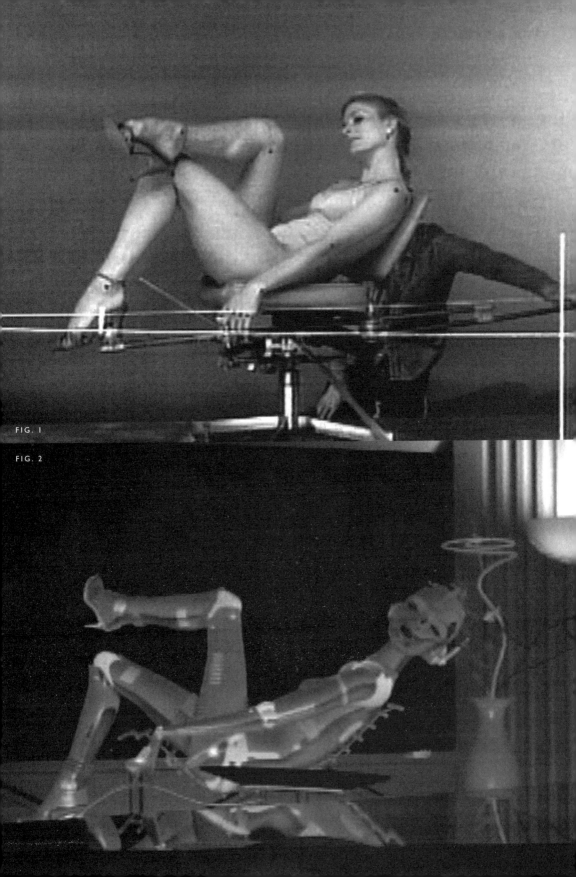

FIG. 1

FIG. 2

Virtual Bodies and Flickering Signifiers

N. Katherine Hayles

*We might regard patterning or predictability
as the very essence and raison d'être of
communication . . . communication is the
creation of redundancy or patterning.*

—Gregory Bateson, *Steps to an Ecology of Mind*

In this last decade of the twentieth century, information circulates as the currency of the realm. Genetics, warfare, entertainment, communications, grain production, and financial markets number among the sectors of society revolutionized by the shift to an information paradigm. The shift has also profoundly affected contemporary fiction. If the effects on literature are not widely recognized, perhaps it is because they are at once pervasive and elusive. A book produced by typesetting may look very similar to one generated by a computerized program, but the technological processes involved in this transformation are not neutral. Different technologies of text production suggest different models of signification; changes in signification are linked with shifts in consumption; shifting patterns of consumption initiate new experiences of embodiment; and embodied experience interacts with codes of representation to generate new kinds of textual worlds.[1] In fact, each category — production, signification, consumption, bodily experience, and representation — is in constant feedback and feedforward loops with the others. Pull any thread in the skein, and the others prove to be entangled in it.

The clue that I want to pursue through these labyrinthian passages is provided by the following proposition: *even though information provides the basis for much of contemporary society, it is never present in itself.* The site where I will pick up this thread is the development of information theory in the years following World War II. In information-theoretic terms, information is conceptually distinct from the markers that embody it, for example, newsprint or electromagnetic waves. It is a pattern rather than a presence, defined by the probability distribution of the

coding elements comprising the message. If information is pattern, then noninformation should be the absence of pattern, that is, randomness. This commonsense expectation ran into unexpected complications when certain developments within information theory implied that information could be equated with randomness as well as with pattern.[2] Identifying information with *both* pattern and randomness proved to be a powerful paradox, leading to the realization that in some instances, an infusion of noise into a system can cause it to reorganize at a higher level of complexity.[3] Within such a system, pattern and randomness are bound together in a complex dialectic that makes them not so much opposites as complements or supplements to one another. Each helps to define the other; each contributes to the flow of information through the system.

Were this dialectical relation only an aspect of the formal theory, its impact might well be limited to the problems of maximizing channel utility and minimizing noise that occupy electrical engineers. Through the development of information technologies, however, the interplay between pattern and randomness became a feature of everyday life. A common site where people are initiated into this dialectic is the cathode tube display. Working at the computer screen, I cannot read unaided the magnetic markers that physically embody the information within the computer, but I am acutely aware of the patterns of blinking lights that comprise the text in its screen format. When I discover that my computerized text has been garbled because I pressed the wrong function key, I experience firsthand the intrusion of randomness into pattern.

This knowledge, moreover, is not merely conceptual. It is also sensory and kinesthetic. As Friedrich Kittler has demonstrated in *Discourse Networks 1800/1900*, typewriters exist in a discourse network underlaid by the dialectic of presence and absence.[4] Typewriter keys are directly proportionate to the script they produce. One keystroke yields one letter, and striking the key harder produces a darker letter. The system lends itself to a model of signification that links signifier to signified in direct correspondence, for there is a one-to-one relation between the key and the letter it produces. By contrast, the connection between computer keys and text manipulation is non-proportional and electronic. Display brightness is unrelated to keystroke pressure, and striking a single key can effect massive changes in the entire text. Interacting with electronic images rather than a materially resistant text, I absorb through my fingers as well as my mind a model of signification in which no simple one-to-one correspondence exists between signifier and signified. I know kinesthetically as well as conceptually that the text can be manipulated in ways that would be impossible if it existed as a material object rather than a visual display. As I work with the text-as-image, I instantiate within my body the habitual patterns of movement that make pattern and randomness more real, more relevant, and more powerful than presence and absence.[5]

In societies enmeshed within information networks, as the United States and other first-world countries are, this example can be multiplied a thousandfold.

Money is increasingly experienced as informational patterns stored in computer banks rather than the presence of cash; in surrogacy and *in vitro* fertilization cases, informational genetic patterns compete with physical presence for the right to determine the "legitimate" parent; automated factories are controlled by programs that constitute the physical realities of work assignments and production schedules as flows of information through the system[6]; criminals are tied to crime scenes through DNA patterns rather than eyewitness accounts verifying their presence; right of access to computer networks rather than physical possession of the data determines nine-tenths of computer law[7]; sexual relationships are pursued through the virtual spaces of computer networks rather than through meetings at which the participants are physically present.[8] The effect of these transformations is to create a highly heterogeneous and fissured space in which discursive formations based on pattern and randomness jostle and compete with formations based on presence and absence. Given the long tradition of dominance that presence and absence have enjoyed in the Western tradition, the surprise is not that formations based on them continue to exist but that they are being displaced so rapidly across such a wide range of cultural sites.

Critical theory has also been marked by this displacement. At the same time that absence was reconceptualized in poststructuralist theory so that it is not mere nothingness but a productive force seminal to discourse and psycholinguistics, so randomness was reconceptualized in scientific fields so that it is not mere gibberish but a productive force essential to the evolution of complex systems. The parallel suggests that the dialectic between absence and presence came clearly into focus because it was already being displaced as a cultural presupposition by randomness and pattern. Presence and absence were forced into visibility, so to speak, because they were already losing their constitutive power to form the ground for discourse, becoming instead discourse's subject. In this sense deconstruction is the child of an information age, formulating its theories from strata pushed upward by the emerging substrata beneath.

The displacement of presence/absence hints at how central pattern/randomness may be in informing contemporary ideas of language, narrative, and subjectivity. The new technologies of virtual reality illustrate the kind of phenomena that foreground pattern and randomness, and make presence and absence seem irrelevant. Already an industry worth hundreds of millions, virtual reality puts the user's sensory system into a direct feedback loop with a computer.[9] In one version, the user wears a stereovision helmet and a body suit with sensors at joint positions. The user's movements are reproduced by a simulacrum on the computer screen called a puppet. When the user turns her head, the computer display changes in a corresponding fashion. At the same time, audiophones create a three-dimensional sound field. Kinesthetic sensations, such as G-loads for flight simulators, can be supplied by the body suit. The result is a multisensory interaction that creates the illusion that the user is *inside* the computer. From my experience with the virtual reality simulations at the Human Interface Technology

Laboratory and elsewhere, I can attest to the disorienting, exhilarating effect of feeling that subjectivity is dispersed throughout the cybernetic circuit. The user learns kinesthetically and proprioceptively in these systems that the boundaries of self are defined less by the skin than by the feedback loops connecting body and simulation in a techno-bio-integrated circuit.

Questions about presence and absence do not yield much leverage in this situation, for the puppet both is and is not present, just as the user both is and is not inside the screen. Instead, the focus shifts to questions about pattern and randomness. What transformations govern the connections between user and puppet? What parameters control the construction of the screen world? What patterns can the user discover through interaction with the system? Where do these patterns fade into randomness? What stimuli cannot be encoded within the system and therefore exist only as extraneous noise? When and how does this noise coalesce into pattern?

The example, taken from technology, illustrates concerns that are also appropriate to literary texts. It may seem strange to connect postmodern bodies with print rather than electronic media, but bodies and books share a crucially important characteristic not present in electronic media. Unlike radio and television, which receive and transmit signals but do not permanently store messages, books carry their information in their bodies. Like the human body, the book is a form of information transmission and storage that incorporates its encodings in a durable material substrate. Once encoding in the material base has taken place, it cannot easily be changed. Print and proteins in this sense have more in common with each other than with any magnetic or electronic encodings, which can be erased and rewritten simply by changing the magnetic polarities. The metaphors of books, alphabets, and printing pervasive in the discourse of genetics are constituted through and by this similarity of corporeal encoding.

The entanglement of signal and materiality in bodies and books confers on them a parallel doubleness. Just as the human body is understood in molecular biology as simultaneously a physical structure and an expression of genetic information, so the literary corpus is at once a physical object and a space of representation, a body and a message. Because they have bodies, books and people have something to lose if they are regarded solely as informational patterns, namely the resistant materiality that has traditionally marked the experience of reading no less than it has marked the experience of living as embodied creatures. From this affinity emerge complex feedback loops between contemporary literature, the technologies that produce it, and the embodied readers who produce and are produced by books and technologies. The result is a network of changes that are moving in complex syncopation with one another. Changes in bodies as they are represented within literary texts have deep connections with changes in textual bodies as they are encoded within information media, and both stand in complex relation to changes in the construction of human bodies as they interface with

information technologies (see Figs. 1 and 2). The term I use to designate this network of relations is "informatics." Following Donna Haraway, I take informatics to mean the technologies of information as well as the biological, social, linguistic, and cultural changes that initiate, accompany, and complicate their development.[10]

I am now in a position to state my thesis explicitly. The contemporary pressure toward dematerialization, understood as an epistemic shift toward pattern/randomness and away from presence/absence, affects human and textual bodies on two levels at once, as a change in the body (the material substrate) and a change in the message (the codes of representation). To explore these transformations, I want to untangle and then entangle again the networks connecting technological modes of production to the objects produced and consumed, embodied experience to literary representation. The connectivity between these parts and ports is, as they say in the computer industry, massively parallel and highly interdigitated. My narrative will therefore weave back and forth between the represented worlds of contemporary fictions, models of signification implicit in word processing, embodied experience as it is constructed by interactions with information technologies, and the technologies themselves.

The next thread I will pull from this tangled skein concerns the models of signification suggested and instantiated by information technologies. Information technologies do more than change modes of text production, storage, and dissemination. They fundamentally alter the relation of signified to signifier. Carrying the instabilities implicit in Lacanian floating signifiers one step further, information technologies create what I will call *flickering signifiers*, characterized by their tendency toward unexpected metamorphoses, attenuations, and dispersions. Flickering signifiers signal an important shift in the plate tectonics of language. Much of contemporary fiction is directly influenced by information technologies; cyberpunk, for example, takes informatics as its central theme. Even narratives without this focus can hardly avoid the rippling effects of informatics, for the changing modes of signification affect the *codes* as well as the subjects of representation.

SIGNIFYING THE PROCESSES OF PRODUCTION

"Language is not a code," Lacan asserted, because he wished to deny any one-to-one correspondence between the signifier and the signified.[11] In word processing, however, language is a code. The relation between assembly and compiler languages is specified by a coding arrangement, as is the relation of the compiler language to the programming commands that the user manipulates. Through these multiple transformations some quantity is conserved, but it is not the mechanical energy implicit in a system of levers or the molecular energy of a thermodynamical system. Rather it is the informational structure that emerges from the interplay between pattern and randomness. The immateriality of the text, deriving from a translation

of mechanical leverage into informational patterns, allows transformations to take place that would be unthinkable if matter or energy were the primary basis for the systemic exchanges. This textual fluidity, which the user learns in her body as she interacts with the system, implies that signifiers flicker rather than float.

To explain what I mean by flickering signifiers, I will find it useful briefly to review Lacan's notion of floating signifiers. Lacan, operating within a view of language that was primarily print-based rather than electronically mediated, not surprisingly focused on presence and absence as the dialectic of interest.[12] When he formulated the concept of floating signifiers, he drew on Saussure's idea that signifiers are defined by networks of relational differences between themselves rather than by their relation to signifieds. He complicated this picture by maintaining that signifieds do not exist in themselves, except insofar as they are produced by signifiers. He imagined them as an ungraspable flow floating beneath a network of signifiers that itself is constituted through continual slippages and displacements. Thus for him a doubly reinforced absence is at the core of signification — absence of signifieds as things-in-themselves as well as absence of stable correspondences between signifiers. The catastrophe in psycholinguistic development corresponding to this absence in signification is castration, the moment when the (male) subject symbolically confronts the realization that subjectivity, like language, is founded on absence.

How does this scenario change when floating signifiers give way to flickering signifiers? Foregrounding pattern and randomness, information technologies operate within a realm in which the signifier is opened to a rich internal play of difference. In informatics the signifier can no longer be understood as a single marker, for example an ink mark on a page. Rather it exists as a flexible chain of markers bound together by the arbitrary relations specified by the relevant codes. As I write these words on my computer, I see the lights on the video screen, but for the computer the relevant signifiers are magnetic tracks on disks. Intervening between what I see and what the computer reads are the machine code that correlates alphanumeric symbols with binary digits, the compiler language that correlates these symbols with higher-level instructions determining how the symbols are to be manipulated, the processing program that mediates between these instructions and the commands I give the computer, and so forth. A signifier on one level becomes a signified on the next higher level. Precisely because the relationship between signifier and signified at each of these levels is arbitrary, it can be changed with a single global command. If I am producing ink marks by manipulating movable type, changing the font requires changing each line of type. By contrast, if I am producing flickering signifiers on a video screen, changing the font is as easy as giving the system a single command. The longer the chain of codes, the more radical the transformations that can be effected. Acting as linguistic levers, the coding chains impart astonishing power to even very small changes.

Such leverage is possible because the constant reproduced through multiple coding layers is a pattern rather than a presence. Pattern can be recognized through redundancy or repetition of elements. If there is only repetition, however, no new information is imparted; the intermixture of randomness rescues pattern from sterility. If there is only randomness, the result is gibberish rather than communication. Information is produced by a complex dance between predictability and unpredictabililty, repetition and variation. We have seen that the possibilities for mutation are enhanced and heightened by long coding chains. We can now understand mutation in more fundamental terms. Mutation is crucial because it names the bifurcation point at which the interplay between pattern and randomness causes the system to evolve in a new direction.[13] Mutation implies both the replication of pattern — the morphological standard against which it can be measured and understood as a mutation — and the interjection of randomness — the variations that mark it as a deviation so decisive it can no longer be assimilated into the same.

Mutation is the catastrophe in the pattern/randomness dialectic analogous to castration in presence/absence. It marks the opening of pattern to randomness so extreme that the expectation of continuous replication can no longer be sustained. But as with castration, this only appears to be a disruption located at a specific moment. The randomness to which mutation testifies is always already interwoven into pattern. One way to understand this "always already" is through the probability function that mathematically defines information in Claude Shannon's classic equations in information theory.[14] Were randomness not always already immanent, we would be in the Newtonian world of strict causality rather than the information-theoretic realm of probability. More generally, randomness is involved because it is only against the background or possibility of nonpattern that pattern can emerge. Wherever pattern exists, randomness is implicit as the contrasting term that allows pattern to be understood as such. The crisis named by mutation is as wide-ranging and pervasive in its import within the pattern/randomness dialectic as castration is within the tradition of presence/absence, for it is the visible mark that testifies to the continuing interplay of the dialectical terms.

Shifting the emphasis from presence/absence to pattern/randomness suggests different choices for tutor texts. Rather than Freud's discussion of "fort/da" (a short passage whose replication in hundreds of commentaries would no doubt astonish its creator), theorists interested in pattern and randomness might point to something like David Cronenberg's film *The Fly*. At a certain point the protagonist's penis does fall off (he quaintly puts it in his medicine chest as a momento to times past), but the loss scarcely registers in the larger metamorphosis he is undergoing. The operative transition is not from male to female-as-castrated-male, but from human to something radically other than human. Flickering signification brings together language with a psychodynamics based on the symbolic moment when the human confronts the posthuman.

I understand "human" and "posthuman" to be historically specific construc-
tions that emerge from different configurations of embodiment, technology, and
culture. A convenient point of reference for the human is the picture constructed
by nineteenth-century American and British anthropologists of "man" as a tool-
user.[15] Using tools may shape the body (some anthropologists made this
argument), but the tool nevertheless is envisioned as an object, apart from the
body, that can be picked up and put down at will. When the claim could not be
sustained that man's unique nature was defined by tool use (because other animals
were shown also to use tools), the focus shifted during the early twentieth century
to man the tool-maker. Typical is Kenneth P. Oakley's 1949 *Man the Tool-Maker,* a
magisterial work with the authority of the British Museum behind it.[16] Oakley, in
charge of the Anthropological Section of the museum's Natural History division,
wrote in his introduction, "Employment of tools appears to be [man's] chief bio-
logical characteristic, for considered functionally they are detachable extensions of
the forelimb." The kind of tool he envisioned was mechanical rather than
informational; it goes *with* the hand, not *on* the head. Significantly, he imagined
the tool to be at once "detachable" and an "extension," separate from yet partaking
of the hand. If the placement and kind of tool marks his affinity with the epoch
of the human, its construction as a prosthesis points forward to the posthuman.
Similar ambiguities informed the Macy Conference discussions taking place
during the same period (1946-1953), as participants wavered between a vision
of man as a homeostatic self-regulating mechanism whose boundaries were clearly
delineated from the environment,[17] and a more threatening, reflexive vision of a
man spliced into an informational circuit that could change him in unpredictable
ways. By the 1960s, the consensus within cybernetics had shifted dramatically
toward reflexivity. By the 1980s, the inertial pull of homeostasis as a constitutive
concept had largely given way to theories of self-organization that implied radical
changes were possible within certain kinds of complex systems.[18] Through these
discussions, the "posthuman" future of "humanity" began increasingly to be
evoked. Examples range from Hans Moravec's invocation of a "postbiological"
future in which human consciousness is downloaded into a computer, to the more
sedate (and in part already realized) prospect of a symbiotic union between human
and intelligent machine that Howard Rheingold calls "intelligence augmen-
tation."[19] Although these visions differ in the degree and kind of interfaces they
imagine, they concur that the posthuman implies a coupling so intense and
multifaceted that it is no longer possible to distinguish meaningfully between the
biological organism and the informational circuits in which it is enmeshed.
Accompanying this change, I have argued, is a corresponding shift in how
signification is understood and corporeally experienced. In contrast to Lacanian
psycholinguistics, derived from the generative coupling of linguistics and sexuality,
flickering signification is the progeny of the fascinating and troubling coupling of
language and machine.

INFORMATION NARRATIVES AND
BODIES OF INFORMATION

The shift from presence and absence to pattern and randomness is encoded into every aspect of contemporary literature, from the physical object that constitutes the text to such staples of literary interpretation as character, plot, author, and reader. The development is by no means even; some texts testify dramatically and explicitly to the shift, whereas others manifest it only indirectly. I will call the texts where the displacement is most apparent information narratives. Information narratives show in exaggerated form changes that are more subtly present in other texts as well. Whether in information narratives or contemporary fiction generally, the dynamic of displacement is crucial. One could focus on pattern in any era, but the peculiarity of pattern in these texts is its interpenetration with randomness and its implicit challenge to physicality. *Pattern tends to overwhelm presence*, marking a new kind of immateriality which does not depend on spirituality or even consciousness, only on information.

I begin my exploration with William Gibson's *Neuromancer* (1984), the novel that sparked the cyberpunk movement and motivated Autodesk, a software company, to launch a major initiative in developing virtual reality technology. Hard on the heels of *Neuromancer* came two more volumes, *Count Zero* (1986) and *Mona Lisa Overdrive* (1988). The *Neuromancer* trilogy gave a local habitation and a name to the disparate spaces of computer simulations, networks, and hypertext windows that prior to Gibson's intervention had been discussed as separate phenomena. Gibson's novels acted like seed crystals thrown into a supersaturated solution; the time was ripe for the technology known as cyberspace to precipitate into public consciousness. The narrator defines cyberspace as a "consensual illusion" accessed when a user "jacks into" a computer. Here the writer's imagination outstrips existing technologies, for Gibson imagines a direct neural link between the brain and computer through electrodes. Another version of this link is a socket implanted behind the ear which accepts computer chips, allowing direct neural access to computer memory. Network users collaborate in creating the richly textured landscape of cyberspace, a "graphic representation of data abstracted from the banks of every computer in the human system. Unthinkable complexity. Lines of light ranged in the nonspace of the mind, clusters and constellations of data. Like city lights, receding . . ." Existing in the nonmaterial space of computer simulation, cyberspace defines a perimeter within which pattern is the essence of the reality, presence an optical illusion.

Like the landscapes they negotiate, the subjectivities who operate within cyberspace also become patterns rather than physical entities. Case, the computer cowboy who is the novel's protagonist, still has a physical presence, although he regards his body as so much "meat" that exists primarily to sustain his consciousness until the next time he can enter cyberspace. Others have completed the transition that Case's values imply. Dixie Flatline, a cowboy who encountered something in cyberspace that flattened his EEG, ceased to exist as a physical body

and lives now as a personality construct within the computer, defined by the magnetic patterns that store his identity.

The contrast between the body's limitations and cyberspace's power highlights the advantages of pattern over presence. As long as the pattern endures, one has attained a kind of immortality. Such views are authorized by cultural conditions that make physicality seem a better state to be from than to inhabit. In a world despoiled by overdevelopment, overpopulation, and time-release environmental poisons, it is comforting to think that physical forms can recover their pristine purity by being reconstituted as informational patterns in a multidimensional computer space. A cyberspace body, like a cyberspace landscape, is immune to blight and corruption. It is no accident that the vaguely apocalyptic landscapes of films like *The Terminator*, *Blade Runner*, and *Hardware* occur in narratives focusing on cybernetic life-forms. The sense that the world is rapidly becoming uninhabitable by human beings is part of the impetus toward the displacement of presence by pattern.

These connections lie close to the surface in *Neuromancer*:

> "Get just wasted enough, find yourself in some desperate but strangely arbitrary kind of trouble, and it was possible to see Ninsei as a field of data, the way the matrix had once reminded him of proteins linking to distinguish cell specialities. Then you could throw yourself into a high-speed drift and skid, totally engaged but set apart from it all, and all around you the dance of biz, information interacting, data made flesh in the mazes of the black market . . ."

The metaphoric slippages between urban sprawl, computer matrix, and biological protein culminate in the final elliptical phrase, "data made flesh." Information is the putative origin, physicality the derivative manifestation. Body parts sold in black market clinics, body neurochemistry manipulated by synthetic drugs, body of the world overlaid by urban sprawl testify to the precariousness of physical existence. If flesh is data incarnate, why not go back to the source and leave the perils of physicality behind?

The reasoning presupposes that subjectivity and computer programs have a common arena in which to interact. Historically, that arena was first defined in cybernetics by the creation of a conceptual framework that constituted humans, animals, and machines as information-processing devices receiving and transmitting signals to effect goal-directed behavior.[20] Gibson matches this technical achievement with two literary innovations that allow subjectivity, with its connotations of consciousness and self-awareness, to be articulated together with abstract data. The first is a subtle modification in point of view, abbreviated in the text as "pov." More than an acronym, pov is a substantive noun that constitutes the character's subjectivity by serving as a positional marker substituting for his absent body.

In its usual Jamesian sense, point of view presumes the fiction of a person who observes the action from a particular angle and tells what he sees. In the

preface to *Portrait of a Lady*, James imagines a "house of fiction" with a "million windows" formed by "the need of the individual vision and by the pressure of the individual will."[21] At each "stands a figure with a pair of eyes, or at least with a field glass, which forms, again and again, for observation, a unique instrument, insuring to the person making use of it an impression distinct from every other" (46). For James the observer is an embodied creature, and the specificity of his location determines what he can see as he looks out on a scene that itself is physically specific. When an omniscient viewpoint is used, the limitations of the narrator's corporeality begin to fall away, but the suggestion of embodiment lingers in the idea of focus, the "scene" created by the eye's movement.

Even for James, vision is not unmediated technologically. Significantly, he hovers between eye and field glass as the receptor constituting vision. Cyberspace represents a quantum leap forward into the technological construction of vision. Instead of an embodied consciousness looking through the window at a scene, consciousness moves *through* the screen to become the pov, leaving behind the body as an unoccupied shell. In cyberspace, point of view does not emanate from the character; rather, the pov literally *is* the character. If a pov is annihilated, the character disappears with it, ceasing to exist as a consciousness in and out of cyberspace. The realistic fiction of a narrator who observes but does not create is thus unmasked in cyberspace. The effect is not primarily metafictional, however, but in a literal sense metaphysical, above and beyond physicality. The crucial difference between the Jamesian point of view and cyberspace pov is that the former implies physical presence, whereas the latter does not.

Gibson's technique recalls Robbe-Grillet's novels, which were among the first information narratives to exploit the formal consequences of combining subjectivity with data. In Robbe-Grillet, however, the effect of interfacing narrative voice with objective description was paradoxically to heighten the narrator's subjectivity, for certain objects, like the jalousied windows or the centipede in *Jealousy*, are inventoried with obsessive interest, indicating a mindset that is anything but objective. In Gibson, the space in which subjectivity moves lacks this personalized stamp. Cyberspace is the domain of postmodern collectivity, constituted as the resultant of millions of vectors representing the diverse and often conflicting interests of human and artificial intelligences linked together through computer networks.

To make this space work as a level playing field on which humans and computers can meet on equal terms, Gibson introduces his second innovation. Cyberspace is created by transforming a data matrix into a landscape in which narratives can happen. In mathematics, matrix is a technical term denoting data that have been arranged into an *n*-dimensional array. Expressed in this form, data seem as far removed from the fascinations of story as random number tables are from the *National Inquirer*. Because the array is already conceptualized in spatial terms, however, it is a small step to imagining it as a three-dimensional landscape. Narrative becomes possible when this spatiality is given a temporal dimension by

the pov's movement through it. The pov is *located* in space, but it *exists* in time. Through the track it weaves, the desires, repressions, and obsessions of subjectivity can be expressed. The genius of *Neuromancer* lies in its explicit recognition that the categories Kant considered fundamental to human experience, space and time, can be used as a conjunction to join awareness with data. Reduced to a point, the pov is abstracted into a purely temporal entity with no spatial extension; metaphorized into an interactive space, the datascape is narrativized by the pov's movement through it. Data are thus humanized, and subjectivity computerized, allowing them to join in a symbiotic union whose result is narrative.

Such innovations carry the implications of informatics beyond the textual surface into the signifying processes that constitute theme and character. I suspect that Gibson's novels have been so influential not only because they present a vision of the posthuman future that is already upon us — in this they are no more prescient than many other science fiction novels — but also because they embody within their techniques the assumptions expressed explicitly in the novels' themes. This kind of move is possible or inevitable when the cultural conditions authorizing the assumptions are pervasive enough so that the posthuman is experienced as an everyday lived reality as well as an intellectual proposition.

In *The Condition of Postmodernity*, David Harvey characterizes the economic aspects of the shift to an informatted society as a transition from a Fordist regime to a regime of flexible accumulation.[22] As Harvey along with many others have pointed out, in late capitalism durable goods yield pride of place to information.[23] A significant difference between information and durable goods is replicability. Information is not a conserved quantity. If I give you information, you have it and I do too. With information, the constraining factor separating the haves from the have-nots is not so much possession as access. The shift of emphasis from ownership to access is another manifestation of the underlying transition from presence/absence to pattern/randomness. Presence precedes and makes possible the idea of possession, for one can possess something only if it already exists. By contrast, access implies pattern recognition, whether the access is to a piece of land (recognized as such through the boundary pattern defining that land as different from adjoining parcels), confidential information (constituted as confidential through the comparison of its informational patterns with less secure documents), or a bank vault (associated with knowing the correct pattern of tumbler combinations). In general, access differs from possession because it tracks patterns rather than presences. When someone breaks into a computer system, it is not her physical presence that is detected but the informational traces her entry has created.[24]

When the emphasis falls on access rather than ownership, the private/public distinction that was so important in the formation of the novel is radically reconfigured. Whereas possession implies the existence of private life based on physical exclusion or inclusion, access implies the existence of credentialing practices that use patterns rather than presences to distinguish between those who do and do

not have the right to enter. Moreover, entering is itself constituted as access to data rather than a change in physical location. In DeLillo's *White Noise* (1985), for example, the Gladney's home, traditionally the private space of family life, is penetrated by noise and radiation of all wavelengths — microwave, radio, television. The penetration signals that private spaces, and the private thoughts they engender and figure, are less a concern than the interplay between codes and the articulation of individual subjectivity with data. Jack Gladney's death is prefigured for him as a pattern of pulsing stars around a computerized data display, and it is surely no accident that Babette, his wife, objects to the idea that a man sexually "enters" a woman. The phrases she prefers emphasize by contrast the idea of access.

Although the Gladney family still operates as a social unit (albeit with the geographical dispersion endemic to postmodern life), their conversations are punctuated by random bits of information emanating from the radio and TV. The punctuation points toward a mutation in subjectivity that comes from joining the focused attention of traditional novelistic consciousness with the digitized randomness of miscellaneous bits. The mutation reaches incarnation in Willie Mink, whose brain has become so addled by a designer drug that his consciousness is finally indistinguishable from the white noise that surrounds him. Through a different route than that used by Gibson, DeLillo arrives at a similar destination: a vision of subjectivity constituted through the interplay of pattern and randomness rather than presence and absence.

The bodies of texts are also implicated in these changes. The displacement of presence by pattern thins the tissue of textuality, making it a semipermeable membrane that allows awareness of the text as an informational pattern to infuse into the space of representation. When the fiction of presence gives way to the recognition of pattern, passages are opened between the text-as-object and representations within the text that are characteristically postmodern. Consider the play between text as physical object and information flow in Calvino's *If on a Winter's Night a Traveler* (1981). The text's awareness of its own physicality is painfully apparent in the anxiety it manifests toward keeping the literary corpus intact. Within the space of representation, texts are subjected to birth defects, maimed and torn apart, lost and stolen, and last but hardly least, pulverized when the wrong computer key is pushed and the stored words are randomized into miscellaneous bits.

The anxiety is transmitted to readers within the text, who keep pursuing parts of textual bodies only to lose them, as well as to readers outside the text, who must try to make sense of the radically discontinuous narrative. Only when the titles of the parts are perceived to form a sentence is the literary corpus reconstituted as a unity. Significantly, the recuperation is syntactical rather than physical. It does not arise from or imply an intact physical body. Rather, it emerges from the patterns — metaphorical, grammatical, narrative, thematic, and textual — that the parts together make. As the climactic scene in the library suggests, the reconstituted corpus is a body of information, emerging from the discourse

community among which information circulates.

The correspondence between transformations in human and textual bodies can be seen as early as William Burroughs's *Naked Lunch* (1959), written in the decade that saw the institutionalization of cybernetics and the construction of the first large-scale electronic computer. The narrative metamorphoses nearly as often as bodies within it, suggesting by its cut-up method a textual corpus as artificial, heterogeneous, and cybernetic as the bodies are.[25] Since the fissures that mark the text always fall *within* the units that comprise the textual body — within chapters, paragraphs, sentences, and even words — it becomes increasingly clear that they do not function to delineate the textual corpus. Rather, the body of the text is produced precisely by these fissures, which are not so much ruptures as productive dialectics bringing the narrative as a syntactic and chronological sequence into being.

Bodies within the text follow the same logic. Under the pressure of sex and addiction, bodies explode or mutate, protoplasm is sucked out of cocks or nostrils, plots are hatched to take over the planet or nearest life-form. Burroughs anticipates Jameson's claim that an information society is the purest form of capitalism.[26] When bodies are constituted as information, they cannot only be sold but fundamentally reconstituted in response to market pressures. Junk instantiates the dynamics of informatics and makes clear its relation to late capitalism. Junk is the "ideal product" because the "junk merchant does not sell his product to the consumer, he sells the consumer to his product. He does not improve and simplify his merchandise. He degrades and simplifies the client." The junkie's body is a harbinger of the postmodern mutant, for it demonstrates how presence yields to patterns of assembly and disassembly created by the flow of junk-as-information through points of amplification and resistance.

The characteristics of information narratives include, then, an emphasis on mutation and transformation as a central thematic for bodies within the text as well as for the bodies of texts. Subjectivity, already joined with information technologies through cybernetic circuits, is further integrated into the circuit by novelistic techniques that combine it with data. Access vies with possession as a structuring element, and data are narrativized to accommodate their integration with subjectivity. In general, materiality and immateriality are joined in a complex tension that is a source of exultation and strong anxiety. To understand the links between information narratives and other contemporary fictions that may not obviously fall into this category, let us turn now to consider the more general effects of informatics on narrative encodings.

FUNCTIONALITIES OF NARRATIVE

The very word *narrator* implies a voice speaking, and a speaking voice implies a sense of presence. Derrida, announcing the advent of grammatology, focused on

the gap that separates speaking from writing; such a change transforms the narrator from speaker to scribe, or more precisely an absence toward which the inscriptions point.[27] Informatics pushes this transformation further. As writing yields to flickering signifiers underwritten by binary digits, the narrator becomes not so much a scribe as a cyborg authorized to access the relevant codes.

To see how the function of the narrator changes, consider the seduction scene from "I Was an Infinitely Hot and Dense White Dot," one of the stories in Mark Leyner's *My Cousin, My Gastroenterologist*.[28] The narrator, "high on Sinutab" and driving "isotropically," so that any destination is equally probable, finds himself at a "squalid little dive" (6).

> I don't know . . . but there she is. I can't tell if she's a human or a fifth-generation gynemorphic android and I don't care. I crack open an ampule of mating pheromone and let it waft across the bar; as I sip my drink, a methyl isocyanate on the rocks— methyl isocyanate is the substance which killed more than 2,000 people when it leaked in Bhopal, India, but thanks to my weight training, aerobic workouts, and a low-fat fiber-rich diet, the stuff has no effect on me. Sure enough she strolls over and occupies the stool next to mine. . . . My lips are now one angstrom unit from her lips. . . . I begin to kiss her but she turns her head away. . . . I can't kiss you, we're monozygotic replicants — we share 100% of our genetic material. My head spins. You are the beautiful day, I exclaim, your breath is a zephyr of eucalyptus that does a pas de bourrée across the Sea of Galilee. Thanks, she says, but we can't go back to my house and make love because monozygotic incest is forbidden by the elders. What if I said I could change all that? . . . What if I said that I had a miniature shotgun that blasts gene fragments into the cells of living organisms, altering their genetic matrices so that a monozygotic replicant would no longer be a monozygotic replicant and she could then make love to a muscleman without transgressing the incest taboo, I say, opening my shirt and exposing the device which I had stuck in the waistband of my black jeans. How'd you get that thing? she gasps, ogling its thick fiber-reinforced plastic barrel and the Uzi-Biotech logo embossed on the magazine which held two cartridges of gelated recombinant DNA. I got it for Christmas. . . . Do you have any last words before I scramble your chromosomes, I say, taking aim. Yes, she says, you first.

Much of the passage's wit comes from the juxtaposition of folk wisdom and seduction clichés with high-tech language and ideas that makes them nonsensical. The narrator sips a chemical that killed thousands when it leaked into the environment, but he is immune to damage because he eats a low-fat diet. The narrator leans close to the woman/android to kiss her, but he has not yet made contact when he is an angstrom away, considerably less than the diameter of a hydrogen atom. The characters cannot make love because they are barred by incest taboos, being replicants from the same monozygote, which would make them identical twins but does not seem to prevent them from being opposite

sexes. They are governed by kinship rules enforced by tribal elders, but they have access to genetic technologies that intervene in and disrupt evolutionary modes of descent. They think their problem can be solved by an Uzi-Biotech weapon that will scramble their chromosomes, but the narrator, at least, seems to expect their identities to survive intact.

Even within the confines of a short story no more than five pages long, this encounter is not preceded or followed by events that relate directly to it. Rather, the narrative leaps from scene to scene, which are linked by only the most tenuous and arbitrary threads. The incongruities make the narrative a kind of textual android created through patterns of assembly and disassembly. There is no natural body to this text, any more than there are natural bodies within the text. As the title intimates, identity merges with typography ("I was a . . . dot") and is further conflated with such high-tech reconstructions as computer simulations of gravitational collapse ("I was an infinitely hot and dense white dot"). Signifiers collapse like stellar bodies into an explosive materiality that approaches the critical point of nova, ready to blast outward into dissipating waves of flickering signification.

The explosive tensions between cultural codes that familiarize the action and neologistic splices that dislocate traditional expectations do more than structure the narrative. They also constitute the narrator, who exists less as a speaking voice endowed with a plausible psychology than as a series of fissures and dislocations that push toward a new kind of subjectivity. To understand the nature of this subjectivity, let us imagine a trajectory that arcs from storyteller to professional to some destination beyond. The shared community of values and presence that Walter Benjamin had in mind when he evoked the traditional storyteller whose words are woven into the rhythms of work echo faintly in allusions to the Song of Songs and tribal elders.[29] Overlaid on this is the professionalization that Lyotard wrote about in *The Postmodern Condition*, in which the authority to tell the story is constituted by possessing the appropriate credentials that qualify one as a member of a physically dispersed, electronically bound professional community.[30] This phase of the trajectory is signified in a number of ways. The narrator is driving "isotropically," indicating that physical location is no longer necessary or relevant to the production of the story. His authority derives not from his physical participation in a community but his possession of a high-tech language that includes pheromones, methyl isocyanate, and gelated recombinant DNA, not to mention the Uzi-Biotech phallus. This authority, too, is displaced even as it is created, for the incongruities reveal that the narrative and therefore the narrator are radically unstable, about to mutate into a scarcely conceivable form, signified in the story by the high-tech, identity-transforming orgasmic blast that never quite comes.

What is this form? Its physical manifestations vary, but the ability to manipulate complex codes is a constant. The looming transformation, already enacted through the passage's language, is into a subjectivity that derives his authority from possessing the correct codes. Countless scenarios exist in popular literature and culture where

someone fools a computer into thinking he is an "authorized" person because he possesses or stumbles upon the codes that the computer recognizes as constituting authorization. Usually these scenarios imply that the person exists unchanged, taking on a spurious identity that allows him to move unrecognized within an informational system. There is, however, another way to read these narratives. Constituting identity through authorization codes changes the person who uses them into another kind of subjectivity, precisely one who exists and is recognized because he knows the codes. The surface deception is underlaid by a deeper truth. We become the codes we punch. The narrator is not a storyteller and not a professional authority, although these functions linger in the narrative as anachronistic allusions and wrenched referentiality. Rather the narrator is a keyboarder, a hacker, a manipulator of codes.[31] Assuming that the text was at some phase in its existence digitized, in a literal sense he (it?) *is* these codes.

The construction of the narrator as a manipulator of codes obviously has important implications for the construction of the reader. The reader is similarly constituted through a layered archeology that moves from listener to reader to decoder. Because codes can be sent over fiber optics essentially instantaneously, there is no longer a shared, stable context that helps to anchor meaning and guide interpretation. Like reading, decoding takes place in a location arbitrarily far removed in space and time from the source text. In contrast to fixed-type print, however, decoding implies that there is no original text — no first editions, no fair copies, no holographic manuscripts. There are only the flickering signfiers, whose transient patterns evoke and embody what G. W. S. Trow has called "the context of no context," the suspicion that all contexts, like all texts, are electronically mediated constructions.[32] What binds the decoder to the system is not the stability of an interpretive community or the intense pleasure of physically possessing the book that all bibliophiles know. Rather, it is her construction as a cyborg, her recognition that her physicality is also data made flesh, another flickering signifier in a chain of signification that extends through many levels, from the DNA that in-formats her body to the binary code that is the computer's first language.

"Functionality" is a term used by virtual reality technologists to describe the communication modes that are active in a computer-human interface. If the user wears a data glove, for example, hand motions constitute one functionality. If the computer can respond to voice-activated commands, voice is another functionality. If it can sense body position, spatial location is yet another. Functionalities work in both directions; that is, they both describe the computer's capabilities and also indicate how the user's sensory-motor apparatus is being trained to accommodate the computer's responses. Working with a VR simulation, the user learns to move her hand in stylized gestures that the computer can accommodate. In the process, changes take place in the neural configuration of the user's brain, some of which can be long-lasting. The computer molds the human even as the human builds the computer.

When narrative functionalities change, a new kind of reader is produced by the text. The effects of flickering signification ripple outward because readers are trained to read through different functionalities, which can affect how they interpret any text, including texts written before computers were invented. Moreover, changes in narrative functionalities go deeper than structural or thematic characteristics of a specific genre, for they shift the modalities that are activated to produce the narrative. It is on this level that the subtle connections between information narratives and other kinds of contemporary fictions come into play.

Drawing on a context that included information technologies, Roland Barthes in *S/Z* brilliantly demonstrated the possibility of reading a text as a production of diverse codes.[33] Information narratives make that possibility an inevitability, for they often cannot be understood, even on a literal level, without referring to codes and their relation to information technologies. Flickering signification extends the productive force of codes beyond the text to include the signifying processes by which the technologies produce texts, as well as the interfaces that enmesh humans into integrated circuits. As the circuits connecting technology, text, and human expand and intensify, the point where quantitative increments shade into qualitative transformation draws closer.

If my assessment is correct that the dialectic of pattern/randomness is displacing presence/absence, the implications extend beyond narrative into many cultural arenas. In my view, one of the most serious of these implications for the present cultural moment is a systematic devaluation of materiality and embodiment. I find this trend ironic, for changes in material conditions and embodied experience are precisely what give the shift its deep roots in everyday experience. In this essay I have been concerned not only to anatomize the shift and understand its implications for literature but also to suggest that it should be understood in the context of changing experiences of embodiment. If, on the one hand, embodiment implies that informatics is imprinted into body as well as mind, on the other it also acts as a reservoir of materiality that resists the pressure toward dematerialization.

Implicit in nearly everything I have written here is the assumption that presence and pattern are opposites existing in antagonistic relation. The more emphasis that falls on one, the less the other is noticed and valued. Entirely different readings emerge when one entertains the possibility that pattern and presence are mutually enhancing and supportive. Paul Virilio has observed that one cannot ask whether information technologies should continue to be developed.[34] Given market forces already at work, it is virtually (if I may use the word) certain that increasingly we will live, work, and play in environments that construct us as embodied virtualities.[35] I believe that our best hope to intervene constructively in this development is to put an interpretive spin on it that opens up the possibilities of seeing pattern and presence as complementary rather than antagonistic. Information, like humanity, cannot exist apart from the embodiment that brings it into being as a material entity in the world; and embodiment is always instantiated, local, and specific. Embodiment can be

destroyed but it cannot be replicated. Once the specific form constituting it is gone, no amount of massaging data will bring it back. This observation is as true of the planet as it is of an individual life-form. As we rush to explore the new vistas that cyberspace has made available for colonization, let us also remember the fragility of a material world that cannot be replaced. □

Thinking the Border and the Boundary

■ Siegfried Zielinski

> "Without doubt, in our society . . . there
> prevails a deep LOGOPHOBIA, a mute fear
> of those events, of that mass of things said,
> of the emergence of all those statements, in
> particular of all that is violent, sudden,
> orderless, and dangerous there, of that great
> and incessant roaring of the discourse."

—Michel Foucault, *The Order of Things*

I.

In Turin, during the latter half of the nineteenth century, the doctor, anthropologist, and physiologist Cesare Lombroso worked with manic zeal on a systematic model to explain deviancy, which in his eyes posed a threat. Lombroso tried to come to grips with, to destroy, behavior that was profoundly disturbing to him personally and to burgeois society in general, by tracing its origins to exclusively physical phenomena in order literally to put it behind bars: all that was revolutionary, eruptive, evil, criminal, and — an ever-recurrent theme — feminine, or any combination of these attributes. Specific physical findings became hardened facts indicative of the abnormal psyche; these were then correlated unscrupulously with a definite vanishing point that endowed Lombroso's endeavour with meaning — to regiment atavism, passion, and madness by measuring it and thus binding it within that very system of order that it continually threatened to break out of.

Lombroso lived and worked in the founding era of the new media. This was the era when the following appeared in print for the first time: Virchow's cell pathology (1858); Fechner's psychophysics (1860); Wundt's lectures on the souls of men and animals (1863); Griesinger's pathology of psychic disorders (1861); and, most important, the classic, major works of applied positivism in Europe (Charles Darwin in translation).

The founding era of the new media at the fin de siècle and but one of the possible reference points to the twentieth: the works of Cesare Lombroso are, in many respects, hypertext-like, networked structures.

First, the form: for the presentation of his evidence, Lombroso availed himself of the entire spectrum of techniques for registering, archiving, and visualizing that had been developed in the latter half of the nineteenth century. Always in parallel, he utilized methods for taking physiological measurements, including electrical recording systems; his beloved craniometry (to measure the criminal skull); the entire range of anthropometry (from measuring ears, eyes, and hairline to analyzing innumerable physiognomic parameters); photography as a medium for systematic records but also as an aid to analysis; all the other techniques employed in crim-inological investigation (such as exegeses on fingerprinting and graphology); and, in addition, his inflationary use of statistics as a descriptive method. The myriad fragments Lombroso accumulated in this way — drawings, pictures, tables, diagrams, bits of text — he then wove into seemingly complex nets of argumentation (in his archive in Turin, a Wunderkammer of horrors, this collected material lies side by side, for the most part not arranged in any order or hierarchy). A distinguishing feature of his books is his obvious delight in classification and structure: e.g., "Woman as a Criminal" consists of two parts with nineteen chapters that contain over 250 subdivisions. The unassailable single fact, the carefully contrived, incontestable "actuality," dictates on a superficial level the structure and rhythm of the texts, which are underpinned again and again by an impressive array of figures on the cases Lombroso investigated. For example, the "observation and study of 23,602 insane persons"[1] led him to the certain conviction that the outbreak of madness coincided with the rising temperatures in certain months of the year.

One of the verbs Lombroso uses most frequently is "to connect." He is a veritable master of conjunction. He links and correlates everything with everything else, even the most disparate data (for the most part, raised by himself) and conjectures. In "The Political Criminal and Revolutions," for example, there are placed side by side maps of France showing "the distribution of races," of political parties and of "the number of geniuses per 10,000 inhabitants."[2] Alongside one another, in like manner, Lombroso classifies the various French départements according to his "genius index" and the "geological soil structure."[3] In the second chapter of volume 2, he connects the frequency and quality of revolts and revolutions in the world with — amongst other things — climatic conditions: air pressure and barometric oscillations" and the "inhibitive influence of mountains of significant height."[4]

The validity of any one, single assertion is not questioned at all, for this is a strategy to create the appearance of complexity. The single fact attains incontesta-bility for through its connection with a plethora of others it becomes unassailable. In an obsessive manner Lombroso practices a kind of associative positivism, and

his opponents — scientific, that is — objected above all to the fact that these attempts to explain deviant behavior gave social causes precedence over individual ones. Lombroso's methods are described very aptly by Kurella:

> If Lombroso had been summoned to the prisons of Libau, Riga, Dorpat, and Reval to determine the causes of the Latvian-Estonian peasant revolt, he would have ascertained what the meteorological situation was at the time of the unrest, researched the exact racial background of the detainees, deduced their degeneracy from their physiognomy and physical characteristics, particularly the skull, determined how many were epileptics, hysterics, lunatics, or alcoholics, subtracted the vagabonds and persons with a criminal record, investigated how many of the women involved were menstruating at the time of the uprising, counted how many of the youths were consumed by belief in a fanatical doctrine . . . and it is very doubtful whether there would have been many individuals left over, had a second expert subscribing to a materialistic view of history been summoned, on whom to prove that the criminal offences were purely economically determined.[5]

3.

The (digital) Net is not a place of virtuality. It is not a possible place — in the Kantian sense of a space that is actively appropriated and thus individualized. The agents of the Net are assistants, algorithmic drones with clearly defined tasks and programs; they are the lackeys of the global computer world. They act on behalf of and on instructions, so, in spite of all their mobility and possibilities for promotion to leading agent, they are for this reason dependent/subordinate. It is possible for them to acquire opinions, but they have no intentions. The Net is thus an impossible place. At least, I propose we think of it as such.

This will make many things easier (both in theory and in practice). As an impossible place (in the sense outlined above), it is not a suitable place for intentionally acting subjects to stay, not even temporarily. And as such (an impossible place), it has neither territory nor definable borders. In it, it is not possible to develop an identity, not even for the interim. The Net only becomes a virtual place if we conceive of it as a representation, a model of our down-to-earth world of experience. This way of thinking does not qualify for the advanced aesthetic praxis of the Net. It does not transcend that which we have already (not yet) understood.

At the end of the twenties — 1929 to be exact — Georges Bataille, Carl Einstein, and Michel Leiris created a space for publishing things marginal and peripheral, things that lead a vagabond existence at the edge of the center, things incomparable and downright incommunicable. The journal *Documents* was a project that experimented with the impossible. Incidents, events, textual manifestations, photos, pictures, accidents: in short, unique phenomena were to come together within the framework of a medium, the form of expression of the

Visual field of a female adolescent thief, J.M., in an undisturbed state, from Lombroso,"Woman as Criminal," 1905.

printed periodical, were to engage and converge in a vibrant relationship devoid of hierarchies. A tactic,[6] that is at once poetic and social, considering the shameless complexity of the world and its power structures. As a product form, this project was impossible and disappeared again quickly from the scene in 1931. Programmatically — a nice paradox — it was committed to the exploration and representation of the heterogenous, in the narrower Bataille sense of everything that is excluded from the system and everyday routine; everything that resists being understood by science: the repellent, the vile, the violent, the instinctiveness of the death drive. (Deleuze and Guattari's favourite phylum of subjects that disturb, to which the schizophrenic, the addict, the sadomasochist, the dreamer . . . belong, originates in thought from the same clan.)

There is no need for us to follow Bataille's *heterology* through all its dark twists and turns in order to reach its nucleus that we want to single out for the purposes of our debate: it is at the same time the ever-recurring attempt and ever-recurring failure to name the Other, the different Other, the strange, and it is the aesthetic project to render us sensible to this other, different, and strange, or to maintain our sensibility for it. In the motion of crossing a border, heterology encircles the impossible place, that is unlocatable, that is actually empty, that in practice is created in the motion of crossing the border.

4.

"With the help of algorithms, we solve problems. However, not all problems are solved algorithmically."[7]

At the risk of slipping on this terminological ice, the algorithm, mathematical and operational foundation of each and every computer as well as of the complete

Visual field of the same person during an apparent psychical epileptic seizure, from Lombroso, "Woman as Criminal," 1905.

mega-apparatus of the Net, is a signifying practice of unambiguity. Processes and solutions to problems can only be expressed as algorithms, "if we can specify a definite (computational) procedure by which means the problem can be solved" (Krämer, 159). The most important characteristics of an "unambiguous procedure for the solution of problems" are elements, determination, generality, and finity.

If we look at these characteristics, we can appreciate what an enormous task faces artistic praxis if it engages with the prinicipally algorithmic rules of communication on the Net and if it enters the Net (providing we still think Adorno's maxim worthwhile that "thought is aesthetic when it remains true to the opacity of its subjects"[8]). Each one of the aforementioned characteristics is in diametric opposition to the ethical and aesthetic requirements of art, that is, to make or keep us sensible to the Unknown, the Other. A heterogeneous phenomenon, neither a component nor a base but rather already something highly compounded, mixed, complex; it is not precisely fixed but roving and ex-territorial; it is not general but specific, condensed (*create* and *concrete* are words related etymologically); it does not operate within finite regulations nor within a finite period of operation, its consequentiality is not forseeable.

The consequences for advanced aesthetic praxis that I deduce from this seemingly clear opposition are not simple, for they encompass two things; they amount to the testing of a double strategy for artistic action that would not be by any means opportunistic.

At the outset stands a very important realization: the claim made for the universality of telematic networks and the digital code as its informative content include an exaggerated and misleading promise of use value, namely, the existence of the possibility of an all-embracing, one-for-all order, that in the course of the history of human thought and nature has always been a hollow

dream and often evoked by the culture industry for its own ends. One-for-all is not the great whole, but the complexly individual, the heterogeneous. That which is truly indivisible is the generality, the concept.

There are aspects of knowledge, experience, and experiences that can be communicated exceptionally well by means of the electronic networks, also aesthetically. These are the aspects that are, in the widest sense, capable of being generalized, reproduced, serialized — processed in symbolic machines. If you form them, you get design, which is not a bad thing. Indeed, we need it in our everyday life. The present praxis on the Net is full of such designer knowledge and experience and its representations (libraries, services, electronic magazines, cafés, galleries, discussion circles, pornographies, etc.).

However, there are other attractions in experience and experiences that elude or are not even capable of reproduction or regimented consequences — however intricately or complicatedly they may be organized: excess that is bound up with a specific place and in the presence of the Other, the extreme muse, the experience of duration tied to a specific locality, the accident, the surprising turn of events, passion, pain. . . . For these unique events the networks are an impossible place, and this impossible place is already fleeing from them, before they have even had time to approach it properly.

From this I deduce that it is our aesthetic duty to take that which is *versus*, that which is turned over, that which is turned inside out, seriously and to combine it with diversity and incalculability. However, this is only feasible if you take up a basic position that is split, somehow schizophrenic: facilitate the symbolic expression of place, of heterogenous events, in the global Net, use the Net to strengthen local events but at the same time keep the option open to do without it. To be inside and to be able to imagine what it is like outside, to be outside and think the inside: it is the high-wire act, the activity itself and the movement on the border that make such a stance posssible.

5 .

This unfinished sketch of an ethical-aesthetically oriented theory and praxis of the Net is influenced by the *Tractatus Logico-Philosophicus* by Ludwig Wittgenstein — that reckless tightrope walker between uncompromisingly precise thinking and life, who went by the premise that philosophy is not something to be sat out on a professorial chair, but rather a continuous action of clarification in its very own medium, language. "Philosophy is not a doctrine it is an activity. . . . The results of philosphy are not "philosophical sentences" but the clarification of sentences. Philosophy should make thought, that otherwise is cloudy and indistinct, clear and should sharply differentiate it" (4.112, p. 41).[9]

The idea of the subject that is contained in this possesses the power to break free of the shackles of ontological ascriptions.

Interface:

"The world and life are one" (5.621, 90).

"The thinking, imagining subject does not exist" (5.631, 90).

"The subject does not belong to the world, it is a border of the world" (5.632, 90).

Ethically justifiable aesthetic action in the Net should, according to this, clarify the fragments of expression contained in it and their relationships to each another. I would term this activity subjective if it were to succeed in making the difference to life/the world able to be experienced by formulating the boundaries of the Net. In principle this is only possible if we exhaust its possibilities. ". . . to go in every direction to the end of the possibilities of the world"[10] — this thought comes from a theoretical work by Bataille on the aesthetic avant-garde and it is still well worth putting it into practice.

Activity on the border thus understood presupposes the constant willingness to and possibility of crossing that boundary. Just as we need an art of distinctiveness as a tool in life, so we also need a science of mind and of nature that takes a stand for uniqueness within diversity. This is difficult to think through, I know, but I shall try nonetheless, at least with reference to media theory: the exceptional media meta-models of the nineteenth and twentieth centuries, mechanics and electronics, that allow us to understand and to reverse so many processes and relationships, are models for working out, to which option and access are central. What we need in the meantime are models of working toward, models of intervention, of operation (*opis*fortune, the root of operating, means riches).

This is what taking action at the border, that which I call subjective, targets in relation to the Net: strong, dynamic, nervous, definitely process-oriented aesthetic constructions, that are introduced into the Net as wandering fictions, not in order to assume a virtual identity there that can then be retrieved in this or that state, but to demonstrate the impossibility of constructing identity through the exchange of pure symbols. The deficits that these constructions exhibit namely that, quasi reeling, they have lost their connection to the real, is that which needs to be developed as their strength: they produce new, autonomous realities that, daydream-like, develop alongside our experiences and our experience into constructs of the mind, visionary models, precipitating meaningful interference with order, turbulence but also inertia, they irritate, they help to make greater complexity imaginable. Peter Bürger once wrote something very nice about Bataille's thought: that there is "something somnambulistic about it: called by name, it crashes."[11] This means no more and no less than inventing a heterology of the symbolic and putting it into practice. I'm afraid that I cannot express it more concretely than that.

This idea has to be combined with a hope, without which it is not redeemable: using the concept of a *physics of uniqueness* (like Otto Rössler tries to think it), artists and scientists will work together in the Net on this kind of an operational ethics and aesthetics.

The principle of such a tactic in the impossible place of the Net: once again,

it is a question of fending off the myth of reason, that takes action against heteroge-
nous diversity for obvious reasons and tries to control it. The existing networks
cannot help us to resist, however seductive, Circe Telekom may appear at first
glance. At best, they can be used as a trial playground. And to realize that would
be a great deal indeed.

To sum up the double strategy for this tactic I have just described:

1. To take seriously the social/cultural/geographic places, the places of identity,
from which and in which we act: to use the networks in order to strengthen them,
that is, to facilitate their expansion, to let them grow stronger. For me, here the
artistic work of Ingo Günther is outstanding — for example, his project on the
library in Sarajevo or the failed one on Civitella or his planned one in Cambodia.

2. To squander the existing, superfluous information-energies *unproductively* as
in the aesthetic practice of the group Knowbotic Research in and with the
networks: their interventions into the processes of the organization and
generation of knowledge with the aid of irritating, turbulent fictions basically
follows an economy of extravagance and is thus totally luxurious.

6.

The French dentist, writer, and apparatus-theoretician of the media, Jean-Louis
Baudry, used the term "recoupement" to designate that "cutting-edge," that interface
of ideological implications of technical visionings that is assigned to the media subject
by the apparatuses' view, as the place of its deceptive and lurching ascertainment.[12]

One of the reasons for including this concept in the title of my presentation
today is that I would like to recommend rereading the central heuristic texts of
apparatus theory. What drives these texts is of paramount interest for us today from
an artistic perspective: the question of how, in the future, to conceive the interfaces
as borders to the world of computer programs and computers themselves.

The concern of apparatus heuristics — in a debate that was by no means
solely confined to film — was not to lose sight of the fact that media apparatus
serves to create illusions, is an instrument to produce a transcendental subject.
Mise-en-scène of the contrived essence of media messages versus the media as clear
and simple apparatus of psychic substitution/compensation! To *dramatize* the
interface is a task that is becoming all the more urgent the more the apparatus
aspects at the border to the world of the Net fade into the background in favor of
more direct connections of powerful imaginations. I am thinking here of
environments that dispense completely with the keyboard, the mouse, and the
screen, where the communication with the programs takes place directly via haptic,
gestural, and spoken mediation: intuitively.

To dramatize the interface means to keep it flexible; to keep or make its
signs/icons recognizable as constructs, as a result of a calculating machine.

I am for a culture of double agents: the orders of the Net managers and entre-

Skulls of female Italian criminals, from Lombroso, "Woman as Criminal," 1905.

preneurs on the one hand and the orders of the individual users on the other come from opposing camps, they follow opposing interests. This must remain absolutely clear.

<div align="center">7.</div>

Etymologically, the prefix *hyper* also means excessive, to overshoot the mark. The want of moderation exercised by Cesare Lombroso in his computations and measurements of deviancy goes far beyond the narrow limits of the deterministic Darwinist method that he himself laid claim to. This manic encyclopaedist ensnared himself in the delirium he produced by setting facts, data, and personal descriptions on and against one another. The text that he spent a lifetime writing is superficially one that the police and the judiciary tried to make use of. The subtext which is present in each and every one of his books on the various types of deviancy, carries a different story. It tells of the obsessive, suffering, and passionate — and in this sense pathological — collector and hunter, who tried to find a way via positivist science to pacify and compensate for his own personal fears and desires (and it is highly probable that, in the main, he did find it). "[T]he passions of a genial mind are vehement," wrote Lombroso in "Genie und Irrsinn" (Genius and Madness). "[T]hey bestow color and life on the ideas projected by the mind. And if we believe to have discerned that passions do not rage with unbridled force in this or that genial person, then the only reason for this is that all these passions must give way to the principal passion: the insatiable craving for fame or the thirst for science and knowledge."[13] The criminal and the genius: Cesare Lombroso must have felt these two poles, individual but striving for autonomous existence, above all in himself. One can also read his books as a trail that he laid for others in order that they, too, would be able to snatch at least a notion of this feeling.

Dante, who, like Petrach, was still very close to the dark, enigmatic side of medieval love poetry ("Minnesang," G. R. Hocke) was practising love already at the age of nine; this we learn from Lombroso. On the same page he quotes from Raphael's fantastic poetry that transforms ideas into feelings, "How sweet is my yoke, how sweet is the chain of her dazzling white arms, when she entwines them round my neck. Death pangs grip me when I tear myself from their embrace. About a thousand other things I shall remain silent, for an excess of enjoyment leads to death."[14] □

TRANSLATED FROM GERMAN BY GLORIA CUSTANCE AND THE AUTHOR.

MRI Scan

FROM VIRTUAL REALITY
TO THE VIRTUALIZATION
OF REALITY

■ S l a v o j Ž i ž e k

How are we to approach "virtual reality" from the psychoanalytical perspective? Let us take as our starting point Freud's most famous dream, that of Irma's injection;[1] the first part of the dream, Freud's dialogue with Irma, this exemplary case of a dual, specular relationship, culminates in a look into her open mouth:

> There's a horrendous discovery here, that of the flesh one never sees, the foundation of things, the other side of the head, of the face, the secretory glands par excellence, the flesh from which everything exudes, at the very heart of the mystery, the flesh in as much as it is suffering, is formless, in as much as its form in itself is something which provokes anxiety. Spectre of anxiety, identification of anxiety, the final revelation of you are this — You are this, which is so far from you, this which is the ultimate formlessness.[2]

Suddenly, this horror changes miraculously into "a sort of ataraxia" defined by Lacan precisely as "the coming into operation of the symbolic function"[3] exemplified by the production of the formula of trimethylamin, the subject floats freely in symbolic bliss. The trap to be avoided here, of course, is to contrast this symbolic bliss with "hard reality." The fundamental thesis of Lacanian psychoanalysis is, on the contrary, that what we call "reality" constitutes itself against the background of such a "bliss"; i.e., of such an exclusion of some traumatic Real (epitomized here by a *woman's* throat). This is precisely what Lacan has in mind when he says that fantasy is the ultimate support of reality: "reality" stabilizes itself when some fantasy-frame of a "symbolic bliss" forecloses the view into the abyss of the Real. Far from being a kind of figment of our dreams that prevents us from "seeing reality as it effectively is," fantasy is constitutive of what we call reality: the most common bodily "reality" is constituted via a detour through the maze of imagination. In other words, the price we pay for our access to "reality" is that something — the reality of the trauma — must be "repressed."

What strikes you here is the parallel between the dream of Irma's injection and another famous Freudian dream, that of the dead son who appears to his

father and addresses him with the reproach, "Father, can't you see that I'm burning?" In his interpretation of the dream of Irma's injection, Lacan draws our attention to the appropriate remark by Eric Ericson that after the look into Irma's throat, after his encounter of the Real, *Freud should have awakened* like the dreamer of the dream of the burning son who wakes up when he encounters this horrifying apparition: when confronted with the Real in all its unbearable horror, the dreamer wakes up; i.e., escapes into "reality." One has to draw a radical conclusion from this parallel between the two dreams: what we call "reality" is constituted exactly upon the model of the asinine "symbolic bliss" that enables Freud to continue to sleep after the horrifying look into Irma's throat. The anonymous dreamer who awakens into reality in order to avoid the traumatic Real of the burning son's reproach proceeds the same way as Freud who, after the look into Irma's throat, "changes the register"; i.e., escapes into the fantasy which veils the Real. What has this to do with the computer? As early as 1954 Lacan pointed out that in today's world, the world of the machine proper, the paradigmatic case for "symbolic bliss" is the computer,[4] as one can ascertain when one enacts a kind of phenomenological investigation, leaving aside (technological) questions of how the computer works, and confining oneself to its symbolic impact, to how the computer inscribes itself into our symbolic universe.

In other words, one must conceive the computer as a *machine à penser* (a thinking machine) in the sense that Levi-Strauss talks about food as an *objet à penser* (to think about) and not just an *objet à manger* (to eat); because of its "incomprehensibility," its almost uncanny nature, the computer is an "evocatory object,"[5] an object which, beyond its instrumental function, raises a whole series of basic questions about the specificity of human thought, about the differences between animate and inanimate, etc.— no wonder that the computer metaphor is reproduced in miscellaneous fields and achieves universal range (we "program" our activities; we do away with a deadlock via "debugging," etc.). The computer is a third, new stage in Marx's scheme of development, which goes from tool (an extension of the human body) to machine (which works automatically and imposes its rhythm on man). On the one hand, it is closer to a tool in that it does not work automatically, man provides the rhythm, etc.; on the other hand, it is more independently active than a machine, since it works as a partner in a dialogue in which it raises questions itself, etc. In contrast to a mechanical machine, its internal action is "nontransparent," *stricto sensu* unrepresentable (we can "illustrate" its workings, as with a clutch or a gear box), and it operates on the basis of a dialogue with the user; for that reason, it triggers in the subject-user a split of the type "I know, but nevertheless. . . ." Of course, we know that it is "inanimate," that it is only a machine; nevertheless, in practice we act toward it as if it were living and thinking. . . .

How then does one "think with a computer" beyond its instrumental use? A computer is not unequivocal in its socio-symbolic effect but operates as some kind of "projective test," a fantasy screen on which is projected the field of miscellaneous

social reactions. Two of the main reactions are "Orwellian" (the computer as an incarnation of Big Brother, an example of centralized totalitarian control) and "anarchistic," which in contrast sees in the computer the possibility for a new self-managing society, "a cooperative of knowledge" which will enable anyone to control "from below," and thus make social life transparent and controllable. The common axis of this contrast is the computer as a means of control and mastery, except that in one case it is control "from above" and in the other "from below"; on the level of individual impact, this experience of the computer as a medium of mastery and control (the computer universe as a transparent, organized, and controlled universe in contrast to "irrational" social life) is countered by wonderment and magic: when we successfully produce an intricate effect with simple program means, this creates in the observer — who of course in the final analysis is identical to the user himself — the impression that the achieved effect is out of proportion to the modest means, the impression of a hiatus between means and effect. It is of particular interest how on the level of programming itself, this opposition repeats the male/female difference in the form of the difference between "hard" (obsessional) and "soft" (hysterical) programming — the first aims at complete control and mastery, transparency, analytical dismemberment of the whole into parts; the second proceeds intuitively: it improvises, it works by trial and thus uncovers the new, it leaves the result itself "to amaze," its relations to the object are more of "dialog."

The computer works most effectively of course as an "evocatory object" in the question of "artificial intelligence"— here, an inversion has already taken place which is the fate of every successful metaphor: one first tries to simulate human thought as far as possible with the computer, bringing the model as close as possible to the human "original," until at a certain point matters reverse and it raises the questions: *what if this "model" is already a model of the "original" itself, what if human intelligence itself operates like a computer, is "programmed,"* etc.? The computer raises in pure form the question of semblance, a discourse which would not be a simulacrum: it is clear that the computer in some sense only "simulates" thought; *yet how does the total simulation of thought differ from "real" thought?* No wonder, then, that the specter of artificial intelligence summons the paradoxes of the prohibition of incest — "artificial intelligence" appears as an entity which is simultaneously prohibited and considered impossible: one asserts that it is not possible for a machine to think, at the same time being occupied in prohibiting research in these directions, on the grounds that it is dangerous, ethically dubious, and so on.

The usual objection to "artificial intelligence" is that in the final analysis, the computer is only "programmed," that it cannot in a real sense "understand," while man's activities are spontaneous and creative. The first answer of the advocates of "artificial intelligence": are not man's creativity, "spontaneity," "unpredictibility," etc., an appearance which is created by the simultaneous activity of a number of programs? So the path toward "artificial intelligence" leads *via* the construction of a system with multiple processors. . . . But the main answer of advocates of "artificial

intelligence" is above all that the computer is far from obeying a simple linear-mechanical logic: its logic follows Gödel's, the logic of self-reference, recursive functions, paradoxes, where the whole is its own part, self-applicable. The idea of a computer as a closed, consistent, linear machine is a mechanical, precomputer age concept: the computer is an inconsistent machine which, caught in a snare of self-reference, can never be totalized. Here the proponents of the computer culture seek the link between science and art: in the principled, not just empirical, nontotality, and inconsistency of the computer — is not such self-reflective activity of the computer homologous to a Bach fugue which constantly takes up the same theme? [6]

These ideas form the basis of the hacker subculture. Hackers operate as a circle of initiates who exclude themselves from everyday "normality" in order to devote themselves to programming as an end in itself. Their enemy is the "normal," bureaucratic, instrumental, consistent, totalizing use of the computer, which does not take into account its "aesthetic dimension." Their "master-signifier," their manna, the aim, trick, of the hack is when one succeeds in beating the system (for example, when one breaks into a protected, closed circuit of information). The hacker consequently attacks the system at the point of its inconsistency — to perform a hack means to know how to exploit the fault, the symptom of the system. The universalized metaphorical range of the hack corresponds exactly to this dimension: so, for example, in the subculture of the hacker, Gödel's theorem is understood as "Gödel's hack," that subverted the totalitarian logic of the Russell-Whitehead system. . . .

Yet in contrast to this search for the point of inconsistency of the system, the hacker's aesthetic is the aesthetic of a "regulated universe." It is a universe that excludes intersubjectivity, a relation to the other *qua* subject: notwithstanding all the danger, tension, amazement which we experience when immersed in a video game, there is a basic difference between that tension and the tension in our relation to the "real world"— a difference which is not that the computer-generated video world is "just a game," a simulation; the point is rather that in such games, even if the computer cheats, it cheats consistently — the problem is only a matter of cracking the rules which govern its activities. So, for the hackers, the struggle with the computer is "straightforward": the attack is clean, the rules are laid down, although it is necessary to discover them, nothing inconsistent can interfere with them as in "real life."

Therein consists the link of the computer world with the universe of science fiction: we conceive of a world in which all is possible, we can arrange the rules arbitrarily, the only predetermined thing is that these rules must then apply; i.e., that world must be consistent in itself. Or, as Sherry Turkle puts it: all is possible, yet nothing is contingent — what is thereby excluded, is precisely the real. Impossible *qua* contingent encounter. . . . This reality, the reality of the other which is excluded here, is, of course, woman: the inconsistent other par excellence. The computer as partner is the means by which we evade the impossibility of the sexual relationship: a relationship with the computer is possible. *Das Unheimliche*

(the eeriness) of the computer is exactly in that it is a machine, a consistent other, stepping into the structural position of an intersubjective partner, the computer is an "inhuman partner" (as Lacan says of the lady in courtly love).[7] One can also explain from this the feeling of something unnatural, obscene, almost terrible when we see children talking with a computer and obsessed with the game, oblivious of everything around them: with the computer, childhood loses the last appearance of innocence.

How then to resolve the discrepancy between the computer universe as a consistent "regulated universe" and the fact that the hacker tries to catch the system precisely at the point of its inconsistency? The solution is elementary, almost self-evident. We simply have to distinguish between two levels, two modes of inconsistency or self-reference: the hacker's finding of the point of nonconsistency, the point at which the system is caught in the trap of its own self-referentiality and starts to turn in a circle, always leaves untouched some basic consistency of the "regulated universe"— the self-reference at which the hacker arrives is, if we can put it thus, a consistent self-reference. The difference between the two levels of self-reference with which we are concerned is contained in Hegel's distinction between "bad" and "proper" infinity — the computer's self-referentiality remains on the level of "bad infinity." We can clarify this distinction with two different paradoxes of self-reference which were both developed along the same subject, a map of England.

First there was an accurate map of England, on which were marked all the objects in England, including the map itself, in diminished scale, on which they again had to mark the map, etc., in bad infinity. This type of self-reference (which is today mainly familiar in the form of television pictures which are reflected by television) is an example of Hegel's bad infinity; the giddiness triggered by this vicious circle is far removed from "proper" infinity which is only approached by the other version of the paradox, which we encounter — where else — in Lewis Carroll: the English decided to make an exact map of their country, but they were never completely successful in this endeavor. The map grew ever more enlarged and complicated, until someone proposed that England itself could be used as its own map — and it still serves this purpose well today. . . . This is Hegel's "proper infinity": the land itself is its own map, its own other — the flight into bad infinity does not come to an end when we reach the unattainable final link in the chain but when we recognize instead that the first link is its own other. From there we could also derive the position of the subject (in the sense of the subject of the signifier): if the land is its own map, if the original is its own model, if the thing is its own sign, then there is no positive, actual difference between them, though there must be some blank space which distinguishes the thing from itself as its own sign, some nonentity, which produces from the thing its sign — that "nonentity," that "pure" difference, is the subject. . . . Here we have the difference between the order of sign and the order of signifier: from the sign we may obtain the signifier by including in the chain of signs "at least one" sign which is not simply removed

from the designated thing, but marks the point at which the designated thing becomes its own sign. The computer's self-referentiality remains on the level of bad infinfity in that it cannot reach any position of turnaround where it begins to change into its own other. And perhaps we could find in this — beyond any kind of obscurantism — the argument for the claim that "the computer doesn't think."

The reason why the computer "doesn't think" thus keeps to the above-mentioned logic of the reverse metaphor where, instead of the computer as model for the human brain, we conceive of the brain itself as a "computer made of flesh and blood"; where, instead of defining the robot as the artificial man, we conceive of man proper as a "natural robot ," a reversal that could be further exemplified in a crucial case-in-point from the domain of sexuality. One usually considers masturbation an imaginary sexual act, i.e., an act where bodily contact with a partner is only imagined; would it not be possible to reverse the terms and to think of the sexual act proper, the act with an actual partner, as a kind of "masturbation with a real (instead of only imagined) partner"? The whole point of Lacan's insistence on the "impossibility of a sexual relationship" is that this, precisely, is what the "actual" sexual act is (let us just recall his definition of phallic enjoyment as essentially masturbatory)! And, as we have already seen, this reference to sexuality is far from being a simple analogy: the Real whose exclusion is constitutive of what we call "reality," virtual or not, is ultimately that of woman. Our point is thus a very elementary one: true, the computer-generated "virtual reality" is a semblance; it does foreclose the Real in precisely the same way that, in the dream of Irma's injection, the Real is excluded by the dreamer's entry into the symbolic bliss — yet what we experience as the "true, hard, external reality" is based upon exactly the same exclusion. The ultimate lesson of virtual reality is the virtualization of the very true reality. By the mirage of "virtual reality," the "true" reality itself is posited as a semblance of itself, as a pure symbolic construct. The fact that "the computer doesn't think" means that the price for our access to "reality" is also that something must remain unthought. □

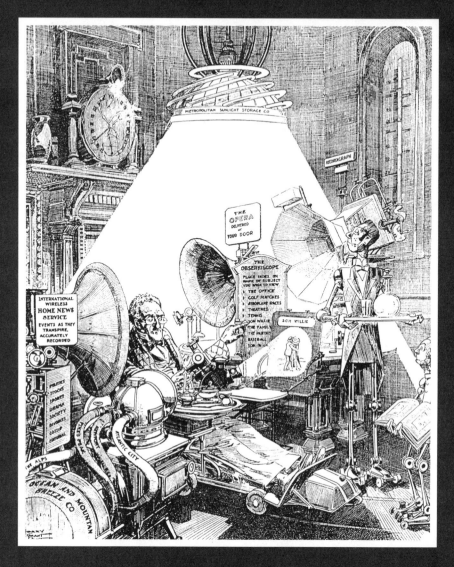

"We'll All Be Happy Then," Life, 1911

An elderly man sits in his parlor, surrounded by all kinds of technical gadgets and robot servants. The tense is a kind of future-in-the-present. Compared with many early depictions of the social role of the new domestic technologies, there is an important difference: the family unit (usually shown together looking at stereoscopic photographs, listening to phonograph recordings, and later listening to radio or watching the television in the cosy atmosphere of the living room) has disappeared. Indeed, other human beings are present only virtually, by means of a TV-like device called the "observiscope," a fantasy device and another manifestation of the "telectroscope," a nineteenth century discursive invention (see text). In this dystopian vision, the observiscope is used as a personal surveillance device, enabling the central figure to peep at his son Willie courting a girl. The view is from behind their backs, of course, and other options include "The Family," "The Office," "Golf Matches," and "Aeroplane Races." Nearby is an "International Wireless Home News Service," which transmits "events as they transpire, accurately recorded," again by choice from a menu, foreshadowing the present commercial on-line services. Additional gadgets emphasize the "mediatization" of domestic life — contact with the outside world will happen exclusively by means of various communication technologies, leaving humans isolated with their perversions. In this image, from the beginning of the twentieth century, we are not very far from the pessimistic late-twentieth-century Baudrillardian vision about the home turned into a "communications satellite." —EH

From Kaleidoscomaniac to Cybernerd:

Notes Toward an Archeology of Media

■ Erkki Huhtamo

In his classic exposé *Archeology of Cinema*, C. W. Ceram sets the prehistory of the moving image straight. He states, "Knowledge of automatons, or of clockwork toys, played no part in the story of cinematography, nor is there any link between it and the production of animated 'scenes.' We can therefore omit plays, the baroque automatons, and the marionette theatre. Even the 'deviltries' of Porta, produced with the camera obscura, the phantasmagorias of Robertson, the 'dissolving views' of Child, are not to the point. All these discoveries did not lead to the first genuine moving picture sequence."[1] In another paragraph Ceram elaborates on his position, "What matters in history is not whether certain chance discoveries take place, but whether they take effect."[2]

Curiously, the profuse illustrations of the English-language edition (1965), collected by Olive Cook, openly contradict these statements, producing an intriguing discursive rupture. A wide array of "chance discoveries," many of those emphatically dismissed by Ceram, have been included, supported by meticulously prepared captions. For many readers this parade of optical "curiosities" from the past must be the most evocative aspect of the book, rather than the author's pedantic attempts to trace the one-by-one steps that purportedly led to the birth of the cinema in the end of the nineteenth century.[3] In his enthusiasm for — or rather obsession with — causal relationships, Ceram only has eyes for two kinds of things: technical inventions and their inventors. Other potential contributing factors (social, commercial, political, psychological, and so on) matter little, serving mostly as background details for the grand panorama of individuals and gadgets that unfold in the foreground. Ceram never ventures into speculations above the "hard" materiality of his sources.[4]

Although such a "high positivistic" tradition of scholarship may seem hopelessly outmoded, its shadow has not completely vanished. Many books on media and technology still retain a narrow, artifact-centered, causal approach. This applies to accounts of electronic and digital technologies, as well. As a case in point, the history of the computer usually has been dealt with in terms of the idea of constant technological progress.[5] Mainframes give way to minicomputers give way to microcomputers. New processors, operating systems, and software appli-

cations appear, replacing their predecessors. Today's computers will be obsolete tomorrow — relegated to the dump. The prime movers of this history are — still — visionary individuals (from Douglas Engelbart to Alan Kay, from Steve Jobs to Bill Gates), whose intuitions are elaborated by faceless engineers at research laboratories and eventually mass-marketed by enormous corporate bodies like Microsoft and Apple.[6]

In such accounts the focus has been almost exclusively on the "internal" history of computing.[7] Most of the important developments, they would have us believe, have taken place within dedicated scientific institutions, populated by privileged insiders (to which the author often belongs, or is at least affiliated). The other common approach is to look at computing strictly from a business point of view. Hardly any attempts have been made to write the "anonymous history" of the computer, along the lines called for by Siegfried Giedion in the 1940s:

> The gaps will show, we hope, how badly research is needed into the *anonymous history* of our period, tracing our mode of life as affected by mechanization [read: digitization] — its impact on our dwellings, our food, our furniture. Research is needed into the links existing between industrial methods and methods used outside industry — in art, in visualization [Giedion's emphasis].[8]

Such an "anonymous history" should include not only the industrial developments, but also the social history of the computer user, the history of the computer as an object of design and as a source of style and fashion, the histories of the computer in counter- and subcultural contexts, the history of the computer's encounter and gradual merger with media culture (from a passive "reflection" in a TV show or a newspaper caricature to the "reality engine" running various media systems), and, indeed, the "mental history" of the computer — the computer as a "dream machine," an immaterial object of desires, fantasies, fears, and utopias. An artifact-centered, chronological account of the computer is not completely misguided (although it could be seen as just another re-enactment of a myth, that of the idea of progress); yet it is severely restricted in its scope, and its very dominance can lead to unfortunate historical and ideological anamorphoses.

THE TAG OF "NEW HISTORICIST"

As the French historian Marc Bloch taught, our conception of the past always depends on our perceptions — the kind of material we choose to focus on, the kind of questions we ask.[9] Any source, be it a detail of a picture, the design of a machine part, or a linguistic formula, can be useful if we approach it from a relevant perspective, viewing it within relevant webs of significations. Another historian with a comparable attitude toward historical sources was, of course,

Walter Benjamin, who, according to Susan Buck-Morss's apt formulation, "took seriously the debris of mass culture as the source of philosophical truth."[10] For Benjamin (particularly in his unfinished *Passagen-Werk*) the various remains of nineteenth-century culture — buildings, technologies, commodities, fashions, but also illustrations and literary texts — could all serve as inscriptions, which, if properly questioned and contextualized, would lead us to understand culture as a multi-layered dynamic construction. In particular, Benjamin was interested in the ways in which a culture perceived itself and conceptualized the "deeper" ideological layers of its construction. As Tom Gunning puts it, "[I]f Benjamin's method is fully understood, technology can reveal the dream world of society as much as its pragmatic rationalization."[11]

In the Benjaminian tradition, the German cultural historian Wolfgang Schievelbusch has shown us how such a concept of history can be used to shed light not only on the explicit topic in question — the railway, artificial lighting, stimulants — but also on the ways in which artifacts are embedded in the complex discursive fabrics and patterns reigning in a culture. From a predominantly chronological and positivistic ordering of things, centered on the artifact, the emphasis shifts into treating history as a multi-layered construct, a dynamic system of relationships, both material and "immaterial." Such approaches have recently gained ground in the field of media studies as well. Various media technologies, such as the telephone, film, radio, television, and the mechanization of writing, have been researched by (re)placing them into their historical, cultural, and discursive contexts by Tom Gunning, Siegfried Zielinski, Friedrich Kittler, Carolyn Marvin, Avital Ronell, Susan J. Douglas, Lynn Spiegel, Cecelia Tichi, William Boddy, and others.[12]

These recent approaches to media history distance themselves from the "objectivist fallacy" of the positivist tradition, admitting that history is just another discourse, a voice in the great chorus of all the voices in a society.[13] Thus historians have began to acknowledge that they cannot ignore the web of ideological discourses constantly surrounding and affecting them. In this sense, history belongs to the present as much as it belongs to the past. It cannot claim an objective status; it can only become conscious of its ambiguous role as a mediator and "meaning processor" operating between the present and the past (and, arguably, the future). Historical writing is re-presenting itself as a *conversational discipline*, as a way of negotiating with the past.[14] Such approaches have sometimes been labeled "new historicist":

> The tag of new historicist has been attached to methods that replace the "old" historicism of the nineteenth century, and which resist the bent of neopositivism, facticity, and the myth of historical objectivity—while at the same time rejecting the notions of the autonomous text found in critical formalism. A new historicism insists on reconnecting text with *context*.[15]

In line with these developments, I would like to present an outline for an approach that I call an "archeology of the media."[16] While I share many interests with the new historicist tendencies, emphasizing a synthetic, multi-perspectival, and cross-disciplinary approach to historical discourse and analysis, I see the aims of an archeology of the media with a more precise focus. I would like to propose it as a way of studying the typical and commonplace in media history — the phenomena that (re)appear and disappear and reappear over and over again and somehow transcend specific historical contexts. In a way, an archeology of the media purports to explain the sense of *déjà vu* that Tom Gunning has registered.[17] Gunning has paid attention to the peculiar double-focus that is often created when we look back into the past from the present — things in the past may suddenly seem strangely familiar, albeit, perhaps, surrounded by phenomena that seem completely alien to us. How do we account for this experience?

FANTASMAGORIE, LA CIOTAT, AND CAPTAIN EO

In the Frankfurt Film Museum, in a display case with various samples of nineteenth-century kaleidoscopes, there is an engraving titled *La Kaleidoscomanie où les Amateurs de bijoux Anglais* ("Kaleidoscomania, or the Lovers of English Jewels," presumably from the first part of the nineteenth century). We see several people (and, in fact, a monkey!) immersed in their kaleidoscopes.[18] There are two "kaleidoscomaniacs" so mesmerized by the visions they see inside the "picture tube" that they don't even notice other men courting their companions behind their backs. In a French lithograph, dated late 1830s to early 1840s, we see a husband bent under the hood of a daguerreotype camera, complaining, "I don't see anything!" Behind his back his cousin is embracing his beautiful wife, saying, "Keep on watching, it will appear!"[19] When stereography became a fad in the 1850s, similar themes arose, with humorous depictions of the less glorious effects of the new fashion — only now the cousin is likely to have been replaced by a door-to-door salesman of stereographic cards.[20]

Recalling C.W. Ceram's convictions, we might wonder if these occurrences are just "chance discoveries," with no causal relationship and thus no historical interest. And is it just another chance discovery that the current revival of immersive, peepshow-like experience in the form of the virtual reality craze has resurrected the figure of the kaleidoscomaniac — this time in the guise of the "cybernerd," whose passion for the other world makes him a fool in this one? The figure has made its appearance in the cinema and in satirical cartoons, as well as on MTV — just recall the animated figures Beavis and Butt-Head in their head-mounted displays, performing "I Got You Babe" with (real-life) Cher.

According to Ceram, there is no historical connection between Étienne

Gaspard Robertson's *Fantasmagorie* shows, which began in Paris at the end of the eighteenth century, and the Lumière brothers' *Cinématographe* presentations a century later. Even the use of the *laterna magica* principle for projecting images on a screen doesn't warrant Ceram positing a connection.[21] However, if we compare period illustrations of *Fantasmagorie* audiences reacting with panic to the ghosts attacking them from the screen with the reports about early cinema audiences fleeing in terror when the train in the Lumière brothers' film *L'Arrivée d'un train à La Ciotat* (1895) seemed to rush straight at them, we probably cannot avoid a sense of *déjà vu*.[22] And for someone who has visited modern-day Disneyland, the association that comes to mind might be the stereoscopic movie spectacle *Captain EO*, starring Michael Jackson. In *Captain EO*, the visual "onslaughts" have been enhanced by the usual 3-D effects, and also by laser beams, which appear to be released from the screen world to the space of the audience.[23] And even if the audience did not react so vividly on the spot, the publicity surrounding the theme-park experience made sure that we believe they did.[24]

Again, we may ask if there is any sense in comparing these occurrences, far apart in time and space, and related to very different technological contexts. I would argue that these parallels are not totally random, or produced completely independently by specific circumstances. Instead, all of these cases "contain" certain commonplace elements or cultural motives, which have been encountered in earlier cultural processes. I would like to propose that such motives could usefully be treated as *topoi*, or "topics," applying the ideas that Ernst Robert Curtius used in his massive study *Europäische Literatur und lateinisches Mittelalter* (1948) to explain the internal life of literary traditions.[25]

The idea of *topoi* goes back to the rhetorical traditions of classical antiquity. According to Quintilianus (V,10,20), they were "storehouses of trains of thought" (*argumentorum sedes*), systematically organized formulas serving a practical purpose, namely, the composition of orations. As the classical rhetoric gradually lost its original meaning and purpose, the formulas penetrated into literary genres. According to Curtius, "[T]hey become clichés, which can be used in any form of literature, they spread to all spheres of life with which literature deals and to which it gives form."[26] Topics can be considered as formulas, ranging from stylistic to allegorical, that make up the "building blocks" of cultural traditions; they are activated and de-activated in turn; new *topoi* are created along the way and old ones (at least seemingly) vanish. In a sense, topics provide "pre-fabricated" molds for experience. They may seem to emerge "unconsciously;" they are, however, always cultural, and thus ideological, constructs. This is my main objection to Curtius, who sometimes resorted to Jungian archetypes to explain the appearance of certain *topoi*.[27] In the era of commercial and industrial media culture it is increasingly important to note that *topoi* can be consciously activated, and ideologically and commercially exploited.

When we deal with *topoi* — such as the ones related to the stereotypical panic reactions to media spectacles — we deal with representations instead of actual experiences; we don't know (and perhaps never will) if any audience ever reacted to a *Fantasmagorie* or a *Cinématographe* presentation in the ways depicted in visual or literary discourses. Claiming that they did or did not would be beside the point. What is interesting is precisely the recurrence of the *topoi* within these discourses. It could even be claimed that the reality of media history lies primarily in the discourses that guide and mold its development, and only secondarily in the "things" and "artifacts" that for writers like Ceram form the core around which everything (r)evolves.

In this respect I share Michel Foucault's determination "[t]o substitute for the enigmatic treasure of 'things' anterior to discourse, the regular formation of objects that emerge only in discourse."[28] These "discursive objects" can with good reason claim a central place in the study of the history of media culture. Even though Foucault referred to media systems only casually, a related (and Foucault-influenced) strategy has been adopted by Friedrich Kittler in his *Discourse Networks 1800/1900*, where he traces the gradual shift from one discursive system to another (the mechanization of writing with all its cultural and ideological implications), drawing on a great variety of inscriptions.[29] As David E. Wellbery has noted, "Kittler's discourse analysis follows the Foucauldian lead in that it seeks to delineate the apparatuses of power, storage, transmission, training, reproduction, and so forth to make up the conditions of factual discursive occurrences."[30] Like Foucault, Kittler is interested in cultural macro-organisms, tracing their constitutions and movements by reading innumerable and heterogeneous cultural fragments (from literary fiction to Freudian case studies to the "anatomy" of the typewriter) with the aid of discourse analysis.

Instead of pursuing a systematic study of Foucauldian "discursive formations"— the ideological traditions of discourses reigning in and, in a way, constituting the life of, a society, based on the interplay of power and knowledge — the media archeological approach I am delineating is actually closer to the field characterized by Foucault somewhat contemptuously as the history of ideas: "the history of those age-old themes that are never crystallized in a rigorous and individual system, but which have formed the spontaneous philosophy of those who did not philosophize. . . . The analysis of opinions rather than of knowledge, of errors rather than of truth, of types of mentality rather than of forms of thought."[31]

I maintain that registering false starts, seemingly ephemeral phenomena, and anecdotes about media can be revealing (even without necessarily being seen as traces of a cultural macro-structure, an *episteme*), if we focus on the meanings that emerge through the social practices related to the use of technology. I agree with Carolyn Marvin, a cultural historian of technology, when she writes that "media are not fixed objects: they have no natural edges. They are constructed complexes of habits, beliefs, and procedures embedded in elaborate cultural codes of communication. The history

of media is never more or less than the history of their uses, which always lead us away from them to the social practices and conflicts they illuminate."[32]

From such a point of view unrealized "dream machines," or *discursive inventions* (inventions that exist only as discourses), can be just as revealing as realized artifacts. A case in point, the "telectroscope," was a discursive invention that was widely believed to exist in the late nineteenth century. It was described as an electro-optical device that enabled an individual to "increase the range of vision by hundreds of miles, so that, for instance, a man in New York could see the features of his friend in Boston with as much ease as he could see the performance on the stage."[33] Articles about the device were published in respected popular scientific journals, such as *La Nature* and *The Electrical Review*; it was even said that Edison invented it. Time and again it was announced that it would be presented to the general audience at the *next* world's fair. Yet the telectroscope never made an appearance except in these discourses, which were widely distributed in the industrialized Western world.

The telectroscope could be interpreted simply as a utopian projection of the hopes raised by electricity and by the telephone, realized decades later in the form of television. It should not, however, be discarded so easily. Television found its dominant form in broadcasting, which was very different from the role offered for the telectroscope as an individual and active "tele-vision machine," meant for individual, person-to-person communication. Jaron Lanier's utopian vision of virtual reality "as the telephone, not as the television of the future" can thus be seen as another incarnation of a *topos* well-known more than a hundred years earlier.[34] It remains to be seen if Lanier's all-embracing, discursive version of Virtual Reality will ever be realized, or if the rudimentary technology that inspired it will finally be molded into a form that is closer to the economically and ideologically constrained structures of broadcast television than to those of telecommunication.[35] The discursive formations that enveloped the emergence of virtual-reality technology at the turn of the 1980s and into the 1990s would provide an appropriate subject of study for the kind of approach I have been trying to delineate.[36]

In summary, it seems to me that a media archeological approach has two main goals. First, the study of the cyclically recurring elements and motives underlying and guiding the development of media culture. Second, the "excavation" of the ways in which these discursive traditions and formulations have been "imprinted" on specific media machines and systems in different historical contexts, contributing to their identity in terms of socially and ideologically specific webs of signification. This kind of approach emphasizes cyclical rather than chronological development, recurrence rather than unique innovation. In doing so it runs counter to the customary way of thinking about technology in terms of constant progress, proceeding from one technological breakthrough to another, and making earlier machines and applications obsolete along the way. The aim of the media archeological approach is not to negate the "reality" of technological development, but rather to offer some balance by placing it within a wider and more multifaceted social and cultural frame of reference. □

All images are by David Blair, from his forthcoming project "Jews in Space."

Metavirtue and Subreality

"The involuntary Walker as Virtuous Subject yet only Semi-intelligent Agent"

OR

"Birds, or No Ledge to Stand on"

■ *David Blair*

DISNEYLAND

It's 9:45 PM, and I'm walking through New Orleans Square at Disneyland in Anaheim, California. The water show is in full swing, with miraculous sudden set changes. . . . The giant pirate boat with fifty actors has turned and is completely hidden behind a corner too small for it, and multiple thirty-foot evil magic-mirror faces hang on mist screens above the water. I decide to take a sudden turn myself, to visit the Pirates of the Caribbean ride. A few feet down the path, the crowd is gone, and the water show almost inaudible. The ride is on a narrow waterway with flat-bottom boats inexorably driven forward through the artificial landscape by a fearsome chain-and-gear mechanism hidden under the water. I'm in my seat, and twenty seconds later we are underground, on a river in a cave system somewhere beneath Disneyland, somewhere in the Caribbean, probably near the storage space of that missing water-show pirate ship. And, simultaneously, I am almost back in the Carlsbad Caverns National Monument, true wonder of the underworld, alone, after midnight, during the production of my film *WAX or the discovery of television among the bees*. Floating on a boat attached by bottom chains to an artificial underground Disney-Caribbean river is not that much different from walking alone, at midnight, through the unbelievable underground and path-determined space of Carlsbad Caverns, moving in half-light among giant rock forms. That afternoon, deeper in the cave, I'd had a beekeeper's suit on and been standing around the corner of the one-way path from a cameraman, almost leaning on a fractionally detailed limestone formation. On the cameraman's cue, I was supposed to create a material wipe suddenly by walking around the corner, but we had to keep delaying the shot as tourists kept appearing behind me on the one-way path . . . surprising me, but not themselves. I was just part of the landscape, and several even said, "The moon, huh?" before turning the next corner and finding the camera. I was part of their ride, but they knew I was also

thousands of feet underneath the moon, maybe somewhere in France on the set of a Melies movie, or perhaps back at Disneyland, back at Pirates of the Caribbean.

An interesting and vital part of navigation in immersive environments is the effect of sudden mode change . . . often, turning a corner, you are instantly in another environment, as if you had just passed through the spatial equivalent of a soft-edged wipe. What is shocking is that these mode changes can often take you to an environment that contradicts the one you just came from, both in appearance, and in meaning and use . . . like turning a smooth corner at the base of the Matterhorn at Disneyland, and ending up at the end of a row of urinals.

The first effect of this spatial mode change, I believe, is that one becomes more susceptible to association. In other words, free navigation in an immersive environment leads to mode changes, and mode changes lead to an increase in association, sometimes internal, and sometimes external. The latter we call coincidence.

Back in the early 1970s, I learned a lot from surreal audio theater pieces put out by the group Firesign Theatre. I hadn't listened to them for almost twenty years until I bought them as used records, in preparation for a trip to SIGGRAPH '93. Off the plane under the memorial statue at the John Wayne Airport in Orange County, California, in an enormous surrounding glass abutment that was the center of a high imperial postmodern building (so obviously built first in the computer that regular holes had been designed in the mold of the parking garage's poured roof to allow what started as elephant feet underground to turn into a grid of optimistic palm trees above), I realized I'd better go to Disneyland before I got too busy. Four hours later, it was closing time at Disneyland, and I was emerging from the bathroom across from the Matterhorn. I'd just bought my first Walkman the month before, and wasn't used to the dual alienation and audio overlay effect you get from a Walkman, so I put the headphones on again with self-conscious semireluctance, and went back to "We're All Bozo's on This Bus" (Firesign Theatre, 1971), written at the beginning of the age of video as an imagination of what government-inflicted simulation might really be like. Putting the story briefly, a bus comes to town, and Clem gets on board. It turns out that the bus is actually a seamless virtual reality environment, that may or may not take Clem to a future amusement park very similar to what I imagine is Ross Perot's vision of the Information Superhighway.

While meeting the audioanimatronic president on the White House Ride, Clem reveals himself as a quasi-revolutionary hacker, who conversationally forces the robot president into maintenance mode, in order to talk to Dr. Memory, the real program running the simulation. Clem is inside the machine, and inside the program, calling out to Dr. Memory: "Read me, Dr. Memory! Read me Dr. Memory!" There's a full moon out, the Matterhorn is white, and the gondola cables are dark and visible against the sky. Suddenly, there's an additional voice and space on the tape, which it takes about ten seconds to identify as coming from the entire southern slope of the Matterhorn, which has begun to speak in the sublime voice of a woman on a microphone saying: "Shutting Down System A. Shutting Down

System A. Check. Shutting Down System B. Check." A male voice replies conversationally to the technical woman from another set of speakers across the way. In the meantime, Clem, who had already succeeded in breaking the president, has just shut down the entire Future Fair.

The effect of modal change and association, whether the latter takes place in the imagination, or in the world as coincidence, is that you end up with a sort of spatial fiction, what Jay Bolter in his book on electronic writing called a topical, or topographic fiction, a fiction of aphorisms and situations, spread in front of you as a field of places that can change from one to the other in a variety of ways. Traveling through the fiction is like navigating through an immersive environment, and vice versa.

HAPTIC DIMENSIONS

Navigation through immersive environments is of course a serious problem in the world, an enjoyable problem in amusement parks, and a highly rhetoricized one in virtual worlds. Already, in an amusement park, we are often on the verge of fiction making. By the time we get to virtual reality, we find ourselves in the midst of a full-blown metafiction.

Metafictions have been described as fictions that examine the creation of systems, especially themselves and other fictions, with particular attention to the ways in which these systems transform and filter reality. There is an assumption in this sort of fiction making that we are locked in a world we have created, a fictional world shaped by narrative and subjective forms developed to generate meaning and stabilize our perceptions. Metafictions don't operate on aesthetic assumptions of verisimilitude, but exult in their own ficticiousness. They assume that there are no true descriptions in fiction, only constructions, which may not have any relation to the world.

Navigation in virtual worlds tends to disrupt the ordinary balance that exists between our exterior senses and our interpretive subjectivity. It is no accident that virtual reality has been compared with hallucinogens. LSD, alcohol, fatigue, and lucid dreaming have all provided us with many examples of this disruption, all tending to reveal what I would call the haptic dimensions of thought: a sudden intuition of the material nature of thought, of how thought is received from the environment, and at the same time transforms the environment. Acid trips, for example, are famous for their mode changes, sudden and powerful associations, and constant commentary on themselves, a unified metafictional experience that often leaves the user with the powerful impression that thought is literally another and different physical sense.

Of course, the same effect is common to exhaustion in immersive environments. After the Matterhorn spoke through speakers, I made the very long walk back to my hotel across the famous vast parking lot, past the gate and down a long street with a new sidewalk that switched from one side of the street to the other every block. Four hours off the plane, with miniature golf to one side, the Charismatic Convention

Center to the other, and naked power pylons above, I was waiting for the next epiphany, as I could barely tell the difference between Disneyland and California. I received my epiphany in the appearance of a small rectangular concrete cover embedded in, and the same color as, the sidewalk. On the molded top there was engraved the word "telephone," which in the tunnel of my exhaustion made me think too clearly about the power lines invisible under the overlit night street, about my telephone at home, barely lit and unseen by my wife, who was certainly asleep in another room; about the last phone I used to call her, a pay phone back at Disneyland — in general, about both the limits of my knowledge, and the connectedness of words, my thoughts, and the world, and how, in making those connections, my thoughts had acted like a strange sense, seeing things so far away, or impossible to see.

I believe this is related to something the mathematician Poincaré said when describing his theory of conventionalism, the main purpose of which was to assert that the space described by the convention of Euclid's theorems did not rule out other spaces with their own self-consistent sets of rules. In certain descriptions of space, he said, there could also be haptic dimensions where every muscle was a dimension.

This thought fascinated people at the turn of the century, and was related by them to the notion that the fourth dimension was an alternate spatial dimension, at right angles to everything we know. In many ways, these enthusiasms were parts of an attempt to deal with subjectivity as a dimension and as a sense — an *n*-dimensional sense, since with so many possible descriptions, there was no point in stopping the count.

Nowadays, with human-computer interface technology, we have come to a literalization of the idea of haptic dimensions. Now, the world can be mapped to muscles, so that a small hand gesture inside a dataglove can be used to navigate, or even to increase the amount of space available in a virtual world.

Speaking about the human-computer interface in his book *Virtual Reality*, Howard Rheingold says,

> We build models of the world inside our head, using the data from sense organs and the information processing capacity of our brain. We habitually think of the world we see as out there, but what we are really seeing is a mental model, a perceptual simulation that only exists in the brain. That simulation capability is where human minds and digital computers share a potential for synergy.

I find it fascinating that Rheingold is not just a great popularizer of virtual reality. He is also a popularizer of lucid dreaming technologies, which allow a dreamer literally paralyzed by sleep to communicate information from a parallel, artificial, and autonomous world out to sleep researchers, using a Morse code of eye wiggles. I take it as a clue that our equivalent of the turn-of-the-century fascination with haptic and higher dimensions can nowadays be found in the theme of potentially autonomous alternate worlds which exist in machines as virtual reality and artificial life, or in our world, as Jurassic Park, and which share among themselves the qualities of metafiction.

In North America, we were already immersed and navigating within Jurassic Park. Of course, *Jurassic Park*, the film, is only a single interstice within an immersive, navigable environment made up of the various media that Jurassic Park, the concept, is presented in, ranging from wearable shirts and wrappings for burgers at McDonalds to many of the booths at SIGGRAPH, and beyond that to future theme-park rides. Metafictional elements are the audiences' navigation within this environment . . . from product to product, from place to place . . . best emblematized by the film audience's common smile at the only really visible product placement in the entire film: the Jurassic Park memorabilia that can be seen on screen in the Jurassic Park gift shop. Given the fact that the film is part of an immersive environment, this moment is more than an advertisement for itself. It is like the Pirates of the Caribbean (though designed for a more limited and practical effect), a metafiction emblem of navigation, modal change, and potential association used to sell you shirts, or whatever you might want when you decide you want it.

Navigation is an important theme within the film. Richard Attenborough, famous film director in our world, stars as the concept- and money-man behind *Jurassic Park*, a world within our world where dinosaurs live again. He transports our main characters to the island in the bellies of helicopters, to see and approve the mystery of his creation. First stop, after a brief witnessing of this creation, is the island's museum movie theater. There everyone is treated to a film within the film,

<div style="text-align: right">Theory</div>

in which Attenborough clones himself to introduce us to the idea of reproduction without sex. Suddenly the movie theater becomes a theme-park ride. Restraining bars come down over the seatbound, a wall opens, and, diorama-style, a living laboratory behind a plate-glass wall begins to scroll past the riders; dinosaur-reproduction workers are visible inside the laboratory. The lawyer character whispers to Richard Attenborough: how marvelous, it's all so realistic . . . are those automatons? Attenborough replies: no, we have no animatronics here. They're real! It is at this moment that the three scientist characters, so taken by this completely immersive environment — there is no question of real or unreal for them! — decide that they have to navigate. Communally, they force up the restraining bars, and exit the ride, cybernetic sailors on this narrative's oceanic pond!

If you've ever seen Mel Brooks's film *Blazing Saddles*, you'll remember the famous horse chase, whose climax is a sudden modal change, where the chase crashes through a painted landscape backdrop, and finds itself backstage. With no loss of momentum, the riders continue on to the next set, where they disrupt a Busby Berkeley–style movie in mid production. That's how I tend to view the scientist's jump off the ride, as well as the famous scene when the autonomous and artificial Tyrannosaurus rex crashes through the Park's unelectric fence at the beginning of the film's recorded disaster.

Of course, by that point in *Jurassic Park*, the associative process is already in overdrive. For instance, what are the dinosaurs? Before seeing them, most people already know that they are this age's miracle of computer-generated pseudo-autonomous entertainment reality. In the film, we also learn they are earthburied bone that can be made visible aboveground in the middle of the Badlands of South Dakota through the use of shock waves generated by elephant-gun shells, which create echoes that can be written to computer screens as image-processed pictures. They are DNA held invisible within mosquitoes doubly hidden within miraculous transparent amber buried deep in the earth, which yet can be dug up, extracted, and revealed as equivalent to the wall-to-wall scrolling alphabetic texture that covers the cinema screen in the movie within the movie at the Jurassic Park Museum — DNA letters actually generated during the dinosaur's fateful afterdeath mating with frogs that can change their own sex. I can't even begin to go into the number of descriptive associations this film can generate. To my mind, it is one of the great associative narratives, a truly atemporal, or should I say spatialized, film.

SGI

Which brings us to Jurassic Park, the potential virtual reality. Several weeks after seeing the movie, two days after Disneyland, I found myself at Discovery Park, part of the Silicon Graphics booth at SIGGRAPH '93. It was here that I had a chance to reconsider what I had thought to be one of the most sublime elements of the film: the

overarching, fractionally dimensional, and ultimately recursive theme best expressed by the main scientist in the phrase "you'll never look at birds the same way again."

If I remember correctly . . . at the beginning of the film, we're in the Badlands with the main scientists, digging fossils. The shotgun shell has gone off, revealing the subterranean velociraptor skeleton on their outdoor, but not particularly mobile, computer screen. In the midst of a violently imaginative fleshing out of the dinosaur's previous body and behavior, the scientist says, "You'll never look at birds the same way again." This phrase, stranger than it seems, and said with awareness of its effect, echoes through the film in hundreds of ways, becoming, as if by default, a main theme. Moments after the fatal pronouncement, Richard Attenborough arrives by helicopter to take the scientists to Jurassic Park, where it is their job to judge whether this high-entertainment concept can fit in our world. The park implodes, the dinosaurs riot, and the scientists barely escape . . . but they do, in the belly of a helicopter. At the film's wordless end, the main scientist looks through the clear window, or dead eye, of his artificial bird, and finds what appears to be the sublime in the image of a pelican winding its wings over the ocean beneath him, which, except for an exterior shot of the helicopter in flight, is pretty much the last shot in the film. Despite all the emotion on his face and in the soundtrack, I have to say that I really don't know what it is the scientist sees, but it certainly is a bird.

At SIGGRAPH, the day before I actually did find my way to SGI's Discovery Park, I was standing two halls away in line at the Virtual Reality Laboratory, part of a virtual reality museum ride created for an exhibit called Imaging, the Tools of Science to be installed at the Chicago Museum of Science and Industry. The visual interface was the Fakespace Boom 2C, a boom-suspended periscopestyle cube with a high-resolution stereoscopic display inside . . . more vividly, something like a large, swivelable, realtime ViewMaster at the end of a very fancy articulating lamp stand. Virtual Reality Lab was essentially a fly ride through several surreal and constructed worlds.

First you find yourself in a bare, circular room, with your previously grabbed portrait on the wall, and a polygonally crude Fakespace Boom 2C recursively in front of you. Back in the real world, with the real boom, you can swivel around and look at the room, all the while inexorably advancing toward your portrait, which, at a certain distance, shivers into fragments that flock together and fly through the hole left by their disassembly. You have to follow them, through the hole, to find yourself floating in the clouds. The birds that were you depart ahead and above. To the side is a girder-thick red wire-frame cow, a sort of surrogate cloud, and directly ahead is a structure that once again you are inexorably heading toward and then through, a sort of open-ended floating skyhouse made of four circuit boards in extreme perspective, and a fifth right ahead. The moment before colliding with the fatal frontal board, you can see the image of a flower, and by the miracle of modal change, you find that you have passed through to emerge out of a patch of flowers in the center of a park, a main natural space in a Potemkin village made of texture-map flats.

This, seen from the particular angle chosen by the Fakespace user, is all projected on a video screen behind the person standing with his head up to the swiveling box. I didn't actually get to put my head up to the box that day, as the line was quite long. Time is always a consideration at SIGGRAPH, and since I didn't have a watch, I turned around to ask the fellow behind me what time it was. Before he started to speak I could see he didn't have a watch, and so I stopped in midsentence, just as he started to say something that I couldn't hear. Out of politeness, I said, "What?" and he said, "Right now," so I said "What?" and he said, "You asked me what time it was, and I said it's right now." I agreed.

Twenty six hours later, just before finally getting to Silicon Graphics' Discovery World, I found myself waiting in line to pay for my lunch at the International Food Court. Again I needed to know what time it was, so I turned around and asked the person behind me. I recognized it was the same fellow just before he inevitably said, "I said, it's right now. Don't you remember?" surprising both of us, as it had been estimated there were 10,000 other people with us in the Anaheim convention center. So, to be polite, as we obviously had something in common, I read his shirt, which said "The Virtual Museum," and asked, "What's the Virtual Museum?" He didn't really want to answer, and I didn't really find out until the next day, when I came across the actual Virtual Museum, back in "Machine Culture," as the art show was known during this SIGGRAPH year. The Virtual Museum being sort of a common interface for inexpensive, individually created virtual worlds, a sort of museum atrium through which one could enter, under arches, any compatible virtual world module you might pick up from the Internet, or a floppy disk. The Virtual Museum describes itself as therefore allowing anyone to explore ancient Egypt, pre-Columbian Peru, and Atlantis. None of this information being offered by my space-time companion at the International Food Court, I decided to push the situation, so I read his convention badge, which always has one's name and job function printed on it at SIGGRAPH . . . apparently he worked for a company called Earth. So I asked, "What's Earth?" and he said, "That's where I live."

After that and lunch, I was off to Discovery Park, where the line was too long, so I talked my way in the back door. "Discovery Park is an Interactive Entertainment and Virtual Reality Experience!" was written on the brochure, and inside, there were birds.

First was a pterodactyl-shaped, user-mountable ride, where a canyon environment appeared on three large high-definition screens in front of the viewer, who steered the flying machine from its virtual back, with wing tips and pterodactyl-head occasionally visible. Everyone in the room could see the screens, and there was a bit of ambiguity whether or not the rider was actually the bird having an out-of-body experience, with the annoyed bird-body continuously attempting to catch the eye of the floating oversoul. Networked to this was the private, two-million-pixel Fakespace Boom 3C, which apparently allowed you to look around while the pterodactyl-person did the steering through the inevitably progressing

air. No one else could see what the person at the Fakespace boom saw. Third node on the network was yet another viewpoint, embodied in a high-resolution and also resolutely private head-mounted display from Kaiser Electro-Optics.

People were also looking at birds differently in the Evans and Sutherland booth, which had SIGGRAPH's other user-mountable flying demo ride, a sort of Sports Simulation Gym where your body was a hang-glider spaceship in an extraordinarily complex and enclosed high-definition city space. In the Reagan-Bush years, we would have immediately thought of the military as the buyer or maker of such flying rides, as well as flying things, and uncontrollable carnivores. But now is the time when we instead remember that Link, inventor of the flight simulator, came to that device from his work designing rides for amusement parks.

Link's flight simulator took the roller coaster off the ground using pneumatic motion, making the rider into a bird in a box. Before computer graphics could match the realism of that motion, miniature landscapes were built, reconstructions of appropriate countrysides, which the flight-simulator pilot could see through a motion-controlled camera that floated on a grid above the model board. In this time before computer graphics, many people identified visual simulation with such physical miniatures, so that there it was no great associative leap from the model board to Disneyland. Of course, at that time, one of the logical associative paths leading out of Disneyland was the idea of government-inflicted simulation, presented "In Technical Stimulation," as the Firesign Theatre put it. And certainly, visiting Anaheim's ancient Disneyland, it is very easy to arrive at an idea of the intimate linkage of entertainment and death, especially in New Orleans Square, where Pirates of the Caribbean begins, after establishing the cave, with skeletal pirates guarding gold, and then proceeds through torture and rape to end with an ecstatically drunken pistol duel held in a gunpowder storage cellar.

In *Jurassic Park*, the one skeptical scientist overhearing Richard Attenborourgh say that a mechanized tour of Jurassic Park is as safe as any amusement park ride, volunteers: "But on the Pirates of the Caribbean, if the pirates get loose, they don't eat the tourists." So what should we see when we look at birds flying free as a tyrannosaurus rex through the air?

In *WAX or the discovery of television among the bees*, Jacob Maker works on a simple, local network of flight simulators, a 1983 precursor to what in 1986 or so became SIMNET, a wide-area simulation networking scheme that allowed a group of pilots sitting in flight simulators somewhere in Tennessee to train with people driving tank simulators in California, all together in the same limited, synthetic environment. This sort of networked simulation prepared the way for the raid on Libya, the invasion of Panama, and ultimately for the Gulf War. The proposed successor to SIMNET is called DSI, or the Distributed Simulation Internet, if I have the correct acronym, which combines broader band width with new graphics and networking standards, literally allowing an army of linked individuals, spread across the globe, to join each other in that military amusement park. Not formally different from what some

people propose for interactive, navigable, immersive cable-TV games. Of course, what does program content mean in the context of this DSI?

Or what is history? One of the first implementations of the DSI was a minute-by-minute, foot-by-foot reconstruction of a Gulf War skirmish known as the Battle of 73 Easting. As you might expect, it plays the battle forward and backward, and allows you to view it from any angle. It also allows you to create alternate battles from this reality base. Considering how much history has already been prepared in cyberspace, it is truly metafictional that 73 Easting was presented to the senate as the first example of virtual history.

Unfortunately, this is a normal theme in the history of the history of technology. Television is an excellent example. According to Steven Spielberg's *Raiders of the Lost Ark*, it was possibly the God of Israel who invented both television and virtual reality. But according to the Nazis and some others, it was Paul Nipkow who discovered television and virtual reality in Berlin in the 1880s. His fascinating electromechanical telephone for the eyes coupled unique spinning-disk spiral scanners, known as image dissectors, with magnetically controlled crystals that occultly served as light valves.

Nipkow worked for the city railroad company during the electrification and "transportification" (which is a deliberate rhyme with *fortification*) of Berlin, designing a streetcar semaphore signal system. It is a not so odd fact that his television system mainly resembled the axles and wheels of a railroad car . . . two spinning-disk scanners synchronized by a fixed axle between.

By the 1890s, the signal system was apparently in place, the job had probably settled down, and in his private inventing life, Nipkow had moved on, bypassing

further development on the television to focus on his new obsession, the invention of a working helicopter.

More than thirty years later in Weimer Berlin, construction began on the Funkturm, the Eiffel Tower of radio, defining what became the communications heart of Berlin, an area so important that it later was given the name of Adolf Hitler Platz. Nipkow was an old man, and practical, low-resolution, mechanical television systems based on his scanning scheme had come into existence in Germany, Britain, the United States, and elsewhere. This was television with less than forty lines, but it was a commercial television, with regular scheduled broadcasts from the Funkturm by 1929. At that moment, it became clear that the real challenge for television engineers lay in high-resolution television. Breakthroughs in high-frequency research promised broadcast systems and receiver sets with over 400 image lines.

Certain people knew that this same technology would also make possible a practical system of radio-wave-based detection and ranging of distant flying objects — what we know as radar. As a result, as mechanical television died a natural death, due in part to the worsening financial situation worldwide, a decision was made in the three main television-producing countries to promote the creation of a popular, entertainment-oriented high-definition television system; the goal, never publicly stated, was to create both the industrial and human resource base necessary to design and manufacture a practical air-defense system.

This created a peculiar situation. Germany provides the best example. First, Hitler declared all German television research a state secret. Then the public search began for facts that would establish German priority in television research — historical priority. Paul Nipkow was snatched from obscurity to become a new national hero,

the Father of Television. England replied, or maybe they started it all, with the Edisonification of John Logie Baird, who became the Other Father of Television.

In every country, television history, like television itself, was discovered, or invented. Books were written, and in other places, factories were built. In 1941, not long after the radar machines were switched on in England, Holland, Germany, and elsewhere, Paul Nipkow died, which triggered his greatest honor. Paul Nipkow's funeral was broadcast live on Fernsehsender Paul Nipkow, the Nazi high-definition television station named after him and broadcasting from atop the Funkturm in Berlin.

PARALLEL WORLDS

More than fifty years after Nipkow, or right now, as my more associationally minded colleague from Earth might say, we have mind amplifiers, as Howard Rheingold calls the modern computer. Artificial realities have increased in number, mechanical and immaterial transportation have improved, and with the necessary increase in modal changes have come increases in the descriptive power of association and metafiction.

So, again, what should we see when we look at birds? Maybe, metafictionally, they could remind us of a navigational ethics: since the ride is so many different possible things, and since on occasion we are on the other side of the ride, go ahead and go where you are going, in whatever way you wish to travel, just try to remember you are responsible if you kill when you get there. Unfortunately, our usual sad situation is very much like that of the religious soul told to remember something after death, who, on arrival in the other world, only remembered once having had a conversation with someone, but not what was said.

Several months ago, at the Cyberspace Conference in Austin, a fellow came up to me and said, "Congratulations, I work at Hughes Aircraft, and I used to have the same job as that guy in your film." In *WAX*, a narrative metafiction, Jacob Maker works on the Intergrated Air Battle Mission Simulator, writing the code that controls the acquisition of target information. It is up to him to make sure that the gunsight displays work, that what the pilot sees, whether by radar, infrared, or simple sight, does coordinate with his use of weapons. By "congratulations," the fellow from Hughes meant that he used to be Jacob. After twelve to sixteen hours in a completely immersive, photorealistic flying environment, it was time to go outdoors, and as he told me: "I'd go outdoors, just out onto the street, and I'd wonder . . . am I supposed to kill now? And what was really strange, you know, was that after a while, I started seeing these lines. They were just floating in the air, like the marks your guy was seeing in the film." The fellow from Hughes was much happier now, as he had gotten himself transferred out to a part of the company that was trying to find a way to convert flight simulators into personal amusement-park pods.

Unfortunately, in either entertainment or war, navigation isn't usually free. It's closer to semi-autonomous. Often, in both, you can go where you want, but only as long as you make sure you kill and spend disposable income. Grotesque narrative dealt with this particular difficulty of navigational ethics in immersive environments long ago, by transferring autonomy to the artificial world . . . by stripping the creator of an artificial world of all free will, and passing a parody of that on to his or her creations. Such fictions are invariably metafictions, as there is always a rather smooth continuum from the created and autonomous world to the narrative itself, which, being also a creation, is implicitly also autonomous. This is halfway to recursion, the creation of endless mirrors, or other interfoldings of space and light, which in metafiction have always led to worlds within worlds, just around the corner from us but burdened with other space-time rules, not just alternate histories, but parallel universes.

When the Jurassic scientist, embedded in the belly of the anonymously piloted helicopter, looks out through the metal bird's window-eye at the free-floating pelican, it is easy for me to make the associative jump to the artificial-life scientists, who watch freely navigating autonomous graphic agents on computer machines, and see life. They claim that automatism, of the kind once given rhetorically in grotesque fictions to describe an ethical dilemma, has now become practical. With this, metafiction becomes perhaps experimentally verifiable. Windows open onto other worlds that might really be there.

The Game of Life is a computer program — a virtual, time-based machine that floats as distributed, changing patterns inside many popular mind amplifiers. This program consists of a small set of rules, a tiny grammar that controls an on/off graphic display of dots clustered together as gridded pixels on the two-dimensional screen you see from outside the machine. The rules turn the pixel dots on and off, and make the dots interact with each other in order to determine the order of this flashing. Some of the patterns resulting from this interaction have the ability to grow and maintain themselves in complicated shapes, which can move through two-dimensional screen space, and even reproduce. Writers and players of the game claim that these dot-group pattern behaviors are mimetic of life itself. They then on occasion argue that anything that so clearly imitates life must be alive itself, potentially with a point of view, as part of a limited but autonomous alternate world embedded within our own.

The Game of Life is an example of cellular automata in action. Cellular automata have also been practically applied to image processing. The pictures to be processed in this manner have often been machine gathered and transmitted to us through great noise from places not part of our normal point of view; for instance, the point of view of someone who can read the constituent parts of your blood; or the point of view of a television camera on the top of a rocket plummeting out of control toward the moon.

Pictures to be processed are divided into pixels; the grammars go to work on these pixels, forcing them to interact, forcing the picture to become more visible to us.

Potentially living, or at least potentially autonomous, pixel groups self-organizing into potentially autonomous, substantial, though still changeable image shapes, leaving us with pictures that have more visible information than before the process started.

As cinema collapses into the computer, where it will meet virtual reality, science, and many other residents of our cultural world, we approach a situation where all the film-production data, gathered from places beyond our ordinary point of view, are passed into a unitary workstation. The maker, sitting in front of the workstation screen, works on this data like cellular automata on pixels, forcing various pieces of meaning to interact so that pictures will become more visible to us. However, simultaneously, the maker will also encounter real automata inside the machine.

The maker slowly navigates through the real-time, proto-narrative space of the production data, applying any of a variety of processes to that data, in any sequence desired, controlling composition within frames and between frames interactively, occasionally mixing real-world images with synthetic objects or character elements — all the time composing literal and associative meaning. All processes, from the manipulation of synthetic geometries to the collation of associations, have been partially mechanized, so that the narrative building proceeds with a partial autonomy that allows the workstation screen to look back. The mind amplifier has become a mirror, and at a rhetorical and virtual distance behind the mirror, anti-eyes connected to an anti-body in an alternate universe embedded in ours watch back with a glimmer of narrative intelligence, ready to play you back all the histories of that 73 Easting patch of desert, including the many possible alternate flight paths of semi-autonomous weapons over that part of virtual Iraq, misguided missiles that are willing to stop and assist you with both spell checking and story building, if that's what the story requires.

In many Japanese newspaper offices, there are old and giant composition typewriters with hundreds of keys for the thousands of pictographic *kanji* characters. Each key has twenty-one shifts — the Roman alphabet almost hides in a single key. Writers, however, now use personal word processors with the same number of typewriter keys we are used to, that hold both the miniature, alternate Japanese phonetic alphabet, along with the Roman. As you type, the computer collates your pseudo-phonetic strokes, compares them with a built-in *kanji* chart, and offers you choices of alternate *kanji*-pictures in a menu at the bottom of the page — a spell checker in reverse, an inadvertent poetry machine mechanizing the processes of association. In cinema, as it slowly collapses into personal computers, *kanji* are replaced by images and sound, and the semi-phonetic alphabet by your descriptions of your images, the computer offering fill-in-the-blanks association opportunities (or, in less delicate software, spell-checking necessities), to help you get that story into reasonably communicative shape.

Give names to pictures in a semi-intelligent picture processor, and the machine begins to sort the pictures into protosequences. The maker looks at these, chooses the clumpings that are pleasing, perhaps adjusts them a bit, then turns back to the

machine, which reapplies its ultimately mutational rules of travel and association, adding organization in several possible ways, which are then again chosen from. Navigation through choices made by the machine soon becomes a primary form of story construction for the maker, who travels through machine-offered potential worlds, choosing the ones that become virtual worlds, leaving a trail of partial and rejected universes behind the maker, who has become a sort of aesthetic eugenicist.

The maker is still on a flat-bottomed boat in Pirates of the Caribbean at Disneyland, traveling inevitably forward, though in this case building rather than viewing. Whether traveling through alternate worlds, traveling through immersive environments that force the creation of association, or traveling through mechanized association in order to create immersive environments, navigational ethics remain a priority. In the future, when you can go anywhere you want, cinema, by whatever name, will become a grotesquerie without grotesques . . . a metafiction where information wants to be free, and stories possessing senses, skills, and resources stutter in and out of existence in digital space-time, on earth and in other worlds. With immersive environments now even embedded within one another, with modal changes available at any moment, and association almost a style of knowledge, it's good to remember, though it may be difficult to remember, what it is you are supposed to remember.

Personally, I work in the area of cinema that I call image-processed narrative: a type of narrative where both the images and the narrative are processed by both myself and machines, and where, in the process, navigational ethics are attempted. So I welcome this, our new protofuture, where the past imitates the future, where metafiction is potentially experimentally verifiable; where, as in the book I read last week, wrinkles in the universal background cosmic microwave radiation led an enviably optimistic popular cosmologist to the conclusion that the universe is alive, that it reproduces, and that as a result there are infinite connected or embedded universes probably related, struggling through the impractical difficulties of evolution in action. A protofuture world where new and old media imitate one another, where the single user is not much different from the single author, and where rhetorical autonomy has been extended to machines — though hopefully, it will be given to people in equal or greater amounts. □

CYBERWAR, GOD AND TELEVISION: INTERVIEW WITH PAUL VIRILIO

■ *Louise K. Wilson*

Beneath Mirabeau bridge flows the Seine
And our love Must I remember
Joy followed always after pain

Let night come sound the hour
Time draws in I remain

Extract from "Mirabeau Bridge" by Guillaume Apollinaire,
quoted by P V at the beginning of the interview.

LOUISE K. WILSON: First of all, I'd like to say that I approach your work
as a visual artist.

PAUL VIRILIO: But, I always write with images. I cannot write a book if I don't
have images.

I believe that philosophy is part of literature, and not the reverse. Writing is not
possible without images. Yet, images don't have to be descriptive; they can be
concepts, and Deleuze and I often discuss this point. Concepts are mental images.

WILSON: In the text "The Museum of Accidents," you write about the problem
of positivism facing a museology of science, and the need for "the science of an
anti-science museum."

VIRILIO: In "The Museum of Accidents," I say at the end of the article that
television is the actual museum. In the beginning, I say a museum of accidents is
needed, and the reader imagines a building with accidents inside. But at the end, I
say, no, this museum already exists, it's television.

This is more than a metaphor: the cinema was certainly an art, but television
can't be, because it is the museum of accidents. In other words, its art is to be the
site where all accidents happen. But that's its only art.

WILSON: So in talking about the simulation industry and its function to "expose the accident in order not to be exposed to it," could you say more about that in its relationship to television?

VIRILIO: One exposes the accident in order not to be exposed to the accident. It's an inversion. There is a French expression that says to be exposed to an accident, to cross a street without looking at the cars, means exposing oneself to be run over. This is more than a play on words, it's fundamental. For instance, when a painter exhibits his work, one says he exposes his work. Similarly, when we cross the street, we expose ourselves to a car accident.

And television exposes the world to the accident. The world is exposed to accidents through television. An editor of the *New York Times* was recently interviewed in *Le Nouvel Observateur*, and he said something that I really agree with: television is a media of crisis, which means that television is a media of accidents. Television can only destroy. In this respect, and even though he was a friend of mine, I believe that McLuhan was completely wrong (in his idyllic view of television).

WILSON: But surely the commodification of the accident happened before television through simulation?

VIRILIO: To start with, the simulator is an object in itself, which is different from televison and leads to cyberspace. The US Air Force flight simulator — the first sophisticated simulators were created by the US Air Force — has been used in order to save gas on real flights by training pilots on the ground. Thus there is a cyberspace vision: one doesn't fly in real space, one creates a poor cyberspace, with headphones, etc. . . . It is a different logic. In a way, the simulator is closer to cyberspace than televison. It creates a different world. So, of course, the simulator quickly became a simulator of accidents, but not only that: it started simulating actual flight hours, and these hours have been counted as real hours to evaluate the experience of pilots. Simulated flight hours and real flight hours became equivalent, and this was cyberspace, not the accident but something else, or rather the accident of reality. What is accidented is reality. Virtuality will destroy reality. So, it's some kind of accident, but an accident of a very different nature.

The accident is not the accident. For instance, if I let this glass fall, is it an accident? No, it's the reality of the glass that is accidented, not the glass itself. The glass is certainly broken and no longer exists, but with a flight simulator, what is accidented is the reality of the glass, and not the glass itself: what is accidented is the reality of the whole world. Cyberspace is an accident of the real. Virtual reality is the accident of reality itself.

WILSON: But then simulation doesn't really pretend to be the glass?

VIRILIO: This is a little hard to explain. We have a sense of reality which is sustained by a physical sensation. Right now, I am holding a bottle: this is reality. With a data

glove, I could hold a virtual bottle. Cybersex is similar: it is an accident of sexual reality, perhaps the most extraordinary accident, but still an accident. I would be tempted to say: the accident is shifting. It no longer occurs in matter, but in light or in images. A Cyberspace is a light show. Thus, the accident is in light, not in matter. The creation of a virtual image is a form of accident. This explains why virtual reality is a cosmic accident. It's the accident of the real.

I disagree with my friend Baudrillard on the subject of simulation. To the word simulation, I prefer the one substitution. This is a real glass, this is no simulation. When I hold a virtual glass with a data glove, this is no simulation, but substitution. Here lies the big difference between Baudrillard and myself: I don't believe in simulationism, I believe that the word is already old-fashioned. As I see it, new technologies are substituting a virtual reality for an actual reality. And this is more than a phase: it's a definite change. We are entering a world where there won't be one but two realities, just like we have two eyes or hear bass and treble tones, just like we now have stereoscopy and stereophony. There will be two realities: the actual and the virtual. Thus there is no simulation, but substitution. Reality has become symmetrical. The splitting of reality in two parts is a considerable event which goes far beyond simulation.

WILSON: What about early cinema as a primitive form of this, when people left the cinema in fright?

VIRILIO: Unlike Serge Daney or Deleuze, I think that cinema and television have nothing in common. There is a breaking point between photography and cinema on the one hand and television and virtual reality on the other hand. The simulator is the stage in between television and virtual reality, a moment, a phase. The simulator is a moment that leads to cyberspace, that is to say, to the process by which we now have two bottles instead of one. I might not see this virtual bottle, but I can feel it. It is settled within reality. This explains why the term *virtual reality* is more important than the word *cyberspace*, which is more poetic. As far as gender is concerned, there are now two men and two women, real and virtual. People make fun of cybersex, but it's really something to take into account: it is a drama, a split of the human being! The human being can now be changed into some kind of spectrum or ghost who has sex at a distance. That is really scary because what used to be the most intimate and the most important relationship to reality is being split. This is no simulation but the coexistence of two separate worlds. One day the virtual world might win over the real world.

These new technologies try to make virtual reality more powerful than actual reality, which is the true accident. The day when virtual reality becomes more powerful than reality will be the day of the big accident. Mankind never experienced such an extraordinary accident.

WILSON: What is your own feeling about that?

VIRILIO: I'm not scared, just interested.

This is drama. Art is drama. Any relationship to art is also a relationship to death. Creation exists only in regard to destruction. Creation is against destruction. You cannot dissociate birth from death, creation from destruction, good from evil. Thus any art is a form of drama standing between the two extreme poles of birth and death, just like life is drama. This is not sad, because to be alive means to be mortal, to pass through. And art is alive because it is mortal. Except that now, art has become more than painting, sculpture, or music: art is more than Van Gogh painting a landscape or Wagner composing an opera. The whole of reality itself has become the object of art. To someone like Zurbarán, who paints still lifes, lemons and pears are the objects of art. But to the electronics engineer who works on the technologies of virtual reality, the whole reality has become the object of art, with a possibility to substitute the virtual with the real.

WILSON: Is there a transcendence of the body?

VIRILIO: That is difficult to say. First, what is under consideration is not only the body itself, but the environment of the body as well. The notion of transcendence is a complex one, but it is true that there is something divine in this new technology. The research on cyberspace is a quest for God. To be God. To be here and there. For example, when I say, "I'm looking at you, I can see you," that means "I can see you because I can't see what is behind you: I see you through the frame I am drawing. I can't see inside you." If I could see you from beneath or from behind, I would be God. I can see you because my back and my sides are blind. One can't even imagine what it would be like to see inside people.

The technologies of virtual reality are attempting to make us see from beneath, from inside, from behind . . . as if we were God. I am a Christian, and even though I know we are talking about metaphysics and not about religion, I must say that cyberspace is acting like God and deals with the idea of God who is, sees and hears everything.

WILSON: What will happen when virtual reality takes the upper hand?

VIRILIO: It already has. If you look at the Gulf War or new military technologies, they are moving towards cyberwars. Most videotechnologies and technologies of simulation have been used for war. For example, video was created after World War II in order to radio-control planes and aircraft carriers. Thus video came with the war. It took twenty years before it became a means of expression for artists. Similarly, television was first conceived to be used as some kind of telescope, not for broadcasting. Originally, Sworkin, the inventor of television, wanted to place cameras on rockets so that it would be possible to watch the sky.

WILSON: So was it only by a matter of degrees that the Gulf War became the "virtual war," and it was live broadcasting that really effected this change?

VIRILIO: The high level of the technologies used during the Gulf War makes this conflict quite unique, but the very process of de-realization of war started in 1945. War occurred in Kuwait, but it also occurred on the screens of the entire world. The site of defeat or victory was not the ground, but the screen. (I wrote a book called *Desert Screen* on the Gulf War.) Thus it becomes obvious that television is a media of crisis, a museum of accidents.

WILSON: This must surely result in some psychic crisis?

VIRILIO: It is as if I was to take my eye, to throw it away, and still be able to see. Video is originally a de-corporation, a disqualification of the sensorial organs which are replaced by machines. . . . The eye and the hand are replaced by the data glove, the body is replaced by a data suit, sex is replaced by cybersex. All the qualities of the body are transferred to the machine. This is a subject I discussed in my last book, *The Art of the Engine.*

We haven't adjusted yet, we are forgetting our body, we are losing it. This is an accident of the body, a de-corporation. The body is torn and disintegrated.

WILSON: With the Gulf War, there was such incomprehension because it was so removed.

VIRILIO: The Gulf War was the first "live" war. World War II was a world war in space. It spread from Europe to Japan, to the Soviet Union, etc. World War II was quite different from World War I which was geographically limited to Europe. But in the case of the Gulf War, we are dealing with a war which is extremely local in space, but global in time, since it is the first "live" war. And to those, like my friend Baudrillard, who say that this war did not actually occur, I reply: this war may not have occurred in the actual global space, but it did occur in global time. And this thanks to CNN and the Pentagon. This is a new form of war, and all future wars, all future accidents will be live wars and live accidents.

WILSON: How will this removal affect people?

VIRILIO: First, a de-realization, the accident of the real. It's not one, two, hundreds or thousands of people who are being killed, but the whole reality itself. In a way, everybody is wounded from the wound of the real. This phenomenon is similar to madness. The mad person is wounded by his or her distorted relationship to the real. Imagine that all of a sudden I am convinced that I am Napoleon: I am no longer PV, but Napoleon. My reality is wounded. Virtual reality leads to a

similar de-realization. However, it no longer works only at the scale of individuals, as in madness, but at the scale of the world.

By the way, this might sound like drama, but it is not the end of the world: it is both sad and happy, nasty and kind. It is a lot of contradictory things at the same time. And it is complex.

WILSON: How can we address this loss?

VIRILIO: The true problem with virtual reality is that orientation is no longer possible. We have lost our points of reference to orient ourselves. The de-realized man is a disoriented man. In *The Art of the Engine,* I conclude by pointing at a recent American discovery, the GPS (Global Positioning System) which is the second watch. The first watch tells you what time it is, the second one tells you where you are. If I had a GPS, I could know where this table stands in relation to the whole world, with an amazing precision, thanks to satellites. This is extraordinary: in the fifteenth century, we invented the first watch, and now we have invented the GPS to know where we are.

When you find yourself in the middle of virtual reality, you don't know where you are, but with this machine, you can know. This watch has been used for ships and not only can it tell you where you are, but also it can tell others where you are. It works in two ways. The question you're asking is really interesting. For one can't even know what it means to be lost in reality. For instance, it is easy to know whether you are lost or not in the Sahara desert, but to be lost in reality! This is much more complex! Since there are two realities, how can we say where we are? We are far away from simulation, we have reached substitution! I believe this is, all in the same time, a fantastic, a very scary, and an extraordinary world.

WILSON: But to return to this question of transcendence

VIRILIO: All in all, I believe that this divine dimension raises the question of transcendence, that is to say the question of the Judeo-Christian God, for instance. People agree to say that it is rationality and science which have eliminated what is called magic and religion. But ultimately, the ironic outcome of this techno-scientific development is a renewed need for the idea of God. Many people question their religious identity today, not necessarily by thinking of converting to Judaism or to Islam: it's just that technologies seriously challenge the status of the human being. All technologies converge toward the same spot, they all lead to a deus ex machina, a machine-God. In a way, technologies have negated the transcendental God in order to invent the machine-God. However, these two gods raise similar questions.

As you can see, we are still within the museum of accidents. That's a huge, cosmic accident, and television, which made reality explode, is part of it. I agree with what Einstein used to say about the three bombs: there are three bombs. The

first one is the atomic bomb, which disintegrates reality, the second one is the digital or computer bomb, which destroys the principle of reality itself — not the actual object — and rebuilds it, and finally the third bomb is the demographic one. Some experts have found out that in five thousand years from now, the weight of the population will be heavier than the weight of the planet. That means that humanity will constitute a planet of its own!

WILSON: Do you always separate the body from technology?

VIRILIO: No. The body is extremely important to me, because it is a planet. For instance, if you compare Earth and an astronomer, you will see that the man is a planet. There is a very interesting Jewish proverb that says: "If you save one man, you save the world. That's a reverse version of the idea of the Messiah: one man can save the world, but to save a man is to save the world. The world and man are identical. This is why racism is the most stupid thing in the world.

You are a universe, and so am I; we are four universes here. And there are millions of others around us. Thus the body is not simply the combination of dance, muscles, body-building, strength, and sex: it is a universe. What brought me to Christianity is incarnation, not ressurection. Because man is God, and God is man, the world is nothing but the world of man — or woman. So, to separate mind from body doesn't make any sense. To a materialist, matter is essential: a stone is a stone; a mountain is a mountain; water is water; and earth is earth. As far as I am concerned, I am a materialist of the body, which means that the body is the basis of all my work.

To me, dance is an extraordinary thing, more extraordinary than most people usually think. Dance preceded writing, speaking, and music. When mute people speak their body language, it is true speaking rather than handicap, this is the first word and the first writing. Thus to me, the body is fundamental. The body, and the territory of course, for there cannot be an animal body without a territorial body. Three bodies are grafted over each other: the territorial body — the planet, the social body — the couple; and the animal body — you and me. And technology splits this unity, leaving us without a sense of where we are. This, too, is de-realization.

There is a Buddhist proverb which I like a lot. It says: "Every body deserves mercy." That means that every body is holy. This is to answer the body question.

Technologies first equipped the territorial body with bridges, aqueducts, railways, highways, airports, etc. Now that the most powerful technologies are becoming tiny (microtechnologies), all technologies can invade the body. These micro-machines will feed the body. Research is being conducted in order to create additional memory for instance. For the time being, technologies are colonizing our body through implants. We started with human implants, but research leads us to microtechnological implants.

The territorial body has been polluted by roads, elevators, etc. Similarly, our animal body starts being polluted. Ecology no longer deals with water, flora,

wildlife, and air only. It deals with the body itself as well. It is comparable with an invasion: technology is invading our body because of miniaturization. [Referring to the interviewer's microphone: "Next time you come you won't even ask — you'll just throw a bit of dust on the table!]

There is a great science-fiction short story — it's too bad I can't remember the name of its author — in which a camera has been invented which can be carried by flakes of snow. Cameras are inseminated into artificial snow which is dropped by planes, and when the snow falls, there are eyes everywhere. There is no blind spot left.

WILSON: But what shall we dream of when everything becomes visible?

VIRILIO: We'll dream of being blind. This is the art of the engine. Art used to be painting, sculpture, music, etc., but now, all technology has become art. Of course, this form of art is still very primitive, but it is slowly replacing reality. This is what I call the art of the engine. For instance, when I take the TGV ("Train a Grande Vitesse") in France, I love watching the landscape: this landscape, as well as works by Picasso or Klee, is art. The engine makes the art of the engine. Wim Wenders made road movies, but what is the engine of a road movie? It's a car, like in *Paris, Texas*. Dromoscopy. Now all we have to do to enter the realm of art is to take a car. Many engines made history.

WILSON: Finally to return to the accident! Is it possible to see the body itself as a simulator? (Within medical aerospace research, for example, the body's own accident, that of motion sickness, can be eradicated.)

VIRILIO: The body has a dimension of simulation. The learning process, for instance: when one learns how to drive a car or a van, once in the van, one feels completely lost. But then, once you have learnt how to drive, the whole van is in your body. It is integrated into your body. Another example: a man who pilots a Jumbo Jet will ultimately feel that the Boeing is entering his body. But what is going on now, or should happen in one or two generations, is the disintegration of the world. Real time "live" technologies, cyberreality, will permit the incorporation of the world within oneself. One will be able to read the entire world, just like during the Gulf War. And I will have become the world. The body of the world and my body will be one. Once again, this is a divine vision; and this is what the military is looking for. Earth is already being integrated into the Pentagon, and the man in the Pentagon is already piloting the world war — or the Gulf War — as if he were a captain whose huge boat became his own body. Thus the body simulates the relationship to the world.

WILSON: Are you suggesting the human body will disappear in all senses of the word?

VIRILIO: We haven't reached that point yet: what I have described is the end, or a vision of the end. What will prevail is this will to reduce the world to the point where one could possess it. All military technologies reduce the world to nothing. And since military technologies are advanced technologies, what they actually sketch today is the future of the civil realm. But this, too, is an accident.

When I was a young soldier, I was asked to drive a huge van while I had never driven a car. Here I am, driving through a German village (this takes place during the occupation), and there was this painter who had settled his ladder on the side of the street. I thought that my big van was going to crash his ladder. That didn't happen. I just passed through. □

This interview was conducted on October 21, 1994, and was originally published in the electronic journal CTHEORY.

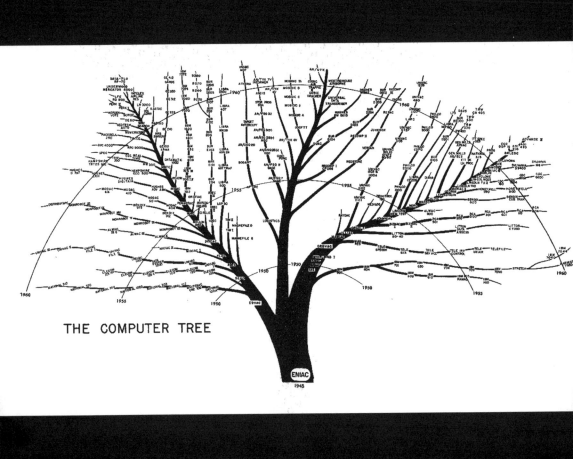

THE COMPUTER TREE

There Is No Software

■ *F r i e d r i c h K i t t l e r*

Grammatologies of the present time have to start with a rather sad statement. The bulk of written texts — including the paper I am reading from to you — does not exist any more in perceivable time and space, but in a computer memory's transistor cells. And since these cells, in the last three decades of Silicon Valley exploits, have shrunk to spatial extensions below one micrometer, our writing may well be defined by a self-similarity of letters over some six decades. This state of affairs makes not only a difference to history when, at its alphabetical beginning, a camel and its hebraic letter *gamel* were just two and a half decades apart. It also seems to hide the very act of writing.

As you know, we do not write anymore. This crazy kind of software engineering suffered from an incurable confusion between use and mention. Up to Hölderlin's time, a mere mention of lightning seemed to have been sufficient evidence of its possible poetic use. Nowadays, after this lightning's metamorphosis into electricity, man-made writing rather passes through microscopically written inscriptions which, in contrast to all historical writing tools, are able to read and write by themselves. The last historical act of writing may well have been the moment when, in the early seventies, Intel engineers laid out some dozen square meters of blueprint paper (64 square meters, in the case of the later 8086) in order to design the hardware architecture of their first integrated microprocessor. This manual layout of two thousand transistors and their interconnections was then miniaturized to the size of an actual chip and, by electro-optical machines, written into silicon layers. Finally, this 4004 microprocessor found its place in the new desk calculators of Intel's Japanese customer,[1] and our postmodern writing scene could just begin. For, actually, the hardware complexity of such microprocessors simply discards manual design techniques; in order to layout the next computer generation, the engineers, instead of filling out uncountable meters of blueprint paper, have recourse to computer-aided design (CAD), that is, to the geometrical or auto-routing powers of the actual generation.

However, in constructing the first integrated microprocessor, Intel's Marcian E. Hoff had given an almost perfect demonstration of a Turing machine. Since 1937, computing, whether done by people or by machines, can be formalized as a

countable set of instructions operating on an infinitely long paper band and its discrete signs. Turing's concept of such a paper machine[2] the operations of which consist only of writing and reading, proceeding and receding, has proven to be the mathematical equivalent of any computable function. Universal Turing machines, when fed with the instructions of any other machine, can effectively imitate it. Thus, precisely because eventual differences between hardware implementations do not count anymore, the so-called Church-Turing hypothesis in its strongest or physical form is tantamount to declaring nature itself a universal Turing machine.

This claim, in itself, has had the effect of duplicating the implosion of hardware by an explosion of software. Programming languages have eroded the monopoly of ordinary language and grown into a new hierarchy of their own. This postmodern Babylonian tower reaches from simple operation codes whose linguistic extension is still a hardware configuration passing through an assembler whose extension is this very opcode up to high-level programming languages whose extension is that very assembler. As a consequence, far-reaching chains of self-similarities in the sense defined by fractal theory organize the software as well as the hardware of every writing. What remains a problem is only the realization of these layers which, just as modern media technologies in general, have been explicitly contrived in order to evade all perception. We simply do not know what our writing does.

For an illustration of this problem, a simple text program like the one that has produced my very paper will do. May the users of Windows or UNIX forgive when I, as a subject of Microsoft DOS, limit the discussion to this most stupid of operating systems.

In order to word process a text and, that is, to become yourself a paper machine working on an IBM AT under Microsoft DOS, you need first of all to buy some commercial files. Unless these files show the file extension names of EXE or of COM, word processing under DOS could never start. The reason is that only COM and EXE files entertain a strange relation to their proper name. At the one hand, they bear grandiloquent names such as WordPerfect, and, on the other hand, a more or less cryptic, because nonvocalized acronym, such as WP. The full name, alas, serves only the advertising strategies of software manufacturers, since DOS as a microprocessor operating system could never read file names longer than eight letters. That is why the unpronounceable acronym, WP, this post-historic revocation of a fundamental Greek innovation, is not only necessary, but amply sufficient for postmodern word processing. In fact, it seems to bring back truly magical power. WP does what it says. Executable computer files encompass, by contrast not only to WordPerfect but also to big, but empty, old European words, such as Mind or Word, all the old routines and data necessary to their self-constitution. Surely, tapping the letter sequence of W, P, and Enter on an AT keyboard does not make the Word perfect, but this simple writing act starts the actual execution of WordPerfect. Such are the triumphs of software.

The accompanying paperware cannot but multiply these magic powers.

Written as they are in order to bridge the gap between formal and everyday languages, electronics and literature, the usual software manuals introduce the program in question as a linguistic agent ruling with near omnipotence over the computer system's resources, address spaces, and other hardware parameters: WP, when called with command line argument X, would change the monitor screen from color A to B, start in mode C, return finally to D, et cetera ad infinitum.

These actions of agent WP, however, are virtual ones, since each of them (as the saying goes) has to run under DOS. It is the operating system and, more precisely, its command shell that scans the keyboard for eight-bit file names on the input line, transforms some relative addresses of an eventually retrieved file into absolute ones, loads this new version from external mass memory to the necessary random access space, and finally or temporarily passes execution to the opcode lines of a slave named WordPerfect.

The same argument would hold against DOS which, in the final analysis, resolves into an extension of the basic input and output system called BIOS. Not only no program but also no underlying microprocessor system could ever start without the rather incredible auto-booting faculty of some elementary functions that, for safety's sake, are burned into silicon and thus form part of the hardware. Any transformation of matter from entropy to information, from a million sleeping transistors, into differences between electronic potentials necessarily presupposes a material event called reset.

In principle, this kind of descent from software to hardware, from higher to lower levels of observation, could be continued over more and more decades. All code operations, despite their metaphoric faculties, such as call or return, come down to absolutely local string manipulations, and that is, I am afraid, to signifiers of voltage differences. Formalization in Hilbert's sense does away with theory itself, insofar as "The theory is no longer a system of meaningful propositions, but one of sentences as sequences of words, which are in turn sequences of letters. We can tell [say] by reference to the form alone which combinations of the words are sentences, which sentences are axioms, and which sentences follow as immediate consequences of others."[3]

When meanings come down to sentences, sentences to words, and words to letters, there is no software at all. Rather, there would be no software if computer systems were not surrounded by an environment of everyday languages. This environment, however, since a famous and twofold Greek invention, consists of letters and coins, of books and bucks.[4] For these good economical reasons, nobody seems to have inherited the humility of Alan Turing who, in the stone age of computing, preferred to read his machine's output in hexadecimal numbers rather than in decimal ones.[5] On the contrary, the so-called philosophy of the so-called computer community tends systematically to obscure hardware by software, electronic signifiers by interfaces between formal and everyday languages. In all philanthropic sincerity, high-level programming manuals caution against the

psychopathological risks of writing assembler code.[6] In all friendliness, BIOS services are currently defined as existing to "hide the details of controlling the underlying hardware from your program."[7] Consequently, in a perfect gradualism, DOS services would hide the BIOS, WordPerfect the operating system, and so on and so on until, in the very last years, two fundamental changes in computer design (or DoD politics) have brought this secrecy system to its closure. Firstly, on an intentionally superficial level, perfect graphic user interfaces, since they dispense with writing itself, hide a whole machine from its users. Secondly, on the microscopic level of hardware itself, so-called protection software has been implemented in order to prevent "untrusted programs" or "untrusted users" from any access to the operating system's kernel and input/output channels.[8]

This ongoing triumph of software is a strange reversal of Turing's proof that there can be no mathematically computable problem a simple machine could not solve. Instead, the physical Church-Turing hypothesis, by identifying physical hardware with the algorithms forged for its computation, has finally got rid of hardware itself. As an effect, software successfully occupied the empty place and profited from its obscurity. The ever-growing hierarchy of high-level programming languages works exactly the same way as one-way functions in recent mathematical cryptography. This kind of function, when used in its straightforward form, can be computed in reasonable time, for instance, in a time growing only in polynomial expressions with the function's complexity. The time needed for its inverse form, however, that is, for reconstructing from the function's output its presupposed input, would grow at an exponential and therefore unviable rates. One-way functions, in other words, hide an algorithm from its very result. For software, this cryptographic effect offers a convenient way to bypass the fact that, by virtue of Turing's proof, the concept of mental property as applied to algorithms has become meaningless.

Precisely because software does not exist as a machine-independent faculty, software as a commercial or American medium insists all the more. Every license, every dongle, every trademark registered for WP as well as for WordPerfect prove the functionality of one-way functions. In the U.S.A., notwithstanding all mathematical tradition, even a copyright claim for algorithms has recently succeeded. At most, finally, there has been, on the part of IBM, research on a mathematical formula that would enable mathematicians to measure the distance in complexity between an algorithm and its output. Whereas in the good old days of Shannon's mathematical theory of information, the maximum of information coincided strangely with maximal unpredictability or noise,[9] the new IBM measure, called logical depth has been defined as: "The value of a message . . . appears to reside not in its information (its absolutely unpredictable parts), nor in its obvious redundancy (verbatim repetitions, unequal digit frequencies), but rather in what may be called its buried redundancy — parts predictable only with difficulty, things the receiver could in principle have

figured out without being told, by only as considerable cost in money, time or computation. In other words, the value of a message is the amount of mathematical or other work plausibly done by its originator, which the receiver is saved from having to repeat."[10] Thus, logical depth in its mathematical rigor, could advantageously replace all the old everyday language definitions of originality, authorship, and copyright in their necessary inexactness, were it not for the fact that precisely this algorithm intended to compute the cost of algorithms in general is Turing-uncomputable itself.[11]

Under these tragic conditions, the criminal law, at least in Germany, has recently abandoned the very concept of software as a mental property; instead, it defined software as a necessarily material thing. The high court's reasoning, according to which without the corresponding electrical charges in silicon circuitry no computer program would ever run,[12] already illustrate the fact that the virtual ambiguity between software and hardware follows by no means, as system theorists would probably like to believe, from a simple variation of observation points. On the contrary, there are good grounds to assume the indispensability and, consequently, the priority of hardware in general.

Only in Turing's paper "On Computable Numbers with an Application to the Entscheidungsproblem" there existed a machine with unbounded resources in space and time, with an infinite supply of raw paper and no constraints on computation speed. All physically feasible machines, in contrast, are limited by these parameters in their very code. The inability of Microsoft DOS to tell more than the first eight letters of a file name such as WordPerfect gives just a trivial or obsolete illustration of a problem that has provoked not only the ever-growing incompatibilities between the different generations of eight-bit, sixteen-bit and thirty-two-bit microprocessors, but also a near impossibility of digitizing the body of real numbers[13] formerly known as nature.

According to Brosl Hasslacher of Los Alamos National Laboratory, "This means [that] we use digital computers whose architecture is given to us in the form of a physical piece of machinery, with all its artificial constraints. We must reduce a continuous algorithmic description to one codable on a device whose fundamental operations are countable, and we do this by various forms of chopping up into pieces, usually called discretization. The compiler then further reduces this model to a binary form determined largely by machine constraints.

The outcome is a discrete and synthetic microworld image of the original problem, whose structure is arbitrarily fixed by a differencing scheme and computational architecture chosen at random. The only remnant of the continuum is the use of radix arithmetic, which has the property of weighing bits unequally, and for nonlinear systems is the source of spurious singularities.

This is what we actually do when we compute up a model of the physical world

with physical devices. This is not the idealized and sure process that we imagine when usually arguing about the fundamental structures of computation, and very far from Turing machines."[14]

Thus, instead of pursuing the physical Church-Turing-hypothesis and, that is, of "injecting an algorithmic behavior into the behavior of the physical world for which there is no evidence,"[15] one has rather to compute what has been called "the prize of programmability" itself. This all-important property of being programmable has, in all evidence, nothing to do with software; it is an exclusive feature of hardwares, more or less suited as they are to house some notation system. When Claude Shannon, in 1937, proved in the probably the most consequential M.A. thesis ever written[16] that simple telegraph switching relays can implement, by means of their different interconnections, the whole of Boolean algebra, such a physical notation system was established. And when the integrated circuit, developed in the 1970s out of Shockley's transistor, combined on one and the same chip silicon as a controllable resistor with its own oxide as an almost perfect isolator, the programmability of matter could finally "take control" just as Turing had predicted.[17] Software, if it existed, would just be a billion dollar deal based on the cheapest elements on earth. For, in their combination on chip, silicon and its oxide provide for perfect hardware architectures. That is to say that the millions of basic elements work under almost the same physical conditions especially as regards the most critical, namely temperature-dependent degradations, and yet, electrically, all of them are highly isolated from each other. Only this paradoxical relation between two physical parameters, thermal continuity and electrical discretization on chip, allows integrated circuits to be not only finite state machines like so many other devices on earth, but to approximate that Universal Discrete Machine into which its inventor's name has long disappeared.

This structural difference can be easily illustrated. "A combination lock," for instance, "is a finite automaton, but it is not ordinarily divisible into a base set of elementary-type components that can be reconfigured to simulate an arbitrary physical system. As a consequence, it is not structurally programmable, and in this case it is effectively programmable only in the limited sense that its state can be set for achieving a limited class of behaviors." On the contrary, "a digital computer used to simulate a combination lock is structurally programmable since the behavior is achieved by synthesizing it from a canonical set of primitive switching components."[18]

Switching components, however, be they telegraph relays, tubes, or finally microtransistor cells, pay a price for their very composability. Confronted as they are with a continuous environment of weathers, waves, and wars, digital computers can cope with this real number-avalanche only by adding element to element. However, the growth rate of possible interconnections between those elements and of computing power as such, is proven to have as its upper bound a square root function. In other words, it cannot even "keep up with polynomial growth rates in

problem size."[19] Thus, the very isolation between digital or discrete elements accounts for a drawback in connectivity which otherwise, "according to current force laws," as well as to the basics of combinatorial logics, would be bounded only by a maximum equaling the square number of all involved elements.[20]

Precisely this maximal connectivity, on the other or physical side, defines non-programmable systems, be it waves or beings. That is why these systems show polynomial growth rates in complexity and, consequently, why only computations done on nonprogrammable machines could keep up with them. In all evidence, this hypothetical but all-too-necessary type of machine would constitute sheer hardware, a physical device working amidst physical devices and subjected to the same bounded resources. Software in the usual sense of an ever-feasible abstraction would not exist any more. The procedures of these machines, though still open to an algorithmic notation, should have to work essentially on a material substrate whose very connectivity would allow for cellular reconfigurations. And even though this "substrate can also be described in algorithmic terms, by means of simulation," its "characterization is of such immense importance for the effectiveness . . . and so closely connected with choice of hardware, that . . ."[21] programming them will have little to do anymore with approximated Turing machines.

In what I tried to describe, drawing quite heavily from recent computer scientists, as badly needed and probably not-too-future machines, certain Dubrovnic observer's eyes might be tempted to recognize, under evolutionary disguises or not, the familiar face of man. Maybe. At the same time, however, our equally familiar silicon hardware obeys many of the requisites for such highly connected, nonprogrammable systems. Between its millions of transistor cells, some million power two interactions take always already place. There is electronic diffusion, there is quantum mechanical tunneling all over the chip.[22] Yet, technically these interactions are still treated in terms of system limitations, physical side effects, and so on. To minimize all the noise that it would be impossible to eliminate is the price paid for structurally programmable machines. The inverse strategy of maximizing noise would not only find the way back from IBM to Shannon, it may well be the only way to enter that body of real numbers originally known as chaos. □

THE WORLD AS INTERFACE

Toward the Construction of
Context-Controlled Event-Worlds

■ Peter Weibel

Over the past 150 years the mediazation and mechanization of the image, from the camera to the computer, have advanced greatly. The transformation of technological images in tandem with the technological transformation of the world through several scientific revolutions have evolved. This evolution of machine-aided image generation and transfer can be divided provisionally into eight stages.

1. The first stage in the production of images with the aid of technology was obviously represented by photography, invented in 1839. The image produced itself without the hand of the artist, whose task was assumed by an independent machine, an image automaton.

2. At roughly the same time, the machine-aided transmission of images over long distances via scanning (breaking down a two-dimensional image into a linear sequence of dots over time) became possible. The telegraph, the telephone, telecopying, Nipkow's 1884 precursor to television, and the "electronic telescope" all contributed to the development of technology-based systems for the transmission of sound and both moving and still images. A machine-based transmission of images by necessity followed the machine-based production of images. Simultaneously, the discovery of electromagnetic waves (Maxwell in 1873, Hertz in 1887) signified the birth of new visual worlds and telematic culture.

3. The disappearance of reality (i.e., real, material, physically tangible space) was followed by the simulation of reality. The spatial form of the image (as in painting) was followed by the temporal form of the image: film. The image was transformed from being a medium of space into a medium of time.

4. The discovery of the electron and the cathode ray tube (both in 1897) established the basic conditions for electronic image production and transfer (leading to television).

5. The magnetic recording of visual signals (instead of sound signals as had been possible since the early 1900s) by video recorder (1951) combined film, radio, and television (image recording and image transmission) in the new medium of video.

6. Transistors, integrated circuits, chips, and semi-conductor technology revo-

lutionized data-processing technology starting in the middle of the twentieth century, ultimately leading to completely machine-generated computer images. The multimedia computer not only unites all the historical possibilities of machine-aided generation and transfer of images, sound and text, but also opens up utterly new perspectives of machine-controlled interactive visual worlds. These worlds possess characteristics that are fundamentally new: virtuality, variability, and viability, in which interactivity between the image and the viewer becomes possible.

7. Interactive telecommunication technology enables art in the network, televirtuality, purely immaterial art in data space, and telepresence. Telerobotics, cable television, interactive television, and digital networks with global span constitute "electronic super highways" (Nam June Paik, 1974). Graphic transmission, the telephone, television, the telefax, wireless telegraphy, radio, etc., evolved as the basis of a telematic culture characterized by the distinction between message-sender and message, between body and message. The vehicle material of the code becomes negligible. Matterless signs travel through space and time, waves spread out, and bodiless communication becomes possible. This realm of immaterial signs has settled into telematic civilization. The post industrial information and code-based era dawns.

8. The next stage — until now banished to the domain of science fiction — is already beginning to become reality in the sphere of interface research and advanced sensory technologies. Whilst currently only external "brain-wave" and "eye-tracker" sensors are used in interactive media applications, the next step is becoming apparent: the development of "brain-chips" or "neuro-chips" in order to bypass classic electronic interfaces and link the brain as directly as possible to the digital realm. Instead of the simulation of artificial and natural worlds, the simulation of the brain itself.

THE TRANSFORMATION OF PERCEPTION IN THE TECHNICAL AGE

The transformation of art under the Industrial Revolution led not only to a machine-based art, but also to the machine-based generation of images, and machine-supported vision. The primacy of the eye, anticipated in the famous lithograph *The Eye, as a Strange Balloon, Drives towards the Infinite* by Odilon Redon (1882), as the dominant sense organ of the twentieth century is the consequence of a technical revolution that put an enormous apparatus to the service of vision. The rise of the eye is rooted in the fact that all of its aspects (creation, transmission, reception) were supported by analog and digital machines. The triumph of the visual in the twentieth century is the triumph of a techno-vision.

This can best be demonstrated by the interpretation of the word "video." The Latin word *video*, meaning "I see," referred to the activity of a subject. Today it is the name of a machine system of vision. This turn shows clearly that we have

entered a new era of vision, the technical vision, the machine-based vision. Machines generate, transmit, receive, and interpret images. Machines observe for us, *see* for us. The eye triumphs only with the help of machines. This mechanical perception has changed both the world and the human perception of the world. With machine vision man has lost another anthromorphic monopoly.

From the iconographical point of view, two formative events occurred in the nineteenth century.

First, through the advent of the technical image the fundamental idea of the image was changed. Hitherto, "the image" was a painting. But with photography the image escaped into other host media. Visual culture was no longer limited to the study of paintings, but extended to the study of photography, film, and so on. Image and vision dichotomized. The result of this encounter between image and technical media was the birth of the visual.

Secondly, another division ocurred, namely the separation of the body and the message, through the invention of telegraphy (around 1840). Prior to this each message needed a physical, material carrier (a horse, a soldier, a pigeon, a ship). Suddenly, a message could be sent without a material carrier. Strings of signs could travel without a body. The scanning principle (invented around 1840) turning the spatial, two-dimensional form of the image into temporal form is central here. The immaterial world of signs established the basis of telematic culture.

THE ART OF MOTION: CINEMATOGRAPHY

The concept of the visual radically changed with the technical transformation of the image, the image apparatus, and apparative perception. The historical condition for the origin of the technical image is the Industrial Revolution, which formulated the human body as a machine. Even human perception was compared with the performance of machines, and found not as reliable, fast, or as perfect as the machine. P. M. Roget (to whom we also owe the thesaurus) discovered the persistence of vision (1824), the layers of the retina on which the afterimage is built. An obsessive metric and machine-oriented study of the human body began, leading to experimental physiology, medicine, psychology. Psycho-physiological research on perception became the analytical model (alongside the machine) for the genesis of technical images. The laws of perception were themselves turned into mechanisms. "Philosophical toys," a cross between technique and illusion, made use of these experimental discoveries. Around 1830 the physicist Michael Faraday constructed optical discs that could create the "illusion of motion," using an apparatus-induced stroboscopical effect. Joseph Plateau built his famous phenakistoscope in 1832. The speed of machines was used to betray the eye and to create the simulation of motion.

The nineteenth century's addiction to motion utilized technical machines to

analyze and to synthesize motion artificially. Machines developed by engineers, physicists, etc., made use of the physiological deficiencies of the eye, discovered by the physicians, to create optical illusions. But these machines allowed only singular access to these joys of simulated motion. The first collective experience of optical illusions was made possible through the laterna magica, which, combined with wheeled-technology by T. W. Naylor in 1843, projected mobile images onto the wall. Two classes of machines were used. One dissected motion into singular images (analyses of motion), the other fused these images into the illusion of a continous movement (synthesis of motion). The later (photographic) cameras of Marey and Muybridge served to analyze motion, while the projector synthesized motion. The combination of the two machines was achieved by the brothers Lumière in the "cinétoscope de projection" in 1895. Throughout the nineteenth century, scanning and sequential photography delivered the basic principles for the construction of those machines that could generate, transmit, and receive images. Not surprisingly, by 1900 the first articles and experiments with names like "television" (Perskyi, 1900), "distant electric vision" (Swinton, 1908), and "image dissector" (Farnsworth, 1927) appeared.

THE ART OF SEEING: OPSEOGRAPHY

The graphic notation of motion, as developed by Marey and Muybridge, was, in the beginning of the twentieth century, not only used to simulate effects of motions, but to study further the laws of perception, the ways of seeing. The experimental filmmakers of the twenties, fifties, and sixties further developed the task of the nineteenth-century experimental physiologists. They created a visual vocabulary that was not made with the intention of creating illusion of motion; they did not want to create the art of motion, but to create the art of seeing. Their aim was to use the laws of perception and optics to create new forms of visual experience, of visual art. They taught us how to see differently with machines, revealing a world of images that could not have been seen or created without these machines. They created a writing of seeing, opseography, instead of motion (cinematography). They observed seeing, unfolded the techniques of seeing the seeing (opseoscopy).

ENDOPHYSICS

Endophysics is a science that explores what a system looks like when the observer becomes part of this system. Is there another perspective possible than that of the internal observer? Are we only inhabitants of the inner side of any interface? What does classical objectivity mean, then? Endophysics shows to what extent objective reality is necessarily dependent on the observer. Ever since perspective was introduced in the Renaissance, and group theory in the nineteenth century, the

phenomena of the world are known to be dependent on the localization of the observer in a lawful manner (co-distortion). Only outside of a complex universe is it possible to give a complete description of it (Gödel's theorem of undecidability). For endophysics the position of an external observer is only possible as a model, outside of a complex universe — not within reality itself. In this sense, endophysics offers an approach to a general model of simulation theory (as well as to "virtual realities" of the computer age).

Endophysics developed from quantum and chaos theory (to which Otto Rossler has contributed since 1975, notably in the famous Rossler Attractor, 1976). Another aspect of endophysics is the reinterpretation of issues related to quantum physics, which has introduced into physics the observer problem. Endophysics differs from exophysics, in that the physical laws of what one is observing are generally different from those of an imagined or real external point of view. Gödel's theorem of undecidability, in contrast, is only valid internally, within the system. An explicit observer has to be introduced into the model world of physics in order to make the existing reality accessible. Endophysics provides a "double approach" to the world. Apart from the direct access to the real world (by the interface of the senses) a second observation position is opened from an imaginary observer position. Is the so-called objective reality only the endo side of an exo world?

The history of cultural production has time and again provided evidence that we sense the possibility of the world only as the endo side of an exo world. The only scientific way of revealing whether the world has a second exo-objective side is to construct model worlds (or artificial worlds) on a level below our world, as endophysics does.

Indeed, the endo approach has great promise for the complex technoworld of the electronic age, which is an age of second-order observer mechanisms. The implications of the industrial (machine-based) and postindustrial (information-based) culture — mechanization, new media, simulation, synthetization, semiosis, artificial reality — are integrated into a new discourse. This approach provides a new theoretical framework for describing and understanding the scientific, technical, and social conditions of the postmodern electronic world. The issues that endophysics addresses — from observer-relativity, representation, and non-locality to the world seen as merely an interface — are the central issues of an electronic and telematic civilization.

The observer reality and contingency of the manifestations of the world revealed to us by endophysics, the difference of observer-internal and observer-external phenomena, provide valuable forms of discourse for the aesthetics of self-reference (the intrinsic world of image signals), virtuality (the immaterial character of picture sequences) and interactivity (the observer-relativity of the image) as we see them defined by electronic art. The endoapproach to electronics implies that the possibility of experiencing the relativity of the observer is dependent on an interface, and that the world can be described as an interface from the perspective of an explicit internal observer. After all, isn't electronic art a

world of the internal observer par excellence by virtue of its participatory, interactive, observer-centered and virtual nature? This leap from one external and dominant viewpoint to an internal participatory viewpoint also determines the nature of electronic art. Electronic art moves art from an object-centered stage to a context- and observer-oriented one. In this way, it becomes a motor of change, from modernity to postmodernity, i. e., the transition from closed, decision-defined and complete systems to open, non-defined, and incomplete ones, from the world of necessity to a world of observer-driven variables, from mono-perspective to multiple perspective, from hegemony to pluralism, from text to context, from locality to non-locality, from totality to particularity, from objectivity to observer -relativity, from autonomy to co-variance, from the dictatorship of subjectivity to the immanent world of the machine.

We propose the introduction of two readings: first, the endo approach to electronics, and second, electronics as the endo approach to the world. The character of electronic art can only be understood as an endophysical principle, since electronics itself is an endo approach to the world. The construction of model- worlds on a lower level, as real worlds with an explicit internal observer (as in closed-circuit installations, where the observer sees him/herself in the observation devices; feedback situations, or where the machine watches itself; or virtual-reality environments, where the hand of the external observer is simulated as part of the internal observer within the image) is in tune with the principle of endophysics. The description of the world in terms of interface and the acknowledgment of the non-objective, observer-objective nature of objects are corollaries of the endophysical theorem. The world interpreted as observer-relative and as interface is the doctrine of electronics interpreted as endophysics. The world changes as our interfaces do. The boundaries of the world are the boundaries of our interface. We do not interact with the world — only with the interface to the world. Electronic art should help us to better understand the nature of electronic culture and the foundations of our electronic world.

Through electronic art we tend more and more to see the world from within. In the age of electronics, the world is becoming increasingly manipulable as an interface between observer and objects. Electronic technology has led to the insight that we are only part of the system that we observe or with which we interact. For the first time we also have access to a technology and theory in which the world is imposed on us as an interface only visible from within. We are now also able to observe the system and the interface from the outside and conceive of the interface as being extended in nanometric and endophysical terms. In this sense we are able to break out of the prison of space and time coordinates described by Descartes. The grid of here and now becomes malleable. Virtual reality, interactive computer installations, endophysics, nanotechnology, etc., are technologies of the extended present, ways of transcending the local event horizon. All of this represents a technology that frees us from instances of reality.

Though the conception of virtual reality (VR) and cyberspace can be traced back to the sixties, their technology did not become available until the late 1980s. In his novel *Simulacron III*, published in 1964 and made into a film by Rainer W. Fassbinder entitled *Welt am Draht* in 1973, Daniel F. Galouye proposed one of the key ideas for VR. The novel is a discussion of the problem of computer simulation from an epistemological, rather than a technological, point of view. Can simulation be recognized as such? Could reality and objectivity depend on factors other than just the observer? Galouye addresses problems of nether regions of model perception and concomitant problems of control by an external observer. The story concerns a corporation, Test PLC, which sets up a giant computer simulation of a large city with a population living under the illusion of inhabiting a "real world." Products are tested on these simulated people in their simulated metropolis before their launch into the real market, i. e., our own reality. The catch is, the simulated town's inhabitants are specifically designed to be complex to a degree, as to be able to generate their own subsequent simulation of a subordinate model world of inhabitants living under the illusion of life in a real world. Their observations eventually lead Test PLC's engineers to conclude in retrospect that they, too, might only be the figments of an apparently real world, which is actually the subordinate simulation of a superior (and system-external) observer; the veracity of their growing suspicions is strongly hinted at in the story. The book is an astonishing and convincing evocation of a principle that we call the endophysical principle.

As human beings we are part of a world that we may also observe. Therefore we can only perceive it from the inside. Nevertheless the world's inhabitants (its internal observers) will always attempt to gain access to the perspective of some Super Observer, to obtain information that would comprehensively describe their world. Endophysics provides one tiny loophole through which such access could be gained. Through the generation of model worlds incorporating an explicit internal observer (who can be described in microscopic detail) in a computer, the otherwise inaccessible "interface" between explicit observer and the rest of the surrounding world can be explicitly explored. Through such a model of world-methods or meta-experiments, the opportunity arises to get behind the interface ("taking a look behind the curtain") and partially disentangle the observer-specific distortions in our own world. With the availability of computers for the generation of simulation, the external operator of a kinetic realm gaining access via the model to a second level of reality hitherto out of bounds is no longer part of witchcraft.[1] As early as 1957 Alder and Wainwright demonstrated the feasibility for the computer simulation of molecular dynamics.[2] The inhabitants (no longer demons) of such a simulated world could in theory have access to specific processes and interventions which would consequentially provide them with information about their world that would normally remain undiscovered. Yet,

useful hints about such processes can only originate from below, from within the world at a subordinate level, and can never be given from above.

Indeed, Kant's conclusion that, objectively, the world will differ from the world as generally perceived, already includes an interface hypothesis. In 1755, in another revolutionary work, mathematical physicist Roger Joseph Boscovich defined the interface hypothesis more accurately: "A common movement shared between us and the world cannot be recognised by us. . . . As the case may be it would even occur that the whole world lying outstretched right before our eyes could contract or extend in a matter of days; yet if this actually occurred there would be no change in the impression on the mind and thus no perception of such a change."[3] In other words, Boscovich says that the world is volatile without us being able to perceive its volatility, since we ourselves are undergoing the same changes. Henceforth, with the predicament of the endo (or interface) position, absolute objectivity must cede to observer-related objectivity. Impossible in the real world, crossing the border and abolishing the determination of the interface by the internal observer has become possible in the model world.

If the world is only clearly defined in its position along the interface between observer and the rest of the world, then it follows that in classical objective reality such an interface would, by definition, be inaccessible. However, the definition of the dependency of the objective world on the observer (quantum theory, Boscovich's model of covariance, Rössler's endophysical principle)[4] does show the way — through an emergency exit. First, the interface can be studied in model worlds containing an explicit internal observer in a classical molecular dynamic simulation of an excitable system (as the observer) and a cooled gas pressure amplifier (as the measuring gauge), with the inclusion of a single micro-particle to serve as the object. From this it also follows that what is objectively revealed cannot be recognized by the affected observer as he is part of it (Boscovich). Objectivity related to the observer's invariance, however, does not lead to the revelation of true objective phenomena (as in Kant). Thirdly we know that a growing awareness of the observer-determined focus of the world can at least be a prerequisite for the dilation of the bars across the prison window of our own world. It suggests that we should be concerned with the recognition that objective reality can only be a reflection of the endo side of an exo world. The consequence could be the recognition, through the application of endophysical principles, of hitherto unrecognizable observer-related phenomena that had been accepted as objective truth by the inhabitants of the real world, and thus mark them with an exophysical question mark. We would then be able to question the validity of apparently inviolate laws guiding the inner workings of the existing universe between observer and world.

An important point at this junction is that the technological media, and particularly the electronic media, represent one such artificial model world, which increasingly stretches over the world. Jean Baudrillard has compared this state of

the postmodern world with metaphorically covering the land (of reality) with a map (of hyperreality, simulation) deducing the "agony of the real" arising out of the inability to differentiate between simulation and reality. Endophysics provides an improved theoretical formula for an articulation of the characteristics of the artificial world, for the model characteristics of the media world. The world of computers may provide part of the instrumentation of the initial stages of endophysics, which is still an emerging science. Virtual worlds are only one special case in point within endophysics.

In the electronic age the "interface" between observer and object has become manipulable. We know that perspective is not entirely "objective," that its objectivity relies on the observer's point of view. The doubts cast by endophysics (subsequent to the theory of relativity, quantum and chaos theories) over the classical, objective nature of the world and its concomitant terms and programs amount to a description of our media and computer worlds, in terms of natural science and physics. Interactive virtual worlds precisely follow the terms defined in meta-experiments, exo and endo sides, subordinate model worlds, non-localised distance correlations (Bell), observer-determined relativity, undecideability (Gödel), internal and external observer, perspective distortion, and so on.

The media represent no more than an attempt, from a position within the universe, to simulate a possible escape from that very universe. Media worlds are no more than artificially generated model worlds which demonstrate that if we are merely internal observers in the real world, we can be both internal and external observer in the media worlds. As toy world within a real universe, the media world according to Lacan must be equated to reality, as it is an "effect of the real." It represents the first instance where communication between internal and external observer, between endo- and exoworld becomes possible. The media world expands the scope of the interface that already exists within the universe between the observer and his world. The media are providing the technology for the extension of dimensions of here and now. The promise is the fulfillment of a yearning for the eternity of now. A yearning for now no longer as a limited, localized experience, but rather a simultaneous, non-local, universal experience.

New perceptions of reality could support or legitimize new art forms. There are several instances in this century when our perception of reality, as well as of ourselves, was radically challenged. Quantum and relativity theories altered the perception of objectivity in the world; psychoanalysis has transformed the perception of the subject. These trends have always found their way into the arts, where they were simultaneously promoted, lamented, delayed, aesthetically idealized, brought to attention, or ignored. An attendant sense of loss, be it aesthetic or epistemological, has been inevitable. It is the price each alteration of reality and any new era has to pay. The electronic universe, with its model worlds and computer simulations, with its interfaces and virtual realities, presents strong evidence to support the belief that comprehension of the world really is an

interface problem. Endophysics presents one opportunity to explore that interface in greater detail than has ever been possible before.

POST-ONTOLOGICAL ART:
VIRTUALITY, VARIABILITY, VIABILITY

We know that the common link between both the technological/visual media of film and photography and the art media of painting and sculpture lies in the way visual information is stored. These material carriers make it extremely difficult to manipulate that information. Once recorded, visual information is irreversible. The individual image is unmoving, frozen, static. Any movement is, at best, illusion. The digital image represents the exact opposite. Here each component of the image is variable and adaptable. Not only can the image be controlled and manipulated in its entirety, but, far more significantly, locally at each individual point. In the digital media all the parameters of information are instantly variable. Once a photograph, film, or video has been transferred into digital media its variability is dramatically improved. In the computer, information is not stored in enclosed systems, rather it is instantly retrievable and thus freely variable. Through this instant variability, the digital image is ideally suited for the creation of virtual environments and interactive installations. Here, the character of the image changes radically. For the first time in history the image is a dynamic system.

Dependency on the observer will be enhanced in a system where information is saved dynamically. The image is transferred into a dynamic field of instantly variable points controlled directly by the observer. The context according to which indeterminate variables will assume their formal shape is now controlled directly by the observer, composing specific images from a field of variables, a variable sequence of binary components. The event experienced by the observer will depend on machine-generated variables determining their apparent shape or sound. The digital signal is defined by its original neutrality. Subsequently, it is transformed by input at the interface, its technological context, into image or sound signals, into a specific event. The image is now constituted by a series of events, sounds, and images made up of separate specific local events generated from within dynamic systems.

When defining the image we must now talk in terms of sequences of events of acoustic and visual variability and virtual information: of dynamic sequences of local (acoustic, visual, or olfactory) events. This vision challenges accepted formal aesthetic assumptions. The experience of events replacing the two-dimensional static image urges a radical revision of visual precepts, and the redefinition of context. The convention of a window onto a small part of a fixed event is becoming one of a door leading into a world of sequenced, multi-sensorial events, consisting of temporally and spatially dynamic experiential constructions that the

observer is free to enter or leave at will. The quantifiable variables are now changed by their context. The context may constitute a different visual system, sound sequence, machine, human observer, distance, or pressure. We are able to construct ever-more sophisticated contextualities with the development of increasingly sophisticated state-of-the-art interface technologies (the human brain, limbs, light, movement, breathing may all transmit impulses via the interface toward the generation of context).

Though it is difficult to pinpoint the dominant influences on our perceptions from among endophysics, micro-particle physics, chaos theory, quantum physics, genetic engineering, or the theory of complexity, it is obvious that we are above all ruled by developments in what is known as computational science. Computers represent the most universal device ever available, just as their combination with the information sciences has advanced the most complex possible conceptual approaches. The current state of development in computer technology represents the pinnacle of technological and scientific research and development, which has accompanied a history of thousands of years of human evolution. It should thus surprise no one if our current perception of the human mind is that of a parallel-processing network computer.

Much will depend on the necessary incorporation of the major questions posed by historic aesthetic and conceptual assumptions. Thus, for instance, Plato's parable of the cave acquires renewed relevance in an age of simulated virtual realities: the existence of mechanical modules in the brain has now become apparent, though their exact role is still very much in doubt; similarly the discovery of the Butterfly Effect in chaos theory has made possible the translation of the observer problem in quantum mechanics into macroscopic dimensions. Clearly any future development of "brain sciences" will have to be vitally concerned with the role of the brain and mind in any conceptions of subjectivity and objectivity. Specific brain functions are already explored through the application and study of visual worlds dealing with interactive functions between observer and artificial universes via a multi-sensorial interface.

With the support of technology, traditional notions of our visual and aesthetic conceptions have been radically altered. The image has mutated into a context-controlled event-world. Another aspect of the variable virtual image is caused by the dynamic properties of its immanent system. As the system itself is just as variable it will behave like a living organism. It is able to react to the context-generated input, altering its own state and adapting its output accordingly. The possible interactive nature of the media arts is therefore constituted by the following three characteristic elements of the digital image: virtuality (the way the information is saved), variability (of the image's object), and viability (as displayed by the behavioral patterns of the image). If we define a living organism as a system characterized by its propensity to react relatively independently to any number of inputs, then it follows that a dynamic visual system of multisensorial variables will approximate a living organism and its behavioral patterns.

Ultimately, the object of these new scenarios consists of and depends on binary information: objects, states, experiences are recorded and saved on data carriers after their transformation into binary code. Thus, the new worlds are virtual worlds. Through the retrieval of such binary data by algorithmic means, the instant manipulation of their content has become possible, and the object has become variable. In any virtual world its state, as well as that of its represented objects, may change according to either intrinsic simulation algorithms, or the reaction to external observer-generated inputs. The term "viability" is applied by Radical Constructivism to complex dynamic systems that are able to change their state autonomously via a feedback reaction, and can react context-sensitively to varying inputs from their surroundings. In this sense viability denotes the possession of lifelike properties with the development of lifelike behavior. The digital trinity of saved virtual information, variability of image-object, and viability of image behavior has in fact animated the image through the generation of a dynamic interactive visual system. In new-media art installations it is possible to incorporate one or several human observers into computer-generated virtual scenarios via computer-controlled junctions in the form of multisensorial interfaces. The traditionally passive role of the observer in art is thus abolished; he turns from a position external to the object to become part of his observed visual realm, whose virtual scenarios will react to his presence and will in turn effect a feedback from him. The interactive installation has undermined our traditional assumptions about the image as a static object.

The next stage in the evolution of new-media art is already conceivable in the form of art in the network. There will be sheer immaterial art worlds floating in the Internet. A yet newer telematic culture will evolve, as interactive television and global telepresence along the new global electronic superhighways and super information highways become possible. Developments beyond that in terms of interface research are as yet relegated to the realm of science fiction. So far only external "brain-wave" sensor technology is available, for instance in the use of eye-tracking sensors. The way forward seems to point to circumventing the necessity for the traditional electronic interfaces with the invention of "brain chips" or "neuro chips." They would access the brain with limited loss of information and link it more directly to the digital universe. We are beginning to be able to foresee a new conception of corporeality and the human body: the appearance of the terminal body that separates between self (internal machine) and body (external machine). Once this development has become feasible, artificial intelligence generated by machines will be applied in the creation of artificial life — sound and visual systems with an increasingly lifelike behavior. Here an increasing contribution will be made by genetic algorithms, autonomous agents, and swarm architecture. The generation of virtual agents equipped with artificial intelligence and inhabiting our data highways is already undergoing preliminary investigation. Researchers like Gerd Doben-Henisch at the Institute for New Media in Franfurt are working on the

development of "Knowbots," immaterial creatures (Maxwell once called his demons of the molecular world "hypothetical beings"), intelligent autonomous agents with virtual bodies who could be taught to learn. They would perform tasks in data banks and along the data highways. On a more banal level, immaterial data-filled spaces are already being set up through the all-encompassing global information networks existing between symbolically significant machines. These spaces are entirely intangible, immaterial, devoid of any corporeality. Conceivably a new kind of entity, the "Knowbot," could be born within these spaces, for which there is no known precedent in history. Whereas robots still maintain some tangible link with the familiar continuity of corporeality and familiar aesthetic assumptions of material reality, even they have internal resources of potentially immaterial spaces ready for link up with available immaterial data networks.

"Knowbots" no longer have a material body. As immaterial entities they consist of formulae, mathematical functions that can be self-transforming and self-reproductive, they can be multilocal, omnipresent, and have many of the characteristics normally associated with human beings. Unrestrained by bodily realities, and independent of any possible user, they are able to manoeuvre themselves into immaterial data spaces, collecting, exchanging, transforming, generating any amount of information. We, as human beings tied to the traditional realities of our aesthetics, determined by the body and its material shape, are unable to register the presence of these "Knowbots." They are the entities most representative of the state of post-ontological art. They are creatures possessing human properties such as (artificial) intelligence, (artificial) life, and (artificial) conscience, yet without any material existence. They represent the subject lacking ontological status.

Ontological art represents the realm of hard fact of the Church-Turing Thesis, where existence and its formulation, recognition and predictability, syntax and semantics converge. Here nature appears in terms of computable numbers and computable images accounted for in a kind of universal computer. However, the real truth of the metaphorical computer reveals an image in direct contradiction. Increasing predictability and computability (chaos theory) has in fact revealed the intrinsic limitations of computability in the aleatoric structures of mathematics as discovered by Chaitin, as well as the absolute nonreducibility of the universe's nonpredictability. This amounts to a meta demasking. The descriptive terms (of macro-, micro-, and meta-universes) are dissipative and reversible. Information must be perceived as floating freely in the digital visual medium, able to be transformed instantly at random. The price paid for the viability of information and the system lies in its volatility defined by variability and virtuality. Post-ontological art represents a dynamic model of covariance between observer, interface, and environment, where the observer may be incorporated as part of that environment or context, constituting a dissipative structure. Genetic algorithms that are able to separate the image from the observer-controlled context will constitute another dissipative structure. Thus, instead of the conventional

world of the picture we have a universe of "free variables" floating in specific event-worlds, which can be comprehensively filled or replaced, and which interact with one another. The image has turned into a model world, autocatalytical as well as context controlled. The animated image constitutes the most radical challenge of our classical visual notions of image and representation. □

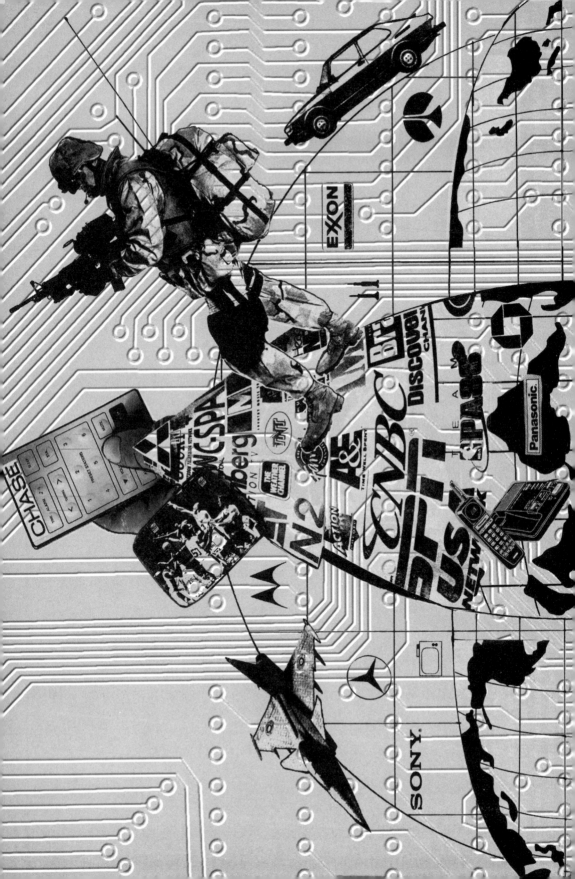

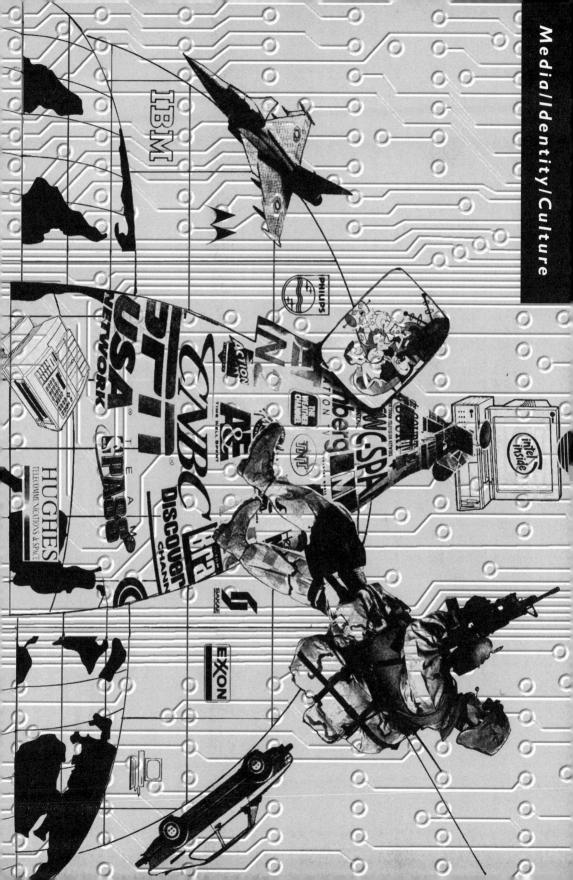

CONSTRUCTIONS AND RECONSTRUCTIONS OF THE SELF IN VIRTUAL REALITY

■ *S h e r r y T u r k l e*

I. IDENTITY WORKSHOPS [1]

In an interactive computer game designed to represent a world inspired by the television series *Star Trek: The Next Generation*, over a thousand players spend up to 80 hours a week participating in intergalactic exploration and wars. They create characters who have casual and romantic sex, who fall in love and get married, who attend rituals and celebrations. "This is more real than my real life," says a character who turns out to be a man playing a woman who is pretending to be a man. In this game, the rules of social interaction are built not received.

In another, more loosely-structured game, each player creates a character or several characters, specifying their genders and other physical and psychological attributes. The characters need not be human and there are more than two genders. All interactions take place "in character." Beyond this, players are invited to help build the computer world itself. Using a relatively simple programming language, they can make a "room" in the game space where they can set the stage and define the rules. That is, they make objects in the computer world and specify how they work. Rachel, an eleven-year-old, built a room she calls "the condo." It has jewelry boxes containing magical pieces that transport her to different places and moments in history. When Rachel visits the condo, she invites her friends, she chats, orders pizza, and flirts. Other players built TVs showing scenes taking place in the rooms of the game, a transportation system to navigate the space, and a magical theater that replays past game events. Some have built robots: a program named "Julia," for example, "pretends" to be a person as she offers directions and helps to locate your friends.

Both worlds exist on international computer networks, which of course means that in a certain sense, a physical sense, they don't exist at all.

The first game, Trek Muse, and the second, LambdaMoo, are examples of a class of virtual worlds known as MUDs — an acronym for "Multi-User Dungeons." [2] In the early 1970s, a role-playing game called Dungeons and Dragons

have found that individuals use computers to work through identity issues that center around control and mastery; in the second, where the computer is used as a communications medium, there is more room to use the control provided by the computer to develop a greater capacity for collaboration and even intimacy. The medium enables the self to explore a social context as well as to reflect on its own nature and powers.

This essay explores constructions and reconstructions of identity in MUD environments. My method of investigation has been ethnographic and clinical: play the games, "hang out" with game players in virtual as well as real space, interview game players in person both individually and in groups. Some of my richest data came from a series of weekly "pizza parties" for MUD-ers within the Boston area. There the topic was open and conversation turned to what was on the players' minds: most often love, romance, and what can be counted on as real in virtual space.

I begin my report from this new social and psychological world by taking one step back to general considerations of how role-playing games enable people to work through issues of identity and then move on to the form this takes in MUDs which enhance the evocative potential of traditional games by further blurring the line between the game and what players refer to as TRW, or the real world.[5]

Traditional role-playing prompts reflection on personal and interpersonal issues, but in games that take place in ongoing virtual societies such as MUDs, the focus is on larger social and cultural themes as well. The networked computer serves as an "evocative object" for thinking about community. Additionally, people playing in the MUDs struggle towards a new, still tentative, discourse about the nature of a community that is populated both by people and by programs that are social actors. In this, life in the MUD may serve as a harbinger of what is to come in the social spaces that we still contrast with the virtual by calling them "real."

2. ROLE-PLAYING GAMES

As identity workshops, MUDs have much in common with traditional role-playing games. For example: the role-playing games played by Julee, a nineteen-year-old who has dropped out of Yale after her freshman year. Part of the reason for her leaving college is that she is in an increasingly turbulent relationship with her mother, a devout Catholic, who turned away from her daughter when she discovered that she had had an abortion the summer before beginning college.

From Julee's point of view, her mother has chosen to deny her existence. When asked about her most important experience in role-playing games, Julee described a game in which she had been assigned to play a mother facing a conflict with her daughter. Indeed, in the game, the script says that the daughter is going to betray, even kill, the mother.

In the role-playing game, played over a weekend on the Boston University campus, Julee and her "daughter" talked for hours: why might the daughter have joined her mother's opponents, how could they stay true to their relationship and the game as it had been written? Huddled in a corner of an empty Boston University classroom, Julee was having the conversation that her mother had not been willing to have with her. In the end, Julee's character chose to ignore her loyalty to her team in order to preserve her daughter's life.

Clearly, Julee projected feelings about her "real" mother's choice onto her experience of the game, but more was going on than a simple reenactment. Julee was able to reexperience a familiar situation in a setting where she could examine it, do something new with it, and revise her relationship towards it. In many ways, what happened was resonant with the psychoanalytic notion of "working through."

Julee's experience stands in contrast to images of role-playing games that are prevalent in the popular culture. A first popular image portrays role-playing games as depressing and dangerous environments. It is captured in the urban legend which describes an emotionally troubled student disappearing and committing suicide during a game of Dungeons and Dragons. Another popular image, and one that has been supported by some academic writing on role-playing games, turns them into places of escape. Players are seen as leaving their "real" lives and problems behind to lose themselves in the game space. Julee's story belies both stereotypes. For her, the game is psychologically constructive rather than destructive. And she uses it not for escape but as a vehicle for engaging in a significant dialogue with important events and relationships in her "real" life.

Role-playing games are able to serve in this evocative capacity precisely because they are not simple escapes from the real to the unreal, but because they stand betwixt and between, both in and not in real life. But in the final analysis, what puts Julee's game most firmly in the category of game is that it had an end point. The weekend was over and so was the game.

MUDs present a far more complicated case. In a certain sense, they don't have to end. Their boundaries are more fuzzy; the routine of playing them becomes part of their players' real lives. The virtual reality becomes not so much an alternative as a parallel life. Indeed, dedicated players who work with computers all day describe how they temporarily put their characters to "sleep," remain logged on to the game, pursue other activities, and periodically return to the game space.

Such blurring of boundaries between role and self present new opportunities to use the role to work on the self. As one experienced player put it, "You are the character and you are not the character both at the same time," and "you are who you pretend to be." This ambiguity contributes to the games' ability to be a place in which to address issues of identity and intimacy. They take the possibilities that Julee found in role-playing games and raise them to a higher power.

3. VIRTUAL REALITIES:
ROLE-PLAYING TO A HIGHER POWER

The notion "you are who you pretend to be" has a mythic resonance. The Pygmalion story endures because it speaks to a powerful fantasy: that we are not limited by our histories, that we can be recreated or can recreate ourselves. In the real world, we are thrilled by stories of self-transformation. Madonna is our modern Eliza Doolittle; Ivana Trump is the object of morbid fascination. But, of course, for most people such recreations of self are difficult. Virtual worlds provide environments for experiences that may be hard to come by in the real.

Not the least of these experiences is the opportunity to play an "aspect of yourself" that you embody as a separate self in the game space. [6]

Peter is a twenty-three-year-old physics graduate student at the University of Massachusetts. His life revolves around his work in the laboratory and his plans for a life in science. He says that his only friend is his roommate, another student whom he describes as being even more reclusive than he. This circumscribed, almost monastic, life does not represent a radical departure for Peter. He has had heart trouble since he was a child; his health is delicate, one small rebellion, a ski trip when he first came up to Boston, put him in the hospital for three weeks. His response has been to circumscribe his world. Peter has never traveled. He lives within a small compass.

In an interview, Peter immediately made it clear why he plays on MUDs: "I do it so I can talk to people." He is logged on for at least 40 hours a week, but it is hard to call what he does "playing a game." He spends his time on the MUDs constructing a life that (in only a seeming paradox) is more expansive than his own. He tells me with delight that the MUD he frequents most often is physically located on a computer in Germany.

> And I started talking to them [the inhabitants of the MUD] and they're like, "This costs so many and so many Deutschmarks." And I'm like, "what are Deutschmarks? Where is this place located?" And they say: "Don't you know, this is Germany."

It is from MUDs that Peter has learned what he knows of politics, of economics, of the differences between capitalism and welfare-state socialism. He revels in the differences between the styles of Americans and Europeans on the MUDs and in the thrill of speaking to a player in Norway who can see the Northern lights.

On the MUD, Peter shapes a character, Achilles, who is his ideal self. Life in a University of Massachusetts dorm has put him in modest and unaesthetic circumstances. Yet the room he inhabits on the MUD is elegant, romantic, out of a Ralph Lauren ad.

Peter's story illustrates several aspects of the relationship of MUD-ing and identity. First, the MUD serves as a kind of Rorschach inkblot, a projection of

fantasy. Second, unlike a Rorschach, it does not stay on a page. It is part of Peter's everyday life. Beyond expanding his social reach, MUDs have brought Peter the only romance and intimacy he has ever known. At a social event held in virtual space, a "wedding" of two regular players on his favorite Germany-based MUD, Peter met Winterlight, one of the three female players. Peter who has known little success with women, was able to charm this most desirable and sought-after player. Their encounter led to a courtship in which he was tender and romantic, chivalrous and poetic. One is reminded of Cyrano who could only find his voice through another's persona. It is Achilles, Peter's character on the MUD, who can create the magic and win the girl.

While Deborah's experience of technology and the self (where she was one-on-one with the computer) centered on issues of identity that were centered around control and mastery, Peter's experience (where the computer is a mediator to a reality shared with other people) has put computation more directly in the service of the development of a greater capacity for friendship, the development of confidence for a greater capacity for intimacy.

But what of the contrast between Peter and Julee? What can we say about the difference between role-playing games in the corridors of Boston University and on computer virtual worlds?

Julee and Peter both appropriate games to remake the self. Their games, however, are evocative for different reasons. Julee's role-playing has the powerful quality of real-time psychodrama, but, on the other hand, Peter's game is ongoing and provides him with anonymity, invisibility, and potential multiplicity. Ongoing: he can play it as much as he wants, all day if he wants, every day if he chooses as he often does. There are always people logged on to the game; there is always someone to talk to or something to do. Anonymous: once Peter creates his character, that is his only identity on the game. His character need not have his gender or share any recognizable feature with him. He can be who he wants and play with no concern that *he*, Peter, will be held accountable in "real life" for his characters actions, quarrels, or relationships. The degree to which he brings the game into his real life is his choice. Invisible: the created character can have any physical description and will be responded to as a function of that description. The plain can experience the self-presentation of great beauty; the nerdy can be elegant; the obese can be slender. Multiplicity: Peter can create several characters, playing out and playing with different aspects of his self. An ongoing game, anonymous personae, physical invisibility, and the possibility to be not one but many, these are the qualities at the root of the holding power and evocative potential of MUDs as "identity workshops." Faced with the notion that "you are what you pretend to be," Peter can only hope that it is true, for he is playing his ideal self.

Peter plays what in the psychoanalytic tradition would be called an "ego ideal." Other players create a character or multiple characters that are closer to embodying aspects of themselves that they hate or fear or perhaps have not ever consciously

confronted before. One male player describes his role-playing as "daring to be passive. I don't mean in having sex on the MUD. I mean in letting other people take the initiative in friendships, in not feeling when I am in character that I need to control everything. My mother controlled my whole family, well, certainly me. So I grew up thinking 'never again.' My 'real life' is exhausting that way. On MUDs I do something else. I didn't even realize this connection to my mother until something happened in the game and somebody tried to boss my pretty laid-back character around and I went crazy. And then I saw what I was doing."

The power of the medium as a material for the projection of aspects of both conscious and unconscious aspects of the self suggests an analogy between MUDs and psychotherapeutic milieus. The goal of psychotherapy is not, of course, simply to provide a place for "acting out" behavior that expresses one's conflicts, but to furnish a contained and confidential environment for "working through" unresolved issues. The distinction between acting out and working through is crucial to thinking about MUDs as settings for personal growth. For it is in the context of this distinction that the much-discussed issue of "MUDs addiction" should be situated. The accusation of being "addicted" to psychotherapy is only made seriously when friends or family suspect that over a period of time, the therapy is supporting repetitions and reenactments rather than new resolutions. MUD-ing is no more "addictive" than therapy when it works as a pathway to psychological growth.

Robert was a college freshman who in the months before beginning college had to cope with his father's having lost his job and disgracing his family because of alcoholism. The job loss led to his parents' relocation to another part of the country, far away from all of Robert's friends. For a period of several months, Robert, now at college, MUD-ed over 80 hours a week. Around the time of a fire in his dormitory which destroyed all his possessions, Robert was playing over 120 hours a week, sleeping four hours a night, and only taking brief breaks to get food, which he would eat while playing.

At the end of the school year, however, Robert's MUD experience was essentially over. He had gotten his own apartment; he had a job as a salesman; he had formed a rock band with a few friends. Looking back on the experience he thought that MUD-ing had served its purpose: it kept him from what he called his "suicidal thoughts," in essence by keeping him too busy to have them; it kept him from drinking ("I have something more fun and safe to do"); it enabled him to function with responsibility and competency as a highly placed administrator; it afforded an emotional environment where he could be in complete control of how much he revealed about his life, about his parents, even about something as simple for other people as where he was from. In sum, MUDs had provided what Erik Erikson called a "psychosocial moratorium." It had been a place from which he could reassemble a sense of boundaries that enabled him to pursue less bounded relationships.[7]

MUDs are a context for constructions and reconstructions of identity; they are also a context for reflecting on old notions of identity itself. Through contemporary

psychoanalytic theory which stresses the decentered subject and through the fragmented selves presented by patients (and most dramatically the increasing numbers of patients who present with multiple personality), psychology confronts the ways in which any unitary notion of identity is problematic and probably illusory. What is the self when it functions as a society? What is the self when it divides its labor among its constituent "altars" or "avatars"? Those burdened by posttraumatic dissociative syndrome suffer the question; inhabitants of MUDs play with it.

These remarks have addressed MUDs as privileged spaces for thinking through and working through issues of personal identity. Additionally, when role-playing moves onto a sustained virtual space there is an attendant growth of a highly structured social world. The development of these virtual cultures is of signal importance: it makes MUDs very special kinds of evocative objects.

4. EVOCATIVE OBJECTS: GENDER, ACTANTS, AND "BOTS"

In *The Second Self* I called the personal computer an evocative object because it provoked self-reflection and stimulated thought. It led to reevaluations and reconsiderations of things taken for granted, for example, about the nature of intelligence, free will, and our notions of what is alive. And I found that the computer did this not just because it presented people with ideas as did traditional philosophy, but because it presented them with experiences, an ongoing culture of personal computing that provoked a new philosophy in everyday life.

The same kind of process, this provocation of new discourse and reflection, is taking place around computer-mediated communications in virtual realities such as MUDs. But the emphasis of the new discourse and reflection is on social and cultural issues as well as individual ones.

One dramatic example is the novel and compelling discourse that surrounds the experience of "gender swapping" in virtual reality. In the MUDs, men may play the roles of women and women the roles of men, a common practice known as "gender swapping." As MUD players talked to me about their experiences with gender swapping, they certainly gave me reason to believe that through this practice they were working through personal issues that had to do with accepting the "feminine" and/or the "masculine" in their own personalities. But they were doing something else as well which transcended the level of individual personality and its dynamics. People were using gender swapping as a first-hand experience through which to form ideas about the role of gender in human interactions. In the ongoing culture of MUDs, these issues are discussed both within the space of the games and in a discussion group on USENET called "rec.games.mud."

Discussion on USENET about gender swapping has dealt with how female characters are besieged with attention, sexual advances, and unrequested offers of

assistance which imply that women can't do things by themselves. It has dealt with the question of whether women who are consistently treated as incompetent may start to believe it. Men playing women in role-playing games have remarked that other male players (read: male characters) sometimes expect sexual favors in return for technical assistance. In this case, offering technical help, like picking up the check at dinner, is being used to purchase rather than win a woman's regard. While such expectations can be subtly expressed, indeed sometimes overlooked in real life, when such things happen in MUDs, they are more visible, often widely witnessed, and openly discussed. As this takes place, the MUD becomes an evocative object for a richer understanding not only of sexual harassment but of the social construction of gender.

MUD-ing throws issues of the impact of gender on human relations into high relief and brings the issue home; the seriousness and intensity of discussions of gender among MUD-ers speaks to the fact that the game allows its players to experience rather than merely observe what it feels like to be the opposite gender or to have no gender at all.

MUDs are evocative objects for thinking about gender, but there are similar stories to tell about discussions in MUD environments about violence, property, and privacy. Virtual communities compel conversations about the nature of community itself.

On a MUD known as Habitat, which ran as an experiment in the United States and has become a successful commercial venture in Japan, players were originally allowed to have guns. However, when you are shot, you do not cease to exist but simply lose all the things you were carrying and are transported back to your virtual home. For some players, thievery and murder became the highlight of the "game." For others, these activities were experienced as a violent intrusion on their peaceful world. An intense debate ensued.[8]

Some players argued that guns should be eliminated; unlike in the real world, a perfect gun ban is possible with a few lines of code. Others argued that what was damaging was not the violence but the trivialization of violence, and maintained that guns should persist, but their consequences should be made more real: when you are killed, your character should cease to exist and not simply be sent home. Still others believed that since Habitat was "just a game," and playing assassin was part of the fun, there could be no harm in a little virtual violence.

As the debate raged, a player who was a priest in real life founded the "Order of the Holy Walnut" whose members pledged not to carry guns. In the end, the game designers divided the world into two parts: in town, violence was prohibited. In the wilds outside of town, it was allowed. Eventually a democratic voting process was installed and a sheriff elected. Debates then ensued about the nature of Habitat laws and the proper balance between individual freedom and law and order. What is remarkable is not just the solution, but the quality of the debate which led up to that solution. The denizens of Habitat were spending

their leisure time debating pacifism, the nature of good government, and the relationships between representations and reality.

Virtual reality is not "real," but it has a relationship to the real. By being betwixt and between, it becomes a play space for thinking about the real world. It is an exemplary evocative object.

When a technology serves as an evocative object, old questions are raised in new contexts and there is an opportunity for fresh resolutions. I conclude with another example of how MUDs are able to recast a set of philosophical questions about personhood and program. People regularly use experiences in computer environments to think through and, in some cases, rework their definitions of personhood, agency, the meaning of the "I." [9]

When in the context of "traditional" computation, people meet a program that exhibits some behavior that would be considered intelligent if done by a person, they often grant the program a "sort of" intelligence, indeed a "sort of" life, but then insist that what the essence of human intelligence or indeed of human uniqueness is what "the computer cannot do." Computers cannot have intentions, feelings, the sense of an "I."

In MUDs, however, intelligent computational entities are present in a new context which gives questions about their status a new urgency and saliency. Some of the inhabitants of these virtual worlds are artificial intelligences, robots, affectionately referred to as "bots," which have been built by enterprising players. When you wander about in a MUD, you find yourself in conversations with them, you find yourself asking them for directions, thanking them for being helpful, ordering drinks from them at a virtual bar, telling them a joke. And you find yourself doing all of these things before you know that they are not people but "things." (Of course, you may be a person "playing" the role "an intelligent Batmobile" or "a swarm of bees.") The "thingness" of the bots is not part of your initial encounter or the establishment of your relationship with them. You have unintentionally played out a Turing test in which the program has won.

Reaction to such experiences is strong, much of it still centered on the question of human uniqueness and "whether a program can be an 'I'." (For example, within the Narrative Intelligence discussion group on the Internet, there is heated and ongoing debate about bots and the question of the "I." In this debate, sophisticated programmers of and players in virtual worlds have admitted to being nonplused when they first realized that they had unknowingly participated in casual social conversation with "artificial intelligences," or AIs.) But there is another discourse as well, marked by two new themes.

First, instead of dwelling on the essence of "bots," conversation among MUDers about programs inhabiting virtual space turns to the ethics of whether "they" should or should not announce their artificiality. This discussion of full disclosure is taking place in the context of a virtual world where changing gender, race, and species is the norm. With people playing robots, there is a new level of self-

consciousness about the asymmetry of demanding that robots not play people.

In the film *Blade Runner* sophisticated androids almost indistinguishable from humans have been given the final defining human qualities: childhood memories and the knowledge of their mortality. This is a world obsessed with the Turing test; the film's hero, Decker, makes his profession diagnosing the real from the artificial. But by the end, Decker who has spent his life tracking down and destroying robots is less concerned with whether he is dealing with an artificial being and more concerned with how to thank one of them for saving his life and how to escape with another of them with whom he has fallen in love. This character becomes a representation of a more widespread ambiguity about notions of real and not real that do not follow from a priori essences but emerge from ongoing relationships.

In this spirit, I note that the second theme of the new discourse on the bots turns away from discussion of their essence and towards the most practical matters of how the AIs function within the community: are they disruptive or facilitating, are they rude or are they kind? In this sense, MUDs may be harbingers of the discourse about the artificial in a post-Turing test world.

There is a lot of excitement about virtual reality. In both the popular and academic press, there is enthusiasm and high expectation for a future in which we don gloves and masks and bodysuits, and explore virtual space and sensuality. However, from a point of view centered on the evolution of our sense of self and self-definition, there is reason to feel great excitement about where we are in the present. In the text-based virtual realities that exist today, people are exploring, constructing, and reconstructing their identities. They are doing this in an environment infused with a postmodern ethos of the value of multiple identities and of playing out aspects of the self and with a constructionist ethos of "Build something, be someone." And they are creating communities that have become privileged contexts for thinking about social, cultural, and ethical dilemmas of living in constructed lives that we share with extensions of ourselves that we have embodied in a program.

Watch for a nascent culture of virtual reality that is paradoxically a culture of the concrete, placing new saliency on the notion that we construct gender and that we become what we play, argue about, and build. And watch for a culture that leaves a new amount of space for the idea that he or she who plays, argues, and builds is a machine. □

THE ART OF CYBERSPACE

■ *P i e r r e L e v y*

From the point of view of its relationship to artistic works, cyberspace seems to cultivate a field of attraction that can be summed up in three interdependent clauses:

1) Messages are invoked, transmitted, sent back, expelled, drawn in, given this or that scenario depending on different tastes and situations, and whatever form they take, the messages revolve around receptors, which are now located at the center (in contrast to the image presented by the mass media).

2) The established differences between author and reader, performer and spectator, creator and interpreter become blurred and give way to a reading-writing continuum that extends from the designers of technology and networks to the final recipient, each one contributing to the activity of the other (disappearance of the signature).

3) The divisions that separate the messages or "works," which appear as microterritories attributed to "authors," tend to become obliterated. Each and every representation may be subject to sampling, mixing, re-utilization, and so forth. According to the emerging pragmatism of creation and communication, nomadic distributions of information fluctuate in an immense deterritorialized semiotic backdrop. It is therefore natural that the creative effort is shifting away from the messages towards the devices, the processes and languages, the dynamic "architectures," and environments.

Certain questions that artists have been asking since the end of the nineteenth century are being asked once again, with even greater insistence, with the emergence of cyberspace. These questions directly alter the "framework": the work and its limits, its presentation, reception, reproduction, distribution, interpretation, and the diverse types of separation that they carry. The framework is so altered that it now appears as if no fence will ever contain this deterritorialization *in extremis*: we must leap into a new space. It is the socio-technical environment of the proliferation and distribution of works that has engendered the mutation. Yet can we continue to speak of works in cyberspace?

For at least several centuries, in the West, the artistic phenomenon has presented itself as follows: a person (the artist) signs a particular object or message (the work), which other persons (the recipients, the public, the critics) perceive,

taste, read, interpret, and evaluate. Regardless of the function of the work (religious, decorative, subversive) or its ability to transcend that function and pierce the enigmatic and emotional core within us, it fits into a classic pattern of communication. The sender and the receiver are absolutely distinct, their roles are clearly assigned. The techno-cultural environment that is emerging, however, gives rise to new art forms, ignoring the distinctions between emission and reception, creation, and interpretation. It is only a possibility that has opened up through the current mutation, a possibility that may never materialize or only very marginally. One hopes, above all, to prevent it from closing up prematurely, before it has explored its rich diversity. This new art form allows what is precisely no longer an audience to experience other methods of communication and creation.

Rather than sending out a message to receptors outside the act of creation who are invited to give meaning to the work after the fact, here the artist attempts to establish an environment, an arrangement of communication and production, a collective event which involves the recipients, transforms interpreters into players, and places the interpretation in the same loop as the collective activity. It is entirely possible that "open works" already foreshadow this direction. They remain, however, within the interpretive paradigm. The receivers of the open work are invited to fill in the blanks, to choose between possible directions, to confront the differences in their interpretations. But it is still a question of magnifying and exploring the possibilities of an unfinished monument, of placing one's initials in the honor roll beneath the artist's signature. Indeed, the art of involvement no longer constitutes a work at all, even open or undefined: it causes processes to emerge, it seeks to open up a career to autonomous lives, it invites one to grow and inhabit a world. It places us in a creative cycle, in a living environment in which we are always already co-authors. Work in progress? It shifts the emphasis from work to progress. Its manifestations will relate to moments, places, collective dynamics, but no longer to people. It is an art that bears no signature.

Utilizing all the resources cyberspace offers, the art of involvement discovers the current of music. How do we make a symphony rise from the murmur of a multiple? How do we transform the sound of a crowd into a chorus, without a musical score? The collective intellect continually brings the social contract into play, it keeps the group in a state of renewal. Paradoxically, to do so requires time, the time to involve individuals, to form ties, to make objects appear, and create common landscapes and to return to them. In comparison to the watch or the calendar, the temporality of the collective imagination may seem delayed, interrupted, splintered. Yet it is all played out in the dark, invisible recesses of the collective: the melody, the emotional tonality, the secret pulse, the connections, and continuity that it binds together at the very heart of the individuals of which it is composed. □

TRANSLATED FROM FRENCH BY KARIN LUNDELL. ORIGINALLY PUBLISHED IN *L'INTELLIGENCE COLLECTIVE. POUR UNE ANTHROPOLOGIE DU CYBERSPACE*, LA DECOUVERTE, PARIS, 1994.

CUI CUI CUI CUI CUI CUI CUI CUI CUI CUI CUI CUI CUI

Are you:

- A MERE DRONE in the ever-expanding DIGITAL WORKPLACE?

- FRUSTRATED by the RAPID PACE of CHANGE in a RADICALLY RESTRUCTURED WORLD?

- A PATHETIC SLAVE to a soulless NUMBER-CRUNCHING MONSTER?

- SHACKLED to a NEO-FASCIST data terminal?

 YES NO

CUI CUI CUI CUI CUI CUI CUI CUI CUI CUI CUI CUI CUI

Perry Hoberman, *Cathartic User Interface*, 1994 (detail)

THE INFORMATION WAR

■ *H a k i m B e y*

Humanity has always invested heavily in any scheme that offers escape from the body. And why not? Material reality is such a mess. Some of the earliest "religious" artifacts, such as Neanderthal ochre burials, already suggest a belief in immortality. All modern (i.e., postpaleolithic) religions contain the "Gnostic trace" of distrust or even outright hostility to the body and the "created" world. Contemporary "primitive" tribes and even peasant-pagans have a concept of immortality and of going-outside-the-body (ecstasy) without necessarily exhibiting any excessive body hatred. The Gnostic trace accumulates very gradually (like mercury poisoning) until eventually it turns pathological. Gnostic dualism exemplifies the extreme position of this disgust by shifting all value from body to "spirit." This idea characterizes what we call "civilization." A similar trajectory can be traced through the phenomenon of "war." Hunter-gatherers practiced (and still practice, as amongst the Yanomamo) a kind of ritualized brawl (think of the Plains Indian custom of "counting coup"). "Real" war is a continuation of religion and economics (i.e., politics) by other means, and thus only begins historically with the priestly invention of "scarcity" in the Neolithic and the emergence of a "warrior caste." (I categorically reject the theory that war is a prolongation of "hunting.") World War II seems to have been the last "real" war. Hyperreal war began in Vietnam with the involvement of television, and recently reached full obscene revelation in the Gulf War of 1991. Hyperreal war is no longer "economic," no longer "the health of the state." The Ritual brawl is voluntary and nonhierarchic (war chiefs are always temporary); real war is compulsory and hierarchic; hyperreal war is imagistic and psychologically interiorized ("pure war"). In the first, the body is risked; in the second, the body is sacrificed; in the third, the body has disappeared. (See P. Clastres on war, in *Archaeology of Violence.*) Modern science also incorporates an antimaterialist bias, the dialectical outcome of its war against Religion—it has in some sense become Religion. Science as knowledge of material reality paradoxically decomposes the materiality of the real. Science has always been a species of priestcraft, a branch of cosmology, and an ideology, a justification of "the way things are." The deconstruction of the real in postclassical physics mirrors the vacuum of unreality which constitutes "the state." Once the image of Heaven on Earth, the state now consists of no more than the management of images. It is no longer a force but a

disembodied patterning of information. But just as Babylonian cosmology justified Babylonian power, so too does the "finality" of modern science serve the ends of the Terminal State, the postnuclear state, the "information state." Or so the New Paradigm would have it. And "everyone" accepts the axiomatic premises of the New Paradigm. The New Paradigm is very spiritual.

Even the New Age with its gnostic tendencies embraces the New Science and its increasing etherealization as a source of proof-texts for its spiritualist world view. Meditation and cybernetics go hand in hand. Of course the information state somehow requires the support of a police force and prison system that would have stunned Nebuchadnezzar and reduced all the priests of Moloch to paroxysms of awe. And modern science still can't weasel out of its complicity in the very-nearly-successful conquest of Nature. Civilization's greatest triumph over the body.

But who cares? It's all relative isn't it? I guess we'll just have to "evolve" beyond the body. Maybe we can do it in a "quantum leap." Meanwhile the excessive mediation of the Social, which is carried out through the machinery of the Media, increases the intensity of our alienation from the body by fixating the flow of attention on information rather than direct experience. In this sense the Media serves a religious or priestly role, appearing to offer us a way out of the body by redefining spirit as information. The essence of information is the Image, the sacral and iconic data complex which usurps the primacy of the "material bodily principle" as the vehicle of incarnation, replacing it with a fleshless ecstasy beyond corruption. Consciousness becomes something which can be down loaded, excised from the matrix of animality and immortalized as information. No longer "ghost-in-the-machine," but machine-as-ghost, machine as Holy Ghost, ultimate mediator, which will translate us from our mayfly-corpses to a pleroma of Light. Virtual reality as CyberGnosis. Jack in, leave Mother Earth behind forever. All science proposes a paradigmatic universalism — as in science, so in the social. Classical physics played midwife to capitalism, communism, fascism, and other modern ideologies.

Postclassical science also proposes a set of ideas meant to be applied to the social: relativity, quantum "unreality," cybernetics, information theory, etc. With some exceptions, the postclassical tendency is towards ever greater etherealization. Some proponents of Black Hole theory, for example, talk like pure Pauline theologians, while some of the information theorists are beginning to sound like virtual Manichaeans.[1] On the level of the social these paradigms give rise to a rhetoric of bodylessness quite worthy of a third-century desert monk or a seventeenth-century New England Puritan — but expressed in a language of postindustrial, postmodern feel-good consumer frenzy. Our every conversation is infected with certain paradigmatic assumptions which are really no more than bald assertions, but which we take for the very fabric or *Urgrund* of reality itself. For instance, since we now assume that computers represent a real step toward artificial intelligence, we also assume that buying a computer makes us more intelligent. In my own field I've met dozens of writers who sincerely believe that owning a PC

has made them better (not "more efficient," but better) writers. This is amusing—but the same feeling about computers when applied to a trillion dollar military budget churns out Star Wars, killer robots, etc. (See Manuel de Landa's *War in the Age of Intelligent Machines* on AI in modern weaponry.) An important part of this rhetoric involves the concept of an "information economy." The post-Industrial world is now thought to be giving birth to this new economy. One of the clearest examples of the concept can be found in a recent book by Bishop Hoeller, a man who is a libertarian, the bishop of a Gnostic Dualist Church in California and a learned and respected writer for *Gnosis* magazine:

> The industry of the past phase of civilization (sometimes called "low technology") was big industry, and bigness always implies oppressiveness. The new high technology, however, is not big in the same way. While the old technology produced and distributed material resources, the new technology produces and disseminates information. The resources marketed in high technology are less about matter and more about mind. Under the impact of high technology, the world is moving increasingly from a physical economy into what might be called a "metaphysical economy." We are in the process of recognizing that consciousness rather than raw materials or physical resources constitutes wealth.[2]

Modern neo-Gnosticism usually plays down the old Manichaean attack on the body for a gentler greener rhetoric. Bishop Hoeller for instance stresses the importance of ecology and environment (because we don't want to "foul our nest," the Earth)—but in his chapter on Native American spirituality he implies that a cult of the Earth is clearly inferior to the pure Gnostic spirit of bodylessness:

> But we must not forget that the nest is not the same as the bird. The exoteric and esoteric traditions declare that earth is not the only home for human beings, that we did not grow like weeds from the soil. While our bodies indeed may have originated on this earth, our inner essence did not. To think otherwise puts us outside of all of the known spiritual traditions and separates us from the wisdom of the seers and sages of every age. Though wise in their own ways, Native Americans have small connection with this rich spiritual heritage.[3]

In such terms (the body = the "savage"), the Bishop's hatred and disdain for the flesh illuminate every page of his book. In his enthusiasm for a truly religious economy, he forgets that one cannot eat "information." "Real wealth" can never become immaterial until humanity achieves the final etherealization of downloaded consciousness. Information in the form of culture can be called wealth metaphorically because it is useful and desirable—but it can never be wealth in precisely the same basic way that oysters and cream, or wheat and water, are wealth in themselves. Information is always only information about some

thing. Like money, information is not the thing itself. Over time we can come to think of money as wealth (as in a delightful Taoist ritual which refers to "Water and Money" as the two most vital principles in the universe), but in truth this is sloppy abstract thinking. It has allowed its focus of attention to wander from the bun to the penny which symbolizes the bun.[4] In effect we've had an information economy ever since we invented money. But we still haven't learned to digest copper. The Aesopian crudity of these truisms embarrasses me, but I must perforce play the stupid lazy yokel plowing a crooked furrow when all the straight thinkers around me appear to be hallucinating.

Americans and other "First World" types seem particularly susceptible to the rhetoric of a "metaphysical economy" because we can no longer see (or feel or smell) around us very much evidence of a physical world. Our architecture has become symbolic, we have enclosed ourselves in the manifestations of abstract thought (cars, apartments, offices, schools), we work at "service" or information-related jobs, helping in our little way to move disembodied symbols of wealth around an abstract grid of Capital, and we spend our leisure largely engrossed in Media rather than in direct experience of material reality. The material world for us has come to symbolize catastrophe, as in our amazingly hysterical reaction to storms and hurricanes (proof that we've failed to "conquer Nature" entirely), or our neo-Puritan fear of sexual otherness, or our taste for bland and denatured (almost abstract) food. And yet, this "First World" economy is not self-sufficient. It depends for its position (top of the pyramid) on a vast substructure of old-fashioned material production. Mexican farmworkers grow and package all that Natural food for us so we can devote our time to stocks, insurance, law, computers, video games. Peons in Taiwan make silicon chips for our PCs. "Towel-heads" in the Middle East suffer and die for our sins. Life? Oh, our servants do that for us. We have no life, only "lifestyle"— an abstraction of life, based on the sacred symbolism of the Commodity, mediated by the priesthood of the stars, those larger-than-life abstractions who rule our values and people our dreams — the media-archetypes; or perhaps "mediarchs" would be a better term. Of course this Baudrillardian dystopia doesn't really exist — yet.[5] It's surprising, however, to note how many social radicals consider it a desirable goal, at least as long as it's called the information revolution" or something equally inspiring. Leftists talk about seizing the means of information-production from the data monopolists.[6] In truth, information is everywhere — even atom bombs can be constructed on plans available in public libraries. As Noam Chomsky points out, one can always access information — provided one has a private income and a fanaticism bordering on insanity. Universities and "think tanks" make pathetic attempts to monopolize information — they, too, are dazzled by the notion of an information economy — but their conspiracies are laughable. Information may not always be "free," but there's a great deal more of it available than any one person could ever possibly use. Books on every conceivable subject can actually still be found through interlibrary loan.[7] Meanwhile someone still has to grow pears and cobble shoes. Or, even if these

"industries" can be completely mechanized, someone still has to eat pears and wear shoes. The body is still the basis of wealth. The idea of Images as wealth is a "spectacular delusion." Even a radical critique of information can still give rise to an overvaluation of abstraction and data. In a *prositu* zine from England called *NO*, the following message was scrawled messily across the back cover of a recent issue:

As you read these words, the Information Age explodes ... inside and around you — with the Misinformation Missiles and Propaganda bombs of outright Information Warfare.

Traditionally, war has been fought for territory/economic gain. Information Wars are fought for the acquisition of territory indigenous to the Information Age, i.e., the human mind itself. . . . In particular, it is the faculty of the imagination that is under the direct threat of extinction from the onslaughts of multi-media overload . . . DANGER — YOUR IMAGINATION MAY NOT BE YOUR OWN. . . . As a culture sophisticates, it deepens its reliance on its images, icons and symbols as a way of defining itself and communicating with other cultures. As the accumulating mix of a culture's images floats around in its collective psyche, certain isomorphic icons coalesce to produce and to project an "illusion" of reality. Fads, fashions, artistic trends. U KNOW THE SCORE. "I can take their images for reality because I believe in the reality of their images (their image of reality)." WHOEVER CONTROLS THE METAPHOR GOVERNS THE MIND. The conditions of total saturation are slowly being realized—a creeping paralysis—from the trivialization of special/technical knowledge to the specialization of trivia. The INFORMATION WAR is a war we cannot afford to lose. The result is unimaginable.[8]

I find myself very much in sympathy with the author's critique of media here, yet I also feel that a demonization of "information" has been proposed which consists of nothing more than the mirror image of information-as-salvation. Again Baudrillard's vision of the Commtech Universe is evoked, but this time as Hell rather than as the Gnostic Hereafter. Bishop Hoeller wants everybody jacked-in and downloaded and the anonymous post-situationist ranter wants you to smash your telly, but both of them believe in the mystic power of information. One proposes the pax technologica, the other declares war. Both exude a kind of Manichaean view of Good and Evil, but can't agree on which is which. The critical theorist swims in a sea of facts. We like to imagine it also as our Maquis, with ourselves as the "guerilla ontologists" of its datascape. Since the nineteenth century the evermutating "social sciences" have unearthed a vast hoard of information on everything from shamanism to semiotics. Each "discovery" feeds back into social science and changes it. We drift. We fish for poetic facts, data which will intensify and mutate our experience of the real. We invent new hybrid "sciences" as tools for this process: ethnopharmacology, ethnohistory, cognitive studies, history of ideas, subjective anthropology (anthropological poetics or ethno-poetics), dada epistemology, etc. We look on all this knowledge not as "good" in itself, but valuable only inasmuch as it helps us to seize or to construct our own happiness.

In this sense we do know of "information as wealth"; nevertheless, we continue to desire wealth itself and not merely its abstract representation as information. At the same time we also know of "information as war";[9] nevertheless, we have not decided to embrace ignorance just because "facts" can be used like a poison gas. Ignorance is not even an adequate defense, much less a useful weapon in this war. We attempt neither to fetishize nor to demonize information. Instead we try to establish a set of values by which information can be measured and assessed. Our standard in this process can only be the body. According to certain mystics, spirit and body are "one." Certainly spirit has lost its ontological solidity (since Nietzsche, anyway) while body's claim to "reality" has been undermined by modern science to the point of vanishing in a cloud of "pure energy." So why not assume that spirit and body are one, after all, and that they are twin (or dyadic) aspects of the same underlying and inexpressible real? No body without spirit, no spirit without body. The Gnostic Dualists are wrong, as are the vulgar dialectical materialists. Body and spirit together make life. If either pole is missing, the result is death. This constitutes a fairly simple set of values, assuming we prefer life to death. Obviously I'm avoiding any strict definitions of either body or spirit. I'm speaking of "empirical" everyday experiences. We experience "spirit" when we dream or create; we experience "body" when we eat or shit (or maybe vice versa); we experience both at once when we make love. I'm not proposing metaphysical categories here. We're still drifting and these are ad hoc points of reference, nothing more. We needn't be mystics to propose this version of "one reality." We need only point out that no other reality has yet appeared within the context of our knowable experience. For all practical purposes, the "world" is "one."[10] Historically however, the body half of this unity has always received the insults, bad press, scriptural condemnation, and economic persecution of the spirit half. The self-appointed representatives of the spirit have called almost all the tunes in known history, leaving the body only a prehistory of primitive disappearance, and a few spasms of failed insurrectionary futility.

Spirit has ruled — hence we scarcely even know how to speak the language of the body. When we use the word information we reify it because we have always reified abstractions — ever since God appeared as a burning bush. (Information as the catastrophic decorporealization of "brute" matter.) We would now like to propose the identification of self with body. We're not denying that the body is also spirit, but we wish to restore some balance to the historical equation. We calculate all body hatred and world slander as our evil. We insist on the revival (and mutation) of "pagan" values concerning the relation of body and spirit. We fail to feel any great enthusiasm for the information economy because we see it as yet another mask for body hatred. We can't quite believe in the information war, since it also hypostatizes information but labels it "evil." In this sense, "information" would appear to be neutral. But we also distrust this third position as a lukewarm cop-out and a failure of theoretical vision. Every "fact" takes different meanings as we run it

through our dialectical prism[11] and study its gleam and shadows. The fact is never inert or neutral, but it can be both good and evil (or beyond them) in countless variations and combinations. We, finally, are the artists of this immeasurable discourse. We create values. We do this because we are alive. Information is as big a mess as the material world it reflects and transforms. We embrace the mess, all of it. It's all life. But within the vast chaos of the alive, certain information and certain material things begin to coalesce into a poetics or a way-of-knowing or a way-of-acting. We can draw certain pro tem conclusions, as long as we don't plaster them over and set them up on altars. Neither information nor indeed any one "fact" constitutes a thing-in-itself. The very word *information* implies an ideology, or rather a paradigm, rooted in unconscious fear of the silence of matter and of the universe. Information is a substitute for certainty, a left over fetish of dogmatics, a *super-stitio*, a spook. "Poetic facts" are not assimilable into the doctrine of information. "Knowledge is freedom" is true only when freedom is understood as a psycho-kinetic skill. Information is a chaos; knowledge is the spontaneous ordering of that chaos; freedom is the surfing of the wave of that spontaneity. These tentative conclusions constitute the shifting and marshy ground of our "theory." The TAZ wants all information and all bodily pleasure in a great complex confusion of sweet data and sweet dates — facts and feasts — wisdom and wealth. This is our economy — and our war. □

COMMON LAW FOR THE ELECTRONIC FRONTIER

Networked Computing Challenges the Laws that Govern Information and Ownership

▪ A n n e W . B r a n s c o m b

"Cyberspace," says John P. Barlow, computer activist and co-founder of the Electronic Frontier Foundation, "remains a frontier region, across which roam the few aboriginal technologists and cyberpunks who can tolerate the austerity of its savage computer interfaces, incompatible communications protocols, proprietary barricades, cultural and legal ambiguities, and general lack of useful maps or metaphors."

It looks much the same to the legal profession. As networks become less the toys of the console cowboys and more ubiquitous in the daily lives of ordinary computer users, a new breed of lawyers is trying to adapt existing laws to the electronic frontier.

The behavior of computer users in cyberspace, a term for electronic space coined by science fiction writer William Gibson, confounds the carefully honed skills of lawyers to make sense of the morass of new uses of information technology. The electronic environment of computer networks is marked by versatility, complexity, diversity, and extraterritoriality. All these characteristics pose challenges to the laws that govern generating, organizing, transmitting, and archiving information.

Today the exchange of information in a network can defy efforts to stop distribution by the very speed with which the deed is accomplished via satellites and optical fibers. In 1988 it took only a matter of hours for the Worm, a rogue computer program, designed by Cornell University graduate student Robert T. Morris, Jr., to circulate through and disable the Internet, the network used by scientists.

The ease with which electronic impulses can be manipulated, modified, and erased is hostile to a deliberate legal system that arose in an era of tangible things and relies on documentary evidence to validate transactions, incriminate miscreants, and affirm contractual relations. What have been traditionally known as letters, journals, photographs, conversations, videotapes, audiotapes, and books merge into a single stream of undifferentiated electronic impulses.

The complex environment and fluid messages make it difficult to determine which version of a document or electronic envelope is the draft or review or "published" copy. The diversity of inputs and outputs also makes it difficult to determine who is the author, publisher, republisher, reader, or archivist.

Under the 1976 revision of the Copyright Law, one must assume that any original work is protected by an unpublished copyright until published. Consequently, when precisely a work is published and under what proviso it is released are matters of considerable legal interest. Is the electronic record a copyrightable "writing"? If so, by an individual or a group? Suppose some members wish to extract portions of the conversation and transmit them to others. Would that constitute fair use or misuse?

Thus, the information industry, which has thrived on a convenient arrangement between vested interests of authors, publishers, and libraries, is now confronting a different economic environment. Computer users have greater freedom to reach out and draw from a digital environment chunks of data in different forms. It is difficult to sort out who is entitled to compensation or royalties from which use of data. Moreover, when a distributed network has multiple participants, it will be more complicated to determine who is entitled to claim recompense for value added.

Lawyers, for whom legal jurisdiction involves the statutory reach of persons residing within certain boundaries, are further confounded by the extraterritoriality (or nonterritoriality) of cyberspace. Electronic communities abound as nodes tied together in a network, be they independent computer bulletin boards or information network providers such as CompuServe, Prodigy Services Company, or the Electronic Information Exchange System (EIES).

The earliest global networks, such as the Society for Worldwide Interbank Financial Telecommunication (SWIFT), a system that transfers funds electronically, operate under very stringent rules to which member banks subscribe when entering the system. University network services are scurrying to set up their own codes of conduct in the aftermath of the Internet Worm. How these codes of conduct will mesh with local, state, and national laws will prove challenging.

A dialogue held on the Whole Earth 'Lectric Link (WELL), a computer network operated out of Marin County, California, by Stewart Brand of *Whole Earth Catalog* fame, suggests that "computer crackers" will push the outer limits of network security as long as any barrier exists to the free flow of information. A recent revolt of Prodigy subscribers protesting censorship of electronic messages indicates that users want more voice in determining the rules under which they will participate.

Yet what information should be free? Weather forecasts, perhaps news of impending disasters, epidemics, pests, volcanic eruptions? It is inconceivable that we should contemplate a society in which everybody must pay a meter to learn that a hurricane is on the way. But as more and more information is provided by the private rather than the public sector, the line between what is public and what is private blurs.

Moreover, the demarcation between public and private seems to change constantly. What was yesterday freely obtainable (network sporting events) comes today on a pay-as-you-go basis (on cable channels). Indeed, one obstacle to networked videotex services has been the reluctance of consumers to pay for information in electronic form when it is available in printed form at a lower cost.

The privatization and commercialization of information do not sit well with computer hackers, who look on computer networks as an open, sharing society in which the skilled contribute to the welfare of the cooperative. Yet, like the pioneers on the Western frontier, they are confronted by those who wish to fence in their private domains.

Many computer professionals, for example, have objected to the proprietary control of the user interfaces, which programmers need to design compatible and sometimes competitive products. One such group, known as the nuPrometheus League (for the Titan who stole fire from the gods and gave it to humankind), distributed some of the source code of Apple Computer's Macintosh to a variety of computer professionals.

The distribution was apparently a protest against aggressive litigation Apple had instigated against Hewlett-Packard Company and Microsoft Corporation. Apple claimed copyright infringement of its source code on the grounds that software sold by the defending companies appropriated the "look and feel" of its user interface.

The letter accompanying the distribution of the source code was signed "nuPrometheus League (Software Artists for Information Dissemination)" and stated: "Our objective at Apple is to distribute everything that prevents other manufacturers from creating legal copies of Macintosh. As an organization, nuPrometheus League has no ambition beyond seeing the genius of a few Apple employees benefit the entire world, not just dissipated by Apple through litigation and ill will."

Apple management, which had once encouraged the sharing of software on floppy disks to encourage the use of its computers, promised to prosecute "to the full extent of the law." It declared that those in possession of the code were recipients of stolen property and could be prosecuted under federal laws that prohibit mailing stolen property across state lines.

But U.S. law also has traditionally recognized that much information is freely available for all the world to take and develop as a shared resource. Indeed, the recent Supreme Court decision of *Feist Publications* v. *Rural Telephone Service Company* confirmed that the concept of shared information is alive and well.

In this case, an independent telephone company refused to license the use of its telephone directory to Feist Publications, which packaged wider-area directories. So Feist extracted the numbers, claiming they were facts that were not susceptible to copyright protection.

The Supreme Court agreed, putting to rest the labored efforts of a long line of lower courts that attempted to craft a "sweat of the brow" theory to cover the substantial investment made by data base providers in gathering, processing, packaging, and marketing their information products.

The application of intellectual property concepts to databases may become more complex as a result of the Feist decision. Under the copyright rubric, only original expression may be copyrighted, not facts or ideas. Computers can scan

pages of data, and, presumably, as long as they don't copy the exact organization or presentation or the software programs used to sort the information, they may not be infringing the copyright of the "compilation," the legal hook on which databases now hang their protective hats.

Unless Congress or the states clarify what in a database can be protected, information providers will have to continue to rely largely on contracts with their users. It is not entirely clear, however, whether a contract that appears momentarily on the screen prior to use is valid if the user has had no opportunity to negotiate the terms. Surely, information will not be shared with competitors unless some quid pro quo is offered or some eleemosynary motive is apparent. Giving away the fruits of intellectual labor without fair and equitable compensation is a policy not destined to survive the rigors of a marketplace economy.

At the other end of the spectrum of the debate over public and private information are the protesters who would like to control the distribution of personal information about themselves. As more computer networks come on-line, more users are becoming aware that personal data are being gathered and correlated for someone else's purposes. The regulation of transaction-generated information, such as the records from telephone calls or credit card purchases, is a legal nightmare waiting to happen.

This issue caught the public interest through the controversy over caller I.D., or automated number identification, which allows holders of "800" numbers — or anyone subscribing to the service — to read a caller's number from a video terminal. This feature permits marketers to greet callers by their first names but, more important, to correlate their names and addresses with purchasing habits.

In fact, the telephone number is fast becoming as least as important an identifier as the social security card or the diver's license number (which is one and the same in many states). Transaction-generated information can be mixed and matched with census data, postal codes, and such other publicly available information as automobile and boat registrations, birth registrations, and death certificates.

This information, which has long been available to small marketers at prohibitive costs from such large corporate information gatherers as Equifax Marketing Decision Systems, can provide precise profiles of poten-tial buyers. But when Equifax joined forces with Lotus Development Corporation to offer an inexpensive product called Lotus Marketplace, a set of optical disks containing data on 80 million households and more than 120 million individuals, 30,000 people wrote in to have their names removed from the database.

Yet that database is typical of the type of information that is available when credit cards or any electronically readable media are used to make a purchase. K-Mart Corporation, Sears, Roebuck and Co., and J. L. Hudson Company collect point-of-sale data from credit card customers and either reward frequent buyers or appeal to their tastes and buying habits. One of the most aggressive of the new

"relationship marketers" is Quaker Oats, which has a database of 35 million households to whom it sends discount coupons and tracks their redemption. Citicorp has been experimenting with a database of two million consenting customers who shop at supermarket chains across the country.

Clearly, the uproar over Lotus Marketplace, which caused it to be canceled, indicates that citizens are becoming apprehensive about the information about them that is being collected and correlated. Yet digital data are almost totally unregulated because they do not neatly fit into any of the legal boxes we have developed over the past 100 years. Traditionally the established laws governing communications apply specifically to mail, newspaper, cable television, and radio broadcasting, in their separate legal pigeonholes. Signals in a digital environment do not differentiate between voice, video, and data.

Already the lines between cable and broadcasting are becoming indistinct, as are the lines between what constitutes a common carrier (the telephone network) and a content provider (newspapers, journals, and books). The common carriers, such as Bell operating companies, are petitioning to become information providers as a quid pro quo for installing optical fiber to the home that will facilitate the fully digital and networked environment of the future.

Ironically, the telephone companies are being besieged by demands to exercise control over the obscenity and pornography offered on the "900" paid-access calls, as anxious parents deplore salacious conversations as well as excessive charges on their telephone bills. But in late 1990, when Prodigy, an on-line service owned by IBM and Sears, admitted to controlling the content of messages posted on electronic bulletin boards, it met with just the opposite reaction from users.

Prodigy was accused of censorship for curtailing an on-line discussion critical of its rates and for discontinuing several controversial computer conferences involving sexual preferences. The public debate blossomed into a full-fledged airing of the nature of open discussion on electronic media.

Prodigy contended that it had the right to screen public messages posted on bulletin boards and conferences, on the basis that it was similar to the Walt Disney Productions cable channel, a family service. Many users disagreed. They likened the electronic forums in which they participated to the coffeehouses of Paris or a street corner or a private gathering in one of their homes.

Indeed, electronic bulletin boards (many operated by individuals who allow access only to their friends) have grown up in an atmosphere of open, uninhibited discussion. The WELL, for example, operates under the assumption that each person owns and is responsible for whatever he or she says.

Whether the law will recognize such individual responsibility and control in electronic media remains to be seen. Nor is it certain that the law will absolve the network provider from liability for messages it allowed to be "published" or distributed. Indeed, there is considerable danger that the law will attempt to cover all electronic media under the same rubric without recognizing the vast diversity

of networks — and diverse forms of communication within the same service — that are currently developing, some within unique cultures.

Law enforcement agents are stepping up the efforts to arrest computer hackers, a term that has come to mean unscrupulous youngsters who wreak havoc with computer systems. In February 1990, members of a hacker group called the Legion of Doom were arrested and charged with breaking into the computers of BellSouth. Three of the targets later pleaded guilty to stealing a BellSouth text file for its 911 emergency telephone system.

Then, in May 1990, a two-year Secret Service operation called Sundevil culminated in 27 simultaneous searches in which 40 computer systems were seized. One indictment for publishing the information was dropped because the defendant's lawyer convinced the authorities that the material was already published. Others are still awaiting indictment without the return of equipment that was seized.

Sundevil precipitated an outcry from computer professionals that constitutional rights were being trampled on, and the electronic Frontier Foundation, devoted to protecting those rights, was established. The incident itself, however, is indicative of the confusion surrounding legal concepts that have survived the test of time in the noncomputer world but may not stand up to scrutiny in the electronic context.

Property has traditionally been something that can be transferred from place to place or person to person. Theft is defined as "depriving the owner of the use thereof." In an electronic environment, although a piece of software or a component of a database may be valuable, the intruder who accesses it without authorization is not depriving the owners or authorized users of its use, unless the data are maliciously destroyed or distorted.

Some forms of miscreant behavior, such as introducing a message bearing a virus into a network, may not be destructive. Still, they may clog the computer's memory, denying authorized users access to their data. Any unauthorized entry alarms network managers because they fear some undesirable and deleterious consequence.

A "hacker" law recently enacted in the U.K. makes unauthorized entry punishishable as a misdemeanor and entry with malicious intent a felony. In the U.S., several states have passed special legislation to expand their computer crime laws to cover the insertion of viruses and other rogue programs into software or network systems.

Proposed federal legislation would expand the Computer Fraud and Abuse Act of 1986 to cover "reckless disregard" for the consequences in addition to specific intent to cause damage or harm. There is also a move to enlarge the definition of venue. Such legislation would make it possible to try an alleged perpetrator in any state through which, from which, or into which some part of the transmission is found to have occurred.

Another potential legal issue surrounds the ability of computers to alter and distort data and images. With computerized capability to cut and paste images,

what you see may not be what actually took place. An incident that occurred in the weeks just before the election of November 6, 1990, in Massachusetts may be a harbinger of more widespread controversies. A popular Boston television journalist, Natalie Jacobson, interviewed the two contenders in the gubernatorial race. Both candidates, John Silber and William Weld, were filmed in their homes to let the viewers see the intimate sides of their characters and family lives.

During the interview, however, Silber berated the audience for denigrating those women who, like one of his daughters (as well as his wife), chose to dedicate their lives to the care of husband, home, and children. The implication of his comments was that working mothers who left children in day care were selfish and uncaring.

The outburst so ruffled working women, a large voting bloc, that the Weld campaign incorporated this segment into a political advertisement. The image of Silber, however, was enlarged and slightly distorted, so that he appeared more menacing than in the original shot. In addition, taking the conversation out of context made his words sound more threatening. The ad was widely criticized, and the Silber campaign took immediate action to have it withdrawn.

The incident raises interesting political as well as legal issues about the ease with which voice, data, and images can be downloaded and manipulated almost instantaneously for retransmission. Should a temporary restraining order have been available to prevent television stations from broadcasting the spot or would that have constituted prior restraint? Should Silber have a case against Weld for libel or slander? If so, what is the appropriate penalty, recompense, or sanction?

On the other hand, should the television station have a right of action against the Weld campaign or other broadcasters for copyright infringement for carrying an excerpt from a copyrighted newsmagazine? Should the television correspondent have a right of action against Weld for distorting the image or changing its context? Was the copying and rebroadcast of the segment a "fair use" of her work product?

Still other relatively unexplored legal territory surrounds the way companies conduct business over networks. A recent California case, *Revlon* v. *Logisticon, Inc.*, was the computer-age equivalent of shutting off the phones for nonpayment. On October 16, 1990, Logisticon, a software firm, brought the operations of Revlon, the cosmetics firm, to a dead halt by remotely disabling the software that managed the distribution of products from warehouse to retail stores. Logisticon justified the curtailment of service because Revlon had refused to make the next scheduled payment under its contract.

Logisticon's action, which was characterized by a Revlon vice president as "commercial terrorism," resulted in a loss of three days of activity at Revlon's main distribution centers. Revlon raced to court, accusing Logisticon of extortion, breach of contract, and trespass, among other complaints. Logisticon claimed a right to disable the software because Revlon had refused to honor the next payment.

The legal issues are myriad. Who "owned" the software installed within the business offices? Was the agreement a "purchase" of software or a "license" to use software? And does it make a difference? Did Logisticon act improperly by disengaging its software so precipitously, or was it acting within its legal rights in disabling the use of its proprietary product? Should it have disclosed to Revlon the existence of the remote capability to disable the software?

Even more important than the substance of legal issues that will arise from data networks is the question of what group will determine which laws or operating rules shall apply. Nowhere is this more clear than in the emergence of computer bulletin boards such as the WELL.

Without question, computer bulletin boards are an electronic hybrid, parts of which may be looked on as either public or private, depending on the desires of the participants. These are analogous to mail, conversations, journals, chitchat, or meetings. Under normal circumstances, this electronic environment might be considered more like a street corner where one is entitled to make informal remarks to one's intimate friends.

But many bulletin boards are accessed by users intent on "publication" for the record — scientists pursuing common interests in a research project, for instance. The cooperative writing may therefore have substantial historical, political, or scientific value as a publishable research paper or journal article or treatise or textbook.

A community is usually governed by its duly enacted laws, which represent the ethical values of the group. But what if the computer conference or electronic bulletin board crosses the borders of two or more states or nations? In that case, more than one legal system may apply with rules that differ within the separate legal dominions. Should the community's laws be those of the geographic or the electronic locus? If the latter, how should the laws be promulgated? Who should administer them? What sanctions should enforce them? What institutions are responsible for resolving disputes in the global information marketplace?

Cyberspace is a frontier where territorial rights are being established and electronic environments are being differentiated in much the way the Western frontier was pushed back by voyageurs, pioneers, miners, and cattlemen. And the entrepreneurs are arriving with their new institutions and information technology, in much the same way as the pony express and railroads pioneered communications networks during the nineteenth century.

Lawmaking is a complicated process that takes place in a larger universe than the confines of legislatures and courts. Many laws are never written. Many statutory laws are never enforced. Legal systems develop from community standards and consensual observance as well as from litigation and legislative determination. So, too, will the common law of cyberspace evolve as users express their concerns and seek consensual solutions to common problems. □

CONTEMPORARY NIHILISM
On Innocence Organized

■ *A D I L K N O G e e r t L o v i n k*

*When reflection has passed through into
infinitude, innocence is reestablished.*

—Heinrich von Kleist

With the emergence of a privileged mediocrity, the innocent life became accessible to the masses. No longer was Joe Average part of a class striving to historical ends (e.g., revolution or fascism); enter a cold era, now devoid of passion. While outside, storms raged and change rapidly followed change, one's own life was left to grind to a halt. Time, regardless of history, fashion, politics, sex, and the media, was to take its due course. The innocent made no fuss, they despised it. "Come what may." Average folks considered themselves cogs in some giant machine, and were proud to admit it. They saw to it the trains ran on schedule, and returned home at night in time for supper. Instead of the old barriers, such as caste, sex, and religion, innocence introduced such bromidae as tolerance, openness, and harmony. Positivism became lifestyle. Positivist critique served the reconstruction of politics and culture. Good times were had, one was busily and dynamically engaged and abundantly employed. A clear and simple view on reality reigned. The innocent did not incorporate the Good, they just hadn't a clue, though not lacking in standards. Crime was not for them. Thus, they involuntarily became the objects of strategies of Good and Evil.

We are talking about a life without drama, immediacy, *Entscheidung*. Things will never get hot. Nothing will ever have to be decided on. You don't need to break out, in order to be just you. Rock ye no boats. The innocent thrive on everyday ritual, it's what makes them happy. A failing washing machine suffices to drive one up the wall: the bloody thing just has to function. The plight against materiality is that it's always breaking down, failing, malfunctioning and generally behaving in odd ways, and that it cannot be quietly replaced. Untrammeled consumption holds a promise that from now on, nothing will ever happen. In this

undisturbed existence, luxury becomes so natural, it goes unnoticed. The innocent conscience is distinguished by its air of cramped grass-rootsiness, evoking a universe where personal irritations may explode without warning: time and again, streetlights, traffic jams and delays, bureaucratic hassles, bad weather, construction noises, diseases, accidents, unexpected guests and ditto incidents, comprise an assault on innocent existence. Nonetheless, one is caught up in uncalled-for events. This attitude of disturbance-deterrence, devoted to job and professional affairs, excludes all risk and has relegated to the attainable the status of sole criterion. The summum bonum of happiness consists of soft porn, moped, the new medium-priced car, one's own house and mortgage, interesting hobbies, club life, kids, elaborate birthdays of family members and friends, book clubs, Christmas cards, cross-stitched embroideries, ikebana, tending the garden, clean clothes, the biosphere of pets and indoor plants, guinea pigs, the rabbit in the yard, the pigeons in the attic, holiday destinations, dinners out, a bit of catching up or a general chat, Greenpeace membership, or tele-adoption through the Foster Parents Plan. This ideal of an unrippled and spotless life is characterized by an endearing pretense of being literally everybody's goal. Innocence is under constant treatment from doctors, therapists, beauticians, acupuncturists, and garage keepers. Innocence likes to be tinkered at. It considers it its duty to develop further and, if necessary, reeducate. Courses are taken, ADILKNO sessions participated in, the theater, concert halls, expos visited, books read, directions to forest walks followed, and martial arts actively engaged in. Innocence as a universal human right encompasses animals, plant life, architecture, landscapes, and cultural expression. This is the condition under which the world may be ultimately salvaged: neither utopian nor fatalistic, but smoothly functioning.

The advertisement campaigns accompanying this way of life appeal to the childlike joy of having one's accomplishments rewarded. Scenes of smiling dads and mums who can afford just anything. A reference to the authoritarian circumstances under which the child is raised to maturity and learns to talk. Innocence presupposes the enclosed security of family, school, company, and sports club. Under "infantile capitalism" (Asada), desire is tempted by the offer of a secure existence. By displaying good behavior, the ongoing changes in the vast world outside are assured not to cause any catastrophes. Rebellion is punished and virtually pointless. The household comprises a fortified oasis. The others are just like you, and moving from one cell to another you get the impression that life is swell. Surprises are solely permissible within well-acquainted constellations. The crush alone makes for a composed exception to the rule. In sex there may yet be room for assaults, with all that may imply. This is why the personal ad is such an innocent medium, having nothing to do with prostitution or moral decline whatsoever. The highlight of innocent existence consists of the wedding day, the happiest day of your life. Marriage is the one occasion in his/her existence on which Joe/Jill Average may dress up in all his/her decorations, and show themselves to the world at large. The

ordering of the wedding gown, the white or red worn for all to see, the bouquet, the bridegroom's shoes, the orchestra outside, the cabriolet or carriage, the cheering onlookers, the historical wedding room, the moving clergyman's speechlet, the standing ovation and gifts, the dinner at some fashionable restaurant, the subsequent feast till the small hours: no trouble or expenses are spared to create surroundings in which everybody ends up getting terribly pissed, yet never severely disgracing themselves. A day to remember in horror for the rest of your life, yet forever impossible to forget, a wound in your life, a mental tattoo ruthlessly inflicted by family members. Millions of couples shack up forever, just so they won't have to cope with this. The pressure lies in the fact that there is no option but for the whole thing to proceed smoothly, so that even if it does, any fun that might have been there is definitely out. The greater misery the night before, the bigger joy come wedding night. Afterwards, it's safe havens forever.

As innocence to a substantial degree consists of defense, it cannot remain neutral under the continuous outside threat facing it (thieves, rapists, hackers, counterfeiters, the incestuous, psychopaths, renegades, bacteria, missiles, toxic clouds, aliens, etc.). Neither can it summon any childlike curiosity concerning events in the outside world. Innocence's protective coating mirrors any threat posed by its environment, thus causing it to take on an aura of organization. The Mafia, youth gangs, criminal conspirators, sects, drug cartels, banditry, pirates are all thought to be after mediocrity's naïveté. They're omnipresent spooks. Before you know, you may be involved, guilty of, or victimized by, fraud. Innocence, desperate to turn its head, to pretend that nothing's the matter, threatens to succumb. Ignorance may prove fatal, a more practical strategy consists of localizing and channeling attacks. Hand out to each individual an electronic guarantee of innocence and sooner or later any felon will end up in some specialist jail. In fact, innocence shouldn't need any legitimization, all this registration and surveillance merely causes it to lose its aura. Everyone is a potential illegal immigrant; even though the contrary may be proven, one remains a risk factor. At the present phase, escape in anonymity becomes daily more dangerous and undesirable. Neutrality thus appears a chosen isolation, the final outcome of which is grotesque exclusion. Those who aren't thoroughly online can make no appeals to organized innocence's compassion.

Organized innocence is obsessed with Evil, gazing at and dissecting it, categorizing and exposing it, in order to finally bypass it altogether. Innocence owes its existence to its seeming opposite. One cannot confess innocence, for every confession must needs be one of guilt, any gesture a false pose pertaining to goodness itself. Everybody is informed to start with, everyone knows all about the next person and there's a silent agreement that some things are best left unsaid. The innocent are discreet and do not interfere with certain hidden domains (of power, of lust, of death). No boundary violations here. Holidays may offer some compensation, but everything has its season. Next of kin are those causing maximum annoyance. They are parsimonious neighbors, noisy kids, funny

couples. First annoyances are quickly made emblems, forever there to fall back on. The others are scrutinized distrustfully, a form of surveillance which it is impossible to sanction since there no longer exists any common intercourse defining a norm. Normality can no longer define any aberration. Only drug-related nuisance, streetwalkers' districts and cribs, travelers' sites and refugees' centers may now temporarily unite citizens in mobs, for fear of declining property values. This neighborhood resistance is not ideologically motivated, one simply never gets down to the point of formulation of transferable ideas. The neighbors are doing model airplanes, oneself preferring Pierre Boulez, what room is left for any exchange? There is more to separate us than mere garden fences. Therefore, too, accusations of racism or discrimination are off the mark here. There isn't any moral order to deteriorate into bigotry.

Stereotypes get blurred. No one knows what a Jew might look like, or what distinguishes Turks from Moroccans ("All Turks go by the name of Ali"). The other's features don't stick, because one has no sense of identity oneself. So much for pc advertising, public-information campaigns, even cookbook recipes. Multiculturalist society is a clash of featureless citizens and the heirs to identities. There is a severe misunderstanding with the Innocent concerning the Other come from afar. There is a great readiness to accept the concept of differing cultures. They're assumed to function in the same type of isolation as ours. Who would wish to visit upon another a dull life like our own, culminating as it does in likewise padded solitude? Tolerance means envy of the other's simplicity. Friday rounds are not considered backward (as were once the strictly Reformed), but as proof of a devotion and consistency no longer available to oneself. The suburbs are polytheistic: everything is believed in. There is more than what's been taught you at school — but what? Seeking, one has found, but anxiety remains as to what more is gonna show up. Gurus, healing stones, skyward apparitions, voodoo, and encounters all slip past, without one having ever a chance of sharing these experiences. For a moment, one gets the impression that there's quite a bit going on, that the surrounding world is full of deep acquaintances, of promises and optimistic prospects. Before long, one finds oneself alone with all the acquired experiential cross-country attributes, the textbooks, perfumed oils, the dandy windbreaker the two of us bought together, remember, the empty personal organizer, and holiday picture albums. What macrosocial guiding principle may dissolve all this weeny human suffering, will resolve our confusion? Where are they, the builders of this new state of affairs, amidst and around us? The refugee, as a cultural carrier, may prove prophetic. Ultimately, it is they who reintroduce to us our exiled spirituality, so sought-after in the West.

Innocence may be lost through committing murder, participating in a little S&M, joining a bikers' club, opting for art, going under cover, yet the underworld of entertainment offers no consolation. One final option much in vogue consists of defecting to the war or genocide. There can, however, be no refuge from the

conglomerate and its diktata. The Mountain Bike, T-shirt, Olilly clothing, compu games, graffiti, bumper sticker, spoiler, cap, sloppy casual wear, hair gel are all the "*objets nomades*" of Jacques Attali's Europe heading for a stylized uniformity. Innocence cannot be negated, or compensated for, by its opposite. The one thing it can't stand is party poopers. This process of decomposition within normality offers no alternative and puts up no fight, nor even does it make a point. Through it, innocence is exhausted. One cannot be spritely and happy all day, forever tearing asunder the grime by constructive thinking. Innocence is not in danger of being wiped out by either revolution or reaction. It can only wither, go under in poverty, slowly vanish out of sight, as though meant to waste away. Grounded love affairs are resolved by ordering a dumpster in which one's accumulated innocence is disposed of, in order to make a cleaner, wilder start after interior redecoration procedures. A generation before, the politicization of the private managed to get some innocence out the front door, but it's regrouped with a vengeance and now has grunge rockers, generation X-ers, trance freaks, and other youth categories all searching in vain for some firm footing they can react against in some other format than that of fashion or the media, innocence's latest organizational modes. Government itself is now the most outspoken antiracist, antisexist, antifascist, antihomelessness, and generally anti-anything the well-intended insurrectionists are liable to oppose. The one thing left for innocent younger generations to vent their anger on is all forms of organized innocence itself. Abundant material for grounding an enormous social movement, to start working at innumerable separate issues, in order to discover a common grounds in all those disparate little divisions. Boycott insurance companies, raid those self-assured infant clothing shops, torch the redundant gift stores — we've a consumers' paradise to destroy! But let's not get excited. We'll have innocence fade away, see it quiet down. Tell you what, we'll not even mention it. □

ADILKNO, the Foundation for the Advancement of Illegal Knowledge (a.k.a. BILWET), Amsterdam, 1995.

TRANSLATED FROM DUTCH BY SAKHRA BEY LA-BEY/ZIEKEND ZOELTJES PRODUKTIES, AMSTERDAM, 1995.

Base pairs

Old strand

Old strand

The Flesh Machine
Wants Your DNA

New strand

New strand

THE COMING OF AGE
OF THE FLESH MACHINE

■ *Critical Art Ensemble*

Over the past century, the two machines that comprise the state apparatus have reached a level of sophistication that neither is likely to transcend. These complex mechanisms — the war machine and the sight machine — will go through many generations of refinement in the years to come; for the time being, however, the boundaries of their influence have stabilized.

The war machine is the apparatus of violence engineered to maintain the social, political, and economic relationships that support its continued existence in the world. The war machine consumes the assets of the world in classified rituals of uselessness (for example, missile systems that are designed never to be used, but, rather, to pull competing systems of violence into high-velocity cycles of war-tech production), and in spectacles of hopeless massacre (such as the Gulf War). The history of the war machine has generally been perceived in the West as history itself (although some resistance to this belief began during the nineteenth century). And while the war machine has not followed a unilinear course of progress, due to disruptions by moments of inertia caused by natural disasters or cultural exhaustion, its engines have continued to creep toward realizing the historical construction of becoming the totality of social existence. Now it has reached an unsurpassable peak — a violence of such intensity that species annihilation is not only possible, but probable. Under these militarized conditions, the human condition becomes one of continuous alarm and preparation for the final moment of collective mortality.

The everpresent counterpart of the war machine is the sight machine. It has two purposes: to mark the space of violent spectacle and sacrifice, and to control the symbolic order. The first task is accomplished through surveying and mapping all varieties of space, from the geographic to the social. Through the development of satellite-based imaging technologies, in combination with computer networks capable of sorting, storing, and retrieving vast amounts of visual information, a wholistic representation has been constructed of the social, political, economic, and geographical landscape(s) that allows for near-perfect surveillance of all areas, from the micro to the macro. Through such visualization techniques, any situation or population deemed unsuitable for perpetuating the war machine can be targeted for sacrifice or for containment.

The second function of the sight machine, to control the symbolic order, means that the sight machine must generate representations that normalize the state of war in everyday life, and which socialize new generations of individuals into their machinic roles and identities. These representations are produced using all types of imaging technologies — as low-tech as a paint brush and as high-tech as a supercomputer. The images are then distributed through the mass media in a ceaseless barrage of visual stimulation. To make sure that an individual cannot escape the imperatives of the sight machine for a single waking moment, ideological signatures are also deployed through the design and engineering of all artifacts and architectures. This latter strategy is ancient in its origins, but with the velocity and the absence of spatial restrictions in the mass media, the sight machine now has the power to systematically encompass the globe in its spectacle. This is not to say that the world will be homogenized in any specific sense. The machinic sensibility understands that differentiation is both useful and necessary. However, the world will be homogenized in a general sense. Now that the machines are globally and specifically interlinked with the ideology and practices of pancapitalism, we can be certain that a hyper-rationalized cycle of production and consumption, under the authority of nomadic corporate-military control, will become the guiding dynamic of the day. How a given population or territory arrives at this principle will be open to negotiation, and is measured by the extent to which profit (tribute paid to the war machine) increases within a given area or among a given population.

In spite of the great maturity of these machines, a necessary element still seems to be missing. While representation has been globally and rationally encoded with the imperatives of pancapitalism, the flesh upon which these codings are further inscribed has been left to reproduce and develop in a less than instrumental manner. To be sure, the flesh machine has intersected both the sight and war machines since ancient times, but, comparatively speaking, the flesh machine is truly the slowest to evolve. This is particularly true in the West, where practices in health and medicine, genetic engineering, and the development of recombinant organisms have thoroughly intersected with nonrational practices (particularly those of the spirit). Even when they were secularized after the Renaissance, these practices have consistently been less successful, when compared to their counterparts, in insuring the continuance of a given regime of state power. Unlike the war machine and the sight machine, which have accomplished their supreme tasks — the potential for species annihilation for the former, and global mapping and mass distribution of ideologically coded representation for the latter — the flesh machine has utterly failed to concretize its imagined world of global eugenics.

The simple explanation for the flesh machine's startling lack of development is cultural lag. As the West shifted from a feudal to a capitalist economy, rationalizing the benefits of production in regard to war was a relatively simple task. National wealth and border expansion were clearly marked and blended well with the trace leftovers of feudal ideology. Manifest destiny, for example, did not

stand in contradiction to Christian expansionism. War, economy, politics, and ideology (the slowest of social manifestations to change) were still working toward a common end (total domination). The rationalization of the flesh, however, could not find a point of connection with theologically informed ideology. Flesh ideology could only exist as two parallel rather than as intersecting tracks. For this reason it is no surprise that one of the fathers of flesh-machine ideology was a man of God. The work of Thomas Malthus represents the ideological dilemma presented to the flesh machine on the cusp of the feudal/capitalist economic shift.

Malthus argued that the flesh did not have to be rationalized through secular engineering, since it was already rationalized by the divine order of the cosmos designed by God Himself. Although the nonrational motivation of original sin would guarantee replication of the work force, God had placed natural checks on the population, so only those who were needed would be produced. The uncivilized lower classes could be encouraged to have as many children as possible without fear that the population would overrun those in God's grace, because God would sort the good from the bad through famine, disease, and other natural catastrophes. For this reason, the flesh could be left to its own means, free of human intervention, and human progress could focus on fruition through economic progress. Spencerian philosophy, arriving half a century later, complemented this notion by suggesting that those fit for survival would be naturally selected in the social realm. The most skillful, intelligent, beautiful, athletic, etc., (whatever traits were desired by the war machine) would be naturally selected by the structure of the society itself — that of "open" capitalist competition. Hence the flesh machine was still in no need of vigorous attention; however, Spencer did act as a hinge for the development of eugenic consciousness by constructing an ideological predisposition for conflating natural and social models of selection (the former arrived a decade or so after Spencer's primary theses were published). This made it possible for genetic engineering to become a naturalized social function, intimately tied to social progress without being a perversion of nature — in fact, it was now a part of nature. At this point eugenic consciousness could continue to develop uninterrupted by feudal religious dogma until its traces evaporated out of capitalist economy, or until it could be better reconfigured to suit the needs of capitalism. While the idea of a eugenic world continued to flourish in all capitalist countries, and culminated in the Nazi flesh experiment of the 1930s and early 1940s, the research never materialized that would be necessary to elevate the flesh machine to a developmental level on a par with the war machine.

Perhaps there is an even simpler explanation. Large-scale machinic development occurs at the pace of one machine at a time, since scarce resources allow for only so much indirect military research. After the war machine came to full fruition during World War II, along with the attendant economic expansion, it became possible to allocate a generous helping of excess capital for the expansion of the next machine. In this case, it was the sight machine that had proved its value during the

war effort with the development of radar and sonar, and thereby jumped to the front of the line for maximum investment. It was also clearly understood at this point that global warfare required new attention to logistic organization. The road between strategic and tactical weapons and logistical needs had leveled out, and this realization also pushed the sight machine to the front of the funding line. Conversely, the need of the Allied powers to separate themselves ideologically as far as possible from Nazi ideology pushed the desired development of the flesh machine back into the realm of nonhuman intervention. Consequently, the alliance between the war machine and the sight machine continued without interruption, delivering increasingly sophisticated weapons of mass destruction. This alliance also gave rise to an ever more enveloping visual/information apparatus — most notably satellite technology, television, video, computers, and the Net.

While the war machine reached relative completion in the 60s, the sight machine did not reach relative completion until the 80s (die-hard web-users might want to argue for the 90s). Now a third machine can claim its share of excess capital, so the funds are flowing in increasing abundance to a long-deferred dream. The flesh machine is here. It has been turned on, and, like its siblings the war machine and the sight machine, it cannot be turned off. As to be expected, elements of the sight and war machines are being replicated in the construction of the flesh machine. It is these moments of replication that are of interest in this essay.

A BRIEF NOTE ON SCIENTIFIC IMAGINATION, ETHICS, AND THE FLESH MACHINE

In the best of all possible worlds, ethical positions relevant to the flesh machine would be primary to any discussion about it. Indeed, to read the literature on the flesh machine (which at this point is dominated by the medical and scientific establishments), one would think that ethics is of key concern to those in the midst of flesh-machine development; however, nothing could be further from reality. The scientific establishment has long since demonstrated that when it comes to machinic development, ethics have no real place other than their ideological role as spectacle. Ethical discourse is not a point a of blockage in regard to machinic development. Take the case of nuclear weapons development. The ethical argument that species annihilation is an unacceptable direction for scientific inquiry should certainly have been enough to block the production of such weaponry; however, the needs of the war machine rendered this discourse silent. In fact, the need of the war machine to overcome competing machinic systems moved nuclear weapons development along at top velocity. Handsome rewards and honors were paid to individuals and institutions participating in the nuclear initiative. In a word, ethical discourse was totally ignored. If big science can ignore nuclear holocaust and species annihilation, it seems safe to assume that concerns about eugenics or any of the

other possible flesh catastrophes are not going to be very meaningful in its deliberations about flesh-machine policy and practice. Without question, it is in the interest of pancapitalism to rationalize the flesh, and it is in the financial interest of big science to see that this desire manifests itself in the world.

Another problem with machinic development could be the institutionally contained Panglossian reification of the scientific imagination. Consider the following quote from Eli Friedman, president of The International Society for Artificial Organs (ISAO), in regard to the development of artificial organs:

> Each of us attempting to advance medical science — whether an engineer, chemist, theoretician, or physician — depends on personal enthusiasm to sustain our work. Optimistic, self-driven investigators succeed beyond the point where the pessimist, convinced that the project cannot be done, has given up. Commitment to the design, construction, and implanting of artificial internal organs requires a positive, romantic, and unrestrained view of what may be attainable. Members of our society share a bond gained by the belief that fantasy can be transformed into reality.

and:

> ISAO convenes an extraordinary admixture of mavericks, "marchers to different drums," and very smart scientists capable of converting "what if" into "why not."

These lovely rhetorical flourishes primarily function to rally the troops in what will be a hard-fought battle for funding. It's time to move fast (the less reflection the better) if the AO model is to dominate the market; after all, there is serious competition from those who believe that harvesting organs from animals (transgenic animals if need be) is the better path along which to proceed. But it is the subtext of such thinking that is really of the greatest interest. From this perspective, science lives in a transcendental world beyond the social relationships of domination. If something is perceived as good in the lab, it will be good in the world, and the way a scientist imagines a concept or application to function in the world is the way it will in fact function. The most horrifying notion, however, is the idea (bred from a maniacal sense of entitlement) that "if you can imagine it, you may as well do it," as if science is unconnected to any social structures or dynamics other than utopia and progress.

Perhaps the only hope is that the funding and the optimism will become so excessive that they will undermine machinic development. The Strategic Defense Initiative, or "Star Wars," is a perfect example of incidental resistance from the scientific establishment. During the Reagan-era bonanza for war-machine funding, the most ludicrous of promises were made by big science in order to obtain research funds. The result was a series of contraptions that epitomize the comedy of science. Two of the finest examples are the rail gun that self-destructed upon launching its pellet projectile, and the deadly laser ray that had a range of only three

feet. While the American taxpayers might see red over the excessive waste, a major section of the scientific establishment was apparently distracted enough by the blizzard of money that they failed to make any useful lethal devices.

IF I CAN SEE IT, IT'S ALREADY DEAD

The war machine and the sight machine intersect at two key points—in the visual targeting of enemy forces (military sites, production sites, and population centers), and in visualizing logistical routes. Once sited and accurately placed within a detailed spatial grid, the enemy may be dispatched at the attacker's leisure, using the most efficient routes and means of attack. As long as the enemy remains invisible, determining proper strategic action is difficult, if not impossible. Hence any successful offensive military action begins with visualization and representation. A strong defensive posture also requires proper visual intelligence. The better the vision, the more time available to configure a counterattack. The significant principle here—the one being replicated in the development of the flesh machine—is that vision equals control. Therefore the flesh machine, like its counterparts, is becoming increasingly photocentric.

Not surprisingly, much of the funding for the flesh machine is intended to develop maps of the body and to design imaging systems that will expedite this process (of which the Human Genome Project is the best-known example). From the macro to the micro no stone can remain unturned. Every aspect of the body must be open to the vision of medical and scientific authority. Once the body is thoroughly mapped and its mechanistic splendor revealed, any body invader (organic or otherwise) can be eliminated, and the future of that body can be accurately predicted. While such developments sound like a boon to humanity, one need not be an expert in the field to be skeptical of their prospects.

While it is hard to doubt the success of the war machine in reducing military activity to the mechanized (that is, fully rationalized structures and dynamics), it is questionable whether the body can be reduced to a similar state regardless of how well it is represented. One major problem is that the body cannot be separated from its environment, since so many of its processes are set in motion by environmental conditions. For example, a toxic environment can produce undesirable effects in the body. Visual representation alerts medicine to an invasion, so action can be taken to contain or eliminate the invader. In this situation, medicine is reactive rather than preventive, and treats only the effect and not the cause. In fact, it diverts causality away from ecological pathologies, and reinvests it back in the body. In this manner, medicine becomes an alibi for whatever created the toxic situation that infected the body in the first place, by acting as if the infectant emerged internally. The problem raised here is the limited frame of representation in regard to the body map, in conjunction with an

emphasis on tactical solutions to physical pathologies. This situation is, of course, understandable, since strategic action would have an undermining effect on the medical market. The one exception to this rule is when the toxic body emerges due to behavioral factors. In this case, the scientific/medical establishment can expand its authority over the body by suggesting and often enforcing behavioral restrictions on patients. In this situation, the science and medical establishment functions as a benevolent police force deployed against individuals to better mold them to the needs of the state.

To complicate matters further, flesh-machine science and medicine have the unfortunate but necessary habit of putting the cart before the horse. The flesh machine, unlike its counterparts, does not have the luxury of developing its visual and weapons systems simultaneously, nor can weapons development precede advanced visual capabilities. The visual apparatus must come first. For example, antibiotics probably could not have been invented before the development of a microscope. Consequently, as in most research and development, a scattershot method is employed, whereby all varieties of vision machines are developed in the hopes that a few may be of some use. This leads to thrilling headlines like the following from Daniel Haney of the Associated Press: "Brain Imagery Exposes a Killer." What this headline refers to is a new medical map, acquired through the use of positron-emission tomography, which reveals the part of the brain affected by Alzheimer's disease, and the degree to which the brain has been eroded by the disease. This map can help physicians to diagnose Alzheimer's up to ten years before symptom onset. The comedy begins with the admission that there is no way to predict when symptoms will begin to appear, and that there is still no known treatment for the disease. All that medical science can do is tell the patient that she or he has the disease, and that she or he will be feeling its effect sometime in the future. The excitement over being able to visualize this disease comes from the belief that if the disease can be seen, then cure is near at hand. Or, in the words of the war machine, "If I can see it, it's already dead."

Since the process of visualization and representation in this case is at best only an indication of a far-off possibility for cure, and hence is of little use for the patient already diagnosed with the disease, it must be asked: who could benefit from this information? Alzheimer's is in fact doubly problematic because it can be visualized before symptom onset, and because genetic mapping can also be used to indicate an individual's likelihood of developing it. The flesh machine's intersection with the surveying function of the sight machine becomes dramatically clear in this situation. Those who would benefit most from this information are insurance companies and the employer of the person likely to be afflicted with the ailment. Such information could be a tremendous cost-cutting device for both. However, ethical discussions about collecting bio-data lead one to believe that this kind of information would remain confidential in the doctor-patient relationship. Perhaps privacy will be maintained. However, it seems more likely that if the information is perceived to lead

to significantly higher profits, resources will be allocated by corporate sources to acquire it. The most common strategy to watch for is legislative initiatives pursued under the spectacle of benevolence. Mandatory drug testing for some in private and public employment, under the authority of employee and public security, is an example of the means by which privacy can be eroded.

Finally there is the problem of representation itself. As the war machine demonstrates, the greater the visualization of a frontier territory, the greater the degree of contestation at the visualized sight. In other words, the more that is seen, the more power realizes what needs to be controlled and how to control it. The brain is certainly going to be the key target, but happily, at this point, the research is too immature to warrant strategic intervention by state power. There are, however, good indicators of how the coming battle will take shape. One needs only to think of the visualization of the body and its connection to varieties of smoking bans (from the legalistic to the normative), or, in terms of populist countersurveillance, of the relationship between toxins (DDT, for example) in the environment to body visualization to understand the connection between vision, discipline, and contestation. The prize-winner, however, is the visualization of uterine space. Feminist critics have long shown how this point of ultra-violent contestation is but the beginning of the age of flesh-machine violence. (This is also a point of great hope, as the discourse of the flesh machine has been appropriated from the experts. At the same time, this conflict has shown how fascist popular fronts are just as adept at appropriation). In regard to uterine space, feminist critics have consistently pointed out that this variety of representation loads the ideological dice by presenting the space as separate from the wholistic bio-system of the woman, thus reinforcing the notion of "fetal space." This idea acts as a basis for "fetal rights," which are then argued as taking precedence over the rights of women.

A new era of bio-marginality has surely begun. Certainly this situation will only be reinforced by the visualization of diseases or abnormalities (actual or potential) in subjects soon to be classified under the sign of the unfit. The unfit will be defined in accordance with their utility in relationship to the machine world of pancapitalism. The mapped body is the quantified body. Its use is measured down to the penny. Without such a development, how could any consumer have trust in the markets of the flesh machine?

SELLING FLESH

One of the oldest manifestations of the flesh machine is the idea of engineering the breeding of plants and livestock to produce what are perceived to be the most functional products within a given cultural situation. Increased knowledge about this task has certainly contributed to the great abundance in the food supply in the first world, thus shifting an individual's relationship to food from one of need to

one of desire. In light of this achievement, industrial food producers have been faced with the task of developing foods that meet the logistical demands of broad-based distribution, while still maintaining a product that the manufacturer can market as desirable. The most productive solution thus far is the manufacture of processed foods; however, the market for food cannot be limited to processed food. The desire for perishable foods is too deeply etched into the culture, and no amount of spectacle can root out this desire. Fortunately for the producers of perishable foods, the product and the market can be rationalized to a great extent. This particular market is of interest because it provides at this moment the best illustration of the market imperatives that are being replicated in the industrial production and distribution of human flesh products. (This is not to say that flesh production will not one day be more akin to processed food; it is only to argue that at present the means of production are still too immature.)

To better illuminate this point, consider the case of apples. At the turn of the century, there were dozens of varieties of apples available to the buying public. Now, in many places, when a consumer cruises through a supermarket in search of apples, the choice has been limited to three (red, green, and yellow). Choice has become increasingly limited partly because of logistical considerations. Like most perishable fruits and vegetables these days, apples are bred to have a long shelf life. In order to have apples all year round, they must be transported from locations that have the conditions to produce them when other locations are unable to. Hence these apples must be able to survive an extended distribution process, and not all varieties of apples are capable of resisting rotting for long periods of time. However, logistics alone does not adequately explain choice limitations. Perhaps more important to the formula are market considerations.

Marketing agencies have understood for decades that desire is intensified most through visual appeal. How a product looks determines the probability of a con-sumer purchase more than any other variable. For apples, the consumer wants brightly colored surfaces, a rounded form, and white inner flesh. In other words, consumers want the perfect storybook apple that they have seen represented since they were children. Apples are bred to suit the cultural construction of "an apple," and only a few varieties of apples can simulate this appearance and meet this desire. This situation is yet another example of Baudrillard's universe of platonic madness, where consumers are caught in the tyranny of representation that passes as essence.

Along with the domination of vision, there comes the need of the producer to offer the consumer a reliable product. The apples one buys tomorrow have to look and taste like the ones bought today. Consequently, there is an elimination of sense data other than the visual. If all that is needed to excite desire is appearance, why bother to develop taste and smell? Especially when a good product can be guaranteed if it is completely tasteless (one can be sure that the apple purchased tomorrow will taste like the one purchased today). In this situation, the tyranny of the image becomes glaringly apparent; one would think that smell and taste

would be the dominating senses when buying foods, since they would best articulate the pleasure of consumption. Not so. It is vision, and unfortunately many of the tastiest apples do not look very good, because they have none of the necessary storybook appeal. Consequently, various types of apples have been eliminated, or limited to distribution in localized markets.

If the principles of product reliability and visual appeal are applied to the production/consumption components (as opposed to those concerned with control) of the flesh machine, the reasons for some recent developments become a little clearer. The first problem that flesh producers must face is how to get a reliable product. At present too little is known about genetic processes to fulfill this market imperative. Consequently, they have had to rely on fooling the naive consumer. For example, one characteristic commonly sought after by those in the techno-baby market is intelligence. Unfortunately this characteristic cannot be guaranteed; in fact, flesh producers haven't the slightest idea how to replicate intelligence. However, they can promise breeding materials from intelligent donors. While using the sperm of a Nobel Prize winner in no way guarantees a smart child (it doesn't even increase the probability, nor does it decrease the probability of having a below-average child), flesh dealers are able to use false analogies to sell their products. If two tall parents have a child, the probability of the child being tall is increased, so, the argument goes, wouldn't it be correct to say that if two people of above average intelligence have a child that it would increase the probability that the child will have above average intelligence? Many consumers believe this line of thought (the myth of hard genetic determinism has always been very seductive) and are therefore willing to pay higher prices for the sperm of an intelligent man than they are for the sperm of an average donor. Although this fraud will probably not continue indefinitely in the future, an important ideological seed is being sown. People are being taught to think eugenically. The perception is growing that in order to give a child every possible benefit in life, its conception should be engineered.

Another common strategy to better regulate flesh products is to take a genetic reading of the embryo while still in the petri dish. If a genetic charac-teristic is discovered that is deemed defective, the creature can be terminated before implantation. Again, parents-to-be can have their eugenic dreams come true within the limits of the genetic test. Even parents using the old-fashioned method of conception have the option of visualization (sonar) to make sure that the desired gender characteristic is realized. In each of these cases, better visual-ization and representation, along with an expanded range of genetic tests, will help to insure that desired characteristics are always a part of the flesh product, which leads to the conclusion that better vision machines are as important for profit as they are for control.

At the same time, remember that the marketing practices of postmodernity do not wholly apply to the flesh machine, and at present tend to function on an as-

needed basis. Fertility clinics, for example, participate as much in the economy of scarcity (although it must be noted that these products and processes do not intersect the economy of need) as they do in the economy of desire. While they may use the practices described above, they also have the luxury of being the only option for those who have been denied the ability to produce flesh materials. Those clinics that can boast a product success rate of over 20 percent (most notably the Center for Reproductive Medicines and Infertility at New York Hospital-Cornell Medical Center, with a success rate of 34 percent) cannot meet the demand for their goods and services. Apparently, the market for flesh goods and services has been preconstructed in the bio-ideology of capitalism.

WHEN WORLDS COLLIDE

Assuming that the flesh machine is guided by the pancapitalist imperatives of control and profit, what will occur if these two principles come into conflict with one another? This has been known to happen as social machines march toward maturity. The sight machine is currently facing this very contradiction in the development of the Net. Currently the Net has some space that is relatively open to the virtual public. In these free zones, one can get information on anything, from radical politics to the latest in commodity development. As to be expected, a lot of information floating about is resistant to the causes and imperatives of pancapitalism, and from the perspective of the state is badly in need of censorship. However, the enforcement of limited speech on the Net would require measures that would be devastating to on-line services and phone-service providers, and could seriously damage the market potential of this new tool. (The Net has an unbelievably high concentration of wealthy literate consumers. It's a market pool that corporate authority does not want to annoy.) The dominant choice at present is to let the disorder of the Net continue until the market mechanisms are fully in place, and the virtual public is socialized to their use; then more repressive measures may be considered. Social conservatism taking a back seat to fiscal conservatism seems fairly representative of pancapitalist conflict resolution. The question is, will this policy replicate itself in the flesh machine?

A good example to evaluate with regard to this issue is the ever-elusive "gay gene," always on the verge of discovery, isolation, and visualization. Many actually anxiously await this discovery to prove once and for all that gayness is an essential quality and not just a "lifestyle" choice. However, once placed in the eugenic matrix this discovery might elicit some less positive associations. In the typical alarmist view, if the gene comes under the control of the flesh machine, then it will be eliminated from the gene pool, thus giving compulsory heterosexuality a whole new meaning. Under the imperative of control this possibility seems likely; however, when the imperative of marketability is considered, a different scenario emerges.

There may well be a sizable market population for whom the selection of a gay gene would be desirable. Why would a good capitalist turn his back on a population that represents so much profit, not to mention that gay individuals as a submarket (CAE is assuming that some heterosexuals would select the gay gene too) must submit to the flesh machine to reproduce? Again, market and social imperatives come into conflict, but it is unknown which imperative will be selected for enforcement.

The example of the "gay gene" at least demonstrates the complexity of the flesh machine, and how difficult the task of analyzing this third leviathan will be. What is certain is that the flesh machine is interdependent with and interrelated to the war machine and the sight machine of pancapitalism, and that it is certainly going to

intensify the violence and the repression of its predecessors through the rationalization of the final component (i.e., the flesh) of the production/consumption process. Until maps are produced for the purpose of resistance and are crossed-referenced through the perspectives of numerous contestational voices, there will be no way, practical or strategic, to resist this new attack on liberationist visions, discourse, and practice. ☐

NOTES

<u>TIMOTHY DRUCKREY</u>

Introduction

1. Friedrich Kittler, "Unconditional Surrender," in *Materialities of Communication*, Hans Ulrich Gumbrecht and K. Ludwig Pfeiffer, eds., (Stanford, CA: Stanford University Press, 1994), p. 328.
2. Friedrich Kittler, "Conversation between Peter Weibel and Friedrich Kittler," in Peter Weibel, *On Justifying the Hypothetical Nature of Art and the Non-Identicality Within the Object World* (1992), p. 169.
3. Steven J. Heims, *John von Neumann and Norbert Wiener: From Mathematics to the Technologies of Life and Death* (Cambridge, MA: MIT Press, 1980), p. 291.
4. N. Katherine Hayles, "Boundary Disputes: Homeostasis, Reflexivity, and the Foundations of Cybernetics," in *Virtual Realities and Their Discontents*, Robert Markley, ed., (Baltimore, MD: Johns Hopkins University Press, 1996), pp. 18, 13.
5. See Jonathan Crary, *Techniques of the Observer: On Vision and Modernity in the Nineteenth Century* (Cambridge, MA: MIT Press, 1990) and Martin Jay "Scopic Regimes of Modernity," in *Vision and Visuality*, Hal Foster, ed., (Seattle: Bay Press, 1988).
6. Michel Foucault, *The Birth of the Clinic* (New York: Pantheon, 1975), p. 39.
7. Miran Bozovic, "An Utterly Dark Spot," in Jeremy Bentham, *The Panopticon Writings* (New York: Verso, 1995).
8. Slavoj Žižek at Ars Electronica 1995.
9. Paul Virilio, *The Vision Machine* (London: British Film Institute, 1994), p. 8.
10. Norbert Wiener, *The Human Use of Human Beings: Cybernetics and Society* (New York: Doubleday Anchor, 1954), p. 23.
11. Vilém Flusser, "On Memory: Electronic or Otherwise," *Leonardo*, vol. 23, no. 4 (1990): 399.
12. Régis Debray, *Media Manifestos* (New York: Verso, 1996), p. 54.
13. "Neuron Talks to Chip, and Chip to Nerve Cell," *New York Times* (August 22, 1995).
14. Evelyn Fox Keller, *Refiguring Life: Metaphors of Twentieth Century Biology* (New York: Columbia University Press, 1995), p. 103.
15. Hubert Damisch, *The Origins of Perspective* (Cambridge, MA: MIT Press, 1994), pp. 46, 20.
16. Gilles Deleuze and Felix Guattari, *A Thousand Plateaus: Capitalism and Schizophrenia* (Minneapolis: University of Minnesota Press, 1987), pp. 7, 12.

<u>MARTIN HEIDEGGER</u>

The Age of the World Picture

References to Appendixes and additional sources within the Notes are to be found in Martin Heidegger, The Question Concerning Technology and Other Essays *(Harper & Row, 1977).*

1. "Reflection" translates *Besinnung*. On the meaning of the latter, see SR 155 no.1. "Essence" will be the translation of the noun *Wesen* in most instances of its occurrence in this essay. Occasionally the translation "coming to presence" will be used. *Wesen* must always be understood to allude, for Heidegger, not to any mere "whatness," but to the manner in which anything, *as* what it is, takes its course and "holds sway" in its ongoing presence, i.e., the manner in which it endures in its presencing. See QT 30, 3 no.1. "What is" renders the present participle *seiend* used as a noun, *das Seiende*. On the translation of the latter, see T 40 n.6.

2. *der Grund seines Wesensgestalt.* Heidegger exemplifies the statement that he makes here in his
 discussion of the metaphysics of Descartes as providing the necessary interpretive ground
 for the manner in which, in the subjectness of man as self-conscious subject, Being and
 all that is and man — in their immediate and indissoluble relation — come to presence in
 the modern age. See Appendix 9, pp. 150 ff.
3. Heidegger's explanatory appendixes begin on p. 137 of *The Question Concerning Technology and
 Other Essays* (Harper & Row, 1977).
4. *Erlebnis,* translated here as "subjective experience" and later as "life-experience," is a term much
 used by life philosophers such as Dilthey and generally connotes adventure and event. It
 is employed somewhat pejoratively here. The term *Erfahrung,* which is regularly translated
 in this essay as "experience," connotes discovery and learning, and also suffering and
 undergoing. Here and subsequently (i.e., "mere religious experience"), "mere" is inserted
 to maintain the distinction between *Erlebnis* and *Erfahrung.*
5. *Entgötterung,* here inadequately rendered as "loss of the gods," actually means something more
 like "degodization."
6. *Grundriss.* The verb *reissen* means to tear, to rend, to sketch, to design, and the noun *Riss* means
 tear, gap, outline. Hence the noun *Grundriss,* first sketch, ground plan, design, connotes a
 fundamental sketching out that is an opening up as well.
7. "Binding adherence" here translates the noun *Bindung.* The noun could also be rendered
 "obligation." It could thus be said that rigor is the obligation to remain within the realm
 opened up.
8. Throughout this essay the literal meaning of *vorstellen,* which is usually translated with "to
 represent," is constantly in the foreground, so that the verb suggests specifically a setting-
 in-place-before that is an objectifying, i.e., a bringing to a stand as object. See pp. 127,
 129–30, 132; cf. Appendix 9, pp. 148 ff. Heidegger frequently hyphenates *vorstellen* in this
 essay and its appendixes so as to stress the meaning that he intends.
9. "The comparing of the writings with the sayings, the argument from the word." *Argumentum ex
 re,* which follows shortly, means "argument from the thing."
10. "Ongoing activity" is the rendering of *Betrieb,* which is difficult to translate adequately. It means
 the act of driving on, or industry, activity, as well as undertaking, pursuit, business. It can
 also mean management, workshop or factory.
11. The verb *stellen,* with the meanings to set in place, to set upon (i.e., to challenge forth), and to
 supply, is invariably fundamental in Heidegger's understanding of the modern age. See in
 this essay the discussion of the setting in place of the world as a picture. For the use of
 stellen to characterize the manner in which science deals with the real, see SR 167–168
 for a discussion in which *stellen* and the related noun *Ge-stell* serve centrally to
 characterize and name the essence of technology in this age, see QT 14 ff.
12. The conventional translation of *Weltbild* would be "conception of the world" or "philosophy of
 life." The more literal translation, "world picture," is needed for the following of
 Heidegger's discussion; but it is worth noting that "conception of the world" bears a close
 relation to Heidegger's theme of man's representing of the world as picture.
13. *durch den vorstellenden-herstellenden Menschen gestellt ist.*
14. *Die Neuzeit* is more literally "the new age." Having repeatedly used this word in this discussion,
 Heidegger will soon elucidate the meaning of the "newness" of which it speaks.
15. The accepted English translation of this fragment is, "For thought and being are the same thing"
 (Nahm).
16. "Preserve" translates *bewahren.* The verb speaks of a preserving that as such frees and allows
 to be manifest. On the connotations resident in *wahren* and related words formed from
 wahr, see T 42 no. 9.
17. The noun *Vernehmer* is related to the verb *vernehmen* (to hear, to perceive, to understand).
 Vernehmen speaks of an immediate receiving, in contrast to the setting-before (*vor-stellen*)
 that arrests and objectifies.
18. *Gebild* is Heidegger's own word. The noun *Gebilde* means thing formed, creation, structure,
 image. *Gebild* is here taken to be close to it in meaning, and it is assumed—with the use

of "structured" — that Heidegger intends the force of the prefix ge-, which connotes a gathering, to be found in the word (cf. QT 19 ff.). "Man's producing which represents and sets before" translates des *vorstellenden Herstellens*.

19. *Wissen, d.h., in seine Wahrheit verwahren, wird der Mensch. . . .* Here the verb *wissen* (to know), strongly emphasized by its placement in the sentence, is surely intended to remind of science (*Wissenschaft*) with whose characterization this essay began. On such knowing — an attentive beholding that watches over and makes manifest — as essential to the characterizing of science as such, see SR 180 ff.

20. Wohl ist enge begrenzt unsere Lebenzeit,
Unserer Jahre Zahl sehen und zählen wir,
Doch die Jahre der Völker,
Sah ein sterbliches Auge sie?

Wenn die Seele dir auch über die eigene Zeit
Sich die sehnende schwingt, trauernd verweilest du
Dann am kalten Gestade
Bei den Deinen und kennst sie nie.

HANS MAGNUS ENZENSBERGER
Constituents of a Theory of the Media

1. Berthold Brecht, *Theory of Radio* (1932), *Gesammelte Werke*, Band VIII, p. 129 seq., 134.
2. *Der Spiegel*, October 20, 1969.
3. El Lissitsky, "The Future of the Book," *New Left Review*, no. 41: 42.
4. *Kommunismus, Zeitschrift der Kommunistischen Internationale für die Länder Südosteuropas*, 1920, pp. 1538–1549.
5. Walter Benjamin, "Kleine Geschichte der Photographie," in *Das Kunstwerk im Zeitalter seiner technischen Reproduzierbarkeit* (Frankfurt: 1963), p. 69.
6. Walter Benjamin, "The Work of Art in the Age of Mechanical Reproduction," *Illuminations* (New York: Schocken, 1969), pp. 223–27.
7. Benjamin, p. 229.
8. Op. cit., p. 40.
9. Benjamin, op. cit., p. 42.

ARTHUR I. MILLER
Visualization Lost and Regained: The Genesis of the Quantum Theory in the Period 1913–1927

Quotations from the *Archive for History of Quantum Physics* are taken from interviews of Werner Heisenberg by Thomas S. Kuhn and are on deposit at the American Institute of Physics in New York City, the American Philosophical Society in Philadelphia, the University of California in Berkeley, and at the Niels Bohr Institute in Copenhagen. At the time I wrote this essay in 1976 I had the benefit of discussions with Gerald Holton and with two pioneers of the quantum theory, E. C. Kemble and J. H. Van Vleck.

1. Niels Bohr, "The Atomic Theory and the Fundamental Principles Underlying the Description of Nature" in *Atomic Theory and the Description of Nature* (Cambridge: Harvard University Press, [1934] 1961), p. 108.
2. Wolfgang Pauli, "Exclusion Principle, Lorentz Group and Reflection of Space-Time and Charge" in *Niels Bohr and the Development of Physics: Essays Dedicated to Niels Bohr on the Occasion of his Seventieth Birthday*, Wolfgang Pauli, ed. (New York: Pergamon Press, 1955), p. 30.
3. "*Anschauung*" is something superior to merely viewing with the senses. It is a kind of sight abstracted from visualization of physical processes in the world of perceptions. For a discussion of the use of "*Anschauung*" in German philosophical writings in the nineteenth

century, see John Theodore Merz, *A History of European Thought in the Nineteenth Century* (New York: Dover, [1904–1912] 1965), vol. III, pp. 205, 445, and vol. IV, pp. 314–315.

4. Gerald Holton sometimes refers to such choices as "thema-antithema couples." See Gerald Holton, *Thematic Origins of Scientific Thought: Kepler to Einstein* (Cambridge: Harvard University Press, 1973).

5. Mogens Anderson, "An Impression" in *Niels Bohr: His Life and Work as Seen by His Friends and Colleagues*, S. Rozental, ed., (New York: Interscience, 1967), p. 322.

6. For discussions of Planck's research in 1900 see Max Jammer, *The Conceptual Development of Quantum Mechanics* (New York: McGraw-Hill, 1966), especially chapter 1, and Martin J. Klein "Max Planck and the Beginnings of the Quantum Theory" in *Archive for History of Exact Sciences*, 1 (1962): 459–479.

7. Albert Einstein, "Über einen die Erzeugung und Verwandlung des Lichtes betreffenden heuristischen Gesichtspunkt," *Annalen der Physik*, 17 (1905): 132–148. For further discussions of Einstein's paper see Jammer, chapter 1; Holton, "On the Origins of the Special Relativity Theory," in note 4, pp. 165–183, especially pp. 167–169; Martin J. Klein, "Einstein's First Paper on Quanta," *The Natural Philosopher*, 2 (1963): 59–86; and Arthur I. Miller, "On Einstein, Light Quanta Radiation and Relativity in 1905," *American Journal of Physics*, 44 (1976): 912–923.

8. Max Planck, "Zur Theorie der Wärmestrahlung," *Annalen der Physik*, 31 (1910): 758–767.

9. Albert Einstein, "Die Plancksche Theorie der Strahlung und die Theorie der spezifischen Wärme," *Annalen der Physik*, 22 (1907): 180–190. For further discussion see Martin J. Klein, "Einstein, Specific Heats and the Early Quantum Theory," *Science*, 148 (1965): 173–180.

10. Henri Poincaré, "The Quantum Theory," in Henri Poincaré, *Mathematics and Science: Last Essays*, John W. Bolduc, trans., (New York: Dover, 1963), pp. 75–88.

11. See Arthur I. Miller, *Insights of Genius: Imagery and Creativity in Science and Art* (New York: Springer Verlag, 1996).

12. Poincaré, *Last Essays*, p. 88.

13. Poincaré, "The Relations between Ether and Matter," *Last Essays*, pp. 89–101, especially p. 93.

14. Niels Bohr, "On the Constitution of Atoms and Molecules," *Philosophical Magazine*, 26 (1913): 1–25, 476–502, 857–875; reprinted with an introduction by Léon Rosenfeld in *On the Constitution of Atoms and Molecules* (New York: Benjamin, 1963). For discussions of these papers see Jammer, especially chapter 2 and John L. Heilbron and Thomas S. Kuhn, "The Genesis of the Bohr Atom," *Historical Studies in the Physical Sciences*, Russell McCormmach, ed., (Philadelphia: University of Pennsylvania Press, 1969), vol. I, pp. 211–290.

15. Bohr, *Atoms and Molecules*, p. 7 of the reprint volume.

16. Niels Bohr, "On the Spectrum of Hydrogen," an Address delivered before the Physical Society of Copenhagen on December 20, 1913 and reprinted in Niels Bohr, *The Theory of Spectra and Atomic Constitution* (Cambridge: Harvard University Press, 1924), p. 11.

17. Niels Bohr, "On the Quantum Theory of Line-Spectra," Kgl. Danske Vid. Selsk. Skr. nat.-mat. Afd., series 8, IV (1918–1922): 1–118. This paper appeared in 1918 and is reprinted in *Sources of Quantum Mechanics*, B. L. Van der Waerden, ed., (New York: Dover, 1967) p. 99.

18. Rudolf Arnheim, *Visual Thinking* (Berkeley: University of California Press, 1971), p. 286.

19. Niels Bohr, "On the Series Spectra of the Elements," an address delivered before the Physical Society in Berlin, April 27, 1920 and reprinted in Bohr, *Theory of Spectra*, pp. 20–60, especially pp. 32–34.

20. See note 17.

21. Bohr, *Theory of Spectra*, p. 27.

22. Albert Einstein, "On the Quantum Theory of Radiation," translated in *Sources of Quantum Mechanics*, pp. 63-77. Originally published in *Physikalische Zeitschrift*, 18 (1917): 121–128. For further discussion of Einstein's paper see Jammer, chapter 3 and Martin J. Klein, "Einstein and the Wave-Particle Duality," *The Natural Philosopher*, 3 (1964): 3–49.

23. Einstein, *Sources*, p. 76.

24. Niels Bohr, "On the Application of the Quantum Theory to Atomic Structure: Part I. The Fundamental Postulates of the Theory," *Proc. Cambr. Phil. Soc.* (Supplement) (1924).

(Originally published in *Zeitschrift für Physik*, 13 [1923]: 117–165. Hereafter all German words appearing in square brackets are from the German version of the work under discussion.

25. Rudolf Ladenburg, "The Quantum-Theoretical Interpretation of the Number of Dispersion Electrons," translated in *Sources of Quantum Mechanics*, pp. 139–157. Originally published in *Zeitschrift für Physik*, 4 [1921]: 451–468.

26. Rudolf Ladenburg and Fritz Reiche, "Absorption, Zerstreuung und Dispersion in der Borschen Atomtheorie," *Die Naturwissenschaften*, 11 (1923): 584–598.

27. Arthur H. Compton, "A Quantum Theory of the Scattering of X-Rays by Light Elements," *Physical Review*, 21 (1923): 483–502. For a discussion of Compton's experiments see Roger H. Stuewer, *The Compton Effect: Turning Point in Physics* (New York: Science History Publications, 1975).

28. Niels Bohr, H. A. Kramers, and John C. Slater, "The Quantum Theory of Radiation," *Sources of Quantum Mechanics*, pp. 159–176. (Originally published in *Zeitschrift für Physik*, 24 [1924]: 69–87, and *Philosophical Magazine*, 47 [1924]: 785–802.) For further discussions of this paper see Jammer, chapter 4; Stuewer, *Compton Effect*; and Klein, "The First Phase of the Bohr-Einstein Dialogue," *Historical Studies*, vol. II, pp. 1–39.

29. For example, H. A. Kramers, "The Law of Dispersion and Bohr's Theory of Spectra," *Sources of Quantum Mechanics*, pp. 177–180 (originally published in *Nature*, 113 [1924]: 673–676), and Max Born, "On Quantum Mechanics," translated in *Sources*, pp. 181–198 (originally published in *Zeitschrift für Physik*, 26 (1924): 379–395).

30. E. N. da C. Andrade, *The Structure of the Atom* (New York: Harcourt, Brace and Company, 1926), p. 685.

31. See, for example, *Archive for History of Quantum Physics*, interview with W. Heisenberg on February 13, 1963: 8.

32. Werner Heisenberg, "Über eine Anwendung des Korrespondenzprinzips auf die Frage nach der Polarisation des Fluoreszenzlichtes," *Zeitschrift für Physik*, 31 (1925): 617–626.

33. R. W. Wood and A. Ellett, "On the Influence of Magnetic Fields on the Polarisation of Resonance Radiation," *Proc. Roy. Soc. London* (A), 103 (1923), pp. 396–403 and R. W. Wood and A. Ellett, "Polarized Radiation in Weak Magnetic Fields," *Physical Review*, 24 (1924): 243–254.

34. Werner Heisenberg, "Quantum Theory and Its Interpretation" in *Niels Bohr: His Life and Work*, p. 98.

35. *Archive for History of Quantum Physics*, interview with W. Heisenberg on February 13, 1963: 14–15.

36. Werner Heisenberg, "Quantum-Theoretical Re-Interpretation of Kinematic and Mechanical Relations," translated in *Sources of Quantum Mechanics*, pp. 261–276. Originally published in *Zeitschrift für Physik*, 33 (1925): 879–893.

37. Wolfgang Pauli, "On the Hydrogen Spectrum from the Standpoint of the New Quantum Mechanics," translated in *Sources of Quantum Mechanics*, pp. 387–415. Originally published in *Zeitschrift für Physik*, 36 (1926): 336–363. The quotation is from p. 387 of *Sources*; however, Van der Waerden's translation of the German *Veranschaulichung* as "visualization" is not correct.

38. Max Born, Werner Heisenberg, and Pascual Jordan, "On Quantum Mechanics II," translated in *Sources of Quantum Mechanics*, pp. 321–385. Originally published in *Zeitschrift für Physik*, 35 (1926): 557–615. The quotation is from p. 322 of *Sources*; however, Van der Waerden's translation of the German "*anschauliche*" as "visualizable" is not appropriate because *anschauliche* is an intuition that is superior to mere visualization. (See note 3.)

39. *Sources*; Here, too, Van der Waerden's translation of *anschauliche* as visualizable is not appropriate.

40. G. E. Uhlenbeck and S. Goudsmit, "Ersetzung der Hypothese vom unmechanischen Zwang durch eine Forderung bezüglich des inneren Verhaltens jedes einzelnen Elektrons," *Die Naturwissenschaften*, 13 (1925): 953–954, and Uhlenbeck and Goudsmit, "The Spinning Electron and the Theory of Spectra," *Nature*, 117 (1926): 264–265. For further discussions see Jammer, chapter 3 and B. L. van der Waerden, "Exclusion Principle and Spin," *Theoretical Physics in the Twentieth Century: A Memorial Volume to Wolfgang Pauli*, M. Fierz and V. Weisskopf, eds., (New York: Interscience, 1960), pp. 199–244.

41. Max Born, *Problems of Atomic Dynamics* (Cambridge: The MIT Press, 1970), p. 128.

42. Andrade, *The Structure of the Atom*, p. 712.

43. (a). Niels Bohr, "Über die Wirkung von Atomen bei Stössen," *Zeitschrift für Physik*, 34 (1925): 142–157; (b). Niels Bohr, "Atomic Theory and Mechanics," *Atomic Theory*, pp. 25–51. (See note 1.) A version was published in *Nature* [Supplement], December 5, 1925.

44. The two important experiments are: W. Bothe and H. Geiger, "Experimentelles zur Theorie von Bohr, Kramers und Slater," *Die Naturwissenschaften*, 13 (1925): 440–441 and A. H. Compton and A. W. Simon, "Directed Quanta of Scattered X-Rays," *Physical Review*, 26 (1925): 289–299.

45. See note 42(a), p. 155. Unless indicated otherwise all translations are mine.

46. These researchers are Louis de Broglie, Thèse (Paris, 1924) and "Recherches sur la théorie des quanta," *Annales de Physique*, 3 (1925): 22–128; and Albert Einstein, "Quantentheorie des einatomigen idealen Gases," *Berliner Berichte*, (1924): 261–267; (1925): 3–14; (1925): 18–25. For further discussions of these papers see Jammer, chapter 5 and Klein (See note 21).

47. See note 42(b), p. 51.

48. Erwin Schrödinger, "Über das Verhältnis der Heisenberg-Born-Jordanschen Quantenmechanik zu der meinen," *Annalen der Physik*, 70 (1926): 734–756; portions are translated in *Wave Mechanics*, Gunther Ludwig, trans., (New York: Pergamon Press, 1968), pp. 127–150. The quotation is on p. 128 of the reprint volume. For further discussions of the relationship of Schrödinger's wave mechanics to the research of de Broglie and Einstein see Klein (See note 21) and Jammer chapter 5.

49. Erwin Schrödinger, "Der stetige Übergang von der Mikro-zur Makromechanik," *Die Naturwissenschaften*, 14 (1926): 664–666.

50. Werner Heisenberg, "Über den anschaulichen Inhalt der quantentheoretischen Kinematik und Mechanik," *Zeitschrift für Physik*, 43 (1927): 172–198, especially 184–189.

51. See Max Born and Pascual Jordan, "Zur Quantenmechanik," *Zeitschrift für Physik*, 34 (1926): 858–888. Translated in part *in Sources of Quantum Physics*, pp. 277–306; Van der Waerden's translation of "wahre Diskontinuumstheorie" (p. 300) as "essentially discontinuum theory" is not appropriate.

52. See, for example, Jammer, chapter 5 and Klein (See note 21).

53. Werner Heisenberg, "Mehrkörperproblem und Resonanz in der Quantenmechanik," *Zeitschrift für Physik*, 38 (1926): 411–426.

54. *Wave Mechanics*, p. 114 (See note 47).

55. Heisenberg: 412 (See note 52).

56. The principal papers are: (a) Max Born, "Zur Quantenmechanik der Stossvorgänge," *Zeitschrift für Physik*, 37 (1926): 863–867; (b) Max Born, "Quantenmechanik der Stossvorgänge," *Zeitschrift für Physik*, 38 (1926): 803–827, translated in part in *Wave Mechanics*, pp. 206–225; and (c) Max Born, "Physical Aspects of Quantum Mechanics," *Nature*, 119 (1927): 354–357.

57. See note 55(a): 863.

58. See note 55(b), p. 206 of *Wave Mechanics*.

59. See note 55(a): 866.

60. See note 55(c): 356.

61. Quoted from Jammer: 272.

62. *Archive for History of Quantum Physics*, Interview with W. Heisenberg on 22 February 1963, p. 30.

63. Werner Heisenberg, "Schwankungserscheinungen und Quantenmechanik," *Zeitschrift für Physik*, 40 (1926): 501–506.

64. See note 61: 3. Indeed, Heisenberg's colleague Jordan rediscovered its results in a paper of 1927 and had to add a footnote that he had not been aware of Heisenberg's paper in note 62. See Pascual Jordan, "Über quantenmechanische Darstellung von Quantensprüngen," *Zeitschrift für Physik*, 40 (1927): 661–666, especially p. 666.

65. Werner Heisenberg, "Quantenmechanik," *Die Naturwissenschaften*, 14 (1926): 889–994.

66. See note 49.

67. See *Archive for History of Quantum Physics*. Interview with W. Heisenberg on February 25, 1963, pp. 11–13.

68. "Discussion with Professor Werner Heisenberg" in *The Nature of Scientific Discovery: A Symposium Commemorating the 500th Anniversary of the Birth of Nicolaus Copernicus*, Owen Gingerich, ed., (Washington: Smithsonian Institution Press, 1975), p. 569.

69. Arnheim, pp. 286–287.

70. See note 65: 18.

71. *Archive for History of Quantum Physics*, Interview with W. Heisenberg on February 28, 1963, p. 7. The relevant papers are P. A. M. Dirac, "The Physical Interpretation of the Quantum Mechanics," *Proc. Roy. Soc. London* (A), 113 (1926), pp. 621–641; Pascual Jordan, "Über eine neue Begründung der Quantenmechanik," *Zeitschrift für Physik*, 40 (1927): 809–838. The papers are discussed in Jammer, chapter 6.

72. *Archive for History of Quantum Physics*, Interview with W. Heisenberg on July 5, 1963, p. 11.

73. *Archive*, 27 February 1963, p. 27.

74. See note 49: 197–198.

75. A version of this lecture is in Niels Bohr, "The Quantum Postulate and the Recent Development of Atomic Theory," *Nature* (Supplement) (April 14, 1928): 580–590; reprinted with a different introduction and no footnotes in note 1, pp. 52–91. For recent discussions of the genesis of Bohr's complementarity principle see Jammer, chapter 7; Holton, "The Roots of Complementarity," in note 4: 115–161; and K. Meyer-Abrich, *Korrespondenz, Individualität und Komplementarität* (Wiesbaden: Steiner Verlag, 1965).

76. See, for example, the preface to Werner Heisenberg, *The Physical Principles of the Quantum Theory*, C. Eckart and F. C. Hoyt, trans., (New York: Dover, 1963). This text is from a set of lectures delivered at the University of Chicago in the spring of 1929.

77. For example, Werner Heisenberg, "Die Entwicklung der Quantentheorie, 1918-1928," *Die Naturwissenschaften*, 26 (1929): 490–496, especially p. 494; *Archive for History of Quantum Physics*, Interview with W. Heisenberg on 12 July 1963, p. 6; and note 74, especially pp. 157ff. The relevant papers are P. A. M. Dirac, "The Quantum Theory of the Emission and Absorption of Radiation," *Proc. Roy. Soc. London* (A), 114 (1927): 243–265 (reprinted in J. Schwinger, ed., *Selected Papers on Quantum Electrodynamics* [New York: Dover, 1958], pp. 1–23); Pascual Jordan and Oscar Klein, "Zum Mehrkörperproblem der Quantentheorie," *Zeitschrift für Physik*, 45 (1927): 751–765; and Pascual Jordan and Eugene Wigner, "Über das Paulische Äquivalenzverbot," *Zeitschrift für Physik*, (1928): 631–651 (reproduced in Schwinger, pp. 41–61).

78. *Archive for History of Quantum Physics*, interview with W. Heisenberg on July 12, 1963, p. 6.

79. I have developed the themes of visual thinking, aesthetics in science and the interplay between art and science in : A. I. Miller, *Imagery in Scientific Thought: Creating 20th-Century Physics* (Cambridge: MIT Press, 1986), A. I. Miller, *Early Quantum Electrodynamics: A Source Book* (Cambridge, UK: Cambridge University Press, 1994) and A. I. Miller, *Insights of Genius: Imagery and Creativity in Science and Art* (New York: Springer-Verlag, 1996). Of particular interest to the theme of this essay is Heisenberg's search for a proper visualizability in quantum physics, which culminated in Richard Feynman's diagrammatic method known as Feynman diagrams.

JEAN-LOUIS COMOLLI
Machines of the Visible

1. See "Technique et idéologie," *Cahiers du cinéma* 229 (May–June 1971): 9–15; translation "Technique and ideology; camera, perspective, depth of field," *Film Reader* 2 (1977): 132–38.

2. Gilles Deleuze and Claire Parnet, *Dialogues* (Paris: Flammarion, 1977), pp. 126–127.

3. With M. Pleynet, 'Economique, idéologique, formel' (interview), *Cinéthique* 3 (1969) — the focus of attention is voluntarily and *first of all* on *one* of the component elements of the camera, the *lens*. For J. P. Lebel — *Cinéma et idéologie* (Paris: Editions sociales, 1971), chapter I — who cites the phenomenon of "persistence of vision," the reference is *geometrical optics*: the laws of the propagation of light.

4. Serge Daney, "Sur Salador," *Cahiers du cinéma* 222 (July 1970): 39.

5. In the general readjustment of codes of cinematic "realism" produced in Hollywood (according, of course, to its ideological and economic norms and objectives, for its profit and for that of bourgeois ideology) with the arrival of sound, the codes of the strictly photographic "realism" of the filmic image are redefined specifically (but not exclusively) in relation to the increasingly important position occupied by the photographic image in bourgeois societies in relation to mass consumption. This position has something to do with that of gold (of the fetish): the photo is the money of the "real" (of "life") assures its convenient circulation and appropriation. Thereby, the photo is unanimously consecrated as general equivalent for, standard of, all "realism": the cinematic image could not, without losing its "power" (the power of its "credibility"), not align itself with the photographic norms. The "strictly technical" level of the improvements of optical apparatus and emulsions is thus totally programmed by the ideology of the "realistic" reproduction of the world at work in the constitution of the photographic image as the "objective representation" par excellence.

BILL NICHOLS

The Work of Culture in the Age of Cybernetic Systems

1. The concept of the double hermeneutic derives from Fredric Jameson, *The Political Unconscious* (Ithaca: Cornell University Press, 1981), especially the final chapter.
2. Walter Benjamin, "The Work of Art in the Age of Mechanical Reproduction" in *Illuminations,* by Harry Zohn, trans., (New York: Schocken Books, 1969), p. 221. Further page references from this essay are given in the text.
3. Walter Benjamin, *Schriften,* 2 vols. (Frankfurt: Suhrkamp Verlag, 1955), I, p. 461. Translated in Fredric Jameson, *Marxism and Form* (Princeton: Princeton University Press, 1971), p. 77.
4. Terry Eagleton, *Marxism and Literary Criticism* (Berkeley: University of California Press, 1976), p. 63.
5. This quote is from James Clifford, "On Ethnographic Surrealism" *Comparative Studies in Society and History,* vol. 23, 4 (October 1981): 559–564, where he offers an excellent description of the confluences between surrealism and certain tendencies within early ethnography in 1920s France.
6. See, for example, the essays in Part III, "Form and Pathology in Relationship" by Gregory Bateson, *Steps to an Ecology of Mind* (New York: Ballantine Books, 1972), where this phrase is introduced and applied to various situations.
7. Quoted in Sherry Turkle, *The Second Self: Computer and the Human Spirit* (New York: Simon and Schuster, 1984), p. 86.
8. Steven J. Heims, *John von Neuman and Norbert Wiener: From Mathematics to the Technologies of Life and Death* (Cambridge, MA: MIT Press, 1980), describes how research on antiaircraft guidance systems led Julian Bigelow and Norbert Wiener to develop a mathematical theory "for predicting the future as best one can on the basis of incomplete information about the past" (p. 183). For an overview of the history of cybernetic theory and cognitive psychology in the context of its military-industrial origins, see Paul N. Edwards, "Formalized Warfare," unpublished ms. (1984), History of Consciousness Program, University of California, Santa Cruz.
9. Jean Baudrillard, "The Implosion of Meaning in the Media and the Implosion of the Social in the Masses" in Kathleen Woodward, ed., *The Myths of Information,* (Madison, Coda Press, 1980), p. 139.
10. Sherry Turkle, p. 264.
11. See Laura Mulvey, "Visual Pleasure and Narrative Cinema," *Screen,* vol. 16, 3 (Autumn 1975): 6–18.
12. Paul N. Edwards, p. 59.
13. See, for example, Paul N. Edwards, for a more detailed account of this synergism between the development of cybernetics and military needs. For a cybernetic theory of alcoholism and schizophrenia, see Gregory Bateson, and Watzlawick, Beavin and Jackson's study of human interaction in a systems framework in *Pragmatics of Human Communication.*

14. John Stroud, "Psychological Moments in Perception—Discussions," in H. Van Foersta, et al., eds., *Cybernetics: Circular Causal and Feedback Mechanisms in Biological and Social Systems,* Transactions of the Sixth Macy Conference (New York: Josiah Macy Foundation, 1949), pp. 27–28.

15. Jean Baudrillard, p. 139.

16. See Nicos Poulantzas, *Political Power and Social Class* (London: New Left Books, 1975), pp. 211–214.

17. James J. Myrick and James A. Sprowl, "Patent Law for Programmed Computers and Programmed Life Forms," *American Bar Association Journal,* no. 68 (August 198): 120.

18. Myrick and Sprowl, p. 121. Some other relevant articles include: "Biotechnology: Patent Law Developments in Great Britain and the United States," *Boston College International and Comparative Law Review,* no. 6 (Spring 1983): 563–590; "Can a Computer be an Author? Copyright Aspects of Artificial Intelligence," *Communication Entertainment Law Journal,* 4 (Summer 1982): 707–747; Peter Aufrichtig, "Copyright Protection for Computer Programs in Read-Only Memory Chips," *Hofstra Law Review,* II (February 1982): 329–370; "Patents on Algorithms, Discoveries and Scientific Principles," *Idea* 24 (1983): 21–39; S. Hewitt, "Protection of Works Created by Use of Computers," *New Law Journal,* 133 (March 11, 1983): 235–237; E.N. Kramsky, "Video Games: Our Legal System Grapples with a Social Phenomenon," *Journal of the Patent Office Society,* 64 (June 1982): 335–351.

19. This case's relevance for computer software litigation is discussed in Peter Aufrichtig's "Copyright Protection for Computer Programs in Read Only Memory Chips,": 329–370.

20. E.N. Kramsky, p. 342.

21. 214 US PQ 33t 7th Cir, 1982, pp. 33, 42, 43.

22. Paula Samuelson, "Creating a New Kind of Intellectual Property: Applying the Lessons of the Chip Law to Computer Programs," *Minnesota Law Review,* 70 (December 1985): 502.

23. Cited in Christine Overall, "'Pluck a Fetus from its womb": A Critique of Current Attitudes Toward the Embryo/Fetus," *University of Western Ontario Law Review,* vol. 24, 1 (1986): 6–7.

24. Overall, p. 7.

25. Anthony Wilden, "Changing Frames of Order: Cybernetics and the Machina Mundi" in Kathleen Woodward, ed., *The Myths of Information,* p. 240.

26. Gregory Bateson, "Conscious Purpose and Nature" in *Steps to an Ecology of Mind,* p. 437.

27. Gregory Bateson, "Style, Grace and Information in Primitive Art," *Steps to an Ecology of Mind,* p. 145.

DAVID TOMAS

From the Photograph to Postphotographic Practice

1. The concept of *subject* denotes that which is or has been *conventionally* photographed and which has or will produce an image on a photosensitive emulsion. It is therefore the object of photographic activity. Although "subject" and "image" are interchangeable terms at the level of the photograph, the term "subject/image" is used in the present case because of its dual emphasis on the taking and making aspects of photographic production: the *choice* of a subject is symbolized by the frame of a viewfinder (a *taking process*) and defined by the *significant difference* produced by its inscription on a photosensitive support (a *making process*). On the role of the light-presence/darkness-absence binary classification system in photography, see David Tomas, "A Mechanism for Meaning: A Ritual and the Photographic Process," *Semiotica,* 46, 1 (1983): 1–39. See also D. Tomas, "The Ritual of Photography," *Semiotica,* 40, 1/2 (1982): 1–25.

2. D. Tomas, "Toward an Anthropology of Sight: Ritual Performance and the Photographic Process," *Semiotica,* 68, 3/4 (1988): 259–260, and *Semiotica,* 23; Gregory Bateson, "The Science of Mind and Order" in *Steps to an Ecology of Mind* (New York: Ballantine Books, 1972), xxiii–xxv; and Leo Strauss, "On the Interpretation of Genesis," *L'Homme,* 21, 1, (1981), 5–20. The relevant portion of the Judeo-Christian origin myth is presented in the first ten verses of Genesis (King James Version):

 1. In the beginning, God created the heaven and the earth.
 2. And the earth was without form, and void; and darkness was upon the face of the deep. And the spirit of God moved upon the face of the waters.

3. And God said, Let there be light; and there was light.

4. And God saw the light, that it was good: and God divided the light from the darkness.

5. And God called the light Day, and the darkness he called Night. And the evening and the morning were the first day.

6. And God said, Let there be a firmament in the midst of the waters, and let it divide the waters from the waters.

7. And God made the firmament, and divided the waters which were under the firmament from the waters which were above the firmament: and it was so.

8. And God called the firmament Heaven. And the evening and the morning were the second day.

9. And God said, Let the waters under the heaven be gathered together unto one place, and let the dry land appear: and it was so.

10. And God called the dry land Earth; and the gathering together of the waters called he Seas: and God saw that it was good.

3. Some of the general cultural connections between the biological eye, photographic camera, and a ritual of photography are outlined in D. Tomas, "Toward an Anthropology of Sight: Ritual Performance and the Photographic Process," see note 2.

4. For a discussion of the relationship between marked and unmarked elements in semiotic systems, see Linda R. Waugh, "Marked and Unmarked: A Choice Between Unequals in Semiotic Structure," *Semiotica*, 38, 3/4 (1982): 299–318. On the importance of light for biological life and the relation of vision to photobiology, see George Wald, "Life and Light" in *Lasers and Light: Readings from Scientific American* (San Francisco: W. H. Freeman, 1969), pp. 101–113.

5. Niépce quoted in Louis Jacques Mandé Daguerre, *An Historical and Descriptive Account of the Various Processes of the Daguerreotype and the Diorama by Daguerre* (facsimile McLean and Giroux editions of 1839), introduction by Beaumont Newhall (New York: Winter House, 1971) McLean edition, p. 41 (emphases in the original). See also the following comments from the first general treatise on photography, Robert Hunt's *A Popular Treatise on the Art of Photography, Including Daguerreotype, and All the New Methods of Producing Pictures by the Chemical Agency of Light* (Glasgow: Richard Griffin, 1841), facsimile edition, introduction and notes James Yingpeh Tong (Athens: Ohio University Press, 1973) facsimile edition, p. iii:

 The announcement of the discovery of a process by which light — the most subtle of the elements, the mysterious agent of vision — was made to pencil, on solid tablets, the objects it illuminated, and permanently fix the fleeting shadow, possessed, at the same time, so much of the marvelous and beautiful, as to excite more than common wonder.

 Today, light is still considered the "agent" of a photographic vision. See, for example, *The Manual of Photography*, revised by Ralph E. Jacobson, in cooperation with Sidney F. Ray, G. G. Attridge and N. R. Axford, (London and Boston: Focal Press, 7th revised edition 1978), p. 20: "PHOTOGRAPHY, as far as the photographer is concerned, starts with light."

6. In Elizabeth Eastlake's words, photographic facts are " . . . neither the province of art nor of description. . . "—both representational mediums embodying an overtly temporal process of inscription, Lady Elizabeth Eastlake, "Photography," *Quarterly Review* (London), 101, (April 1857): 442–468. Reprinted in Beaumont Newhall, ed., *Photography: Essays and Images* (New York: Museum of Modern Art, 1980) pp. 81–95, p. 94.

7. On the linear nature of historical knowledge, see Claude Lévi-Strauss, *The Savage Mind* (London: Weidenfeld and Nicolson, [1962] 1972), p. 258.

8. Eastlake, op.cit., note 6, p. 93.

9. Friedrich Nietzsche, *Twilight of the Idols and the Anti-Christ*, R. J. Hollingdale, trans. and commentary, (New York: Penguin Books, [1968] 1979), p. 38, see also Appendix C, pp. 190–191.

10. Bateson, op. cit., note 2, "Form, Substance, and Difference," pp. 448–465; "Pathologies of Epistemology," pp. 478–487, and "The Roots of Ecological Crisis," pp. 488–493.

11. Ibid., p. 465.

12. Friedrich Nietzsche, *The Use and Abuse of History*, trans. Adrian Collins (Indianapolis: Bobbs-Merrill, [sec. ed.] 1979), p. 6.
13. Ibid., p. 8.
14. Ibid., pp. 9–11, 69. The "super-historical" is a second trans-historical consciousness that functions inversely from the unhistorical because it operates from within the confines of the historical to negate the differences upon which the great narrative of history is forged. The super-historical is the condition of all art and religion, a condition that refuses to acknowledge the transience of the present. Instead, it seeks the eternal and continuing in which a historical consciousness cannot exist because it is the product of change and evolution, or, in Nietzsche's words, "the process of becoming."

KEVIN ROBINS

The Virtual Unconscious in Postphotgraphy

1. Walter Benjamin, "A Small History of Photography," in *One Way Street and Other Writings.* (New Left Books, 1979 [1931]), pp. 240–257.
2. W. Leith, "At home with Mr. Hockney," *Independent on Sunday* (October 21, 1990): 37.
3. Fred Ritchin, "The End of Photography as We Have Known It" in *Photovideo: Photography in the Age of the Computer*, P. Wombell, ed., (Rivers Oram, 1991), pp. 8–15.
4. Timothy Binkley, "Camera Fantasia: Computer Visions of Virtual Realities," *Millennium Film Journal* 20-1 (1988–1989): 19, 8.
5. Roger F. Malina, "Digital Image-Digital Cinema: The Work of Art in the Age of Post-mechanical Reproduction," *Leonardo* supplemental issue (1990): 33.
6. Timothy Druckrey, "L'amour faux," *Perspektief* 37 (1989–1990): 37, 41.
7. Richard Wright, "Computer Graphics as Allegorical Knowledge," *Leonardo* supplemental issue (1990): 69.
8. J. Coates, (1911) *Photographing the Invisible* (L. N. Fowler, 1911), p. viii.
9. Susan Sontag, *On Photography* (Harmondsworth: Penguin Books, 1979), pp. 8–9.
10. S. Fisher, "Virtual Interface Environments" in *The Art of Human-Computer Interface Design* (Reading, MA: Addison-Wesley, 1990) B. Laurel, ed., p. 430.
11. S. Fisher, "Virtual Interface Environments," p. 433.
12. Kevin Robins, and Les Levidow, "The Eye of the Storm," *Screen* 32(3) (1991): 324–328.
13. Paul Virilio, *War and Cinema.* (New York: Verso, 1989), p. 65.
14. E. Thomas, and J. Barry, "War's New Science," *Newsweek* (February 18, 1991): 21.
15. B. Swain, "Virtually a Perfect World," *The Guardian* (June 14, 1990).
16. Timothy Binkley, "Digital Dilemmas," *Leonardo* supplemental issue: 13–19 (1990): 18.
17. Gene Youngblood, "The New Renaissance: Art, Science and the Universal Machine," in *The Computer Revolution and the Arts*, R. L. Loveless, ed., (Tampa, FL: University of South Florida Press, 1989), p. 18.
18. Michael Naimark, "Realness and Interactivity," in B. Laurel, ed., *The Art of Human-Computer Interface Design* (Reading, MA: Addison-Wesley, 1990), pp. 457.
19. Gene Youngblood, *The Computer Revolution and the Arts*, pp. 15–16.
20. John Perry Barlow, "Being in Nothingness," *Mondo 2000*, 2 (1990): 41.
21. Howard Rheingold, *Virtual Reality*, (New York: Summit, 1991), p. 353.
22. Timothy Druckrey, "Revenge of the Nerds: An Interview with Jaron Lanier," *Afterimage* (May 1991): 9.
23. A. M. Willis, "Digitalisation and the Living Death of Photography," *Culture, Technology and Creativity in the Late Twentieth Century* in P. Hayward, ed., (John Libbey, 1991), p. 198.
24. Timothy Leary, "The Interpersonal, Interactive, Interdimensional Interface" *The Art of Human-Computer Interface Design*, in B. Laurel, ed., (Reading, MA: Addison-Wesley, 1990), p. 232.
25. Vivian Sobchack, "New Age Mutant Ninja Hackers," *Artforum* (April 1991): 24–25.
26. Timothy Binkley, *Millennium Film Journal* 20–1: 28.
27. Claude Raulet, "The New Utopia: Communication Technologies," *Telos* 87 (1990): 51–52.
28. G. Skirrow, "Hellivision: An Analysis of Video Games" in *The Media Reader*, M. Alvarado and J. Thompson, eds., (British Film Institute, 1990), p. 330.

29. J. Grotstein, *Splitting and Projective Identification* (New York: Aronson, 1981), pp. 138, 131.
30. H. Segal, "Silence is the Real Crime," *International Review of PsychoAnalysis* 14(2) (1987): 9, 7.
31. A. Utley, "Enter a Realm of the Senses," *The Higher* (formerly the *THES*) (September 6, 1991): 44.
32. P. Davison, "The victims of victory," *Independent on Sunday* (September 8, 1991).
33. Gene Youngblood, *The Computer Revolution and the Arts*, p. 15.

ROY ASCOTT

Photography at the Interface

1. The cover of the February 1982 *National Geographic* shows a pyramid that was digitally moved to accommodate design needs. Stewart Brand reports this in *The Media Lab* (New York: Viking Penguin, 1987).
2. Marshall Blonsky, *On Signs* (New York: Oxford University Press, 1985).
3. Paul Watzlawick, *The Invented Reality* (New York: W.W. Norton & Company, 1984).
4. Hypermedia provides for a nonlinear linking and navigation of multimedia data (photo, graphics, text, video, audio).
5. Inventor of hypertext and of "Xanadu," the vision of a globally connected knowledge network.
6. Apple plans to market an interface with user-friendly sensory modes which will replace the keyboard and mouse.
7. Raymond Williams, *Problems in Materialism and Culture* (London, 1980).
8. Neil Postman, *Amusing Ourselves to Death* (New York: Viking Penguin, 1985).
9. Paul Feyerabend, *Three Dialogues on Knowledge* (Oxford, 1991).
10. Richard Rorty, *Contingency, Irony, Solidarity* (New York: Cambridge Universiy Press, 1989).

RAYMOND BELLOUR

The Double Helix

1. Pierre Scheffer, "Compte rendu de la table tenue à Paris le 16 janvier 1986" in *Comment vivre avec l'image*, ed. Maurice Mourier (PUF, 1989), p. 340.
2. Hubert Damisch, *L'Origine de la perspective* (Flammarion, 1987).
3. Hubert Damisch, *Théorie du nuage* (Seuil, 1972), pp. 166–179. This includes, in particular, the scheme that I have outlined here.
4. Hubert Damisch, *L'Origine de la perspective*, p. 114.
5. Leonardo de Vinci, *Carnets* (Gallimard, 1942, repub. "Tel", 1987) vol. 2: 226–30.
6. Robert Klein, Henri Zerner, *Italian Art 1500–1600*, Sources and Documents in the History of Art series, H. W. Janson, ed. (Prentice Hall, 1966), p. 7. The whole of the section on the "comparative merits of the arts" goes from pp. 4–17.
7. In a recent article, "L'analogie réenvisagé (divagation)," in *Christian Metz et la théorie de cinéma* (*Iris*, 10, special issue April 1990, Méridiers Klincksieck), Jacques Aumont distinguishes between three "values" of the term analogy: empirical analogy (defined by perception); ideal or objective analogy (contained in the objects themselves); ontological or idea (going back to the invisible). My "impression of analogy" covers roughly the first two senses, which I find difficult to distinguish between.
8. Peter Galassi, "Avant la Photographie, l'art", in Alain Sayag and Jean Claude Lamagny ed., *L'invention d'un art* (Centre Georges Pompidou, 1989). In English "Before Photography: Painting and the Invention of Photography," 1981). Jacques Aumont comments on it in *L'OEIL interminable* (Librarie Séguier, 1989), pp. 38–43.
9. To the negative; the medium; light; point of view and centering; movement and instantaneity; the actualized motif; realism; geometrization and abstraction. In Françoise Heilbrun, Bernard Marbot, Phillipe Néagu ed., *L'invention d'un regard* (Réunion des musées nationaux, 1989).
10. It would suffice simply to go through the accounts which, from Delacroix to Picasso, are scattered throughout the book *The Painter and the Photograph* by Van Deren Coke, (Albuquerque: University of Mexico Press, 1964) to see to what point the commonplace notion of a liberation of painting by photography, which Galassi wanted to shrug off too lightly, is quite correct.

11. Cf. on these points Hubert Damisch, *Théorie du nuage*, pp. 253–276 and pp. 312–319; and Jacques Aumont, *L'OEIL interminable*, pp. 9–27.

12. Cf. Jean Claude Marcadé, "La réflexion de Malévitch sur le cinéma", in Germain Viatte ed., *Peinture, cinéma, peinture* (Hazon, 1989); Giovanni Lista, "l'ombre du geste," in *Le Temps d'un mouvement* (Centre nationale de la photographie, 1987); Annette Michelson, L'homme à la caméra: de la magie à l'épistémologie, in Dominique Noguez, ed., *Cinéma: Théorie, Lectures, Klincksieck* (1973).

13. To complete Barthes's very correct view, "it is the advent of photography—and not as has been said, of the cinema, that divided the history of the world," *La Chambre claire, Cahiers du Cinema* (Seuil/Gallimard, 1980): 138; we could add: but it was the advent of cinema that divided the history of art.

14. Pascal Bontizer, *Décadrages, Cahiers du Cinema* (1985): 100–101.

15. Jean-Paul Fargier, "L'ange du digital", *Où va la vidéo? Cahiers du Cinéma* (1986). Cf. also "Dernière analogie avant le digital," *Cahiers du cinéma*, 341 (November 1982).

16. Cf. for example several writings by Edmond Couchot: "La mosaïque ordonnée" *Video, Communications*, 48 (1988); "L'odysée, mille fois ou les machines à langage", *Machines virtuelles, Traverses*, 44–45, 1988; "La synthèse du temps", in Jean Louis Weissberg, ed., *Les chemins du virtuel* (Centre Georges Pompidou, 1989).

17. "I hope we'll be able to see that in our lifetime: the end of the camera! When I'm in Paris. I'll buy a big bottle of champagne and I'll save it for that day, for the day when there will be no more camera. When I pop the cork it won't be because of a death, but to celebrate one of the most important mutations in the history of images. It may comparable to the fate of perspective, the illusionist space of the Renaissance." "L'espace à pleine dent," interview with Bill Viola by Raymond Bellour, in Jean-Paul Fargier, ed., *Où va la vidéo? Cahiers du cinéma*, 341: 70.

18. Id. ibid., p. 72.

19. Id. Ibid.

20. Barthes wrote of literature (in 1971): "the Text partakes in its way of a social utopia; (. . .) if the Text does not achieve the transparence of social relationships, at least it achieves the transparence of language relationships," *Le Bruissement de la langue* (Seuil, 1984), p. 71.

21. Cf. Joel Magny, "You know what? I'm happy," *Cahiers du cinéma*, 412 (October 1988).

22. Cf. Serge Daney, "Du défilement au défilé," *La recherche photographique*, 7 (1989). Discussing the relationships between photography and the cinema, the freeze frame and the "défilé" in Godard and Fellini, Daney mentions the situation according to which the cinema spectators themselves have "become very mobile in relation to the images which have become more and more static."

23. André Bazin, concerning *Lettre de Sibérie* in *Le cinéma français de la Libération à la Nouvelle Vague, Cahiers du cinéma* (1983): 180.

24. Quoted by Julia Kristeva, in "Ellipse sur la frayeur et la sidération spéculaire," *Psychoanalyse et cinéma*, Communications, 23 (1975): 73.

25. Quoted by Marie-José Baudinet, in *Nicéphore, Discours contre les iconoclastes* (Klincksiek, 1989), p. 9.

26. In *L'image-mouvement* and *L'image-temps* (Minuit, 1983 and 1985).

27. Jean Baudrillard, *The Evil Demon of Images* (Sydney: The Power Institute of Fine Arts, 1987).

28. Maurice Blanchot, *Le Livre à venir* (Gallimard, 1959), pp. 266-269.

KATHY RAE HUFFMAN

Video, Networks, and Architecture:
Some Physical Realities of Electronic Space

1. Paul Virilio, "The Overexposed City," in *Lost Dimension*, Daniel Moshenberg, trans., *Semiotext(e)*, (1991), p. 25.

2. *Informatics* is the study of computer systems, networks, memory banks, and terminals.

3. Gilles Deleuze, "Mediators," in *Incorporations*, Jonathan Crary and Sanford Kwinter, eds., (ZONE, 1992), pp. 628–633.

4. "Intelligente Ambiente," for Ars Electronica, 1994, co-curated by Carole Ann Klonarides and

Kathy Rae Huffman. A video program of thirty-eight single-channel works, in four
 sections, including the topics:

 1). Interim: Within and Beyond Confinement
 2). Interference: The Invisible Matrix
 3). Interstitial: Between What Is (Seen)
 4). Intervention: The Tactical Tourist

5. Woody Vasulka, "The New Epistemic Space," in *Illuminating Video*, Doug Hall and Sally Jo Fifer,
 eds., (New York: Aperture, 1989), pp. 465–470.

6. Marc Ries, *film+arc festival*, catalogue, Graz, Austria, p. l3.

7. Virilio, p. 25.

8. Some artists who were important to early video experiments were Peter Campus, Nam June
 Paik, Terry Fox, Shigeko Kubota, Vito Acconci, Bill Viola, Joan Jonas, and William Wegman.

9. Early experimenters in television: Douglas Davis, Allen Kaprow, Nam June Paik, Kit Galloway
 and Sherrie Rabinowitz, Jamie Davidovich, Richard Kriesche, Bob Adrian, David Hall,
 and Roy Ascott.

10. Virilio, p. 74.

11. Yorb World: http://www.itp.tsoa.nyu.edu/~yorb
 Ponton European Media Art Lab: http://ponton.uni-hannover.de/
 The Electronic Cafe International: http://www.ecafe.com/

12. Peter Eisenman, "Unfolding Events" in *Incorporations*, Jonathan Crary and Sanford Kwinter, eds.,
 (ZONE, 1992), p. 423.

13. Virilio, p. 17.

KIM H. VELTMAN

*Electronic Media: The Rebirth of Perspective and
the Fragmentation of Illusion*

I am very grateful to Jonathan Shekter and David Pritchard for reading the paper and offering
criticisms. I thank the following for specific help: Robert Lansdale, for providing figures 2–4 from his
research; Professor Derrick De Kerckhove for drawing my attention to the *City of Giotto* and for
note 31, Jordan Christensen for note 39, and Ed Barry of Kodak, Canada, for notes 23 and 40. I am
grateful to Eric Dobbs for stimulating some of the comments concerning cultural differences.

1. Fritz Novotny, *Cezanne und das Ende der wissenschaftliche Perspektive* (Vienna: Scroll, 1939).

2. H. H. Arnason, *A History of Modern Art* (London: Thames and Hudson, [1969], 1983), p. 9.

3. During this period Panofsky (1927) also wrote his landmark essay on perspective as a symbolic
 form, but major discussions concerning its implications did not begin until later.
 See, for example, John White, "Developments in Perspective," *Journal of the Warburg and
 Courtland Institutes* (London: 1949–1951) and the rebuttal by M. H. Pirenne, "The
 Scientific Basis of Leonardo da Vinci's Theory of Perspective," *The British Journal
 for Philosophy of Science*, 3 (1952): 169–185. There will be a considerably more thorough
 survey of these discussions in the author's *Literature on Perspective*, which is Volume 3
 of a four-volume standard bibliography on perspective.

4. It is noteworthy that national standards for technical drawing were established with respect
 to distinctions between first-angle (Britain) and third-angle (United States) projection in
 the 1920s and 1930s.

5. For an introductory bibliography on algorithms for perspective in computer graphics, see
 William G. Mitchell, *The Reconfigured Eye: Visual Truth in the Post-Photographic Era*
 (Cambridge, MA: MIT Press, 1993), pp. 244–245.

6. See Mitchell, *The Reconfigured Eye*, pp. 117–135.

7. See the author's "Developments in Perspective," in *The Visual Mind: Art and Mathematics*,
 Michele Emmer, ed., (Cambridge, MA: MIT Press, 1993), pp. 199–205.

8. Jurgis Baltrusaitis, *Anamorphoses ou perspectives curieuses* (Paris: Vrin, 1957).

9. I am grateful to my colleague and friend André Corboz for bringing this example
 to my attention.

10. Christoph G. Brandenberger, *Koordinatentransformation für digtale kartographische Daten mit Lagrange — und Spline —Interpolition* (Zürich: Institut für Kartographie, Eidgenössische Technische Hochschul e, 1985).

11. For another description, see Bruno Ernst, *Der Zauberspiegel des Maurits Cornelis Escher* (Berlin: Taco, 1986).

12. For a basic description of the difference between vector and rastor graphics, see Mitchell, *The Re-Configured Eye*, pp. 4–6.

13. See Mitchell, *The Reconfigured Eye*, p. 154.

14. See Mitchell, *The Reconfigured Eye*, p. 4.

15. Robert Lansdale, *Texture Mapping and Resampling for Computer Graphics*, M.A.Sc., Department of Electrical Engineering, University of Toronto, January 1991.

16. A more detailed analysis of these problems would explore how Lansdale's approach, which is an extension of image-precision algorithms, reverses the direction of projection used in Renaissance perspective, whereas object-precision algorithms maintain the direction of the projection used in Renaissance perspective.

17. Benoit Mandelbrot, *The Fractal Geometry of Nature* (New York: W. H. Freeman, 1977).

18. Michael Fielding Barnsley, *Fractals Everywhere: The First Course in Fractal Geometry* (Boston: Academic Press, 1988).

19. See L. Casey Larijani, *The Virtual Reality Primer* (New York: McGraw-Hill, Inc., 1993).

20. *The Kodak Guide to Imaging*, Michael D. Gurley and Frederick P. Burger, eds., (Rochester: Eastman Kodak, 1993), p. 5.

21. See Michael McGreevy, "Virtual Reality and Planetary Exploration," *Virtual Reality: Applications and Explorations*, Alex Wexelblatt, ed., (Boston: Academic Press, 1993), pp. 163–197.

22. For further discussion of these problems, see the author's "Ottica, percezione e prospettiva," in *Specchi americani: riflessi e metamorfosi delle tradizioni filosofiche europee nel nuovo mondo*, Catrina Maronne, ed., (San Sepolcro: 1994).

23. Heinrich Klotz, Florian Rötzer, and Peter Weibel, "Perspektiven der Computerkunst. Ein Gespräch" in *Künstliche Spiele*, Georg Hartwagner, Stefan Iglhaut, and Florian Rötzer, eds., (Munich: Boer, 1993), p. 123.

24. Charles Champlin, *George Lucas, The Creative Impulse: Lucasfilm's First Twenty Years* (New York: Harry Abrams, 1992). For a more detailed study see Thomas G. Smith, *Industrial Light and Magic: The Art of Special Effects* (New York: Ballantine Books, 1986).

25. Steve Aukstakalnis, David Blatner (*The Art and Science of Virtual Reality: Silicon Mirage* [Berkeley: Peachpit Press, 1992], pp. 238–242) regarding two programs that have been developed to this end, namely, n-Vision and Capri.

26. Kim Michael Fairchild, "Information Management Using Virtual Reality-Based Visualizations," in *Virtual Reality Application and* Explorations, Alan Wexelblatt, ed., (Boston: Academic Press, 1993), pp. 43–74.

27. See Grigore Burdea, Phillipe Coiffet, *La realité virtuelle* (Paris: Hermes), p. 196. This book also contains a useful bibliography on pp. 355–376.

28. Armand Fellous, "STV-Synthetic TV: From Laboratory Prototype to Production Tools," in *Virtual Worlds and Multimedia*, Nadia Magnenat Thalmann and Daniel Thalmann, eds., (Chichester: John Wiley and Sons, 1993), pp. 127–133.

29. Gerhard Schmitt, "Virtual Reality in Architecture," in *Virtual Worlds*, pp. 85–97.

30. Francesco Antinucci, "La città di Giotto. Installazione di realtà virtuale," Realizzazione: Infobyte; Produzione: Instituto di psicologia del CNR in collaborazione con ENEL, reported in *Futuro remoto* (November 25–December 15, 1993, Mostra d'Oltremare, Napoli, (Ercolano: La Buona Stampa, 1993): 14.

31. See the video "A Vision of Virtuality," (GMD: Schloss Birlinghoven, December, 1993).

32. One of the interesting aspects of the increasingly international scene is that the same software is being used for different ends in Japan, Canada, and the Unites States, while at the same time, Toronto firms such as Topix and Spin Productions are creating applications for Canada, Japan, and the United States.

33. This has led to a new field of scientific visualization. For a basic introduction see Richard Mark

Freidhoff, William Benzon, *The Second Computer Revolution: Visualization* (New York: Harry Abrams, 1989).

34. Warren Robinett, "Electronic Expansion of Human Perception," *Whole Earth Review* (San Francisco, Fall 1991): 16–21. One fascinating application of this principle is explored in Robinett's article, "The Nanomanipulator: A Virtual Reality Interface for a Scanning Tunneling Microscope," CB # 3175, UNC, Chapel Hill, NC 27599–3175. Robinett has also produced one of the standard attempts to classify the experiences in new technologies in "Synthetic Experience: A Proposed Taxonomy," *Presence*, vol. 1, 2 (Spring 1992): 229–247.

35. Steve Aukstakalnis, David Blatner, *The Art and Science of Virtual Reality*, pp. 23–24.

36. Ken Pimentel and Kevin Teixeira, *Virtual Reality: Through the New Looking Glass* (New York: Intel/Windscrest/McGraw-Hill, Inc., 1992), pp. 7, 17.

37. For a survey of recent studies, see Michael Kiene, *Giovanni Paolo Pannini: Römische Veduten aus dem Louvre* (Braunschweig: Anton Ulrich Museum, 1993).

38. Mitchell, *The Reconfigured Eye*, pp. 244–245.

39. The following is taken from newsgroups:
 sci.crypt,talk.politics.crypto,sci.answers,news.answers,talk.answers; Subject: Cryptography FAQ (01/10: Overview); January 17, 1994. Organization: The Crypt Cabal; Reply-To: crypt-comments@math.ncsu.edu Many people have contributed to this FAQ. In alphabetical order: Eric Bach, Steve Bellovin, Dan Bernstein, Nelson Bolyard, Carl Ellison, Jim Gillogly, Mike Gleason, Doug Gwyn, Luke O'Connor, Tony Patti, William Setzer. We apologize for any omissions:

6.8. What is 'authentication' and the 'key-exchange problem'?
The 'key-exchange problem' involves (1) ensuring that keys are exchanged so that the
 sender and receiver can perform encryption and decryption, and (2) doing so in
 such a way that ensures an eavesdropper or outside party cannot break the code.
 'Authentication' adds the requirement that (3) there is some assurance to the
 receiver that a message was encrypted by 'a given entity' and not 'someone else.'
The simplest but least available method to ensure all constraints above are
 satisfied (successful key exchange and valid authentication) is employed by private
 key cryptography: exchanging the key secretly. Note that under this same scheme,
 the problem of authentication is implicitly resolved. The assumption under the
 scheme is that the only sender will have the key capable of encrypting sensible
 messages delivered to the receiver. While public-key cryptographic methods solve a
 critical aspect of the 'key exchange problem,' specifically their resistance to analysis
 even with the presence of a passive eavesdropper during an exchange of keys,
 they do not solve all problems associated with key exchange. In particular, since
 the keys are considered 'public knowledge' (particularly with RSA) some other
 mechanism must be developed to testify to authenticity, because possession of keys
 alone (sufficient to encrypt intelligible messages) is no evidence of a particular
 unique identity of the sender.
One solution is to develop a key-distribution mechanism that assures that listed keys are actually
 those of given entities, sometimes called a 'trusted authority.' The authority typically
 does not actually generate keys, but does ensure via some mechanism that the lists of
 keys and associated identities kept and advertised for reference by senders and
 receivers are 'correct.' Another method relies on users to distribute and track each
 other's keys and trust in an informal, distributed fashion. This has been popularized as
 a viable alternative by the PGP software which calls the model the 'web of trust.'
Under RSA, if a person wishes to send evidence of their identity in addition to an encrypted
 message, they simply encrypt some information with their private key, called the
 'signature,' additionally included in the message sent under the public-key encryption
 to the receiver. The receiver can use the RSA algorithm ' in reverse' to verify that the
 information decrypts sensibly, such that only the given entity could have encrypted

the plaintext by use of the secret key. Typically the encrypted 'signature' is a 'message digest' that comprises a unique mathematical 'summary'
of the secret message (if the signature were static across multiple messages, once known previous receivers could use it falsely). In this way, theoretically only the sender of the message could generate their valid signature for that message, thereby authenticating it for the receiver. 'Digital signatures' have many other design properties as described in Section 7.

40. On the problems involved, see *Ethics, Copyright, and the Bottom Line*, Stewart McBride, ed., (Camden: Center for Creative Imaging) particularly Fred Richtin, "An Image Based Society," pp. 29–36. For reference to Kodak's research, see "When It's Created It's Copyrighted," in *The Kodak Guide to Imaging*, Michael D. Gurley, Frederick P. Burger, eds., (Rochester: Eastman Kodak, 1993), pp. 39–40. There is also an electronic bulletin board sponsored by ASMP and supported by Kodak called the *Electronic Picture Round Table (EPIX)*. See also the book by Fred Richtin, *In Our Own Image: The Coming Revolution in Photography* (New York: Aperture, 1990).

41. Sven Sandström, *Levels of Unreality: Studies in Structure and Construction in Italian Mural Painting* (Uppsala: Almqvist and Wikselld, 1963). (Acta Universitatis Upsallensis, Figura. new Series, 4).

LEV MANOVICH
The Automation of Sight: From Photography to Computer Vision

1. Charles Eames and Ray Eames, *A Computer Perspective: Background to the Computer Age* (Cambridge: Harvard University Press, 1990), pp. 65–67.
2. Quoted in Eames and Eames, p. 67.
3. For a survey of perspectival instruments, see Martin Kemp, *The Science of Art* (New Haven: Yale University Press, 1990), pp. 167–220.
4. Kemp, pp. 171–172.
5. Kemp, p. 200.
6. See Bruno Latour, "Visualization and Cognition: Thinking with Eyes and Hands," *Knowledge and Society: Studies in the Sociology of Culture Past and Present*, (vol. 6 1986): 1–40.
7. For a comprehensive account of 3-D computer graphics techniques, see William J. Mitchell, *The Reconfigured Eye: Visual Truth in the Postphotographic Era* (Cambridge: MIT Press, 1992), pp. 117–162.
8. Jasia Reichardt, *The Computer in Art* (London and New York: Studio Vista and Van Nostrand Reinhold Company, 1971), p. 15.
9. L. G. Roberts, *Machine Perception of Three-dimensional Solids*, MIT Lincoln Laboratory TR 315, 1963; L.G. Roberts, *Homogeneous Matrix Representations and Manipulation of N-Dimensional Constructs*, MIT Lincoln Laboratory MS 1405, 1965.
10. "Retrospectives 11: The Early Years in Computer Graphics at MIT, Lincoln Lab, and Harvard," in *SIGGRAPH '89 Panel Proceedings* (New York: The Association for Computing Machinery, 1989), p. 72.
11. This mixture of automated and preindustrial labor is characteristic of the early uses of computers for the production of images. In 1955 the psychologist Attneave was the first to construct an image which was to become one of the icons of the age of digital visuality—random squares pattern. A pattern consisted of a grid made from small squares colored black or white. A computer-generated table of random numbers has been used to determine the colors of the square—odd number for one color, even number for another. Using this procedure, two research assistants manually filled in 19,600 squares of the pattern. Paul Vitz and Arnold B. Glimcher, *Modern Art and Modern Science* (New York: Praeger Publishers, 1984), p. 234. Later, many artists, such as Harold Cohen, used computers to generate line drawings which they then colored by hand and transferred to canvas to serve as a foundation for painting.

12. For further discussion of the problem of realism in 3-D computer graphics, see Lev Manovich, "'Real' Wars: Esthetics and Professionalism in Computer Animation," *Design Issues* 6, no. 1 (Fall 1991): 18–25; Lev Manovich, "Assembling Reality: Myths of Computer Graphics," *Afterimage*, vol. 20 (September 1992): 12–14.

13. Mitchell, *The Reconfigured Eye*, p. 118.

14. "Retrospectives II: The Early Years in Computer Graphics at MIT, Lincoln Lab, and Harvard," p. 57.

15. Remko Scha, "Virtual Voices," *Mediamatic*, vol. 7 (1992): 33. Scha describes two fundamental approaches taken by the developers of voice-imitating machines: the genetic method which imitates the physiological processes that generate speech sounds in the human body and the gennematic method which is based on the analysis and reconstruction of speech sounds themselves without considering the way in which the human body produces them. While the field of computer vision, and of other fields of artificial intelligence, first clearly followed gennematic method, in the 1980s, with the growing popularity of neural networks, there was a shift towards the genetic method — direct imitation of the physiology of the visual system. In a number of laboratories, scientists are beginning to build artificial eyes which move, focus, and analyze information exactly like human eyes.

16. Eames and Eames, *A Computer Perspective*, p. 100.

17. Manuel De Landa, "Policing the Spectrum" in *War in the Age of Intelligent Machines* (New York: Zone Books, 1991), pp. 194–203.

18. De Landa, p. 214.

19. The first paper on image processing was published in 1955. L.S.G. Kovasznay, and H.M. Joseph, "Image Processing," *Proceedings of IRE*, vol. 43 (1955): 560–570.

20. Rafael C. Gonzalez and Paul Wintz, *Digital Image Processing* (Reading, MA: Addison-Wesley Publishing Company, 1977), p. 2.

21. Quoted in De Landa, p. 200.

22. Within the field of computer vision, a scene is defined as a collection of three-dimensional objects depicted in an input picture. David McArthur, "Computer Vision and Perceptual Psychology," *Psychological Bulletin*, vol. 92 (1982): 284.

23. Paul R. Cohen and Edward A. Feigenbaum, eds., *The Handbook of Artificial Intelligence* (Los Altos, CA: William Kaufmann, Inc., 1982), vol. 3: 139.

24. L. G. Roberts, "Machine Perception of Three-dimensional Solids," *Optical and Electo Optical Information Processing*, J.T. Tippett, ed. (Cambridge: MIT Press, 1965).

25. Cohen and Feigenbaum, *The Handbook of Artificial Intelligence*, p. 129.

26. Cohen and Feigenbaum, *The Handbook of Artificial Intelligence*, p. 127.

27. Latour, "Visualisation and Cognition," p. 8.

28. Cohen and Feigenbaum, *The Handbook of Artificial Intelligence*, p. 141.

29. Cohen and Feigenbaum, *The Handbook of Artificial Intelligence*, p. 128.

30. Cohen and Feigenbaum, *The Handbook of Artificial Intelligence*, p. 131.

31. David Lowe, "Three-dimensional Object Recognition from Single Two-dimensional Images, "Robotics Report," vol. 62 (New York: Courant Institute of Mathematical Sciences, New York University, 1986).

32. Cohen and Feigenbaum, *The Handbook of Artificial Intelligence*, pp. 254–259.

FLORIAN RÖTZER

Between Nodes and Data Packets

Translator's note: In this text, "suburb" refers to the German "Vorstadt" or French "banlieue" rather than to the middle or upper-class American suburb.

1. Brauner, Josef and Roland Bickman, *Die Multimediale Gesellschaft*, (Frankfurt: 1994), p. 123.

2. Häußerman, H., ed., *New York: Strukturen einer Metropole* (Frankfurt: 1993), p. 18.

3. Dubet, Francois and Didier Lapeyronnie, *Im Aus der Vorstädte: Der Zerfall der demokratischen Gemeinschaft* (Stuttgart: 1994), p. 118.

I am indebted to Brooks Landon and Felicity Nussbaum for their helpful comments on this essay.

1. Among the studies that explore these connections are Jay Bolter, *Writing Space: The Computer, Hypertext, and the History of Writing* (Hillsdale, NJ: Lawrence Erlbaum Associates, 1991); Michael Heim, *Electric Language: A Philosophical Study of Word Processing* (New Haven: Yale University Press, 1987); and Mark Poster, *The Mode of Information: Poststructuralism and Social Context* (Chicago: University of Chicago Press, 1990).

2. The paradox is discussed in N. Katherine Hayles, *Chaos Bound: Orderly Disorder in Contemporary Literature and Science* (Ithaca: Cornell University Press, 1990), pp. 31–60.

3. Self-organizing systems are discussed in Grégoire Nicolis and Ilya Prigogine, *Exploring Complexity: An Introduction* (New York: Freeman and Company, 1989); Roger Lewin, *Complexity: Life at the Edge of Chaos* (New York: Macmillan, 1992); and M. Mitchell Waldrop, *Complexity: The Emerging Science at the Edge of Order and Chaos* (New York: Simon and Schuster, 1992).

4. Friedrich A. Kittler, *Discourse Networks 1800/1900*, Michael Metteer with Chris Cullens, trans., (Stanford: Stanford University Press, 1990).

5. The implications of these conditions for postmodern embodiment are explored in N. Katherine Hayles, "The Materiality of Informatics," *Configurations: A Journal of Literature, Science, and Technology* 1 (Winter 1993): 147–170.

6. In *The Age of the Smart Machine: The Future of Work and Power* (New York: Basic Books, 1988), Shoshana Zuboff explores through three case studies the changes in United States workplaces as industries become informatted.

7. Computer law is discussed in Katie Hafner and John Markoff, *Cyberpunk: Outlaws and Hackers on the Computer Frontier* (New York: Simon and Schuster, 1991); also informative is Bruce Sterling, *The Hacker Crackdown: Law and Disorder on the Electronic Frontier* (New York: Bantam, 1992).

8. Sherry Turkle documents computer-network romances in "Constructions and Reconstructions of the Self in Virtual Reality," *Life on the Screen: Identity in the Age of the Internet* (New York: Simon and Schuster, 1995), also reprinted in this volume; Nicholson Baker's *Vox: A Novel* (New York: Random House, 1992) imaginatively explores the erotic potential for better living through telecommunications; and Howard Rheingold looks at the future of erotic encounters in cyberspace in "Teledildonics and Beyond," *Virtual Reality* (New York: Summit Books, 1991), pp. 345–77.

9. Howard Rheingold surveys the new virtual technologies in *Virtual Reality*. Also useful is Ken Pimentel and Kevin Teixeira, *Virtual Reality: Through the New Looking Glass* (New York: McGraw-Hill, 1993). Benjamin Woolley takes a sceptical approach toward claims for the new technology in *Virtual Worlds: a Journey in Hyped Hyperreality* (Oxford: Blackwell, 1992).

10. Donna Haraway, "Manifesto for Cyborgs: Science, Technology, and Socialist Feminism in the 1980s," *Socialist Review* 80 (1985): 65–108; See also "The High Cost of Information in Post World War II Evolutionary Biology: Ergonomics, Semiotics, and the Sociobiology of Communications Systems," *Philosophical Forum* XIII, 2–3 (1981–1982): 244–75.

11. Jacques Lacan, "Radiophonies," *Scilicet* 2/3 (1970): 55, 68. For floating signifiers, see *Le Séminaire XX: Encore* (Paris: Seuil, 1975), pp. 22, 35.

12. Although presence and absence loom much larger in Lacanian psycholinguistics than do pattern and randomness, Lacan was not uninterested in information theory. In the 1954–1955 *Seminar*, he played with incorporating ideas from information theory and cybernetics into psychoanalysis. See especially "The Circuit" pp. 77–90 and "Psychoanalysis and Cybernetics, or on the Nature of Language" pp. 294–308 in *The Seminar of Jacques Lacan: Book II*, edited by Jacques-Alain Miller (New York: W. W. Norton and Co., 1991).

13. Several theorists of the postmodern have identified mutation as an important element of postmodernism, including Ihab Hassan in *The Postmodern Turn: Essays in Postmodern Theory and Culture* (Columbus: Ohio State University Press, 1987), p. 91, and Donna Haraway,

"The Actors Are Cyborgs, Nature Is Coyote, and the Geography Is Elsewhere: Postscript to 'Cyborgs at Large,' " in *Technoculture*, Constance Penley and Andrew Ross, eds., (Minneapolis: University of Minnesota Press, 1991), pp. 21–26.

14. Claude E. Shannon and Warren Weaver, *The Mathematical Theory of Communication* (Urbana: University of Illinois Press, 1949).

15. The gender encoding implicit in "man" (rather than human) is also reflected in the emphasis on tool usage as a defining characteristic, rather than say altruism or extended nurturance, traits traditionally encoded female.

16. Kenneth P. Oakley, *Man the Tool-Maker* (London: Trustees of the British Museum, 1949). p. 1

17. The term "homeostasis," or self-regulating stability through cybernetic corrective feedback, was introduced by physiologist Walter B. Cannon in "Organization for Physiological Homeostasis," *Physiological Reviews*, 9 (1929): 399–431. Cannon's work influenced Norbert Wiener, and homeostasis became an important concept in the initial phase of cybernetics from 1946–1953.

18. Key figures in moving from homeostasis to self-organization were Heinz von Foerster, especially in *Observing Systems* (Salinas, California: Intersystems Publications, 1981) and Humberto R. Maturana and Francisco J. Varela, *Autopoiesis and Cognition: The Realization of the Living* (Dordrecht Reidel, 1980).

19. Howard Rheingold, *Virtual Reality*, pp. 13–49; Hans Moravec, *Mind Children: The Future of Robot and Human Intelligence* (Cambridge: Harvard University Press, 1988), pp. 1–5, 116–122.

20. The seminal text is Norbert Wiener, *Cybernetics: Or Control and Communication in the Animal and the Machine* (Cambridge: MIT Press, 1948).

21. Henry James, *The Art of the Novel* (New York: Charles Scribner's Sons, 1937), pp. 46–47.

22. David Harvey, *The Condition of Postmodernity: An Enquiry into the Origins of Cultural Change* (New York: Blackwell, 1989).

23. The material basis for informatics is meticulously documented in James Beniger, *The Control Revolution: Technological and Economic Origins of the Information Society* (Cambridge: Harvard University Press, 1986).

24. For an account of how tracks are detected, see *Cyberpunk*, pp. 35–40, 68–71.

25. David Porush discusses the genre of "cybernetic fiction," which he defines as fictions that resist the dehumanization that can be read into cybernetics, in *The Soft Machine: Cybernetic Fiction* (New York and London: Methuen, 1985); Burroughs's titular story is discussed on pp. 85–111. Robin Lydenberg has a fine exposition of Burroughs' style in *Word Cultures: Radical Theory and Practice in William Burroughs' Fiction* (Urbana: University of Illinois Press, 1987).

26. Fredric Jameson, *Postmodernism, or, the Cultural Logic of Late Capitalism* (Durham: Duke University Press, 1991), Introduction, xxxix.

27. Jacques Derrida, *Of Grammatology*, Gayatri C. Spivak, trans., (Baltimore: Johns Hopkins University Press, 1976).

28. Mark Leyner, *My Cousin, My Gastroenterologist* (New York: Harmony Books, 1990) pp. 6–7.

29. Walter Benjamin, "The Storyteller," *Illuminations*, Harry Zohn, trans., (New York: Schocken, 1969).

30. Jean-François Lyotard, *The Postmodern Condition: A Report on Knowledge*, Geoff Bennington and Brian Massumi, trans., (Minneapolis: University of Minnesota Press, 1984).

31. It is significant in this regard that Andrew Ross calls for cultural critics to consider themselves hackers in "Hacking Away at the Counterculture," in *Technoculture*, pp. 107–134.

32. George W. S. Trow, *Within the Context of No Context* (Boston: Little Brown, 1978).

33. Roland Barthes, *S/Z*, Richard Miller, trans., (New York: Hill and Wang, 1974)

34. Paul Virilio and Sylvere Lotringer, *Pure War*, Mark Polizzotti, trans., (New York: Semiotext(e), 1983).

35. "Embodied virtuality" is Mark Weiser's phrase in "The Computer for the 21st Century," *Scientific American*, 265 (September 1991): 94–104. Weiser distinguishes between technologies that put the user into a simulation with the computer (virtual reality) and those that embed computers within already existing environments (embodied virtuality or ubiquitous computing). In virtual reality, the user's sensorium is redirected into functionalities compatible with the simulation; in embodied virtuality, the sensorium continues to

function as it normally would but with an expanded range made possible through the environmentally embedded computers.

SIEGFRIED ZIELINSKI
Thinking the Border and the Boundary

1. Cesare Lombroso, "Genie und Irrsinnin ihren Beziehungen zum Gesetz, zur Kritik und zur Geschichte," (Leipzig: Philipp Reclam jun., 1905), p. 23.
2. Cesare Lombroso and R. Laschi, *Der politische Verbrecher und die Revolutionen* vol. 2 (Hamburg: Verlagsanstalt und Druckerei, vormals J.F. Richter, 1892), plates V–VI, figs. 1–6.
3. Lombroso and Laschi, vol. 1, diagram II, p. 156f.
4. Lombroso and Laschi, vol. 1, p. 47ff.
5. Hans Kurella, *Cesare Lombroso als Mensch und Forscher* (Wiesbaden: Bergmann, 1910), p. 2.
6. In a passage in his "Dispositive der Macht," Michel Foucault gives a condensed summary of his concept of archaeology that demonstrates his affinity with the "Documents" project: "Activization of local . . . species of knowledge as opposed to the scientific hierarchization of knowledge and the power effects inherent therein . . . archaeology would be the specific method for analyzing local discourses and genealogy would be the tactic that, starting from the local discourses described in this manner, allows the species of knowledge that surface, liberated from subjugation, free play" (German edition, Berlin, 1978, p. 65).
7. Sybille Krämer, *Symbolische Maschinen. Die Idee der Formalisierung in geschichtlichem Abriss* (Darmstadt: Wissenschaftliche Buchgesellschaft, 1988). All further references to Krämer in text are to this work.
8. Many thanks to Hinderk M. Emrich.
9. All quotations taken from the German edition of Wittgenstein's *Tractatus Logico-Philosophicus* (Frankfurt: Suhrkamp, 1960).
10. Cited in Jürgen Habermas, "Zwischen Erotismus und Allgemeiner Ökonomie," in J. Habermas *Der philosophische Diskurs der Moderne* (Frankfurt 1985), p. 267.
11. Peter Bürger, *Das Denken des Herrn Bataille. Zwischen Hegel und dem Surrealismus* (Frankfurt: Suhrkamp, 1992), p. 48.
12. Cf. our German translation of Baudry's essay "Ideologische Effekte erzeugt vom Basisapparat" in Eikon (Wien), Heft 5, 1993, and Baudry's two major essays in the French original: *Jean-Louis Baudry, L'effet Cinéma* (Paris: Edition albatros, 1978).
13. Lombroso, "Genie und Irrsinn," 1905, p. 23.
14. Lombroso, "Genie and Irrsinn," p. 22.

SLAVOJ ŽIŽEK
From Virtual Reality to the Virtualization of Reality

1. See Sigmund Freud, *Interpretation of Dreams* (Harmondsworth: Penguin Books, 1977) Chapter 11.
2. "The Seminar of Jacques Lacan," *Book 11: The Ego in Freud's Theory and in the Technique of Psychoanalyis,* (Cambridge: Cambridge Unversity Press, 1988), pp. 154–155.
3. Ibid., p. 168.
4. Ibid., Chapter XXIII.
5. See Sherry Turkle, *The Second Self: Computers and the Human Spirit* (New York: Simon and Schuster, 1984).
6. See Douglas R. Hofstadter's cult book *Gödel, Escher, Bach: An Eternal Golden Braid,* (New York: Basic Books, 1978).
7. Turkle offers here a rather naive psychological interpretation: the subculture of the hacker is a culture of male adolescents who are running away from sexual tensions into a world of formalized "adventure," in order to avoid "burning their fingers" with a real woman. Their attitude is inconsistent: they fear loneliness, at the same time being afraid of the approach of the other, woman, who because of her inconsistency is undependable; she can cheat, betray trust. The computer is a salvation from this dilemma: it is a partner; we are no longer alone, and at the same time it is not threatening, it is dependable and consistent.

From Kaleidoscomaniac to Cybernerd:
Notes Toward an Archeology of Media

1. C. W. Ceram, *Archaelogy of Cinema*, Richard Winston, trans., (London: Thames & Hudson, 1965), p. 17.

2. C. W. Ceram, *Archaelogy of Cinema*, p. 16.

3. This purpose is served much better by Franz Paul Liesegang's equally classic chronology of the prehistory of the cinema, *Dates and Sources: A Contribution to the History of the Art of Projection and to Cinematography*, Hermann Hecht, trans. and ed., (London: The Magic Lantern Society of Great Britain, 1986) [originally published in German, 1926]. A more recent attempt in historical chronology has been made by Maurice Bessy in his *Le mystère de la chambre noire: Histoire de la projection animée* (Paris: Editions Pygmalion, 1990). Bessy's year-by-year account incorporates plenty of hard-to-find documents illuminating the "discursive" side of the prehistory of the cinema—the attitudes, fears, and hopes of contemporaries. An exhaustive chronology of the immediate development leading to the cinema has been compiled by Deac Rossell, *A Chronology of Cinema 1889–1896, Film History*, vol. 7, 2 (Summer 1995).

4. This approach is epitomized by such popular accounts of the history of the computer as *A Computer Perspective*, by the office of Charles & Ray Eames, Glen Fleck, ed., (Cambridge, MA: Harvard University Press, 1973), and Peggy A. Kidwell & Paul E. Ceruzzi, *Landmarks in Digital Computing: A Smithsonian Pictorial History* (Washington and London: Smithsonian Institution Press, 1994). There is no need here to emphasize the well-known historical ties between the idea of progress and the Industrial Revolution.

5. A good example of such a hero-based account of the computer is Howard Rheingold's useful but biased *Tools for Thought: The People and Ideas behind the Next Computer Revolution* (New York: Simon & Schuster, 1985).

6. This is even the case with Raymond Kurzweil's massive compendium *The Age of Intelligent Machines* (Cambridge, MA: MIT Press, 1990).

7. Siegfried Giedion, *Mechanization Takes Command: A Contribution to Anonymous History* (New York: W. W. Norton, 1969 [1948]), p. vi.

8. Marc Bloch, *The Historian's Craft*, Peter Putnam, trans., (Manchester: Manchester University Press, 1954) [originally published in French, 1949].

9. Susan Buck-Morss, *The Dialectics of Seeing: Walter Benjamin and the Arcades Project* (Cambridge, MA: MIT Press, 1989), p. ix.

10. Tom Gunning, "Heard over the Phone: *The Lonely Villa* and the de Lorde Tradition of the Terrors of Technology," *Screen*, vol. 32, 2 (Summer 1991): 185.

11. See Tom Gunning, op cit. and "The World as Object Lesson: Cinema Audiences, Visual Culture and the St. Louis World's Fair, 1904," *Film History*, vol. 6 (1994): 422–444; Siegfried Zielinski, *Audiovisionen. Kino und Fernsehen als Zwischenspiel in der Geschichte*, (Reinbek bei Hamburg: Rowohlt, 1989); Friedrich A. Kittler, *Discourse Networks 1800/1900*, Michael Metteer with Chris Cullens, trans., (Stanford: Stanford University Press, 1990 [1985]) and *Grammophon Film Typewriter* (Berlin: Brinkmann & Bose, 1986); Avital Ronell, *The Telephone Book: Technology, Schizophrenia, Electric Speech* (Lincoln: University of Nebraska Press, 1989); Carolyn Marvin, *When Old Technologies Were New: Thinking About Electric Communication in the Late Nineteenth Century* (New York and Oxford: Oxford University Press, 1988); Susan J. Douglas, *Inventing American Broadcasting 1899-1922* (Baltimore and London: The Johns Hopkins University Press, 1987); Lynn Spiegel, *Make Room for TV: Television and the Family Ideal in Postwar America* (Chicago and London: The University of Chicago Press, 1992); Cecelia Tichi, *Electronic Hearth: Creating an American Television Culture* (New York and Oxford: Oxford University Press, 1991); William Boddy, "Electronic Vision: Genealogies and Gendered Technologies," a paper presented at the Finnish Society for Cinema Studies Conference, Helsinki, January 1993 (unpublished).

12. For a brilliant analysis of historical writing as a discursive practice, see Hayden White, *Metahistory: The Historical Imagination in Nineteenth Century Europe* (Baltimore: Johns Hopkins University Press, 1973).

13. Benjamin's influence could also be detected behind this emphasis. According to Susan Buck-Morss's interpretation, in *Passagen-Werk* he aimed at writing a " 'materialist philosophy of history,' constructed with 'the utmost concreteness' out of the historical material itself. . . . As the 'ur-phenomena' of modernity, they were to provide the material necessary for an interpretation of history's most recent configurations." (Susan Buck-Morss, op.cit., p. 3.)

14. Anne Friedberg, *Window Shopping. Cinema and the Postmodern* (Berkeley: University of California Press, 1993), p. 6.

15. Other media scholars, particularly in Germany, have used this concept, according to their own definitions. See for example Siegfried Zielinski: "Medienarchäologie. In der Suchbewegung nach den unterschiedlichen Ordnungen des Visionierens," *EIKON* (Vienna), Heft 9 (1994): 32–35.

16. Tom Gunning: "Heard over the Phone," op. cit., p. 185.

17. The kaleidoscope was invented by the British scientist Sir David Brewster in 1815 or 1816; his *Treatise on the Kaleidoscope* was published in 1819.

18. Reproduced in Rolf H. Krauss, *Die Fotografie in der Karikatur* (Seebruck am Chiemsee: Heering-Verlag 1978), p. 49.

19. See the anonymous stereograph dating from the 1860s, reproduced on a ViewMaster reel (Reel X, image 5) annexed to the Wim van Keulen book *3D Imagics: A Stereoscopic Guide to the 3D Past and its Magic Images 1838–1900*, AA Borger (The Netherlands): 3-D Book Productions, 1990. For another manifestation of the same motive, see the stereogram visible on the table in C. W. Ceram, op. cit., p. 112. For a general history of stereography, see William C. Darrah, *The World of Stereographs* (Gettysburg: William C. Darrah, 1977).

20. The film projector is basically a modified *laterna magica*, in which the transparent glass slides have been replaced by roll film. Making the film move in front of the lens required a machinery that derived from clockwork mechanisms, as well as from revolvers and machine guns. Robertson projected from behind the screen, with a moving lantern (on wheels, or on tracks); the Lumières (usually) from the front of the screen (and behind the audience). The physical movement of the lantern was replaced by the virtual movement on the screen.

21. Two illustrations showing audience reaction, said to date from 1797 and 1798, but probably later, have been published in Ceram, op. cit., p. 38. The reaction to the Lumière film may be a purely discursive creation. There are scattered remarks: writing about his first *cinématographe* show (in the *Nijegorodskilistok* journal, July 4, 1896) the Russian writer Maxim Gorki mentions that "it had been said that it [the train] will rush straight into the obscurity where we are," but he is disappointed. The train rushing toward the audience was featured in early Lumière posters or sketches (see Emmanuelle Toulet, *Cinématographe, invention du siècle*, Paris: Gallimard, 1988, pp. 11, 14.) The motive also appeared in early films about a fool who cannot tell the difference between reality and illusion in the cinema, such as *The Countryman and the Cinematograph* (R. W. Paul, 1901).

22. Paying attention to similarities, we should not try to explain away differences: *Fantasmagorie* was connected with the tradition of magic shows, with the fascination of the show being in the unexplained quality of the tricks. In the case of the Lumière screenings, the *cinèmatographe* as a technical novelty was an important aspect of the appeal of the show. Thus the projector was kept visible for the audience, whereas Robertson's magic lanterns were hidden from sight. Yet Charles Musser's observation that "Robertson's remarks [in his *Mémoires*] played on the simultaneous realization that the projected image was only an image and yet one that the spectator believed was real" may apply to the Lumière's (early) audiences as well. See Charles Musser, *The Emergence of Cinema: The American Screen to 1907*, part 1 of the *History of the American Cinema* (New York: Charles Scribner's Sons, 1990), p. 24.

23. A promotional video (1993) by the Showscan Corporation, a company producing and marketing specialty film, opens with a simulation theater sequence where wind, smoke, water, fire, a fish and even a UFO are "thrown" from the screen to the audience space. The audience reactions show pleasure rather than terror.

24. Ernst Robert Curtius, *Latin Literature and the European Middle Ages*, Willard R. Trask, trans., (London and Henley: Routledge and Kegan Paul, 1979) [originally published in German, 1948].

25. Ernst Robert Curtius, *Latin Literature and the European Middle Ages*, p. 70.

26. "[An allegorical figure in Balzac's *Jésus-Christ en Flandre* (1831)] is only comprehensible by the fact that it is rooted in the deeper strata of the soul. It belongs to the stock of archaic proto-images in the collective unconscious." (Ernst Robert Curtius, *Latin Literature and the European Middle Ages*, p.105.)

27. Michel Foucault, *The Archaelogy of Knowledge*, A. M. Sheridan Smith, trans., (London: Tavistock, 1982), p. 47.

28. Friedrich Kittler, *Discourse Networks 1800/1900*, Michael Metteer with Chris Cullens, trans., (Stanford: Stanford University Press, 1990).

29. Preface to Kittler: *Discourse Networks 1800/1900*, op. cit., p. xii.

30. Preface to Kittler: *Discourse Networks 1800/1900*, pp. 136–137.

31. Carolyn Marvin, *When Old Technologies Were New*, op. cit., p. 8. Mark Poster has criticized Marvin's "culturalist" position for not going "far enough in questioning dominant theoretical and disciplinary paradigms in relation to the new communicational forms." See Mark Poster, *The Mode of Information* (Chicago: The University of Chicago Press, 1990), p. 5.

32. *Electrical Review* (May 25, 1889): 6, cit. Marvin, op. cit., p. 197.

33. See John Perry Barlow, "Life in a Data-Cloud. Discussion with Jaron Lanier," *Mondo 2000*, 2. Innovations like the CU-SeeMe software, the Internet Phone, and the VRML programming language have been claimed to be rudimentary steps toward the realization of Lanier's vision.

34. A model for this could be the Sega Channel, an interactive, all-video-game channel planned for cable television. Sega may adopt its previously developed head-mounted display for home use as an interface to be used for both individual and collective game playing through the Sega Channel.

LOUISE K. WILSON

Cyberwar, God and Television: Interview with Paul Virilio

CTHEORY would like to thank Magali Fowler and Rania Stesan for assistance with translation during the interview. A very special thank you to Gildas Illien for the actual translation of the text from French into English.

FRIEDRICH KITTLER

There is No Software

1. Klaus Schrödl, "Quantensprung," *DOS* 12/1990, 102.f.

2. Cf. Alan M. Turing, "On Computable Numbers, with an Application to the Entscheidungsproblem," *Proceedings of the London Mathematical Society*, Second Series, vol. 42 (1937): 249.

3. Stephen C. Kleene, as quoted by Robert Rosen in "Effective Processes and Natural Law," *The Universal Turing Machine. A Half-Century Survey*, Rolf Herken, ed., (Hamburg-Berlin-Oxford, 1988), p. 527.

4. Johannes Lohmann, "Die Geburt der Tragödie aus dem Geiste der Muzik," (Archiv für Musikwissenschaft, 1980): 174.

5. Andrew Hodges, *Alan Turing: The Enigma* (New York, 1983), p. 399.

6. "TOOL Praxis: Assembler-Programmierung auf dem PC," *Ausgabe 1*, (Würzburg 1989): 9.

7. Nabajyoti Barkalati, *The Waite Group's Macroassembler Bible* (Indiana, 1989), p. 528.

8. Friedrich Kittler, "Protected Mode," *Computer, Macht und Gegenwehr. InformatikerInnen für eine andere Informatik*, Ute Bernhardt and Ingo Ruhmann, eds., (Bonn, 1991): 34–44.

9. Friedrich Kittler, "Signal-Rausch-Abstand," *Materialität der Kommunikation*, Hans-Ulrich Gumbrecht and K. Ludwig Pfeiffer, eds., (Frankfurt/M., 1988): 343–45.

10. Charles H. Bennett, "Logical Depth and Physical Complexity," *Herken*: 230.
11. With thanks to Oswald Wiener/Yukon.
12. M. Michael König, "Sachlich sehen," *Probleme bei der Überlassung von Software* (c't 3, 1990), 73 (Bundesgerichtshofentscheidung vom 2.5.1985, Az. I ZB 8/84, NJW-RR 1986, 219. Programs are defined as "Verkörperungen der geistgen Leistung, damit aber Sachen").
13. I am at a loss of understanding how Turing's famous paper could, in its first line, "briefly describe the 'computable numbers' as the real numbers whose expressions as a decimal are calculable by finite means" (On Computable Numbers, 230), then proceed to define the set of computable numbers as countable and finally call Pi, taken as "the limit of a computably convergent sequence," a computable number (256).
14. Brossl Hasslacher, "Algorithms in the World of Bounded Resource," *Herken*: 421.f.
15. Hasslacher, *Herken*: 420.
16. Friedrich-Wilhelm Hagemeyer, "Die Entstehung von Informationskonzepten in der Nachrichtentechnik," *Eine Fallstudie zur Theoriebildung in der Technik in Industrie und Kriegsforschung*, Phd. dissertation, Berlin, (1979): 432.
17. Alan Turing, "Intelligent Machinery, A Heretical Theory," in Sarah Turing and Alan M. Turing (Cambridge, 1959), p. 134.
18. Michael Conrad, "The Prize of Programmability," *Herken*: 289.
19. Conrad, *Herken*: 293.
20. Conrad, *Herken*: 290.
21. Conrad, *Herken*: 304.
22. cf. Conrad, 303.f.

PETER WEIBEL
The World as Interface

1. cf. "Maxwell's demon," in J.C. Maxwell, *Theory of Heat* (New York, 1872).
2. B. J. Alder and T. E. Wainwright, *Studies in Molecular Dynamics* (J. Chem. Phys. 27, 1957), pp. 1208–09.
3. R.J. Boscovich, Theoria Philosophia Naturalis (Vienna, 1758); reprint: *A Theory of Natural Philosophy* (Cambridge: MIT Press, 1966).
4. Otto E. Rössler, Endophysik. *Die Welt des inneren Beobachters*, Peter Weibel, ed., (Berlin, 1992).

SHERRY TURKLE
Constructions and Reconstructions of the Self in Virtual Reality

1. Amy Bruckman, a graduate student at MIT's Media Laboratory, was my research assistant and dialogue partner during a summer of intensive work on the MUD phenomena; my understanding of this activity and its importance owes much to our collaboration. The felicitous phrase "identity workshops" for describing the MUD's psychological power is of her coinage.
2. For a general introduction to LambdaMOO and MUD-ing, see Pavel Curtis, "Mudding: Social Phenomena in Text-Based Virtual Realities," Proceedings of DIAC92. (Available via anonymous ftp from parcftp.xerox.com, pub/MOO/papers /DIAC92.) and Amy Bruckman, "Identity Workshop: Emergent Social and Psychological Phenomena in Text-Based Virtual Reality," March, 1992, unpublished. On virtual community in general, see Allucquère Rosanne Stone, "Will the Real Body Please Stand Up?: Boundary Stories about Virtual Cultures" in Michael Benedikt, ed., Cyberspace: First Steps (Cambridge: MIT Press, 1992).
3. Sherry Turkle, *The Second Self: Computers and the Human Spirit* (New York: Simon and Schuster, 1984).
4. Turkle, *The Second Self*, p. 144.
5. For more material on the contrast with traditional role-playing see Gary Alan Fine, *Shared Fantasy: Role-Playing Games as Social Worlds* (Chicago: The University of Chicago Press,

1983). Henry Jenkins' study of fan culture, *Textual Poachers: Television Fans and Participatory Culture* (New York: Routledge, 1992), illuminates the general question of how individuals appropriate fantasy materials in the construction of identity.

6. "The Well" has a "topic" (discussion group) on "On-line Personae." In a March 24, 1992 posting to this group F. Randall Farmer noted that in a group of about 50 Habitat users, about a quarter experienced their online personae as separate creatures that act in ways they do in real life, and a quarter experienced their online personae as separate creatures that act in ways they do not in real life.

7. Of course, taking the analogy between a therapeutic milieu and virtual reality seriously means that incidents when players lose their anonymity are potentially psychologically damaging. In therapy, the transference is to the person of the therapist or to the therapy group; in virtual space, the transference is to the "body" of the MUD often as represented by its "wizards" or system administrators.

8. For more detail on this example, see Chip Morningstar and F. Randall Farmer, "The Lessons of Lucasfilm's Habitat," in Benedikt, ed., *Cyberspace: First Steps* (Cambridge: MIT Press, 1992), pp. 289–291.

9. See Turkle, "Thinking of Oneself as a Machine," in *The Second Self: Computers and the Human Spirit* (New York: Simon and Schuster, 1984).

HAKIM BEY

The Information War

1. The new "life" sciences offer some dialectical opposition here, or could do so if they worked through certain paradigms. Chaos theory seems to deal with the material world in positive ways, as does Gaia theory, morphogenetic theory, and various other "soft" and "neohermetic" disciplines. Elsewhere I've attempted to incorporate these philosophical implications into a "festal" synthesis. The point is not to abandon all thought about the material world, but to realize that all science has philosophical and political implications, and that science is a way of thinking, not a dogmatic structure of incontrovertible Truth. Of course quantum, relativity, and information theory are all "true" in some way and can be given a positive interpretation. I've already done that in several essays. Now I want to explore the negative aspects.

2. Stephan A. Hoeller, *Freedom: Alchemy for a Voluntary Society* (Wheaton, IL: Quest, 1992), pp. 229–230.

3. Hoeller, *Freedom: Alchemy for a Voluntary Society* : 164.

4. Like Pavlov's dogs salivating at the dinner bell rather than the dinner—a perfect illustration of what I mean by "abstraction."

5. Although some might say that it already "virtually" exists. I just heard from a friend in California of a new scheme for "universal prisons"—offenders will be allowed to live at home and go to work but will be electronically monitored at all times, like Winston Smith in *1984*. The universal panopticon now potentially coincides one-to-one with the whole of reality; life and work will take the place of outdated physical incarceration—the Prison Society will merge with "electronic democracy" to form a Surveillance State or information totality, with all time and space compacted beneath the unsleeping gaze of RoboCop. On the level of pure tech, at least, it would seem that we have at last arrived at "the future." "Honest citizens" of course will have nothing to fear; hence terror will reign unchallenged and Order will triumph like the Universal Ice. Our only hope may lie in the "chaotic perturbation" of massively linked computers, and in the venal stupidity or boredom of those who program and monitor the system.

6. I will always remember with pleasure being addressed, by a Bulgarian delegate to a conference I once attended, as a "fellow worker in philosophy." Perhaps the capitalist version would be "entrepreneur in philosophy," as if one bought ideas like apples at roadside stands.

7. Of course information may sometimes be "occult," as in conspiracy theory. Information may be "disinformation." Spies and propagandists make up a kind of shadow information economy, to be sure. Hackers who believe in freedom of information have my sympathy,

especially since they've been picked as the latest enemies of the Spectacular State, and subjected to its spasms of control-by-terror. But hackers have yet to "liberate" a single bit of information useful in our struggle. Their impotence, and their fascination with Imagery, make them ideal victims of the Information State, which itself is based on pure simulation. One needn't steal data from the post-military-industrial complex to know, in general, what it's up to. We understand enough to form our critique. More information by itself will never take the place of the actions we have failed to carry out; data by itself will never reach critical mass. Despite my loving debt to thinkers like Robert Anton Wilson and T. Leary I cannot agree with their optimistic analysis of the cognitive function of information technology. It is not the neural system alone which will achieve autonomy, but the entire body.

8. "Nothing Is True," *NO* 6, Box 175, Liverpool L69 8DX, UK.

9. Indeed, the whole "poetic terrorism" project has been proposed only as a strategy in this very war.

10. "The 'world' is 'one'" can be and has been used to justify a totality, a metaphysical ordering of "reality" with a "center" or "apex": one god, one king, etc., etc. This is the monism of orthodoxy, which naturally opposes Dualism and its other source of power (evil)— orthodoxy also presupposes that the one occupies a higher ontological position than the many, that transcendence takes precedence over immanence. What I call radical (or heretical) monism demands unity of one and many on the level of immanence; hence it is seen by orthodoxy as a turning-upside-down, or saturnalia, which proposes that every one is equally divine. Radical monism is "on the side of" the many—which explains why it seems to lie at the heart of pagan polytheism and shamanism, as well as extreme forms of monotheism such as Ismailism or Ranterism, based on "inner light" teachings. "All is one," therefore, can be spoken by any kind of monist or anti-dualist and can mean many different things.

11. A proposal: the new theory of Taoist dialectics. Think of the yin/yang disk, with a spot of black in the white lozenge, and vice versa — separated not by a straight line but an s-curve. Amiri Baraka says that dialectics is just "separating out the good from the bad"— but the Taoist is "beyond good and evil." The dialectic is supple, but the Taoist dialectic is downright sinuous. For example, making use of the Taoist dialectic, we can reevaluate Gnosis once again. True, it presents a negative view of the body and of becoming. But also true that it has played the role of the eternal rebel against all orthodoxy, and this makes it interesting. In its libertine and revolutionary manifestations, the Gnosis possesses many secrets, some of which are actually worth knowing. The organizational forms of Gnosis — the crackpot cult, the secret society — seem pregnant with possibilities for the TAZ/Immediatist project. Of course, as I've pointed out elsewhere, not all Gnosis is dualistic. There also exists a monist Gnostic tradition, which sometimes borrows heavily from Dualism and is often confused with it. Monist Gnosis is anti-eschatological, using religious language to describe this world, not Heaven or the Gnostic Pleroma. Shamanism, certain "crazy" forms of Taoism and Tantra and Zen, heterodox sufism and Ismailism, Christian antinomians such as the Ranters, etc.— share a conviction of the holiness of the "inner spirit," and of the actually real, the world. These are our spiritual ancestors. □

SELECTED BIBLIOGRAPHY

Aronowitz, Stanley, Barbara Martinsons, and Michael Menser, eds. *Technoscience and Cyberculture.* New York: Routledge, 1996.

Ascott, Roy. "Connectivity: Art and Interactive Telecommunications." *Leonardo,* Journal of the International Society for the Arts, Sciences and Technology (Guest Editors: Roy Ascott and Carl Loeffler), 24, 2, 1991.

Ascott, Roy. "From Appearance to Apparition: Dark Fiber, Boxed Cats, and Biocontrollers." *Intermedia,* 1, 1.

Ascott, Roy. "Is there Love in the Telematic Embrace?" *Art Journal* (Guest editor: Terry Gips. New York, College Art Association of America), 49, 3, Fall 1990.

Ascott, Roy. "La photographie à l'interface." *Digital Photography,* Centre National de la Photographie, Paris, 1992.

Ascott, Roy. "No Simple Matter: Artist as Media Producer in a Universe of Complex Systems." *AND, Journal of Art,* 28, 1993.

Ascott, Roy. "Telenoia: Art in the Age of Artificial Life." *Leonardo,* 26, 3, 1993.

Bailey, James. *Afterthought: The Computer Challenge to Human Intelligence.* New York: Basic Books, 1996.

Balsamo, Anne. *Technologies of the Gendered Body: Reading Cyborg Women.* Durham: Duke University Press, 1996.

Barglow, Raymond. *The Crisis of the Self in the Age of Information.* New York: Routledge, 1994.

Baudrillard, Jean. *The Ecstasy of Communication.* New York: Semiotext(e), 1988.

Baudrillard, Jean. *The Evil Demon of Images.* Sydney: The Power Institute of Fine Arts, 1987.

Baudrillard, Jean. *Fatal Strategies.* New York: Semiotext(e)/Pluto, 1990.

Baudrillard, Jean. *Simulations.* New York: Semiotext(e), 1983.

Bellour, Raymond. *Henri Michaux ou une mesure de l'être.* Paris: Gallimard, 1965.

Bellour, Raymond. *Jean-Luc Godard: Son + Image.* New York: Modern Museum of Art, 1992.

Bellour, Raymond. *Oubli: textes.* Paris: La Différence, 1992.

Bellour, Raymond. *Passages de l'image.* Paris: Centres Georges Pompidou, 1990.

Bender, Gretchen and Timothy Druckrey, eds. *Culture on the Brink: Ideologies of Technology.* Seattle: Bay Press, 1993.

Benedikt, Michael, ed. *Cyberspace: First Steps.* Cambridge: MIT Press, 1992.

Beniger, James. *The Control Revolution: Technological and Economic Origins of the Information Society.* Cambridge: Harvard University Press, 1986.

Benjamin, Walter. "A Small History of Photography." *One Way Street and Other Writings.* London: New Left Books, 1979 [1931].

Bentham, Jeremy. *The Panopticon Writings.* New York: Verso, 1996.

Bey, Hakim. *Immediatism.* San Francisco: AK Press, 1995.

Bey, Hakim. *The Temporary Autonomous Zone, Ontological Anarchy, Poetic Terrorism.* New York: Autonomedia, 1995.

Blonsky, Marshall. *On Signs.* New York: Oxford University Press, 1985.

Boden, Margaret, ed. *The Philosophy of Artificial Intelligence.* New York: Oxford University Press, 1996.

Bogard, William. *The Simulation of Surveillance.* New York: Cambridge University Press, 1996.

Bolter, Jay David. *Writing Space: The Computer, Hypertext, and the History of Writing.* Hillsdale, NJ: Lawrence Erlbaum Associates, 1991.

Brahm, Gabriel, Jr. and Mark Driscoll, eds. *Prosthetic Territories: Politics and Hypertechnologies.* Boulder: Westview Press, 1995.

Brand, Stewart. *The Media Lab: Inventing the Future at MIT.* New York: Viking Penguin, 1987.

Branscomb, Anne W. *Who Owns Information?* New York: Basic Books, 1994.

Branscomb, Anne W., ed. *Toward a Law of Global Communications Networks.*

Brook, James and Iain A. Boal, eds. *Resisting the Virtual Life: The Culture and Politics of Information.* San Francisco: City Light, 1995.

Buck-Morss, Susan. *The Dialectics of Seeing: Walter Benjamin and the Arcades Project.* Cambridge: MIT Press, 1989.

Bukatman, Scott. *Terminal Identity: The Virtual Subject in Post-Modern Science Fiction.* Durham: Duke University Press, 1993.

Bush, Vannevar. *Pieces of the Action.* New York: Morrow, 1970.

Bush, Vannevar. *Science is Not Enough.* New York: Morrow, 1967.

Campbell-Kelly, Martin and William Aspray. *Computer: A History of the Information Machine.* New York: Basic Books, 1996.

Ceram, C. W. *Archaelogy of Cinema.* Richard Winston, trans. London: Thames & Hudson, 1965.

Comolli, Jean-Louis. "Machines of the Visible." *The Cinematic Apparatus.* Teresa de Laurentis and Stephen Heath, eds. New York: St. Martins Press: 1980.

Conley, Verena Andermatt, ed. *ReThinking Technologies.* Minneapolis: University of Minnesota, 1993.

Cooke, Lynne and Peter Wollen, eds. *Visual Display: Culture Beyond Appearances.* Seattle: Bay Press, 1995.

Coyne, Richard. *Designing Information Technology in the Infomation Age.* Cambridge: MIT Press, 1995.

D'Agostino, Peter. *Transmission: Theory and Practice for a New Television Aesthetics.* New York: Tanam Press, 1985.

Damisch, Hubert. *The Origins of Perspective.* Cambridge: MIT Press, 1994.

Daston, Lorraine and Peter Galison. "The Image of Objectivity." *Representations,* 40, Fall 1992.

Debray, Régis. "The Three Ages of Looking." *Critical Inquiry,* 21, 3, Spring 1995.

Debray, Régis. *Media Manifestos.* New York: Verso, 1996.

De Landa, Manuel. *War in the Age of Intelligent Machines.* New York: Zone Books, 1991.

Deleuze, Gilles and Claire Parnet. *Dialogues.* Paris: Flammarion, 1977.

Derrida, Jacques. *Of Grammatology.* Gayatri C. Spivak, trans. Baltimore: Johns Hopkins University Press, 1976.

Dery, Mark. *Escape Velocity.* New York: Grove Press, 1996.

Dreyfus, Hubert L. *What Computers Can't Do: The Limits of Artificial Intelligence.* New York: Harper and Row, 1979. Originally published in 1972.

Druckrey, Timothy. "L'amour faux." *Perspektief,* 37, 1989–1990.

Druckrey, Timothy. "Revenge of the Nerds: An Interview with Jaron Lanier." *Afterimage,* May 1991.

Druckrey, Timothy, ed. *Iterations: The New Image*. Cambridge: MIT Press, 1994.

Edwards, Paul. *The Closed World: Computers and the Politics of Discourse in Cold War America*. Cambridge: MIT Press, 1996.

Enzensberger, Hans Magnus. *Civil Wars: From L.A. to Bosnia*. New York: New Press, 1995.

Enzensberger, Hans Magnus. *Critical Essays*. New York: Continuum, 1982.

Feenberg, Andrew and Alastair Hannay, eds. *Technology and the Politics of Knowledge*. Bloomington, Indiana University Press, 1995.

Foucault, Michel. *Discipline and Punish: The Birth of the Prison*. New York: Pantheon, 1979.

Foucault, Michel. *Madness and Civilization: A History of Insanity in the Age of Reason*. New York: Pantheon, 1973.

Foucault, Michel. *The Birth of the Clinic*. New York: Pantheon, 1975.

Foucault, Michel. *The Order of Things*. New York: Pantheon, 1973.

Friedberg, Anne. *Window Shopping: Cinema and the Postmodern*. Berkeley: University of California Press, 1993.

Flusser, Vilém. *Towards a Philosophy of Photography*. Göttingen: European Photography, 1984.

Gerbel, Karl and Peter Weibel, eds. *Genetic Art - Artificial Life*. Vienna: PVS Verleger, 1993.

Giedion, Siegfried. *Mechanization Takes Command: A Contribution to Anonymous History*. New York: W. W. Norton, 1969 [1948].

Goodman, Cynthia. *Digital Visions: Computers and Art*. New York: Harry N. Abrams, 1987.

Gray, Chris, ed. *The Cyborg Handbook*. New York: Routledge, 1995.

Halberstan, Judith and Ira Livingston, eds. *Posthuman Bodies*. Bloomington: Indiana University Press, 1995.

Hall, Doug and Sally Jo Fifer, eds. *lluminating Video*. New York: Aperture, 1989.

Hanhardt, John G., ed. *Video Culture: A Critical Investigation*. Layton, Utah: Peregrine Smith, 1986.

Haraway, Donna. "Manifesto for Cyborgs: Science, Technology, and Socialist Feminism in the 1980s." *Socialist Review*, 80, 1985.

Haraway, Donna. *Modest_Witness@Second_Millenium.FemaleMan.©Meets_OncoMouse™: Feminism and Technoscience*. New York: Routledge, 1996.

Haraway, Donna. *Simians, Cyborgs, and Women: The Reinvention of Nature*. New York: Routledge, 1991.

Harvey, David. *The Condition of Postmodernity: An Enquiry into the Origins of Cultural Change*. New York: Blackwell, 1989.

Hassan, Ihab, ed. *The Postmodern Turn: Essays in Postmodern Theory and Culture*. Columbus: Ohio State University Press, 1987.

Hayles, N. Katherine. *Chaos Unbound: Orderly Disorder in Contemporary Literature and Science*. Ithaca: Cornell University Press, 1995.

Hayles, N. Katherine. "The Materiality of Informatics." *Configurations: A Journal of Literature, Science, and Technology*, 1, Winter 1993.

Hayles, N. Katherine. *Virtual Bodies: Informatics and Comtemporary Literature*. Forthcoming.

Heidegger, Martin. *Being and Time*. New York: Harper and Row, 1962.

Heidegger, Martin. *Poetry, Language, Thought*. New York: Harper and Row, 1971.

Heidegger, Martin. *The Essence of Reasons*. Evanston: Northwestern University Press, 1969.

Heidegger, Martin. *The Question Concerning Technology and Other Essays.* New York: Harper & Row, 1977.

Heidegger, Martin. *What is Called Thinking?* New York: Harper Torchback, 1972.

Heims, Steven J. *John von Neuman and Norbert Wiener: From Mathematics to the Technologies of Life and Death.* Cambridge: MIT Press, 1980.

Huffman, Kathy Rae. "Interactive Interferences: Artists Interactive Television and the Challenge of the New Multimedia Television." *On The Air.* Heidi Grundmann, ed. Innsbruck: Transit, 1993.

Huffman, Kathy Rae, ed. *Video: A Retrospective.* Long Beach: Long Beach Museum of Art, 1984.

Huffman, Kathy Rae. "Video Art: What's TV Got To Do With It?" *Illuminating Video: An Essential Guide to Video Art.* Doug Hall and Sally Jo Fifer, eds. New York: Aperture in association with Bay Area Video Collection, 1987.

Huffman, Kathy Rae. Dorine Mignot, and Julie Lazar, eds. *The Arts for Television.* Amsterdam: Stedelijk Museum of Art; Los Angeles: Contemporary Museum of Art, 1987.

Huhtamo, Erkki. "Encapsulated Bodies in Motion: Simulators and the Quest for Total Immersion." *Critical Issues in the Electronic Media.* Simon Penny, ed. Albany: SUNY Press, 1995.

Huhtamo, Erkki. "Seeking Deeper Contact: Interactive Art as Metacommentary." *Convergence.* University of Luton & John Libbey, U.K., Autumn 1995.

Huhtamo, Erkki. "Time Machines in the Gallery: An Archeological Approach in Media Art." *Immersed in Technology: Art and Virtual Environments.* Mary Anne Moser, ed. Cambridge: MIT Press, 1996.

Iglhaut, Stefan, Armin Medosch, and Florian Rötzer, eds. *Stadt am Netz.* Bollman Verlag, 1996.

Jameson, Fredric. *Postmodernism, or, the Cultural Logic of Late Capitalism.* Durham: Duke University Press, 1991

Jameson, Fredric. *The Political Unconscious.* Ithaca: Cornell University Press, 1981.

Jones, Steven, ed. *Cybersociety: Computer Mediated Communication and Community.* Thousand Oaks: Sage, 1995.

Katsh, M. Ethan. *Law in A Digital World.* New York: Oxford University Press, 1995.

Keller, Evelyn Fox. *Refiguring Life: Metaphors of Twentieth Century Biology.* New York: Columbia University Press, 1994.

Kittler, Friedrich A. *Discourse Networks 1800/1900.* Michael Metteer with Chris Cullens trans. Stanford: Stanford University Press, 1990.

Kittler, Friedrich A. *Grammophon Film Typewriter.* Berlin: Brinkmann & Bose, 1986.

Kittler, Friedrich A. "Protected Mode." *Computer, Macht und Gegenwehr: InformatikerInnen für eine andere Informatik.* Ute Bernhardt and Ingo Ruhmann, eds. Bonn: 1991.

Kittler, Friedrich A., "Signal-Rausch-Abstand." *Materialität der Kommunikation.* Hans-Ulrich Gumbrecht and K. Ludwig Pfeiffer, eds. Frankfurt/M.: 1988.

Kurzweil, Raymond. *The Age of Intelligent Machines.* Cambridge: MIT Press, 1990.

Lanham, George. *Hypertext: The Convergence of Contemporary Literary Theory and Technology.* Baltimore: Johns Hopkins University Press, 1992.

Latour, Bruno. *Aramis or The Love of Technology.* Cambridge: Harvard University Press, 1996.

Laurel, Brenda. *Computers as Theater.* Reading, MA: Addison-Wesley, 1991.

Leeson Hershman, Lynn. *Clicking in: Hot Links to a Digital Culture.* Seattle: Bay Press, 1996.

Levidow, Les and Kevin Robins, eds. *Cyborg Worlds: The Military Information Society.* London: Free Association, 1989.

Levy, Pierre. *L'Intelligence collective, pour une anthropologie du cyberspace.* Paris: La Découverte, 1994.

Levy, Pierre. *Qu'est-ce que le virtuel?* Paris: La Découverte, 1994.

Liesegang, Franz Paul. *Dates and Sources: A Contribution to the History of the Art of Projection and to Cinematography*, Hermann Hecht, trans. and ed. London: The Magic Lantern Society of Great Britain, 1986.

Lister, Martin, ed. *The Photographic Image in Digital Culture.* New York: Routledge, 1995.

Lovejoy, Margot. *Postmodern Currents: Art and Artists in the Age of Electronic Media.* Ann Arbor and London: UMI Research Press, 1989.

Lovink, Geert. *Adilkno's 'Empire of Images.'* Amsterdam, 1985.

Lovink, Geert. *Cracking the Movement: Squatting Beyond the Media.* New York: Autonomedia, 1994.

Lovink, Geert. *Der Datendandy.* 1994.

Lovink, Geert. *MedienArchiv.* Bollmann Verlag, 1993.

Ludlow, Peter, ed. *High Noon on the Electronic Frontier: Conceptual Issues on Cyberspace.* Cambridge: MIT Press, 1996.

McLuhan, Marshall. *The Gutenberg Galaxy: The Making of Typographic Man.* Toronto: University of Toronto Press, 1972.

Manovich, Lev. *The Engineering of Vision from Constructivism to Virtual Reality.* Forthcoming.

Marvin, Carolyn. *When Old Technologies Were New: Thinking About Electric Communication in the Late Nineteenth Century.* New York and Oxford: Oxford University Press, 1988.

Megill, Allan, ed. *Rethinking Objectivity.* Durham: Duke Univesity Press, 1994.

Miller, Arthur, I. *Early Quantum Electrodynamics: A Source Book.* Cambridge, UK: Cambridge University Press, 1994.

Miller, Arthur, I. *Imagery in Scientific Thought: Creating 20th Century Physics.* Cambridge: MIT Press, 1986.

Miller, Arthur, I. *Insights of Genius: Imagery and Creativity in Science and Art.* New York: Springer-Verlag, 1996.

Minsky, Marvin. *Society of Mind.* New York: Simon and Schuster, 1985.

Mitchell, William J. *City of Bits: Space, Place, and the Infobahn.* Cambridge: MIT Press, 1995.

Mitchell, William J. *The Reconfigured Eye: Visual Truth in the Postphotographic Era.* Cambridge: MIT Press, 1992.

Moser, Mary Anne, ed. *Immersed in Technology: Art and Virtual Environments.* Cambridge: MIT Press, 1996.

Mumford, Lewis. *Art and Technics.* New York and London: Columbia University Press, 1952, 6th printing 1966.

Mumford, Lewis. *The Myth of the Machine: Technics and Human Development.* New York: Harcourt, Brace and World, 1966–1967.

Nichols, Bill. *Blurred Boundaries: Questions of Meaning in Compemporary Culture.* Bloomington: Indiana University Press, 1994.

Nichols, Bill. *Ideology and the Image.* Bloomington: Indiana University Press, 1981.

Nichols, Bill. *Representing Reality: Issues and Concepts in Documentary.* Bloomington: Indiana University Press, 1991.

Penley, Constance and Andrew Ross, eds. *Technoculture*. Minneapolis: University of Minnesota, 1991.

Penny, Simon, ed. *Critical Issues in Electronic Media*. Albany: SUNY Press, 1995.

Pool, Ithiel de Sola. *Technologies Without Boundaries: On Telecommunications in a Global Age*. Cambridge: Harvard University Press, 1990.

Popper, Frank. *Art of the Electronic Age*. New York: Harry N. Abrams, Inc., 1994.

Poster, Mark. *The Mode of Information: Poststructuralism and Social Context*. Chicago: University of Chicago Press, 1990.

Postman, Neil. *Amusing Ourselves to Death*. New York: Viking Penguin, 1985.

Postman, Neil. *Technopoly: The Surrender of Culture to Technology*. New York: Alfred Knopf, 1992.

Reichardt, Jasia. *Cybernetics, Art and Ideas*. Greenwich, CT: New York Graphic Society, 1971.

Rheingold, Howard. *Virtual Reality*. New York: Summit, 1991.

Ritchin, Fred. *In Our Own Image*. New York: Aperture, 1990.

Ritchin, Fred. "The End of Photography as We Have Known It." *Photovideo: Photography in the Age of the Computer*, P. Wombell, ed. London: Rivers Oram, 1991.

Rivlin, Robert. *The Algorithmic Image*. Redmond, WA: Microsoft Press, 1986.

Robertson, George and Melinda Mash, et al., eds. *FutureNatural: Nature/Science/Culture*. New York: Routledge, 1996.

Robins, Kevin. *Into the Image: Culture and Politics in the Field of the Image*. New York: Routledge, 1996.

Robins, Kevin and Frank Webster. *Information Technology: Post-Industrial Society or Capitalist Control?* Norwood, NJ: Ablex, 1986.

Robins, Kevin and Frank Webster. *The Technical Fix: Education, Computers and Industry*. New York: St. Martins Press, 1989.

Robins, Kevin, and Les Levidow "The Eye of the Storm." *Screen*, 3, 1991.

Ronell, Avital. *The Telephone Book: Technology, Schizophrenia, Electric Speech*. Lincoln: University of Nebraska Press, 1992.

Rötzer, Florian. *Die Telepolis: Urbanitaet im digitalen Zeitalter*. 1995.

Rötzer, Florian, ed. *Cyberspace: Zum medialen Gesamtkunstwerk*. Munich: Klaus Boer Verlag, 1993.

Sale, Kirkpatrick. *Rebels Against the Future*. New York: Addison-Wesley, 1995.

Shannon, Claude E. and Warren Weaver. *The Mathematical Theory of Communication*. Urbana: University of Illinois Press, 1949.

Smith, Merritt Roe and Leo Marx, eds. *Does Technology Drive History?* Cambridge: MIT Press, 1994.

Snow, C. P. *The Two Cultures*. Cambridge: Cambridge University Press, 1959.

Stone, Allucquère Rosanne. *The War of Desire and Technology at the Close of the Mechanical Age*. Cambridge: MIT Press, 1995.

Taylor, Lucien, ed. *Visualizing Theory*. New York: Routledge, 1994.

Tomas, David. "A Mechanism for Meaning: A Ritual and the Photographic Process." *Semiotica*, 46, 1, 1983.

Tomas, David. "The Ritual of Photography." *Semiotica*, 40, 1/2, 1982.

Tomas, David. *Transcultural Space and Transcultural Beings*. Boulder: Westview Press, 1996.

Tomas, David. *Theory Rules*. Toronto: YYZ Books/University of Toronto Press, 1996.

Turkle, Sherry. *Life on the Screen: Identity in the Age of the Internet.* New York: Simon & Schuster, 1995.

Turkle, Sherry. *Psychoanalytic Politics: Jacques Lacan and Freud's French Revolution.* New York: Guilford Press, 2nd ed., 1992.

Turkle, Sherry. *The Second Self: Computers and the Human Spirit.* New York: Simon and Schuster, 1984.

Veltman, Kim H. *Leonardo's Method.* Brescia: Centro Richerche Leonardiane, 1993.

Veltman, Kim H. "Linear Perspective and the Visual Dimensions of Science and Art." *Leonardo da Vinci Studies I,* 1986.

Virilio, Paul. *The Lost Dimension.* New York: Semiotext(e), 1991.

Virilio, Paul. *The Art of the Motor.* Minneapolis: University of Minnesota Press, 1995.

Virilio, Paul. *War and Cinema: The Logics of Perceprtion.* New York: Verso, 1988.

Webster, Frank. *Theories of the Information Society.* New York: Routledge, 1995.

Wechsler, Judith, ed. *On Aesthetics in Science.* Cambridge: MIT Press, 1981.

Weibel, Peter, ed. *On Justifying the Hypothetical Nature of Art and the Non-Identicality within the Object World.* Köln: Walter Konig GW, 1992.

Wiener, Norbert. *Cybernetics: Or Control and Communications in the Animal and the Machine.* Cambridge: MIT Press, 1967. Originally published in 1948.

Wiener, Norbert. *God and Golem.* Cambridge: MIT Press, 1964.

Wiener, Norbert. *The Human Use of Human Beings.* New York: Anchor Books, 1959.

Williams, Raymond. *Problems in Materialism and Culture: Selected Essays.* London: Verso UK, 1985.

Wilson, Louise K. "The Electronic Caress: Notes from an Unconscious Subject." *Public,* 1996.

Wilson, Louise K. "Weapons of Deconstruction?" *Parachute,* 1994.

Winner, Langdon. *Autonomous Technology: Technics-Out-of-Control as a Theme in Political Thought.* Cambridge: MIT Press, 1977.

Wombell, Paul, ed. *Photovideo: Photography in the Age of the Computer.* London: Rivers Oram Press, 1991.

Woodward, Kathleen, ed. *The Myths of Information.* Madison: Coda Press, 1980.

Zielinski, Siegfried. *Audiovisionen: Kino und Fernsehen als Zwischenspiel in der Geschichte.* Reinbek bei Hamburg: Rowohlt, 1989.

Žižek, Slavoj. *Looking Awry: An Introduction to Jacques Lacan Through Popular Culture.* Cambridge: MIT Press, 1991.

Žižek, Slavoj. *The Metastases of Enjoyment: Six Essays on Women and Causality.* New York: Verso, 1994.

Žižek, Slavoj. *The Sublime Object of Ideology.* New York: Verso, 1989.

Zuboff, Shoshana. *The Age of the Smart Machine: The Future of Work and Power.* New York: Basic Books, 1988. □

Author Biographies

R o y A s c o t t is a pioneer of telematics and interactivity in art. His seminal projects include *Terminal Art* (1980), *La Plissure du texte: A Planetary Fairy Tale* (Electra, 1984), and *Aspects of Gaia: Digital Pathways Across the Whole Earth* (Ars Electronica, 1989). In 1966 he published *Behaviorist Art and the Cybernetic Vision* (Cybernetica). Over ninety of his texts have been published in several languages. Ascott is on the board of numerous international journals, juries, and festivals, and advises many European government and private cultural organizations. He was also a commissioner for the Venice Biennale in 1986 ("Tecnologica e Informatica"). Ascott was formerly dean of the San Francisco Art Institute and a professor of communications theory at the University of Applied Arts in Vienna. He is currently the director of the Centre for Advanced Inquiry in the Interactive Arts (CAIIA) at the University of Wales College, Newport, and lectures widely throughout Europe and North America.

R a y m o n d B e l l o u r was born in 1939 in Lyons, where he studied literature, and later became a film critic for both daily and weekly magazines and newspapers. Bellour also worked for the journal *Cinema, Lettres Francaises*. After founding the revue *Artsept* in 1963, he entered the Centre National des Recherches Scientifiques, where he is currently director of research. *Alexandre Astruc* (1963) was his first book on cinema, and two years later he published *Henri Michaux*, his first on literature. In the beginning of the eighties Bellour became increasingly interested in video, photography, and mixed media, while continuing his writings on romanticism, literature, and cinema. In 1989 he participated in the exhibition *Passage de l'image*, and in 1991 he joined the cinema revue *Trafic*.

H a k i m B e y is best known for his "zine" publications, which have been collected in *T.A.Z. The Temporary Autonomous Zone, Ontological Anarchy, Poetic Terrorism* (Autonomedia, 1995), and more recently *Immediatism* (AK Press, 1995). For Bey there is no disappearance without reappearance.

D a v i d B l a i r is a filmmaker best known for his work on *WAX or the discovery of television among the bees*. He works primarily through image-processed narrative techniques, and is currently working on his next film, *Jews in Space*.

Anne Branscomb, a communications and computer lawyer, is a legal scholar-in-residence at Harvard University's Program on Information Resources Policy. She has served as chair of the Communications Law Division of the American Bar Association and as a member of the steering committee of the National Academy of Sciences Project on Rights and Responsibilities of Users of Computerized Information Networks. A frequent contributor to both popular and professional journals on the relationship between information technology and the law, she is the editor of *Toward a Law of Global Communications Networks*.

Vannevar Bush (1890–1974) is the pivotal figure in hypertext research. His conception of the "memex" introduced, for the first time, the idea of an easily accessible, individually configurable storehouse of knowledge. Bush did his undergraduate work at Tufts College, where he later taught. His master's thesis (1913) included the invention of the Profile Tracer, used in surveying work to measure distances over uneven ground. In 1919, he joined MIT's Department of Electrical Engineering, where he stayed for twenty-five years. In 1932, he was appointed vice-president and dean. At this time, Bush worked on optical and photocomposition devices, as well as a machine for rapid selection from banks of microfilm. Further positions followed: president of the Carnegie Institute in Washington, DC (1939); chair of the National Advisory Committee for Aeronautics (1939); director of the Office of Scientific Research and Development. This last role was a presidential appointment that made him responsible for the 6,000 scientists involved in the war effort.

Jean-Louis Comolli is a French cinematographer, critic, and theorist of Italian descent. As editor-in-chief of *Les Cahiers du Cinéma* from 1966 to 1971 he addressed such themes as ethics, politics, and aesthetics. During these years he developed his first fictional film, *La Cecilia*. A well-known documentary filmmaker, Comolli has worked on many projects for television, including the documentation of all of the elections in Marseille from 1989 to 1999. His films include *Les Deux Marseillaises* (doc., 1968), *La Cecilia* (1975), *On ne va pas se quitter comme ça* (doc., 1980), *L'Ombre rouge* (1981), and *Balles perdues* (1982).

Timothy Druckrey is an independent curator and writer whose work focuses on photographic history, electronic media, and theory. He is the editor of *Iterations: The New Image* (MIT Press, 1994) and most recently, *Culture on the Brink: Ideologies of Technology* (Bay Press, 1994), an anthology of essays published in association with the Dia Center for the Arts.

Hans Magnus Enzensberger is a poet, essayist, journalist, translator, and dramatist. He is the author of many books including *Civil Wars: From L.A. to Bosnia* (New Press, 1995), *Europe, Critical Essays* (Continuum, 1982); and *The Consciousness Industry.*

Vilém Flusser, born in 1920, emigrated in 1939 to Brazil, where he taught the philosophy of science at the University of São Paulo. He returned to Europe in the 1970s while writing on the philosophy of language and photography. His book *Towards a Philosophy of Photography* was published in 1984 by European Photography (Göttingen). Flusser's writing on technology developed into an extended discourse with electronic media. He wrote and lectured widely on communications, science, and representation. Dozens of his books published in Europe remain mostly untranslated. He died in 1992.

N. Katherine Hayles, a professor of English at UCLA, is the author of *Chaos Unbound: Orderly Disorder in Contemporary Literature and Science* (Cornell University Press, 1995). She is currently completing *Virtual Bodies: Informatics and Contemporary Literature.*

Martin Heidegger (1889–1976) is widely regarded as one of the central figures of the existentialist movement, and has had a major influence in the areas of phenomenology and ontology. His seminal work, *Sein und Zeit* (Being and time), (Harper & Row, 1962) affected the philosophical and cultural landscape of continental Europe for decades. One of Heidegger's later works, *The Question Concerning Technology* (HarperCollins, 1977), deals with the issue of dehumanization in modern society, which Heidegger termed the "darkening of the world."

Kathy Rae Huffman is a freelance curator, writer, and networker based in Austria since 1991. She has been active in the field of media art since the early 1980s. Huffman was curator of the Long Beach Museum of Art from 1979–1984. From 1984–1991 she served as curator/producer of the Contemporary Art Television (CAT) Fund, at the ICA Boston and the WBGH New Television Workshop. Huffman is currently a member of HILUS intermediale Projektforschung, a production and research platform for art and new technology in Vienna specializing in networking and metadesign. She created a real/virtual Internet project, "Siberian Deal," with Eva Wohlgemuth, which was awarded the multimedia prize at the Videofest Berlin, 1996.

Erkki Huhtamo is a media researcher, writer, and curator. He worked as a professor of media studies at the University of Lapland, Finland, between 1994–1996, and pursues his activities as a wandering scholar. Huhtamo has published numerous studies and articles in ten languages. Among the most recent are "Encapsulated Bodies in Motion: Simulators and the Quest for Total Immersion," in *Critical Issues in the Electronic Media* (SUNY Press, 1995); "Seeking Deeper Contact: Interactive Art as Metacommentary," in *Convergence* (University of Luton & John Libbey, U.K., Autumn 1995); and "Time Machines in the Gallery: An Archeological Approach in Media Art," in *Immersed in Technology: Art and Visual Environments* (MIT Press, 1996). Huhtamo has lectured worldwide and curated several international exhibitions of media art, including Digital Mediations, with Stephen Nowlin (Art Center College of Design Gallery, Pasadena, CA, 1995).

Friedrich Kittler has a doctorate in philosophy and has been a professor of aesthetics and the history of media at the Institute of Aesthetics, Humboldt University, in Berlin since 1993. Kittler studied German and French literature and philosophy at the University Freiberg/Breisgau. His publications include: *Discourse Networks 1800/1900* (Stanford University Press, 1990), *Grammophon Film Typewriter* (Brinkmann & Bose, 1986), *Dichter Mutter Kind* (1991), and *Draculas Vermächtnis: Technische Schriften* (1993).

Pierre Levy, born in 1956, is a philosopher and professor in the hypermedia department at the University of Paris at St. Denis. He is also a scientific advisor for TriVium, a French software company. Levy is a member of the *Revue Virtuelle* council at the Centre Georges Pompidou in Paris, and has published seven books about the cultural meanings of the digital revolution. His last two books are *L'Intelligence collective, pour une anthropologie du cyberspace* (La Découverte, 1994) and *Qu'est-ce que le virtuel?* (La Découverte, 1994).

Geert Lovink, born in 1959 in Amsterdam, Holland, studied political science at the University of Amsterdam. He is a member of Adilkno, the Foundation for the Advancement of Illegal Knowledge, a free association of media-related intellectuals (Agentur Bilwet in German). Lovink is a radio program producer for Radio Patapoe and VPRO radio in Amsterdam, and a co-founder of The Digital City, the Amsterdam-based Freenet, and Press Now, the Dutch support campaign for independent media in former Yugoslavia. Over the last few years he lectured on media theory in Bucharest and Budapest, and participated in conferences on independent media, the arts, and new technologies in Eastern Europe. Among his publications are Adilkno's "Empire of Images" (1985);

"Cracking the Movement" (1990/Bewegungslehre, 1991/1994) on the squatter movement in Amsterdam; "Hoer zu oder Stirb" (1992) on free radio; "MedienArchiv" (1992/Bollmann Verlag, 1993); and "Der Datendandy" (1994).

L e v M a n o v i c h is a theorist and critic of new media. He was born in 1960 in Moscow, where he studied fine arts and computer science. He completed his education in the United States, receiving a Master's degree in experimental psychology from New York University and a Ph.D. in visual and cultural studies from the University of Rochester. He has lectured widely on electronic art, and his writings have been published in seven countries. He is an assistant professor at the University of Maryland, where he teaches computer graphics, computer animation, and the theory and history of media. In 1995, he was awarded a Mellon Fellowship in Art Criticism by the California Institute of the Arts. He is currently working on two books: a collection of essays on digital realism and a history of the social and cultural origins of computer-graphics technologies, entitled *The Engineering of Vision from Constructivism to Virtual Reality*.

A r t h u r I . M i l l e r is a professor of history and the philosophy of science, and heads the department of science and technology studies at University College London. He is a Fellow of the American Physical Society, a corresponding Fellow of l'Académie Internationale d'Histoire des Sciences, and is director of the International History of Physics School at the Ettore Majorana Centre for Scientific Culture in Erice, Sicily. Professor Miller has lectured and written extensively on the history and philosophy of nineteenth- and twentieth-century science and technology, cognitive science, scientific creativity and the relation between art and science. He is the author of several books, including *Albert Einstein's Special Theory of Relativity: Emergence (1905), Early Interpretation (1905–1911)*, and *Imagery in Scientific Thought: Creating 20th Century Physics* (MIT Press, 1986). He has been featured on numerous radio and television programs. His latest book, *Insights of Genius: Imagery and Creativity in Science and Art*, is scheduled for publication in 1996.

B i l l N i c h o l s edited two volumes of the anthology *Movies and Methods* (University of California Press, 1976, 1985) and authored *Ideology and the Image* (Indiana University Press, 1981), *Representing Reality: Issues and Concepts in Documentary* (Indiana University Press, 1991), and most recently, *Blurred Boundaries: Questions of Meaning in Contemporary Culture* (Indiana University Press, 1994). He is currently working on several books that address questions of style and cross-cultural representation.

K e v i n R o b i n s works at the Centre for Urban and Regional Development Studies at the University of Newcastle. He is co-author, with Frank Webster, of *Information Technology: Post-Industrial Society or Capitalist Control?* (Ablex, 1986) and *The Technical Fix: Education, Computers, and Industry* (St. Martin's Press, 1989). Robins is also co-editor with Les Levidow of *Cyborg Worlds: The Military Information Society* (Free Association, 1989).

F l o r i a n R ö t z e r , born in 1953, pursues his study of philosophy as a freelance writer, critic, curator of exhibitions, and organizer of international conferences. His work deals primarily with the philosophy of digital media and informational society, as well as media aesthetics. He is the author of *Die Telepolis. Urbanitaet im digitalen Zeitalter* (1995), and editor of both *Zukunft des Koerpers I*, *Kunstforum International tome 132* (1995), and *Kunstforum International tome 133* (1996). As a member of the Medienlabor Muenchen, he is working on a new online magazine for culture and politics called *Telepolis* (http://www.ix.telepolis.de). He currently resides in Munich, Germany.

A l l u c q u è r e R o s a n n e S t o n e is an assistant professor and director of the Interactive Multimedia Laboratory (ACTlab) at the University of Texas at Austin. She is also director of the International Conferences on Cyberspace (http://www.actlab.utexas.edu/~Sandy).In *The War of Desire and Technology at the Close of the Mechanical Age* (MIT Press, 1995), Stone examines the myriad ways modern technology is challenging traditional notions of gender identity.

D a v i d T o m a s is an artist and anthropologist who has exhibited widely and has written on the cultures of imaging systems, the history of cybernetics, cyborgs, and contemporary art practices. He is the author of *Transcultural Space and Transcultural Beings* (Westview Press, 1996), a co-editor of *Theory Rules* (YYZ Books/University of Toronto Press, 1996), and a guest editor of a recent issues of *Public* on aspects of "touch" in contemporary art. In 1994–1995 he was a Mellon Fellow in contemporary art criticism in the California Institute of the Arts.

S h e r r y T u r k l e is a professor of the sociology of science at the Massachusetts Institute of Technology and a licensed clinical psychologist, holding a joint doctorate in personality psychology and sociology from Harvard University. She is the author of *Psychoanalytic Politics: Jacques Lacan and Freud's French Revolution* (Guilford Press, 2nd ed., 1992), *The Second Self: Computers and the Human Spirit* (Simon & Schuster, 1984) and, most recently, *Life on the Screen: Identity in the Age of the Internet* (Simon & Schuster, 1995). She lives in Boston, Massachusetts.

Kim H. Veltman is the director of the Perspective Unit at the University of Toronto. Born in Workum, Friesland, in the Netherlands, he is also a doctor of philosophy (history and philosophy of science) at the Warburg Institute in London. His publications include *Leonardo da Vinci Studies I: Linear Perspective and the Visual Dimensions of Science and Art* (1986) and *Leonardo's Method* (Centro Richerche Leonardiane, 1993).

Paul Virilio was born in Paris in 1932, and is the former director of the École Spéciale d'Architecture in Paris, where he is still a professor of architecture. He is the author of *Bunker Archeology* (Princeton Architectural Press, 1975), *Speed and Politics* (Semiotext(e), 1986), *War and Cinema* (Routledge Chapman & Hall, 1988), *The Vision Machine* (Indiana University Press, 1994), and several other books on technology and theory.

Peter Weibel was born in 1945, and studied at the Film Academy in Paris and later studied medicine, mathematics, and philosophy in Vienna. Since 1975 he has had many solo and group exhibitions. He has served as visiting-professor at universities in Vienna, Kassel, Halifax, and Buffalo. From 1986 to 1995 he served as program director of Ars Electronica in Linz, Austria. Since 1989 he has served as director of the Institute for New Media at the Stadelschule in Frankfurt/Main. Selected publications include *Studien zur Theorie der Automaten* with F. Kaltenbeck (1974); *Virtuelle Welten* with G. Hattinger (1990); *Strategien des Scheins: Kunst-Computer-Medien* published with F. Rötzer (1991); *Das Bild nach dem letzten Bild* published with C. Meier (1991); *Cyberspace: Zum medualen Gesamtkunstwerk* published with F. Rötzer (1993); and *Genetische Kunst - Kunstliches Leben* published with K. Gerbel (1993).

Louise K. Wilson was born in 1965, and recently completed an MFA in Studio Arts at Concordia University in Montreal. Her installation and performance work has been presented in solo and group exhibitions in North America and Europe. Among her published articles are "Weapons of Deconstruction?" *Parachute*, 1994; "Cyberwar, God and Television: Interview with Paul Virilio," originally published in the electronic journal *CTHEORY*; and "The Electronic Caress: Notes from an Unconscious Subject," *Public*, 1996. She lives in Devon, England.

Siegfried Zielinski has written numerous books on art, philosophy, history, and theory at the Academy of Media Arts, Cologne, and is founding principal of its new arts school.

S l a v o j Ž i ž e k was born in 1949 in Ljubljana, Slovenia, and is senior researcher at the Institute for Social Sciences at the University of Ljubljana. Best known in the United States for Lacanian analyses of film, and especially of Hitchcock, he has used Lacan (along with Kant, Hegel, Marx, and Althusser) to offer new accounts of ideology, critique, radical evil, and, most recently, the disintegration and reconfiguration of Eastern Europe. Žižek's recent works in English include *The Sublime Object of Ideology* (Verso, 1989); *For They Know Not What They Do: Enjoyment as a Political Factor* (Verso, 1991); *Enjoy Your Symptom!: Jacques Lacan in Hollywood and Out* (Routledge, 1992); and *Tarrying With the Negative: Kant, Hegel, and the Critique of Ideology* (Duke, 1993). He has also edited volumes on Lacan and on ideology. □

CREDITS

PHOTOGRAPHS: Unless otherwise noted, all photographs are courtesy of, and copyright by, the artists. pp. 14, 19 courtesy of Julia Scher and äda'web; p. 120 Ken Feingold, *Where I Can See My House from Here*, 1994 (composite image); p. 239, copyright by the Boeing Company; p. 246: photograph from *S,M,L,XL*, by Rem Koolhaas and Bruce Mau, The Monacelli Press, Inc., New York, 1995; p. 320, Ken Feingold, *Childhood/Hot and Cold Wars*, 1993 (detail).

TEXTS: All texts are courtesy of, and copyright by, the authors, except as noted: "The Information War," by Hakim Bey and "The Coming of Age of the Flesh Machine," by Critical Art Ensemble are both ⓐ anti-copyrighted. pp. 29–45, "As We May Think," by Vannevar Bush was originally published in the July 1945 issue of *The Atlantic Monthly* and is reproduced here with their permission; pp. 47–61, "The Age of the World Picture" from *The Question Concerning Technology and Other Essays* by Martin Heidegger. English language translation copyright © 1977 by Harper & Row, Publishers, Inc. Reprinted by permission of HarperCollins Publishers, Inc.; pp. 62–85, "Constituents of a Theory of the Media," by Hans Magnus Enzensberger. Copyright © 1974 by the *New Left Review*. From *Critical Essays*, German Library Volume 98, edited by Reinhold Grimm and Bruce Armstrong. Reprinted by permission of the Continuum Publishing Company; pp. 86–107, "Visualization Lost and Regained," by Arthur I. Miller from *On Aesthetics in Science*. Copyright © Judith Wechsler; pp. 108–117, "Machines of the Visible," by Jean-Louis Comolli. Copyright © Teresa deLaurentis, editor, from *The Cinematic Apparatus*. Reprinted with permission of St. Martin's Press, Incorporated (U.S.A.) and Macmillan Ltd. (U.K.); pp. 145–153, "From the Photograph to Postphotographic Practice," by David Tomas, was originally published in *SubStance*, 55, 1988: 59–68. It has been re-edited for the present volume.; pp. 154–163, "The Virtual Unconscious in Postphotography," by Kevin Robins was originally published in *Science as Culture*, vol. 3, part 1, 14: 99–115; pp. 165–171, A shorter version of "Photography at the Interface," by Roy Ascott was published as "La photographie à l'interface," in *Digital Photography* by the Centre National de la Photographie, Paris, 1992; pp. 173–199, "The Double Helix," by Raymond Bellour, from the catalog *Passages de l'image*, Musée nationale d'art moderne, Centre Georges Pompidou, 1991; pp. 200–207, an earlier version of "Video, Networks, and Architecture," by Kathy Rae Huffman was published in the Ars Electronica catalog *Intelligente Ambiente*, Band 1, Summer 1994, pp. 156–160; pp. 209–227, "Electronic Media," by Kim H. Veltman was originally published in *Illusion and Simulation* [Begegnung mit der Realität], Stefan Iglhaut, Florian Rötzer, and Elisabeth Schweeger, eds. (Cantz Verlag, 1995); pp. 229–239, an earlier version of "The Automation of Sight," by Lev Manovich was presented at the conference "Photography and the Photographic: Theories, Practices, Histories" at the University of California, Riverside, in April 1994. A part of the paper appeared in the author's essay "Mapping Space: Perspective, Radar and Computer Graphics," *Computer Graphics Visual Proceedings*, Thomas Linehan, ed. (New York: ACM, 1993); pp. 242–245, "Digital Apparition," by Vilém Flusser was originally published as "Digitaler Schein" by Florian Rötzer (Suhrkamp Verlag). The English translation by Andreas Broeckmann has been edited for this volume; pp. 259–277, "Virtual Bodies and Flickering Signifiers," by N. Katherine Hayles, appeared in *October 66* (Fall 1993), pp. 69–91.© 1993 by October Magazine Ltd. and the Massachusetts Institute of Technology. Reprinted by permission of The MIT Press Journals; pp. 290–295, "From Virtual Reality to the Virtualization of Reality," by Slavoj Žižek, appeared in *On Justifying the Hypothetical Nature of Art and the Non-Identicality of the Object World*, Peter Weibel, ed. (Köln: Galerie Tanja Grunert, 1992); pp. 297–303, an earlier version of "From Kaleidoscomaniac to Cybernerd," by Erkki Huhtamo appeared in the ISEA 1994 catalog, edited by Minna Tarkka (Helsinki: University of Art and Design, 1994), Series B 40, pp. 130–135; pp. 321–329, "Cyberwar, God and Television: Interview with Paul Virilio," by Louise K. Wilson, was originally published in the electronic journal CTHEORY (ctheory@vax2.concordia.ca) in December, 1994 (Volume 18, Number 1–3) and is printed here with their permission; pp. 354–365, "Constructions and Reconstructions of the Self in Virtual Reality," by Sherry Turkle, originally published in *Mind, Culture, and Activity*, vol. 1, no. 3 (Summer 1994); pp. 376–383, "Common Law for the Electronic Frontier," by Anne W. Branscomb was originally published in *Scientific American*, September 1991: 145–157. ☐

ACKNOWLEDGMENTS

A project of this scope is necessarily a collaborative effort. Stretching the boundaries and holding to the practicalities is never an easy matter, and much gratitude for on-going discussion, professional nudging, and good humor go to Michael Sand at Aperture for supporting and sustaining this book through all of its stages. The authors, scattered throughout the world, gave their work, time, suggestions, and enthusiasm at every point in a time of overwhelming schedules and transformation. For this one can only thank them formally and hope that the book serves to incite yet further discourse. For the splendid cover images I would like to thank Alan Rath, Cheryl Haines, and SmartArt Press. The Critical Art Ensemble contributed the extraordinary images dividing the sections of the anthology. For their incisive work and advice I offer thanks and deep respect. I am truly grateful to Andreas Broeckman at V2 in Rotterdam, who translated the Flusser text, and who offered much help along the way. Some of the work for this book was done while on a stipend sponsored by the Kulturreferat in Munich, arranged by Stefan Iglhaut and Florian Rötzer. The work at the Villa Waldberta and the Medienlabor, Munich, demonstrated — sometimes too clearly — that telecommuting worked. To both my sincere thanks. The interns at Aperture, Cindy Williamson and Lesley Martin, spent countless hours ensuring that all the details were in order and to them I express my indebtedness and appreciation. Finally, I want offer my deepest appreciation to Sandy Stone, who took time from a dizzying schedule to write the preface for this book. Both a pioneer and a presence, Sandy has always found a way to civilize, scrutinize, and cultivate a community whose circumference seems ever-expanding. □

THIS BOOK WAS MADE POSSIBLE, IN PART, BY A GENEROUS
GRANT FROM THE HARRIETT AMES CHARITABLE TRUST.

Library of Congress Catalog Card Number: 96-83972
Hardcover ISBN: 0-89381-677-9
Paperback ISBN: 0-89381-678-7

Book design and composition by Susi Oberhelman
Jacket design by Christine Heun
Printed and bound by Quebecor Printing, Fairfield, Inc.

The staff at Aperture for *Electronic Culture* is: Michael E. Hoffman, Executive Director; Michael Sand, Editor; Stevan A. Baron, Production Director; Helen Marra, Production Manager; Anne Haas, Copy Editor; Lesley Martin and Cindy Williamson, Editorial Work-Scholars; Meredith Hinshaw and Laura Roberts, Production Work-Scholars.

Aperture Foundation publishes a periodical, books, and portfolios of fine photography to communicate with serious photographers and creative people everywhere. A complete catalog is available upon request. Address: 20 East 23rd Street, New York, New York 10010. Phone: (212) 598-4205. Fax: (212) 598-4015.

Aperture Foundation books are distributed internationally through:

Canada: General Publishing, 30 Lesmill Road, Don Mills, Ontario, M3B 2T6. Fax: (416) 445-5991. United Kingdom: Robert Hale, Ltd., Clerkenwell House, 45-47 Clerkenwell Green, London EC1R OHT. Fax: 171-490-4958. Continental Europe: Nilsson & Lamm, BV, Pampuslaan 212-214, PO Box 195, 1382 JS Weesp. Fax: 31-294-415054.

For international magazine subscription orders for the periodical *Aperture*, contact Aperture International Subscription Service, PO Box 14, Harold Hill, Romford, RM3 8EQ, England. Fax: 1-708-372-046. One year: £29.00. Price subject to change.

To subscribe to the periodical *Aperture* in the US write Aperture, P.O. Box 3000, Denville, NJ 07834. Tel: 1-800-783-4903. One year: $44.00.

FIRST EDITION

10 9 8 7 6 5 4 3 2 1